The Postmodern Educator

Studies in the
Postmodern Theory of Education

Joe L. Kincheloe and Shirley R. Steinberg
General Editors

Vol. 89

PETER LANG
New York • Washington, D.C./Baltimore • Boston
Bern • Frankfurt am Main • Berlin • Vienna • Paris

The Postmodern Educator

Arts-Based Inquiries and Teacher Development

Coedited by
C. T. Patrick Diamond
and Carol A. Mullen

PETER LANG
New York • Washington, D.C./Baltimore • Boston
Bern • Frankfurt am Main • Berlin • Vienna • Paris

LIBRARY OF CONGRESS CATALOGING-IN-PUBLICATION DATA

The postmodern educator: arts-based inquiries and teacher development /
co-edited by C. T. Patrick Diamond and Carol A. Mullen.
p. cm. — (Counterpoints; vol. 89)
Includes bibliographical references (p.) and index.
1. Teachers—Training of. 2. Teachers—In-service training. 3. Arts—Study and
teaching. 4. Postmodernism and education. 5. Action research in education.
I. Diamond, C. T. Patrick. II. Mullen, Carol A. III. Series:
Counterpoints (New York, N. Y.); vol. 89
LB1707.P67 370'.71—dc21 98-24674
ISBN 0-8204-4101-5
ISSN 1058-1634

DIE DEUTSCHE BIBLIOTHEK-CIP-EINHEITSAUFNAHME

The postmodern educator: arts-based inquiries and teacher development /
C. T. Patrick Diamond and Carol A. Mullen, coed.
–New York; Washington, D.C./Baltimore; Boston; Bern;
Frankfurt am Main; Berlin; Vienna; Paris: Lang.
(Counterpoints; Vol. 89)
ISBN 0-8204-4101-5

Cover design by Bill Kealy
Cover mechanical by James F. Brisson

The paper in this book meets the guidelines for permanence and durability
of the Committee on Production Guidelines for Book Longevity
of the Council of Library Resources.

© 1999 Peter Lang Publishing, Inc., New York

Printed in the United States of America

*This book is dedicated
to the next generation of arts-based researchers.
We thank those who through their risk-taking and pioneering work
have imagined arts-based approaches into being.
We also thank those who reconceptualized
and freed up the established canons of education.
They helped give life to arts-based inquiry,
teacher development, and this book.
We hope that these guides can recognize themselves
in these pages.*

Contents

List of Figures xi

Foreword Shirley R. Steinberg & Joe L. Kincheloe xv

Notes on Coeditors and Contributors xix

Acknowledgments xxv

Credits xxix

Prologue **An Invitation to an In-quest**
 C. A. Mullen & C. T. P. Diamond 1

Part I **WHY ARTS-BASED INQUIRY
 AND TEACHER DEVELOPMENT?** **13**

Chapter 1 **Art Is a Part of Us: From
 Romance to Artful Story**
 C. T. P. Diamond & C. A. Mullen 15

Chapter 2 **The Air and Iron, Light and Dark
 of Arts-Based Educational Research**
 C. T. P. Diamond & C. A. Mullen 37

Chapter 3 **Mirrors, Rivers, and Snakes:
 Arts-Based Teacher Development**
 C. T. P. Diamond & C. A. Mullen 65

**Part II EXAMPLES OF ARTS-BASED INQUIRY
AND TEACHER DEVELOPMENT 93**

Chapter 4 **"Finding the Pieces" of a Personal Canon:
Teachers as "Free Artists of Themselves"**
C. T. P. Diamond, B. L. Borho,
& P. F. Petrasek 95

Chapter 5 **Encountering Little Margie,
My Child Self as Artist: Pieces
From an Arts-Based Dissertation**
M. Buttignol 121

Chapter 6 **Whiteness, Cracks and Ink-Stains:
Making Cultural Identity with
Euroamerican Preservice Teachers**
C. A. Mullen 147

Chapter 7 **Reciting and Reviewing the Educator
Self: An Exhibition of Five Self-Works**
C. T. P. Diamond 191

Chapter 8 **Signs of Ourselves: Of Self-
Narratives, Maps, and Essays**
C. T. P. Diamond 223

Chapter 9 **Stories of Breakout: Academic
Gatekeepers, Prisoners, and Outlaws**
C. A. Mullen & C. T. P. Diamond 253

Chapter 10 **Carousel: A Metaphor for Spinning
Inquiry in Prison and Education**
C. A. Mullen 281

Chapter 11 **"Roped Together": Artistic Forms
of Comentoring in Higher Education**
C. T. P. Diamond & C. A. Mullen 315

Chapter 12 **Musical Chords: An Arts-Based Inquiry in Four Parts**
C. A. Mullen, C. T. P. Diamond, M. Beattie, & W. A. Kealy 341

Chapter 13 **"From the Next Scale Up": Using Graphic Arts as an Opening to Mentoring**
W. A. Kealy & C. A. Mullen 375

Chapter 14 **"Hello, Can You Play?": Life's Roles with Puppet Performances**
J. Kaufman 397

Chapter 15 **Animals and Curriculum Masters**
N. Paley & J. Jipson 409

Chapter 16 **"WH ERE SH OULD WE BE GIN?": Palimpsest as "Space Probe"**
C. T. P. Diamond, R. Arnold, & C. Wearring 423

Postlogue **A Quest: Birthing the Postmodern Individual**
C. T. P. Diamond & C. A. Mullen 449

Subject Index 465

Figures

Figure 1 **Transitions: Dissolving and
Emerging Phases/Faces**
K. Mantas (1993) 5

Figure 2 **Your Window onto Our Windows**
C. A. Mullen, C. T. P. Diamond,
& W. A. Kealy (1998) 10

Figure 3 **Drawing Hands**
M. C. Escher (1948) 47

Figure 4 **The Comic Storyboard Form**
R. Taylor (1997) 55–56

Figure 5 **Hand with a Reflecting Sphere**
M. C. Escher (1935) 71

Figure 6 **Your River or Snake Segments**
M. Pope & P. Denicolo (1993) 82

Figure 7 **From Books to Butterflies**
K. Mantas (1998) 104

Figure 8 **Kindergarten Poem**
M. Buttignol (1995) 133

Figure 9 **Rules of My Life: "Eat No One's Dust"**
Megen (1996) 172

Figure 10 **Mufaro's Beautiful Daughters**
 C. A. Mullen (1997) 178

Figure 11 **People Stick to Their Own Crowds**
 Wilda (1996) 182

Figure 12 **Triple Self-Portrait**
 N. Rockwell (1960) 232

Figure 13 **Metaphor of Knowledge**
 K. Mantas (1998) 233

Figure 14 **Metaphor of Transformation**
 K. Mantas (1998) 234

Figure 15 **A Submerged Landscape**
 C. A. Mullen (1998, revised) 273

Figure 16 **Carol's Carousel: A Photographic Spin**
 C. A. Mullen (1998) 287

Figure 17 **Body Regulation in Space**
 K. Mantas (1995-1996) 289

Figure 18 **Captive Carousel-Rider**
 C. A. Mullen (1997) 290

Figure 19 **The Butterfly Launch**
 A. Melton (1998) 328

Figure 20 **The Möbius Strip: Improvising
 Through Artistic Keyboarding**
 W. A. Kealy (1998, revised) 348

Figure 21 **Intermingling Bars with Person**
 K. Mantas (1995-1996) 352

Figure 22 **Window on a Red Room**
 W. A. Kealy (1971) 362

Figure 23 **A Mentoring Mosaic of the
 Neo-Impressionist Movement**
 (W. A. Kealy, 1998) 381

Figure 24 **Academic Family Tree as Starburst**
 (W. A. Kealy, 1994) 382

Figure 25 **Puppet Types in Jan's Bag**
 J. Kaufman (1990) 399

Figure 26A **Eyes and Puppets Created by
 South American Participants** 400

Figure 26B **Puppets Used for Teaching Spanish**
 J. Kaufman (1993) 400

Figure 27 **Annie, Jan, and the Kids**
 J. Kaufman (WFSU-TV, 1986) 402

Figure 28 **Animals and Curriculum Masters**
 J. Jipson & N. Paley (1998)
 A–K 412–422

Figure 29 **Tightrope Walker**
 M. Leunig (n.d.) 453

Figure 30 **Our Window onto Your Windows**
 C. T. P. Diamond, C. A. Mullen,
 & W. A. Kealy (1998) 461

Foreword

Shirley R. Steinberg
Joe L. Kincheloe

I would guess that for as long as humans have been asking questions, women and men have searched for a way to define art. Plato not only defined art, but defined the vocations, the purposes, and the ideologies of artists and their place within society. Cornellius declared that education should always be within the confines of the church and that art should reveal matters of religiosity and scripture. In 19th century France, art was defined by the Romantic Era, followed by the Realists. The movements were embraced by the art public and naturally fueled by art critics who were part of the art establishment. In the latter part of the century, a group of young artists attempted to usurp the Realist movement. The group did not insist on painting literal interpretations of subjects, rather they saw art as a collage of light, movement, and color, an impression. Ushered in by Claude Monet, Edgar Degas, Edouard Manet, Auguste Renoir, Paul Cezanne, and others, Impressionism was born, not without objection. The Parisian public and art critics saw the movement as an insult to "true" art: Impressionism was perceived as a mess of unfinished sketches and "color so raw that it hurt their eyes" (Janson & Janson, 1966, p. 128). New artists were forbidden to exhibit in the Salon de Beaux Arts and the Impressionists eventually organized their own exhibits, which were scorned and ignored by the "educated" and wealthy French (Kincheloe, Steinberg, & Tippins, 1998).

Within 30 years, the definition of art had radically changed and, indeed, the once rebellious palette-toting upstarts in Paris became the new traditionalists. Born from social and ideological marginalization, Impressionism became the new definition of visual art. Of course, we know that art in every medium has been formed and reformed to the point that one would be indicted as an essentialist to define what exactly

"it" is. (That does not, however, prevent many scholars/artists from *try-ing* to define art.) In my attempt to discuss the importance of the arts within the teaching of students, I will not define what I believe the arts to be, but I validate and enthusiastically support the assertions and ideas presented by Mullen and Diamond in this important book.

Alfred North Whitehead contended that there are educational stages that should be anticipated and followed, which would, consequently, allow a fullness of learning to take place. Suggested by Whitehead as the first stage is "Romance." In my own redefinition of Whitehead, I would like to propose that the Romance "stage" become the Romance "theme," designed to permeate throughout the learning process. With the loving use of the arts throughout the curriculum, I believe we are able to capture this romance, build upon it, and create classrooms that are filled with the experiential magic of learning. The arts allow our students to "become" within the environment of the curriculum where they are free to access a variety of media in which to express them-selves (Steinberg, 1998, pp. 136–37).

This book is about teacher researchers, it is about reflective inquir-ers, and it is about social activists. Using a literacy of the arts, we find that not only are the arts instructive, romantic, and exciting, but that they can be and are political. We learn to fight the desire of the New Right to return to basics by reinstating the importance of the arts. Diamond and Mullen have done a fine job in putting together teacher-friendly, theory-inspired readings for the classroom teacher and teacher educator. They suggest that we have knowledge of curriculum theory and development, *and* a commitment to rigor in our exposure to the arts (sometimes, by any means necessary). By the use of curriculum theory and rigor, we are able to integrate knowledge, create a bricolage of research, and to interpret what we learn, what we teach. These "steps" lead us to the ability to make meaning of our world. As mean-ing makers, teachers and students are committed to combining their curricular knowledge with a knowledge and love of the arts, evolving into cultural citizens of a world that does not use narrow definitions (Kincheloe, 1991). The ability to expand the world, to make meaning, and to use different ways of knowing allows us to fulfill ourselves as humans who participate in the eternal learning experience of life.

Enjoy this book, use it, and celebrate it. The authors have bared their artistic souls in order to expand the abilities of teachers and students. With the committed integration of the arts within the cur-riculum, maybe we can create a school life that can reflect a crystal stair, a potential path to collective acceptance and social justice.

References

Janson, H. W., & Janson, D. J. (1966). *The story of painting.* New York: Harry N. Abrams.

Kincheloe, J. (1991). *Teachers as researchers: Qualitative inquiry as a path in empowerment.* London: Falmer.

Kincheloe, J., Steinberg, S. R., & Tippins, D. (1998). *The stigma of genius: Einstein and beyond modern education.* New York: Peter Lang.

Steinberg, S. R. (1998). Romancing the curriculum with student research. In S. R. Steinberg & J. L. Kincheloe (Eds.), *Students as researchers: Creating classrooms that matter.* London: Falmer.

Notes on Coeditors
and Contributors

Coeditors' Biographies

C. T. Patrick Diamond is Professor at the Center for Teacher Development, the Ontario Institute for Studies in Education, University of Toronto, 252 Bloor Street West, Toronto, Ontario, Canada M5S 1V6. Dr. Diamond's areas of specialization include arts-based narrative inquiry, qualitative research, and personal construct psychology. He is an associate editor for *Curriculum Inquiry*. He has published over 140 works, including a 1991 book, *Teacher Education as Transformation: A Psychological Perspective*, in which he explored the reconstruction of teachers' meanings through the uses of narrative inquiry, role-playing, and writing (Open University Press). Dr. Diamond has published extensively in journals such as *Australian Educational Researcher, Curriculum Inquiry, Empirical Studies of the Arts, Journal of Curriculum Studies*, and *Teaching and Teacher Education*. He is completing a three-year research project on preservice and induction teacher education that is funded by the Social Science and Humanities Research Council of Canada.

Dr. Diamond has taught summer institutes for teachers in Australia, Canada, and Brazil. Previously, Dr. Diamond was Director of the Queensland College of Art, the largest art school in higher education in Australia. He was also a consultant for the Art Gallery of Ontario. Email: *ctpdiamond@oise.utoronto.ca.*

Carol A. Mullen is Assistant Professor in the Department of Educational Foundations, Leadership, and Technology, College of Education, 4036 Haley Center, Auburn University, Auburn, Alabama 36849-5221. Dr. Mullen specializes in arts-based narrative development,

innovative curriculum programming, mentorship, and diversity. She is an associate editor of *Latino Studies Journal* and consulting editor for *Interchange*. Dr. Mullen has conducted research in prisons, universities, and schools, and has published in such journals as *Interchange, Journal of Applied Social Behavior, Journal of Curriculum Studies, Latino Studies Journal, Studies in Art Education,* and *Taboo: The Journal of Culture and Education.* Dr. Mullen's 1997 books are *Imprisoned Selves: An Inquiry into Prisons and Academe* and *Breaking the Circle of One: Redefining Mentorship in the Lives and Writings of Educators. Breaking the Circle of One* received the 1998 Division K Research Award, "Exemplary Research in Teaching and Teacher Education Award," from the American Educational Research Association. Her book that is in press, *New Directions for Mentoring: Creating a Culture of Synergy,* focuses on comentoring across faculty lines within a university-school partnership (Falmer Press). Other works include guest editorial issues with *Latino Studies Journal, Theory Into Practice,* and *The Professional Educator.*

Dr. Mullen currently teaches courses in leadership and professional development. She has taught courses in philosophy, multiculturalism, and cultural foundations at Texas A&M University, and in qualitative data analysis at Florida State University. She received her doctorate in curriculum studies and teacher development at the Ontario Institute for Studies in Education, University of Toronto, Canada. Email: mulleca@mail. auburn.edu.

Contributors' Biographies

Roslyn Arnold is Associate Professor or Reader in the Faculty of Education at the University of Sydney, Australia. She has developed a theory of psychodynamic pedagogy that is attracting attention in literacy development, special education, and juvenile justice. She is a published poet and is currently working on her second collection of poems.

Mary Beattie is Associate Professor at the Ontario Institute for Studies in Education, University of Toronto, where she teaches in the preservice and graduate programs. She is the author of *Constructing Professional Knowledge in Teaching: A Narrative of Change and Development* (Teachers College Press, 1995). Recent articles appeared in *Curriculum Inquiry, The Curriculum Journal, Educational*

Research, and the *Asia-Pacific Journal of Teacher Education.* Her ongoing research and writing focus on teachers' knowledge, professional development, educational reform, and narrative inquiry.

Betty Lou Borho is an elementary teacher at Sir Edgar Bauer School for the Waterloo District Separate School Board, Kitchener, Ontario. Her experiences include specialization in primary education, consultative responsibility for teacher inservice and programs development, participation on school and board-level curriculum committees, presentation of workshops, and associate teacher involvement. She has published in *Orbit.* As a grade two teacher, Betty Lou initiated team teaching with a colleague. Her professional interests include personal narrative, professional reading, and reflective practice. Betty Lou received her Master of Education at the Ontario Institute in Education, University of Toronto.

Margie Buttignol is a teacher with experience at the elementary, secondary, and teacher preservice levels. Her doctoral research at the Ontario Institute in Education, University of Toronto, combined the topics of creativity, teacher transformation, and arts-based inquiry. Margie has contributed two chapters to *Researching Teaching: Exploring Teacher Development Through Reflexive Inquiry* (editors Ardra L. Cole and J. Gary Knowles, Allyn & Bacon, in press). She is a member of the editorial board of the Among Teachers Community (AcT) journal. Margie is a Pakenham Scholar and a recipient of an Ontario Graduate Student award.

Jan Jipson is Professor of Education at National Louis University. Her recent books include *Repositioning Feminism and Education: Perspectives on Educating for Social Change* (with Petra Munro, Susan Victor, Karen Jones, and Gretchen Freed Rowland); *Daredevil Research: Re-Creating Analytic Practice* (with Nick Paley); *Intersections: Feminisms/Early Childhoods* (with Mary Hauser); and, forthcoming, *Questions of You: Constructing Collaborative Life* (also with Nick Paley).

Jan Kaufman is a professional puppeteer who performs and conducts workshops, demonstrations, and seminars throughout the world for both the public and private sectors. She presents for a wide range of audiences on topics ranging from puppetry and communication to

drug abuse, child abuse, self-esteem enhancement, educational improvement, and entertainment. Jan has performed in many elementary and high schools as well as at hospitals and prisons. She has also taught third grade and was Head of the Drama Department at Lakewood High School in California. Jan holds a M.A. degree in secondary education and a B.A. in art and drama from Chapman University, California.

William A. Kealy is Associate Professor of the Department of Educational Research at Florida State University in Tallahassee, Florida 32306-4453. He is also Associate Director of the Center for Performance Technology, Florida State University. Previously, he was a professor at Texas A&M University. Dr. Kealy has taught courses in instructional media design and production and technology in the schools. He conducts research in the area of human learning through text and graphic displays, and has published in *Contemporary Educational Psychology, British Journal of Educational Psychology, Journal of Educational Psychology, Reading Psychology, Journal of Experimental Education,* and *Educational Technology Research and Development.*

Dr. Kealy is also contributing to research on mentorship and support groups in higher education. His doctorate is in learning and instructional technology from Arizona State University. Dr. Kealy was formerly an art director at an advertising agency in Honolulu, Hawaii. His love of art and devotion to the creative process spans three decades–from his baccalaureate in fine arts at Cooper Union, New York, to advertising art direction, to his current interests in the area of multimedia instruction. Email: *wkealy@cpt.fsu.edu.*

Kathy Mantas is a secondary level teacher with the Toronto District School Board. Her teaching areas emphasize language and the visual arts. Although her background in the visual arts is eclectic, she has specialized in printmaking. Kathy is currently working on her Doctorate of Education at the Ontario Institute for Studies in Education, University of Toronto. Her professional interests lie in teacher development, with a focus on preservice teachers, curriculum studies, and the arts.

Ashley Melton attends Florida State University School in Tallahassee on an almost regular basis. Ashley loves expressing herself through

art and really enjoys the detailed, complex drawings and etchings of M. C. Escher. Outside school, Ashley lives an active life seeking fun. She hopes to lead a full and prosperous life making beautiful art and studying oceanography. To her friends Ashley is called "wonderful," and to new acquaintances, nothing less.

Nick Paley is a Professor of Education at George Washington University. He is the editor of *Finding Art's Place: Experiments in Contemporary Education and Culture; Daredevil Research: Re-Creating Analytic Practice* (with Jan Jipson); and other writings and projects that explore relationships between artistic practice and the production of educational knowledge. His new book, *Questions of You: Constructing Collaborative Life* (also with Jan Jipson), was published in 1998.

Peter Petrasek teaches theology, English, and integrated studies at Cardinal Newman High School (M.S.S.B.) in Scarborough, Ontario. An interdisciplinarian with 14 years of teaching experience, he has been involved in writing secondary school curriculum that integrates peace and social justice issues. He has published in *Orbit*. Peter is an active member of the Canadian Catholic Organization for Development and Peace and regularly conducts social justice workshops. He is currently pursuing a Master of Arts in Curriculum at the Ontario Institute for Studies in Education, University of Toronto.

Clare Wearring is an Honours Graduate in education from the University of Sydney and teaches at Menia High School in metropolitan Sydney, Australia. She specializes in English and History. Her Honors thesis explored the relationship between psychodynamic pedagogy, drama, and literacy.

Acknowledgments

In a multiform book assembled by two coeditors and a total of 13 contributors, we acknowledge the echoing voices and intentions of many others:

> The frontiers of a book are never clear-cut; beyond the title, the first lines, the last full stop, beyond its internal configuration and its autonomous form, it is caught up in a system of references to other books, other texts, other sentences: it is node within a network. (Foucault, 1972, p. 23)

> All words have the "taste" of a profession, a genre, a tendency, a party, a particular work, a particular person, a generation, an age group, the day and hour. Each word tastes of the context in which it has lived, its socially charged life; all words and forms are populated by intentions. (Bakhtin, 1986, p. 292)

Within the "system of references" this book represents, we wish to thank its authors, whose "words" and artworks have given many "forms" to arts-based research. These postmodern educators are themselves classroom teachers, dissertation candidates, visual and literary artists, and professors of education. As coeditors, we have enjoyed working with our contributors. We acknowledge the jointness of our insights and assistance.

Many hands at, and associated with, Peter Lang Publishing have connected to make this book possible. We thank Joe L. Kincheloe and Shirley R. Steinberg, General Editors of the *Counterpoints Series*, for supporting this project. We appreciate being given the opportunity to contribute to their breakthrough dialogue on the role of the postmodern in education. Our heartfelt thanks to Shirley Steinberg, who further assisted by inviting perspectives on theater and performance, cultural and popular studies. These inclusions have broadened our overall effort in blending the arts with educational inquiry.

Christopher S. Myers, Managing Director at Peter Lang, acted as catalyst by bringing "light" to this project. He ensured its transition from prospectus to published text, and always kept a steady hand for us. Lisa Dillon, Production Manager, gave special attention to our technical questions as well as to the typesetting of this book.

Our warm thanks also go to William A. Kealy, Associate Professor at Florida State University, for his technical support on this project involving the direction of graphics. He also prepared original artworks: the illustration and design of the book cover and, as a collaborator, the bookend "window" graphics (Figure 2 and Figure 30).

Patrick Diamond expresses gratitude for the research grant he was awarded from the Social Sciences and Humanities Research Council of Canada (SSHRC), which supported his contributions to the book.

References

Bakhtin, M. (1986). *The dialogic imagination.* (C. Emerson & M. Holoquist, Trans.). Austin, TX: University of Texas.

Foucault, M. (1972). *Madness and civilization.* (R. Howard, Trans.). London: Tavistock.

Credits

The following pages constitute a continuation of the copyright page. We are grateful to certain individuals for permission to "exhibit" their artworks. We also appreciate the permission granted by editors of the following journals and books to republish, in revised and elaborated form, the following works.

In Chapter 1, Pat Von Loewenstein's "You're Out!" appeared in the special issue, "Learning Together: Each in their own Way," of *Among Teachers: Experience and Inquiry,* 23 (1992), 75–80. It is incorporated with permission from this journal of the Among Teachers Community, sponsored by the Centre for Teacher Development, The Ontario Institute for Studies in Education, University of Toronto and Center for Research for Teacher Education and Development, University of Alberta.

Chapter 2 contains the illustration, "Drawing Hands," by M. C. Escher (1948) and is reprinted by permission. Copyright © 1998 Cordon Art B.V.–Baarn-Holland. All rights reserved.

The poem by Barbara Jensen (1997) is reprinted by permission. The illustration, "I'm Flying," is reprinted by permission of Rick Taylor (1997).

Chapter 3 is a revision of a paper presented at the Teacher Education and Reflection Institute (TERI97) given by Patrick Diamond at Pontificia Universidale Catolica de Sao Paulo (PUCSP) in July 1997. The Institute was sponsored by the Fundacao de Amparo a Pesquisa do Estado de Sao Paulo (FAPESP). Another version of the original paper is forthcoming in the *ESPecialist* (PUCSP). The poems by Xavier Fazio and Dilma Maria De Mello, both produced in 1997, are reprinted by permission.

First, the illustration, "Hand with a Reflecting Sphere," by M. C. Escher (1935), is reprinted by permission. Copyright © 1998 Cordon Art B.V.–Baarn-Holland. All rights reserved. Reproduction by permission of the National Gallery of Canada and George Escher, Mahone Bay, Nova Scotia, 1989.

Second, the illustration, "Your River or Snake Segments," by Maureen Pope and Pam Denicolo (1993, p. 541), is reprinted by permission of Elsevier Science.

In Chapter 4, Figure 7, "From Books to Butterflies," by Kathy Mantas (1998) is reprinted by permission.

Chapter 6 draws on Carol A. Mullen's short article, "Becoming multicultural educators: The journey of white preservice teachers," appearing in *Among Teachers: Experience and Inquiry, 23* (1997), 3–5. It was used for this lengthy chapter with permission from this journal of the Among Teachers Community.

Chapter 7 is a revision of C. T. Patrick Diamond's paper published in *Teaching and Teacher Education: An International Journal of Research and Studies,* 9(5/6), 1993, 511–517. Permission of Elsevier Science is acknowledged. An earlier version was presented as a paper at the annual meeting of the American Educational Research Association, Atlanta, April 1993.

The poem by Peter Petrasek (1997) is reprinted by permission.

Chapter 8 is a revision based on C. T. Patrick Diamond's chapter published in G. J. Neimeyer & R. A. Neimeyer (Eds.), *Advances in personal construct psychology III,* 79–100. Greenwich, CT: JAI Press, 1995. An earlier version was presented as an invited plenary address at the Sixth Biennial Conference, *Constructivism: Boundaries and Frontiers,* North American Personal Construct Network, Indianapolis, June 1994. Another version appeared as a chapter in A. Cole & D. E. Hunt (Eds.), *The doctoral thesis journey: Reflections from travellers and guides* (pp. 53–60). Toronto: OISE Press, 1994.

The illustration, "Triple Self-Portrait," by Norman Rockwell (1960) is reprinted by permission of the Norman Rockwell Family Trust. Copyright © (1960) The Norman Rockwell Family Trust.

Also, the illustrations "Metaphor of Knowledge" and "Metaphor of Transformation" by Kathy Mantas (1998) are reprinted by permission.

Chapter 10 includes Carol Mullen's own carousel artwork (Figure 17), which originally appeared in her book, *Imprisoned selves: An inquiry into prisons and academe* (1997, UPA). Reprinted with permission from University Press of America.

Also, Carol Mullen's poem, "Carousel," originally appeared in the special issue, "Listening as Active Caring," of *Among Teachers: Experience and Inquiry,* 17 (1995), 12. Reprinted with permission.

Chapter 11 is a revision of a paper originally presented at the annual conference of the American Educational Research Association, New York, April 1996. A more fully developed version was published by coauthors C. T. Patrick Diamond and Carol A. Mullen in the *Journal of Applied Social Behaviour,* 1997, *3*(2), 49–64.

Permission was granted by Ashley Melton, with guardian consent, to include Figure 19.

Chapter 12, by coauthors Carol A. Mullen, C. T. Patrick Diamond, Mary Beattie, and William A. Kealy, is a development of the chapter, "Arts-based educational research: Making music," in M. Kompf, W. R. Bond, D. Dworet, & R. T. Boak (Eds.). (1996). *Changing research and practice: Teachers' professionalism, identities, and knowledge* (pp. 175–185). Adapted and extended by permission of Falmer Press.

Permission granted by Falmer Press includes use of William Kealy's original artwork, a möbius strip, revised by him as Figure 20 and for the design of the book cover.

A much earlier version of chapter 12 was presented as a paper at the annual conference of the International Study Association on Teacher Thinking, Brock University, St. Catharines, August 1995.

Chapter 16 is a revision of a paper by C. T. Patrick Diamond and others published in *The Australian Educational Researcher,* 1998, *23*(4), 83–96. Included with permission. Peter Petrasek's (1997) palimpsest, based on a 1983 course paper, is reprinted by permission.

Figure 29 in the Postlogue, "Tightrope Walker" by Michael Leunig (n.d.), is printed by permission of Michael Leunig and "The Age" (David Syme and Co.).

Coeditors' Note: Many of the artworks appearing in this book were produced as original designs by artists who were guided by our invitation to create particular images and themes. All titles on Kathy Mantas' artworks as well as the one by Ashley Melton were captioned by us. We thank Jeff Nolte, artistic photographer and master printer, for the rendering of Kathy Mantas' illustrations.

An Invitation to an In-quest

Carol A. Mullen
C. T. Patrick Diamond

Birth or Death? There was a Birth, certainly,
We had evidence and no doubt. I had seen birth and death,
But had thought they were different; this Birth was
Hard and bitter agony for us. (Eliot, 1961, p. 98)

Before me floats an image, man or shade,
Shade more than man, more image than shade;
For Hades' bobbin bound in mummy-cloth
May unwind the winding path.
I call it death-in-life and life-in-death. (Yeats, 1996, p. 248)

An In-quest into the Death of Modernism

A detective thriller or "whodunit" often begins in the middle of things with a postmortem examination. This could be either into the cause of a questionable death or into the effects of an unlikely birth. Although no one medical examiner presided at our paired autopsy-delivery, we are reminded of our terms of reference, or is it endearment? There is now no educational coroner to hold an inquest into the death of modernism and the birthing of postmodernism. Instead a range of experts and interested witnesses have gathered before the bench just as they had earlier around the operating table.

An inquest is an official inquiry into the details and causes of an incident. As in arriving at a medical diagnosis and a judicial verdict, our inquiry involves minute, careful acts of investigations, and leaps of imagination. We probe events through systematic examination and through entertaining novel possibilities. This process resembles tracking

down and then either disposing of a "beast," as in the tale of
Frankenstein's creature ("bound in mummy-cloth"), or vindicating an
epistemological advance, as in the strange case of postmodernism.
Our two parallel events, the death of one way of knowing and the
birth of another, are closely and mysteriously interrelated. We wonder
if the death is/was a sudden or a lingering passing and if the birth will
unleash a monster or provide unsuspected treasure. All the circum-
stances connected by the case must answer one another like notes in
music. But there can be no final judgment as to culpability or inno-
cence. Ultimate truth eludes us, as it does in the story of Grace Marks,
the 19th century prisoner, whose guilt and innocence was ensnared in
"hints and portents, . . . intimations, . . . [and] tantalizing whispers,
. . . a lovely and enigmatic mirage" (Atwood, 1996, p. 424), culminat-
ing in a quilt that she stitched together for herself.

Our aim is neither to bring miscreants or heretics to trial nor to
detect the causes and course of a crime or blasphemy. We seek in-
stead to understand a death and a birth. The death may represent a
loss of nerve, a surrender of puzzlement and possibility for the illusion
of mastery and measurement. The birth may help us to recapture what
has been previously lost or abandoned. Our medical-courtroom scene
provides the site for many purposes to be played out: a crowded as-
sembly of gatekeeping judges and apologists who pledge their alle-
giance to different forms of authority and plead their causes; an aus-
tere operating theater with its gleaming instruments; and unexpectedly,
a space for games and wonder.

Our dedicated educational detectives resemble Eliot's (1961) travel-
ing magi and the monkish inquisitors in Eco's (1984) *The Name of
the Rose,* in that they all have spent their professional lives in rigor-
ous study. But we are convened neither to witness the word made
flesh nor to pass merciless judgment on suspected murderers and her-
etics. Our expert sleuths investigate not a fading "corpse/corpus" but
one made up of writings, texts, arguments, knowledge claims, belief,
and practice. In the "true church" or entrenched paradigm in educa-
tion, this corpus has been operated on by using an empirical form of
research called "Modernism" and in service of a previously triumphal
metanarrative—not of faith but of science. The interested parties who
gather around the table where flickering life all but expires are
variously named Poststructuralists, Contextualists, Constructivists,
Narrativists, Postmodernists, and arts-based inquirers. We have as-

sembled, at this moment, also to witness how another "body," that of postmodern social science, may be birthed partly by our faltering and chaotic contributions. As Yeats (1996) wrote, artistic creation involves "the fury and the mire of human veins."

Some of the more established educator detectives have devoted their energies to justifying the importance of innovative thinking and unexpected research strategies. A second generation of novice, "would be" detectives have actually been experimenting with the galvanizing ideas and practices of arts-based inquiry. They acknowledge that the early detectives have unwound "the winding path." Without them, the newly arrived could not have ventured so far nor have been overheard to say: "Even if we weren't sick and tired of modernity, at least in the various guises modernism has presented it to us, [we would still have to do more than] . . . mourn the corpse with worn-out scholarship, methodology, criticism" (Readings & Schaber, 1993, p. 1). Conversely, without the newcomers' allegiance, the authority of the established detectives would not have been as widely recognized. We are now witnessing changes in spheres of relative influence with newer forms of arts-based research being conducted in universities, schools, prisons, and other sites and being reported in the literature and at conferences.

The detectives around the autopsy table and before the bench know one another to varying degrees. Their intimate knowledge of the corpus of empirical knowledge has been won at the cost of years of conflict and hardship. Some have accepted the need to struggle to unwind how they view knowledge and authority—and themselves. Unlike the classic mystery story where the deceased is usually a stranger or an unknown quantity to the detectives, all at this gathering have been close to the modernist "body." They experienced its previous vigor, sometimes as a gatekeeping power limiting experimentation but at other times as a source of creative tension.

As educator detectives, we too are struggling to challenge the dominance of empirical forms of research, and to promote new forms of inquiry. We seek to advance styles of investigation that openly admit self-scrutiny and participatory forms of inquiry and development. Still casting its pall over the hardened "counter-reformers" in the gathering, the modernist shade has not quite expired, nor will it. Epistemological claims to certainty and truth that derived from the psychological sciences remain deeply privileged and ingrained in education. The

standardized research form of writing and report that has prevailed in educational inquiry reduces human experience to knowledge claims based on issues of justification, evidence, and evaluation. We have inherited a narrow inquiry space and a set of procedures that focus on matters of classification, categorization, methodology, implementation, and measurement. But, despite all the controls and interventions, empirical educators have failed to achieve the certainty of all-knowing judges. For some, this failure is "hard and bitter agony"; for others, it is a release from the obligation to arrive at a single, definitive diagnosis and verdict, heralding the acceptance of inevitably partial and complicit perspectives.

The more established among the arts-based researchers have persistently backtracked to understand the events and influences that have brought the "modernist" body to its final gasp. It is not so easy as taking a pulse. The established detectives have, in a sense, understood that in order to transform educational research they needed to prepare by gathering as much information as possible about the origins, development, and effects of empiricism. They have also pioneered and validated arts-based research as a set of methods, forms, and processes for creating new understanding in education and inquiry. Like Monsieur Dupin, the learned detective in Edgar Allan Poe's (1936) *The Murders in the Rue Morgue*, the established educators have relied on detailed analysis and keen observation in their investigations. Dupin possesses penetrating insight into human character and events. The aspiring detective who observes Dupin's approach to playing cards uses his own emerging awareness to speculate more broadly on the game:

> to have a retentive memory, and proceed by the "book," are points commonly regarded as the sum total of good playing. But it is in matters beyond the limits of mere rule that the skill of the analyst is evinced. He makes, in silence, a host of observations and inferences. So, perhaps, do his companions; and the difference in the extent of the information obtained, lies not so much in the validity of the inference as in the quality of the observation. . . . Our [expert] player confines himself not at all; nor, because the game is the object, does he reject deductions from things external to the game. He examines the countenance of his partner . . . considers the mode, . . . notes every variation, gathering a fund of thought. (pp. 58–59)

We too are scrutinizing the faces of a departing force and of a newborn power (see Figure 1). Just as court-cards win the hand, so too in

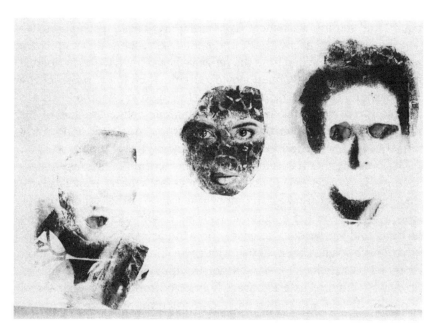

Figure 1 *Transitions: Dissolving and Emerging Phases/Faces* (K. Mantas, 1993)

the postlogue we examine the case for leaving our fingerprints to mark our ephemeral inquiries.

The figures in our text are part of our overall canvas along with our figurative, image-based writing. The visuals do not just fit into their respective chapters but disrupt and move them along. As in allegory, we seek to compose our arts-based narrative inquiries out of a succession of allusions and literary or visual images. Awareness, like self, is multiple and fragmented, divided against itself in the act of observing and being. The visuals enter the text to concretize and challenge our stance and agency/powerlessness in the inquiry—just as images on passports, drivers' licenses, and library and credit cards both exert control over self-image and express plurality. We are conscious of the problem of referring to self (Rugg, 1997).

By clearing obstructions and exposing the limitations of much previous social science research, experienced educator advocates have birthed a creation made up of first qualitative, then narrative, and now arts-based forms of inquiry. A composite conceptual neologism. Paradoxically, they have done this by mainly relying on empirical

traditions. However, they also imagined and theorized new forms of inquiry and self into existence. As aspiring arts-based researchers, we have been convinced by their arguments and flights of imaginative fancy. We have benefited from the reflexive ways that have been opened up by those who, like Conan Doyle's Sherlock Holmes, have set the precedent and taken the risks. As Renza (1990) notes, Agatha Christie's Hercule Poirot was later able to use his comic self-awareness of his own pompous airs to interrogate any precursor's "nonironic noncomical projection of his [or her] unself-consciousness" (p. 189).

The practice that has evolved as the new writing of arts-based self-narrative is not yet set in textbook stone—as a heart beat it is still irregular and faint, and all the more precious. As the writers of this book, we focus on the enigmatic qualities of experience, celebrating the open and elusive state of educational inquiry and teacher development. This book has been, for us, a journey along a slippery lakeshore. It has led us to educational sites not traditionally considered proper subjects of inquiry; to arts-based, hybridized forms, including visual renditions of text and shared story construction; and to participants not typically regarded as actual researchers. However, while these teachers, dissertation candidates, students, prisoners, performers, and selves may seem to make up an unusual cast even for narrative action research, they show that they are equal to the task of scholarly deduction and artistic inquiry.

Among those educators who are puzzling over just what this empirical death and arts-based birthing may imply, there are those who have already abandoned and adopted these respective forms—even if unbeknown to themselves. Wherever the deeply personal, intimate encounter with experience is courted and expressed in inquiry, there is the beat of artistic impulse. With this book we hope to offer

> ways in which the arts, in particular, can release imagination to open new perspectives, to identify alternatives. The vistas that might open, the connections that might be made, are experiential phenomena; our encounters with the world become newly informed. When they do, they offer new lenses through which to look out at and interpret the educative acts that keep human beings and their cultures alive. (Greene, 1995, p. 18)

We see arts-based explorations as rewriting rule-bound procedures for examining the bodies of the recently deceased and the newly born. Some of these counterpoints in education function as melodies, merely added as limited accompaniments to the shifting dominant or "given

melody." Other counterplots proceed as more confident, radical re-constructions of research and practice. With its diverse and particu-larized collection of research approaches, the Counterpoints Series (Peter Lang) itself offers new melodies to the world of education. In *The Postmodern Educator,* we offer yet another perspective on stud-ies of theory and educational practice. We hope that this book will contribute to the growth of evocative and disturbing modes of artistic inquiry and development. These innovative forms are displayed in this series, which itself honors postmodernism for offering unprecedented opportunities.

This book is being birthed at a time of confusion, shift, and fracture in educational research and practice, as well as throughout institu-tional settings and the wider community. As budding Postmodernists, we realize that what we offer is only a beginning to investigations and opportunities in arts-based inquiry and teacher development. In addi-tion to theorizing, we provide examples of arts-based, narrative, and participatory approaches. Rather than offering a comfort text and familiar space, we seek to provide "proliferations, crossings, and over-laps, . . . multiple openings, networks, and complexities of prob-lematics" (Lather, 1997, p. 299).

Where there may be some glaring inconsistencies and even outright contradictions in how we have approached and represented artistic inquiry and development, we acknowledge that we are part of the breakup of the old and the startup of the new. A collage/montage. Postmodernism is not just "what is new, what is modern. It must be in some sense after the new, *post*, and yet must *at the same time* not yet have arrived, must have got caught in the post" (Readings & Schaber, 1993, pp. 5–6, italics in original). We offer our book as a "palimpsest, an abrasion on old parchment [as] when a word [or world] has been removed and replaced by another" (Zencey, 1997, p. 255, chapter 16).

In the following pages, we welcome the long awaited development of arts-based approaches to postmodern theory and practice. We ar-gue for, and provide new tools for, representing and inquiring into educational questions and the teacher-researcher self. We float be-tween text and figure, image and shade, evidence and doubt, and be-tween ways of thinking that no longer provide a hold on events and those that are being birthed. In the midst of death-in-life and life-in-death, we are detectives in-quest and in need of creativity. Although we feel that "things fall apart; the center cannot hold," we do not yet

know whether it is boon or "rough beast, its hour come round at last,/ [that] Slouches towards Bethlehem to be born." (Yeats, 1996, p. 187).

And so, dear readers, we invite you to use our arts-based, educational inquiry text, including content and form, in your own creative ways. We have tried to suggest a new vision of inquiry and teacher development.

> When [you as] readers recreate that vision, [you] may find that new meanings are constructed, and old values and outlooks are challenged, even negated. When that occurs, the purposes of art have been served. (Barone & Eisner, 1997, p. 78)

Just as we repeat the Möbius strip visual on the book cover and in chapter 12, we provide you, our readers, with two windows or arts-based "ponder pages," one following at the end of this Prologue and the other at that of the Postlogue. These devices are meant to help frame your inquiries. Opening the first window that bears our joint author names, you may choose to write about how the Möbius strip and the Frankenstein image function as centrally important metaphors in our book. Although at first sight the two figures may not seem complementary, the two sides of the strip remind us of doubling, relationship, and interconnection. Textual and musical composition, science and art. Just like the fallen Lucifer (Latin for light-bringer or morning star) and the biblical God, the creature is the other side of the creator. Dr. Frankenstein is complicit in the fate of his monster just as Prospero is in that of Caliban, Byron in that of Dr. Polidori, Daedalus in that of his son, Icarus, and detectives in that of their criminal nemeses—and as self is in the fate of others. So too parents are responsible for their children, teachers for their students, and dissertation supervisors for their candidate colleagues. We use the Frankenstein image of postmodernism to suggest some of its shifting qualities ranging from those of an alien grotesque to those of a marvelous invention.

You may also choose to write about how the book provides an arts-based (curving and triangular) window opening onto a spiraling nebula—an expanding universe at the center of things. Although widely recognized, astronomical constellations such as Gemini (identified with Castor and Pollux, the twin patron deities of sailors and voyagers) are no more than conventional dot-to-dots, joining neighboring stars to form familiar patterns in different parts of the night sky. The contributors to our book also form an association of like-minded spirits, hopefully appealing to our readers. Just as Cortez was inspired on first glimps-

ing the New World of the Pacific, so too Keats was uplifted on first reading Chapman's translation of Homer:

> Then felt I like some watcher of the skies
> When a new planet swims into his ken. (in Stillinger, 1982, p. 34)

Galileo recharted the heavens as no longer belonging totally to a higher power but as part of the human world and readable by the imaginative and mathematical use of forms. Ironically the earth itself was also being replaced by the sun as the center of this universe. Responsibility and exile. The possibilities of postmodern educators may be expanded by their similar willingness to look for the new, forming a community of fragmenting and multiplying selves through their arts-based practice. We can each ready ourselves to be awakened to the ongoing creation of different worlds—of self, research, and classroom. We, the authors, invite shifts in all sorts of hierarchy. As in a previous preface (Mullen, Cox, Boettcher, & Adoue, 1997), "[we speak] in verse form, overlapping voices beginning and completing each other's poetic thoughts . . . cycling in and out of each other's lives/cycling back, checking in/sharing the real stuff of life/a relationship that looks different/depending on where you stand" (p. xxiii). We argue that inquiry

> schooling and teacher education . . . need to be reconstrued as revolving not around the authority of politicians and educational researchers but around that of teachers and their students (p. xiii). . . . Teachers are neither more nor less than their way[s] of understanding the universe. Central to that understanding is the interpretive choices they make in locating themselves within that universe. (Diamond, 1991, p. 123)

We hope that you as our readers may enjoy opening windows onto new worlds of arts-based inquiry and development. The first opens onto ours (see Figure 2), the second onto yours (see Postlogue, Figure 30). For both window graphics, you can start from the top left and read across, line-by-line (as with traditional text); or you can read on the diagonal; or, you can even begin at the bottom left-hand corner, going across and then up the rows (as in the stained glass windows of some cathedrals). There are many ways of representing and reading arts-based inquiry and development, almost like playing a game of noughts and crosses. The "windows" represent another image of invention, just like Frankenstein's motley collection of parts.

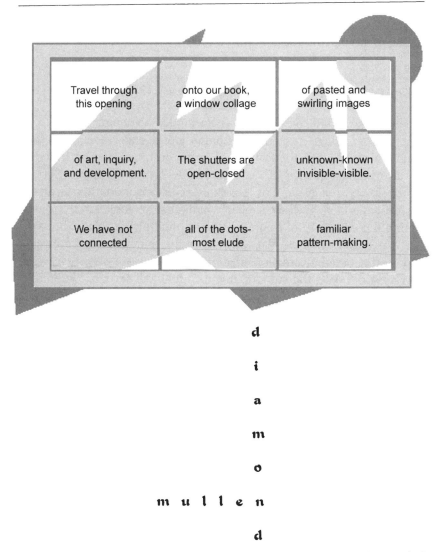

Figure 2 *Your Window onto Our Windows* (C. A. Mullen, C. T. P. Diamond, & W. A. Kealy, 1998)

References

Atwood, M. (1996). *Alias Grace*. Toronto: Doubleday.

Barone, T. E., & Eisner, E. (1997). Arts-based educational research. In R. M. Jaeger (Ed.), *Complementary methods for research in education* (pp. 73-103). Washington, DC: American Educational Research Association.

Diamond, C. T. P. (1991). *Teacher education as transformation: A psychological perspective*. Milton Keynes, UK: Open University Press.

Eco, U. (1984). *The name of the rose*. San Francisco: Harcourt Brace Jovanovich.

Eliot, T. S. (1961). *Selected poems*. London: Faber and Faber.

Greene, M. (1995). *Releasing the imagination: Essays on education, the arts, and social change*. San Francisco: Jossey-Bass.

Lather, P. (1997). Drawing the line at angels: Working the ruins of feminist ethnography. *Qualitative Studies in Education, 10*(3), 285–304.

Mullen, C. A., Cox, M. D., Boettcher, C. K., & Adoue, D. S. (Eds.). (1997). *Breaking the circle of one: Redefining mentorship in the lives and writings of educators*. New York: Peter Lang. (Counterpoints Series)

Poe, E. A. (1936). The murders in the Rue Morgue. *Tales of mystery and imagination* (pp. 56-99). New York: Cuneo Press.

Readings, B., & Schaber, B. (1993). Introduction: The question mark in the midst of modernity. In B. Readings & B. Schaber (Eds.), *Postmodernism across the ages: Essays for a postmodernity that wasn't born yet* (pp. 1–28). New York: Syracuse University Press.

Renza, L. A. (1990). Influence. In F. Lentricchia & T. McLaughlin (Eds.), *Critical terms for literary study* (pp. 186–202). Chicago: University of Chicago Press.

Rugg, L. H. (1997). *Picturing ourselves: Photography and autobiography*. Chicago: University of Chicago Press.

Stillinger, J. (Ed.). (1982). *John Keats: Complete Poems*. Cambridge, MA: Harvard University Press.

Yeats, W. B. (1996). *The collected poems of William Butler Yeats*. (R. J. Finneran, Ed.). New York: Scribner.

Zencey, E. (1997). *Panama*. New York: Berkley Books.

PART I

WHY ARTS-BASED INQUIRY AND TEACHER DEVELOPMENT?

Chapter 1

Art Is a Part of Us: From Romance to Artful Story

C. T. Patrick Diamond
Carol A. Mullen

As I fixed my eyes on the child, I saw something glittering on his breast. I took it; it was a portrait of a most lovely woman. In spite of my malignity, it softened and attracted me. For a few moments I gazed with delight on her dark eyes fringed by deep lashes, and her lovely lips; but presently my rage returned: I remembered that I was for ever deprived of the delights that such beautiful creatures could bestow; and that she whose resemblance I contemplated would, in regarding me, have changed that air of divine benignity to one expressive of disgust and affright. (the "monster" creation in Mary Shelley's *Frankenstein*, 1818/1994, p. 117)

Maggie kept her eyes closed. She kept her hands still where they pressed against his chest. But she couldn't keep her entire body from tightening at the touch of his mouth and his tongue and his hands. Good grief! How could such a mountain of a man create such delicate shivers in every nook and cranny of her body? Maggie didn't believe in taking and not giving. Her arms locked around his neck. Her mouth molded his. Warm, liquid desire streaked through her. By the time Mac lifted his head once more, her breath came as swift and as rough as his. (Merline Lovelace's *Maggie & Her Colonel*, 1996)

Ever Thought of Writing About Being a Teacher?

Publishers' recruiting materials for romance writers usually urge aspiring authors to write love stories using a "tried and true" formula, one that is evident in the Lovelace excerpt. In the midst of a culture that suspects the course of true love and its trials, Mills and Boon romances still sell over 220 million copies a year (Guinness, 1990). The guidelines for writing a book with the rose imprint insist on the need for a

genuine love of storytelling, freshness and originality of approach, an individual touch, and a particular way of telling the story. Not bad advice for any writing. But there are also certain inviolable rules: "No adultery, no alcoholism, no graphic sex, no petty worries, no serious problems, no subplots, no cynicism. 'Love' in the title and conquering all. Instant recognizability. Sincerity and happy ending essential" (Macken, 1990, p. 62). The hero is to be without self-doubt and the heroine without feminist independence.

Harlequin romance novels, such as *The Mistletoe Kiss, Reform of the Rake, A Wife for Christmas, Her Secret Santa, Relentless Flame, A Foolish Heart,* and *A Royal Romance,* unintentionally parody our need for genuine relationships. Their simplistic form and reverence for gender-based stereotyping contrast with the ornate complexity of Victorian era novels, which continue to engage literary readers. Today's unreflexively romantic fiction is full of the fantasy of old fashioned values. Traditional morality comes into conflict with unleashed passion, but in the end there is resolution, and usually an "honorable" one. Love is like a warm bath and all will is surrendered. Such romances pale by comparison with the novels of Charles Dickens and Charlotte and Emily Brontë.

Classical as well as artful contemporary literary texts challenge and extend how we respond to life, deepening thought about the human condition. Perhaps a notable difference between artful stories created for startlement rather than mere consumption is that the former enlarge other possibilities of identity, thought, and action. For example, Byatt's (1993) *Angels and Insects* shows the necessity of imposing our very own and not derivative patterns upon experience in order to make sense of it, providing "for the promotion of useful knowledge and human wonder . . . [and] suggesting an *aim* for all our aimless poking about" (pp. 17, 28). Such visions are not of living happily ever after and, indeed, are rarely "manufactured" mainly for material profit.

Advertising agencies may use romance and clever stories to "move product" (Zipes, 1997, p. 39); newspapers and magazines may print sensational stories to improve circulation figures; television talk show hosts may coax ordinary people into disclosing intimate secrets on air in order to boost ratings; and criminals may tell all to ghost writers for money. But artful stories are more than marketable commodities— they give shape and meaning to experience. Artists order and reconsider experience in order to learn and share something about them-

selves. By virtue of their example, they awaken the artist in others and the multiple possibilities of telling and sometimes living yet other tales. They help us to reflect upon and redraft our plans and dreams. In this book, we encourage other educators to see themselves as artists capable of creating their own "novels" of experience and development. The work of a lifetime is to discover who we are. To find our way out of the wasteland in which the glare of scientism and one-eyed reason reduces even rock to dust, we invite our postmodern readers to join us in William Blake's (1966) prayer:

May God us keep
From single vision & Newton's sleep!

In this book, we offer stories, poems, essays, self-narratives, and visuals of arts-based inquiry and teacher development that have been plotted as complex webs rather than as predictable straight lines. Throughout the following pages we do not "put our experience into claims that propositions can carry" (Eisner, 1997, p. 7). We offer instead an open "reading" and remapping of art and education, self and other, reflexivity and action, promise and perils. Arts-based forms, or what Jipson and Paley (1997) call "tightwire activity" (p. 6), "create not argument but worlds, and a world, by definition, is an attitude toward a complex of experience, not a single argument or theme, syllogistically proposed" (Vidal, 1993, p. 38). New forms of representation are needed to convey what artistic educators experience and learn.

Eco's (1984) *The Name of the Rose* is not merely a quasi-medieval novel. It also provides a postmodern romance that evokes the past and disrupts chronology in an uncanny way. In his *Postscript to The Name of the Rose*, Eco defines postmodernism not as a trend to be chronologically defined but rather as a way of operating. The postmodern attitude is like that of a man who loves a very cultivated woman and knows that he cannot simply say to her, "I'm crazy for you." He knows that she knows that these words have become clichés in popular romances. But there is a solution. He can say, "As a character in a book with the rose imprint might say, I'm crazy for you." Having disclaimed any pretension to innocence, he has still said what he wanted: "that he loves her, but he loves her in an age of lost innocence" (Eco in Dipple, 1988, pp. 74–75). Irony can serve sincerity. Postmodernism is

> A new Romantic movement with its own discrete types of irony and renewed
> parataxis [or uses of fragmentation]. Fumbling as it must over the creation of
> new forms, postmodernism now embraces all writers whose self-conscious
> structures can defined as . . . narratives that are endlessly self-reflexive in . . .
> parodic modes. (Dipple, 1988, p. 47)

Postmodern educators can turn their theory and practice into such
"monstrous" fictions.

Arts-Based Inquiry and Teacher Development

For several years, we (Patrick and Carol) have been developing arts-
based ways of operating with teachers, teacher educators, and
marginalized others that we now extend into this book. We use *teacher
researchers* as inclusive of classroom teachers, graduate students who
are (or were) teachers, and teacher educators (who are professors con-
cerned with teacher development). We encourage teacher researchers,
whom we see as reflective inquirers and social activists, to use arts-
based inquiry as an emerging form of alternative research that is ap-
propriate to a postmodern age. Storytelling and narrative writing fos-
ter educator development. Such inquiry can even promote reform in
teacher education and other professional areas. We support teacher
researchers who use artistic inquiries to advance learning in schools,
universities, prisons, and other sites. Throughout the book we ad-
dress these two fundamental, interrelated issues.

1. Arts-based narrative inquiry is a form of qualitative research that
 powerfully promotes the development of teacher researchers
 through deepening their understanding of the experience of self
 and others, and
2. Perspectives can be transformed, and teacher education and hu-
 man learning can be renewed, when teacher researchers use
 arts-based textual strategies to reflect on experience and invite
 others to respond to these inquiries.

This book is primarily about understanding and showing how arts-
based inquiry can be used to rethink and promote teacher researcher
development. Artistic activities that can promote inquiry involve the
choice and use of creative forms to give ordered expression to per-
sonal feelings, imaginative ideas, and topics of concern (Sarason, 1990).
Operating within the postmodern context that is "characterized by

fragmentation, chaos, and a lack of coherence" (Craft, 1997, p. 93), our guiding but never totally coherent selves seek to shape inquiry and development in a holistic way. How we feel and think is influenced by those methods and choices we make in representing content, and by the perspectives we use to view form and content. The dynamic quality of the narrative "scripts" that we produce is intensified when "multiple narratives [become combined] within a single performance which may have many dramatic beginnings, middles, and endings" (Denzin, 1997a, p. 187) and which in part are influenced by the readers' and/or viewers' reactions.

Understanding the experience of self in relation to coparticipants and the changing world helps define both qualitative inquiry and teacher development as a "professional knowledge context [that] has a sense of expansiveness and the possibility of being filled with diverse people, things and events in different relationships" (Clandinin & Connelly, 1996, p. 139). Although we believe that inquiry into features of the intertextual, peopled "landscape" of education and research has taken an artistic and postmodern turn, this has yet to be fully explored. We offer tales of travel across this territory in Part II.

Approaches to teacher education seem polarized between two positions, one of narrow, external accountability and control and the other of internal autonomy and limitless personal transformation (Hollingsworth & Sockett, 1994). This book stands at this imagined divide between quantitative, scientific approaches and qualitative, arts-based approaches (see chapter 2). The top-down, "trickle down" approach to improvement that is entrenched in the current North American educational terrain may only undermine teachers' and learners' engagement in inquiry and development. University research findings on "hot topics" would continue to be handed down as codified knowledge for teachers to apply in their classrooms. This approach has been critiqued by Clandinin and Connelly (1992) with the use of their "conduit metaphor." They suggest that the countering "maker role" needs to be adopted. We offer the teacher as postmodern educator as a lively example of this "maker" metaphor. We also endorse Eisner's (1996) "art of teaching" metaphor, which values "art as a form of life . . . that makes aesthetic experience possible" in the realms of "curriculum planning, explaining, interpersonal relationships, and assessment" (pp. 12–13). For example, in chapter 6, Carol uses arts-based forms of engagement and assessment to enhance learning about "whiteness" with preservice teachers.

Without slipping into "dichotomous modernist thinking that teachers' knowledge should now be privileged, it is important to support, hear, and acknowledge teachers as practitioners and researchers of educational knowledge" (Hollingsworth & Sockett, 1994, p. 11). The developmental version of teacher education emphasizes the centrality of teachers as makers of an epistemology of their practice that is actively researched and reflected upon. As artists, teacher researchers engage in re/vision, novelty, and reflexivity. Because "postmodern social scientists" also engage in these ways of making experience and in understanding narrative educational research (Barone, 1995), teacher researchers can claim to work as postmodern social scientists.

We believe that the more "rational" modes of inquiry and of teacher education can be complemented by arts-based forms that make experience more accessible, concrete, imaginable, and affecting. Rather than being restricted to the guidelines of traditional, expository essays alone, teachers as educational artists can describe and convey facets of experience through personalizing and fictionalizing them in literary and visual forms (see Part II). Through framing and reframing the suggestions that we sketch in this book, teachers may be able to portray their experiences of teaching and learning more intensely and with greater developmental impact.

The Crisis in Representation:
The Postmodern Self and Text

Postmodernism has ushered in a period in which possibilities for understanding and practicing social science in ways not yet thought of will continue to increase. Postmodernism will also continue to be interrogated by those who feel threatened by fundamental changes in ways of knowing (Barone, 1995; Craft, 1997; Denzin, 1997b). What Derrida (1978) has called "the as yet unnameable" is slowly beginning to proclaim itself in education. There is a proliferation of paradigms, emphasizing creative and analytic experimentation, including one that is known as arts-based (e.g., Barone & Eisner, 1997; Blumenfeld-Jones & Barone, 1997; Diamond, Mullen, & Beattie, 1996; Diamond & Mullen, 1997; Eisner, 1991, 1993, 1997; Finley & Knowles, 1995). Entire issues of educational journals have been devoted to the relationship between art and research, and specifically to the role of experimental texts in representing and theorizing teaching and research (see, e.g., Barone, 1995; Bresler, 1995).

The reception that such developments have received ranges from hostility through caution to euphoria. These same reactions can occur within individuals as they oscillate between resistance and enthusiasm, much like the field of teacher education itself. Sayer (1992) demonstrates his opposition to arts-based research by consigning his realist reaction to the so-called *cognoscenti* (connoisseurs), to endnotes "written in plain English." Relegating narrative inquiry to an appendix, he dismisses calls for greater concern with the art of description as possibly signaling "an indulgent and amateurish celebration of 'literary' ways of writing . . . often associated with a slide toward a complacent advocacy of . . . ineffable qualities" (p. 264). Ironically, Sayer's (1992) criticism seems much less incisive than Henry Louis Gates Jr.'s (1992) witticism: "Oscar Wilde once quipped that, when good Americans die, they go to Paris. I think in Paris, when good theories die, they go to America" (p. 186). The twist is achieved through the use of chiasmus, a Greek criss-crossing, arts-based form.

We do not have to be lost in euphoria to recognize postmodernism as a self-conscious moment of transition in research that may yield opportunities for arts-based inquiry and teacher development. Texts such as *Finding Art's Place* (Paley, 1995) and *Daredevil Research* (Jipson & Paley, 1997) provoke and encourage discoveries in the unexpected, multifocused, sensual, ambiguous, and indirect aspects of experience. In such works, visual imagery and depiction enliven and are inseparable from the literary, educational texts. While postmodernists have been accused of both wearing theory "upon their sleeve" and having anti-theoretical lapses, they do "pedestal" literary approaches. And with good reason—"literary processes—metaphor, figuration, narrative—affect the ways cultural phenomena are registered, from the first jotted 'observations,' to the completed [work], to the ways these configurations 'make sense' in the determined acts of reading" (Clifford, 1984, p. 4).

Determined acts of reading suggest that the writer-reader relationship is an active one where readers recreate meaning for themselves. This relationship has the potential to be taken further in postmodern narrative research where readers artfully re(de)construct texts. As Eisner (1993) writes: "Humans do not simply have experience; they have a hand in its creation, and the quality of their creation depends upon the ways they employ their minds" (p. 5). Because educational research and teacher education are still so little affected by postmodernism, rationales for and examples of such practices are urgently required.

Even though as writers of this book we are seeking to invent (or rediscover) insights into educational forms and meaning, we do not subscribe to any kind of "enlightenment story of the gradual but steady progress of reason and freedom" (Lyotard, 1984, p. 86). Light-based metaphors for accumulating knowledge imply the passive receipt of rays from a source of wisdom from on high, or of being chosen by someone tall and handsome/beautiful. Postmodernists replace the idea even of a single radiating self as a stable, unified, conscious subject with that of a lightheaded, fluid, constantly changing community of multiple selves that struggles within and for consciousness (see Figures 13 and 14 in chapter 8). They call for texts that openly contradict themselves, maintaining first one thing and then another and then still another (Booth, 1985). Both subject and text offer multiple opportunities for representation, emergences, comment, and speechlessness.

Any self or text is "not as a line of words releasing a single 'theological' meaning (the 'message' of an Author-God) but a multi-dimensional space in which a variety of writings, none of them original, blend and clash" (Barthes, 1977, p. 146). New writing needs to be appreciated on its own terms rather than from the traditional stance that writers who "experiment textually" are somehow "abdicat[ing] their responsibilities as qualitative [researchers]" (Denzin, 1997b, p. 5). Teacher researchers who experiment with arts-based, literary forms may create the conditions for locating new epiphanies within texts and people's lives. Their texts and selves are manifestations of consciousness and artifacts to be analyzed and responded to. However, unlike a best selling romance, a postmodernist work cannot be judged in terms of its transparency, generalizability, and marketability. "In principle [it cannot] be governed by preestablished rules, and it cannot be judged according to a determined judgment. Those rules and categories are what the work of art is itself looking for" (Lyotard, 1984, p. 81). We make and evaluate our own works.

Announcing the death even of the subject and the author, Barthes (1977) typifies what Rosenau (1992) characterizes as skeptical postmodernists. Such writers reject all truth claims and repudiate modernist approaches to representation. As affirmative postmodernists we also reject the single vision of any metanarrative. But we can go on by developing "counternarratives" and "counterpractices" that are composed of "the little stories of those individuals and groups whose knowledges and histories have been marginalized . . . in the telling of official narratives" (Peters & Lankshear, 1996, p. 2). Awakening from

the sleep of science, writers can continue to search for, and find ways to replace, standardized research reports with storytelling accounts of local events and daily experience (e.g., Diamond, 1991; Mullen, 1997; Mullen, Cox, Boettcher, & Adoue, 1997). The writers in this book join other postmodern educators in calling for subjective, evocative, and playful representations of as many indeterminate versions of reality as possible. We see as useful those stories that "sketch out" new landscapes of art, research, and practice and that interrogate those that are "taken for granted." We welcome the arts-based view of representation as inexact and even as a kind of failure to convey anything other than an emergent conception (Lather, 1993; Lyotard, 1984).

Arts-Based Representations

Experience is the bedrock upon which meaning is constructed. Eisner (1993) describes "those who are called artists [as having] for their subject matter the qualities of things of direct experience" (p. 73). Dewey (1938) distinguishes between experience and "an" experience. While the former is a feature of daily life and lacks design or form, a vital experience stands out meaningfully in our minds because of its contributions to an ending. The culmination and the path chosen to reach the ending make the experience meaningful. The quality that pervades the experience often emerges only after being represented in artful form.

Any form of representation serves to filter, organize, and transform experience into the meanings that make up and display our knowledge. Representation is the "process of transforming the contents of consciousness into a public form so that they can be stabilized, inspected, edited, and shared with others" (Eisner, 1993, p. 6). As forms vary from scientific propositions to arts-based expressions, so do the kinds of experience that they make possible (see chapters 2 and 13). For example, Miles and Huberman (1994) describe a display as the use of a visual format that presents "an organized, compressed assembly of information that permits conclusion drawing and action" (p. 11). They emphasize qualitative forms that compress data, such as histograms, matrices, graphs, scatterplots, charts, and networks, rather than aesthetic forms.

Stories, drawings, dialogue, collage, painting, split text, photomontage, and dance/performance are, however, arts-based forms for constructing *and* interrupting (freeze frame) how we can experience or

"know" our experience. Just as an assembly of still frames can be galvanized with light into a moving picture, so too a postmodern inquiry consists of different components drawn from widely dispersed sources. Using a filmic procedure, fragments are juxtaposed into a sequence that emphasizes the function of the personal as a discourse of knowledge and the value of formal experimentation as a strategy with epistemological goals (Ulmer, 1989).

The explanatory text has been the most frequent form used in qualitative research to represent meaning. It typically emphasizes habits of reasoning, including justification, over demonstration of ideas. Narrative research is itself often used to preserve this static form of text. Not surprising, then, the artful aspects of even narrative have been underdeveloped in some previous inquiries (Barone & Eisner, 1997). An arts-based text, such as a novel or poem, is shaped by dynamic recurrences, as of characters, images and tone, meter and rhyme, that are "super-added" so that we can communicate not "truths" but emotions (Jones & Tydeman, 1972, p. 44). Tolstoy (1930) describes the activity of art as seeking to "evoke in oneself a feeling one has once experienced and, having evoked it in oneself, then by means of movements, lines, colors, sounds, or forms expressed in words, so to transmit that feeling that others experience the same feeling" (pp. 172–173). It may be that the effectiveness of arts-based postmodern activity depends upon the degree to which it arouses (rather than "transmits") particular feelings and images and the degree to which it momentarily captures and provokes experiential learning.

In the preface to *Lyrical Ballads,* Wordsworth (1802) explained that he used incidents and agents from everyday or ordinary life as his content (in Jones & Tydeman, 1972). Coleridge's (1967) subjects were drawn from the romantic and supernatural. His narrative poem, *The Rime of the Ancient Mariner*, illustrates the above contrast in form by using a split text format. The work is arranged as two vertical columns. In the following quatrain, the artful foregrounding in the poem contrasts with the flat statement of the prose commentary. The reader's artistry is needed in response:

And the Al-	Water, water, everywhere,
batross begins	And all the boards did shrink;
to be avenged.	Water, water, everywhere,
	Nor any drop to drink.

Foregrounding is prominence given to formal features that are motivated and functional. It contributes powerfully to the writer's total meaning (Halliday, 1973). The repetitions of lines one and three, of the word, "water," of rhyme ("shrink/drink"), and of alliterative consonants (w, s, d) evoke through their prominence the trance-like horror of dying of thirst while calling for water in the midst of an ocean. Even the ship's timbers dry out and shrink. This fable of a life-in-death journey through pain and loss to reconciliation may also be applied to educators. Awash in rationalist models of knowing that accept a universe of neat correspondence, educators are often left with no space for their own arts-based activities. Like killing the Albatross, neglect of artistic self is a crime that inevitably results in the mortification of creativity and, hence, in a half-life. Artistic and social forms of expression can create the conditions for promoting self-acceptance, self-esteem, resilience, and synergy within and between human beings.

As readers, we are more affected by the repeated images and metaphors of a poem than we are by the propositions and statements of a prose gloss, though restraint and omission can also be used artfully (see Samuel Beckett, Graham Greene, and Ernest Hemingway). We all may know educators who adhere strictly to research conventions by day and who gain imaginative release through narrative works of fiction and nonfiction at night, writing and reading essays for the left hand (see chapter 5). Images created by artistically rendered forms give us insights that stir and inform us in ways that only they make possible. No matter how accurate a declarative explanation may be, it can never give us the life experience it comments upon (see "You're out!" below).

Art for Inquiry and Development: Making Experience "Special"

In the chapters in Part I, we adopt an instrumental view to argue that arts-based inquiry is art pursued for inquiry's sake and not for art's own sake. Here we also provide a rationale for such approaches since "few people like to be lost. When the terrain is new, we need context" (Eisner, 1997, p. 9). In the chapters in Part II, we provide working examples of arts-based concepts-in-action and of actual artistic practices in various institutional settings. Since "coming to a . . . new self-conception is hardly ever a process that occurs simply by reading

some theoretical work" (Fay, 1977, p. 232), some readers may prefer to begin with Part II. Its arts-based texts may entice them into powerful, vicarious experience (Barone & Eisner, 1977) and into experimenting with their own inquiries. If readers are interested in further understanding what worked, they could then return to Part I.

We seek to avoid the charge of aestheticism by showing that art is not limited to a self-enclosed few. As our book attempts to show, we are not playing an exclusive, hyper-literate game. Although artistic activity is potentially inclusive, its ability to engage and transform individuals is lost if it is treated as only the province of rare gifts. Striving to make meaning through metaphors and artistic shaping can be seen as not just a postmodern obsession but as "the fundamental drive, which one cannot for a single instant dispense with . . . for one would thereby dispense with man himself" (Nietzsche cited in Booth, 1985, p. 131). We believe that *all* teacher researchers are inherently artistic shapers by their birthright. They can all take experience out of the ordinary by making it "special" (Dissanayake, 1995).

In suggesting that narrative research, educational inquiry, and teacher development are forms of "art," we return the term "art" to its older usage of "art as skillful fashioning of useful artifacts" (Clifford, 1984, p. 6). Since the last century, art has become associated with upper class leisure and over-cultivated sensibility. However, we seek to show that "the making of [texts] is artisanal, tied to the worldly work of writing." As arts-based researchers, then, we do not presume to produce works of "capital A-Art" or to satisfy some abstract, logocentric criteria. Instead, we show how everyone can shape experience by using the artistic forms of elaboration (super-adding) or economy (imaginative omission). We are all natural mariners on the ocean of art. As Hellman (1976) explained:

> You are good in boats not alone from knowledge, but because water is a part of you, you are easy on it, fear it and like it. . . . This is what we mean by instinct (p. 152).

Art is also a part of us. By making experience noteworthy, we arouse the interest of others, enlisting their empathy in pursuit of new experience, fresh forms of inquiry, and further development. Jackson (1992) describes the arts-based way of teacher development as that of "wonder . . . [or of] altered sensibility" (p. 66). Our book provides examples of this form of "education in action." We provide a collection of teaching and research materials that seek to promote reflec-

tion and to help teachers to engage teaching and themselves differently. The actualities of individual cases are put visibly and dramatically to take readers to various educational scenes and issues.

An Arts-Based Narrative Inquiry

Pat von Loewenstein (1995), a teacher researcher, wrote the following account in a master's course on research methods that Patrick Diamond taught in Alberta. Pat, then a graduate student, had a science background, and this was the first story that he had ever written. Questions follow the narrative account to facilitate response to the inquiry and to engage the reader's own related experiences in education.

"You're Out!"
by Pat von Loewenstein

"Y ou're out!" cried the school secretary who was now acting as umpire for our Friday afternoon ball game. I smiled as I trotted off the field, glad that it was Friday afternoon, glad it was May, and glad that Wendy was pitching for our team. Man could she windmill a fastball! Little wonder she was a natural–youngest in a "ball family" with five older brothers. As I reached the backstop and turned towards the north to watch the opposition take their place in the field, I caught the glint of a small orange car coming down the road. "So he's chosen this Friday afternoon to do it," I said softly to myself. Two gophers played peek-a-boo with the 7th grader playing third base. The boy who was pitching, a grade 11 student, snarled at him to get into the game. He was taking out his frustrations on the younger player. It wasn't easy having a ninth grader outpitch you–especially when the opposing pitcher was a girl named Wendy. But that was reality here. The third baseman was consoled by Shelly the shortstop. At age 14, she had more common sense than the whole school put together. Yes, that was real-ity here at the small prairie school. They had to play together, for there were not all that many to play with. The orange Datsun pulled to the edge of the road and the superintendent of schools climbed out. He stretched a bit before he walked towards me. He wasn't your typical looking superintendent, no gray yet, still young, barely 35. With his love of ball and the task he had to perform this afternoon, you can bet he wouldn't mind trading me places, at least for this afternoon. "That's three away," called the umpire, checking her clicker. A mini twister whipped across the ball diamond. Clouds of dust enveloped us. The gophers hid and the kids hooted and cajoled as they made their way to their positions. "Cover right for me, Marty?" I called out.

"OK," Marty responded.

Seeing Marty in right field, the batter who had just stepped up to the plate changed hands. I looked at the superintendent. He knew why the boy had changed. Everyone did. In jest, I handed my glove to the superintendent. He smiled and shook his head. We talked about his son's ball team and the planned events of the coming weekend. However, the small talk did not last long. We both knew why he had come. He asked

where Merv was and I pointed towards the diamond across the road. Funny we said very little else about it that day. I reckon we discussed it enough during the year. These things had to be done before the end of May. I squinted into the hot afternoon sun. Ahead two figures were deep in conversation. Although they were out of earshot, I knew exactly what was being said. By the time their short exchange had taken place, the early transfer bus was parked and waiting, doors open, at the school. The next few moments are always pandemonium at a school. Ours was no different. A hand waved as the orange Datsun sped by. I responded. More buses came and left with their noisy loads. Merv and I met on the crown of the road as we made our way towards the school. "He just let me go, Pat," Merv blurted out.

"Told me my contract would not be renewed." Merv's shoulders were more rounded than usual. The corners of his eyes were moist. He was troubled and shaken. "Said he could not see me continuing on here." Merv rambled. "I thought things were going along just fine. I talked to him at the trackmeet last week. He said nothing then. Nothing. Why? Why now?" There was silence. What does one say that makes sense at this point? Then he nervously began talking again. He was upset but not yet angry, just dazed by the recent news. The anger would come later. We headed slowly towards the staffroom. For a time I just listened. Once inside I tried to console him. I guess this is natural. It was not sympathy I felt but empathy. "It's a tough situation, Merv," I began. "But these things happen and after all that has happened this year does it really come as a surprise? Wouldn't a fresh start in a different school be better?"

A list of incidents ran through my mind like a grocery cashier's sales slip.

Merv and I had discussed matters. But at this time I doubt whether Merv had the same list. There was more silence. Merv was staring blankly out the window. Doug, the other teacher, bounced into the staffroom. He was all excited and anxious to get started on his weekend. He and Merv were off to a big fastball tournament. Doug did not know but he soon would. As I climbed into my pickup, the school secretary leaned across the hood of her car and quietly said, "Pat, there was no other way." She was sincere. She must have read my mind through the look on my face. She was good at that. She had intuition. I thought of Merv most of that weekend. And even now, years later, I wonder if there was or could have been another way. I wonder what Merv's story would be if he told his version these many years later.

Teacher evaluation never really concerned me until my first year of teaching. At university I was concerned with getting a respectable report during my student teaching but that was the extent of it. I knew that in my first year or second year of teaching my superintendent would visit me, and if all went well he/she would write a report which would include a recommendation for permanent certification. About two thirds of the way through my first year, my principal at the time complimented me by noting that I was doing a fine job. I was naturally pleased but the more I thought about it the more I began to question his comment. How did he know what my teaching was like? He had never been in my class. Finally, I inquired as to how he knew what was going on in my class. How could he comment on the quality of instruction and thus the quality of the learning environment? His reply was that "principals just knew these things," they could "feel" the condition of a class

and a teacher. This comment was not an answer. It was the trigger which started my interest in teacher evaluation. The more I thought about his comments and watched the real world of education, the more critical I became of teaching and the lack of consistent teacher evaluation. Thoughts of past teachers flooded my mind. There had always been "good" and "bad" teachers. Why did the "bad" ones stay? Who was in charge of evaluation? What qualities did "good" teachers hold? These issues simmered in my mind. The answers would come with experience, training, education, and a lot of reflection.

About a year and a half later, I assumed the principalship of a small rural school. There were three of us with grades 7 to 11 to teach. My first year went quite well. How did I know? Well, I just sort of "knew" those kinds of things. Plus there were no complaints or calls to the superintendent and the kids were well behaved. In my second year as principal, I received a new teacher. For name's sake we have called him "Merv." It did not take long before I got an uneasy feeling about Merv and his abilities as a teacher. I just sort of "knew." The kids were getting louder and so were the parents. By the first report card I knew I had a problem. To the public I was the principal of the school and thus in charge of all aspects of its operation, including staff. In reality I had more control over the quality of toilet paper than the quality of teaching in my school. I questioned myself and others, read material from the Alberta Teachers' Association, studied the County teacher evaluation policy, and talked to Merv. Two elements made conditions rough for me in this situation. First of all I got along very well with Merv. Although socially we were not "buddy-buddy," we did enjoy hunting

together and playing hockey. The second aspect was the intimate nature of a small school. You can't hide much when you're in a three room school. My first year concerns regarding teacher evaluation now haunted me in a very realistic way. Although I tried not to show it, I felt uneasy discussing an individual's teaching without actually observing it. Plus I now came to fully realize that principals evaluating teachers in Alberta was not the norm. As a solution to my problem we embarked upon a school-wide effective teaching program after the Christmas break. I learned something but Merv did not. In retrospect I guess I was hoping for osmosis to work on Merv. At the end of the year Merv was let go.

To this day the whole situation still troubles me. Had justice been served? For the kids, yes. An ineffective teacher was removed. But what about for Merv? With more experience, with more evaluative clout, could I have helped Merv become an effective teacher? Thus my current intent to make teacher evaluation a more beneficial experience had its roots back in my experiences in the late 70s as a novice school principal. Not long after my year with Merv came the push in Alberta to have school principals more formally involved in teacher evaluation. The "changing role of the principal," some called it. In actual fact a teacher in Alberta who was teaching that the Holocaust of World War II had not taken place had started it. The case (Keegstra versus the County of Lacombe, 1983) brought teacher evaluation to center stage in the Province of Alberta. By the end of 1984, Alberta Education had formulated a policy which required Alberta school jurisdictions to put into place regular, fair, and consistent teacher evaluation policies for the purpose of "(1) assist-

ing in the professional development of teachers, and (2) taking appropriate action on teachers whose teaching practice was substandard" (Duncan, 1984). School boards scrambled and set about developing their own teacher evaluation policies which would satisfy Alberta Education's general requirements. Groups such as the Alberta Teachers' Association and the Alberta Trustees' Association debated issues such as formative versus summative evaluation. There was much dialogue and skepticism. All over the province people scrambled to get a handle on teacher evaluation. Seminars and workshops flourished. "Experts" crisscrossed the province. Teacher evaluation policies were written and procedures put into place. Teachers were evaluated. Some for the first time (Duncan, 1984).

Now, in the 90s, what is the state of teacher evaluation in Alberta? Have we fulfilled Alberta Education's two guiding principles? What is the state of the professional development or growth concept of teacher evaluation? Do teachers find evaluation a meaningful experience? And what about the marginal teacher? Does equity for the student exist? Perhaps it is time we educators refocus upon "meaningful" teacher evaluation.

Arts-Based Activities

1. Provide an account of your experience of having been evaluated by or of evaluating others. How could you best share with someone else what happened? In what ways is Pat's account different from most other research reports you may have read (for example, of leadership or staff appraisal)? How different are the two sections in which his account is written, that is, "You're out . . . these many years later" and "Teacher evaluation never . . . 'meaningful' teacher evaluation"? Which of these two sections engages your empathy more—the shaped narrative or the argued exposition? Why?

2. What is the significance of the story's title and its baseball setting? How effective is the writer's use of the metaphor? What is the effect of details such as Pat's fielding as backstop? What is the effect of the internal monologue: "So he's chosen this Friday afternoon to do it"? Does the young superintendent climbing out of an orange Datsun function as the *deus ex machina* of Greek tragedy?

3. Why is "That's three away" included? Why is the actual conversation between Merv and the superintendent left unsaid? Is imaginative omission or "constructive neglect" (Eisner, 1995, p. 4) a means of artistic expression? If so, say why. What is the effect of "He just let me go, Pat"? What does one say in Pat's position? Do "principals just know these things"? How did Pat "know"

how to use literary devices in his account? As Dillard (1982) argues, we do "not produce a work and then give it a twist by inserting devices and techniques here and there like acupuncture needles. The work itself is the device" (p. 29).

4. What obligations do we incur when we tell anyone else's story? How is our story complicit in theirs? How can we decide whose is the more compelling or convincing story? How can we arbitrate between the different points of view expressed in Pat's story of Merv's being "let go," including those of the superintendent, the parents, and students, and those of others that may not have been heard? What could other witnesses such as one of Merv's practice teaching supervisors/associate teachers or a university preservice mentor have added?

5. Although Merv is "cast out," he may be also sentenced to a more constrained view of himself. How could teachers and students be seen as "in prison"?

Summary Comments

"Real" life educational questions are complex and any answers are limited. In postmodernist social science, no knowledge claim is privileged. What we are left with is a romantic affirmation of multiple realities and an acknowledgment of different interpretations. Pat wonders "what Merv's story would be if he told his version these many years later." We all might question how justice can ever be served and how the marginal participant can fare. Later in this book we depict prison as the darker side of education, with those in authority (supervisors) doubling as wardens and guards (see chapters 9, 10, 11, and 12). We show how each is a nonidentical twin. The postmodern pursues that which is doubled, imperfect, and unfinished. We all are at-risk.

In the strange case of postmodernism, it may seem that "you can say anything you want, but so can everyone else" (Rosenau, 1992, p. 137). But this "brave new world" is not a futile one where "anything goes." Dipple (1988), for example, describes the imaginative omission or minimalism that marks neo-realists as "barren anti-adjectival, anti-adverbial unwittiness" (p. 11). While paradoxically it may seem that the more we are persuaded by the arguments of postmodernism the less we can do with them, we can write to represent the author in the text. We can ensure that individual practitioner voices are heard in the stories of inquiry and development. By attending to our own artful

practices, we can learn how our lives and texts intersect with others'
and enrich our own.

In the case of modernist social science, a winner is longed for. The
modernist paradigm demands premature closure of ideas and relation-
ships in the name of certain knowledge. Only one of any two rival
theories can be considered "correct" and the majority of rewards are
reserved for the very few. In the contrasting postmodernist world, we
float amid the conflict, ambiguity, and instability. We sail in a more
equal space where everyone can be an artistic "winner." The combi-
nation of postmodern forms may seem to produce an unusual vessel
or, to mix the metaphor, an unpredictable, fascinating monster cre-
ation. But all of us as educators can redraw our own portraits and
those of schools, rekindling our love affair with teaching and inquiry.
We encourage the postmodern educator researcher to be a creator-
hero/ine-writer-artist-interpreter-theorist. Art is a part of us.

References

Barone, T. E. (1995). The purposes of arts-based educational research. *International Journal of Educational Research, 23*(2), 169–180.

Barone, T. E., & Eisner, E. (1997). Arts-based educational research. In R. M. Jaeger (Ed.), *Complementary methods for research in education* (pp. 73–103). Washington, DC: American Educational Research Association.

Barthes, R. (1977). *Image, music, text* (S. Heath, Trans.). London: Fontana.

Blake, W. (1966). *Blake: Complete writings.* (G. Keynes, Ed.). London: Oxford University Press.

Blumenfeld-Jones, D. S., & Barone, T. E. (1997). In J. Jipson & N. Paley (Eds.), *Daredevil research: Re-creating analytic practice* (pp. 83–107). New York: Peter Lang. (Counterpoints Series)

Booth, D. (1985). Nietzsche on the subject as multiplicity. *Man and World, 18,* 121–146.

Bresler, L. (1995). A symposium on arts, knowledge, and education. *Educational Theory, 45*(1), 1–84.

Byatt, A. S. (1993). *Angels and insects.* London: Vintage.

Clandinin, D. J., & Connelly, F. M. (1992). Teacher as curriculum maker. In P. Jackson (Ed.), *The handbook of research on curriculum* (pp. 363–401). New York: Macmillan.

————. (1996). A storied landscape as a context for teacher knowledge. In M. Kompf, W. R. Bond, D. H. Dworet, & R. T. Boak (Eds.), *Changing research and practice: Teachers' professionalism, identities, and knowledge* (pp. 137–148). London: Falmer Press.

Clifford, J. (1984). Introduction: Partial truths. In J. Clifford & G. E. Marcus, (Eds.). *Writing culture: The poetics and politics of ethnography* (pp. 1–26). Berkeley: University of California Press.

Coleridge, S. T. (1967). *The rime of the ancient mariner.* In D. Perkins (Ed.)., English romantic writers (pp. 404–413). New York: Harcourt Brace Jovanovich. (Original work published 1798)

Connelly, F. M., & Clandinin, D. J. (1988). *Teachers as curriculum planners: Narratives of experience.* New York: Teachers College Press.

————. (1990). Stories of experience and narrative inquiry. *Educational Researcher, 19*(5), 2–14.

————. (1995). *Teachers' professional knowledge landscapes.* New York: Teachers College Press.

Craft, A. (1997). Identity and creativity: Educating teachers for postmodernism? *Teacher Development: An International Journal of Teachers' Professional Development, 1*(1), 83–96.

Denzin, N. K. (1997a). Performance texts. In W. G. Tierney & Y. S. Lincoln (Eds.), *Representation and the text: Re-framing the narrative voice* (pp. 179–217). Albany, NY: State University of New York Press.

————. (1997b). Do unto others: In defense of the new writing. *Taboo: The Journal of Culture and Education, 1*, 3–16.

Derrida, J. (1978). *Writing and difference* (A. Bass, Trans.). Chicago: University of Chicago Press.

Dewey, J. (1938). *Education as experience.* New York: Macmillan.

Diamond, C. T. P. (1991). *Teacher education as transformation: A psychological perspective.* Milton Keynes, UK: Open University Press.

Diamond, C. T. P., Mullen, C. A., & Beattie, M. (1996). Arts-based educational research: Making music. In M. Kompf, W. R. Bond, D. H. Dworet, & R. T. Boak (Eds.), *Changing research and practice: Teachers' professionalism, identities, and knowledge* (pp. 175–185). London: Falmer Press.

Diamond, C. T. P., & Mullen, C. A. (1997). Alternative perspectives on mentoring in higher education: Duography as collaborative relationship and inquiry. *Journal of Applied Social Behaviour, 3*(2): 49–64.

Dillard, A. (1982). *Living by fiction.* New York: Harper & Row.

Dipple, E. (1988). *The unresolvable plot: Reading contemporary fiction.* London: Routledge.

Dissanayake, E. (1995). *Homo aestheticus: Where art comes from and why.* London: University of Washington Press.

Duncan, N. A. (1984). *An assessment of formal teacher evaluation practices in Alberta.* Edmonton, Alberta: Alberta Educational Planning Service.

Eco, U. (1984). *The name of the rose.* San Francisco: Harcourt Brace Jovanovich.

Eisner, E. W. (1991). *The enlightened eye: Qualitative inquiry and the enhancement of aesthetic experience.* New York: Macmillan.

———. (1993). Forms of understanding and the future of educational research. *Educational Researcher, 22*(7), 5–11.

———. (1996). Is 'the art of teaching' a metaphor? In M. Kompf, W. R. Bond, D. Dworet, & R. T. Boak (Eds.), *Changing research and practice: Teachers' professionalism, identities, and knowledge* (pp. 9–19). London: Falmer Press.

———. (1997). The promise and perils of alternative forms of data representation. *Educational Researcher, 26*(6), 4–10.

Fay, B. (1977). How people change themselves: The relationship between critical theory and its audience. In T. Ball (Ed.), *Political theory and praxis* (pp. 200-233). Minneapolis: University of Minneapolis Press.

Finley, S., & Knowles, J. G. (1995). Researcher as artist/Artist as researcher. *Qualitative Inquiry, 1*(1), 110–142.

Gates Jr., H. L. (1992). *Loose canons: Notes on the culture wars.* New York: Oxford University Press.

Guinness, D. (1990, April 10). Mills & Boon feel their oats. *The Bulletin*, pp. 90–91.

Halliday, M. A. K. (1973). *Explorations in the function of language.* London: Edward Arnold.

Hellman, L. (1976). *Pentimento.* London: Quartet Books.

Hollingsworth, S., & Sockett, H. (1994). Positioning teacher research in educational reform: An introduction. In S. Hollingsworth & H. Sockett (Eds.), *Teacher research and educational reform* (pp. 1–20). Part I, Ninety-third Yearbook of the National Society for the Study of Education. Chicago: University of Chicago Press.

Jackson, P. W. (1992). Helping teachers develop. In A. Hargreaves & M. G. Fullan (Eds.), *Understanding teacher development* (pp. 62–74). New York: Teachers College Press.

Jipson, J., & Paley, N. (Eds.). (1997). *Daredevil research: Re-creating analytic practice.* New York: Peter Lang. (Counterpoints Series)

Jones, A. R., & Tydeman, W. (1972). *Wordsworth: Lyrical ballads.* London: Macmillan.

Lather, P. (1993). Fertile obsession: Validity after poststructuralism. *The Sociological Quarterly, 34*(4), 673–693.

Lovelace, M. (1996). *Maggie & Her Colonel.* Harlequin Enterprises. [On-line]. Available: http://www1.romance.net/currentmonth/serial/index.html.

Lyotard, J. F. (1984). *The postmodern condition.* Minneapolis: University of Minneapolis Press.

Macken, D. (1990, November 24). Heroine addicts. *Sydney Morning Herald*, pp. 60–63.

Miles, M. B., & Huberman, A. M. (1994). *Qualitative data analysis: An expanded sourebook* (2nd ed.). Thousand Oaks, CA: Sage Publications.

Mullen, C. A. (1997). *Imprisoned selves: An inquiry into prisons and academe.* New York: University Press of America.

Mullen, C. A., Cox, M. D., Boettcher, C. K., & Adoue, D. S. (Eds.). (1997). *Breaking the circle of one: Redefining mentorship in the lives and writings of educators.* New York: Peter Lang. (Counterpoints Series)

Paley, N. (1995). *Finding art's place: Experiments in contemporary education and culture.* New York: Routledge.

Peters, M., & Lankshear, C. (1996). Postmodern counternarratives. In H. A. Giroux, C. Lankshear, P. McLaren, & M. Peters. *Counternarratives: Cultural studies and critical pedagogies in postmodern spaces* (pp. 1–39). New York: Routledge.

Rosenau, P. M. (1992). *Post-modernism and the social sciences: Insights, inroads, and intrusions.* Princeton, NJ: Princeton University Press.

Ross, S. D. (1987). *Art and its significance.* Albany, NY: SUNY Press.

Said, E. W. (1996). *Representations of the intellectual.* New York: Vintage.

Sarason, S. B. (1990). *The challenge of art to psychology.* New Haven, CT: Yale University Press.

Sayer, A. (1992). *Method in social science: A realist approach.* London: Routledge.

Shelley, M. (1818/1994). *Frankenstein.* Oxford: Oxford University Press.

Tolstoy, L. (1930). *What is art?* (L. & A. Maude Trans.). London: Oxford University Press.

Ulmer, G. (1989). *Teletheory.* New York: Routledge.

Vidal, G. (1993). *United States: Essays 1952–1992.* New York: Random House.

von Loewenstein, P. (1992). "You're out!" *Among Teachers: Experience and Inquiry.* Toronto: Among Teachers Community, Centre for Teacher Development, OISE/UT.

Zipes, J. (1997, September-October). Tales worth telling. *UTNE Reader*, pp. 39–42.

Chapter 2

The Air and Iron, Light and Dark of Arts-Based Educational Research

C. T. Patrick Diamond
Carol A. Mullen

It may perhaps seem to you as though our theories are a kind of mythology. But does not every science come in the end to a kind of mythology like this? Cannot the same be said today of your own Physics? (Freud, in his correspondence with Einstein, cited in May, 1991, p. 11)

How did you contrive to grasp
The thread which led you through the labyrinth?
How build such solid fabric out of air?
How on such slight foundation found this tale,
Biography, narrative? or, in other words,
How many lies did it require to make
The portly truth you here present us with?
(Robert Browning, 1996, *Mr. Sludge, "The medium,"* p. 348)

Fictions and Labyrinths

Literary critics are often criticized for "portly" or overstated writing that does not live up to the radical experimentalism that they urge upon postmodern artists. We appreciate the irony that we, too, plead the case for arts-based research in expository essay form in this chapter. In Part I, we concentrate on arguing for arts-based research as a promising lead in inquiry and as a developmental strategy for educators. After seeking to broaden the appeal of artistic approaches in educational research, we provide extended examples of their practices in Part II. As postmodernist educators, we ask throughout all the chapters: "Which world is this? What is to be done in it? Which of my

selves is to do it?" (McHale, 1987, p. 10). We use arts-based activities in each chapter to criss-cross between modes of reasoned logic and creative imagination, both of which are forms of inquiry.

All inquiry, whether fashioned after natural science or the arts, strictly consists of no more than fictions (from *fingere*, to make or craft). Our foundations are always slight. Whenever we report an inquiry, we deliberately choose, or fall back unaware on, a particular form to represent the meanings that we construct out of our research experience. When the ways in which we "order" our ideas and assumptions are not consciously grasped, we can only function in a conventional way, attributing our understandings to external sources and ascribing to them impersonal meaning and value as if just in the nature of things. When the processes by which we come to know are estranged from ourselves, then "our capacity to [represent and] theorize critically about the vulnerabilities and possibilities of our conditions and practices is diminished" (Britzman, 1992, p. 31).

Arts-based forms of inquiry differ from scientific ones in that they are self-consciously shaped. They differ in the degree to which features of the medium of expression are foregrounded or given prominence (see chapter 1). Only art explicitly announces and cultivates its fabricated nature. As Dewey (1958), the philosopher poet, explains: "Science states meanings; art expresses them. Statement sets forth the conditions under which an experience of an object or situation may be had. . . . The poetic as distinct from the prosaic, aesthetic art as distinct from scientific, expression as distinct from statement, does something different from leading to an experience. It constitutes one" (p. 84).

Arts-based modes best accommodate and express the direct aspects of experience (Donmoyer, 1990). For Merv and Pat in chapter 1, these aspects included pain, guilt, self-doubt, and not knowing. In contrast, positivist social science confidently emphasizes declarative, procedural, and logical forms of knowledge and thought. Such a reasoned mode of working with the instrumental iron of "facticity" (Updike in Winokur, 1986, p. 33) is not compatible with the experiential, human science mode of working with the unconfined and life-giving air of imagination. Greene (1995) calls for release of the imaginative capacity as a prerequisite to developing the "ability to look at things as if they could be otherwise. . . . To tap into imagination is to become able to break with what is supposedly fixed and finished, objectively and independently real. It is to see beyond what the imaginer has

called normal or 'common-sensible' and to carve out new orders in experience" (p. 19).

In contrast to promoting openness and indeterminacy, Krathwohl (1993) believes that, "of all knowledge sources, only science and the reasoning authority routinely seek and survive testing and challenge" (p. 50). For him, only science contributes to "uncertainty reduction and therefore to the development of knowledge" (Barone, 1995, p. 170). Krathwohl (1993) emphasizes the hegemony of propositional discourse and in his textbook on methods of educational research provides no references to "artist" or "self" (except to prefix "esteem"). However, he does present an inquiry continuum that extends from quantitative to qualitative researchers, including pragmatists, analyzers, synthesizers, theorizers, multiperspectivists, humanists, and particularists. Each researcher type occupies a different world, exemplifying another view of what constitutes worthwhile inquiry and preferred methods in educational research.

Researchers who use arts-based forms to frame their qualitative inquiries may focus on any one, or a cluster, of the above nonpragmatic modes to guide their approaches. In this chapter, we overlay much of the continuum with artful methods of inquiry. We argue for, and provide brief examples of, artistic forms, including fantasy and literature (allegory, fables, paradigm parables, riddles, plays, and poems), visuals (films, storyboards, texts written across their subject matter, and Möbius strips), "mystories" (Ulmer, 1989) or narratives of self, and short stories or novellas. Successful arts-based texts serve two of the fundamental purposes of educational inquiry, that is, "uncertainty enhancement" (Barone, 1995, p. 177) and "value negation" (p. 176). What most differentiates such a text "from a numbers-based and/or theoretically grounded scientific text . . . is an assessment of its ability to speak to those . . . readers who do not share frames of reference formed in us by our life experience" (p. 176). Such a text seeks to teach readers to see through the eyes of other people and to awaken the artist-storyteller in them.

Beyond the Qualitative-Quantitative Divide

At the risk of maintaining too sharp a distinction, we have begun by contrasting science and arts-based approaches. While the term "science" derives from *scientia*, Latin for knowledge, if we were to know a rose only by its Latin or botanical name, *rosa*, and not experience

its fragrance, we would miss much of its pleasure and meaning (Eisner, 1981). Experience escapes the hold of logic as Marlow, Conrad's (1902/1990) narrator in *Heart of Darkness*, also found. The two main approaches to research endorse a different view of truth and certainty. While scientific research emphasizes a formula for reaching "certain truth," arts-based research invites the search for partial understandings. From an arts-based position, the natural sciences model, composed of simple generalization, propositional forms of reasoning, and rigid principles, has become more difficult to attain and less appealing to defend. However, as affirmative or revisionary postmodernists, we do not wish to portray quantitative inquiry as simply the antagonist of qualitative research either. Instead, we endorse a kind of "omniform social science" (Barone, 1995, p. 171) in which distinctions are blurred.

We believe it important not to set up one kind of research just as a foil against the other, damning the one to darkness, in comparison with which the other appears as a state of blissful enlightenment. Although fundamentally different, they are also related ways of pursuing the same "artful science" of inquiry. There is one culture of inquiry, not two warring worlds: "The scientist and the artist, far from being engaged in opposed or incompatible activity, are both trying to extend our knowledge and experience by the use of creative imagination subjected to critical control" (McGee, 1973, p. 68). We, the authors, field scientific and artistic approaches against each other, representing them as moving between dark and light, iron and air, only to suggest new possibilities and to reappraise more of the range of experience. We can "hold two opposed ideas in the mind at the same time and still retain the ability to function" (Hampden-Turner, 1971, p. 39). As Freud suggested to Einstein, beyond the usual divide of numbers and words, there are continuities and complementary aims to be realized among the different approaches to myth making.

The Emergence of Arts-Based Educational Research

If qualitative research is now coming of age rather than merely into vogue, arts-based varieties of inquiry are only beginning to emerge. Such inquiry addresses a problem in teaching by using artistic forms to give ordered expression to ideas and feelings that are particular to the researcher. The personal and the aesthetic are central to arts-based research, while the treatments of topics of concern are intensified.

Arts-based, phenomenological humanists, such as Barone (1997), Greene (1993), and Grumet (1990), if they could be so located on the above continuum, provide interpretive accounts of emotionalized experience. Such texts are simultaneously argued narratives. They have the literary and catalytic power to engage and transform readers, encouraging them to question and draw upon their own imaginative as well as experiential resources. Humanistic inquirers articulate and make more affecting those qualities that lie below the surface of experience. Particularists, like Connelly and Clandinin (1988, 1990), Denzin (1992), and Richardson (1992), by way of further example, might be located at an even more subjectively oriented position. Without loss of context, they show how individuals can discover the narrative patterns that affect and work for them through telling the stories that inform their lives.

Wolcott (1990) also dramatically personalizes the world of his research. He even traced the story of his own near murder at the hands of "Brad," the "subject" of a previous case study written to address the issue of educational inadequacy. In facing the "fire and spit" (Updike, in Winokur, 1986, p. 33) of this experience, including the loss of his library and previous understandings, Wolcott dropped his concern for validity. His deeper insights into, and imaginative discoveries about, human waste and darkness were fed instead by reflexivity and intuition. This is the revelatory function of art which "throws off the covers that hide the expressiveness of experienced things . . . and orders them in a new experience of life" (Dewey, 1958, p. 104). Arts-based representations have the potential to break through the limits of conscious understanding to speak even beyond their maker's means (Lather, 1995).

Barone (1987a, 1987b, 1992, 1995) characterizes researchers who are working at this end of the spectrum as nonscience fictionalizers. They provide a complementary form of knowledge to that produced by pragmatic scientists. To challenge the premises, principles, and procedures of quantitative research, they begin by treading water. Then they dive in at the deep end, using the techniques of novelists, poets, painters, autobiographers, literary ethnographers, and dramatists to break the surface of experience. The most promising research forms may no longer be derived from natural science but from what may be called the *romantic* or novelistic sciences.

Unlike the sentimental love stories referred to in chapter 1, educational fictions in which "real" people and events appear with invented names in "real life" dilemmas are known as *romans-à-clef*. In another

form of lightly fictionalized autobiography, *Bildungsroman*, the experiences of the central character's early life and development are brought to the foreground. The relationship of arts-based to scientific inquiry may also be thought of in terms of the break-away development of the romance group of European languages. With the decline of the *Pax Romana* and its imposed language of occupation, the languages of the provinces were able to grow in their different ways.

This shift of interest in the content and form of research heralds a form of inquiry that resists the confident realism not only of meta-analyses of large scale, empirical correlational studies (as of classroom interaction), but even of the 1,000-page, triple decker novel, poetic sagas and epics, and large, six-foot narrative paintings. Despite the claims of television and radio newscasts, "telling it like it is" is impossible. Even traditional qualitative research forms, such as field methods that involve interviewing and participant observation, are no more to be trusted than storytelling and poetic encounters with self and others (Clifford & Marcus, 1984). The familiar concerns of validity and reliability are complemented by those of aesthetic expression and self-reflexivity. These arts-based concerns are themselves inquired into and, as a result, are clarified or collapsed.

We are seeking to invent postmodern versions of inquiry to transform the ways in which classrooms, teacher development, and inquiry are represented. As a mode of writing, literature is distinguished by its quest for its own elusive individuality. The identity of the text, the determinacy of meaning, the integrity of the author, and the validity of interpretation all play a role in the representational character of such texts (Mitchell, 1990). "The essence of literature [or art] is to have no essence, to be protean, undefinable, to encompass whatever is situated outside it" (Culler, 1982, p. 182). By using the alarmingly short circuit of the enigmatic novella (see Conrad, 1902/1990; Borges, 1962; and Barth, 1968), we can express a condition of artistic knowing in which the essentials of any affair always lie beyond our reach and power of intrusion. In the next sections, we suggest textual and visual strategies for arts-based inquiry.

Forms of Arts-Based Inquiry

Realism promised unity and continuity and was supposed to express these "conditions" of reality. It was supposed to mirror and criticize

reality, console us, and tame our increasingly fragmented selves and experiences. However, despite all the injunctions to "get real," realism and "hard-core" reality are unattainable. Postmodern inquiry is indifferent to such concerns for coherence and closure. Rather than feeling at a loss, artistic researchers can go on by avoiding (or working through to the point of exhaustion or boredom) the prosaic writing style and reporting conventions of much social science. What we now see as constraints in representation to be avoided include passive voice; omniscient narrator lacking personality; long, awkward, repetitive authorial voice-overs; impersonations of the participants' individual voices; a smoothing over of human differences, conflict, and tension; lack of concrete particularity and detail; tone deafness; and "most disheartening, the suppression of narrativity (plot, character, event)" (Richardson, 1992, p. 131). More positively, artistic researchers seek language uses that are evocative, metaphorical, figurative, connotative, poetic, and playful (Barone, 1987b). By experimenting with artistic form, they learn about themselves and their deeper capacities while connecting with the flight paths or deadends of others.

Eisner (1977, 1981, 1991, 1993), Barone (1983, 1987a, 1995, 1997), and Barone and Eisner (1997) have championed and pioneered the use of arts-based research genres. Barone (1987a) describes qualitative, ideographic inquirers as adapting strategies and methods associated with literary criticism and the arts to describe and assess facets of education. These researchers represent their practice artistically and then, as educational critic-connoisseurs, respond aesthetically to the accounts. If artistic form renders the immediacy of experience, criticism (*krisis*, Greek for judgment) promotes appreciation of the representation. In focused, sensitive ways, connoisseurs (*cognoscere*, Latin for "to know") serve as expert readers, directing attention to the qualities expressed in arts-based inquiries.

Unlike literary critics, educational critics do not overemphasize the formal, aesthetic side of things alone (Greene, 1993). We can each become expert readers of ourselves. Autobiographical narrative helps us to become critics of our own arts-based texts. New reading "focuses upon the self and its history, slows down movement, makes it stay, so it becomes more visible, its details discernible" (Pinar, Reynolds, Slattery, & Taubman, 1995, p. 584). To encourage us to leave our safe anchorages and to sail the open seas in search of other ways, some new arts-based departures are suggested below.

The Literature of Fantasy:
Which World or Self Is This?

Artistic research provides ways for us to set out on and chart our journeys into the exotic territories of the marvelous and the uncanny. The supernatural is never far off in fantasy. In Coleridge's *Ancient Mariner*, the dead sailors rise up from the decks of the enchanted ship and "man" the rigging. While we know that some things literally cannot occur, in fantasy we allow them to. "Speculative fabulation" (Scholes, 1975, p. 29) presents a world different from the one we know. The fantasized unknown allows us to confront the known. Like fiction of the future (the marriage of science and fiction), fantasy thrives on hypothesis, provisional supposition, and the suspension of belief as well as disbelief. The literature of fantasy helps us to become more malleable so that we can play with a "what if?" or imagined universe.

Inquiry into what educators can make of themselves, of others, and of all the meshing or clashing of their intersecting worlds, is so important a task that it deserves all the rich variety of insight that we can bring to it (Bruner, 1990). Among the promising strategies for expressing this aim, we include escape fantasy, personal story (self-narrative or verbal portrait), dramatic monologue or account, farce, tragedy, black comedy, adventure story, magical fairy tale, wonder or horror tale, fable, and detective or mystery story. As research genres, these forms suggest new ways of asking questions of the world to make it a more expansive yet less certain place.

While actual arts-based applications in educational research are still less easily located than their literary precursors, fantasy is a promising form from which to borrow because it provides a set of plights in the human condition to which we all must react (Bruner, 1987). Unlike the obvious "facts" produced by personless observation and closed logic, enigmatic stories of the fantastic deliberately puzzle readers with their ambiguous, self-referential, and metaphysical qualities. *Avant-garde* metafiction, with its densely allusive, tragic and mock heroic fantasies, teaches us that we cannot simply rely on existing maps (see chapter 8). Instead, educational inquiry can be written as tantalizingly short texts, brimful of the unexpected. By following the examples of Borges (1962), Eco (1984), and Barth (1968), compact literary fables can be spun about teaching and inquiry.

In *Labyrinths*, a collection of fictions, essays, and parables, Borges (1962) evoked the postmodern view of experience through the sus-

tained use of self-conscious allegory (see chapter 16). Glimpses of what has been lost are presented not as a linear continuum but as vertiginous labyrinths. As Wolcott (1990) testified, at the end of an inquiry all that may remain is the endless recurrence of tragic loss. In the "Library of Babylon," Borges depicts the universe as infinite and always starting over. No narrator can ever reach the Book of Books or "the truth." The unknowable, insoluble mazes imposed by experience contrast with the more readable semblances of order made by empirical researchers. Artistic inquiry resembles an open-ended, intriguing puzzle rather than an endpoint. Nothing ever quite connects, nor does it need to. Like the world at large, experience and inquiry consist of elusive sets of hieroglyphs.

Whenever we write, we borrow endlessly from the past, and other books and sources, including ourselves. Borges' work has influenced many Latin American writers, the French *nouveaux romanciers* like Barthes, American experimentalists like Barth and Barthelme, and Italian writers like Calvino and Eco. But not even Jorge Luis Borges can provide the key to understanding the labyrinth. He is parodied by Eco (1984) in *The Name of the Rose* as Jorge of Burgos, the text-obsessed librarian, who hoards rather than shares knowledge. Borges' admired image is invoked by the novelist as a red herring to distract the reader from too easily unraveling the detective plot. Like Milton before him, Borges went blind—just as he was appointed Director of the National Library of Argentina to preside over 800,000 books. The extent to which texts speak to texts leads us to wonder if all genres and forms have been exhausted and can only be mimicked and played against, as in pastiche. Shakespeare exploited the works of others like so many hand-me-downs. Writing leads to more writing and texts lean against texts. In writing to inquire, we fumble to create new, self-conscious forms.

Whenever we read, we also actively cocreate the text in transactions with all its authors. Each reader is the space where all the quotations that make up a text are inscribed without being lost (Barthes, 1977b). In chapter 4, Patrick and Betty Lou show how her past reading as a teacher continues to influence her practice. New insights arise out of reconsidering earlier ones. In chapter 6, Carol discusses aspects of her former preservice teacher course by reconsidering texts in the area of multicultural education for their "treatment" of Euroamerican identity issues. Any inquiry into the life of an educator, whether set in a prairie, an inner urban or a faraway starworld, remains

a tentative examination. We cannot discover the center of the labyrinth by always just turning left—or right.

Educational research based on the uses of fantasy resembles a series of roads that fork endlessly. Corridors, galleries, stairways, mazes, and abysses lead to still others in an inexhaustible regress. This is an anguishing image of incompleteness. Kafka's novels, *The Castle* and *The Trial*, were both unfinished but limitless works. In fantasy, we make our way through apparent causes and effects but without final resolution. Only ironic, partial insight is possible. This realization provides confirmation of one of the most ordinary features of all experience. Inquiry is a way of going on. We, the editors, seek here and elsewhere to work with teacher researchers on arts-based projects that promote their self-reflection and shared authorship. Like postmodern writers, our participating authors struggle to translate themselves into self-reflexive literary texts.

Arts-Based Activities

1. Try being a fictional hoaxer like Borges. Pretend that a story written about your classroom or research practice has already been published. Write a review of the story, including its author, title, publisher, and preface writer. Whitman and Burgess allegedly also reviewed their own works using other names.
2. You are a space-traveling supply teacher who has reached Dystopia, a lost and deteriorating city, in another time and place. Describe your first day.
3. Upon returning home you decide to set up an excursion for other teachers. Design a brochure to entice them. For example, "Other planets, invasions by superbrains, busybody robots, spaceship battles in the galaxies, worlds that collide . . . all guaranteed."

The meanings of experience are innumerable, as in an infinite game of chance. Despite the impossibility of ultimate success, we still strive to find our way out of difficulty. Authors can see only as in a refracting mirror, in darkness, and can know only partially, even as Shakespeare played with the confusion of double twins with the same names in *The Comedy of Errors*. Inquirers can never see face to face and never know as they are known. They cannot know even who they are or who or what they will become.

Even the narrator and the central figure in a narrative are not the same person. Borges (1962) ends his parable of the duality of the writer and the written-self with the admission: "I do not know which one of us has written this page" (p. 247). Writers struggle to find out who is the creator and who is the impostor (Roth, 1992). As in Escher's (1948) *Drawing Hands* (Figure 3), only playful, reconstructive acts of further experience, combining precision of detail with gravity and absurdity, are possible. The self in a work is generated by an autobio-

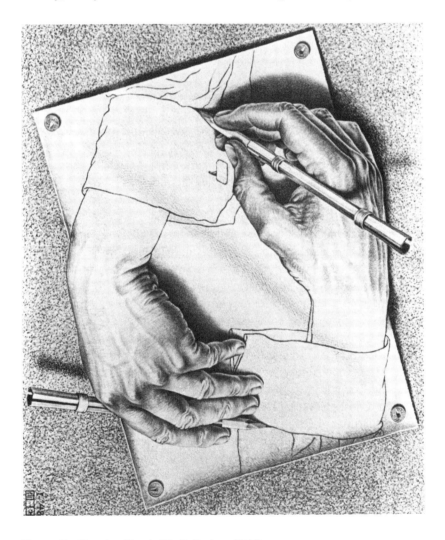

Figure 3 *Drawing Hands* (M. C. Escher, 1948)

graphical encounter between the writer, his or her ideas, and past self (Barthes, 1977a). The author confronts his or her creature in a one-on-one interview.

Like Borges, Eco uses the plot of the detective novel as a metaphysical mode, the unraveling (or impossibility) of which can lead to major epistemological breakthroughs or impasses. Eco's (1984) William of Baskerville is successor to Conan Doyle's Sherlock Holmes. Edgar Allen Poe's detective, C. Auguste Dupin, is the fiction alter ego for the American philosopher, C. S. Peirce, just as Nick Carter supersedes the original Pinkerton man. Whatever the genealogy of such super-sleuths, the subjective worlds of classroom teachers will not yield to any omniscient, Victorian-like narrator-researcher. The inquirer is an adept but fumbling detective.

If a qualitative study were organized as a mystery novel, as Wolcott (1994) suggests, researcher and subjects could be shown as spies behind "enemy" lines, with deception everywhere and reports from the front cryptically encoded. In her spy novel, A Gap in the Records, McKemmish (1985) juxtaposes characters, time periods, and styles of writing to push against usual detective fiction. She shows how the deliberate and accidental forms of power operate in order to resist them. In real life, Ben Jonson, Chris Marlowe, and W. Somerset Maugham were secret agents as well as literary artists. In inquiry as in Seneca's plays, there are no "big," sustainable plots, only antitheses and what Browning would call "lies."

Far from being from "the party of unsound method" (Conrad, 1902/1990, p. 63), arts-based researchers become robust fictionalizers (Barone, 1995) by borrowing self-consciously from postmodern fiction. Although arts-based researchers may be accused either of solipsism, believing that the whole world has been fabricated in their own minds, or of doing "unlicensed metaphysics in a teacup" (Dillard, 1982, p. 11), fiction, with its epistemological turn, may prove to be "as profound (and perhaps out of the same cradle) as the invention of modern physics" (Bruner, 1987, p. 21). Any research story can be better understood in the context of those brewed in the other "teacups" of colleagues and students, and even by our other selves as they change over time.

While the form of condensed parables and detective stories may at first seem more important than their content, the narrative means is part of the experience. These stories seek neither truth nor likelihood, aiming neither to convince nor to persuade. Rather, as Wolcott

(1990) shows, they seek to provoke disbelief and astonishment. Genuinely, educational experience is unsettling. Mullen (1997) surprises readers by connecting the unlikely realms of penal and pedagogical experience. She contrasts the processes of imprisonment with those of being held captive in the rigid bonds of educational research and pragmatic paradigms of knowing. In bookish, pseudo-essays such as "The mirror of enigmas," Borges (1962) puckishly retaliates against such constriction by providing mock scrutinies of overreliance on authorities who are of his own invention! He always works into a story the idea of not being sure of things because that is the way reality is.

By turning in on themselves, self-investigative pieces and their footnotes make a "plot" out of the interplay of creation and critique. As postmodern researchers constantly monitoring our own processes, we resist easy endings and narrative unity. We are always *Lost in the Funhouse* (Barth, 1968), a dark wood, a labyrinth, or a swamp. The literature of fantasy reminds us that even self-narrative is an unstable enterprise, never more than a shaky prelude to the next round of investigations. As self-narrators, we present our materials and apparent conclusions but without final answers. We are always back at the beginning, pondering the mystery.

Barth (1968) assembled a sequence of fantastic short stories that are strung together not to close a simple circuit but to present a plot twist, coiling back upon itself, tail in mouth. That we continue means merely that we continue. Our classroom lives and the experiences of inquiry that we research do not have simple beginnings, middles, and happy endings; nor can they necessarily be told in any linear way. Like Barth's opening tale, they are like an endlessly recurring Möbius-strip of events that are webbed around others (see chapter 12). As we reach out to the future and "beat on, boats against the current, [we are inevitably] borne back ceaselessly into the past" (Fitzgerald, 1950, p. 172).

Fantasy continually reminds us that all stories are artifices, and that narrators are not reliable. For nontraditional researchers, as for the character, Marlow, there may be "a sense of extreme disappointment . . . [that previously they have] been striving for something altogether without substance" (Conrad, 1902/1990, p. 42). Far from being a denial or escape from the qualities of reality, arts-related research provides an extension and confirmation of their primary features. The most we can hope for is partial knowledge of self and other. We

fabricate our illusions and may even dream the universe and ourselves within it.

For Dewey (1958), a dreamlike element of reverie often enters in the creation of works of art. The structure of unconscious modes can be tapped in narrative explorations of the self that are produced in the interplay between dreams, their recording, and lived experiences (Mullen, 1994). By playing with arts-based strategies, such as dream recording, we can incite irrational states, including fascination, enchantment, melancholy, frustration, and distraction (Lather, 1995). The highly self-conscious, fictive labyrinths of Borges, with their pastiches of scholarly and historical documentation, deadpan realism, and bizarre fantasy, provide paradigm parables of hybridized, postmodern representation (Mitchell, 1990).

Arts-Based Activities

1. Write about a teacher whose back half of the classroom has been taken over by the ghosts of former teachers who also taught there. They have been temporarily sealed off behind a makeshift partition of discarded desks and chairs. The superintendent has unexpectedly arrived to appraise the teacher.
2. Your school library has eliminated all its natural vermin only to be invaded by fantastic creatures from its collection of books, including unicorns, dragons, griffins, sphinxes, and more. How can they be welcomed into your current classroom or research projects?
3. It is your first appointment. You are the new tutor for two small children in a large, isolated family home. The children's former tutor disappeared mysteriously. There is a strange key but no matching door.
4. If writers become books when they die, which would you choose to inhabit? Perhaps you might choose to enter into one of its characters. Calvino chose Mercutio from *Romeo and Juliet* because this character saw every experience, whether comic or tragic, as an opportunity for inventive wit. "I admire above all his lightness in a world of brutality, his dreaming imagination . . . and at the same time his wisdom. . . . [He] is a Don Quixote who knows very well what dreams are and what reality is, and he lives both with open eyes" (Dipple, 1988, pp. 102–103).

Using Visuals, (My)stories, Poems, and Novellas

Research experiments are also being made with other creative genres to convey the subjective qualities of experience. Realizing that all texts are only stand-ins for the actual experience being described and interpreted, we are challenged to provide our own nonrealist accounts. For example, Denzin's (1992, 1997) research plot is itself deconstructive, weaving a critique of empirical realism with a call for new writing, performance texts, and specifically "mystories" (Ulmer, 1989). These self-narratives, like docudramas, report the marker or epiphanic experiences of ordinary life. These events are "interactional moments that leave marks on people's lives. . . . [They] have the potential for creating transformational experiences for the person. . . . In them personal character is manifested and made apparent. . . . Having had this experience the person is never quite the same again" (Denzin, 1989, p. 15). Over 60 years ago, Bergman (1988) entered the darkness of a nursery wardrobe to experience his epiphany by turning the handle of a heavy magic lantern. As in silent photo-plays, the shadows turned their pale faces toward the child and spoke in inaudible voices to his secret feelings.

In a cinematic inquiry, the boundaries between life and art, reality and dream, can be questioned and crossed. As life and reality dissolve, art and dream become tangible. In Denzin's (1992) reading of Bergman's *Persona*, one woman is mute and withdrawn, while the other is voluble and expressive. This recalls the contrast traditionally drawn between qualitative and quantitative forms of inquiry. Crucial elements of video fiction or "teletheory" have been missing from previously sanctioned research: there have been no "real" people in the here and now, and sequences of events are seldom so flat and linear. Figures and plots can be foregrounded in new forms of inquiry, such as interpretive biography (Denzin, 1989), autoethnography (Diamond, 1992), and narrative ethnography (Mullen, 1997).

Multiform visual methods currently being explored in qualitative educational research include the use of perspective to produce close-ups (the intimacy of first person revelations) and long-shots (the detachment of third person reflection). Additionally, those who employ arts-based techniques explore artful data display (Blumenfeld-Jones & Barone, 1997); visuals that tell more than words can and that provoke reaction (Jipson & Paley, 1997); musical and literary renderings of

text (Mullen, Diamond, Beattie, & Kealy, chapter 12); simultaneous and interrupted voices (Jipson & Wilson, 1997); poetic meditations on cultural and political themes (Greene, 1993); dialogue journaling (shared story writing) as a resource for collaborative inquiry (see chapter 11); dialogue and story as reader's theater/script (Clark, Moss, Goering, Herter, Lamar, Leonard, Robbins, Russell, Templin, & Wascha, 1996); performance texts based on the writer's personal history and the audience's cocreation (Denzin, 1997); and greater self-referentiality and self-auditing proclaiming the presence of the researcher (Barone, 1997). These new multimedia forms are part visual, part montage, and part cinematic.

A multiform text may write itself across its own subject matter, mixing the printed text with photographs, lyrics from songs, and with lines from films, diaries, and journals. Denzin (1992) cites an exemplary text by McGuire (1991), which consists of a (my)story analysis of the discourse on anorexia nervosa. Her handwritten and typed text is written across another text made up of xeroxed photographs of the bodies of models taken from fashion magazines. In chapter 5, Margie shares a poem (written in her left hand) that she wrote to Mrs. MacDonald, her kindergarten teacher, superimposed over a photograph of herself in pigtails taken on one of her first days at school. Margie learned to distrust and to put on hold her artistic child-self.

As shown below in Figure 4, Rick (in Diamond & Dixon, 1997), an artistic teacher-researcher, used a storyboard, comic book format to illustrate the stresses of a teacher's day that Barbara, another teacher at his school, had represented in a poem. In *Ulysses*, Joyce opened up the experiences of a single day shared by three characters (or aspects of a self) criss-crossing in Dublin. In Ashton-Warner's (1963) artful text called *Teacher*, she tells the stories of single words. Her young Maori children in a New Zealand school create their own personally significant vocabulary and, in the process, discover their own intense meanings, pictorial representations, and "movement from the inside outward" (p. 95).

Educational researchers experimenting with the self and the study of other educators include: Barone (1983, 1997), Howard (1989), Peshkin (1988), Stark (1991), Teitel (1994), Trumbull (1990), and Wolcott (1990). Richardson (1992) provided a challenging example of a fictionalized, arts-based research text and a self-study of its effects. She transformed the transcript of an interview into a poem, shaping the words spoken by a single adult mother from the South. Richardson

chose Louisa May as a test-case among her interviewees precisely because her transcript posed such a difficult and limiting problem. It was almost totally lacking in image, metaphor, and poetry.

Richardson uses a dramatic monologue, a hybrid genre in which a lead character does all the talking, as in a play. "One of the pleasures of reading [such] a . . . monologue is the unfolding of the whole drama that it presents in miniature" (Mitchell, 1990, p. 19). In Browning's (1996) poem, "My Last Duchess," the Duke of Ferrara describes a painting of his late wife to the agent of a count whose daughter is to be married to the duke. The husband reveals that he gave orders for his first wife's independence to be tamed. Such mystifying aspects of Browning's work prefigure Kafka's use of inexplicability. Richardson's poem is also a representation of a speech act, and thus of a speaker (Louisa May), a listener (Richardson), and a specific setting (the South). In this poem, the victim, Louisa May, is able to speak out but cannot make things happen. Unlike the Duke, she cannot give commands. Louisa May's speaking picture evokes her personhood and situation in ways that scientific, expository statements could not.

By also emulating postmodern formal innovations, Richardson (1992) embeds the poem within her own first person account of her experience of writing the poem. She reports that she felt transformed and more integrated when her overactive researcher and suppressed poet selves found each other. Representing inquiry as poetry was also a way of decentering her unreflexive self so as to create a space for her experiencing self. Richardson was left feeling both exhilarated and more cautiously contemplative about what "doing research" meant. It no longer seemed sterile, ritualized, and narrowly conceived.

In two tradition-breaking novellas, Barone (1983, 1997) introduced an outstanding art teacher and a student "at risk," locating them both within the context of the surrounding Appalachian Mountains. These verbal portraits display enduring qualities of backwoods simplicity and self-reliance, reminiscent of characters from Thomas Hardy's regional novels. Sustained metaphor and disarming reversals challenge settled notions of schooling and of educational research. Rather than recounting a litany of facts or stating a case, Jipson and Paley (1997) also show how artistic research can put together words and visuals, public and private lives, in new and surprising ways to provide glimpses of previously unguessed insights.

By comparison, some traditional research texts may seem like clumsy recapitulations of what is already "known." Wolcott's (1990) shock

story of the murderous "sneaky kid" overturns straightforward no-
tions of self-survival, victimization, and justice to show how the par-
ticular rather than the general engages understanding and enlarges
sympathy. Wolcott's version of Brad's story inspires uneasiness. It
seems impossible "to convey the life sensation of any given epoch of
[any]one's existence, . . . its subtle and penetrating essence. . . . We
live, as we dream—alone" (Conrad, 1902/1990, p. 26). Arts-based
research moves us through its experience-based evocations, partly
unraveling but always retaining mystery. Although all paths give out,
our curiosity is engaged.

Arts-Based Activities

1. You have prepared to videotape your class's next set of activi-
 ties for a presentation at the school's next open house. Without
 warning, the camera begins filming you.
2. Barbara Jensen (Diamond & Dixon, 1997), a teacher researcher
 in her second year, wrote an autobiographical poem (pp. 54,
 57) about the dizzying round of the teacher's everyday activi-
 ties. Rick Taylor, a teacher at the same school, responded in
 comic book or storyboard form (Figure 4).

"I'm Flying" by Barbara Jensen

Running up and down the hall,
Have to go return a call,
Off to get a story book,
Organize the things to cook,
Write some facts upon a chart,
Prepare the paint for morning art,
Showing spunk and initiative,
As I gather math manipulatives,
Problems arise, must intervene,
Need some change for caffeine machine,
John falls and scrapes his knee,
Sarah wants to meet with me,
Get a Band-Aid, get some ice,
Share solutions, give advice,
Stop the goofing in the hall,
Confiscate a bouncy ball,
Wait in line to use the loo,

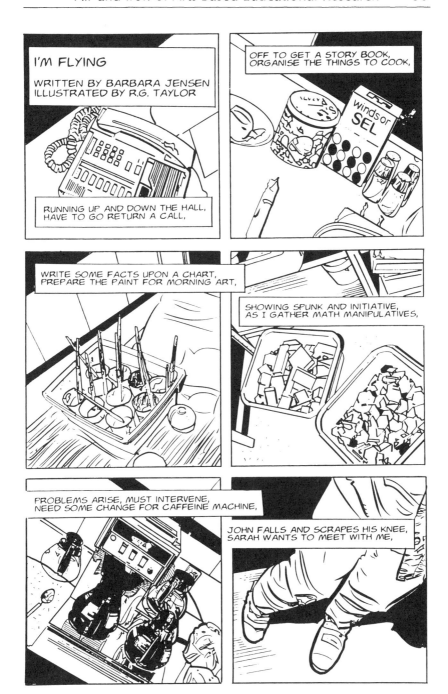

Figure 4 *The Comic Storyboard Form* (R. Taylor, 1997)

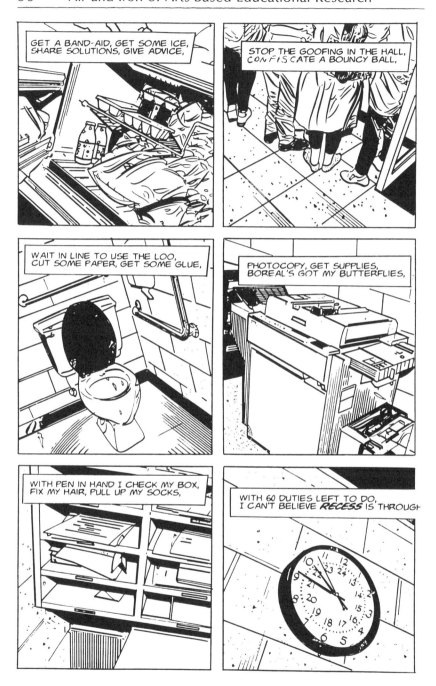

Figure 4 *The Comic Storyboard Form* (R. Taylor, 1997)

Cut some paper, get some glue,
Photocopy, get supplies,
Boreal's got my butterflies,
With pen in hand, I check my box,
Fix my hair, pull up my socks,
With 60 duties left to do,
 I can't believe RECESS is through!!!

1. With what aspects of teaching does Barbara, the teacher researcher, help us to empathize? On first reading, her poem may seem only slight with touches of teacher whimsy and self-effacement. However, its breathless short lines also represent the daunting "busyness" of teaching. How many roles and responsibilities does the teacher discharge in a single day? How many of these involve him or her in professional duties? The disparity suggests that the teacher is being forced to become some kind of juggling improviser or multiskilled Swiss army knife. What is the effect of so few pedagogical and personal needs being addressed? What results from a teacher's being constantly fraught, mobilized, on the alert, and yet also trivialized? What is the effect of the *not* unexpected last line? "Pull up my socks" is an example of telling ambiguity, providing not only a literal description but also a self-improving injunction. Dedicated teachers are constantly enrolling in workshops, upgrading, taking courses.

2. What additional impact does Rick's documentary version of the fragment of a day provide? What image would you have chosen for the very last frame? Rick's clock face reminds us that teachers are typically harried, hurrying on, anxiously trying to cover the curriculum, and striving to cope with the latest developments and unexpected accidents. What is the effect of Barbara's own image not being included? Is the selfless teacher doomed to be faceless and forgotten? Can we ever know the extent of a good teacher's influence? What can a teacher do to prevent the flying or drowning?

Barbara and Rick may have found what Connelly and Clandinin (1988) called "new ways of talking about educational experience. We need a new language that will permit us to talk about ourselves in situations and that will also let us tell stories of our experience" (p. 59).

Summary Comments

"The arts must be taken no less seriously than the sciences as modes of discovery, creation, and enlargement of knowledge in the broad sense of advancement of understanding" (Goodman, 1978, p. 102). When artistic forms such as narrative, short stories, fantasy, visuals, poems, and dramatic monologues are exploited, meanings can be constructed that might otherwise elude us. Aesthetic inquiry exploits the power of form to inform (Eisner, 1981, 1991), rendering qualities of experience expressively through the ways that the form itself is shaped. As educators, we can then uncover how we experience and represent our classroom and research worlds. Retelling and expressing in our own words means learning to speak on our own behalf and no longer relying on the authority and forms of others. (See our stories of breakout in chapter 9.) By not only incorporating customary voices but also by trying out new ones, arts-based inquiry releases further understanding.

Dewey (1938, 1958) conceived of education and art as experience. By linking education and art, researchers can represent the enjoyable or disconcerting meaning of experience for themselves and others. Artistic researchers do their thinking and feeling in the very qualitative media that they work in. Their research depends upon the expressive and intensely personal shaping of experience. Postmodern novelists write about writing novels, poets about composing poetry, and films are made about film-making. Educational researchers are also becoming more conscious of the need to write about and understand their practice. We offer this book as a further step in this self-reflexive direction.

No one system of categories can impose a simple order upon arts-based research, its relationship to other forms of inquiry, and all the possible crossovers. Arts-based research belongs to no one genre such as the literary or visual arts, providing instead many subtle tools for the examination of self and other worlds. Such methods "remain the personal concern, approach, and attack of an individual, and no catalogue can ever exhaust their diversity of form and tint" (Dewey, 1950, p. 173). By overlaying much of the research continuum with arts-based approaches, we are able more deeply to experience "the full *parfum* and effluvia of being human, [the] feathery ambiguity and rank facticity, the air and iron, . . . of our daily mortal adventure" (Updike, in Winokur, 1986, p. 33), including the light and dark. To

adapt Vidal's (1993) contrast of the American annex with the French school of postmodernism, if empirical research "charts our courses point to point, [arts-based inquiry] sights from the stars" (p. 122).

No Last Word

As postmodern researchers sinking hip deep in debris (or hubris), we are self-consciously trying to splice together different inquiry genres, styles, and attitudes. When we engage the meanings of teachers, prisoners, and the marginalized, we seek a tone that is sincere and sacred rather than skeptical. As Calvino noted, "for a prisoner, escape has always been a good thing, and an individual escape can be a first necessary step toward a collective escape" (cited in Sanders, 1997, p. 56). However, when engaging the self, the operations of power, and other topics, the tone is more self-mocking than serious, reflecting a continuum of purposes and possibilities ranging from escape to escapism. Arts-based inquiry juxtaposes fictions-labyrinths, science-art, fiction-nonfiction, straight-ironic, violent-comic, high-low, original-copy, shapes-scraps, and science-fiction. We wish we could say more but we cannot. Postmodernism is "brain damage caused by art. [We] could describe it better if [we] weren't afflicted with it" (Barthelme in McHale, 1987, p. 219). As Dillard (1982) encourages us, "every mode is an option now. It is anybody's ball game" (p. 123).

Arts-Based Activities: What Is to Be Done?

Browse through the following items arranged for a garage sale of postmodern, arts-based forms. Adapt any of them to inquire into your teaching or research: a paradigm parable; a playful or abstract abstract; a collage assembled from the transcribed voices of a video- or audio-taped lesson; a text written across its own subject matter; a split text or palimpsest (twice written on, see chapter 16) of a teacher or student's single day; a shape or nonsense poem that evokes classroom or administrative styles; a picture book or storyboard version of a teacher's day; a sequence of magical or angry (my)stories; a fantastic class or staffroom dialogue; a one act play in search of a plot on discipline; an introduction to a library thriller; a riddle, proverb, or fable about teaching in the future; or a Möbius strip (see chapter 12) about professional development.

References

Ashton-Warner, S. (1963). *Teacher.* New York: Simon & Schuster.

Barone, T. E. (1983). Things of use and things of beauty: The Swain County High School arts program. *Daedalus, 112*(3), 1–28.

———. (1987a). On equality, visibility, and the fine arts program in a black elementary school: An example of educational criticism. *Curriculum Inquiry, 17*(4), 421–446.

———. (1987b). Research out of the shadows: A reply to Rist. *Curriculum Inquiry, 17*(4), 453–463.

———. (1992). On the demise of subjectivity in educational inquiry. *Curriculum Inquiry, 22*(1), 25–38.

———. (1995). The purposes of arts-based educational research. *International Journal of Educational Research, 23*(2), 169–179.

———. (1997). Ways of being at risk: The case of Billy Charles Barnett. In R. M. Jaeger (Ed.), *Complementary methods for research in education* (pp. 105–111). Washington, DC: American Educational Research Association.

Barone, T. E., & Eisner, E. (1997). Arts-based educational research. In R. M. Jaeger (Ed.), *Complementary methods for research in education* (pp. 73–103). Washington, DC: American Educational Research Association.

Barth, J. (1968). *Lost in the funhouse.* New York: Doubleday.

Barthes, R. (1977a). *Roland Barthes* (R. Howard, Trans.). New York: Hill & Wang.

———. (1977b). *Image music text* (S. Heath, Trans.). New York: Hill & Wang.

Bergman. I. (1988). *The magic lantern.* Harmondsworth: Penguin.

Blumenfeld-Jones, D. S., & Barone, T. E. (1997). In J. Jipson & N. Paley (Eds.), *Daredevil research: Re-creating analytic practice* (pp. 83–107). New York: Peter Lang (Counterpoints Series)

Borges, J. L. (1962). *Labyrinths: Selected stories and other* writings. D. A. Yates & J. I. Irby (Eds.). New York: New Directions.

Britzman, D. P. (1992). The terrible problems of knowing thyself: Toward a poststructural account of teacher identity. *Journal of Curriculum Theorizing, 9*(3), 23–46.

Browning, R. (1996). *Mr. Sludge, "The medium . . . "* In J. C. Berkey, A. C. Dooley, & S. E. Dooley (Eds.), *Complete works of Robert*

Browning, 6 (pp. 285–351). Athens, OH: Ohio State University Press.

Bruner, J. (1987). Life as narrative. *Social Research, 54*:(1), 1–32.

———. (1990). *Acts of meaning.* Cambridge, MA: Harvard University Press.

Clark, C., Moss, P. A., Goering, S., Herter, R. J., Lamar, B., Leonard, D., Robbins, S., Russell, M., Templin, M., & Wascha, K. (1996). Collaboration as dialogue: Teachers and researchers engaged in conversation and professional development. *American Educational Research Journal, 33*(1), 193–231.

Clifford, J., & Marcus, G. E. (Eds.). (1984). *Writing culture: The poetics and politics of ethnography.* Berkeley, CA: University of California Press.

Connelly, F. M., & Clandinin, D. J. (1988). *Teachers as curriculum planners: Narratives of experience.* New York: Teachers College Press.

———. (1990). Stories of experience and narrative inquiry. *Educational Researcher, 19*(5), 2–14.

Conrad, J. (1902/1990). *Heart of darkness.* New York: Dover.

Culler, J. (1982). *On deconstruction: Theory and criticism after structuralism.* New York: Cornell University Press.

Denzin, N. K. (1989). *Interpretive interactionism.* Newbury Park, CA: Sage.

———. (1992). The many faces of emotionality: Reading Persona. In C. Ellis & M. G. Flaherty (Eds.), *Investigating subjectivity* (pp. 17–30). New York: Sage.

———. (1997). Do unto others: In defense of the new writing. *Taboo: The Journal of Culture and Education, 1*, 3–16.

Dewey, J. (1938). *Education as experience.* New York: Macmillan.

———. (1950). *Democracy and education.* New York: Macmillan.

———. (1958). *Art as experience.* New York: Capricorn Books.

Diamond, C. T. P. (1991). *Teacher education as transformation: A psychological perspective.* Milton Keynes, UK: Open University Press.

———. (1992). Autoethnographic approaches to teacher education: An essay review. *Curriculum Inquiry, 22*(1), 67–81.

Diamond, C. T. P., & Dixon, B. (1997). *In our own words: Teachers' stories.* Manuscript submitted for publication.

Dillard, A. (1982). *Living by fiction.* New York: Harper & Row.

Dipple, E. (1988). *The unresolvable plot: Reading contemporary fiction.* New York: Routledge.

Donmoyer, R. (1990). Generalizability and the single-case study. In E. W. Eisner & A. Peshkin (Eds.), *Qualitative inquiry in education: The continuing debate* (pp. 175–200). New York: Teachers College Press.

Eco, U. (1984). *The name of the rose.* San Francisco: Harcourt Brace Jovanovich.

Eisner, E. W. (1977). On the use of educational connoisseurship and educational criticism for the evaluation of classroom life. *Teachers College Record, 78*(3), 325–388.

———. (1981). On the differences between scientific and artistic approaches to qualitative research. *Educational Researcher, 10*(4), 5–9.

———. (1991). *The enlightened eye: Qualitative inquiry and the enhancement of aesthetic experience.* New York: Macmillan.

———. (1993). Forms of understanding and the future of educational research. *Educational Researcher, 22*(7), 5–11.

Fitzgerald, F. S. (1950). *The great Gatsby.* Harmondsworth: Penguin.

Goodman, N. (1978). *Ways of worldmaking.* Cambridge, MA: Hackett.

Greene, M. (1993). The passions of pluralism: Multiculturalism and the expanding community. *Educational Researcher, 22*(1), 13–18.

———. (1995). *Releasing the imagination: Essays on education, the arts, and social change.* San Francisco: Jossey-Bass.

Grumet, M. (1990). On daffodils that come before the swallow dares. In E. W. Eisner & A. Peshkin (Eds.), *Qualitative inquiry in education: The continuing debate* (pp.101–120). New York: Teachers College Press.

Hampden-Turner, C. (1971). *Radical man.* New York: Doubleday.

Howard, G. (1989). *A tale of two stories: Excursions into a narrative approach to psychology.* Notre Dame, IN: Notre Dame Academic Publications.

Jipson, J., & Paley, N. (Eds.). (1997). *Daredevil Research: Re-creating analytic practice.* New York: Peter Lang. (Counterpoints Series)

Jipson, J., & Wilson, B. (1997). TH AT DIA LOG UE AT NI GHT. In J. Jipson, & N. Paley (Eds.), *Daredevil research: Re-creating analytic practice* (pp. 161–183). New York: Peter Lang. (Counterpoints Series)

Krathwohl, D. R. (1993). *Methods of educational and social science research: An integrated approach.* New York: Longman.

Lather, P. (1995). The validity of angels; Interpretive and textual strategies in researching the lives of women with HIV/AIDS. *Qualitative Inquiry, 1*(1), 41–68.

May, R. (1991). *The cry for myth.* New York: Delta.

McGuire, G. (1991). Writing the anorexic body. Sociology Department, University of Illinois at Urbana-Champaign. Unpublished manuscript.

McHale, B. (1987). *Postmodern fiction.* New York: Methuen.

McKemmish, J. (1985). *A gap in the records.* Melbourne: Sybylla Press.

Mitchell, W. J. T. (1990). Representation. In F. Lentricchia & T. McLaughlin (Eds.), *Critical terms for literary study* (pp. 11–22). Chicago: University of Chicago Press.

Mullen, C. A. (1994). A narrative exploration of the self I dream. *Journal of Curriculum Studies, 26*(3), 253–263.

————. (1997). *Imprisoned selves: An inquiry into prisons and academe.* New York: University Press of America.

Mullen, C. A., Cox, M. D., Boettcher, C. K., & Adoue, D. S. (Eds.). (1997). *Breaking the circle of one: Redefining mentorship in the lives and writings of educators.* New York: Peter Lang. (Counterpoints Series)

Peshkin, A. (1988). In search of subjectivity–one's own. *Educational Researcher, 17*(7), 17–21.

Pinar, W. F., Reynolds, W. M., Slattery, P., & Taubman, P. M. (1995). *Understanding curriculum: An introduction to the study of historical and contemporary curriculum discourses.* New York: Peter Lang.

Richardson, L. (1992). The consequences of poetic representation: Writing the other, rewriting the self. In C. Ellis & M. G. Flaherty (Eds.), *Investigating subjectivity* (pp. 125–137). New York: Sage.

Roth, P. (1992). *Operation Shylock: A confession.* New York: Simon & Schuster.

Sanders, S. C. (1997, September–October). The most human art. *UTNE Reader,* pp. 54–56.

Scholes, R. (1975). *Structural fabulation: An essay on fiction of the future.* London: Notre Dame Press.

Stark, S. (1991). Toward an understanding of the beginning-teacher experience. *Journal of Curriculum and Supervision, 6*(4), 294–311.

Teitel, L. (1994). Re-inventing myself as a teacher. *Teaching Education, 6*(1), 85–90.

Trumbull, D. J. (1990). Evolving conceptions of teaching: Reflections of one teacher. *Curriculum Inquiry, 20*(1), 161–182.

Ulmer, G. (1989). *Teletheory.* New York: Routledge.

Updike, J. (1986). In J. Winokur (Ed.), *Writers on writing: A compendium of quotations.* Philadelphia: Running Press.

Vidal, G. (1993). *United States: Essays 1952–1992.* New York: Random House.

Wolcott, H. F. (1990). On seeking–and rejecting–validity in qualitative research. In E. W. Eisner & A. Peshkin (Eds.), *Qualitative inquiry in education: The continuing debate* (pp. 121–152). New York: Teachers College Press.

————. (1994). *Transforming qualitative data: Description, analysis, and interpretation.* London: Sage.

Chapter 3

Mirrors, Rivers, and Snakes: Arts-Based Teacher Development

C. T. Patrick Diamond
Carol A. Mullen

[There] was a shifting and shining creature that nobody had ever caught but that many said they had glimpsed in the depth of the mirrors. In those days the world of mirrors and of men were not, as they now are, cut off from each other. (Borges, 1974, p. 67)

The mind and the world [are] inextricably fitted twin puzzles. The mind fits the world and shapes it as a river fits and shapes its own banks. (Dillard, 1982, p. 15)

Another *Fin-de-siècle*: "Art for the Sake of Development!"

Postmodernism refers in part to radical innovations in inquiry and also to its invariable fragmentation. At the end of the second millennium, knowledge is no longer seen as the mere reproduction of an objective reality. Contrary to the claims of correspondence theories of truth, all our knowledge is shaped by our language and constructs. As in the previous *fin-de-siècle*, the current "death dance of principles" (Schorske, 1981, p. xix) and the demise of metanarratives enable individuals and whole social groups to search for a new series of identities, belief systems, and realities. As Schorske (1981) writes: "Indifference to any relationship with the past [and its forms] liberates the imagination to proliferate new forms and new constructs" (p. xviii). It is time now to shake off the past and even for some new war cries

such as "art for the sake of development!" to resound through teacher education.

In this chapter, we argue for and show how educators' development can be promoted as a shifting and transforming of self through arts-based, reflexive inquiry. This is the (auto)biographical work of "reflective self-representations reflected upon" (Grumet, 1976, p. 80). By representing and reconstruing our perceptions of a multiple teacher self, we can also counter our inner and outer critics and their allegations of solipsism and narcissism. In short, it is a time to fall into the arms of the accuser, becoming self-preoccupied in the act of discovering new forms of arts-based research that push against our external, seemingly fixed, teacher researcher identities.

Teacher education can be as different from teacher development as passive consumption is from active composition. If "reading is the process by which a reality is consumed: writing is the very production of that reality" (Block, 1980, p. 230). The developing postmodernist educator resembles, metaphorically speaking, the active reader who constructs the meaning of texts but with openness, ambiguity, and indeterminacy (Barone, 1995). The modernist educator, on the other hand, resembles the passive reader for whom meaning is directed, non-negotiated, and hence closed. In short, postmodern, self-directing, autonomous approaches to development contrast with modernist, regulating, controlling forms of teacher education. Through raising conscious awareness of self-practice, different versions of teacher effectiveness can be stretched and improved in self-chosen ways. Some of the textual, allegorical means to pluralizing rather than homogenizing teacher identity and "reality" include the following arts-based activities: teacher self-characterizations; contrasting different aspects of teacher self; mapping the development of a teaching career (using journals or diaries, timelines, rivers, or snakes); curriculum subject autobiographies; and metaphors of teaching and inquiry.

The Self in Teacher Education and Development

Although we experience a "self" every morning of our lives when we shave or do our hair, self remains an elusive construct and any coming and going between the worlds of mirrors and of people is not without risk. Although it may seem that to develop a self it must first be "caught," we create one in the very act of seeking it (Randall, 1995). Whenever as educators we want to improve our teaching, we can take a look at

our practice, then at how we are viewing it, and finally at the effects of trying alternatives. By representing and reflecting upon our experience of teacher self, and by repeating this cycle again and again, we promote development. We assemble, construct, and reconstruct a teacher self as we build and renovate any other idea—as a continuing journey of selfhood, undertaken through making and sharing texts about it, and within supportive, synergistic contexts provided by others. By definition, a self is socially constructed (Dewey, 1938). But a postmodern self also involves individual artifice, contradictions, and lived dilemmas.

Although Patrick had been "in" teacher education since the 1970s, he is only now getting "into" his own, facing the implications of what it means to pursue self-directed forms of teacher educator-researcher development. For the past decade, he had been helping experienced teacher colleagues to complete their masters' and doctoral studies and their dissertation journeys. As Patrick's first doctoral candidate in Canada, Carol engaged in a program of research with him. We (Patrick and Carol) became committed to learning about successful writing partnerships in education that originated in supervision (e.g., Barone & Eisner, 1997; Clandinin & Connelly, 1996). Together, we aimed to (a) create a new design of mentoring relationships based on more democratic principles, (b) construct inclusive communities with teachers, and (c) advance relational forms of research using an interpersonal writing style. With each other and other teacher colleagues, we have found that arts-based approaches provide textual (see chapters 11 and 12) and graphic strategies (see chapter 13) that enable us to project greater meaning upon our experience of teaching, collaboration, and development. With others, we take "time out" to chart how we choose (or not choose) to restructure our self-perspectives over the course of our teaching and academic careers.

If we accept for the moment that reflective interchanges among people and one's multiple selves can be productive, the term "development" may be in danger of becoming yet another catch-phrase. In the process of "developing," teachers and educators can be hindered in their capacity to create and to initiate projects by coercive influences that dictate how they are to function. Traces of the 19th century myth of progress intrude, in such a case, so that to be "more developed" or forward-looking carries with it more prestige than does "less developed" or "backward." There can be something condescending in the unthinking use of the term so that "less developed," whether

applied to a teacher, community, region, or culture, carries a pejorative tone. There is the implication that "to be 'developed' is better than not to be and an expectation that the 'less developed' will 'get with it' and develop" (Aitken, 1997, p. 5), usually by falling in behind the lead of a more powerful, "all-knowing" other.

Jackson (1992) uses the term "teacher development" to refer to how individual teachers change in the course of their careers. He limits its use to changes that are desirable and positive, including increases in ability, skill, power, strength, wisdom, insight, virtue, and happiness. Development also needs to be reserved for teacher learning that is self-directed and that cannot be imitated or imposed. What develops is neither a collection of treasured "tips" nor a hoard of guarded self-deceptions. Rather what develops is a theory of a more effective teacher-self that is constantly "put to the test" so that richer explanations of ongoing practice will result. A teacher's self-movement is not relentlessly unilinear; it includes pauses and cyclic returns. Development proceeds in a manner other than as in a projectable curve like a cannon shot. Development cannot be "measured" by using linear, rational tools.

As Bannister argued of the doctrine of reflexivity, development means that teachers are "free to choose personally relevant issues of research, to draw on and make more explicit, personal experience, to enjoy the wisdom and companionship of their 'subject'" (cited in Reason & Rowan, 1981, p. 199), which includes their teacher self. Arts-based approaches allow them to experience and demonstrate the insights that they gain from such inquiries. Teachers learn best, as we all do, "through using their own experience through active involvement and through thinking about and becoming articulate about what they have learned" (Lieberman, 1995, pp. 591–592). Developmental learning is an active process whereby we learn to make more conscious the meanings that we make out of a lifetime of teaching, including those of a teacher self.

In contrast, traditional "outside-in" approaches to teacher education and teacher change seem to imply that teachers can simply have things "done" to them by external forces. These forces can include subject heads, consultants, curriculum specialists, administrators, parents, public opinion leaders, legislators, publishers and editors, and teacher educator-researchers. Any outsider who seeks to enslave teacher selves might be demonized as a "spider who sits at the heart of his web waiting for his prey to come to him" (Coetzee, 1987, p. 120). For

example, commitment to school research has typically resulted in scholarly opportunities for university researchers only. Changing modernist research practices and conventions into genuinely collaborative learning opportunities for all will require a fundamental shift in how teacher educators relate to, and learn from, teachers. Over the years, in their attempt to work "on" schools rather than "with" them to achieve educational goals, university faculty and researchers have often been accused of acting as if they were intellectually superior (Diamond, 1992; Hargreaves & Fullan, 1992; Mullen, Cox, Boettcher, & Adoue, 1997; Sarason, 1993).

When internalized, such oppression may function as a harsh inner critic whose undermining allegation is that self-concern is "mere narcissism." Teachers are subject to the demoralizing assertion that self is unimportant to professional practice and even to teacher educators! Borges' teasing refutation of such charges is that "the existence of a single 'I' at any given moment can be the only measure of reality" (Woodall, 1996, p. 167)—and any "I" is multiple. Peshkin (1992) writes of "six subjective I's [that] are points on a map of myself [as an experienced school-based fieldworker]": Ethnic-Maintenance I, Community-Maintenance I, E-Pluribus-Unum I, Justice-Seeking I, Pedagogical-Meliorist I, and Nonresearch-Human I" (pp. 104–105). In the following section, we suggest some "indigenous, inside-out" strategies that may provide educators with release from the unreasonable demands of others and from their own feelings of inadequacy.

Mirrors and Self-Reflections

Although any methodology remains a matter of strategy and not of morality, personalistic approaches are consistently alleged to court self-infatuation. As Virginia Woolf (1976) recalls:

> There was a small looking-glass in the hall. By standing on tiptoe I could see my face in the glass. When I was six or seven perhaps . . . I only did this if I was sure I was alone. I was ashamed of it. A strong feeling of guilt seemed naturally attached to it. (pp. 67–68)

Okely (1995) defends reflexive approaches against the charge of self-absorbed deviance since "self-adoration is quite different from self-awareness and a critical scrutiny of the self" (p. 2). Those who would protect the self from scrutiny could be as easily labeled as self-satisfied and arrogant in presuming that their presence and relations with others

are unproblematic. While self-agnosia, or the elimination of the self, leads to blindness, self-multiplication promotes at least partial insights into teaching and inquiry. We can shape our teacher researcher self-image, scripting and reappraising it as a series of revisable possibilities for the drama of the classroom, staffroom, school, university, field-work, and other sites. Any self exists within the context of others and research that validates "others" or external frames of reference must, of necessity, also validate self-directed practice.

As Escher (1935) shows in his self-portrait in *Hand with a Reflecting Sphere* (Figure 5), he is posing within the confines of the concrete world. But, by looking more deeply into the pupil of one of his eyes, we see a death's head that gives us pause as we ponder our mortality. Similarly, by looking at ourselves as teachers in the act of looking, we acquire second or double sight. We come to know our teaching and are able to review it only by self-reflecting. The introspective art professor and protagonist in Mitchell's (1992) *For Art's Sake* confides that he does "most of my dreaming when I'm awake and working in my studio [but not without struggle as the] initial euphoria had dimmed within [the] first few successive whole days alone in the studio" (pp. 40, 117). In writing about our reflections, we reveal our partial understandings to ourselves. But self-regard in a moment of being is not easily accomplished, as the failure of Narcissus prefigures. It is as impossible to reach out to any final or "real" self as it is crucial to struggle to do so.

As Woodall (1996) writes, "perhaps the only thing we can rely on is fiction, untruth, a strange place where . . . the constructs of empirical reality are made ghostly by the visionary but 'truer' tools of a tale" (p. 117). Borges (1974), in his mirror tale from the *Book of Imaginary Beings*, shows how "subjectivity presupposes reflection, a representation of experience as that of an experiencing self" (Dews, 1986, p. 31). Subject and method, artist and model, they very nearly but never totally coincide. There is "affinity without identity, and difference without domination" (p. 44). For example, as the student-artists in Margaret Atwood's (1988) novel, *Cat's Eye*, found, the fleshy female model that they attempt to draw is either turned into a beautiful object or, as for the protagonist, "a person-shaped bottle, inert and without life" (p. 272). Something of the original fluidity of intuition can be lost. As Borges feared, the shapes in and behind the mirror might also begin to move of their own accord and rob us of self-possession. The unification and reduction of a teacher's meanings to

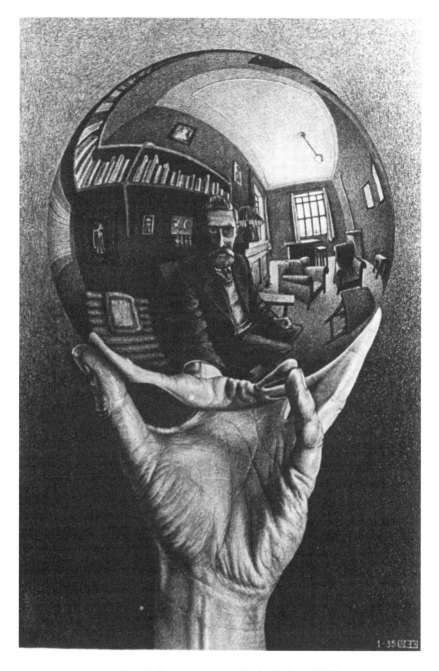

Figure 5 *Hand with a Reflecting Sphere* (M. C. Escher, 1935)

slavish reflections, even by a researcher self, might destroy them. Thought guided by the unifying thread of causation can neither plumb the farthest recesses of being nor correct it. There always remains a barrier between the representation and the represented.

Conrad, a Polish sailor who wrote fluently in French but then chose English as the medium for his novels, offers a paradigm of an emerging artistic self. His *Heart of Darkness* (1902/1990) provides an allegory of the difficulties of writing and of grappling with language. His novella was completed just as he had adopted the landlocked life of writing. He used it to "look back to the beginning of the process, his last and most audacious voyage out to his farthest point of navigation" (Clifford, 1988, p. 96). On his own expedition up the Congo, Conrad carried with him the initial chapters of his first novel written in awkward but powerful English. As teacher researchers, we too can learn to articulate more artfully what we carry with us and what happens to it when we set a new investigative course. Like a change of name, nationality, or location, teacher development involves a shift in self-perception. It might just be that "intoxication" with some aspect of life must be felt for "art to exist, [or] for any sort of aesthetic activity or perception to exist" (Nietzsche, 1968, p. 71).

Professional Self-Characterizations

In the next sections, we outline textual and visual strategies that can be used to raise the level of our conscious awareness of self-practice. We can all do this, but not so easily. We always wonder what part of the self will be writing about or representing what other part of the self in order to reclaim and reflect upon the representation. Even autobiographical approaches can provide only the roughest of mirrors to reflect our Heraclitan images, including shadowy dreams and fears. As Foe, the ghostwriter, tried to convince Susan, the source of the castaway story, "in every story there is a silence, some sight concealed, some word unspoken . . . [and until] we have spoken the unspoken we have not come to the heart of the story." To this she replied: "I would rather be the author of my own story than have lies told about me. . . . There will always be a voice to whisper doubts" (Coetzee, 1987, pp. 141, 149). At the other extreme, abuses of narrative distortion are referred to by Crites (1979) in his theological argument as an aesthetics of self-deception. Either way, whether the persuasive force behind the artist's medium is the "truth" or a lie, self-reflexive composition reveals some aspects of the self, but others remain concealed.

Our thoughts, as well as our creative impulses and expressions, connected as we feel them to be, are what we mean by selves (James, 1962). We agree with Frye (1963) that "everything man [sic] does that's worth doing is some kind of construction, and the imagination is the constructive power of the mind set free to work on pure construction, construction for its own sake" (p. 50). The worst that could be done by academies, schools, and critics would be to suppress the constructivist energies of teacher researchers, hence devaluing these "selves" and robbing them of primacy and worth. As educators, we can resist the suppression of our developing teacher selves by realizing that:

> We cannot take a step in life or literature without using an image. It is hard to take more than a step without narrating. . . . The stories of our days and the stories in our days are joined in that autobiography we are all engaged in making and remaking, as long as we live, which we never complete, although we all know how it is going to end. (Hardy, 1975, p. 4)

We can explore the different refractions of our developing teacher selves by considering the following expressions: the ideal teacher self that we envision becoming; the "real" or present teacher self that we feel we are; and the darker teacher self that we fear to remain. We, the writers, seek below to mirror these aspects and interconnections of our teacher researcher identities by using self-descriptions, contrasting or sorting, mapping, and autobiographical and metaphor-making activities.

The Teacher Researcher I Am— the Teacher Researcher I Hope to Become— the Teacher Researcher I Fear to Be

These three constructs or reflections of self represent leading players in the unfolding drama of our development as teacher researchers. Other prominent cast members include personal selves, family, teacher colleagues, and students. By exploring the contributions of a multiplicity of selves and others, we can counter the charge that considering a self-conscious, self-identical subject implies a modernist and a coercive unification (Dews, 1986). Like Borges and Pessoa, we experiment with permutations of self to explore their developmental possibilities (see chapters 6, 7, 8, and 10). In the following arts-based activities, the use of "we" and "you" invites the reader to coparticipate in self-chosen ways.

The Teacher Researcher I Am

List 6 to 10 ways (use adjectives or phrases) that you think now describe you as teacher and researcher. These descriptors show which teacher and researcher qualities you now perceive yourself as embodying.

The Teacher Researcher I Hope to Become

List 6 to 10 qualities that describe for you the kind of teacher and researcher you hope to become. These descriptors show which teacher and researcher qualities you perceive as important for you to acquire.

The Teacher Researcher I Fear to Be

List 6 to 10 attributes that describe for you the kind of teacher and researcher you fear to remain. These descriptors show which teacher and researcher qualities you perceive as important to shed.

A Personal Reflection on Your Teaching

Using the above listings, you have described three different aspects of your teacher and researcher selves. By reflecting on these self-characterizations you can specify the qualities you want to affirm or change in your teaching.

> Thinking about the teacher-researcher you are, the teacher-researcher you hope to become, and the teacher-researcher you fear to become, now describe how any two of these aspects of self are alike in some important way in relation to teaching and/or research and at the same time different from the third aspect.

The bipolar dimension or present preoccupation that you devise provides an important clue to how you are plotting the scenario of your teaching. For example, you might contrast enthusiastic, indirect, and learner-centered teaching with routinized, directive, and teacher-centered instruction. You might also contrast the cultivation of personal feelings with an overemphasis on the cognitive, knowledge-based outcomes of teaching. However we choose to depict ourselves as teachers, eventual transformation may consist of movement away from the kinds of teacher-researcher we believe that we now are and that we especially fear to be but toward the kind of teacher-researcher that one day we want to become. This is only a general notion of one possible scenario for teacher-researcher development.

Gergen and Gergen (1986) contrast progressive, regressive, and stability narratives as three forms for arranging events in temporal order toward attaining a goal. These forms "exhaust the fundamental options for the direction of movement in evaluative space" (p. 27). In a tragedy, a progressive narrative is followed by a regressive narrative, with life and events falling to pieces. In comedy, the sequence is reversed. If a progressive narrative is followed by repose or a stability narrative, the result is "happily ever after." Teacher development consists of a balancing act: nurturing self-defined positive qualities, while discarding negative ones. An unfolding account of such events resembles a detective story that begins with mystery and puzzlement but that ends with some questions answered and some sense of understanding accomplished (see prologue).

Borges' vision of fiction and reality was greatly affected by Stevenson's (1987) doubling image of "man [as] not truly one, but truly two" (p. 104). In a gothic, melodramatic tale of "hide and seek," Dr. Jekyll is presented as a composite of good and bad. He is not so much transformed into Mr. Hyde, but instead projects a concentrate of evil to become a degenerate self. However, there are three and not just two selves: the original Jekyll, the murderous Hyde, and the Jekyll residue left after Hyde takes over. The descent from elevation is into catastrophe: "The lower side of me, so long indulged, so recently chained down, began to growl for license" (p. 41). Jekyll's fall is "wholly toward the worse" (p. 109).

Arts-Based Activity
How might you use the Jekyll-Hyde metaphor of transformation to play with new perspectives on your own life changes in the face of pressing events? What other metaphors of transformation exist in literature, the visual arts, and film that you might imaginatively and usefully employ?

Becoming More Like the Teacher-Researcher
You Aspire to Become

Merlin the Magician (and Arthur's mentor) believed in learning in happy ways and called for "being born again, like little ones" (White, 1958, p. 12). We can perhaps tap into this ideal aspect of teacher self by reconnecting with memories of our sense of wonder—experienced, perhaps, as children or in dreams. Childlike vision is fresh and new.

Wordsworth (1965) has taught us about the role of reverie in composition. His imagines himself as a boy-poet in "The Prelude or Growth of a Poet's Mind," one who releases passion, making a "boyish sport" of everything around, namely the pleasure of the woodland, hills, and grove. The Earth is his playground and his mind, "half-conscious," is stirred to

> look about; and should the chosen guide
> Be nothing better than a wandering cloud,
> I cannot miss my way. I breathe again!
> Trances of thought and mountings of the mind
> Come fast upon me: it is shaken off,
> That burthen of my own unnatural self,
> The heavy weight of many a weary day
> Not mine, and such as were not made for me.
> (pp. 203–204, lines 16-23)

Some further prompts to help re-enchant and renew one's teacher-researcher self follow.

Arts-Based Activity

What was your favorite nursery rhyme, fairy story, or picture book when growing up? What was the central dilemma or challenge to be faced? Did you like the ending or resolution? Who was the magic helper? Were there things that, as a child, you wanted said to you that were not? What did you trust? Were you disappointed? Visualize the favorite space in which you were able to experience emotional or creative release. Where can you find another safe place today in which to wander/wonder?

Though you might begin as an apprentice in wonderland, you can become a wizard weaving spells for yourself and others. A reborn sense of wonder is an antidote against the boredom and even disappointment of later years. By revisiting the experience of teaching, researching, writing, and creating with childlike awe, our eyes may be reopened to a rekindled excitement (Carson, 1956/1990). We need to cling to, affirm, and celebrate what is special to us.

Patrick taught at a teacher institute that was based on these constructs and practices of arts-based inquiry and teacher development in San Paulo in 1997. Participant Dilma Maria De Mello wrote poetry, including "The teacher I want to become":

> I don't know
> what sort of teacher I want to become

> I want to be a different one
> but I think
> there are so many teacher things to become
> that I'd rather continue being an alive one
> Maybe I'd like to be
> the teacher I am (at that future moment)
> Again thinking about
> The teacher I hope to become.

Time past, present, and future is captured here, not with empirical precision, but as imagined by the teacher-researcher as she becomes self-aware of her own processes. This reflection reminds us, the chapter writers, of a passage in T. S. Eliot's (1963) *Burnt Norton*:

> Time present and time past
> Are both perhaps present in time future
> And time future contained in time past.
> If all time is eternally present
> All time is unredeemable. . . .
> What might have been and what has been
> Point to one end, which is always present. (p. 189)

Becoming Less Like the Teacher-Researcher You Fear to Be

Squeers in Dickens's *Hard Times* and Mrs. Appleyard in Lindsay's *Picnic at Hanging Rock* typify a darker teacher self, as does Mr. Casaubon from George Eliot's *Middlemarch*. Casaubon, with his sterile labors, is the prototype of the dry, life-denying academic, uselessly accumulating details for an unwritten masterpiece, *The Key to All Mythologies*. As if under a spell, all joy and direction in work have been lost. Similarly, Miezitis (1994) reflects on how graduate students may encounter mentors who themselves had unhappy or even traumatic dissertation experiences and who have developed unhelpful pedagogic styles. Forward (1989) offers suggestions for overcoming the hurtful legacy of others which may help you also to escape from becoming the negative kind of teacher you fear. You might respond to any of the following invitations.

Arts-Based Activities

1. As a child, when did you experience loss of hope? When do you now feel angry? Was your childhood marked by harsh criticism

or hypercritics? Did you sometimes feel powerless or inadequate? What do you now regret or grieve for? Did you have to be the caregiver at an early age? Do you expect the best or the worst of others and under what circumstances? Do you seek approval or expect rejection, and in what contexts? How do we avoid perpetuating the worst that was done to us? How can we remember the best? Although we could not help what happened to our younger selves, by engaging in self-reflection we can take responsibility for what we now make of it.

2. What does your critic say about you and your teaching and research? (e.g., "Listen, you're out of luck. You know you'll never make it. Why bother?") What does that tell you? When you attend carefully to the tone and words, whose negative voice do you hear? Is it that of a discouraging parent, a teacher, a so-called expert, an instructor, a coach, or a supervisor? What usually begins a critical attack on your self-esteem? Looking back over such episodes, what does your critic really want from you? How can you distance yourself from this depressing critic or at least put it on hold? How can you enlist even this adversary as an active collaborator in your teacher development? What other aspects of your evolving selves can you encourage to "talk out" on your behalf and in your best interest?

We derived the three teacher self components—the teacher-researcher you are, the teacher-researcher you hope to become, and the teacher-researcher you fear to be—from Rank's (1936) notions of positive will, creative will, and counter-will. As in self-concept theory, reconciling the tensions between these aspects of self could lead to transformation. In this romantic struggle between good and evil, the hero/ine does not regress like Jekyll but, filled with hope, takes command and vigorously engages in the adventure of self-discovery. The inner custodian or dictator guardian may have its origins in the fearful demands that some parents make of their children. The teacher we fear to be may be sabotaging our best efforts at self-chosen movement by acting as a severe faultfinder or angry tyrant. Talking back helps regain control. In the empowering words of Sheey (1977): "No foreign power can direct our journey from now on. It is for each of us to find a course that is valid by our own reckoning" (p. 364).

Those forces opposed to us and our dreams may not be foes with whom we can so readily do battle. Rather than confronting imposition

from without, we may be faced with a tragic inner Hyde. Depending on the plot we impose on, or evolve for, our story of self, we can experience teaching as romance, tragedy, or satire. Whatever its cast, no form can provide the last word. Partly for this reason, we need to feel free to explore our multiple selves in their varied expressions, including those of magical child, doubting adult, and writer-artist, to see what turns out.

Autobiography: Spin Yourself a Lifeline

Take a journey in your own mind through your life as a teacher-researcher to devise connections between your beginnings and endings. Draw a horizontal line stretching from your birth year to the present to chart the course of your learning-teaching life so far. Leave space to locate positive (helping) events above the line and negative (hindering) ones below it. Group these sets of events into phases, and name them. What overall pattern can you devise to make sense of it all? Is it one of general turnings or sudden swervings? Focus on the watersheds, turning points, memorable moments, or marker events in your development. These could occur through a single experience or as a gradual shift. What was the effect of your first day at school either as a student in front of the teacher desk or behind it as a beginning teacher? When did you first decide to become a teacher? Does your teaching narrative so far resemble one of development or of loss, or of fluctuating tension?

If the balance of your entries favors difficulties rather than successes, perhaps you are playing out an unsatisfying teaching scenario. How you choose to group and interpret events depends on the vantage point that you are using to view them in the present. What might once have seemed like a professional earthquake (a resignation) might subsequently be reconstrued as a hiccup, if you were subsequently promoted or gained a better position, or alternatively, if you reassessed your dreams only to have discovered a better path! When the perceived ending changes, so does the meaning of the preceding events and overall episodic event. Previous instances of help or connection can then become visible.

Spinning an autobiographical timeline provides a thread along which you can string events to form a narrative of personal and professional significance. Until sorted like beads onto a chain, events have no inevitable order. They remain separate, haphazard, episodic, and broken

until, like a newspaper or film editor, we impose on them a sense of unfolding or collapsed purpose. We can keep rearranging the pieces until the order suits our interpretation. We project meaning onto our development to see it as some combination of flowing-blocked, smooth-abrupt, lush-arid, intense-deadened, causal-random, isolated-patterned. The above self-portraits and charts of self constitute fragments from the book of your teaching that is illustrated from your image-system of selves.

Arts-Based Activity
And now, sit back and embark on a new learning experience by re-envisioning your autobiographical timeline. Take a look at what you have created, and rethink its overall shape. Is any more complete and emerging shape suggested in the clusters and lines? Can you reorganize your timeline into a more imaginative shape, such as a butterfly, puffball, or pinwheel?

The River Road to Development

The above autobiographical timeline provides a comprehensive mapping of events sorted according to whether they were helpful or a hindrance to your development. The next activity provides a more intensive charting of pivotal moments in your development. Explorers have persistently sought to find navigable river roads leading from coasts into unknown interiors. The Lagrée-Garnier expedition, for example, traveled more than 3,700 miles over two years up the Mekong, the Indochinese river of despair. Lured by the mystery of their sources and by the promise of trade, others have also gone upstream along the Congo, the Amazon, the Nile, the Ganges, the Yangtze, the Danube, the Mississippi, and the Murray.

In the largest and most blank spaces on the childhood maps poured over by Marlow (Conrad's [1902/1990] narrator in *Heart of Darkness*), there was "a mighty big river, resembling an immense snake uncoiled, with its head in the sea, its body at rest far over a vast country, and its tail lost in the depths of the land" (pp. 5–6). Both river and snake can be considered sacred sources of wisdom since the whole length of their bodies is always in contact with the Earth and its secrets.

We can visualize and draw our teaching and researching life as a winding river or snake (see Pope & Denicolo, 1993, p. 541). This can be run through the phases of its development from the source (or tail)

at the top of the page to the mouth of the present at the bottom. Using Figure 6, what will you name your river? Geertz (1995) called his river course *After the Fact* since it consisted of "hindsight accounts of the connectedness of things that seem to have happened: pieced together patternings" (p. 2) involving two countries, four decades, and an anthropologist.

Arts-Based Activity

Will you journey upstream or downstream? Where does your river come from and go to? Are you cut off from or connected with what you have known? If each turn represents a shaping experience or critical incident that influenced the direction of your teaching and researching life, what proper names can you assign to these different points along the length of your river? Where is it swift, where slowed? What are the side streams? Where can you locate your main channel? Marlow's journey led to a heart of darkness and all the horror impenetrable to human thought. But can something else be glimpsed, some shining but partial reflection of self? Can the course of your river be changed so that it joins the Milky Way, glittering with promise?

Each river image provides a distinctively reflecting and coloring medium. Each teacher-researcher self entertains and records, amplifies and interprets, self and others in its own ways. Mullen (1994) used dream recordings and analysis to conduct research into stories of herself as a young practitioner in education in an effort "to show how I mythologize my teaching self and practice as they live in my imagination and world" (p. 255). Reflecting on the experience of making meaning out of disjointed practice and dream fragments, she turned to poetry:

Electrifying Blue Is She by Carol A. Mullen

Each morning
electrifying blue is she
who raises her sleepy neaa,
wind-blown and twisted with sleep,
to gather the broken shells
and paste them around her home
like a child's attempt at collage.

We can scrutinize how we use words, images, and interpretations in deciding and naming which moments and aspects of self are impor-

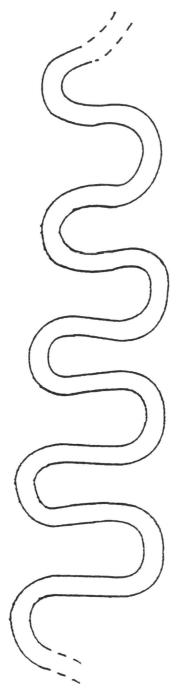

Figure 6 *Your River or Snake Segments* (M. Pope & P. Denicolo, 1993)

tant for us. As Dilthey (cited in Rickman, 1976) explains, by seeking the connecting threads in our lives we have already created connections that we are now putting into words. The segments formed by our conceptions of a teacher self hold present and past events together as a resonating construct. These events are lent special significance both in themselves and for the passage of our careers. Such experiences are preserved by memory, being lifted out of the endless stream of what has been forgotten.

Coles (1995), as both psychiatrist and narrativist, analyzed his career of 30 years to reflect on his persistent preoccupations and those of others. He cites T. S. Eliot to affirm that the universal may be found in the particular and the local:

> Not the intense moment
> Isolated, with no before and after,
> But a lifetime burning in every moment
> And not the lifetime of one man only. (in Coles, p. 141)

The experiences of discovering emerging patterns of personal meaning within one's self and by one's self enable an individual to set out on a new voyage. Accounts of a teacher self and its up-river odysseys also reveal more than just a singular pattern. Our stories connect and resonate with those of others. In grasping the particular, we apprehend the universal. An estimated 1,100 tributaries flow into the 3,891 miles of the Amazon, making it the world's longest river. But Geertz (1995) rejects any explanatory image of a vast river, combining multiple side channels, as entailing too much tidy order. For him, "it is not history one is faced with, nor biography, but a confusion of histories, a swarm of biographies. There is an order of some sort but it is the order of a squall or street market" (p. 2). What localized storms, compromises, or unexpected discoveries have marked your teaching and researching life?

Subject Autobiographies and Metaphors

Using autoethnographic methods (Diamond, 1992) or narrative ethnographic techniques (Mullen, 1997) we can self-disclose, retrace, and revise our meanings. While not everybody may feel comfortable as a writer experimenting with scriptocentric, narrative approaches, we all tell our stories. In a 1997 course with Patrick Diamond on teacher development, Xavier Fazio wrote a subject or topic poem (see below) about teaching "Reproduction" to a year 10, general science class. He

wonders how well they have learned—and he has taught! There may often be a gap between what young adults know of life and what counts as knowledge in school.

Learning Meiosis by Xavier Fazio

I write about Meiosis* on the board.
Do they learn Meiosis?
I illustrate Meiosis using a video.
Do they learn Meiosis?
I demonstrate Meiosis using pipe cleaners.
Do they learn Meiosis?
They draw Meiosis in their notebooks
Do they learn Meiosis?
I give them microscopic slides to see Meiosis.
Do they learn Meiosis?
I test them on Meiosis.
Do they learn Meiosis?
Class median 64%.

*Note: Meiosis is a cellular phenomenon that involves the formation of gametes (e.g., egg and sperm cells in mammals) for the process of sexual reproduction.

Frank Leddy, a colleague and head of a high school mathematics department, described the current emphasis in his curriculum subject. No longer confined to transmitting an established body of knowledge, mathematics engages teachers and students to become better problem solvers, more mathematically inquisitive, and better able to make sense of this form of inquiry. To invite his teacher colleagues and students into dialogue about the subject, Frank shares his self-story with them and then invites them to write their mathematical autobiographies. You might choose to explore your own subject area.

Arts-Based Activities

1. Compose a poem about how a class is understanding a topic that you are teaching them.
2. Write about your successes and failures in any school subject. We all have both. Recall your earliest memories of a particular elementary or high school subject. What are the things that you liked and disliked about it? Explain how you believe that you can

now best learn this subject. In what ways have your subsequent teaching and research experiences touched upon this subject, and how have you made sense of it?

If the very word "mathematics" strikes fear and muffled terror into the hearts of some, it makes wonderful sense for others. For example, Billy Twillig is described as calculating "with the ease of a coastal bird haunting an updraft" (DeLillo, 1976, p. 13). He clearly perceived the arch-reality of mathematics in its austerity, simplicity, and permanence; in its inevitability adjacent to surprise; in its precision as a language; and in its pursuit of connective patterns and significant form. Write, using freeform or a prose poem, about how you perceive your teaching (or curriculum subject) and research (or exploratory project).

Having charted our development and that of our teaching subject, images such as the teacher as mirror reflection or earnest explorer provide us with compact, imaginative ways of thinking about and redirecting our understandings of education. We can pessimistically adapt Conrad's (1902/1990) image of the little steamboat ("hugging the bank against the stream, like a sluggish beetle crawling on the floor. . . . It made you feel very small, very lost," p. 31) to represent the teacher as a lone inquirer. In the opening scene of Kafka's novella, *The Metamorphosis*, Gregor awakes to find that he has apparently been transformed into a monstrous beetle. His plight may parallel that of some teachers who are oppressed by isolation and alienation. Using a contrasting image from Walt Whitman, the teacher can be optimistically depicted as a courageous spider spinning tales and ceaselessly launching forth the delicate gossamer thread of inquiry, suspended in its own webs of significance (see Figure 29 in the postlogue).

Arts-Based Activity

What personal metaphor might you use for your development as a teacher, researcher, and any other roles that might inhabit you?

While our image may vary from that of a leavening bread maker to that of a fragile, emerging butterfly, we always need to listen to our own inner rhythms. Self needs to be let to hatch by itself, being trusted to unfold gradually from its cocoon. As an impatient helper (or some eager staff developer) found to his dismay, "my breath had forced the butterfly to appear, all crumpled, before its time. It struggled desperately and, a few seconds later, died in the palm of my hand"

(Kazantzakis, 1959, pp. 129–130). The beetle or butterfly, as an extended metaphor, can develop into an allegory of self, providing a story in which characters and events acquire double meaning as in a fable or parable (Clifford, 1984). The local story of a teacher-researcher cannot resist becoming a more general one of teaching and of inquiry.

Summary Comments

As Pinar, Reynolds, Slattery, and Taubman (1995) conclude, there are only fictive selves: "The self is an aesthetic creation, and the means by which the self is planned and 'built' are story-telling and myth-making" (p. 494). Even though our inquiring teacher self can only be glimpsed and never finally caught in all its shifting depths, we become more self-fashioning and responsible through practicing reflexive, arts-based inquiry. By working with refracted self-images and with the support of others, we can critique and transform our teaching and inquiry. When we devise professional self-portraits through autobiographies, timelines, dream recordings, charts, maps, and metaphors, we also avoid the traps set by others and our own self-imposed limitations. Whatever allegorical form we use to shape the story of our struggle to develop, once we reflect on what teaching now means to us, what it has meant and may come to mean, we become better able to control its varied outcomes.

We began this chapter with a concern for the self that dangles from a mere thread in teacher education and the literature. We have portrayed teachers both as delicate, elusive quarry pursued by hunters, and as intrepid explorers. It is all too easy to caricature such an arts-based perspective as a form of self-adulation or unreflecting egoism in which all experience is relentlessly funneled into the workings of an individual's understandings. We acknowledge that self is a coconstruction whose meanings are embedded, embodied, and borrowed. Within the narrow accountability ethos that characterizes recent moves against educators, teachers' individual passions and creativities are in danger of being squeezed out by a barrage of external requirements.

When the premium is placed on teacher-researcher compliance, the outcome is that their individual satisfactions, the effectiveness of their contributions, and their overall sense of self are sapped. The cost is not trivial since "our lives teach us who we are" (Rushdie, 1991,

p. 414). The defense and multiplication of teacher selves are essential to development. Like the world at large, a self remains blank, purposeless, chaotic, and indifferent until we project meaning, hope, and diversity onto it and reflect on the mirrored effects. At the beginning of this new millennium, we are invited rather than condemned to recreate our selves and the universe. "Far from providing any unifying premises or principles of coherence for comprehending continuity" (Schorske, 1981, p. xx), a shifting, discursive self, continuously reorganizing itself, reaffirms the complexity of postmodernism, which is itself a composite creation with permutations of identity.

At the end of Patrick's 1997 teacher institute, this poem was written:

Give the Teachers a Blank Sheet by Dilma Maria de Mello

The next time you give teacher training
You don't have to do anything
Give the teachers a blank sheet
Just sit down and wait

Some of them will do nothing
Some of them will wait for the directions
Some will try to guess what you expect them to do
Some will try the same picture they have been trained to do

But, maybe on the second session
Some of them may think that
you are such a crazy "expert"
Then they may start doing whatever they want
A house, a road, a butterfly.

I was given a blank sheet
And I realized
how many beautiful things
I was able to draw
I was an artist and I didn't know that!

The next time you give teacher training
give the teachers a blank sheet
Some of them may throw it away
Some may pour their theories on it
Some may just fly.

Toward an Art of Engagement

In the "twilight of the absolute," any artistic engagement needs to start with a "blank sheet" if teacher-researchers are to be spared top-down training that is too far removed from their practice to make any difference. This is not to say that teacher-researchers themselves are blank slates to be written upon but rather that they/we need the opportunity to become engaged differently, and on our own terms. We turn now to a series of chapters (Part II) that pursue varied perspectives on "teacher researcher as artist." The book itself, at a fundamental level, endorses a view of arts-based inquiry and teacher development as an empowering form of learning with others. We support the view that the postmodern educator is immersed in

> An art of engagement [that] is people centered and critical. By critical we mean that identities should not be prey to superficial stereotypes, that mechanisms and processes are established to allow lived, changing, complex, and problematized identities to emerge. For us, engagement is about empowerment. In that sense it is a political statement as much as an artistic one. (Dunn & Leeson, 1997, p. 27)

References

Aitken, J. L. (1997). *Gesamtkunstwerk*/An amalgamation. *Curriculum Inquiry, 27*(1), 1–6.

Atwood, M. (1988). *Cat's eye.* Toronto: McClelland and Stewart.

Barone, T. E. (1995). The purposes of arts-based educational research. *International Journal of Educational Research, 23*(2), 169–179.

Block, A. (1988). The answer is blowin' in the wind: A deconstructive reading of the school text. *Journal of Curriculum Theorizing, 8*(4), 230–252.

Borges, J. L. (1974). The fauna of mirrors in *The book of imaginary beings* (pp. 67–68). Harmondsworth: Penguin.

Carson, R. (1956/1990). *The sense of wonder.* Berkeley, CA: The Nature Company.

Clifford, J. (1984). On ethnographic allegory. In J. Clifford & G. E. Marcus (Eds.), *Writing culture: The poetics and politics of ethnography* (pp. 98–121). Berkeley, CA: University of California Press.

————. (1988). *The predicament of culture.* Cambridge: Harvard University Press.

Coetzee, J. M. (1987). *Foe.* Harmondsworth: Penguin.

Coles, R. (1995). *The mind's fate: A psychiatrist looks at his profession.* New York: Little, Brown & Company.

Conrad, J. (1902/1990). *Heart of darkness.* New York: Dover.

Crites, S. (1979). The aesthetics of self-deception. *Soundings, 62,* 107–129.

DeLillo, D. (1976). *Ratner's star.* London: Vintage Books.

Dewey, J. (1938). *Education as experience.* New York: Macmillan.

Dews, P. (1986). Ardorno, post-structuralism and the critique of identity. *New Left Review, 57,* 28–44.

Diamond, C. T. P. (1991). *Teacher education as transformation: A psychological perspective.* Milton Keynes, UK: Open University Press.

————. (1992). Accounting for our accounts: Autoethnographic approaches to teacher voice and vision. *Curriculum Inquiry, 22*(1), 67–81.

Dillard, A. (1982). *Living by fiction.* New York: Harper & Row.

Dunn, P., & Leeson, L. (1997). The aesthetics of collaboration. *Art Journal, 56*(1), 26–37.

Eliot, T. S. (1963). *Collected poems (1909–1962)*. London: Faber and Faber.

Forward, S. (1989). *Toxic parents: Overcoming their hurtful legacy and reclaiming your life*. New York: Bantam.

Frye, N. (1963). *The educated imagination*. Toronto: Hunter Rose.

Geertz, C. (1995). *After the fact: Two countries, four decades, one anthropologist*. Cambridge: Harvard University Press.

Gergen, K. J., & Gergen, M. M. (1986). Narrative form and the construction of psychological science. In T. R. Sarbin (Ed.), *Narrative psychology: The storied nature of human conduct* (pp. 22–44). New York: Praeger.

Grumet, M. (1976). Towards a poor curriculum. In W. Pinar & M. Grumet. *Towards a poor curriculum* (pp. 67–88). Dubuque, IA: Kendall/Hunt.

Hardy, B. (1975). *Tellers and listeners: The narrative imagination*. London: Atlone Press.

Hargreaves, A., & Fullan, M. G. (1992). Introduction. In A. Hargreaves & M. G. Fullan (Eds.), *Understanding teacher development* (pp. 1–19). New York: Teachers College Press.

Jackson, P. W. (1992). Helping teachers develop. In A. Hargreaves & M. G. Fullan (Eds.), *Understanding teacher development* (pp. 62–74). New York: Teachers College Press.

James, W. (1962). *Psychology: The briefer course*. New York: Collier.

Kazantzakis, N. (1959). (C. Wildman, Trans.). *Zorba the Greek*. Oxford: Bruno Cassier.

Lieberman, A. (1995). Practices that support teacher development. *Phi Delta Kappan, 76*(8), 591–596.

Miezitis, S. (1994). The journey continues: From traveller to guide. In A. L. Cole & D. E. Hunt (Eds.), *The doctoral dissertation journey: Reflections from travellers and guides* (pp. 99–108). Toronto: OISE Press.

Mitchell, W. O. (1992). *For art's sake*. Toronto: McClelland-Bantam.

Mullen, C. A. (1994). A narrative exploration of the self I dream. *Journal of Curriculum Studies, 26*(3), 253–263.

————. (1997). *Imprisoned selves: An inquiry into prisons and academe*. New York: University Press of America.

Mullen, C. A., Cox, M. D., Boettcher, C. K., & Adoue, D. S. (Eds.). (1997). *Breaking the Circle of One: Redefining Mentorship in the Lives and Writings of Educators*. New York: Peter Lang. (Counterpoints Series)

Nietzsche, F. (1968). *Twilight of the idols of the Anti-Christ*. New York: Penguin Books.

Okely, J. (1992). Anthropology and autobiography: Participatory experience and embodied knowledge. In J. Okely & H. Callaway (Eds.), *Anthropology and autobiography* (pp. 1–28). London: Routledge.

Osborne, M. (1996). *River road to China: The search for the source of the Mekong, 1866–1873*. London: Allen and Unwin.

Peshkin, A. (1992). The personal dimension: Rapport and subjectivity. In C. Glesne & A. Peshkin (Eds.), *Becoming qualitative researchers: An introduction* (pp. 93–107). New York: Longman.

Pinar, W. F., Reynolds, W. M., Slattery, P., & Taubman, P. M. (1995). *Understanding curriculum: An introduction to the study of historical and contemporary curriculum discourses*. New York: Peter Lang.

Pope, M., & Denicolo, P. (1993). The art and science of constructivist research in teacher thinking. *Teaching and Teacher Education, 9*(5/6), 529–544.

Randall, W. L. (1994). *The stories we are: An essay on self-creation*. Toronto, ON: University of Toronto Press.

Rank, O. (1936). *Truth and reality*. New York: Knopf.

Reason, P. & Rowan, J. (1981). *Human inquiry: A sourcebook of new paradigm research*. Chichester, UK: Wiley.

Rickman, H. P. (Ed. and Trans.). (1976). *W. Dilthey: Selected writings*. Cambridge: Cambridge University Press.

Rushdie, S. (1991). *Imaginary homelands: Essays and criticism*. London: Granta Books.

Sarason, S. B. (1993). *The case for change: Rethinking the preparation of educators*. San Francisco: Jossey-Bass.

Schorske, C. E. (1981). *Fin-de-siècle Vienna: Politics and culture*. New York. Vintage Books.

Stevenson, R. L. (1987). *Strange case of Dr. Jekyll and Mr. Hyde*. New York: Signet Books.

White, T. H. (1958). *The book of Merlyn*. Austin, TX: University of Texas Press.

Woodall, J. (1996). *The man in the mirror of the book: A life of Jorge Luis Borges*. London: Sceptre.

Woolf, V. (1976). *Moments of being*. New York: Harcourt Brace.

Wordsworth, W. (1965). *The prelude: Selected poems and sonnets* (Rev. Ed.). New York: Holt, Rinehart & Winston.

PART II

EXAMPLES OF ARTS-BASED INQUIRY AND TEACHER DEVELOPMENT

Chapter 4

"Finding the Pieces" of a Personal Canon: Teachers as "Free Artists of Themselves"

C. T. Patrick Diamond
Betty Lou Borho
Peter F. Petrasek

[Shakespeare] understood Latine pretty well: for he had been in his younger yeares a School-master in the Countrey. (Christopher Beeston, the son of a fellow actor of Shakespeare, in Burgess, 1996)

The context and the conduct of teacher education today grossly underestimate the potential for productively challenging teachers and their professors with a mission that pulls at their very highest ideals. (Goodlad, 1990, p. 253)

Biblical and Literary Canons

An expanding and intensifying array of demands encroaches on teachers and their classrooms. These include government mandates for statewide (provincial) and/or national testing, new policy requirements such as mainstreaming, and the repeated injunction to "do more with less"; media sniping and allegations of declining standards and overly generous conditions; rapid changes in technologies; ethnocultural shifts in student populations; and the aging of the teacher population that faces the challenges of stagnation and demoralization. In the battle to gain public support, critics of teachers and teacher-researchers may be surprised to learn that Shakespeare was very possibly a tutor-teacher in the so-called lost years, from 1584 to 1592.

What we do know with greater certainty is that Shakespeare attended the Stratford grammar school, whose only purpose, as its name

proclaims, was to teach Latin grammar. Such grammar was extracted from preserved classical texts and consisted of a syntax, a vocabulary, and an orthography (see Lily's, 1522, *Grammaticis rudimenta*). Non-English canonical texts were offered as a paradigm for the use of grammatical English. Like science, the study of grammar was supposed to produce a more correct, standardized, and refined version of one's native tongue.

Greene (1592) and other London rivals criticized Shakespeare for his lack of university education (having "little Latin and less Greek"); for being an insufficiently qualified literary plagiarist ("an upstart crow, beautified with our feathers"); for being a versatile jack-of-all-trades (an actor-playwright or "an absolute Johannes factotum"); and even for his excessive love of language ("a river of words [that] needed to be curbed, slowed down, cooled, quenched," Burgess, 1996, pp. 94, 237). There is no record of Shakespeare's attending university, so he probably had to rely on books and experience to further his education. In the Elizabethan manner, however, he made lively use of material from Ovid, Plautus, and Plutarch. Teachers are similarly steeped in experience, possessing many talents and a love of books. They too are used to public criticism and even condescension. In this chapter, we show how engaging in arts-based inquiries may help teachers to reclaim respect and to challenge their highest ideals.

Such is Shakespeare's achievement that periodically a critic will liken any who accept his authorship of the plays "to the plodding Inspector Lestrade; the truth can only be revealed by [this self-proclaimed] Sherlock Holmes" (Bate, 1997, p. 65) The anti-Stratfordians cannot accept that an intruder from below, "a provincial grammar-school boy, [is] the greatest artistic genius the world has ever seen" (Bate, 1997, p. 68). They seek to canonize instead Marlowe, Florio, Bacon, and especially aristocrats such as the seventh earl of Shrewsbury, the seventeenth earl of Oxford, the sixth earl of Derby, King James, and Queen Elizabeth herself—all as rival candidate authors of the works of Shakespeare. According to the Baconian heresy, "only a heavily erudite man, university trained, skilled in the law and the sciences, his eyes and ears schooled by the grand tour, could write the works traditionally attributed to . . . Shakespeare. . . . But it is nonsense to suppose that high art needs high learning. . . . A work of art is [not] of the same order as a work of scholarship" (Burgess, 1996, pp. 38–39).

Although, like teachers, begrudged recognition by some, Shakespeare has never gone missing from the literary canon of great writers. As its center, he wrote 38 plays, 24 of which are considered masterpieces. Canon (from the Greek, *kanon*, for reed or rod) was first used as an instrument of measurement but then came to mean rule or law. In the 4th century AD, the canon was used "to signify a list of texts or authors, specifically the books of the Bible [from the Greek, *biblia*, for books]" (Guillory, 1990, p. 233). In this context, the canon suggests a principle of selection with some authors being canonized as worthier of preservation than others. Just as Christian canonizers assembled approved texts to form the Greek New Testament as the word of God, they excluded early gnostic writers as in error. The disputed biblical works consisted of kabbalistic, extravagant parable-like texts. For 400 years after the Reformation, forbidden texts were placed on the Index as dangerous to the faith and never to be read unless in expurgated editions. Some legislators and parent groups also may seek to impose a hierarchy of selected texts on schools, while banning others.

In the last two centuries, literary rather than scriptural canonization has involved the selection of classic texts, judged on aesthetic rather than religious grounds, as works of art. Bloom (1994) is the author of some 19 books, editor of over 30 anthologies, and general editor of 6 literary criticism series. As an antagonist of postmodernism, he includes among the aesthetic criteria: "Mastery of figurative language, originality, cognitive power, knowledge, [and] exuberance of diction" (p. 29). Accordingly, Bloom canonizes the Bible (the King James version of the Old and New Testaments), Borges, Cervantes, Chaucer, Dante, Goethe, Homer, Ibsen, Kafka, Milton, Montaigne, Pessoa, Proust, Shakespeare, Tolstoy, and Virgil as "the" Western authoritative writers. If he had to, Bloom would reduce the list to two, the Bible and Shakespeare.

Shakespeare's greatest originality is found not just in his use of language but in his representation of characters. Shakespeare depicts self-changes in figures such as Hamlet, Falstaff, and Lear on the basis of their "self-overhearing" (Bloom, 1994, p. 48). Soliloquies allow characters to speak their thoughts out loud, presenting their conditions of mind and examining their motives. Shakespeare's heroes engage themselves in their soliloquies, contemplating themselves as works of art, and becoming "free artists of themselves" (Bloom, 1994,

p. 70). Arts-based inquiries such as self-narrative consist of extended, written soliloquies that may provoke teachers' development, allowing them to burst the bonds of constraining form.

In order to incorporate as many literary influences as possible, Borges drew upon the whole conservative canon and more. He held that literature is more than a continuity. In his vision, authorial identities are blurred so that the canon becomes "indeed one vast poem and [intercanonical] story composed by many hands through the ages. . . . All writers were at once everyone and no one, a single living labyrinth of literature" (Bloom, 1994, p. 470). Shakespeare is the most striking instance of the writer who is "at once everyone and no one." His works, like all literature, are plagiaristic to some degree. As Seneca (the Roman playwright famous for pithy sayings and stoically suffering heroes) confessed, "whatever has been well said by anyone is mine" (in Winokur, 1986, p. 118). Far from housing any particular canon, the mission of public libraries, like that of teacher development, ought to be to preserve as much as possible, making no distinction between approved and noncanonical holdings. However, institutions reflect gendered and racial prejudices, with only approved texts being accessible.

Teachers' Personal Canons

In this chapter, we show how personal canons are assembled by two teachers on developmental grounds, that is, as greatly contributing to their growth as teachers. Betty Lou's canon consists of writers who have affected her development as a teacher, while Peter's consists of fragments from his developmental self-narratives. The criterion of individual impact allows us to ask about how the personal process of canon-formation takes place. A teacher's canon is different from those of scripture or literature, consisting of stories about favorite, touchstone authors and about developmental or puzzling aspects of teaching. When assembled, these entries form a catalogue of personally approved authors and memories represented as "overhearings" of teacher self.

In chapters 7 and 8, Patrick presents his narratives of self as a teacher educator-researcher. In this chapter, we present and reflect on two teachers' self-narratives. We sought to avoid an asymmetrical we-relationship, with the researcher being placed behind and above the teachers, less visible but still atop the hierarchy of understanding. Patrick

tried to avoid imposing a research interpretation on the teachers' inquiries. Instead he introduces and responds to their accounts, supporting them like a Shakespearean prologue with bookend sections. Betty Lou and Patrick met as a teacher-colleague and a teacher educator-researcher, respectively, in a graduate course on teacher development. As a former teacher consultant, Betty Lou had elected to return to the classroom and was looking for new ways of promoting the growth of her teacher self. Peter took a more recent and distinctly more arts-based version of the same graduate course with Patrick. Though the work of teaching was not becoming easier, Peter felt easier with it.

In each instance, the teachers shared and discussed their teaching narratives with Patrick and quickly entered into a collaborative relationship with him, which allowed them further to document and reflect on their own processes. Adopting Newman's (1992) view of "practice-as-inquiry" (p. 3), Patrick helped Betty Lou and Peter to look at their own teaching and then situated it within a larger conversation about teaching and inquiry. Like all teacher meanings, theirs deserved representation and discussion. As Sewall (1986) quotes Goethe, "nothing achieves meaning apart from that which neighbors it" (p. 81). We insert into this chapter the authority of our experience as different "I's," separated by time but joined in collaboration. We coauthor a braided narrative of inquiry of, and for, development.

Lessening the Degrees of Separation

As "indigenous" ethnographers studying their own meanings, Betty Lou and Peter offer "new angles of vision and depth of understanding" (Clifford, 1984, p. 9). Their self-generated or first-order inquiries are grounded in "an ideology of teacher autonomy" (Hollingsworth & Sockett, 1994, p. 12) rather than of teacher control. This difference is further explained in terms of those between teacher development and teacher education, knowledge transformation and knowledge telling (Scardamalia & Bereiter, 1987), and "walking the walk" and "talking the talk." Dewey (1910) contrasts "knowing as a process of inquiry or mode of intelligent practice" with "knowledge as collecting information."

While legislative or externally imposed prescriptions of acceptable or ideal teacher performance may satisfy demands for public explicability and assessment, little account is usually taken of the

unpredictable and uncertain nature of the classroom and of teaching (Sockett, 1987). Teachers are expected to build a huge knowledge base (consisting of subject matter or pedagogic content, classroom organization and management, curriculum development, sociocultural contexts of teaching, technological advances, and learning theories), but often at the expense of knowing about children and teacher self.

In his classic but condescending description of the context of teaching, Waller (1932) depicts teachers as isolated, of low social standing (like Shakespeare), business-like, devoted to standards, insecure, unenthusiastic, and noncreative! When power over teachers is being sought, the strategy consists of grossly underestimating their talents. But who has the right to control or to study and portray others? As Geertz (1995) insists, "when we speak of others in our voices, do we not displace and appropriate theirs? . . . Who writes whom?" (p. 107). The authority for decisions about teachers' practice no longer resides just with researchers. In contrast to Waller's top-down rendering of teachers' meanings, in this chapter we present an interplay of differently positioned but parallel utterances. Intertextually, we play off each other's meanings. Like critical friends, we take care not to bestow privilege on any one of us lest the others become "objects" of study. During the final stages of Patrick's doctoral case study (Diamond, 1979), he felt that he was in danger of objectifying a subgroup of 15 teachers.

The prevailing culture surrounding teaching often seems to encourage the imposition of bureaucratic solutions to teaching problems and to foster cynicism between teachers, researchers, administrators, and legislators regarding each other's intentions (Schlechty & Vance, 1983). Coles (1995) worries that institutional rigidities cause the sensibilities of practitioners to die. "In some ways our hearts must live. . . . We must manage to blend poetic insights with a craft and unite intimately the rational and the intuitive" (p. 11). Through self-narrative or self-study, teachers can combine a scholarly stance with the intimacy of friendship. First and third person voices then mingle as new writing is born out of old (see chapters 7 and 8).

According to Doyle and Carter (1996), even some teacher educator-researchers may also distrust practitioners, seeming to disdain their practice. Intermittently, they leave their campuses to make all-in-one visits to gather classroom "data," only to disappear again. Underrepresented and undervalued, teacher voices are then silenced or turned inward in self-reproach. In these research tales, teachers may feel that they are turned into anecdotes for the more powerful to

dine out on. But it is not just researchers who may seem self-serving and dismissive.

Ouisa, the wife of a wealthy art dealer in Guare's (1990) play, *Six Degrees of Separation*, tried to maintain the integrity of her experience with Paul, an impostor who had changed their lives. She asked her husband, Fran: "How do we fit what happened to us into life without turning it into an anecdote with no teeth and a punch line. . . . We become these human juke boxes spilling out these anecdotes. But it was an experience. How do we keep the experience?" (pp. 61–62). Similarly, how can we as researchers maintain the integrity of the experiences that we share with teachers and later represent on their behalf? However well intentioned, we may still insert degrees of separation between the experience and our storied representations of it. Presuming to represent others can drift into impersonation or ventriloquation (Diamond, 1992), undermining their authority.

Whether researching or being researched, knowledge of self and others cannot be adequately promoted within unequal power relations. Development requires that teachers coparticipate in empowering inquiries that protect them from being managed and manipulated. They need to be reoriented, focused, and energized toward knowing the reality of their own practice in order to transform it (Lather, 1986). Teachers are honored as persons when power is shared not only in application but even in the generation of knowledge. The relational conditions required for achieving this catalytic effect include an environment of openness and trust in which perceptions and feelings are made more conscious to self, and in which experiences are reflected upon in terms of a new vocabulary, as of a self-narrative or a personal canon of development. Collegial arrangements enable fresh conceptualizations of teaching to be expressed (Lather, 1991) and acted upon.

Books and Self-Narratives as
Reflectors of Development

As arts-based educators, we can cobble together, as in a folio marking our development, stories of our reading and teaching lives. This enables us better to grasp who we are as teachers and where we are headed. As readers and writers, we have been continuously experiencing artfully shaped narratives, ranging from the fairy tales read to us as children, through the books that we are assigned at school, to the novels and the films that we eventually choose to enjoy as adults.

Barthes (1966) describes the narratives of the world as numberless. They are present in myth, legend, fable, short story, epic, history, tragedy, comedy, painting, stained glass windows, cinema, comic strips, journalism, and conversation. As in a personal canon, we each make our own selection of narratives from our past reading, writing, and viewing. Just as "you know the fiction-writer by his [or her] library" (Burgess, 1996, p. 39), so too we can come to know teachers by their preferred books and stories. Burgess, one of the greatest of all literary journalists (Vidal, 1993), wrote over 28 novels and other works, including autobiographies and treatments of Marlowe and Shakespeare. Shakespeare's many originals, if not his own library, included Seneca, Ovid (translated by Golding), Plutarch (translated by North from Amyot's French translation), Rabelais, and Montaigne (translated by Florio).

In his biography of Emily Dickinson, one of the female writers admitted to the West European canon, Sewall (1986) used the metaphor of a reflector or mirror to suggest how her relations with others in her life may have defined her literary character. Sewall searched in vain through Dickinson's family and ancestry to find those people who had influenced her. He found that she herself had already identified her most important influences not as actual individuals, but as her favorite books. She described these as "magic keys . . . , the dearest ones of time, the strongest friends of the soul—books" (p. 81). Montaigne similarly spent his retirement reading and rereading his library of over one thousand books. He wrote "to himself about himself and about what he had been reading which became himself" (Vidal, 1993, p. 510).

Books were also the touchstone for reality for Borges. His father's library was the chief event in his life as a child. Reading books rather than practicing grammar led to his mastery of English. Oscar Wilde's story of *The Happy Prince* was a favorite. Borges concluded that perhaps the only thing we can rely on is fiction. He was first employed full-time as a municipal librarian. He later became a teacher at a number of higher education institutions before being appointed Director of the Argentinean National Library, where he wandered the book-lined corridors for 18 years. At 80 years of age he confessed: "I always thought of Paradise as a library" (Woodall, 1996, p. 296). Borges' own inner library consisted of Cervantes, Conrad, De Quincey, Dickinson, James, Kafka, Kipling, Melville, Stevenson, Wells, and Whitman. In the magic realism of Borges' enigmatic stories, narrators often present themselves as the innocent receptors of strange tidings from uncharted frontiers. His last short story was based on a dream in which his own memory was lost but replaced by that of Shakespeare.

The irony depends upon a trace of Borges somehow still surviving in order to entertain the dilemma.

The development of teachers cannot be understood without also considering their reference books, notes, and networks of family, friends, students, colleagues, and mentors. For example, to understand how Luria's career and thought evolved, Cole (1979) went back to the books and ideas that had stirred Luria from his student days. Cole tried to imagine himself into Luria's mind. In this chapter, Betty Lou takes account of those books that she found had most affected her teaching ideas and practices, while Peter recalls the people and events that had affected his. With all teacher colleagues who become course members, Patrick seeks to ensure that there is a secure, uninterrupted space for their original voices to be heard. This chapter is an outgrowth of that relationship in two versions of the same course with Betty Lou and Peter respectively. They were each accorded the status of independent writers.

Finding Teachers' Canonical Texts

In her self-narrative, Greene (1991) writes of the significance of imaginative literature when it comes to the opening of teachers' perspectives and their individual pursuits of meaning. Teachers are able to "tap the wellsprings of their own experiences as they lend their lives to works of fiction" (p. 203). Her library of sources includes Crane, Fitzgerald, Hemingway, Melville, Twain, and Wharton. Encounters with such literary figures permit teachers to visualize alternative possibilities. As invitations into other consciousnesses, these texts can set up interrogations for teacher-readers that provoke transformation. Reading may expose teachers to numerous meanings that the world of teaching can have for those who inhabit it (Greene, 1988) but, in the schools, teachers may have few opportunities to think about their reading and its influence on them. As Figure 7 suggests, teachers may begin by reading widely, but they then need to take flight by writing about themselves and their practice.

Coles (1995) recommends a diet of novelists, short-story writers, and poets, including Carver, Chekov, Eliot, Ellison, Orwell, Tolstoy, and William Carlos Williams, because they "have a lot of good judgment, if not rare wisdom, to offer social scientists. They are less narrowly deterministic, less forgetful of ironies and ambiguities" (p. 237). As Betty Lou and Peter show, a teacher's career consists of a series of stories about how reading and teaching coalesce over time to form the

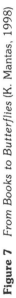

Figure 7 *From Books to Butterflies* (K. Mantas, 1998)

equivalent of an individually shaped work of fiction. In the process of reading, Coles (1995) suggests that less attention be devoted to uncovering second-order generalizations about the development of literature and more to enjoying stories as ways of seeing the world and deepening its mystery. The terrain of fiction presents life's ironies, complexities, ambiguities, inconsistencies, and paradoxes. Reading and writing fiction, even based on our own teaching lives, enables us to leap out of one world and into another, re-imagining the characters that are created. Many writers, including teachers, have a grasp of the mind's life that may extend the range of our empathy for others.

Teacher educators need to encourage teachers, and themselves, "to stick fast to [their preferred] stories, to take them on as companions or friends, as warnings, as reminders, as teachers" (Coles, 1995, p. 334). Although "books were the objects with which Borges was to develop his most intimate relationships" (Woodall, 1996, p. 13), teachers are not at any risk of turning into a Mr. Chips or a Miss Dove simply from engaging in arts-based experiences. They are not courting a kind of Quixotic fate wherein they unreflectively build an entire identity and a self-narrative from their over-involvement with characters taken from narratives. Literature provides prototypes that help formulate our perceptions of our teacher selves, but without dominating the continuing design. Teachers can construct their own personal canons using arts-based methods.

Teaching and Inquiry as Working Together

Patrick's Self-Narrative

Teachers such as Betty Lou and Peter have taught me to listen and also to think back to when I first began to teach. I had not consciously chosen to become a teacher. I had always thought I would be a white-coated researcher in a scientific laboratory. I remember having first "taught" by invitation. The pupil also turned out to be a teacher-in-preparation. I was still in high school. John was the local paper boy. At 12, he had a voice too low and large for his size. John's family lived near the park, which overlooked the beach where we all played football or "Red Rover cross over." His father had just died and a family friend, the owner of the newspaper shop, or "paper man" as we called him, was looking out for him. John was sitting for the scholarship examination so that he could continue on from primary and into secondary school. This rite of passage entailed a stressful series of external exams, mainly requiring large doses of rote learning.

The paper man asked if I would please help John. Of course. Not thinking to ask who had recommended me, I carefully prepared for my weekly coaching

sessions. I turned out all sorts of treasures to share with John so he could become "a better writer." I don't remember how old I was when I had first begun to keep notebooks filled with essay topics, English exercises, grammar drills, and favorite passages and vocabulary exercises. These were gleaned from my reading of adventure stories taken from the "boys' own" popular canon. English heroes always outwitted the Spanish at sea or later the Germans in the air. My preferred style was archaic and ponderously wordy! Going over my collection of past examination papers, I introduced John to spelling demons and what "they," the external examiners, were likely to demand during the statewide ordeal. After John passed successfully, I unexpectedly received my first payment for teaching, a year's subscription to *Time* magazine from the paper man. I cut out and filed stories that I liked, enjoying the wider world coverage and crisp reporting style. A movie cartoon version of "The ant and the grasshopper" fable (called "Mr. Hoppity comes to town") had deeply impressed me as a child. Even today I hoard phrases and references from my reading—just in case.

After graduating from four years of teacher training, I was in my second year and appointed to a local high school when I again met John, one of the senior students. He was still short, burly, and reliable. Becoming a wordy and intense university student, he also took degrees in the humanities. Two years later, I was pleased, as an associate teacher at another high school, when John was assigned to me for supervision. He was also to become an English teacher. Later still, when I joined the university education faculty, John took a graduate class with me on his way to becoming a high school principal. When last he wrote, he had two daughters and a reputation for a being a strong and enlightened school leader in a rural setting. I know that John retains his distinctive voice. I am gradually finding mine. Working with teachers as graduate students, I have learned to share my self-narratives with them before asking them to share theirs with me. Rather than using set essay topics and past papers as I did when I first taught John, I now encourage teachers to use arts-based forms to write about their teaching. I too have become a paper man.

Arts-Based Activities

1. Do you remember the first person you taught? What did that person teach you? What would you now share with him or her?
2. It is the last lesson of your last day of teaching. What will you miss? What will be lost?

A Literary Canon on the Theme of Childhood

The following is an extract from the outline of the course that Betty Lou and I shared in 1992. It was called "Perspectives on Teaching and Teacher Development." I have continued to refine this course over the years.

Assemble 10 extracts (with their bibliographic details) which inquire into how teachers and their work are regarded and evoked by writers and teachers (see Coles, 1989). These excerpts could be taken from authors that you feel have most influenced your development as a teacher. Include extracts, for example, from short stories (such as by Updike or Cheever) and nonfictional storytelling (such as by Barone or *Among Schoolchildren* by Kidder), novels (such as *Hard Times* by Dickens, *The Moviegoer* and *The Last Gentleman* by Percy, *The Rainbow* by Lawrence, *Descant for Gossips* by Astley, and *Up the Down Staircase* by Kaufman), plays, filmscripts, letters, and poems that provide accounts of teachers' experiences, and especially your own. In your commentary, discuss some of the most pressing questions that are posed by your literary inquiry into the meaning of your teaching and your development. Examples of previous inquiries by teachers will be shared.

Betty Lou's following self-narrative is based on her original response to my assignment or invitation.

Betty Lou's Self-Narrative

When I started to reflect on the books that I had read, it was very easy to list titles by prominent educator-researchers such as David Elkind and Frank Smith. Their voices have been influential in helping me to develop my current teaching practices and educational understandings. Yet I also attach great importance to more literary types of books as I reflect on what teaching and teacher development mean to me. I can readily recall the powerful impact that certain books have had on me at different times. I had not realized this before I began reviewing my reading.

I soon noticed that children and childhood supplied the common thread in the books I selected. As I had not made a conscious effort to move toward this kind of theme, I wondered what led me to it. As Jean Little (1987) says of her work, she too took her memories and rearranged them, filling in details as she went along.

> I do not really remember every word that I or others said so long ago. I do, however, know exactly how I felt and what we were likely to have said. If I had included all the background material . . . , this might have turned into a full scale, factual autobiography. I could not let that happen. The child I was would never have forgiven me. (p. i)

This self-narrative of my reading similarly represents the essence of those stories that I find have most influenced me.

When reflecting on my growth as a teacher, I found that my greatest change in practice came when I was willing to trust and place the highest value on the children. I felt myself increasingly becoming an advocate of children and their needs. At the same time as I was making my shift to "the children's point of view," I was reading several books by Tory Hayden and Mary MacCracken. These authors provided stories of their personal experiences of teaching

children who were severely challenged. Like Hayden (1980), I am "all the while pursuing the elusive answers to these children, the magic keys that will then fully open them to my understanding. Yet, within me, I have long known there are no keys, and for some children even love will never be enough" (p. 7). I was encouraged to keep trying harder to do what was needed to help the children.

When I read Hayden's other books, I felt overwhelmed by what is required when we work with severely challenged children on a daily basis. Her accounts made any difficulties that I may have been experiencing seem comparatively light. Her powerful message was that there is no other choice but to become intimate with as much of a child's story as possible. Often a teacher does not realize what children go through out of school. We have to ensure that children have some of their best hours of the day with us.

Hayden (1981) also wrote about receiving a letter from a teacher friend. This triggered a connection that helped her solve a problem that she had been struggling with. The letter was from an old friend who was also teaching disturbed children. She had helped her class to make ice cream one day. "My mind ignited as I read the letter. Ideas were coming so fast I could not catch them in order. This was just the thing for [us] . . . to do. . . . This would make us a class. . . . I could make it into a reading experience, a math lesson" (pp. 49–50).

This extract shows how teachers experiment to provide learning experiences that meet children's needs. Teachers always search for potentially useful topics to integrate into their programs and try to adapt the strategies that others have used. I continuously look for connections and also use the children's "know how" in one area of the curriculum to develop it further in another. The children in my classroom can use and record material successfully in their Math folders because they also know how to use their reading and writing folders.

Hayden (1981) wrote about her need to collaborate with other educators to understand her own teaching. She wanted to bounce ideas off others. She needed to explore those regions of the children's behavior that she could not comprehend. She felt that her "best thinking was always done aloud" (p. 49). MacCracken (1973) wrote similarly about the unexpected benefits of teacher cooperation.

> We built on each other's ideas and bailed each other out when we got in trouble. The children could watch us, could see it working. Our children, all of whom had trouble relating to people, no longer had to watch silently as a teacher struggled to establish rapport with a child. Instead here were two people who worked together. (p. 150)

The atmosphere was contagious and the teachers found that the children also began to laugh and to work more contentedly alone and together.

This extract confirmed that I consider my four years of team teaching as the very best of my teaching life. My team partner became a very close friend

as well as a colleague. Much of the strength of this relationship was dependent upon both of us supporting and respecting one another's work. With teachers working comfortably with one another, the children learn to contribute to the caring atmosphere. This helps them to work toward becoming teachers for one another.

My personally significant "reflectors" also included children's novels that I had read aloud at home to my own school age children. These books helped me to explore the different kinds of relationships that children deal with in their lives. In Paterson's (1977) *Bridge to Terabithia*, Jess befriends Leslie, a new student, because he admires the very special quality of her imagination. She has a wealth of storied experiences. Together, Jess and Leslie build their own magic kingdom. Despite the dangers, they use a rope to swing across the river to get to their secret land of Terabithia.

> It was Leslie who had taken him from the cow pasture into Terabithia and turned him into a king. He had thought that was it. Wasn't king the best you could be? Now it occurred to him that perhaps Terabithia was like a castle where you came to be knighted. After you stayed for a while and grew strong you had to move on. For hadn't Leslie even in Terabithia tried to push back the walls of his mind and make him see beyond the shining world? (p. 126)

Reading other children's books, such as *Mine for Keeps* by J. Little; *Sarah, Plain and Tall* by P. MacLachlan; *The Great Gilly Hopkins* by K. Paterson; and *The Chalk Box Kid* by C. R. Bulla, confirmed how powerful relationships are for children. In my second grade class last year, two boys consistently worked together. They developed such a degree of support and sensitivity to one another's learning needs that I gave credit to the one who helped his friend become a reader and writer. The help given by one and the confidence developed by the other was inspirational. They both became the stronger.

As teachers, we are increasingly encountering demands for higher standards and more accountability. In sympathy with teachers, Elkind (1981) opposes any further shrinking of childhood. He seeks to preserve childhood since it has "its own way of seeing, thinking and feeling and nothing is more foolish that to try to substitute ours for theirs" (p. 3). I agree that there is little room today for "late bloomers." All children need time to grow, to learn and to develop. To treat them differently from adults is not to discriminate against them but rather to "recognize their special estate" (p. 21).

The more I read such books, the more strongly I feel that teachers need to be teachers *for* children rather than teachers *of* children. We must put the needs of children first in everything we do. When school programs are developed for them as teenagers in the transition years, we must remember that "they are the young of the species and . . . they require the care, protection and guidance of the adults . . . if they are to survive and to flourish" (Elkind, 1984, p. 100).

In addition to being learner advocates, I agree with Smith (1986) that two of the essential characteristics of good teachers is that "they are interested in what they teach and enjoy working with learners. Indeed they are learners themselves" (p. 171). We need to teach the world that we are autonomous classroom experts. We must become apologists for children. As Jean Little's (1986) puzzle image shows, teacher development involves life-long learning: "I'm choosing more than one road. I'm putting myself together. . . . But it is like a jigsaw puzzle. I keep on finding new pieces" (p. 63).

A Musical Canon on the
Theme of Social Justice

A teacher's canon is the reflection of the self-logic of his or her practice. It resembles a form of imitative counterpoint or variations on a theme. A musical rather than a biblical or literary canon refers to a developed piece in which the different parts or voices take up the same theme successively, either at the same or at a different pitch (see chapter 12). In his self-narrative, Peter develops the theme of social justice in his different voices as child, brother, son, student, teacher, and father. He searches for people and events that have affected the tune of his teacher self, which he sings to himself. His self-narrative consists of a canon of four entries from the arts-based portfolio that he too devised in response to taking "Perspectives on Teaching and Teacher Development" with Patrick in 1997. The four parts include favorite childhood stories, the first person he taught, a childhood report card, and his metaphors of teaching.

Peter's Self-Narrative: Favorite Childhood Stories

My parents bought an anthology of literature for children from a door-to-door salesman. It came in a 12-volume set of hardcovers with the word "Childcraft" embossed in gold on the front of each. I remember these books vividly for they contained many treasures, including fables, nursery rhymes, legends, folk tales, short stories, mysteries, and pictures of modern art. The story of Hansel and Gretel was my favorite. This was a classic tale of good and evil, and I liked the idea of bad people being punished. It appealed to my sense of justice. When I was five years old, my godmother took me to see the opera *Hansel and Gretel*. Several minutes after the brother and sister pushed the witch into the oven, the orchestra became quiet and I heard the lone sound of a triangle . . . ding, ding. I turned to my godmother and said, "That's the sound from the oven. It means she's cooked."

When I think back on those stories now, I also see things that I was not consciously aware of as a child. Poverty lies at the heart of many of these fairy tales. Reading them now, I get a sense of the desperation that must have been felt in the small villages of Europe as people struggled to feed their families in the face of war, oppression, and disease.

Steven Sondheim's musical, *Into the Woods*, explores the psychological dimensions of these fairy tales. Going "into the wood" is also an interior journey into the self and the dark secrets hidden there. My quest for self-knowledge could not be accomplished in isolation. I could not be a hermit in the desert. For me, self-realization is ultimately bound up with integration into a loving and nurturing community. I enjoyed this musical when the drama club at my high school produced it three years ago. The performance struck a chord with my fond memories of "going into the woods" across the street from where I lived as a child. The darkness and mystery of the woods were tempered by the friendly sound of a trickling brook and the activities of a great variety of animal and plant life. We played hide and seek in these woods and rode our bicycles across the worn footpaths. Here, we came alive. I also spent time thinking about myself and my world in the cool damp.

What attracted me to fairy tales and fables and parables? Was it the clear division between right and wrong, good and evil? I wanted stories with a lesson at the end, morality tales. Even today I look for that element in film and theater. I'm not much interested in art for art's sake. I want my art to come with a social message.

The First Person I Taught

I have four younger brothers and I suppose I have taught them much over the years, especially when they were younger. Michael, the youngest, is the one that I was most conscious of teaching, the one whom I deliberately set out to teach. I think I taught him to read. I loved reading to him, especially poetry by Dennis Lee. I can recite that stuff word for word, even now! Michael and I read all of Tolkien's *The Hobbit* and most of the trilogy that follows, as well as C. S. Lewis's *Chronicles of Narnia*. But what did Michael teach me?

Michael had a wonderful openness to the world, an insatiable appetite for knowledge and he loved to be tickled! Most of all, he loved to hide under the covers of his bed with a book and a flashlight, reading late into the night. He was the first in the family to need glasses because of reading in poor light. More than anyone else, I think that he taught me how to be a father. (Our father died of cancer when Michael was five and I was 16.) Michael would call from his bedroom while I was trying to study in the adjoining room. It was my first year of university. When he called, I couldn't resist. I'd drop everything and go to him. Inevitably we would end up talking and reading or play-fighting, long past his bedtime. I'm like that with my own children now. I think I spoiled him. He lives too much in his head. Perhaps I'm spoiling my own children too. But they *do* love books and tickling, and spending time with Dad! Can there be such a thing as too much praise?

Peter's Childhood Report Card

Too much
praise can give a
kid a big head. But
at least he'll always
be confident in
his own ability
to do well at
what-
ever
he tries.

As I grew older, a certain smugness took over. I began to feel I was better than others. Miss Kirby wrote in my Grade 6 report card: Peter has a tendency to ridicule others.

I felt bad about that and
became aware of a mean
streak inside of myself. I
realized I was not perfect.
Our parents taught us to
be responsible and help
with all the chores. We
learned to cook, clean
and sew. We became
self-sufficient children.
I had a happy childhood.

Wonder	Brothers
who he	Sisters.
takes	Free to
after?	roam
Look	in the
what he	woods
made!	on the
Such a	other
gifted	side of
young	the road
boy.	and play
Loving	all day.
Praise, Parents	Doting, loving
Parents' Praise	Grandparents

My Metaphors of Teaching

In the beginning, I construed teaching in terms of birth and death, since these seemed to encompass the experience of change and transformation that have been part of my personal life, and my teaching to some extent. At other times, I have expressed my metaphor as a canoe trip. I have also thought

of it as a subway train pulling out of the station, and running after it—an expression of the busyness of teaching. But my most powerful metaphors of teaching have developed in conjunction with a school project that has become my passion over the past two years, that is, the Peace Garden at my high school. I now see myself as both gardener and handyman.

The gardener plants seeds but is not the main event; the garden is. The gardener is in the background, helping it to happen, in awe of the mystery of life's cycles and rhythms. It is a position of trust. The garden is a site of transformation. Each seed is transformed into a plant or flower. The caterpillar into a butterfly. Shades of brown are transformed into greens, reds, yellows and golds, in a profusion of foliage and insect activity. The gardener cannot remain too far apart and cannot avoid getting his or her hands in the soil. The connection with the earth is real, and satisfying, and transforming. The garden is both a mystery beyond his or her doing and a result of that careful stewardship.

The kind of transformation that I'm interested in has to do with broadening students' perspectives on the world and changing the world itself into a more peaceful, just, and harmonious place. In religious terms, I believe that the goal of education is to teach people how to be cocreators of God's kingdom. This is not a dream, but a reality that we work for here and now, through our loving action and peaceful relationships.

I believe in social purpose. I believe that the role of the teacher is to help students develop a critical awareness of the structures and values of the world around them in order to identify social injustice and remedy it. My motivation for this is rooted in my faith, though I'm not that comfortable with strident language about the "true God," which carries with it an inappropriate tone of intolerance. I like the gardening metaphor because it incorporates two types of transformation: that of the gardener and of the garden. I relate this to my central concern: how can I as a teacher communicate my sense of personal transformation to my students so that together we might work for social change?

The other metaphor connected with the garden is that of the handyman or *bricoleur*. I really enjoy fixing things, taking things apart, and figuring them out. There's something very satisfying about creating something new and growing out of a jumble of raw materials. The peace garden at my school has involved just this kind of work. It has been done with students and teachers side-by-side. I have been able to show students how to mix mortar, prepare a bed for planting, and spread mulch. I had no idea we could do it.

At the outset, some students were concerned that the space we had chosen was too small and boxed-in by brick walls on three sides (the fourth wall is glass). We argued that it was a good space because we could control access and protect it. But there is another, perhaps more compelling reason why the brick walls are important. They represent the alienation experienced by many people. Our challenge is to transform these walls into something beautiful, to bring in more light from above, to foster growth and abundance from below. We cannot escape the world, anymore than we can ourselves. But through mindful work and persistent hope we can transform the world and ourselves from within.

Patrick's Response

This section is based on a redrafted compilation of my letters to Betty Lou and Peter, thanking them for their contributions to the course. "Perspectives on Teaching and Teacher Development," from which the earlier self-narratives sprang. Both made their practice their art. They provide the central text in this chapter. Jack Brown, another teacher who took the same version of the course as Betty Lou, characterized the role of aiding a teacher's self-narrative inquiry as that of a "bezel." This device supports the stone of value to help give it a location. The gem can then be reflected on, polished, and its qualities brought more clearly to light. In arts-based teacher development, the jeweler and the gem are one and the same.

Both literary and musical canons are narrative patterns that make sense of, and give meaning to, a lifetime of teaching. Like myths (May, 1991), they are guiding self-interpretations of our inner selves in relation to the outside world. I tried to make sense of Betty Lou's and Peter's accounts of their practice and the ways in which their stories intersected with mine. Our joint narrative allowed us to take our bearings on our inner landscapes. Betty Lou's reading canon had placed its stamp on her teaching. Her selections and reflections had made further contributions. By placing the developing parts and metaphors in his writing canon, Peter revealed more of his educational agenda. By placing his understandings and frameworks in the foreground, he saw more clearly where he stood in relation to his own development as well as to that of his students.

The separation of our written contributions to the chapter may not capture the dynamic of shifts and the passage of time in our relationships. These were negotiated in dialogue and more closely resembled an interwoven conversation or circulating exchange with frequent turn-taking of "author-ity." Belief in childhood was central to Betty Lou's perspective, belief in social justice to Peter's. These were the canonical stories of teacher self that they told themselves. By moving into an inquiry in which multiple voices are reflected on, they can escape the limitations of any one dominant voice, or of being stuck for too long in one position. The function of a canon is not to make further review unnecessary but rather to hold things together long enough so that an even better array can be assembled.

Self-narrative allows us to transform how we perceive our teaching by helping to articulate the canon that shapes it. Teachers can renew

and direct themselves with the help and example of attentive and caring others, including their students. As Bakhtin (in Clark & Holquist, 1984) described it, such a relationship is a quest. We go out to others in order to come back a "self." Empathy promotes individuation. We "live into" other consciousnesses and then return to our own. We see the world through the others' eyes but without completely fusing with their version of things: "A second necessary step . . . is to return to [our] own horizon" (Clark & Holquist, 1984, p. 78). No two people, such as the teacher and the author being read (or the team partner or students being worked with), can ever occupy exactly the same space at the same time. What we each see is governed by the place from which it is seen. Present insight is never absolute but needs to be changed by movement into different positions. Self-narratives help us to entertain alternatives. But we can never gain more than a glimpse.

Becoming "Free Artists of Ourselves"

The canon is a metaphor for inquiry that promotes mutual advantage in which the set of relationships transcends the sum of individual components. Books, stories, and poems are part of each teacher's individual canon. Canons are like mountaintops jutting out of the sea: "Self-contained islands though they may seem, they are upthrusts of an underlying geography that is once local and, for all that, a part of a universal pattern. And so, they are part of a more general intellectual geography" (Bruner, 1990, p. ix). Betty Lou's inquiry into her preferred books and Peter's into his own accounts also revealed the underlying outcrops in their experienced knowledge. Betty Lou's metaphor was of a puzzle; Peter's, of a peace garden. In their personal canons or guiding fictions, Betty Lou sacramentalizes childhood, as Peter does social justice. Both teachers seek to reduce isolation. They show that development consists of exploring a personal point of view that is constantly trying to enlarge itself. In order to see our present position, we need to get outside it and into a new one. Reading and writing texts help take us out of ourselves.

Like Bloom (1994), we defend the different canons not in terms of intrinsic worth but rather of returning to the reader "as the deep self, our ultimate inwardness" (pp. 10–11). The best use of a canon is to "augment one's own growing inner self" (p. 30) and to test "reality." The center and the end of arts-based inquiry is that of a teacher self. Inquiry serves the aim of development. In a postmodern age, subjectivity

is "something to capitalize on rather than to exorcise" (Glesne & Peshkin, 1992, p. 104). As for Dewey (1938), growth is best provided by a form of association, a sharing of a common language, ideas, and interests. Such an arrangement provides interaction among different voices, using collective efforts to solve problems.

Self-narrative provides a key to understanding the development of teachers' knowledge-in-use. By subsuming our own viewpoint and those of others, we extend our understandings of experience. We grow by discovering how we and others achieve some glimpses into our versions of reality. In arts-based narrative inquiry, we pursue how we gain, use, and enhance our personal knowledge. Books, stories, poems, arts-based forms, children, and teacher selves represent loans of consciousness that challenge our current versions of reality.

Summary Comments

In this chapter, we have presented two teachers' self-narratives as developmental canons. The teachers' arts-based activities turned their sense of teaching and themselves into a growth experience. We highlighted the texts that spoke and contributed to their development. By identifying the different voices in their texts, they found their own. Becoming more conscious of how and what they knew, they became less dependent on others for approval. Different versions of teaching help us to decide what we should do to realize further our vision of teaching. This multiple capacity allows us to acknowledge differences and to achieve authenticity within connectedness. Through self-narrative, we can find our separate and shared voices and so devise ways to act more insightfully together. This is our ability to preserve and to extend the "we" within the "I." We learn what stories of teaching we are enacting and what ones are still possible.

Teachers gain understanding of their practice and their teacher selves through arts-based inquiry. Expressed in artistic forms, their inquiries count as research, even if only grudgingly admitted by some academics through the "practical" backdoor. Like the anti-Stratfordians, such knowledge competitors demur that, although inquiry is useful to teachers in their everyday work lives, even improving their practice, it does not really amount to "formal" research. But teachers can represent and reflect upon the formation of their practice, inspiring others to join the inquiry. As Sherlock Holmes ironically consoled Dr. Watson: "Come, my dear fellow, no one knows everything! Not even me"

(Dibbin, 1989, p. 179). Rather than merely granting teachers permission, teacher-researchers need to become their aides, acting as reflectors, as the teachers represent and reconsider how they have come to know.

Each of us has a particular canon of books and memories in which we find images of ourselves reflected for reconsideration: "The more we understand ourselves and can articulate reasons why we are what we are, do what we do, and are headed where we have chosen, the more meaningful our life will be" (Connelly & Clandinin, 1988, p. 11). To become the best teachers that we can be, we may need to rediscover our lost kingdoms and build our peace gardens. There are always other pieces to find and different parts to be sung.

Arts-Based Activities
1. List some of your favorite books. What do they show you about how students and teachers learn?
2. What does the teacher that you fear to be now prevent you from doing, that you could do as a child?
3. If we are what we read, Ouisa describes herself as color without structure, "a collage of unaccountable brushstrokes" (in Guare, 1990, p. 62). She asks: "How much of your life can you account for?" How do you describe and account for your teaching?
4. If you were to lose your memory and were able to have it replaced by that of any writer, whose would you chose?
5. "Teachers are 'free artists of themselves.' Each teacher has his or her own way of seeing things, and nothing is more foolish than to try to substitute ours for theirs." Imagine a professional development day at your school that begins with this manifesto. How would you plan the rest of the day's activities?

References

Barthes, R. (1966). Introduction to the structural analysis of narrative. Occasional paper, Centre for Contemporary Cultural Studies, University of Birmingham, UK.

Bate, J. (1997). *The genius of Shakespeare.* London: Picador.

Burgess, A. (1996). *Shakespeare.* London: Vintage.

Bruner, J. (1990). *Acts of meaning.* Cambridge, MA: Harvard University Press.

Bulla, C. R. (1987). *The Chalk Box Kid.* Toronto: Random House.

Clark, K., & Holquist, M. (1984). *Bakhtin.* Cambridge, MA: Harvard University Press.

Clifford, J. (1984). On ethnographic allegory. In J. Clifford & G. E. Marcus (Eds.), *Writing culture: The poetics and politics of ethnography* (pp. 1–26). Berkeley, CA: University of California Press.

Cole, M. (1979). *The making of mind: A personal account of Soviet psychology.* Cambridge, MA: Harvard University Press.

Coles, R. (1995). *The mind's fate: A psychiatrist looks at his profession.* New York: Little, Brown & Company.

Connelly, F. M., & Clandinin, D. J. (1988). *Teachers as curriculum planners: Narratives of experience.* New York: Teachers College Press.

Dewey, J. (1910/1974). Science as subject matter and as method. In R. Archambault (Ed.), *John Dewey on education: Selected writings* (pp. 182–192). Chicago: University of Chicago Press.

———. (1938). *Experience and education.* New York: Macmillan.

Diamond, C. T. P. (1991). *Teacher education as transformation: A psychological perspective.* Milton Keynes, UK: Open University Press.

———. (1992). Autoethnographic approaches to teacher education. *Curriculum Inquiry, 22*(1), 67–81.

Dibbin, M. (1989). *The last Sherlock Holmes story.* London: Faber.

Doyle, W., & Carter, K. (1996). Educational psychology and the education of teachers: A reaction. *Educational Psychologist, 31*(1), 23–28.

Elkind, D. (1981). *The hurried child.* Don Mills, ON: Addison-Wesley.

———. (1984). *All grown up and no place to go.* Don Mills, ON: Addison-Wesley.

Geertz, C. (1995). *After the fact: Two countries, four decades, one anthropologist.* Cambridge, MA: Harvard University Press.

Glesne, C., & Peshkin, A. (1992). *Becoming qualitative researchers: An introduction.* New York: Longman.

Goodlad, J. I. (1990). *Teachers for our nation's schools.* San Francisco, CA: Jossey-Bass.

Greene, M. (1988). Qualitative research and the uses of literature. In R. R. Sherman & R. B. Webb (Eds.), *Qualitative research in education: Focus and methods* (pp. 175-189). London: Falmer Press.

————. (1991). The educational philosopher's quest. In D. L. Burleson (Ed.), *Reflections: Personal essays by 33 distinguished educators* (pp. 200–212). Bloomington: Phi Delta Kappa Educational Foundation.

Guare, J. (1990). *Six degrees of separation.* New York: Vintage.

Hayden, T. L. (1980). *One child.* New York: Putnam.

————. (1981). *Somebody else's kids.* New York: Putnam.

Hollingsworth, S., & Sockett, H. T. (1994). Positioning teacher research in educational reform: An introduction. In S. Hollingsworth & H. T. Sockett (Eds.), *Teacher research and educational reform* (pp. 1–20). Part I, Ninety-third Yearbook of the National Society for the Study of Education. Chicago: University of Chicago Press.

Kelly, G. A. (1955). *The psychology of personal constructs*, 1 & 2. New York: Norton. (New edition published 1992, London: Routledge.)

Lather, P. (1986). Research as praxis. *Harvard Educational Review, 56*(3), 257–277.

————. (1991). *Getting smart: Feminist research and pedagogy with/in the postmodern.* New York: Routledge.

Little, J. (1962). *Mine for keeps.* Toronto: Little, Brown & Company.

————. (1986). *Hey world, here I am!* Toronto: Kids Can Press.

————. (1987). *Little by little.* Toronto: Penguin.

MacCracken, M. B. (1973). *A circle of children.* Philadelphia: Lippincott.

MacLachlan, P. (1985). *Sarah, plain and tall.* New York: Harper & Row.

May, R. (1991). *The cry for myth.* New York: Delta.

Newman, J. (1992). Mirror, mirror. *English Quarterly, 24,* 1–3.

Paterson, K. (1977). *Bridge to Terabithia*. New York: Thomas Y. Crowell.

————. (1978). *The great Gilly Hopkins*. New York: Thomas Y. Crowell.

Scardamalia, M., & Bereiter, C. (1987). Knowledge telling and knowledge transforming in written compositions. In S. Rosenberg (Ed.), *Advances in applied linguistics: Reading, writing and language learning* (pp. 142–175). New York: Cambridge University Press.

Schlechty, P., & Vance, V.S. (1983). Recruitment, selection, and retention: The shape of the teaching force. *The Elementary School Journal, 83*(4), 469–487.

Seneca. (1986). In J. Winokur (Ed.), *Writers on writing: A compendium of quotations*. Philadelphia: Running Press.

Sewall, R. B. (1986). In search of Emily Dickinson. In W. Zinsser (Ed.), *Extraordinary lives: The art and craft of American fiction* (pp. 6390). New York: Book of the Month.

Sockett, H. T. (1987). Has Shulman got the strategy right? *Harvard Educational Review, 57*(2), 208–218.

Smith, F. (1986). *Insult to intelligence*. Toronto: Fitzhenry & Whiteside.

Vidal, G. (1993). *United States: Essays 1952–1992*. New York: Random House.

Waller, W. (1932). *The sociology of teaching*. New York: Wiley.

Chapter 5

Encountering Little Margie, My Child Self as Artist: Pieces From an Arts-Based Dissertation

Margie Buttignol

Every child is an artist. The problem is how to remain an artist once one grows up. (Picasso, cited in Cameron, 1992, p. 20)

We have to realize that a creative being lives within ourselves, whether we like it or not, and that we must get out of its way, for it will give us no peace until we do. (Richards, 1989, p. 27)

Prelude

My doctoral dissertation on teacher creativity (Buttignol, 1998) provides the context for this arts-based teacher self-narrative. Based on heuristic inquiry (Moustakas, 1990), my research emanates from my self as researcher, and from me, Margie. The heuristic process involves openness and discovery. Far from being predictable and safe, I experience varying degrees of lows, flounderings, ambiguities, vacuums, chaos, and even fears. But, along with heuristic discovery, there is also the possibility of self-awakening or transformation. In this chapter, I take you with me as a reader on a process of uncovering and recovering two different pieces of my lost creative self, as writer and teacher-artist. Each of the twin pieces is composed from narrative fragments of my life that I have accumulated in written form over time (Buttignol, 1994–1995). I also include a linking encounter with my child self as artist at five years of age. She is Little Margie.

The notion of a fully formed, once and for all, essential unitary self is challenged by postmodern theorists (Bloom, 1996; Britzman, 1992; Miller, 1994; Pinar, 1988; Weedon, 1987). What they offer instead is the conceptualization of self as composed of a multiplicity or complex web of selves. In this view, the essence of who we are is not something predetermined and handed to a person at birth; rather, it is something we are continually fashioning. The quest of each person is to seek out her or his "true" essence in the course of a lifetime (Randall, 1995). Painful ruptures can occur along the way. In my journey, I needed to meet Little Margie, my childhood artist-self, before I could proceed with my self-creation and my dissertation.

I commence Piece One, "Dear Diary and Other Tales of Writing," by describing the struggles of my creative self for artistic expression and for regaining my writer's voice. Piece Two, "P.S. I was the Quiet Girl with the Blonde Pigtails and Other Tales of Creativity," follows on from Piece One, but delves more deeply into my understandings of the "essence" of my experiences of creativity before arriving at the key conception of myself as "teacher as artist." In Piece Two, I go on to provide an autobiographical account over time of my creative and schooling experiences, from kindergarten to doctoral studies. I am less interested in "managing" (Heshusius, 1994) or "taming" (Peshkin, 1988) my subjectivity than in disclosing my reasons for choosing this kind of inquiry into teacher creativity. I began my dissertation by situating my self at the core of my research. I am impelled to disclose how my crystallizing experiences or creative "epiphanies" (Denzin, 1989) have shaped my views of my self as a teacher.

A golden Ariadne-like thread connects my recollected stories about learning, creating, and teaching. My narrative has led me down through a spiraling labyrinth. I am attracted to this Greek myth because, like Theseus pursuing Minotaur, I am descending into the underworld of my own unconscious. The Cretan labyrinth was built by Daedalus to contain the half-man, half-bull that fed on human flesh. As a master carpenter, Daedalus also created human-like figures who walked with open eyes. I am still holding to my narrative thread, penetrating more and more deeply into the depths. I have passed more than one Minotaur. I ask: "Who is holding onto the other end of the thread? Is it one of my selves?"

Through using my creative life history, threading the little pieces together, I have pursued my "perspective transformation" (Diamond, 1991), that is, I am trying to see, for the first time, the possibility that

I my self am a "teacher as artist." Through using this metaphor, I am beginning to understand the use of paradox as a guiding conceptualization for understanding curriculum, teaching, and leading a creative life. I struggle to intertwine my theoretical and personal practical knowledge (Clandinin & Connelly, 1989, 1992; Connelly & Clandinin, 1988) together with who I have been, who I am, who I am becoming, and who I wish to be—all aspects of my teacher self.

Throughout the two pieces that I share here, "Dear Diary and Other Tales of Writing" and "P.S. I was the Quiet Girl with the Blonde Pigtails and Other Tales of Creativity," I use uppercase and lowercase text to contrast different aspects of my self. Lowercase "i" represents my diminished and reduced self. This is in the period of my life from kindergarten to the beginning of doctoral studies when i learned to listen to others more than to my self. Uppercase "I" represents my fuller, creative, transformed self. This self figured in the period of early childhood before I entered the school system. This self re-emerges only in the latter period of my doctoral studies, when I began to listen to my self and others, at the same time. This state of paradoxical tension between self and other(s) is central to my personal understanding of the essence of creativity. I have written "myself" as "my self" to accentuate both "my" and "self."

Subjectivity is constantly in flux. Sometimes it is difficult to know which of my selves is speaking, which "i" or "I" is being engaged and then represented in text. As my transformation progresses, I am tempted to change some of the "i's" and "I's" with each new reading of my autobiographical chapter. I have decided to date this text now at January 21, 1998, and leave the "I's" and "i's" as they were to capture this moment in terms of my developing levels of subjectivity. I am convinced that my dissertation experience has begun a transformation in my perspective and that process needs to be documented so that my readers can be convinced of the reasonableness of my claim to have changed.

Both Piece One of this chapter, "Dear Diary and Other Tales of Writing," and Piece Two, "P.S. I was the Quiet Girl with the Blonde Pigtails and Other Tales of Creativity," consist of vignettes of different lengths. I refer to these self-portraits as "pieces" because they represent fragments of my life that I have composed as a narrative that is generally chronological. I do not have topic sentences for the pieces of my life; neither a plot nor an ending: "As an idiosyncratic text, [self-narrative] is personal both in its selection of events and in its

expression or style" (Diamond, 1991, p. 93). This personal signature is rendered also in terms of my format. The vignette titles are **bolded** and have been imbedded as the first lines of each text. In Buttignol (1998) the first letter of the words introducing each vignette has been enlarged, fashioned after the style of a child's storybook. Metzger (1992) validates and celebrates the use of such "pieces" of writing when she emphasizes that form arises from content and content arises from form. The reconciliation of this dialectic, she believes, is art.

> A piece can go in many directions, may resemble a prose poem, may be a meditation, a musing, a review, may incorporate poetry, criticism, anything at all, everything, into it. Nevertheless, each "piece" has a very precise form, determined by the content and the language. (p. 22)

> How will we know, then, when we have found the right form, when the words are right, when the meaning is fully expressed? We will know by the necessity they convey and the beauty and elegance they exude. (p. 23)

To reclaim my voice I have decided to omit citations from the literature in these autobiographical pieces. Like bell hooks (1989), I choose not to perpetuate further what I now see as my servitude.

Presenting My Postmodern Text

Like Finley and Knowles (1995), I present a postmodern or arts-based work "that generates meaning not only through its content but also through the form in which the content is displayed" (p. 111). Venturing further into postmodernism, I welcome the anxiety of leaving uncertainties and conflicts unresolved, and some questions unanswered. Throughout my dissertation, I describe my inner conflicts and make them central to my narrative (Bloom, 1996). These stories contain my "narrative truth" (Bruner, 1990, p. 111), as I remembered it piece by piece. I no longer feel the need to pursue a neat fairy tale ending for this chapter, the dissertation, or for my self.

Like Ronai (1992), I invite you, as my reader, to join in conversation with me in the margins to "vicariously live, an experience through the medium of the text" (p. 123). Theresa Amabile (1990), a researcher who studies creativity, was chastised by her grade one teacher for being too creative. She wonders why she still draws like a grade one child. She claims: "I study creativity because I'm still trying to figure out something that happened in grade one" (p. 61). My quest into

creativity also began with a similar kindergarten experience that I now share.

In addition to the use of pieces of writing, I also use the form of an unsent letter that I retrospectively wrote to my kindergarten teacher, Mrs. Mac Donald. I wrote it in my left or childhood hand. It is me speaking from my childhood voice. It is juxtaposed over my kindergarten portrait. A prose poem that follows the unsent letter (Figure 8) represents my reflections of *that* day in kindergarten, almost 40 years later. I use the unsent letter to link Piece One and Piece Two. I use the prose poem to introduce Piece Two.

Piece One: Dear Diary and Other Tales of Writing

i always wanted to keep a diary. In childhood and adolescence i started diaries a number of times but then never wanted to write in them because the book itself intimidated me. Usually the diary was a birthday or Christmas present from a friend or relative. It was always a small bound book with an image of a girl on the cover. The cover was usually padded plastic. I remember one diary. On its pastel blue cover was a teenage girl with her hair in a pony-tail. She was wearing a "poodle skirt" that was chic in the 50s and she was standing beside a little record player. Musical notes were floating around her head. i never felt as if i was the girl on the cover. i hated that lock on the side of the diary because i did not want to have to worry about opening it each time i wanted to write. Having to deal with the key was another annoyance. i always forgot where i put the tiny metal keys and often found myself locked out of my own diary–out of my own "truth."

In those diaries of my youth, there was a limited amount of space allowed for each day. If it was a one year diary, there was about a page for each day. If it was a five year diary, there were only a few lines. i thought that i had to write exactly the amount that the book allowed me for each day. If i had a lot to write one day, my handwriting had to be made tiny so that all of the words could be squeezed in. If i didn't have much to say, the writing had to be in big letters to try to fill up the space allowed for me that day. i wanted to have secrets to write in the diary, but i never had any important enough to include. Instead, i enjoyed writing letters, making scrapbooks and collages. i did them for fun. Diaries were no fun for me at all! Having to find the key, open the lock, find the right page, write in the size of

space that someone else had decided i needed was all too restrictive. So, after a few attempts at keeping a diary, i gave up. It would be 30 years later that I would find my own way to unravel the thread of a diary-sketchbook.

i just could not do it the right way. I wish now that i could have just thrown those diaries out when i realized that they did not work for me. Instead, i put them away in the back of a drawer in my bedroom dresser. Every time that i came across those unused diaries they were a painful reminder of my silence. i thought that there was something wrong with me. All of my girlfriends and girl cousins said that they used their diaries every day. Not me.

After my Mother died when i was 14, i found her red diary in the top drawer of her dresser. It was there where it had always been in the very back corner of her drawer. There were also a bundle of love letters from my Father, my Aunt's blonde braid, some rosaries, our baby teeth, holy medals, war medals, lacy perfumed handkerchiefs, make-up, gloves, and some costume jewelry. My eyes fixed hungrily onto Mummy's red diary. Had she left it there for me? i picked it up and pushed the button on the side—and the lock opened. Hoping to learn something more about my Mother, i tenderly leafed through the lined pages. But i put the diary back into the back of her drawer. Mummy had not taken to formal diaries either. The pages were mostly blank with the odd entry noting an appointment or a special date. I wonder now how much I am like her. I have decided to fill my blank pages with my more recent discoveries.

I did not have my very own writer's voice until very recently. i never even thought that i could have one. Only real writers write in books. How could i have ever thought that for a moment that i could call myself a writer! i learned, rather i was trained, to write in a rational formulaic way, in school, for school. And that is where my writing stayed—as a school subject. But my personal letter and note writing was always a passion. "To write properly you must always start with the topic sentence, then go to the body, and end with the conclusion. You must always follow this sequence in this order if you are ever going to learn how to be a good writer."

I can still hear teacher-after-teacher-after-teacher, year-after-year-after-year recite these dicta like a solemn litany. In school, teachers

tried to teach me how to write and edit at the same time, and i found this impossible. i felt as if i was expected to be perfect the first time around. "After all, your writing is supposed to be you" the teachers told me in so many words. Fearing that my disorderly written eruptions betrayed a chaotic and savage mind, i was often embarrassed by them. i never knew what would come out on paper until it was there. i never understood the poetry that we learned about in school. i hated those rhymes that we were forced to write. "Pay attention to the rhyming scheme. AA BB AA," the teachers would say. i always wondered how you could apply a formula to writing prose and poetry, but who was i to be thinking about things like that when i couldn't even follow the rules for writing properly?

Once in grade 10 we had an assignment to make an anthology of our 10 favorite poems. Not having any favorites of my own, i figured that i needed to find some that i could pretend were. So i did what i thought i was supposed to do and found nine conventional rhyming poems that i did not understand at all. The tenth poem was one by Ezra Pound. i do not even remember what it was about now. i do remember that Ezra Pound spoke to me in his poetry. i wondered if it was really poetry. It did not rhyme. It was like a prose poem. When i was assembling my anthology, i buried Ezra's poem in the middle, sandwiched between those rhyming ones, just to be safe. i even cut some dark images and words from magazines and glued them into a border around my Ezra Pound poem. The other nine pages of my anthology i left blank, apart from the text of those contrived sounding rhyming poems, that is. I found later that Ezra struggled with darker parts of his self and was institutionalized.

Throughout my formal education, i learned to follow all of the rules about writing well, very well. My writing developed just like those teachers thought it should but i always saw it as superficial, mechanical, empty, and so not me. One teacher talked about "creative writing" but juxtaposing the words "creative" and "writing" was too much of a contradiction for me to grasp. If a teacher had allowed me to write a letter, much more of the real me would have appeared on those lined Hilroy notebook pages, I am sure. i never expressed my self in school. i did not see the point in taking a chance and risking being humiliated. i just did what i was told to do. It made life easier for me at the time. i could regurgitate facts on paper exceptionally well. But i could not write about who i was nor how i felt.

Carl Jung kept a diary as he was developing his theory of collective consciousness. In this book he recorded his images, dreams, fantasies, themes, and all the connections he saw between them. He even wrote conversations between himself and his "anima" that he felt represented the "female" side of his mind. My husband Rudy told me that, in Italian, "anima" means soul. I wonder now what was happening to my soul in school as i was learning how to write "the right way." Jung's anima looked still like an old man and he named him "Philemon." I wonder about my composite Theseus-Daedalus, a brave hero-artist maker.

Just hearing the words "for this course you need to keep a diary" always enraged me. It always felt like yet one more thing I had to do. And i never could do it "the right way." I see now that i needed to discover "my own way." But in school, there was never any thought of doing that. Doing things "the right way" was doing things "the same way" as everyone else. i gave up looking for "my own way" unless i received encouragement. But this was something that i seldom experienced in my early school days. Like an angel's visits, prompts of encouragement to be different were rare. Mostly, i gave into doing things "the same way." i got the message that life would be much easier for me if i just "went with the flow" and stayed on the straight and narrow. Forget the labyrinth. From kindergarten on, i got more and more practice at coloring inside the lines (see Mrs. Mac Donald below).

Before i began this doctoral dissertation, i never thought about the possibility of finding and recreating my self. i thought of my self as a more or less fixed entity. It never occurred to me to reflect upon the relationship between, say, "the person I am" and "the teacher I am" or that i could make changes in the future based on examination of the past. When I first learned about Patrick Diamond's use of the "teacher I am" as a theoretical construct, I had difficulty accepting how I could be more than one teacher self. Before taking his course, it seemed such a schizophrenic prospect. i had no idea that there could be concepts of teacher change and transformation. Patrick and I are now coinquirers. The things that I had learned previously through taking additional teacher qualification courses i viewed mostly in terms of adding knowledge and skills to my teaching repertoire. From my

experience, teachers were just the same when they taught me as when they taught my little sister Jeannie, seven years later. At the same time, i often felt blocked and unable to do what i really wanted to do, especially in school. As a teacher, there had been many times when i had to come up with an unusual solution to a nagging problem. If my idea *was* approved, i charged ahead full steam; but, if someone said, "You can't do that," i usually backed down and retreated, steam turning into suffocating smolder. i always wanted to be like Joan of Arc or a fierce Amazonian warrior—a heroine. But i didn't know how.

It is hard to examine your own beliefs and assumptions about life because they are a part of you. Greek and Roman myths, Medusa, Athena, and Sisyphus. i thought myths were just a subject that you learned in school! It is even more difficult to examine the myths that we create about ourselves. We do not stop to ask ourselves why we do the things that we do. We just do them. I often do not have a rational explanation for why I am doing something new in my own way. It is more of a feeling way of knowing. It just feels right inside. I am learning things about my self through my writing.

The first thing that I remember about going to school was that everyone had to know how to color inside the lines. All summer long before kindergarten I practiced coloring inside the lines with my Crayola crayons. I had even developed a technique to ensure that I did not venture outside those lines. I first traced around the inside of whatever form I was coloring with a thick colored line. Then it was easy to just color in the middle. I used to love coloring in with my Crayola crayons. Coloring books made me feel so big. I knew that coloring books would get me ready for going to school. I practiced and I practiced. It was hard not to color on top of the coloring book lines. i knew that i couldn't do that at school and be successful. So i practiced and practiced coloring inside the lines—just barely touching it from the in-side so that there was no white gap between the lines and my coloring—but never on those lines. Never touching the lines i learned to always stay safe alongside them. Before I thought of going to school, I had drawn freehand on huge pieces of unlined paper or had made my own paintings with my hands or a paintbrush. But getting ready for kindergarten, I knew that those coloring books would best prepare me.

Paul Gauguin, the painter, did not want his intimate journal to be a book. Throughout his journal he repeated the phrase, "This is not a book," to remind himself that the form that he needed to express himself was more like painting. He experimented, by taking away, adding, and following his intuition to discover what would happen. Like Gauguin and Jung, i needed to have a diary form free of traditional conventions and rules, and no locks and keys to keep me out! Like Little Red Riding Hood, i needed to wander off the path and see what i could find, even if by chance i came across something menacing like the wolf. I wonder now if that dreaded form is part of my self?

Artists use sketchbooks, writers use diaries and journals. I have put both forms together in my sketchbook. Who do i think I am!

Sometimes my writing is neat, sometimes it is so messy that I can hardly read it. Sometimes I write very large, sometimes very small. Sometimes I draw, sometimes I doodle. Sometimes I tape in things that I find in a newspaper or magazine, or that friends send as notes. Sometimes I write single words, sometimes I *write* lists. Sometimes I just write about how I am feeling, sometimes unsent letters. Sometimes I write poetry and it does not rhyme. I never plan what I am going to do. I see what I have done after it appears on the page. It is always a surprise. I think of each of my books as a sketchbook, made up of my mind notes. Like Carl Jung, I am getting to know my own "anima." My only rule is that there are no rules in my sketchbook. I always write the date of my entries, but I do not see this as a rule. Everything about me goes into the same sketchbook. It would not make sense to me to split off my different roles or the different parts of my life into different books. I am beginning to see how I can use my sketchbook to shape the form of my dissertation. Through my sketchbook, I am practicing my writer's voice. I realize that I have more than one. Through my writing, I am getting practice coloring outside of the lines.

When i was selecting my first "sketchbook," i had some requirements in mind. Size was probably the most important consideration. The book had to be small enough to fit into my purse because i needed to carry it at all times to catch my fleeting thoughts. It needed to have an "everyday" look so that i would not be afraid to scribble and scrawl in it. It needed to be durable so that it would not fall apart.

It needed to have a flexible binding so that i could photocopy pages easily. The pages had to have a smooth writing surface so that my pen could just glide effortlessly over it. i did not want anything that was predated, presectioned, or too fancy looking. Like Gauguin, I also did not want anything that looked like a textbook. A crafted Hilroy 300-page, 6" × 9" spiral spine notebook was my choice. It has lined pages even though I would have preferred unlined. I bought the first one at Business Depot for $1.99. Besides the lines, the only other thing that I do not like about the Hilroy 300-page model is that it is divided with colored poster board into "5 subjects." When I get to one of these colored sections, I write on them like another piece of paper. Like Daedalus, I love materials and shaping them.

For me, the writing tool is just as important as the choice of the writing format. I like tiny, sharp, black lines of writing that run smoothly onto the paper. The feeling of flow is very important for my expression. Sometimes my writing trickles out of my pen like water in a slow creek; sometimes it swirls like water descending in a whirlpool; sometimes it bursts to the surface like water from an underground spring; sometimes it cascades like water over a waterfall; sometimes it swells like a tidal wave; sometimes it meanders like a slowing river; sometimes it is blocked like the water in my garden hose when it gets kinked; and sometimes it has deep undercurrents and powerful cross currents. I need the feel of the flow.

I detest the feel of that scratchy confrontation that some pens inflict on paper. I have tried a number of fine black markers and uniball pens and by far, the best one to date is the PILOT Hi-Techpoint V5 Extra Fine. At first, I used the PILOT Fineliner but the Hi-Techpoint Extra Fine is even better. It has an ink reservoir for the overflow, and so I can write holding the pen bottom down, as when I am writing in bed. One day I misplaced my PILOT Extra Fine and I had to use a uniball pen that I had in my purse. I was drawing so furiously in my sketchbook that the sharp tip of the uniball ripped through the paper! I have not used any color in my sketchbook, yet. But, last week I found myself trying out fine colored markers with tiny tips like paint brushes, and some Crayola felt markers called Overwriters.

In those diaries of my childhood, i felt a terrifying pressure to write every day and to fill every page as rigidly dictated. With my sketchbook, I make entries whenever I want to. I try not to panic

when I do not have time to get everything down as images and ideas and thoughts drift rapidly through me. I have learned that the same idea comes around again and again. If I am unable to capture it at one sitting, I will the next, or the next, or the next after. The silent times between dates in my sketchbook also speak to me.

Breathe in through the nose, breathe out through the mouth— inspiration, expiration. Closing my eyes and doing this simple exercise before writing helps me to focus on the present and empty my mind, all in the matter of a few deep breaths. Turning off the computer screen so that I cannot see the text as I type allows my writer's voice out. With the screen turned off, I cannot fall back into the trap of trying to write and edit at the same time. i learned that skill all too well in school. Writing or typing with my nondominant left hand releases my childlike writing voice. My dissertation topic, teacher creativity, erupted out of an unsent letter that I wrote to my kindergarten teacher. Diamond introduced me to this form. I next use that letter to link Pieces One and Two. Written with my left hand, I superimposed that text over a phantom-like version of my kindergarten portrait (see Figure 8). My eyes then gazed outwards. Only now am I able to gaze within my self.

Piece Two: "P.S. I was the Quiet Girl with the Blonde Pigtails" and Other Tales of Creativity

My reflections on that unsent letter to Mrs. Mac Donald follow as a prose poem:

> I remembered *that* day. It was sometime in 1955. Almost 40 years later, I reflect on it.

> I am sitting stiffly in a little brown wooden desk. My hands are folded on top of the desk. A new package of six Crayola crayons has been placed at the top right-hand corner of my desk. "Do not touch until you are told," the teacher warns in a booming voice from somewhere behind me in the room.

> All of the desks in the kindergarten are bolted onto long tracks which are bolted to the floor. The desks do not move. We cannot move. The walls are painted that washed-out green color that you still see in old institutions. The air is thick with that sickening lunch pail smell, and plasticene. A large brown wooden teachers' desk is at the front of the class close to the window and facing us. A gray metal garbage can sits in its place near the door.

> The large gray teacher moves around the classroom. The smacking sound she makes with her shoes as they hit the floor is all that can be heard in the room.

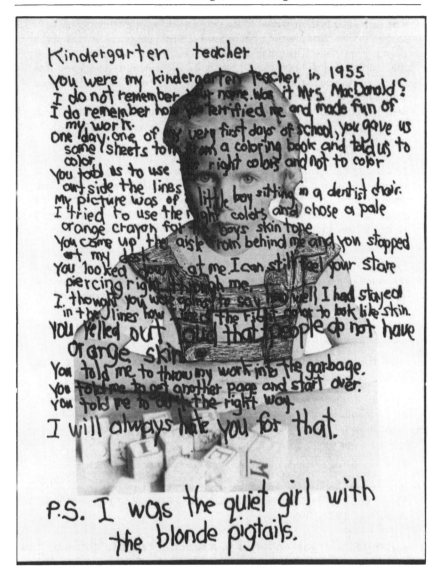

Figure 8 *Kindergarten Poem* (M. Buttignol, 1995)

I am waiting.
My hands are still folded.
I want to be a good student. I want her to think that I am smart. I want to fit in.
I want to belong.

The large gray teacher places a page, torn from a coloring book, on each student's desk. We have not been ordered to begin yet, so I just look at the page in front of me. The picture is of a little boy sitting in a dentist chair with the dentist standing beside him. I had been to the dentist and I knew that almost everything in the dentist's room was white. The little boy was covered with a large sheet and the dentist was wearing one of those medical uniforms with buttons down the side of the neck and along the shoulder. "There is not much to color in this picture," I thought to myself, "everything is white."

I eyed my Crayolas without moving my head.

I looked at the picture again. There was some skin showing. "I'll use that orange crayon very lightly to color in all of the skin," I said to myself. So, when the large gray teacher ordered us to begin coloring, I went right to the orange crayon. As I was coloring the skin an even, pale orange I was very careful to stay inside the lines. That is one thing that I knew for sure—in school you could never color outside of the lines.

I felt the large gray teacher approaching my row, from behind. I can still hear the sound of her large sensible shoes as they smacked against the floor. She stopped beside my desk, to my right side. She did not say anything at first. She did not need to. I felt her glare pierce through my body. In that frightful silence, I felt like I was awaiting the death sentence. In a way, I was. Part of me died that day.

"Skin is not orange!" she roared. "Throw that page in the garbage and get another one. Start all over and do it right this time."

I do not remember much of what happened after that, other than throwing my page into the gray metal garbage can by the door. I can still picture it there, in with the smelly apple cores, wax-paper wrappings and empty glass milk containers.

i got the message that day from the large gray kindergarten teacher.

When i went home from school that day i did not tell anyone, not even my Mother and my Father. That story stayed inside of me for 40 years. (Margie, Anthology, 1994-1995)

I read my kindergarten letter to a teacher friend, Michele. She told me another story about a similar kindergarten experience. A student was instructed by his kindergarten teacher to cut out figures from comics and paste them onto paper, in a particular way. He spent quite some time choosing which comics to use, how to place them, turning his page this way and that way, making sure that the form was just right. Then he lovingly glued each piece down. The teacher came around. "You have not followed instructions! This is no good at all! Throw it in the garbage and do it over. The right way!" This student dropped out of kindergarten that day. He later became an artist. i

stayed, learned to follow instructions, and to do things the right way. i became a teacher. Now I ask myself: "Is it possible for me to be an artist and a teacher at the same time?"

When I was a child, the word "curriculum" conjured up the image of a very large, well-used, handwritten, parchment-paged text. i thought that "the curriculum" was a blueprint, written by some very wise people with enchanted fountain pens who knew what all children should learn and for all time. The word "curriculum" was both shrouded in mystery and bright with untarnished authority. Teachers talked about "curriculum" in hushed tones, as they talked about other adult topics that we children would just not understand. For me, "curriculum" meant memorizing dates and names and times tables, and i never saw myself as part of it. "Curriculum" meant the hard subjects like math, science, history, and geography. "The curriculum" was fixed, carved in stone tablets like the Ten Commandments in my Baltimore Catechism. Somehow i got the idea that the arts were not part of "curriculum." They were something else, done on Friday afternoons after recess, soft and fluffy and just for fun. The older i got, the less the arts seemed to be tolerated in school.

When i began graduate study at the Ontario Institute for Studies in Education at the age of 38, i was surprised that there was a whole department devoted to "curriculum." "What for?" i asked. "What can i learn about something that never changes?" At that point, i had been a teacher for four years. My ideas about curriculum had indeed become deeply and seemingly irrevocably etched within my understandings.

At some point early in my development i began to polarize artists and scientists. At one pole, i saw scientists as rational and objective, concerned with the intellect, knowledge, and "the truth." At the other pole, i saw artists as irrational, subjective, and concerned with expressing emotions. i thought that knowledge was some thing "out there" that could only be expressed in numbers and scientific language.

i went to school so that i would learn how to think; for me, school had nothing to do with self-expression and being myself. i had no conception of personal expression or experience through

dancing, drawing, music, or sculpture yet i cherished all of those things. i had determined that school and self-expression were just antithetical. In grade five, i was told by the teacher that i was being "just a little too creative" when i juxtaposed a man's face onto a cupid's body for the St. Valentine's Day box. The teacher punished me because he said that I was making fun of the Principal. i had to memorize a very long prayer for the next day.

As time went by, i became a withdrawn self in the classroom. That is what i thought was supposed to happen at school. The values and beliefs that shape behavior through often unspoken rewards and punishments had compelled the creative part of me to go into hiding. Outwardly, I became an obedient and attentive student. i stopped asking questions, taking risks, daydreaming, and expressing my uniqueness in school. i kept my hands folded on top of each new desk. Dry repetition, rigid routines, and conformity to rules took away my personal initiative and along with that my creativity. However, one of my former teachers still recalled me at a recent high school reunion as "such an air head." Better than gray. Only later would I discover Freud, who connected daydreaming and children's play with creativity. The first traces of imaginative activity are to be looked for in the child.

I reflect upon the teachers of my past. Some teachers evoke bright memories, others shadows, and some bland few, nothing. I reflect too on what Diamond introduced me to as different aspects of self. I wonder how each of my past teachers has influenced my ideas about "the teacher I am, the teacher that I think I am supposed to be, the teacher I want to be," and "the teacher I fear to be." I wonder how "the teacher I am" is related to "the person I am." Where does my "I" or "my self" stop, and where does my "teacher self" begin? Is my teacher self my "I" or my "i"? I fear that my "teacher self" has overpowered my "I" and "my self." I fear that my "teacher self" has kept my "I" and "my self" as "i."

When I was a little girl I never played "teacher." And I never let anyone play "teacher" on me. In my mind "play" and "teacher" did not fit together. In school, I quickly learned to stop guessing and asking questions, concentrating instead on the one correct answer, the teacher's. Product was everything and process nothing.

It may seem ironic that I have focused on teacher creativity in my doctoral research. I think that it is more paradoxical. Over the past three years, I have read countless books, journal articles, and personal accounts on creativity and I see that my experience of stifled creativity in school is not unique. In kindergarten, I started to abandon an important part of my self. At the age of five, i sensed that, at school, learning to conform was more important than expressing my self. My current choice of heuristic research in teacher creativity echoes my passion and my pain. It propels me into the unknown territory of researching my self.

When i was in elementary school, art always took place on Friday afternoons, after recess. i learned how to get good marks in art by following instructions, finishing on time, cleaning up, and crafting something that looked exactly like the one that the teacher made. i did not know then that i could express my self with art. i still felt that art was something that a person did for fun. The only exposure to art history that I had was from a dusty print called "The West Wind" by the Canadian painter, Tom Thomson. We were not taught anything about him other than that he drowned in a canoe accident in Algonquin Park. "The West Wind" just hung there high on the grade six classroom wall, beside the clock. Every time that I looked at the clock I also saw "The West Wind." I remember thinking that it looked so dark and sad. I wondered about Thomson and why he painted that way. Did he have a premonition?

When i was in high school, there was no art; just real subjects like mathematics, history, english, and geography. The closest thing to art was home economics. The highlight of the cooking course was making a lunch of frozen green peas in cream sauce on toast. i did all of the cooking at home for a family of five and wondered when i would ever use a recipe like that. We also did sewing in home economics. Always dreaming about being a fashion designer like Coco Chanel, i had been sewing since i was about seven years old. In class, we all had to make the same shift dress in a solid color. i got in trouble because I brought in orange and yellow striped fabric. The teacher shook her head and said, "You'll never be able to match up the stripes properly!"

On my fridge is a magnet of Michelangelo's statue of David. One of my Aunts went to Florence in the early 60s. She brought back

slides of the works of art that she saw there. i was allowed to see the slides of paintings of holy scenes like the Annunciation when the angel Gabriel came to Mary, and told her that she was going to be the mother of Christ. But, when the statues of naked men were shown, i was told to leave the room. i wondered what it was that i was not supposed to see and why it was bad.

My Uncle John was an artist. Everyone in my family used to make fun of Uncle John because he was always "away in the bush" painting landscapes like Tom Thomson. "He's strange. Why doesn't he get a real job?" they all said. My Grandmother and her three sisters played the piano and gave private lessons in their homes. My Aunt was a fashion designer. My other Grandmother died in a psychiatric hospital. She was a painter. "She was touched" people would say about her as they tapped their index fingers against their temples. i wondered what she was touched with. With so many artistic people in my family, i was always discouraged from a life in the arts. "It's all right for a hobby when you're young but you can't make a living *that* way," relatives on both sides of my family would warn.

What are my assumptions about creative people and where did those assumptions come from? I decided to fill out the Creativity Form that I designed for my research (see the arts-based activities below). The descriptors that I used for creative people include: "scattered, reclusive, can be anti-social, mad, exciting, colorful, can be anguished if blocked creatively, driven if in a creative 'flare,' misunderstood at times, hard to understand, fun but sometimes scary to be around, people who require freedom and time." Six reflexive responses follow below as taken from another part of the Creativity Form (Buttignol, 1995). This is where I think that my assumptions about creative people came from:

My Dad thought artists were crazy but fun.

My Mom thought artists were interesting people who showed their work in galleries and museums.

In my family, **artists were considered okay as long as the expression was just for a hobby.**

Among my childhood friends artists were considered as flakes.

My childhood God thought artists were blessed with genius.

As a child i thought that artists were always on the edge of insanity.

When i was a little girl i had a recurring nightmare. A madwoman lived under my bed and she haunted me day and night. If i stepped too close to the side of the bed, she would grab me by the ankles with her bony white hands and try to pull me under, down into her deep black pit. Who is this crone and where do I want her to take me? Why do I still dress up as a witch on Halloween? Are dreams distorted or disguised wishes? Dare I now wander to that edge of that unknown pit?

When i was in teacher training at the Faculty of Education, i sat at my desk, hands folded. "Strange that she's talking about creativity in a curriculum course," i thought, as a professor introduced herself and her creativity research with children. i wondered how she would find enough creative children in schools to study. i was even more perplexed when she handed me a pink questionnaire inquiring about *my* creativity. As a student teacher, i needed to learn about "the curriculum," not creativity. i had come to believe that only very special people like Michelangelo and Mozart could be creative. In my mind, creativity in school was an impossibility.

During my heuristic process that helped me begin the dissertation, I telephoned that same professor. Puzzled because I could find little literature about teachers examining their own creativity, I asked her if I was overlooking something. She was silent for a moment and then she laughed: "It seems that people still believe that you either have it or you don't and that's that!" she conceded.

Fourteen years ago i became a teacher. Fearing that "curriculum" meant denying self-expression, i headed off into an area in education where there was no ready-made curriculum to follow. In the early 80s, the idea that there could even be educational curricula for learners with severe disabilities was new; so too was the idea that these people could learn at all.

When i was learning to be a teacher, Dewey and Tyler were introduced to me in the form of tiny paperback books. I realize now that i knew Dewey and Tyler in my first years of teaching better than i thought i did then. From the very beginning of my work with students with severe disabilities, i knew that the goals of instruction had to be clearly established before trying to develop curricula. i also knew that those goals must begin with the students. Reflecting on that first year of teaching I realize that I did use my creativity because there was nothing else for me to rely upon. There were no textbooks or experts to tell me what to do.

Mikey was a nonspeaking 10-year-old with autism. i asked myself: "What does Mikey need to know?" He had no worldly experience. Before coming to our downtown elementary school, he had spent his days in an institution for the "mentally retarded." He had never even gone to the corner store, never taken a ride on a public bus. He had no friends. "What does Mikey need to know?" i asked myself over and over and over. Early in the school year, i had a conversation with his mother. She telephoned to see if Mikey was using his "behaviors" at school. She was particularly concerned about one "behavior." Whenever there was a knock on the door, Mikey's Mother told me, he would race to the door, and kick the visitor in the shin. As the visitor was bending down nursing the injury, Mikey would bite the visitor on the head! "Yes, Mikey does that at school," i admitted. "What did teachers at his other school do?" I asked. Silence and then: "They put a screen over his head or they sprayed him in the face with water or they strapped him into a time-out chair," Mikey's mother explained.

i wondered how punishing Mikey would make his "behaviors" vanish. Why had Mikey kicked and bit visitors? In his own way, Mikey was telling us that he needed to learn a simpler form of saying "hello." Without Tyler's structure for organizing curriculum and Dewey's emphasis on experience and social responsibility, i could not have even begun with Mikey. I would learn later that Dewey encouraged teachers' artistry and dreaming.

I have a recurring dream. I am chewing gum and my teeth fall out and become stuck in it. I wake up gagging, afraid that I will swallow my teeth. I read that, in some societies, in initiation ceremonies teeth were extracted and swallowed to symbolize death and rebirth. I wonder, "What I am being initiated into?"

Nearing completion of my doctoral work I am faced with a paradox. I began graduate work to develop my rational skills to cope within the educational bureaucracy. I now know that to flourish in my work and in my life I need to use my intuition and artistic ways of knowing to complement the rational ones. Personal recreation and transformation arise from this synthesis. Flowing from this, I have developed the key conception of "teacher as artist." My teaching practice can be my art. I wonder how to integrate artistry and rationality in my teaching and in my life, and why before I have been afraid to use my creative abilities as a teacher.

Follow your bliss: Find your "I's"! I believe that education should prepare students for the inevitable tension between inner and outer life, between the paradoxes of self-expression and conformity. Daily life is enveloped in paradoxes yet schools have been unable to teach students about living and honoring such ways, while following what Joseph Campbell called their own versions of bliss. Living with paradox is constantly adjusting to the flow *between* the polarities rather than aligning with only one. We need to see polarities as a dialectic promising relationship, rather than a dualism threatening confrontation. Some of the everyday polarities that I have experienced include: self/other; process/product; fancy/fact; intuitive/rational; art/science; self-expression/social control; means/ends; discovery/discipline; existentialism/behaviorism; and artist/teacher. Why is it that in school we are always forced to pick the one right answer? Why do we fear ambiguity and tension? Out of such struggles comes creativity.

Final Fragment: Sometimes I think that my husband Rudy knows me better than I know my self. He echoes over and over, "You need inspiration not instruction! You don't need manuals. You need to break away!" Break away from what, I wonder. Get on the outside of what?

Summary Comments

My doctoral inquiry into teacher creativity took me back to my self. The inner reflection that is represented in these vignettes has been transformational for me as a person, a teacher, and a researcher. These fragmented pieces of my experience of creativity reveal my

motivation for this dissertation and my professional development. The unsent letter to my kindergarten teacher turned a painful epiphany into a transformational one. Like May (1975/1994), I need "courage to create."

I am asking: "How can I become a teacher as artist?" I could find little detailed advice as to methods from teachers, artists, and researchers who have gone before me, only fragments of information and guidance. Among the exhortations, Grumet (1983) asserts "that it is an essential property of art to challenge convention" (p. 32). She cautions me that "terrible vulnerability accompanies aesthetic practice" (p. 37). Grumet (1983) also recommends that teachers who see their teaching as art find ways of "combining seniority with determination, with a reputation for eccentricity, and a little larceny" (p. 37). Diamond (1995) tells me to "stop apologizing and become an apologist." Russell's (1995) comment, "I think you're onto something," gives me hope that I will find what I am looking for even though I am unsure of how to recognize it. Diamond and Russell agreed to join my dissertation committee.

Barone (1983) warns me that school personnel and the public need to be sensitized to "the institutional constraints and other 'frame factors' that discourage teachers from facilitating truly aesthetic and educational experiences" (p. 26). Eisner (1983) describes the art of teaching as "precisely the willingness and ability to create new forms of teaching—moves that were not part of one's existing repertoire" (p. 11). Stenhouse (1984) advises me that art is improved by critically exercising it. Rubin (1985) tells me that what I need to do to become "teacher as artist" involves nurturing my own natural teaching style based on who I am as a person. Becoming the "teacher as artist" involves listening to my own pulse and that of each student. I need to be "mindful" (Langer, 1989; Miller, 1994). Miller also agreed to join my dissertation committee.

I still wonder how to integrate my artistry and rationality (Arnheim, 1986). I need to learn from that little kindergarten me that dwells within. Only now do I realize that Little Margie has been holding onto the other end of my narrative thread. I like her and those pieces of encouragement that others have handed on to me. Like her, they never knew what they were posting to me. So now, I am posting these pieces to you, my reader (Buttignol, *Contract with My Self*, dated January 21, 1998).

Arts-Based Activities

1. Write an unsent letter to Little Margie using your nondominant hand.

2. Write an unsent letter to Mrs. Mac Donald (or your own Mrs. Mac Donald if you have one) using your nondominant hand.

3. Buy a box of Crayola crayons. See what happens when you touch them, smell them, and use them!

4. Examine your beliefs about creativity by filling in these blanks:
 My Mother thought creative people were _____
 My Father thought creative people were _____
 In my family, creative people were considered _____
 Among my childhood friends creative people were considered

 As a child I thought that creative people were _____

5. This is how Dante writes about reaching an impasse in his Prologue to the *Inferno*:
 > I went astray
 > from the straight road and woke to find myself
 > alone in a dark wood. (Dante, in May, 1991, p. 154)

6. How are you experiencing the midpoint of your teaching preparation, teaching career, or dissertation?

7. Freud (1908) saw the writer as doing the same things as a child at play. Children create a world of fantasy that they take very seriously, investing it with a great deal of affect (cited in Ross, 1987). How do you see this connection between children's play and artistic creation?

8. Begin to collect little "pieces" of your own creativity narrative. When you have enough, put them together using whatever form best represents you.

References

Amabile, T. M. (1990). Within you, without you: The social psychology of creativity and beyond. In M. A. Runco & R. S. Albert (Eds.), *Theories of creativity* (pp. 61–89). London: Sage.

Arnheim, R. (1986). *New essays on the psychology of art.* Berkeley, CA: University of California Press.

Barone, T. (1983). Education as aesthetic experience: "Art in Germ." *Educational Leadership, 40*(4), 21–26.

Bloom, L. R. (1996). Stories of one's own: Nonunitary subjectivity in narrative representation. *Qualitative Inquiry, 2*(2), 176–197.

Britzman, D. P. (1992). The terrible problem of knowing thyself: Toward a poststructural account of teacher identity. *Journal of Curriculum Theorizing, 9*(3), 23–46.

Bruner, J. (1990). *Acts of meaning.* Cambridge, MA: Harvard University Press.

Buttignol, M. (1994–1995, December-February). *Anthology.* Unpublished manuscript.

————. (1995). *How secondary school teachers experience their own creativity: Stories of arts-based teacher transformation.* Unpublished doctoral thesis proposal, Ontario Institiute for Studies in Education/University of Toronto, Toronto.

————. (1996, January 21, 1998). *Contract with my self.* Unpublished manuscript.

————. (1998). Coloring outside the lines: Transformative experiences of creativity and teacher self(ves). Unpublished doctoral dissertation, The Ontario Institute for Studies in Education, University of Toronto, Toronto.

Cameron, J. (1992). *The artist's way: A spiritual path to higher creativity.* New York: G. P. Putnam's Sons.

Clandinin, D. J., & Connelly, F. M. (1989). Personal knowledge in curriculum. In T. Husen & T. Nevill (Eds.), *International encyclopedia of education, research and studies* (Supp. 1, pp. 577–580). Oxford: Pergamon.

————. (1992). Teacher as curriculum maker. In P. W. Jackson (Ed.), *Handbook of research on curriculum* (pp. 363–401). New York: Macmillan.

Connelly, F. M., & Clandinin, D. J. (1988). *Teachers as curriculum planners: Narratives of experience.* New York: Teachers College Press.

Denzin, N. (1989). *Interpretive interactionism.* Newbury Park, CA: Sage.

Diamond, C. T. P. (1991). *Teacher education as transformation.* Milton Keynes: Open University Press.

————. (1995, January-December). Personal communication with C. T. P. Diamond.

Eisner, E. W. (1983). The art and craft of teaching. *Educational Leadership, 40*(4), 4–13.

Finley, S., & Knowles, J. G. (1995). Researcher as artist/Artist as researcher. *Qualitative Inquiry, 1*(1), 110–142.

Grumet, M. (1983). The line is drawn. *Educational Leadership, 40*(4), 28–38.

Heshusius, L. (1994). Freeing ourselves from objectivity: Managing subjectivity or turning toward a participatory mode of consciousness? *Educational Researcher, 23*(3), 15–22.

hooks, b. (1989). *Talking back: Thinking feminist.* Toronto: Between the Lines.

Langer, E. (1989). *Mindfulness.* Reading, MA: Addison-Wesley.

May, R. (1975/1994). *The courage to create.* New York: W. W. Norton & Company.

————. (1991). *The cry for myth.* New York: Delta.

Metzger, D. (1992). *Writing for your life: A guide and companion to the inner worlds.* San Francisco: Harper San Francisco.

Miller, J. L. (1994). "The surprise of a recognizable person" as troubling presence in educational research and writing. *Curriculum Inquiry, 24*(4), 503–511.

Miller, J. P. (1994). *The contemplative practitioner: Meditation in education and the professions.* Toronto: OISE Press.

Peshkin, A. (1988). In search of subjectivity—one's own. *Educational Researcher, 17*(7), 17–21.

Pinar, W. F. (1988). "Whole, bright, deep with understanding": Issues in qualitative research and autobiographical method. In W. F. Pinar (Ed.), *Contemporary curriculum discourses* (pp. 134–153). Scottsdale, AZ: Gorsuch Scarisbrick.

Randall, W. L. (1995). *The stories we are: An essay of self-creation.* Toronto: University of Toronto Press.

Richards, M. C. (1989). *Centering: In pottery, poetry and the person.* Middletown, CT: Wesleyan University Press.

Ronai, C. R. (1992). The reflexive self through narrative: A night in the life of an erotic dancer/researcher. In C. Ellis & M. G. Flaherty (Eds.), *Investigating subjectivity* (pp. 102–124). Newbury Park, CA: Sage.

Ross, S. D. (1987). (Ed.). *Art and its significance: An anthology of aesthetic theory.* Albany, NY: State University of New York Press.

Rubin, L. J. (1985). *Artistry in teaching.* New York: Harper & Row.

Russell, H. H. (1995, November 22). Personal communication with H. H. Russell.

Stenhouse, L. (1984). Artistry and teaching: The teacher as focus of research and development. In D. Hopkins & M. Wideen (Eds.), *Alternative perspectives on school improvement* (pp. 67–76). London: Falmer Press.

Weedon, C. (1987). *Feminist practice and poststructuralist theory.* New York: Basil Blackwell.

Chapter 6

Whiteness, Cracks, and Ink-Stains: Making Cultural Identity with Euroamerican Preservice Teachers

Carol A. Mullen

Each night, without fail, she prayed for blue eyes. Fervently, for a year she prayed. Although somewhat discouraged, she was not without hope. To have something as wonderful as that happen would take a long, long time. (Morrison, 1994, p. 46)

All that I know of our [Arab] history and the history of the Indian Ocean I have got from books written by Europeans. Without Europeans, I feel, all our past would have been washed away, like scuff-marks of fishermen on the beach outside our town. Home was hardly a place I could return to. Home was something in my head. It was something I had lost. (Naipaul, 1979, pp. 18, 114)

Journeying to the Interior: A Far-Off Place

In this chapter I explore issues related to teacher identity construction that are concerned specifically with Euroamerican preservice or beginning students. Some of them come from minority backgrounds and, like Naipaul's (1979) Salim, an East African Muslim of Indian origin who left the coast to journey to the interior, they find themselves set up in a far-off place. But they remain outsiders, never at home. Ironically, only the Euroamericans seem to offer proof that they even exist. Such teachers feel like a minority within a minority ("just a teacher"). Identity for them is like double consciousness or a series of Chinese boxes, each nesting within another. Here, the postmodern educator resembles a negotiating artist at work in the making of personal cultural identity and broader democratic projects. Just as Pecola Breedlove

learned that "a blue-eyed, yellow-haired, pink-skinned doll was what every girl child treasured" (Morrison, 1994, p. 20), as teachers we learn to make ourselves according to the ideas we have of our possibilities. The struggle between different descriptions of the world is both internal and external.

My aim in this essay is twofold: one, to show aspects of what was involved in the artistic making of cultural identity for a particular group of preservice teachers; and two, to contribute to the literature in teacher education that is concerned with the challenge of the many descriptions provided by multicultural education. On the first point, I have learned that for many young Euroamerican students their own cultural background and identity are a sort of nonethnic, noncultural "default setting." Thus, any discussion of culture, ethnicity, language, and identity is automatically assumed to be about "Others." On the second point, I argue that both common understandings of "multicultural education" and some popular textbooks in the area often omit an important element in the story.

The literature on which this discussion relies is representative of that in multicultural education and includes scholarship on democratic education. The use of a single case study based on my experience as a beginning teacher educator, from 1995–1996, provides a practical context for discussion of the underlying issues at stake. I draw upon the constructions of "majority," but also "minority" students, for insights into the development of cultural teacher identity for Euroamerican persons.

This discussion is organized beginning with multicultural terms and a paradox of teacher development. The role of "whiteness" in a multicultural agenda is subsequently advanced and explored in detail. Responses to the question, "Why study whiteness in a multicultural curriculum?" follow. Next, a discussion of cultural teacher identity research is advanced using perspectives of white and nonwhite educators. An emerging case study analysis follows of my multicultural education course with predominately Euroamerican preservice teachers. Arts-based representations of cultural self-identity are pursued both inside and outside of the classroom and within the imagined spaces afforded by vicarious and real encounters with others. A preliminary discussion of shifting and transforming selves as an "unfinished work in progress" is offered. Finally, summary comments are provided with a view toward releasing self-critical activism in personal development and teacher education. Teacher artworks appear in the case study section of this chapter.

Multicultural Terms and the Paradox
of Teacher Development

It was so reassuring to see that there were people in the class who understood that multicultural education is so much more than teaching about different cultures. (Wanda, preservice teacher, excerpt from letter, December 1996)

If, as my former preservice student teacher asserts, "multicultural education is so much more than teaching about different cultures," then what "more" is involved? Wanda's reflection echoes the pressing question of academics who ask, "What does the study of multicultural education need to involve beyond traditional ethnic studies aimed at empowering marginalized groups and mitigating racial and gender forms of prejudice?"

A new body of scholarship (e.g., Banks, 1994; Churchill, 1995; Freire, 1996; Giroux, 1996a; McIntyre, 1997a, 1997b; McLaren, 1994; Mullen, 1997a, 1997b; Nieto, 1996) is emerging that is concerned with the role of teacher researchers (teachers and teacher educators) in advancing multicultural agendas that go beyond "reflect[ing] and perpetuat[ing] European American values and worldviews . . . [to achieve] a truly pluralistic society [as] a desired state" (Nieto, 1996, p. 289). An essential means to achieving this end is Euroamerican investment in complex issues of ethnicity, identity, diversity, and fairness (Giroux, 1996a; Greene, 1993; hooks, 1994; Saucedo, 1996). At this time, self-reflective, politicized writings on "whiteness" by Euroamerican scholars appear only sporadically in the teacher education literature. In my reading, noteworthy examples of provocative challenges to the status quo include Scheurich's (1993) personal discussion of white academic racism, privilege, and hierarchy within the academy; Giroux's (1997) scholarly analysis of "whiteness" in a historical, pedagogical, and political context that concerns white students and their potential contribution to a broader democratic project; and McIntyre's (1997a, 1997b) action-based study of "whiteness" with female Euroamerican preservice teachers that provoked engagement and critique.

I am looking back on my 1995–1996 teaching year as I explore the teacher identity constructions of those 105 education majors enrolled in the required undergraduate course "Foundations of Education in a Multicultural Society." My students were mostly Euroamerican but also from minority cultures. They were in their third year of a four-year program in a higher education context in a large public institution in the United States. The campus was located within the dryness of a

seemingly flat, unremarkable landscape. But, as my experience of being there became alive with new challenges, the landscape assumed new contours and details worth exploring. Having migrated from Toronto, Canada, I struggled to formulate my own understandings of cultural self-identity as a new faculty member in an unfamiliar place. What felt foreign to me was the persisting influence of the agricultural, the mechanical, and the military.

I am using the term *Euroamerican,* instead of white or Anglo, except where "whiteness" is under consideration. I also use *Euroamerican* interchangeably with *majority,* as in *majority culture.* However, at times I use "white" where the above terms have already been contextually established. I am following Nieto's (1996) use of "Euroamerican," which she advocates for making obvious the cultural origins of most "whites" in North America who are not English in origin ("Anglo"), but rather European and ethnic. A deeper layer of Euroamerican identity is revealed in Pinar's (1995) passionate view of cultural identity as associated with multiethnicity and personal, social, and political repression:

> The American self is not exclusively or even primarily an European American male self. Fundamentally, it is African American, Asian American, Hispanic American, Native American, female, homosexual self. . . . By refusing to understand curriculum as a racial text, [white] students misunderstand who they are as racialized, gendered, historical, political creatures. . . . Because knowledge of American culture is characterized by distortions, repressions, and silences—what holds true for the South holds true in regional different ways for the nation—American identity is deformed. . . . this requires understanding curriculum as a text of identity. (pp. 25–29)

Identity is like a cultural collage, variously arranged and glued together. The concept of "whiteness," as it is being developed in the literature, is characterized "by various attempts to locate Whiteness as a racial category and to analyze it as a site of privilege, power, and ideology" (Giroux, 1997, p. 289). Such representations, Giroux claims, were especially important for the resistance they provided to the popular press that generally supported a view of white men as victims of racial prejudice. However, and as Giroux (1997) himself emphasizes in pursuit of what it means to deal explicitly with whiteness or "pinkness":

> there are too few attempts to develop a pedagogy of Whiteness that enables White students to move beyond positions of guilt or resentment. There is a curious absence in the work on Whiteness regarding how students might ex-

amine critically the construction of their own identities in order to rethink Whiteness as a discourse of both critique and possibility. (pp. 314–315)

Giroux's own views on the need for a pedagogy of whiteness are articulated within only a theoretically framed discussion. Examples of actual cultural identity experimentation with preservice students, and others in education, are therefore needed to engage our empathy. In response to this call, I am experimenting with the struggles and rewards of engaging preservice teachers as they construct and critique their own cultural self-identities. Respecting the importance of remaking cultural identity with Euroamerican students is definitely a controversial position. For some other academics, "whiteness" is to be exclusively equated with a dangerous white male practice characterized by a pervasive form of racism particularly aimed at debunking "blackness" (Gresson III, 1996). Similarly, the affiliation of knowledge with power helped create an image of the East that provided the justification for the supremacist ideology of imperialism (Rushdie, 1991). I think that "whiteness" has yet to be sensitively developed, then, as a sound pedagogic approach to the "making" and "remaking" of student cultural self-identity. Banks (1993) also upholds this substantive approach to student-centered instruction and the framing of cultural issues:

> The challenge that teachers [and teacher educators] face is how to make instructional use of the personal and cultural knowledge of students while at the same time helping them to reach beyond their own cultural boundaries. Although the school [and university] should recognize, validate, and make use of student personal and cultural knowledge in instruction, an important goal of education is to free students [and prospective teachers] from their cultural and ethnic boundaries and enable them to cross cultural borders freely. (p. 8)

A paradox is suggested here: how do we help preservice teachers to understand that, while claiming their cultural self-identity, they also need to be able to release its energy so that the "self" they have made can assume new, heterogeneous, and inclusive forms? Greene (1993) eloquently explains this riddle of teacher development:

> Cultural background surely plays a part in shaping identity, but it does not determine identity. It may well create differences that must be honored; it may occasion styles and orientations that must be understood; it may give rise to tastes, values, even prejudices that must be taken into account. . . . Paulo Freire makes the point that every person ought, on some level, to cherish her

or his culture; but he says it should never be absolutized. . . . There has,
however, to be a feeling of ownership of one's personal history. (p. 16)

Self is a fleeting position in language, an effect of discourse. Own-
ership is freedom, freedom is ownership. To help communicate this
paradox of teacher identity development to my preservice class, I used
familiar objects and subjects just as Morrison (1994) used childhood
dolls. For example, a preliminary exercise featured the engagement or
commitment rings worn proudly on the fingers of many female stu-
dents in their early 20s. The males were not excluded, as many of
them had given rings to females and/or partners in other classes and
places. And, like some of the females in the class, a few were already
married and had children.

The "engagement ring" connected me with my students. I had dif-
ficulty understanding their concern for stability and certainty even in
their youth. In my mid-30s, I had just married for the first time, an
occasion that had preceded, by a mere week, the teaching of this
course. The students often asked about my ring and the story behind
it. I could see that my newly married status gave my students some-
thing to identify with, even though they saw as curiosities my "ad-
vanced" age, "childless" state, and continuing independence. Some
students lovingly (or longingly?) sketched their rings in their journal
books (wedding albums?) and wrote about them as precious gems
requiring care that eventually needed to be passed down to family
members.

Later, with intervening cultural encounters underway with each other
and with others, I returned to the topic of the engagement ring. But
this time the students spoke of the "engagement ring" somewhat dif-
ferently, as something they continued to want to claim but also to
share through enriching connections with a community of persons
seemingly like, and unlike, themselves. The exclusive tightness of the
"engagement ring" had loosened just as the concentric circle, or com-
mon center of our class, had widened to include others—but not all.

The postmodern interregnum or breakup provides imaginary home-
lands for more people and groups. Only by starting with where my
students were "at," and by respecting their values while setting condi-
tions for the development of more expansive ones, could I hope to
encourage reflection about the possibility of a more inclusive, more
connected democratic community. I wanted to find ways to engage
students in becoming critical, self-reflective learners, capable of think-
ing imaginatively, performing artistically, and taking risks on behalf of

their own development. We used literary and artistic methods of inquiry, including reflective journal writing and collage, to provoke different cultural encounters and locations. Without engaging with artistry in our development as multicultural educators, our learning would have been stifled and would have led to little, if any, change.

Artistic play with teacher identity development can never be completely "free" because it is shaped by contextual influences and historical events. This particular university, for example, has continued to thrive within a military-based educational context. Nontraditional, same sex relationships seemed just too threatening even to be mentioned. Women and minorities have only been "let in" over the last few decades. (A broader view of the Euroamerican colonization of the Southwest is available from the political perspective of Chicano/a educators. Noteworthy are Acuña's (1988) historical discussion and Anzaldúa's [1987] lyrical description.) The history of minority and gender colonization could be felt in subtle forms, and observed more overtly, in the immediate environment. Despite the conflict and violence that had been influential in the historic shaping of their university setting, and despite the current publicized incidences of alleged racist-name calling of minority students *by teachers* in several nearby schools, my white students were stumped by my invitation. I had asked them to "write about a scenario that you have personally experienced, read about in Kozol's (1991) *Savage Inequalities,* or know about that is an example of racial segregation." Jody wrote:

> I can't think of an example of racial segregation. I do know that I don't have any black friends, and honestly very few from any other race except my own. Maybe that can be my example of racial segregation in my life. The fact is that I am pretty much racially segregated. Why is it that blacks are concentrated in one area of most cities? Why is it that blacks were used by so many for slavery? Why do I fear them? I mean, I'm afraid they'll get mad at me for saying something wrong. Why is it that I think black people are all angry? (journal entry, February 1996)

Petra, an Indian student (from India), provided an example of racial segregation that revealed contradictions within her own value system and life experiences. While her narration tells how racial boundaries limit individuals, its prosegregationist leanings are also evident:

> One of my experiences with racial segregation was from when I used to live in East Africa. At that time, people kept servants; my family had a couple. The different ways blacks and whites were treated was obvious. Most blacks were poor and uneducated, treated as if on a lower level than whites. Socializing

was done each within their own race. *What I mean is that keeping a sepa-ration between blacks and whites works in many situations,* but also keeps both races limited in how much they can learn and experience. (journal entry, January 1996, italics added)

Racial fear or loathing is internalized even by its victims. Entire races can be grotesquely demonized as a result.

Advancing Whiteness as a Multicultural Agenda

Issues of "whiteness" have yet to be made relevant to teacher prepara-tion with respect to student identity development and multicultural programming. But how can Euroamerican preservice teachers develop personally and professionally without close examination of their own cultural self-identity? Furthermore, how can the teaching-learning pro-fession move forward itself without close examination of the cultural self-identity of its white student population? Teacher educators can function in critical ways to strengthen educational reform efforts by facilitating personal and cultural forms of student identity develop-ment.

By *cultural self-identity* I refer to the representation of race, ethnicity, gender, and other forms of identification viewed from per-sonal, political, ideological, and sociological locations. Majority preservice students can benefit enormously from minority classmates who share their own identity formulations, woundability, and dilem-mas. This effort can create a more open context for assisting white students in rethinking their own identity with respect to personal and social practices, and belief systems.

The Euroamerican preservice teachers in my classroom were as-sisted in their development by minority classmates who took risks with relative ease, although not always, because of their own cultural flex-ibility and multiethnic frames of reference. The courage and accom-plishments of the few Mexican-American classmates, won in the face of childhood poverty, family upheaval, and cultural dislocation, obvi-ously affected those majority students who were partnered with them in study groups. The multiplicity of locations and selves available to my minority students was apparent in their bilingualism and biculturalism. Like Salim, they demonstrated the ability to "juggle cul-tures," to use Anzaldúa's (1987) metaphor of cultural flexibility, within their home, university, communities, and countries.

Why Study Whiteness in a
Multicultural Curriculum?

In this section, I look at "whiteness" (and its consequences for a postmodern view of multiculturalism) because talk about whiteness can accomplish three aims. One, students can be assisted to become more receptive to ideas of cultural pluralism. This is based on my premise that majority students are most responsive to change when their person and culture are not interrogated or dismissed altogether. Rather, they respond well to a delicate balance of respect and concern in having their person and culture combined with those of others to create a vision of a new society. Two, an expanded vision of the multicultural educator can be facilitated despite conflicting personal and political forces. And three, the cultural self-identity development of students can be promoted as an important step in freeing the lives of future students and families.

A personal and professional sense of urgency shapes this discussion of "whiteness." For many multicultural educators, any study of whiteness is to be associated with "White Studies" and, hence, ethnocentrism. While educator Churchill's (1995) "reading" of university systems is arguably accurate, it also shuts down other possibilities, other ways of seeing and remaking "whiteness":

> the university system in the United States offers little more than the presentation of "White Studies" to students—general population and minority alike. The curriculum is virtually totalizing in its emphasis, not simply on an imagined superiority of Western endeavors and accomplishments, but on the notion that the currents of European thinking comprise the only really natural— or at least truly useful—formation of knowledge/means of perceiving reality. (p. 18)

My "reading" of Churchill's position grew out of the panic I experienced in preparing young, white students for a professional career in schools in the Southwest. Any setting steeped in "White Studies" poses a serious challenge to the multicultural goals of creating an inclusive, diverse community. This sense of "panic," I learned, is widespread. Other teacher educator-researchers (e.g., Cushner, McClelland, & Safford, 1996; Irvine, 1992) also foresee trouble as minority public school students are increasingly being taught by Euroamerican female teachers instructed in "conventional" (read "Euroamerican") teaching methods. While the problem of diversifying the teaching force is being

examined, others of us must face the current reality of this pressing
problem.

Arts-Based Activity

Recall a place where you have taught or studied and think about a
particular scenario, incident, or exchange that was troubling in regard
to racial or gender identity. Recall the details of what occurred and jot
them down. Now try to "label" those Eurocentric and multicultural
forces that may have been at work in your particular example. Are you
able to make clear distinctions between these forces, or do they blur?
Are there any surprises? Reflect on the emerging patterns and test
them against another example drawn from your experience.

This chapter might seem to mirror the "literature on multiculturalism
[which] frequently assumes a predominately White setting in need of
being made more inclusive" (McKinnon, 1997, p. 295); however, I am
attempting to go further. I am making explicit both dilemmas of iden-
tity development in a white majority setting and strategies that seek to
engage otherwise disinterested students. Although reflections by mi-
nority students are included, I mainly focus on majority students be-
cause strenuous efforts are needed for involving them in critical
multicultural ideologies and practices. Preservice teacher identity can
be made more effective where teacher education programs invite stu-
dent learning, input, and critique in the teaching and reform of courses.

Inviting the teacher education community into this discussion in-
volves risk. My pedagogy and values could be misconstrued. Any talk
of cultural identity for Euroamericans can be judged, for example, as
signalling white-supremacist ideology (Bauerlein, 1992). I therefore
propose a distinction between "talk about whiteness" and "white talk."
Talk about whiteness promotes critical awareness of issues involved in
multicultural education, whereas "white talk" is that which

> serves to insulate white people from examining their/our individual and col-
> lective role(s) in the perpetuation of racism. It is a result of whites talking
> uncritically with/to other whites all the while resisting critique and massaging
> each other's racist attitudes, beliefs, and actions. (McIntyre 1997b, pp. 45–46)

A second but different risk involves the very pursuit of critical
multiculturalism as a topic of educational inquiry. By *critical
multiculturalism*, I mean a restructuring of teacher education in or-
der to change situations of injustice that build upon the cultural

resources of all students in the reform of university and school systems. How can teacher educator-researchers help others to learn despite the defensiveness, retaliation, and sabotage?

Critical awareness is necessary for furthering personal knowledge and for developing a genuine sensitivity to the deeper problems of American culture that are represented by de/culturalizing influences. *Deculturalization* refers to how the Euroamerican culture has dominated the vision of North America by "reject[ing] the idea of a multicultural society and advocat[ing] the creation of a unified American culture" (Spring, 1997, p. 3)—the blue eyes and yellow hair. Native American lands were, for example, taken over in the name of English colonism and resistance to nonwhite immigration continues in force today.

Critical multicultural research generally "lacks the support of a tradition, of mentors, of trained scholars, and of institutional structures" (Stiehm, 1995, p. 151). This is, quite simply, new ground. However, it is also evident that "textual mentors" and risk-takers, such as James Banks, James Cummins, Paulo Freire, Sonia Nieto, Christine Sleeter, and Joel Spring, are establishing a multicultural tradition that is contributing significantly to furthering the current post-Civil Rights Movement in North America. While conceptions of race, culture, identity, and democracy are being broached in the literature, the concept of "whiteness" remains impoverished despite the sprinkling of attention that is beginning to be paid to it.

Arts-Based Activities

1. What dolls or toys were "must-have's" in your childhood? Why did Pecola dismember her "blue-eyed Baby Dolls"?

2. Jot down any associations you may have with the multicultural educators and/or their works noted in this chapter. Extend the list to include writers, teachers, artists, activists, and so on, who have influenced your multicultural thinking and work in the classroom, on educational projects, and in life. List the qualities, skills, and/or forms of enterprise that each person represents to you. Now examine the various items in your lists of personal multicultural influences. Are there any patterns emerging around what qualities or skills your "influences" share and where they differ? Finally, think about what your pattern reading reveals about your own cultural self with respect to values.

"White Alert!"—White Cultural Identity
Missing in Multicultural Textbooks

I have found discussions of Euroamerican cultural identity to be mostly absent from popular multicultural textbooks. Preservice teacher curriculum resources typically emphasize information about "minority" ethnic groups and cultural contexts, histories, and learning styles. Tiedt and Tiedt (1995), for example, provide activities and resources in the design of a knowledge base for a multicultural curriculum. In the curricular textbooks, strategies for enriching students' multicultural learning are generally aimed at identifying their cultural roots and ethnic stories (such as in Tiedt & Tiedt, 1995), as well as the role of institutions and schools in perpetuating racism and inequality (as shown in Grant & Gomez, 1996).

In multicultural textbooks the concept of "ethnic studies" is largely separated from "ethnocentricism." The latter is described very briefly, when at all. *Ethnocentricism* is commonly presented as a middle-class European belief structure steeped in negative historical patterns that involve assimilation and colonization, as well as problematic contemporary values such as individuality and competition. It is, in brief, viewed as a deep-rooted societal problem taking the form of cultural domination and oppression. The pervasive logic of these curricular writers is that we *need to avoid* working with middle-class Euroamerican cultures. Its representatives are viewed as being already too steeped in their own values to be able to understand, and empathize with, persons of color, particularly those who are poor and/or of lesser-ranking status. This makes good sense to me. I can imagine, as Campbell (1996) asserts, that Euroamerican teachers are typically too culturally self-absorbed to be able to relate to their minority students and to appropriately assess their work and behavior.

It is for these reasons and others that white preservice teachers need to be able to go beyond "lip-synching" definitions of concepts like ethnocentricism and multiculturalism. They can obviously spend a lot of time and energy generating frameworks and examples of white chauvinism/racism but without having any real empathy or feeling behind the words. Ethnocentricism needs to be turned into a powerful tool in becoming more fully human and in learning about white cultural self-identity issues, regardless of the teacher being Euroamerican, bicultural, or of color.

The reform strategy generally endorsed by current textbooks in teacher education involves resocialization of white preservice teachers through exposure to culturally responsive frameworks that are principally focused on African-American and Latino/a cultures (e.g., Campbell, 1996; Cushner, McClelland, & Safford, 1996; Grant & Gomez, 1996). There are no arts-based development strategies available in such texts, only assertions, for helping preservice teachers to understand their own personal and professional cultural self-identity. Examples of case studies of "reform" could certainly have helped me in my first year of teaching preservice students.

The implicit assumption that I question here is whether attention given to a Eurocentric curriculum in preservice teacher courses will only serve to reinforce student self-absorption and, moreover, resistance to the development of a pluralistic society. I am proposing that preservice teachers can be helped through a close and sensitive examination of concepts and practices of whiteness as they influence and have an impact on self, other, education, and society. Without this link to the self, "the other" will continue to be stereotyped, even in teacher education courses, as a categorical catch-all, as a disembodied abstraction, and as a derivative of oppressive societal patterns. These are socialized ways of seeing and of knowledge building that we all need to grapple with and change.

As already established, the concept and practice of whiteness *per se* is underdeveloped in popular teacher education textbooks, which are aimed at inclusion, diversity, and pluralism. "Whiteness" is only fleetingly mentioned even in those scholarly and highly influential texts that inform multicultural studies. For example, descriptions of Euroamerican terminology and socializing influences in Nieto's (1996) textbook are given some prominence, but the focus is mainly on the challenges that student minorities encounter in the educational system. We need to heighten our awareness of cultural groups and minority individuals' dilemmas within schooling systems and the wider society. I found Nieto's *Affirming Diversity* useful in the second half of my preservice course. I sought to raise consciousness after beginning the bridge to a more critically aware, cultural self.

As Banks (1994) asserts, attention needs to be devoted to Euroamerican ethnic groups, such as Jewish and Polish Americans, in the design of a multicultural curriculum. However, Banks does not show how white students can go about engaging in the development

of their cultural identity. Spring's (1997) book, in its second edition, contains a new chapter on the colonization of America by English settlers and of the impact of white exclusivist values on the shaping of the nation. Although this discussion provides helpful examples of racial and cultural superiority, and in a language accessible to the preservice teacher, Spring does not address the cultural self-identity issues of students or teachers.

As a beginning teacher educator, I was not prepared for the initial resistance of my Euroamerican students to learning about issues of diversity, pluralism, and democracy—let alone to considering themselves as being in the process of developing as multicultural educators. On our first day together, they claimed to have been already "saturated" in relation to these critical areas in their other education courses. They also claimed to have no cultural identity or ethnic background and to lack interest in their own genealogy. I realized that only by validating my students as persons with distinct histories, noteworthy interests, and understandable intentions could I be "let in," and thus "permitted" to engage with them in investigating cultural patterns that have shaped them as individuals. My compass of survival, then, was turned toward getting to know my students, and they one another, within a broader landscape.

Through designing a series of opportunities, I brought together my majority and minority students (African-American, Latino/a, and other) in common agendas of exploration. I was experimenting with integrating "whiteness" in a multicultural education atmosphere that works for all students. I strongly agree with Gollick and Chinn (1994), and others, that teachers need to use students' cultural backgrounds in developing material for multicultural curricula that are aimed at the expression of healthy, nonexploitative human relationships. And, I would add, that students' cultural backgrounds probably need to be drawn upon most heavily during the first half of the preservice curriculum and then to be revisited in the second half, which continually turns back on itself.

Multicultural education often promotes the identity and needs of distinct cultural groups. We agreed that we would attempt to be all-inclusive and that we would undertake this challenge within our very own classroom. We learned that culture itself encompasses the rituals, beliefs, and practices of all members of society and includes localized knowledge (Martin, 1996). We also celebrated philosophies of teaching that honor the "curriculum of the person" (Connelly & Clandinin,

1988). We identified sources of strength and sought to build bridges to each other and to the outside world. Even those students who openly resisted the university's recent mandatory ruling regarding multicultural coursework for preservice teachers were included as valuable spokespersons in our climate of diversity. Others who showed great promise as multicultural educators were mostly African-American and Latino/a. They were actively "ethnic" in our discussion groups as well as inclusive of other cultures. Minority students can help to create a new set of relationships and foundation of understanding as majority students struggle to develop as reflective cultural inquirers.

Once my students gained experience in discussions and lived cultural encounters, I was able to develop organic frameworks *with them* for studying the following topics: artistic and expansive methods for engaging cultural self-identity; challenges to cultural identity development for minority and majority *persons* and groups; racism, chauvinism, and sexism as shaping influences in one's own immediate and broader contexts; and structural inequalities in universities, schools, and the professions. To varying degrees, students pursued knowledge of these multicultural issues in personally relevant ways.

The goal was not to simply accumulate and assess knowledge but rather to empower "an expanding community, taking shape when diverse people, speaking as *who* and not *what* they are, come together in speech and action . . . to constitute something in common among themselves" (Greene, 1993, p. 13, italics in original). For me, the creation of a diverse community is essentially an artistic process that demands participation in others' lives and an invitation to others *to be* in one's own. With a special arts-based effort, nonurban, racially insulated contexts can be transformed to promote these challenging aspects of development.

On Becoming Cultural Makers and Ethnic-Enriched Selves

This is the crux of my concern: students who study multiethnic materials that exclude (or marginally include) the dominant (white) culture probably infer that this population is not "cultural" and that it is somehow peripheral to the study of ethnicity and to their identity as educators. Elitist structures in education and government (Bastian, Fruchter, Gittell, Greer, & Haskins, 1986) fail to be "problematized" in relation to issues of social justice and equality by students not invested in

democratic aims. They can learn to recognize themselves as cultural beings who choose *not* to live passively within a racially polarized society (Kent, 1996, p. 48). This invitation to see choice and to expand conditioned ways of living offers students a more realistic and humane approach than attaching blame and assigning fault. In other words, all students need to develop concepts and practices of themselves as cultural makers rather than as unconscious receptors of the constructs of history, policy, curriculum, and society. Where transformative, activist work is already underway by students who are more self-directed and concerned, acknowledgment needs to be provided, for example, as in responses to journal entries.

I found it necessary to link the fundamental role of "whiteness" in the identity formation of my students to challenge their sociopolitical self-views. I asked them, for example, to consider instances of "whiteness" in Cisneros' (1984) classic novel, *The House on Mango Street.* As one student noted, the young Latina narrator powerfully conveys the influence of "whiteness" by using literary metaphors expressed through the "I/eye" of her self: "At school [Euroamericans] say my name funny as if the syllables [of Esperanza] were made out of tin and hurt the roof of your mouth. But in Spanish my name is made out of a softer something, like silver" (p. 11). The author does not resort to expository prose (as I am here) to reveal the insensitivity of English speakers who mispronounce Spanish names, which are potent with feeling and history. Instead, the novel possibly has impact because the main character uses metaphor and story to name her experience without limiting what she can become.

Self-invention almost never had free reign in my classroom; it was restrained, or ensnared, by my students' upbringing and socialization. Threads of this Euroamerican description or straightjacket included students' insular backgrounds, rural lifestyles, and strict religious family practices; personal fear of difference and encounters with minorities; minimal exposure to minorities, and then mostly in service roles; little first-hand knowledge about institutional practices of inequality; conflicting views on the value of multiculturalism from faculty and societal leaders; identification of multiculturalism as a "black" liberation movement only; and the illusion of self as prejudice- and value-free. However, students could identify potent instances in which families and towns were racially biased. Circumstances surrounding Latino/a academic failure in Massachusetts schools (Rivera & Nieto, 1993) show clearly that curriculum is a political force that creates fences by

constraining the "unorthodox" along linguistic, cultural, and gender lines.

A crucial goal for multicultural education could be to enlarge the human community through cultural identity development and empathetic connection. Arts-based inquiry offers multicultural education ways of engaging students in self-examination as living cultural artifacts. Cultural identity, as a concept and process, affirms the right of people to think of themselves as "cultural" or "ethnic." It could also give teachers and students the confidence and reflective tools necessary to transform "mainstream-centric curriculum" into inclusive, ethnic-enriched, and informed curricula (Banks, 1994).

Cultural Teacher Identity Research

Though ethnicity may be immutable like one's heritage, cultural identity is receptive to new influences and, hence, invites change, even at an accelerating rate. Craft (1997) associates teacher identity development with the capacity to "create and construct multiple personal identities" within an increasingly postmodern world that is characterized by "instability, complexity, transience, and lack of conformity" (pp. 83, 85). Cultural teacher identity research, broadly conceived, includes the constructs of person, citizen, and worker (Furlong & Maynard, 1995), as well as socialized and racial being, and activist development and transformation (McIntyre, 1997a, 1997b; Mullen, 1997a, 1997b; Sleeter, 1996). Cultural identity is associated with power, privilege, knowledge, and whiteness by some Euroamerican scholars (e.g., Giroux, 1996a; McIntyre, 1997b; Pinar, 1995; Sleeter, 1996) and by many more nonwhite critically thinking scholars (e.g., Banks, 1994; Cuádraz, 1997; hooks, 1994; Nieto, 1996; Padilla, 1997; Saucedo, 1996).

Ethnically bicultural teacher researchers, like myself, escape such neat categorization in works focused on cultural identity investigation aimed at issues of whiteness and diversity (e.g., Mullen, 1997c). Euroamerican academics typically do not express their personal and cultural identity within scholarship and pedagogy perhaps for the reason that this ethnic location has always been assumed.

Arts-Based Activity
Invite your students to locate a statement written (or spoken) by a minority person who has reflected on white culture with regard to Euroamerican/American identity, beliefs, and practices. Select

examples from an artistic source, such as a work of literature, a film, or something else. Then have students join a discussion group to gain insights into their own examples of white cultural identity as viewed from an "outsider's" frame of reference. Chart their reactions to challenge their thinking. Then turn examples into artistic representations that are adjusted to student age and level. In the first example below, students draw scenes from their own neighborhoods and/or those that they consider dangerous. They use a combination of pictures and text (photomontage) to "people" and "color" their artwork, and to form a narrative out of their associations. A follow-up session would provide a forum for discussing the implications of their constructed neighborhoods, especially in relation to cultural identity (i.e., values, judgments).

From Latina writer, Sandra Cisneros' (1984) *The House on Mango Street:*

> Those who don't know any better come into our neighborhood scared. They think we're dangerous. They think we will attack them with shiny knives. They . . . got here by mistake. But we aren't afraid. We know the guy with the crooked eye is Davey. . . . All brown all around, we are safe. But watch us drive into a neighborhood of another color [such as white?] and our knees go shakity-shake and our car windows get rolled up tight and our eyes look straight. Yeah. That is how it goes and goes. (p. 28)

From African-American writer, Alice Walker's *The Color Purple* (1982):

> [The president of Monrovia] has a lot of white-looking colored men in his cabinet. . . . we had tea at the presidential palace. The president talked a good bit about his efforts trying to develop the country and about his problems with the natives, who don't want to work to help build the country up. It was the first time I'd heard a black man use that word. I knew that to white people all colored people are natives. . . . I did not see any of these "natives" in his cabinet. And none of the cabinet members' wives could pass for natives. (p. 132)

Understandably, both the practice of cultural self-examination and focused attempts to understand the nature of white society have perhaps been most profoundly undertaken by nonwhite persons. Saucedo (1996), a Mexican-Irish American student, learned that white university classmates could neither talk about nor claim their own "whiteness":

> This bothered me because everything that they do each day, in some way or another, is tied to their ancestry and the color of their skin. . . . [Whiteness] is

a passive identity, one which is conferred by the rest of society and not con-
sciously adopted by its possessor. If one is white one is simply dissolved into
whiteness. . . . To be ignorant of one's ethnicity, of one's role in society, and
of one's self, is also white privilege. (pp. 99–100)

The "passive identity" of white students led Saucedo to redefine his relationship to the majority culture. He decided to intensify his own experience of particularity by seriously limiting all forms of contact with the white majority. His need to distance himself probably serves as a warning: Euroamerican students will need to examine their own "whiteness" in order to "incorporate an expanded and more accurate concept of who we [or they] are as individuals and as civic creatures" (Pinar, 1995, p. 29). A new forum for discussing racist thoughts and practices is provided by the Freirian Participatory Action Research (PAR) model. In this way, the issues and lives of participants are used as material for comment, critique, and consciousness-raising (see, e.g., Freire, 1996; McIntyre, 1997a, 1997b; Padilla, 1997).

Euroamerican influences as well as white supremacist ideas and practices can be confronted within a critical multicultural framework. Preservice students can, for example, learn to identify Eurocentric influences within traditional curriculum, classrooms, and schools which tend to privilege elitist (or dominant) white groups. They can also learn to distinguish Eurocentric influences from white supremacist actions by investigating real-life racial incidents that have helped to shape their own university communities and towns.

The Rosewood event of 1923, which occurred in the Southeast, has warranted inquiry that continues today. This was an act of white supremacist violence that destroyed an entire African-American community and that has since become the subject of a book and film. According to a university report compiled by Jones and associates (1993), the Rosewood community was driven from the area by white mobs, which killed six blacks and destroyed homes. An alleged assault upon a white woman by a member of this former black community was allegedly sufficient, in white southern society, to warrant this retaliation. Racial violence against African-Americans also occurred in numerous other communities throughout the South during this era. The white leaders were willing to tolerate such white misbehavior. This fueled racism.

Students might, for example, search for the ways in which the Rosewood event has infiltrated their immediate and wider community. They could examine their own university context for white Eurocentric

practices, such as outright denial, as well as distortions of recorded facts and justifications, for past racism. As an example of historic segregation, students of a predominantly white college will generally view an African-American college as segregated before accepting that their own college is somewhat racially exclusive, as well as steeped in nonintegrationist origins and trends in college education. Because they do not ask why their own college is mostly "white," they fail to inquire into the different reasons for the spread of nonwhite colleges (which are, regardless, much fewer in number than white colleges).

Questions to ask of all of us are as follows: What are some examples of ethnocentricism within North American universities, and what has been the effect on neighboring schools, colleges, and towns? Also, What forms of activism are required to create an inclusive, democratic community of such large public institutions and, under what conditions, if any, might ethnic exclusivity be appropriate?

Arts-Based Activity
Invite your students to find examples of ethnocentric practices at work within their immediate setting and/or in a nearby community. Have them document their findings as well as early and subsequent reflections. Then create discussion groups to look at what students find. Discuss any changes that may have occurred within their own descriptions (outlooks, beliefs, and values). Reflect on the possible contributions of students to "remaking" history/legacy and current events.

Students can learn that political processes keep some elements of American identity alive while repressing others. For instance, even the concepts of "mainstream" and "diversity" are misleading. The mainstream of today's American society includes facets of diversity in class, race, language, and exceptionality (The National Coalition of Educational Equity Advocates, 1994). Prospective teachers can also benefit from understanding how hiring practices continue to be influenced by patriarchal and racist systems (Ashton, 1996). Resistance to diversity in universities and schools is evident in strong reactions to (a) the "hiring [of] minorities through affirmative action programs [which Euroamerican persons often think] threaten their jobs or the prestige of their departments or institutions," and (b) the validating of cultural differences (Leon, 1993, p. 11).

As indicated, teacher education programs need to support the cultural development of preservice students as they develop their identity

as multicultural educators. A bridge to multiethnic approaches, persons, and contexts can be productively built through cultivating the teacher self and personal curriculum. How might a curriculum of the person be used to promote multicultural awareness of the preservice teacher? Students can benefit from seeing themselves as stakeholders in the making and remaking of curriculum, school, and culture. Without such a change to the curriculum, "majority" preservice students will probably continue to fail to internalize issues relating to identity, race, gender, and the international community. Using impersonal language to depict minorities as sources of oppression and targets of deprivation confounds this problem. Similarly, describing the majority population as a source of power and injustice may serve only to create defensive and noninclusive postures—and more barriers.

An Emerging Case Study of a
Preservice Teacher Classroom

The students in my preservice course were seniors whom I met as a newly landed immigrant from Canada. During our initial class, I "interviewed" the class as a whole and then each individual in turn, taking notes and then later examining the material for patterns. In their feedback to me, the majority students made two compounding assertions: one, by virtue of being "Anglos," they have no ethnic background or identity; and two, Anglos are successful professionally and otherwise because of their strong work ethic and related values. There was no talk of Euroamericans as developers of a racial-gender hierarchy within the professions and in society, or of themselves as recipients of unequal distributions of human rights, opportunity, material goods, privilege, and power. Such protected forms of cultural perception confirm McIntyre's (1997b) findings about how white preservice students attribute their successes to personal and family values, or to essentially nonracialized issues. Like McIntyre's own self-study group, my white students generally saw themselves as American citizens with inherent and absolute rights based on family lineage traceable to the United States and to "white" parts of Europe.

Arts-based forms of learning with my students proved more helpful to my students' development than scholarly reading, with the exception of Kozol's (1991) *Savage Inequalities* and Nieto's (1996) case studies. Most students first saw the Kozol not as an ethnographic

field study steeped in the storytelling tradition, but as a tragic story about race and poverty based on a tale of fantasy. They saw Nieto as presenting a series of complex multicultural issues that were organically derived from minority students' own stories of schooling. Students similarily responded positively to being treated as individuals and persons with enriching stories to tell about identity and professional issues. They resisted being talked about in general terms and retreated whenever we turned to the scholarly literature.

Our classroom opened out onto a military-based university campus and, still further, onto a racially conflicted setting. It was not surprising, then, that the requirement of a single course in multicultural education for all students had been openly contested, even among some education majors and educators, and denied legitimacy. These actions support Banks' (1994) contention that the ""irrelevance of multicultural education" argument [used within universities is] a convenient and publicly sanctioned form of resistance and . . . a justification for inaction" (p. 7).

Supporters of a required campus-wide multicultural course had been alerted, before I arrived, to the dangers of theorizing and practicing transformative, antiracist agendas. There was open opposition to the various support groups that were created by those of us who taught multiculturalism and who sought to infuse other courses with critical consciousness. These reactions confirmed that white classrooms need to be actively interrupted by, and infused with, culturally diverse students, conflicting viewpoints, and transparent political stances. White places have been historically safeguarded. It is possible that nonurban, relatively insulated universities have greater "liberty" to function as relatively uncontested sites of white majority control and power.

Cultural Identity as an Interracial Self

White culture functions at times as a covert historical and political expression of separation, exclusion, and difference. It follows that majority preservice students generally lack a consciousness of racially and socially constituted identity. In contrast, minority students often have well-developed racial and social identities. Not surprising, then, minority students' writings provided a more self-conscious treatment of racial issues:

> I know that I don't want my teachers to single me out basically because I am
> Hispanic. But I don't want people to forget that I am Hispanic. I think that
> there is a difference there. I don't want to be treated any differently than any
> other student. I want to be given the same opportunity and the same environ-
> ment. I want to be taught the same, like any other student. (journal entry,
> April 1996)

As another example:

> I think to myself, I can't do this anymore. But I can't quit. It means a great
> deal to me to be that role model for my little cousins who haven't got a stable
> environment. My whole family doesn't have much education. When I came
> here [to university], I had to learn how to study. It was very hard for me
> because in high school I didn't study and wasn't encouraged to. I don't know
> what that says about the elitist school I came from, the curriculum, teachers,
> or who I was as a black student. (journal entry, April 1996)

Minority students were also generally active in multicultural and
ethnic-based campus organizations, and even national-level organiza-
tions (e.g., The National Hispanic Institute). White students generally
resisted any examination of their own identity and culture (Pinar, 1995),
which helps to explain their lack of commitment to multiethnic organi-
zations. "Whiteness" is a difficult topic to pursue with Euroamerican
students for many such reasons. They have been taught to repress
perspectives on their own identity as politicized/racialized/gendered
selves. White preservice teachers need to experience an altering I/eye
to enable them to reevaluate their own identity descriptions. Never-
theless, even beginning attempts at cultural self-representation can
sometimes falter.

In contrast, when efforts at examining one's cultural identity prove
worthwhile, "the self [can be understood as] relationally constituted"
(p. 560). From this point of view, Dewey's (1938) notion of the self—
as a cultural matrix inseparable from society and from situations in
which interactions occur—prefigures the current claims of
multiculturalism. The self, by Bruner's (1990) definition, is a study of
transactional relationships within which one's story is perpetually in
progress. The "self," in relation to "other(s)," can also be a source of
political unrest that is associated with intrusion, conflict, and exploita-
tion (Saucedo, 1996). While white students gain complexity from be-
coming interracial, they will also need to know how to monitor the
effect they have on others, including those who feel that such efforts
are unwarranted, invasive, and even offensive.

Arts-Based Representations of Cultural Self-Identity

The In-Class Cultural Encounter

Interrupting Student Distribution Patterns

Although all human beings are united through the "soul" in Du Bois' writing (1903/1989), they still suffer from racial forms of separation. Almost a full century after this declaration, my students' "natural" impulse was to segregate themselves physically, emotionally, and intellectually. The white-picket fences went up automatically.

Students used race, gender, culture (e.g., Texan born or identified, university emblems, rituals, and events), and subcultural identification (e.g., Corps of Cadets, cheerleaders, athletes, football fans, sororities) to secure personal comfort, but at the expense of diversity. Such cultural boundaries, when fixed, prove debilitating for students who value, as some of mine did, learning how to relate to minority children, parents, and teachers. I interrupted the seating arrangement after seeing how the students' "natural" tendency was to group along racial, gender, and subcultural lines. Students wrote their first journal entry about their new microcultural groupings and what they thought the value and effects might be.

I rearranged seating along lines of dissimilarity and constantly altered new patterns. This proved to be a simple, postmodern strategy for creating the ecological conditions for both formal and informal cultural encounters. Initially, the unexpected seating arrangement provoked contrary responses as to the right to comfort and personal space and choice. But as new friendships formed around tables, the new groupings ceased to be an issue. A potential breakthrough occurs when students see for themselves how they frequently use "difference" (or sameness) as a means of social selection, screening, privilege, and even mockery and oppression (McLaren, 1994).

Personal Ethnic Maps and Performances

I also used personal ethnic mapping as an arts-based strategy to encourage an acceptance of diversity. This simple exercise generated valuable information about strongly held cultural opinions in the Southwest. For example, while a process of self-naming exhibited a range of group identifiers (e.g., American, Anglo, Latino/a, Hispanic, Chicano/a, Mexican-American, African-American, black American, and Indian [not aboriginal]), the descriptors were loaded with cross-cultural judgments and misconceptions. For example, those few Euroamerican

female students who had males of color as friends, boyfriends, and, in one case, a husband, often experienced prejudice, silence, rejection, and, occasionally, open debate from within their own cultural group. Interracial dating was criticized in terms of religious and family values and a vague notion of predestiny as related to cultural grouping.

Another example of an issue of cultural identity was raised by a "black American" student, Rachel. She told us how, as a high school student with a "light complexion," she had been mocked by peers, both minority and white. People had reacted to her skin color, either alleging that she was too black or not black enough to belong to their respective camps and clubs. Her story of personal and cultural pressure underscores a larger societal problem—inherently racist students and school cultures will reject perceived deviations from the color norm. Malcolm X's light-skinned, African-American mother certainly experienced Rachel's fate, albeit to a greater extent and with severe consequence, not only from the townspeople but even from her own darker skinned husband (Malcolm X & Haley, 1964).

After "encountering" my preservice teachers' experience in these ways, I was committed to examining, with them, the Eurocentric *and* expansive forces at work within their own "submerged" personal and cultural identity. For example, a white student named Megen (meaning "strength") designed a cover for his journal book. It contained images of mental and physical strength and proclaimed "Go with your strength" (see Figure 9). Like the others, he visually expressed aspects of his self-identity. Artworks were "presented" to the class as a whole with an explanation of selected images and words.

In a follow-up journal entry describing his choice of imagery, Megen focused on how

> being a male in Elementary Education is not real common. I am definitely a minority in all of my classes. This cultural mindset that others hold does not really bother me at all. People can believe what they want, but as long as I enjoy what I'm doing I do not care what they think. (January 1996)

Megen's defensive posture persisted throughout additional self-representations and the course. Although resistant to becoming a multicultural educator, Megen helped me to see that "whiteness" is not a conscious racial identity. Fear of difference and protected feelings of manhood constitute a pervasive but unrecognized experience. These tacit dimensions of white teacher identity function to make any exercise in "border crossing" unappealing and challenging. However,

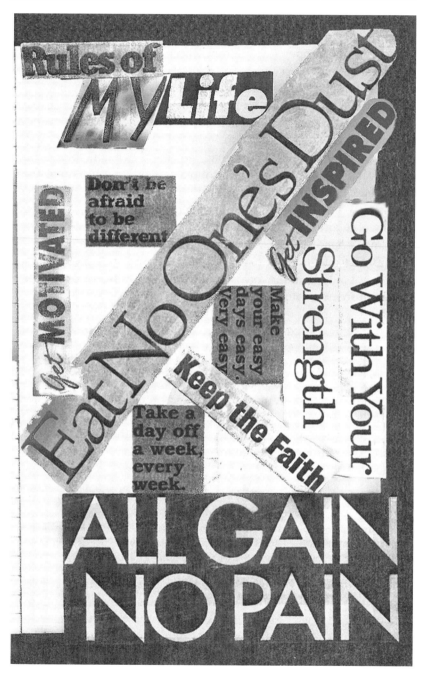

Figure 9 *Rules of My Life: "Eat No One's Dust"* (Megen, 1996)

they also helped to emphasize that potential insight into human nature, and any new "paradigm," is perhaps deepest at the "borders" and, for our purposes, on the boundaries of intersecting cultures.

Rational scientific arguments reinforce this very point—Charles Darwin's famous voyage to the South American Galápagos islands, for example, proved to be an experiment in border-crossing where every species was on the margin. The various plants and animals, such as land birds and reptiles, encountered by the fascinated Darwin (1839/1989) were virtually all "undescribed kinds which inhabit this archipelago, and no other part of the world" and yet these "organic beings . . . [which are] peculiar [have a] general form [that] strongly partakes of an American character. . . . This similarity in type, between distant islands and continents, while the species are distinct, has scarcely been sufficiently noticed" (pp. 275, 286–287). Darwin's revolutionary thinking about the evolution of species was inextricably linked to his self-appointed location on "the margins" both of the discovered world and of the biological and geological fields.

At the end of the semester, Megen was featured in an in-class student performance that revealed the "mindset" of a man stuck in a hole. In the group presentation which Megen had helped to script, he played the main character, someone who overtly rejected the help of strangers seemingly different from himself. First, he belligerently rejected the aid of female students who spoke aloud in protest against colleges that support a military preparatory culture. He then rejected the help of supporters of an opposing college football team. Next, the "man in the hole" rejected the aid of a white female, an African-American male, a Latino/a couple, and three homeless youths. These passersby were told to "go away, scat."

Megen only allowed himself to be helped by someone just like himself—that is, a white, middle-class, blue-eyed male from his own college. As he came out of the "hole" (staged as a boxed-in space behind the teacher's desk), he told us to hold our applause until we grasped the deeper cultural messages of the performance. Megen led the discussion. And then, to our surprise, his group performed the skit again, but this time he let the first person who made contact, an African-American female, assist him. The connecting hands were dramatized with sincerity and in slow motion, and we all sat spellbound.

This presentation, and the way it played with culture and personhood, exemplified how the "aesthetic will venture into those undefined, taboo spaces where the unpresentable in the culture is felt

and made visible, seeking a performance sublime for postmodernism" (Denzin, 1997a, p. 181). Without the arts-based opportunity to express their own evolving cultural identity through such empowering aesthetic forms, the students may never have been able to associate multicultural education with adventures in learning.

In-class Student Interviews

To support discovery work in identity construction during the semester, I established conditions for same-race and mixed racial interviewing in class. Students at first resisted the possibility that they could learn about diversity in a same-race partnership. I myself was not certain. However, as it turned out, the white pairings proved helpful. Students found expressions of diversity in such differences as ethnic roots/origins, religious practice and outlook, upbringing and family lifestyles, teaching interests and emphases, and professional goals.

The majority students then conducted (auto)biographic interviews with Latino/a and African-American classmates. The minority students risked sharing, to varying degrees, their strategy of deliberately submerging aspects of themselves in order to cope within a Eurocentric-based university setting. Private thoughts and responses typically kept undercover by individuals were shared, to varying degrees, by cultural pairs. Students wrote about their development as teacher researchers, contrasting dimensions of their cultural self with their interviewees. They incorporated snippets of conversation (from their notes taken during conversations) as well as visual representations. Friendship collages and photomontages, terms I devised for the assignment, highlighted the invitation to cocreate cultural identity with a searching, authentic other.

Interview pairs used photographs, drawings, words, and images taken from eclectic sources (e.g., photo albums, letters, newspapers, and magazines) to create their artworks. They created interracial and ethnically diverse images that pulled, without apology, on even their subcultural white affiliated selves (e.g., Roman Catholic and Baptist religious symbols). As one unexpected outcome of our arts-based activities in class, a white student incorporated, into her wedding ceremony, a Latino/a ring ritual.

Arts-Based Activity

Create a friendship collage or photomontage (using photographs and words) with someone whom you perceive to be similar to yourself.

Cocreate visual patterns that reflect your individual and shared tastes, interests, and values. Incorporate words taken from personal writing (e.g., letters, poems, journals, lists, jottings), the media, or elsewhere. Photocopy your artwork or import the scanned image into a computer program and play with it some more. Now repeat your efforts but with a colleague whom you consider to be dissimilar from yourself. To what extent were your prior judgments about perceived similarities and differences accurate? What did you learn about yourself in cultural self-identity terms?

Out-of-Class Cultural Encounters

Despite modest gains made in class, a special effort was needed by students preparing for multicultural leadership development. My majority students needed practice interacting with others—they feared inter-racial contact within even their immediate environment. With this insight gained from student journals, I designed a series of encounters to provide for cultural expansion and self-critique. Everyone, including myself, was required to approach a group of people whom we perceived to be different from ourselves. (I chose to approach a group of uniformed male cadets.)

While brainstorming, students cited skin color as a marker of "difference" and criterion for our making contact with strangers. With additional probing, they included age, gender, occupation, and "things sometimes invisible," such as temperament, attitude, and values. Journal entries were framed to describe a preencounter view of difference, chosen target of contact, and expectations about what might happen. Postreflective writings included descriptions of the event as well as an appraisal of new feelings or thoughts. Ideas from prescribed and self-directed readings were included, where relevant, with these reflections.

A wide range of experiences was shared, from the formation of new friendships to surprises and unanticipated collisions, some joyful, others strained. Most students had felt very awkward upon approaching strangers, including those readily available to them on campus. Most students had made several attempts over a period of a few days or weeks before summing up the necessary courage, whereas a few had felt too nervous to even undertake this exercise.

Each student subsequently stood up and shared his or her experience. Students spontaneously referred to themselves as being racially inhibited—a state one person distinguished from shyness—which was attributed to having been raised within traditional families, exclusive

schools, and racially phobic towns. In the several instances where an encounter was somehow deflating, students speculated as to how *they* might have been perceived. Carlos, a Latino, shared how he had been rejected by a group of white female students on campus who had whispered a racist slur and laughed. He was definitely discouraged from initiating any future conversations with nonminority females. However, the white female students encouraged Carlos to persist in his own community-building efforts despite any rejections from their gender.

Unifying elements of humanity emerged for students through their stories of encounter and of connection. The activity further unified the group as they came to realize that the encounters had ultimately been with themselves: "I guess I had a cultural mindset that people from China were shy and reserved, but in fact Maggie was very outgoing. I was the one who was shy and reserved at first" (journal entry, February 1996).

Students who had taken risks began to appreciate how they could shift their homogeneous, protected selves in favor of more culturally open, newly configured selves. Reflecting in my journal on another student's noteworthy cultural encounter, I wrote:

> Glen, a cadet in my class, has become involved in healthy ideological disputes with the on-campus military culture. He has frequently met with high- and low-ranking persons regarding a new policy targeting the unequal treatment of enlisted women and minorities. Regularly, I receive updates from Glen on his latest (anticipated or concluded) encounters with officers and cadets. He tries out his thinking on me. Glen has observed how the cadets resist acculturation of minorities and women in the military. He is worried about how his ideas will be received by those from whom he is seeking acceptance and reward in the form of a potential leadership position. Yet, Glen is also becoming more and more energized by his own activism.
>
> It is exciting to see Glen prepare for meetings with officers and how, just as he searches for the "right words" to impress them during these intimidating occasions, maintains his own vision of equal treatment and fair representation. He is living a [postmodern] experience as his "old self" questions why and fears rejection, and "emerging self" anticipates a more inclusive tomorrow. (journal entry, May 1996)

Over time, as Glen shared his journal entries and gained support in class for his political agenda, he "divulged" his otherwise protected Latino origins. We had learned that synergy among people can enable border-crossing, even within ourselves and among our multiple selves.

Without the support of a field-based component of the course, I relied on other forms of border-crossing to promote the development of teachers' cultural identity. As Glen exemplifies above, the students needed to become invested in their own consciousness of identity. But they also needed opportunities to encounter critically thinking whites and persons of color. Those who took the greatest risks in the encounter exercises showed the greatest promise of developing their own cultural forms of practice.

As a highlight, three of my white female students met periodically with a black female student from Africa. They learned from their interviewee that Black, as a category of race, limits understanding of how Africans are culturally unique, even in relation to African-Americans. The African student-interviewee shared that her cultural self was steeped in tribal identity and ritual; conversely, she perceived that African-American university students, as a group, still needed to successfully "decolonize" their minds about inherently racist structures and climates. (See hooks [1994] for a perspective on colonizing influences in Africa.) White students presented their interpretation of the African culture punctuated with insights gained from the interview. But, once again, they found that their description of this distant land and the African newcomer was ultimately about themselves and their own interpretive processes.

I was inspired to create an artwork that represented how three of my white students courageously stretched their own racial identity beyond anything that they had previously known. In addition to "performing" Africa and African identity as young white women, they also developed and exhibited curricular resources/materials. Figure 10, "*Mufaro's Beautiful Daughters*," is an artistic composite based on photographs that I had taken of the presentation, including its activities. The title is borrowed from Steptoe's (1987) classic story about Mufaro's encounters with his beautiful African-American daughters who had very different temperaments. The twist in my photomontage is that it is based not on African-American personhood *per se* but rather on white female identification and recreation. The incorporating, merging, and blurring of cultural identities, such as in the presentation and photomontage, illustrates the postmodern educator at work in a rapidly changing cultural landscape. Where the imagination is open, and the defensive posture relaxed, new textures, colors, and layers can be crafted.

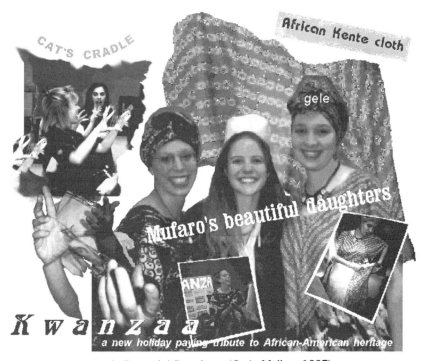

Figure 10 *Mufaro's Beautiful Daughters* (C. A. Mullen, 1997)

As a preservice class, we struggled with the ethical dilemma of who "owns" culture and who has the right to the story and performance of specific cultures. We discussed the question, "How might preservice Euroamerican females, dressed in African kente cloth and 'performing' be perceived and by whom?—as voyeurs? cultural exploiters or neocolonizers? performing artists? anthropological researchers? self-interested entrepreneurs? cultural pioneers? developing multicultural educators?" The assumption cannot be made that one's own identity transformations will automatically be received by others as authentic, especially by those who are understandably guarded.

Despite such gains in cross-cultural awareness and because of the complexities, we cautiously reviewed our new steps. We had only begun to imagine the possibilities of claiming border crossing and of integrating this experience into our deepest cultural expressions (hooks, 1994). Despite the unevenness in becoming more culturally open, students responded with greatest interest to the African-Euroamerican presentation. They exchanged epiphanic stories about their own in-

tercultural learning that were (auto)biographical, professional, and performance-based (Denzin, 1997b). At such peak moments, we created a global community for ourselves, part-researched, part-imagined, part-historic.

We ultimately staged not an objective truth about various ethnic communities from around the world but rather an intersubjective creation of our own evolving, arts-based, teacher researcher identities. The call is for educators to embark on a "journey that will take us collectively across cultural, linguistic, and racial frontiers that at one time loomed in the distance like the edge of the world" (Cummins & Sayers, 1995, p. 163). As persons investing in a better tomorrow, we will need to generate narratives and reflective tools to guide our intercultural learning so that we can learn to "view the world [and ourselves] from different cultural frames of reference" (Spring, 1996, p. 163).

Explorations in identity transformation can have an impact on the rigor of heritage work and on those possibilities of how we tell and live our cultural stories. The "trying on" of black ethnic identity by white people has many potential meanings. Negative ones include racial mockery, the appropriation of black culture by whites, and other continuing forms of colonization. Another possibility, however, is the "trying on" of black ethnic identity by those who are searching for inter-racial connections and, hence, striving for a higher level of consciousness and a greater capacity for inclusiveness. Such explorations in identity transformation demonstrate how different cultural forms can be translated by preservice students into meaningful expressions that, in turn, can be tried-out in their future classrooms. Such work is necessary on many levels. It can, for example, influence the success of multicultural programming with teacher education programs, schools, and prisons (Feuerverger & Mullen, 1995). It can also have an influence on the majority culture, which has yet to embrace a changing America and its own shades of brown, in addition to the cultural traditions these represent (Pinar, 1995).

The Unfinished Work:
Cultural Identity Transformation

I now better understand some of the cultural identity struggles of my former preservice students. As a group, they were living the paradox of becoming multiculturally aware while harboring a taken-for-granted

identity of whiteness. I am a Native American-Irish teacher educator who was family "trained" as culturally naive, unaware of both my own whiteness and native roots. I find it disturbing that the white population allegedly needs to trace its ethnic origins for the reason that immigrant generations are responsible for the "increasing distortion" of its "true origins" (Lieberson & Waters, 1989). I instead support what I see as a postmodern view of cultural identity. This honors an ongoing creative tension between one's ethnic origins and emerging configurations of self. For teacher-researchers who seek easy answers and resolution even of the unknown, this position is frustrating.

In my preservice classes we used "yellow women's stories" (Allen, 1986) to help identify aspects of our evolving cultural identities that were rooted in other cultures. This is the name for those stories that promote the centrality of Native American women's roles in nature, and within life-systems and their own tribes. Yellow women's stories concern cultural self-identity issues because they offer parables and rituals of self-empowerment. Why yellow? The females in the Keres tribe paint their faces to perform stories about being recognized as women at the gate into the afterlife. A high value is placed on women and their special contributions within matriarchal societies. To wear the color of who we want to be and where we are going as multicultural leaders is an artistic way of exploring cultural identity. One of my black American students described the color she wants to be as a multicultural leader in this way:

> The most shocking thing that anyone has ever told me was that my job didn't matter and that I wasn't setting a real goal. He [a white business major] was implying that my vision of the future is not purposeful. I wanted to put him in his place and tell him the true meaning of becoming a teacher. Even today I can't forget that remark. Some people do not realize that teaching is a full-time job and that it involves the most important thing a person can do— impact a child's life and, through this process, change negative mindsets about teachers and students. (journal entry, April 1996)

The color of who one of my white students wants to be as a multicultural leader was expressed in this way:

> Being a "multicultural" person is sometimes painful. I have a student who is black and poor and also very kind. Her Dad has been in prison for murder. She now lives with her Dad, who does our household maintenance, and his girlfriend, a pregnant teenager. Sara doesn't have any winter clothes, and only has one bra[ssiere]. It is painful for me to think that I will travel home to my five-bedroom home. . . . I am sticking with my student teaching so that I can one day write on a child's heart. (journal entry, April 1996)

Resonances can be heard, across race, in these statements about the challenge of becoming a multicultural educator and the reward of influencing children's lives.

Yellow women's stories celebrate how being different or how "difference" itself can contribute balancing elements to society. Like "Thought Woman," who represents the source of creation in American Indian literature (Allen, 1986), my few African-American and Latino/a preservice students also formed empowering images of themselves, but against an even more troubling landscape. They shared how they are being looked upon, in higher education and society, as academically "at-risk" or "not at-risk," as though these two categories predict pathology or happiness. They generated stories of discrimination in their arts-based activities that revealed strength of vision. Wilda, a Latina student, created a photomontage of the college campus as steeped in the discriminatory practice of racial segregation (see Figure 11). She explained: "We are all around one another, peaceful and polite, but we do not interact. We all need to focus on how much we actually are alike" (journal entry, March 1996). As go-getters committed to professional development, community activism, and mentorship of the young, these students refused to accept the label of "at-risk."

In a formal study that I conducted with 11 Latina preservice students outside my classes, I further explored some of the problematic issues involved in cultural self-identity development. I learned that words such as "at-risk," "prejudice," "minority," and "broken home" are promoted on the outside of their inner circles. To the Latina students, these represent outsider terms, driven by a Eurocentric frame of reference. Such labels perpetuate challenges for minorities and present obstacles to a living knowledge of their experiences, aspirations, and dreams (Mullen, 1997b).

No arts-based representation of one's cultural identity can ever be "finished." The artworks and narrative snapshots presented in this chapter reflect the energy and integrity required of beginning multicultural educators. Jean Arp (cited in Arnason, 1981), the mid-20th-century French surrealist painter, worked with torn-paper collages. His art can be read in the context of a personal knowledge study. Even as his art came to be celebrated for its inevitable cracks and ink-stains, the artist's own identity can be interpreted as altering drastically over time:

> The search for an unattainable perfection, the delusions that a work could be perfectly finished, became a torment. I cut the papers for my collages with extreme precision and smoothed them down with a special sandpaper. . . .

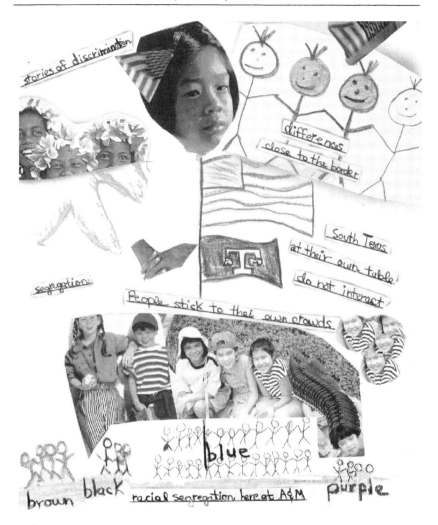

Figure 11 *People Stick to Their Own Crowds* (Wilda, 1996)

The tiniest crack in a bit of paper often led me to destroy a whole collage.
. . . The word "perfection" means not only the fullness of life but also its end,
its completion, its finish; the word "accident" implies not only chance, fortu-
itous combination, but also what happens to us, what befalls us. . . . I began
to tear my papers instead of cutting them neatly with scissors. I tore up draw-
ings and carelessly smeared paste over and under them. If the ink dissolved
and ran, I was delighted. (pp. 354–355)

The arts-based inquiries in this chapter also show that the "broken
or discontinuous nature of [postmodern] experience entails that the

classic rules about form or structure cannot be true to that experience; rather, it is necessary to work through a kind of chaos or unstable form that will accurately express its essential instability" (Rushdie, 1991, p. 168). Even one's interior is regularly invaded by the descriptions of the majority, threatening to dismiss, trivialize, and misread cultural identity.

Summary Comments: Beyond Musical Chairs

In response to Milligan's (1996) question, "can multicultural education work where the teachers and students are almost exclusively white?" (p. 49)—I answer, yes, but imagination, integrity, cross-checking, and resourcefulness are needed. Students need to be shown how and why they need to explore the nature of their own whiteness or relationship to it. Otherwise, Euroamerican students may have no choice but to view themselves either as superior or as guilty perpetrators of the racial polarization of society. A study of multiculturalism that excludes one's own culture is counterproductive, like being left standing in a game of musical chairs. As anyone who has played the game knows, the one left standing is unenthusiastic about the game and oblivious to its outcome. By contrast, if multiculturalism is construed as the study of all cultures and persons, then white students become invested and can claim their right to call themselves "cultural."

Conversations with minority and majority students at all levels can help us to understand how educational programming needs to be restructured to honor their cultural identity issues and development. Preservice students will be challenged and they will soar as they begin to see themselves as participants in a vision for an America that cherishes its cultural diversity. Later in their professional practice, they will be teachers more likely to carry the message of multiculturalism to the young.

Teacher-researchers have yet to exploit the use of Freirian, critically thinking and participatory, circles to create racially mixed groupings and networks. Those who would not typically engage in sustained interactive dialogue about their own cultural identity can be encouraged to do so. New understanding can be reached by exchanging stories of identity, socialization, and influence, as well as of racial feelings, experiences, and issues. Such conversations in colleges of education need to enable those in schools, and other public spheres to "produce their own self-images, tell their own stories, and engage in respectful dialogue with others" (Giroux, 1996b, p. 47). Researchers

who have created such conditions often focus on the multifaceted con-
struction of self-identity but within Euroamerican, African-American,
and Latino/a *unicultural* affiliations.

Does the invention of cross-racial participatory groups hold prom-
ise for other teacher-researchers? Who is currently engaged in such
practices? How can such processes be facilitated and documented to
offer benefit to others? What might be some of the strengths and
pitfalls of operating such groups within schools, universities, prisons,
and elsewhere? Could the use of cyberspace facilitate not just interac-
tion among cultural groups but also the invention of new individual,
collective, and global identities? How might the arts-based multicultural
strategies illustrated in this chapter be extended to cross-racial partici-
patory contexts and openly contested multicultural domains?

Ideally, intercultural contact would be available, as a starting place,
for study within classrooms. However, white majority classrooms, when
viewed as sites of ideological dominance, are implicitly exclusive of
the "multiple narratives, histories, and voices of culturally and politi-
cally subordinated groups" (Giroux, 1996b, p. 45). If we take as a
given that all educational practices are political, then teacher and
students can work deliberately to build new coexisting ideological
repertoires.

Anzaldúa (1987) uses the term, *la facultad,* to mean the capacity
to see below the surface. I conclude by asserting that *la facultad* can
be promoted through the arts-based making of cultural self-identity—
whether by means of photomontage, performance, journal writing,
and/or cultural encounter. Opposing the creation of a multicultural
teacher self are those political forces seeking to keep *la facultad* at
bay. But, they can also be incorporated into artistic representations of
cultural identity to show tension and controversy. Whether the South-
west or Southeast, any place is like Salim's African outpost, a

> piece of earth [and] many changes . . . come to it! Forest at a bend in the
> river, a meeting place, an Arab settlement, a European outpost, a European
> suburb, a ruin like the ruin of a dead civilization, the glittering Domain of a
> new Africa, and now this. (Naipaul, 1979, p. 269)

Salim's childhood home on the east coast had been an Arab-
Indian-Persian-Portuguese place. Any place is settled by original na-
tions, who are invaded and colonized by Europeans, who in turn are
dispossessed by postcolonial or ethnic nationalism, which then yields
to endless racial contempt, strip malls, and disappointment. Unless

the place becomes a home for all, it risks becoming no one's land. If we wish to uphold basic human justice, we must do so for all, not just for our own—even if it takes a long, long time. As Said asks and replies, "What happens to landless people? Our truest reality is expressed in the way we cross over from one place to another" (in Rushdie, 1991, p. 171).

Acknowledgments

I am grateful to the preservice teachers who generously shared selections of their journals, letters, and artworks for the purpose of this publication. Their names have been changed. Also appreciated is the permission granted by my three white students to use the photographs I took of their presentation of Africa.

References

Acuña, R. (1988). *Occupied America: A history of Chicanos* (3rd ed.). New York: HarperCollins.

Allen, P. G. (1986). *The sacred hoop: Recovering the feminine in American Indian traditions.* Boston, MA: Beacon Press.

Anzaldúa, G. (1987). *Borderlands, La Frontera: The new mestiza.* San Francisco: Aunt Lute.

Arnason, H. H. (1981). *History of modern art.* New York: Harry N. Abrams.

Ashton, P. T. (1996). Improving the preparation of teachers. *Educational Researcher, 25*(9), 21–22, 35.

Banks, J. A. (1993). The canon debate, knowledge construction, and multicultural education. *Educational Researcher, 22*(5), 4–14.

————. (1994). *Multiethnic education: Theory and practice* (3rd ed.). London: Allyn and Bacon.

Bastian, A., Fruchter, N., Gittell, M., Greer, C., & Haskins, K. (1986). *Choosing equality: The case for democratic schooling.* Philadelphia, PA: Temple University Press.

Bauerlein, M. (1992). Can whites search for tribal roots? *Utne Reader, 52,* 83–85.

Bruner, J. (1990). *Acts of meaning.* Cambridge, MA: Harvard University Press.

Campbell, D. E. (1996). *Choosing democracy: A practical guide to multicultural education.* Englewood Cliffs, NJ: Merrill.

Churchill, W. (1995). White studies: The intellectual imperialism of U.S. higher education. In S. Jackson & J. Solís (Eds.), *Beyond comfort zones in multiculturalism: Confronting the politics of privilege* (pp. 17–35). Westport, CT: Bergin & Garvey.

Cisneros, S. (1984). *The house on Mango Street.* New York: Vintage Books.

Connelly, F. M., & Clandinin, D. J. (1988). *Teachers as curriculum planners: Narratives of experience.* New York: Teachers College Press.

Craft, A. (1997). Identity and creativity: Educating teachers for postmodernism? *Teacher Development: An International Journal of Teachers' Professional Development, 1*(1), 83–96.

Cuádraz, G. H. (1997). The Chicana/o generation and the Horatio Alger myth. *The NEA Higher Education Journal, 13*(1), 103–120.

Cummins, J., & Sayers, D. (1995). *Brave new schools: Challenging cultural illiteracy through global learning networks.* New York: St. Martin's Press.

Cushner, K., McClelland, A., & Safford, P. (1996). *Human diversity in education: An integrative approach* (2nd ed.). New York: McGraw-Hill.

Darwin, C. (1989). *Voyage of the Beagle.* New York: Penguin Books. (Original work published in 1839 by Henry Colburn.)

Denzin, N. K. (1997a). Performance texts. In W. G. Tierney & Y. S. Lincoln (Eds.), *Representation and the text: Re-framing the narrative voice* (pp. 179-217). Albany, NY: State University of New York Press.

———. (1997b). Do unto others: In defense of the new writing. *Taboo: The Journal of Culture and Education, 1*, 3–16.

Dewey, J. (1938). *Experience & Education.* New York: Macmillan.

Du Bois, W. E. B. (1989). *The souls of black folk.* New York: Penguin. (Original work published in 1903 by A. C. McClurg & Company)

Feuerverger, G., &. Mullen, C. A. (1995). Portraits of marginalized lives: Stories of literacy and collaboration in school and prison. *Interchange, 26*(3), 221–240.

Freire, P. (1996). *Pedagogy of hope: Reliving pedagogy of the oppressed.* New York: Continuum.

Furlong, J., & Maynard, T. (1995). *Mentoring student teachers: The growth of professional knowledge.* New York: Routledge.

Giroux, H. A. (1996a). *Living dangerously: Multiculturalism and the politics of difference.* New York: Peter Lang.

———. (1996b). Is there a place for cultural studies in colleges of education? In H. A. Giroux, C. Lankshear, P. McLaren, & M. Peters (Eds.), *Counternarratives: Cultural studies and critical pedagogies in postmodern spaces* (pp. 41–58). New York: Routledge.

———. (1997). Rewriting the discourse of racial identity: Towards a pedagogy and politics of whiteness. *Harvard Educational Review, 67*(2), 285–320.

Gollnick, D. M., & Chinn, P. C. (1994). *Multicultural education in a pluralistic society* (4th ed.). New York: Macmillan.

Grant, C. A., & Gomez, M. L. (1996). *Making schooling multicultural: Campus and classroom.* Englewood Cliffs, NJ: Prentice-Hall.

Greene, M. (1993). The passions of pluralism: Multiculturalism and the expanding community. *Educational Researcher, 22*(1), 13–18.

———. (1995). *Releasing the imagination: Essays on education, the arts, and social change.* San Francisco, CA: Jossey-Bass.

Gresson, III, A. D. (1996). Postmodern America and the multicultural crisis: Reading *Forrest Gump* as the "call back to whiteness." *Taboo: The Journal of Culture and Education, I,* 11–33.

Hoffman, D. M. (1996). Culture and self in multicultural education: Reflections on discourse, text, and practice. *American Educational Research Journal, 33*(3), 545–569.

hooks, b. (1994). *Outlaw culture: Resisting representations.* New York: Routledge.

Irvine, J. J. (1992). Making teacher education culturally responsive. In M. E. Dilworth (Ed.), *Diversity in teacher education: New expectations* (pp. 79–92). San Francisco, CA: Jossey-Bass.

Jones, M. D., Rivers, L. E., Colburn, D. R., Dye, R. T., & Rogers, W. W. (1993). *The Rosewood report: A documented history of the incident which occurred at Rosewood, Florida, in January 1923.* Tallahassee, FL: Florida State University. (Submitted to The Florida Board of Regents, December 22, 1993)

Kent, N. J. (1996). The new campus racism: What's going on? *Thought & Action: The NEA Higher Education Journal, 12*(2), 45–57.

Kozol, J. (1991). *Savage inequalities: Children in America's schools.* New York: HarperCollins.

Leon, D. J. (1993). *Mentoring minorities in higher education: Passing the torch.* Washington, DC: National Education Association.

Lieberson, S., & Waters, M. (1989). The rise of a new ethnic group: The unhyphenated American. *SSRC Items, 43,* 7–10.

Malcolm X, & Haley, A. (1964). *The autobiography of Malcolm X.* New York: Ballantine Books.

Martin, J. R. (1996). There's too much to teach: Cultural wealth in an age of scarcity. *Educational Researcher, 25*(2), 4–10, 16.

McIntyre, A. (1997a). Constructing an image of a white teacher. *Teachers College Record, 98*(4), 653–681.

———. (1997b). *Making meaning of whiteness: Exploring racial identity with white teachers.* Albany, NY: State University of New York Press.

McKinnon, T. (1997). The dilemmas of lived multiculturalism. In P. Freire, J. W. Fraser, D. Macedo, T. McKinnon, & W. T. Stokes (Eds.), *Mentoring the mentor: A critical dialogue with Paulo Freire* (pp. 293–301). New York: Peter Lang. (Counterpoints Series)

McLaren, P. (1994). *Life in schools: An introduction to critical pedagogy in the foundations of education* (2nd ed.). Toronto: Irwin.

Milligan, J. A. (1996). Teaching "second-sight": Crossing the color line in freshman composition? *Multicultural Education, 3*(3), 48–50.

Morrison, T. (1994). *The bluest eye*. New York: Plume.

Mullen, C. A. (1997a). Hispanic preservice teachers and professional development: Stories of mentorship. *Latino Studies Journal, 8*(1), 3–35.

———. (1997b). Post-sharkdom: An alternative form of mentoring for teacher educators. In C. A. Mullen, M. D. Cox, C. K. Boettcher, & D. S. Adoue (Eds.), *Breaking the circle of one: Redefining mentorship in the lives and writings of educators* (pp. 145–174). New York: Peter Lang. (Counterpoints Series)

———. (1997c, Fall). Becoming multicultural educators: The journey of white preservice teachers. *Among Teachers: Experience and Inquiry, 23*, 3–5.

Naipaul, V. S. (1979). *A bend in the river*. Harmondsworth: Penguin.

National Coalition of Educational Equity Advocates. (1994). *Educate America: A call for equity in school reform*. Chevy Chase, MD: The Mid-Atlantic Equity Consortium.

Nieto, S. (1996). Affirming diversity: The sociopolitical context of multicultural education (2nd ed.). New York: Longman.

Padilla, F. M. (1997). *The struggle of Latino/a university students: In search of a liberating education*. New York: Routledge.

Pinar, W. F. (1995). The curriculum: What are the basics and are we teaching them? In J. L. Kincheloe & S. R. Steinberg (Eds.), *Thirteen Questions: Reframing education's conversation* (2nd ed.) (pp. 23–30). New York: Peter Lang.

Rivera, R., & Nieto, S. (1993). *The education of Latino students in Massachusetts: Issues, research, and policy implications*. Boston, MA: University of Massachusetts.

Rushdie, S. (1991). *Imaginary homelands: Essays and criticism*. London: Granta Books.

Saucedo, D. (1996). Chicanismo, DuBois, and double-consciousness. *Latino Studies Journal, 7*(3), 90–101.

Scheurich, J. J. (1993). Toward a white discourse on white racism. *Educational Researcher, 22*(8), 5–10.

Sleeter, C. E. (1996). *Multicultural education as social activism.* Albany, NY: State University of New York Press.

Spring, J. (1996). *American education* (7th ed.). New York: McGraw-Hill.

————. (1997). *Deculturalization and the struggle for equality: A brief history of the education of dominated cultures in the United States* (2nd ed.). New York: McGraw-Hill.

Steptoe, J. (1987). *Mufaro's beautiful daughters.* New York: Lothrup, Lee, and Shepard.

Stiehm, J. (1995). Diversity's diversity. In D. T. Goldberg (Ed.), *Multiculturalism: A critical reader* (pp. 140–156). Boston, MA: Blackwell.

Tiedt, P. L., & Tiedt, I. M. (1995). *Multicultural teaching: A handbook of activities, information, and resources* (4th ed.). Boston: Allyn and Bacon.

Walker, A. (1982). *The color purple.* New York: Simon & Schuster.

Chapter 7

Reciting and Reviewing the Educator Self: An Exhibition of Five Self-Works

C. T. Patrick Diamond

I, too, have stories to tell, views to unfold, images to impart, theories to argue, and am eager to expose them. It is in accounts of [things] that we traffic. Stories about stories, views about views. (Geertz, 1995, pp. 61, 62)

There, that is the whole of it, it is only what "I," so they say, here kneeling at the edge of literature, can see. In sum, the law. The law of summoning: what "I" can sight and what "I" say that I sight in this site of a recitation where "I/ we" is/are. (Derrida, 1981, p. 77)

First and Third Person Voices: Autobiographical Selves

In chapter 3, we suggested ways for teachers to imagine and represent ever-changing combinations of their present, past, and possible selves, including the teacher "I am," "fear to be," and "hope to become." In this chapter, I argue for and use self-narrative as an arts-based way of inquiring into, and gaining knowledge about, my educator self. After having previously explored ways in which others may access their reflexive self-consciousness (Diamond, 1991), I now seek to summon up my own experiencing self and to cite it in a narrative site so as more fully to possess it. Emulating the third person, expository arguments of Derrida (1981), and Bakhtin (1981), and then the more first person, artistic examples of Nietzsche (1967), Pessoa (1988, 1991), and Borges (1964), I reflect on the contributions of my third and first person voices to the development of my educated self, that is, to

reclaiming more of "me/us." These aspects of self serve as structures through which my understanding is organized.

Using five fragments of arts-based forms, I explore my engagement with writing and inquiry. This developmental story is first represented as an "effect of a combat of forces" (Booth, 1985, p. 144) between my different voices but then, more collaboratively, as a chorus that contributes to my shifting overall pattern. Because the third person, communicative voice is usually preferred in academe to that of the first person, expressive voice, I use arts-based narrative to help reclaim this marginalized aspect of self. I revisit two previously published papers (Diamond, 1988, 1993) to provide second thoughts about them and to write my way into further development. Reciting initial experiences of rejection and conformity encouraged me to share a painful narrative of childhood self and to recover a poem about death that I had previously removed (see below).

My initial self-effacement is replaced by an ironic, provisional series of self-portraits. I insert into the text the authority of the personal experience out of which the self-narratives are made. I differentiate between, and then describe, these aspects of self. Each situated and represented self is a consciously shaped literary production and scrutinizing each has the potential for provoking greater development. Like teaching and inquiry, self is not a given, but instead is constructed in community. Through writing, we turn these "senseless" unknowns into meaningful topics for further exploration. This chapter shows that, even when self becomes the central text, the self who later reads the writing is different from the author who wrote it. If allegory is a fable of abstract personifications, self-narrative is a fable of individual agents (Borges, 1964). The selves proposed in a self-narrative quietly aspire to be everyone.

Auto-bio-graphy is a narrative of self, a life history told in the first person by a fictionalizing, recreating self. It is "the highest and most instructive form in which the understanding of life confronts us. Here is the outward phenomenological course of a life which forms the basis for understanding what has produced it within a certain environment" (Dilthey, 1960, p. 89). In this discussion, I collect fragments of an educational autobiography of schooling and focus on all three of its components, that is, on the *autos* or the self, the *bios* or the social context, and on the *graphia* or the act of writing that creates the discourse between the writer and the reader of the text (Franzosa, 1992). Its first reader is the authorial self.

I do not just contrast first and third person forms as merely antithetical, although this provides dramatic impact. Steiner (1978) describes the difference in terms of speaking inwardly to self or speaking outwardly to others. "Manifest modes of self-address" (p. 366) test and verify our being. Such voices are different from those of "the highly defined, focused and realized articulacy of a learned text [with] taut analytic moves" (p. 366). Just as selfhood consists of fissionizing but merging voices, autobiographical writing strategies that employ "the 'I'" or its equivalent separate only to shade imperceptibly into one another.

Autobiography is usually written in the first person and choosing to write from this point of view sets up a number of expectations. It is as if the writer guarantees the authenticity of the events that are related in the text and is willing to take responsibility for, and stand behind, the accuracy of the account (Graham, 1991). But the autobiographies of Gorki and Henry Adams were written in the third person (Abbs, 1976). By including a 16-year-old narrator with Bangladeshi parents, Peter Petrasek, a graduate student and contributor to this book, portrays himself in the third person as the teacher he thinks his students see. He plays with the relationship between his writing self and his "written about" self. Peter was 16 when his father died. As in Shakespeare's plays, Peter and his father had been close friends.

No School on Saturday by Peter Petrasek

We went to the beach today
To collect rocks for the peace garden.
We hadn't planned it that way,
But when we found we needed more round smooth rocks
To finish the mosaic,
We said, "Let's get them now."

It was Saturday at noon and nobody had anything else to do,
So we piled into the van, the four of us and him.
He was worried that we didn't all have seat belts,
Also the permission form had nothing about going to the beach,
But we didn't care.
Anton and me up front, Yensi and Rosa in the back
Sitting beside the wheelbarrow and a lawnmower.
The bumps were fun.

There was a "No Trespassing" sign where we parked to climb down to the beach,
But the construction crew had gone for the weekend
And we guessed they wouldn't mind us stopping here for a few rocks,
Just a few rocks for a peace garden.
He used a spade to dig steps into the vine-covered slope.
So we could climb down easily
And carry the buckets of rocks back up to the wheelbarrow.

The autumn sun came through the clouds while we were there,
Brilliant over the lake water washing against the shore.
The rocks are wondrous at that beach, so many colours and shapes.
Anton found some with fossils in them
And Yensi found a brick polished smooth by the water,
A perfect candle holder.
Rosa picked up glass worn to soft shapes, like costume jewellery.
The best rocks are at the water's edge, just under the surface,
So he and I took off our shoes to wade in and get them.
He stayed in that frigid lake for more than half an hour!
Crazy,
But he said you get used to the cold.
What really hurt were the hard pebbles against the tender soles of the feet.
"We spend too much time indoors," he said.
"Too much time sitting at desks."

We stopped for juice after an hour.
"You sit too," we said to him.
He's always moving, explaining, doing—
I couldn't relax until he finally sat down and accepted the cup
(we only bought one).

The lake turns different shades of green and blue,
Too bad the nuclear power station spoils the view.
(Of course, he had to explain how a reactor works, for Rosa's benefit.)

Heavy work, it was, carrying the buckets up the hill,
On our own, nine big buckets of rocks, lugged to the top,
Then Anton pushing the wheelbarrow to the van.

We stopped for pizza on the way back to school.
He insisted on paying,
Saying he really appreciated our help,

Saying he makes more money than we do.
Which is true.

Yensi wanted to know if he spoke any other languages besides English—
She and Rosa speak Spanish and understand *pocco* Italian.
They're from El Salvador, Anton is Sri Lankan, my mother came from
 Bangladesh—
He said, "French, but it's rusty."
No Czech.
His father died when he was 16, and never taught them the language.
After the pizza we unloaded the rocks at the peace garden.
And he drove us home.
I was thinking my mother would be worried
Because I had forgotten to phone,
But mostly I was thinking about Yensi's sister, Rosa,
And how thankful I felt to have spent a day
Away from crowded corridors, annoying bells, feeling cramped and hurried.

Arts-Based Activities

1. How do you think your pupils see you? Peter thinks his depict
 him as "always moving, explaining, doing."
2. What can you pick up from the edge of your memories of
 schooldays that reminds you of "glass worn to soft shapes"?
3. Borges' Pierre Menard became Cervantes in order to usurp the
 authorship of *Don Quixote*. Summon up what happens when a
 previously lost aspect of your teacher self returns to take over
 your classroom completely.
4. Why has much educational research and teacher education put
 a "No Trespassing" sign on the self?

<div align="center">

Many Voices in One:
The Disquiet of Development

</div>

During the time I taught at the teacher institute in San Paulo in 1997,
José Carlos Diogo wrote that he was struggling to get back in touch
with missing aspects of his teacher self, including his path-finder, ar-
tistic, inquiring, in-waiting, struggling to understand, "would it be pos-
sible?" and "the penny has dropped" selves. Diogo (as he prefers to be
known) represented his catalogue of recovered selves in the form of
shape poems and images that he appropriated from popular Portu-
guese magazines. Bakhtin may have explored his otherness or multiple

subjectivities by publishing texts also under the names of Voloshinov (see Gagnon, 1992) and Medvedev. Postmodern theorists champion such a text-based development of self. They "endow [a] text crowded environment with honorific significance," that is, they see "writing or canonical heterogeneity" (Renza, 1990, p. 199) as providing a means to liberation. Later in this chapter I represent my missing selves in an exhibition of five works.

To imagine reality, a person structures experience into forms, that is, as people, things, thoughts, and feelings. Forms both free and delimit our world—even that of self. When viewed traditionally, the self has been seen not as a mosaic of pieces but as a monolith that is relatively consistent. In contrast, a postmodern self is viewed as a multifaceted, dynamic set of differently imagined selves. The construction of self as a subject is theorized by feminist, postmodern scholars as a site of identity production (Bloom & Munro, 1995). They reject any humanist or psychological notion of a unitary self.

Weedon (1987) defines subjectivity as "the conscious and unconscious thoughts and emotions of the individual, her sense of herself, and her ways of understanding her relations to the world" (p. 32). She too refutes the assumptions that there are fixed meaning claims that can be made and that self is seamlessly unified with an essence that is unique, fixed, and coherent and that makes people what they are. Self is more verb than noun, more process than entity. Life history or autobiographical inquiry is needed, which allows for the complexity, ambiguity, and contradictions of lived experience to disrupt the traditional coherence of text.

Presaging such a postmodernist position, Nietzsche (1967) also rejected epistemological foundationalism and replaced any secure standard of "truth" with partial insights. Since reality is a historical and social product, we need to acknowledge our personal and shared role as the source of our understandings and how limited they all are. The importance of the subjective meanings that we give to our lives needs to be emphasized. Nietzsche offers a view of art that is based on splits or tensions between passion and order, that is, between first and third person voices. His challenge was to integrate these differences into a forum of self-expression.

Originally using the form of a dialogue with Wagner, Nietzsche proposed art as a metaphysical activity. Sixteen years later, Nietzsche provided a self-review and criticism of his book and of how he had lacked the courage to find a language in which to express his indi-

vidual views. Instead he had labored with formulae derived from Schopenhauer and Kant. Nietzsche then questioned his former authoring self: "Dear sir,/What in the world is romantic if your book isn't ? . . . Listen to your self, my dear pessimist and art-deifier, but with open ears" (Ross, 1987, p. 177). Nietzsche found his previous book to not have any sense of selves, and to be ponderous, embarrassing, sentimental, uneven, and only for the initiates.

Pessoa (1991) is acclaimed as Portugal's greatest representative of postmodern sensibility and thought. He was a poetic fictionalizer who consistently studied the development of his voices as his complex central text. Although he spent his daily life translating the foreign correspondence of others and writing for himself only by night, he is now enshrined among the 26 figures central to the Western canon (Steiner, 1996). He explained:

> I unravel like a multicolored skein. . . . I make yarn
> figures out of myself. . . . Living is knitting according
> to the intentions of others. But as we do it, our
> thoughts are free and all the enchanted princes can
> stroll through their parks between the instants when
> the hooked ivory needle sinks into the yarn. (p. 7)

Growing up in the Portuguese consulate in Durban, South Africa, Pessoa used Portuguese at home, and English at school and on the street. He also studied French, which he came to write fluently. He later described himself as playing many people in the one person. As an "objective introvert" (Pessoa, 1988) he sought to find his "real" or alternative selves with their multiplicity intact. Like Conrad, he remained a multilingual exile.

Pessoa accepted and cultivated his dividedness so completely that he wrote poems under his own name and also entire volumes of poems pseudonymously under those of three other writers (Alberto Caeiro, Richardo Reis, and Alvaro de Campos). Paradoxically, he set himself free by exploring his self in terms of a quartet or exhibition of acclaimed voices, each representing a segment of his personal thoughts and feelings. In his prose diary, *The Book of Disquiet*, Pessoa (1991) added yet another *alter ego*, Bernardo Soares, to his Dickensian gallery of multiple personalities. Over his lifetime, he persistently transformed himself into a complex set of written possibilities. Even as a child, he held long dialogues with imaginary others, creating a pen pal who wrote back to him. Like an artist's sketch pad, the 1991 diary

consists of outlines, tentative ideas, pentimenti, and published and publishable pieces. It is "an image or projection of the literary imagination at work" (Mac Adam, 1991, p. xviii), approximating the infinite, Borgesean book.

Pessoa carries the ghostwritten, poetic autobiography beyond both third person autobiography and one of his favorite poems, "Song of Myself," by Whitman. Bloom (1994) sees Whitman's "me myself, the real me, my soul" as the imaginary, utopian figure that Whitman, the center of the American canon, would have liked to be. It is his strongest creation. Pessoa provided an even more fantastic invention of selves. With his heteronyms or "psychic cartography" (Bloom, 1994, p. 487), Pessoa is credited with surpassing the irrealist fiction created by Borges. Free verse or prose poems may help arts-based educators also to play with alternative modes of self-representation and to turn their backs on 19th-century realist traditions. Although endlessly different, selves can be represented as a catalogue that celebrates communion rather than secession.

The literary discourse of arts-based inquiry provides teacher education with a powerful, developmental paradigm. Like Vygotsky, Luria, and Bakhtin, Pessoa construed a life of thought as authoring. In this tradition, the individual self is seen primarily as a narrativist or author-reader (Kozulin, 1991). The reality of Pessoa's words and fictions so enlarged his sense of daily unreality that, like Borges, he saw himself as a self-invented character taken from fiction. Combining everyday lived experience with abstruse concepts produces a metaphysical effect. Both writers experimented ironically with permutations of self. Pessoa died in 1935 at age 50, grieving that

> What we are
> Cannot be transfused into word or book.
> However much we give our thoughts the will
> To be our soul and gesture it abroad
> Our hearts are incommunicable still.
> The abyss from soul to soul cannot be bridged. (p. xiii)

Even Pessoa's (1991) own name means *persona*, a person or an assumed character in one's own writing. In Latin, it means a mask worn by an actor. Pessoa's main reason for living was to write, to become a book himself (Mac Adam, 1991).

Words provide a major vehicle for embodying thought. Pessoa, a harbinger of skeptical postmodernism, felt that we are sentenced to be

alienated even from ourselves by the very means that we use to try to reach understanding. And yet, despite his pessimism about the outcome of the struggle, it is not logocentric to acknowledge words as one of our chief means of sorting out and organizing "reality," however provisionally. Words help us gain some purchase on our constructive processes. We can expand these kinds of possibilities by learning the language of our different selves, and so become "multicultural" objective introverts, writing in our first and third persons. To gain voice is to increase our expressiveness and meaning.

Through writing, aspects of the self become more audible and possible. We invent and distinguish our different voices through attending to them as our self-representations. As a teacher educator-researcher, I am trying to reclaim and expand my self by becoming a more visible and self-aware author, expressing new voices, especially the personal and the artistic. Becoming more self-consciously reflexive in my writing and learning to accept its constructedness, I now question the exclusive authority of third person writing, which previously confined my experience of self. I begin to trace how I have come to say what I have come to say (Geertz, 1995).

Releasing the Personal:
"I, Too, Have Stories to Tell"

Like Diogo, I came to realize that parts of my self were missing. The personal self is a crucial but neglected part of the range of possibility in my teacher education. In my writing, I had always remained the marginal notes and never become the central text. Such self-sites may still be suspected in academic writing as unreliable, illegitimate, and even trivial. The personal and the arts-based may be discounted as outside of, and inferior to, the distanced, neutral, measured, and public discourse of even an ethnographic self. Postmodern forms challenge such misgivings by interrupting any tyrannous voice, resisting closure and extending play.

In published writing, we traditionally lecture to others and only rarely talk with them. If the academic community is represented and organized by its written discourse (as in networks of papers, articles, reviews, and books), so too the interpretive community of selves that we each may seek to create is made up of public and personal voices. Each provides another "way of seeing and knowing . . . in the hall of mirrors" (Shulman, 1991, p. 394). Each aspect of self constructs,

apprehends, and writes its own interpretation of reality. Since each voice provides a further opportunity for restructuring experience, its expression adds to our modes of thinking, feeling, and experiencing.

If writing in teacher education research seems only rarely to connect us with our own lives and subjectivity, developing a broader community of voices offers a metaphor for encouraging the interplay of many kinds of experience. Embracing such contraries in an internal conversation eventually leads to the production of new and larger frames of reference. However, the discourse of teacher education still consists largely of the imposed language of expository scholarship. Writing for academic publication is usually like "knitting according to the intentions of others" (Pessoa, 1991, p. 7). The introduction of the more personal writing of self-narrative is necessary if self-multiplication, arts-based practice, and postmodern stances are to be realized.

Transformation is not a personal variation on the Enlightenment dream of direct knowledge communicated easily and independently of place and time to an improving self. There are always struggles, pauses, and false leads. Ayn Rand's "make-over" story exemplifies the problematic results of narrative self-invention. When she arrived in New York in 1926 from Petrograd as Alisa Rosenbaum, she changed her first name to Ayn after a Finnish writer she had never read: "In her arms she carried the battered mechanism of her full metamorphism. . . . a Remington Rand typewriter, from which she would, within weeks, take the rest of her name and begin to recompose her life" (Roth Piermont, 1995, p. 72). There is disagreement as to the value of her later self-incarnations.

Narrative provides arts-based opportunities for postmodern educators each to gain a distinctively thoughtful presence or series of registers within which they can explore the different experiences of their private and public, fictitious and factual selves. Presence is established when thoughts and feelings are called forth by and in community rather than isolation. More space needs to be opened up for the display of awareness of different aspects of self in teacher education, including the unfolding of personal knowledge.

The narrative of self is not a mode of self-voyeurism but a means of probing personal experience while also examining different topics as, in this instance, a teacher educator-researcher's practice. Narrative is "both phenomenon and method" (Connelly & Clandinin, 1990, p. 2), allowing us to construct ourselves multivocally. Such an approach helps us to name the structured quality of our experience and also the pat-

tern of the inquiry. Yet postmodern, arts-based inquiry in the reflexive moment is distinctive in the degree to which it lacks a shared and codified conception of what and how it is done, formulated, and reported. One way that the self-conscious inquirer may proceed is by exploring and showing the textual features and devices that are used to construct a plausible and persuasive account. The self-positioning act of writing makes self and its processes available for further reflection.

Such writing is, as Richardson (1994) asserts, a "method of inquiry," a way of knowing and finding out about self and others, and one's topic. A person's experience of his or her articulation with social structures generates an embedded sense of self. By writing about an issue in different ways, we can discover new aspects of the issue and our relationship to it. My topic in the sections below concerns rejection in academe and childhood. In self-narrative, we put ourselves into our own texts, nurturing individuality, and lay claim to knowing something. "A postmodern position allows us to know something without claiming to know everything" (Richardson, p. 518).

In many teacher education programs, the focus may be on controlling rather than valuing teachers' words and knowledge. But each of us can revise our selves and reform our conditions by finding words to write about them. Putting words together to form new and surprising patterns always reflects something previously unguessed about life. As a child, I felt words gave me freedom to roam. Narrative inquiry promotes the individual and shared transformation of personal and social stories that Connelly and Clandinin (1995) call an "awakening" form of teacher education. In the five reflective self-narratives or exhibits that follow, I make figures out of my first and third person selves so as to restructure my experience within the context of my present authoring and reading self.

Reciting/Resiting/Resighting My Previous Self-Narratives: Exhibits 1 and 2

Whenever we write and publish, we risk having our personal voices muffled or silenced. Our experiencing, immediate, first person self is easily overwhelmed by the observing, controlling third person that we assemble out of the demands of powerful others such as parents and reviewers. This was my experience while revising a paper (Diamond, 1988), which I later present as "exhibit one," that I had submitted on the development of my agenda as a teacher educator. I was

uncomfortable lecturing to teachers as "the expert." I felt the loss of any witnessing "I."

In exhibit one, I depict my development as if I were one of Kelly's (1955/1992) "personal scientists," rationally reconstruing my practice, predicting future action, and weighing the likely consequences. Although I had intended to produce a self-storying essay, I retreated into an academic conceptualization derived from formal, developmental stage theory. I packaged the contours of my journey into five general phases that I labeled with conventional signposts: preconjectural, dogmatic, decision-making, inventive or conjectural, and emancipatory.

Although sensing that development involves a shift backwards from rationalist abstraction to disciplined intuition, that is, from a third person to a first person vantage point, I allowed professional misgivings and the imagined readings of critical others to crowd out my more personal concerns. What could have been narrative and expressive became acceptably controlled and expository. Percept, concrete experience, practice, and fragmentary story all yielded to concept, abstraction, theory, and to "ascent" by stages. I lacked the courage to quiet my too-theoretical voice. I am still seeking, as the present chapter shows, to promote more "symmetrical communication" (Diamond, 1988, p. 139) between my voices. But the overdominant professor-self always tries to sink "the needle into the yarn" (Pessoa, 1991, p. 7).

When the editor changed my 1988 title from "Confessions of an ex-educational lecturer" to "Construing a career: A developmental view of teacher education and the teacher educator," I acquiesced. "Confessions," I now realize, would have conjured up images of a series of indiscretions, however mild, which "gave the lie" to prevailing assumptions and dominant ideas. I began to wonder if there was any voice in my academic writing that remained my own. My reticence to "go public" with the personal is shown by the use of colons in nearly all my published titles—even in this present chapter! I cloak my first person evocations in more general statements. Being uneasy about the primacy of subjective representations and about any declaration of my feelings, even to myself, I seek their legitimization through association with rational propositions. I remain less present to myself and others. My pain as an only child made me wary of authority. In any "telling," I had to be self-censoring, hiding behind the gaps.

The dilemma of remaining a person while practicing as a teacher-researcher may be transcended by valuing each aspect of self as con-

tributing to the building of an interpretive, branching community. But it is difficult to "climb down" and to share our personal representations of our own practice and selves. In high school, I had to take Latin instead of the "suspect" Romance languages. We learned that "real men don't cry" and the arts are not for them. Although an athlete, I still preferred to read my books and skipped lunchtime practice for sports. I now need to reconcile some of the tensions between my perspectives and to allow for each to become more present to the other. Academically, I am reviewing exhibits 1 and 2. This critique led to the restoration of exhibit 3 and the composition of exhibits 4 and 5. Curating my own "diary of disquiet" may help me to recover and redefine my authoring self. Like Nietzsche (1967), I ask questions of my earlier authoring self. I represent the two original papers (Diamond, 1988, 1993a), the poem, and the two self-narratives that I add below as five works in a retrospective exhibition of self. Like Sam, a visual artist that I taught to interview himself (Diamond, 1993b), I too am re-viewing my own "exhibition," developing connections to my self and my works over time. But how is an educational critic-artist supposed to do this? What do words or rules mean in arts-based educational inquiry and teacher educator development?

When Sterne's (1983) hero, Tristram Shandy, reviews the sections into which his story might be told, he exclaims: "The deuce of any rule!" In contrast, I have always taken seriously and abided by the rules as long as I could. But then I forge my own and strike out in the postponed direction. I had originally tried to complete exhibit 2 by composing a letter to myself ("Dear Pat,/Your paper") about exhibit 1 as if I were also a trusted friend and slightly mischievous colleague. I produced a second person draft of self. Unlike the traditional, correspondence model of autobiography, which tends to subordinate the text to that which it is presumably about (the author), the text is of primary concern to arts-based narrators.

> If the premise of autobiographical referentiality that we can move from knowledge of the text to knowledge of the self proves to be fiction, the text becomes paradoxically not less precious but more: in making the text the autobiographer constructs a self that would otherwise not exist (Lejeune, 1989, p. xxiii).

I tried to reclaim and represent missing aspects of my self by using the markers of my previous texts. When a reviewer strongly objected to the initial version of exhibit 2 because of its letter to self and poem for

Clem (see below), I retreated to the suggested, safer/prosaic form of "second thoughts."

I am now trying to feature more of my personal voice that may have been present in exhibits 1 and 2. I allowed the personal to be partly silenced as the price of acceptance. On one level, the split between my authoring and publishing selves may show the limitations of my writing self. On another, it may be that it is only now, these years later, from the distance of advancing time, that I can detect "gains" in my development. Much like the responses of Pessoa's pen pal, the insights of reviewers may have assisted rather than slowed my development. But Pessoa's (and Borges') doublings were self-inventions and not imposed requirements. Self-interrogation may powerfully help us to entertain different versions of ourselves and to consider which are more important and when.

I now review exhibit 1 to show changes in my constructive processes. The introductory and concluding sections of this 1988 paper now seem too hortatory and moralizing. My voice was more convincing when I concentrated on my actual experience as, for example, a beginning lecturer in curriculum and instruction, wearing the shorts and long socks of a self-satisfied "master" teacher. I confessed to removing the fourth wall of my then recent real-life classroom and to seeking to invoke my "successes" so vividly as to coerce the novice teachers into adopting my version of innovative teaching. I broadcast my classroom gospel to them.

Some of the appropriations in exhibit 1, as in "academic cargo cult, immaculate perception," and "learning as theory formulation," now seem too intrusive. While something borrowed can be something "true," 33 citations show an overreliance on the authority of others. My voice was in danger of self-suppression. When internalized, the demands for writing for publication may pose a threat, especially to finding and maintaining even a temporary version of self. My use of the "portray-betray" contrast was taken up again when I later discussed the omission of the voices of teachers and of the persons of teacher researcher-educators from much of the debate (exhibit 2). If the neglect in the instance of teachers amounts to subjugation of voice, in the second instance of teacher researcher-educators it may amount to protection. While the literature has been subdued on the topic of teacher researcher-educators, some may be depicted as having penetrated "deep forests" only to gather up the remnants of so-called "less developed" societies that are allegedly constituted by classroom teachers.

Such one-way traffic resembles an invasive sortie into occupied territory, with opposing forces competing for limited supplies of power and authority (Bakhtin, 1981). I later encourage my past selves (see exhibits 4 and 5) to peer out through the curtain of my treehouse with its "trailing tendrils of narrow leaves." Relatively few incursions or revelations have been made to disturb the intimacy of life among powerful "tribes" nearer to hand. Educational researchers and their published ethnographies of the classroom practices of others could, of course, be referred to. An attitude of colonization or of indifference could be redressed by researchers inquiring into their own processes— and "coming clean" (see chapter 9). The observed, the observers, and the institutions of observation are then placed on the same critical plane.

My developing perspective is still reflected in several of the other contrasts that are implicit in exhibit 1. These include "private-public, personal-professional, cognition-affect, relevance-rigor, metaphor-model, participation-detachment, learning-lecturing," and "teaching-research." As academics, we may feel that we have to choose between either teaching or scholarship. Publishing in scholarly journals can be construed as neither a self-aggrandizing nor a self-diminishing activity but rather as an opportunity to become advocates for teachers and self. We can move from a protective to an exploratory position regarding inquiry into our development (Holly, 1989).

The problems of development stem from the difficulties that we each face in developing our multiple "I's." Just as Pessoa (1991) explored himself as a "multi-colored skein," I am sorting out my overbearing, silencing voice from the other more tentative voices and reflecting on issues of appropriate turn-taking in daily and written discourse. My third person voice needs to express itself less as a censor (see chapter 3) and more as a collaborator. I now wonder about some of the silences in exhibit 1. Any coherent text or self always conceals empty and conflicted spaces. In a postmodern novel, Calvino (1992) described the effect of a misbound text in which blank pages alternate with densely detailed ones. The tightly interwoven work is "suddenly riven by bottomless chasms as if the claim to portray fullness revealed the void beneath" (p. 43).

There are gaps in exhibit 1 about how, as an academic, I go about enhancing my prospects for advancement. Bateson (1990) laments that pressure almost compels us to publish in "isolated driblets" (p. 181) to lengthen if not strengthen our resumes. Although Vidal (1993) complains that university teachers "can only rise in the academic

bureaucracy by writing at complicated length about what has already been written about" (p. 115), writing about writing by different aspects of self is not to be dismissed. Only teacher educator-researchers can change teacher education, and only then by first understanding themselves and their practice.

A Restoried Poem: Exhibits 2 and 3

While preparing exhibit 2, I found that there was little research writing that I wanted to read or emulate. Inquiry was still largely destoried. As Bruner (1993) shows, until recently, even most ethnographers have sharply segmented their investigative self from their personal self. Only the preface, acknowledgments, and introduction, and sometimes the afterword and endnotes, have served as personally revealing spaces. Sapir and Benedict published ethnography in anthropology journals and poetry in literary journals. Others have used different publishers or pseudonyms to segregate their arts-based, personal writing from their professional accounts. Some researchers publish two books, one the standard report and the other a personal field memoir or confessional text. These separations are sometimes political acts, not just benign gestures. Scholars have also often waited until their writing and career have been all but completed before undertaking work on a personal development text. In this vein, Jung (1961) wrote his autobiography, with prompting and assistance, at the end of his lifelong career, and not without doubt about exposing personal details to the public. He was well into his 80s when he wrote his autobiography, warming to the task of telling stories about his development and early memories. Where he had missed even a single day of writing, he reported experiencing unpleasant symptoms until his writing resumed.

I too wanted to enact my own stories rather than to serve only as a character in the narrative scripts of others, including those told by my third person self. I had included a poem in early draft versions of exhibit 2. This was in the form of a eulogy for Clem, the Australian colleague and gifted sportsman mentioned earlier who had died of cancer at age 50. I wrote the poem after the style of Gerard Manley Hopkins' "Felix Randal," one of Clem's favorites. *Felix* is Latin for happy. I last shared a meal with Clem and his family when they were living outside of Birmingham, England the year he completed his award-winning doctoral dissertation. A year later I heard that he was again in England but for life or death test results. He had tried every therapy.

For Clem: Exhibit 3 by C. T. Patrick Diamond

Mentor and friend,
He is dead then. Dead at fifty.
A trusted friend and lovely colleague.
His high forehead and tight curls receded to a spot,
a mark, a lump—and dead at fifty.
Golf and trotting and barbecues and beer,
Wit and friendship, all gone.
Now his wife sits alone. How to comfort daughter and son?
No one now to bounce them on his knee or swing that cricket bat.
Dear Clem, the measure of a man,
and dead at fifty.

A reviewer dismissed my draft of exhibit 2 (Diamond, 1993a) as "a confusing and confused Tower of Babel [that] marked narrative's degenerate turn toward mere narcissism." While the parallel between my account of authoring alternative selves and Babelism may have merited the invocation of this Hebrew parable of unrealistic and punished hubris, it also exemplifies diversification. In my Icarian text, I took risks by exemplifying a crowded textual environment. I found out only later that Borges (1939) had written a short story called "The library of Babel" to invoke a nightmarish vision of the inaccessibility of all knowledge in all languages (see Woodall, 1996). Without reducing the reviewer to a caricature, he or she may have sensed that something was/is happening to the ways we think about the ways we think. The reviewer quizzed me from the page: "Who was Clem anyway?" But how do you explain when some *one* is everyone? Clem was no mere invention of mine. He once had his own life.

There seemed to be nowhere in my published work for dealing with personal regret, mortality, and friendship—certainly not for a mini-miracle play about a better academic self who personified many virtues! I deleted the poem (recovered only now and with great difficulty). But I knew that narrative is a condition of temporal experience and loss a recurring theme in postmodern experience. When regret about the past (or fear of the future) impinges on the present, everything is experienced as "out of joint." We lament with Heywood that it is not "possible/to undo things done; to call back yesterday." Regret can never be totally overcome since we know that our "days are numbered. The future always becomes the past. The future is always death" (Richardson, 1995, p. 208).

What may have upset that reviewer-critic was not so much that my poem was so poor an attempt but rather that poetry makes inescapable the recognition that "all texts are constructed—prose ones too; therefore, poetry helps problematize reliability, validity, and 'truth'" (Richardson, 1994, p. 522). Poetry consists of language that is super-added or minimalized, foregrounding or downplaying spoken and literary rhythm, meter, assonance, alliteration, and rhyme (see chapter 1). I was pursuing an arts-based inquiry, not a work of art or a definitive self-representation. Better versions of "truth" consist in our reinterpreting of our predecessors' reinterpreting of previous reinterpretations, even when they are our own. Rather than "regarding truth, goodness, and beauty as eternal objects which we try to locate and reveal, ... [we can regard] them as artifacts whose fundamental design we often have to alter" (Rorty, 1982, p. 92). So too with writing and self.

Like Barthes (1977) writing on Barthes, I am now using a form of the literary journal whose five fragments self-reflexively explore my writer's relationship not only with friends and selves but with the writing. I am not just in pursuit of an old version of myself to restore it like a monument. I do not say "I am going to describe one of my selves" but rather "I am writing a series of texts." Barthes' (1977) disjointed collection of text upon text was alphabetically arranged, with some in the first person and some in the third. So far in this chapter, I have revisited three exhibits to reassert the first person aspect of my teacher-researcher self. Two more exhibits follow. I am struggling to become more responsible for my development by attending to the contributions of the personal in my work. Reading the following nostalgic story of my school age loss of Eden, I realized that I once replied to the impositions of more powerful others such as my father, only with unprotesting silence. The Edenic myth evokes a picture of the birth and development of consciousness (May, 1991).

"By the Beach": Exhibit 4

Out on the horizon, huge sand dune islands smoothed the ocean surf to rolling swells—except when gray cyclones and king tides came flooding in from the Pacific. For all my childhood we lived beside what was called the seaside. On nights when the air was dead you could hear sluggish waves lapping onto the rocks of the shallow bay just over the hill. Late on hot summer days you could sometimes smell the seaweed cast up to rot on the mudflats. At other times, it was sour pineapple

waste from a city cannery. And rarely, when the north-easterly blew, I could catch the fresh breath of another life.

We lived in a poor bayside, family suburb 13 miles north of the state capital. It was called Shorncliffe and was thought to have taken its name from a former German resident. Although a wealthy medical practitioner, he was interred during the Great War. Others thought the name derived from the German for the steep cliffs that framed the headland and creek areas. At any rate, Shorncliffe was undeniably the northern terminus of a sprawling rail service—the end of the line.

Before people could afford cars or divorces, crowds of immigrant families traveled from all over the city to swim and to picnic there. With short, dark haired fathers leading the charge, they ran, swinging open and then slamming shut the brown compartment doors before the steam train quite stopped. They raced through the sundried and gardenless railway park, slowing up the steep hill, past the collapsing "Strand" picture show and the adjoining blocks of rundown shops, across the carefully mowed cliff park with its painted bandstand, and then down the paths to stake their claim to a shady spot under the cotton trees above the gray sand of the beach. Hordes of butchers and bakers also came with their families for annual union holidays. I would hear the floating sounds of cheered foot races and organized happiness.

A long pier stood far out from the retaining sea wall for fishermen. They came with nets, jag lines with colored lures, and with mysterious packets of bait retrieved from the bottoms of plastic carry bags. Half way out, and east from the bitumen pier surface, there was an L-shaped row of thick posts that had been encased in now-barnacle-encrusted concrete. Galvanized shark-proof wire netting hung from them to make the enclosure safe for swimmers. Small waves buoyed up jellyfish, trailing tentacles behind them like bunches of flowers. Only the fragile bluebottles with their long-barbed tendrils had a worse sting. The "jellies" plopped through the loosely hanging netting either to be cast up or to be blown onto the littered beach. I would sit with a friend, Brian, silent on a support under the pier, watching the endless ebb and flow of water, and feeling the peace. The netting often gaped in need of repair, but I never saw a shark. There were rumors of dorsal fins, and even of Hammerheads and Grey Nurses. Once they were landed and cut open, it was said that they were always full of baby sharks—or broken remains.

We moved into this seaside haven after my father's return from the war in the Pacific. He first worked in an abattoir but then found a government job. The wooden house that we rented and bought with his veteran's war-service loan was old and peeling. It was called "The Willows." My father cut down, dug out, and burned all the willow trees that had dotted the large yard. He planted rows of flowers and shrubs

behind cement garden edges and mower tracks that he poured using hinged creosoted boarding. The property was a large regimented triangle with its long diagonal fronting Rainbow Street and Signal Row. The rest of it petered out to a tiny back gate swinging out onto a lane. Here, beside the outhouse, my father set off another triangle of yard to form a "chook" pen. Its six-feet-high fence was made of chicken wire nailed to three supporting posts.

The middle one was a four-inch-thick trunk of saved willow. In time, it sprouted thin branches that shot out at all angles. As a boy of eight, I would climb and sit snug in its spreading fork. I patiently wove the trailing tendrils of narrow leaves into a thick draping curtain to shield me from the house. I enclosed myself in a cool treehouse to enjoy the privacy and calm of my own "green thoughts in a green shade" (like Marvell's *The Garden*). When cut with a penknife, the tree's dark bark could be peeled back to the white, acrid bone. I sat up there each afternoon, floating high above the chickens and my anxieties. But my father cut it down. Although he could always volunteer the name of the good thief to impress others, he never made mention of my tree. My father had no time either for the second Adam, who ascended the tree at Calvary, flanked on either side, to carry out His Father's will.

Arts-Based Activities

1. Write an unsent letter to Patrick, the struggling author, or to Pat in his boyhood treehouse.
2. Begin a self-narrative account of any aspect of your teaching or childhood that involved either the outdoors or loss and regret.
3. Interview yourself about a defining moment that you may have charted in your teaching or learning career in chapter 3.
4. Pessoa wrote: "I don't know who I dream I am" (Steiner, 1996, p. 79). In nightmares, who do you dream you are?
5. Your school principal discovers that you have published a series of ironic short stories based on your experiences at that school. Describe the ensuing scene or provide a rationale for or defense of your action.

My Reader Self Responds to My Writer Self: Reviewing Four Exhibits and Finding a Fifth

For me, my four self-narratives or exhibits (dealing with the difficulties of getting published, including a poem, and the death of a treehouse) represent epiphanies in development. They are allegories not of any sudden illumination but rather of gradual realization arising out of my experience. They represent important meanings that provide both

insight into my younger and older selves and an acuter overall sense of my life. They are part of my story of birth and death, of decline and renewal. Recognizing them as special helps me trigger increased energy and greater self-awareness of change and resistance. I found in them new reasons to recommit to writing and to my authoring self. I now wonder about the self-pitying victim and the overuse of the dash, not just to add a twist of insight but to suggest the feeling of having been left behind or abandoned.

More generally, I agree that self-narrative provides a personalized, revealing text in which the author can tell stories of his or her own lived experience. "Using dramatic recall, strong metaphors, images, characters, unusual phrasing, puns, subtexts, and allusions, the writer constructs a sequence of events, a 'plot,'. . . asking the reader to 'relive' the events emotionally with the writer" (Richardson, 1994, p. 521). Aspects of the self can be rendered through flashback, flashforward, deep characterization, tone shifts, interior monologue, omniscient narration, and especially metaphor. Such arts-based devices need to be tried rather than merely listed.

Peeling back the tree bark is like unraveling the skein of my untold stories, allowing me to reconstrue the pain underneath. I was not responsible for what happened as a child. Jung (1961) also referred to an original revelation, associated with his early memory of a dream sequence. This preoccupied him for the rest of his life. My tree is a kind of original revelation that has preoccupied me. Struggling to ascend the tree also mirrors a recurring childhood dream of mine. Carol Mullen, as a close reader of my work, encouraged me to share it.

"Old King Cole": Exhibit 5

My earliest and only remembered dream returned so often in childhood that I dreaded night. Now, I need to return to the puzzle posed by the dream. Haunting feelings and dim cartoon shapes provide me with initial clues. It always began with my looking up, along a diagonal, at a brightly lit figure on stage. To reach him, I had to complete a long climb and a difficult balancing act. He looked like a happy court jester, with bells jingling at the dangling ends of his cap and long sleeves. He sat high up on a wide throne, smiling and kind. His shining costume was made up of large squares of color, cut on an angle to form diamonds. He leaned forward and beckoned me on with his bright eyes. Then he rocked his head from side to side and his face lit up. But it was not easy to reach my father.

I looked down. Darkness. My bare feet hurt. I can still feel them. They were being deeply creased along the soles. I was tightrope walking up a steeply inclined, black metallic "wire." Later I recognized it as

the corner edge or apex of an L-shaped bed rail turned over onto its base. I was caught, ascending this painful, triangular trail, seemingly without progress. As I looked up, my father changed into a less than jolly Old King Cole. He was still laughing but derisively. His big face now shone blank like Humpty Dumpty's. He was cruel, enjoying my distress. He did not help me although I waited. I was in danger of falling into "the void beneath." He laughed. Night after night I could never reach him. Only now have I realized that the figure always changed from good to bad and always to my surprise and confusion. What came crashing down, falling backwards so that it couldn't be put back together again? Dark, confused fragments of nursery rhymes haunted me:

Old King Cole was a merry old soul and a merry old soul was he.
He called for his pipe and he called for his bowl,
And he called for his fiddlers three.
Four and twenty black birds,
baked in a pie.
When the pie was opened,
the birds began to sing.
Wasn't that a dainty dish,
to set before the King?
Little Jack Horner sat in a corner.
He put in his thumb and pulled out a plum saying,
"What a good boy am I!"
Little Miss Muffet
Sat on a tuffet
eating her curds and whey.
Then down came a spider
Who sat down beside her
And frightened Miss Muffet away.

Where did that will-o'-the-wisp dream come from? What did it mean? I read that a dream is like a work of art. "For all its obviousness it does not explain itself and is never unequivocal. A dream presents an image in much the same way that nature allows a plant to grow, and we must draw our own conclusions" (Jung in Ross, 1987, pp. 520–521). I also remember a childhood image of a blue breakfast china plate that always set me wondering. It showed a pagoda, two birds in the sky, a boat in the foreground, a fence, a triple-arched bridge across which move three Chinese figures, and there too, overhanging the bridge, was a willow tree. From what were they retreating?

I also remember not yet being at school. Night after night, I waited in the dark for my father's heavy breathing to tell me that he was asleep

in their bedroom. Then I quietly eased out of bed, holding the mattress side down so that its springs gave no sound, and tiptoed across the cool floor into the hallway. My toes stuck to the cool brittleness of the lino and then unglued noisily as I tried to creep into their doorway. I waited silently beside my mother's side of the bed hoping she would sense me and stir. At first, she quietly let me slip into bed with them. I woke up in the morning between them, relieved that everything seemed happy and safe. At first, he didn't seem to mind. I was afraid of things I couldn't understand. But, as always, he changed his mind. It was forbidden. "He has to sleep in his own bed." She explained: "The boy's only frightened." Was it my fear of the dream?

He was always planning, perfecting schemes to keep everyone (and everything) in their place. And so he spread out double newspaper sheets flat on the floor as a black print obstacle race for me to "run." The gauntlet stretched from my bed down the hallway to their bed. In this way he could detect when I first stepped onto the floor and slowly began to make the crossing. "Get back into bed!" And then he blamed my mother. She had to give in and led me back—anything for peace. Some nights I still tried to inch rigidly along, muscle by muscle, alone in the moonlight. It seemed like hours. Then the paper moved treacherously under me. I gave up and crawled back into my bed. In the morning, still not satisfied, he inspected the newsprint trail for any disturbance in his orderly pattern. "Children should be seen and not heard." Once at school, I took refuge in a treehouse—but not for long.

I now contrast the effect, years later, of reading May's (1991) third person observation that "the triangular form of the perdurable relationship (between father-mother-child) is the ladder the child must climb as he grows in the world" (p. 75) with that of actually experiencing the loss of innocence. My exhibition of self-works confirms for me that a writer's "psychic disposition permeates his [or her writing] root and branch" (Jung in Ross, 1987, p. 518). I realize that the tree is a private symbol for me. It held me in the knowing. As Cooper (1978) explains, the weeping willow signifies mourning, unhappy love, and exile. But there is strength in weakness. The oak that resists the storm is broken. The willow, in contrast, bends and gives way. It survives and springs back into its former self when the danger is past. Fontana (1993) celebrates the tree as infused with creative energy that can be harnessed, allowing access to other states of being. A tree is a place of peace and refuge, even a symbol of the unconscious where there are secrets to be discovered and memories to be faced. I have found one such story.

My adult son always told me I was oblique. Augustine tried to avoid looking at himself by maintaining that we "are opaque to ourselves no less than to others. . . . We are not who we think we are" (O'Donnell, 1992, xviii). However, Augustine was forced to admit that his unspoken past had silenced him. That other life shut him down. Risking hubris, he accepted his self-consciousness and gave voice to it. As O'Donnell (1992) commented:

> Augustine's truth had eluded him for many years; it appears before us as a trophy torn from the grip of the unsayable, after a prolonged struggle on the frontier between speech and silence. What was at stake was more than words. The "truth" of which Augustine spoke was not merely a quality of a verbal formula, but veracity itself, a quality of the living person. Augustine "made the truth" in this sense—became himself truthful—when he found a pattern of words to say the true thing well. (p. xivi)

Transformation of teacher researcher-educator self consists of rebuilding our explanations of how classrooms and inquiry "work"—and especially how we construct our selves. Development consists of reclaiming voice and remodeling perspective. The metaphors of voice and review help conceptualize how we come to know (and not know). Using the device of an artist's exhibition, I am providing purchase on self and others, accommodating both my first and third person voices within my community of selves. Even as my concern in this chapter is with inquiry and development, my writer and reader selves can be seen to expand to include more voices, that is, the self I was in 1944, in 1948, in 1988, in 1993, the self I am now, and the self I want to become—all reaching out to the future from the present. If confinement and surveillance suggest a tower, the developing self is for me a branching tree that is built upon our observations of self and others. Through writing, the bark and the skein can be untangled but then reintegrated as an expression of an unfolding narrative of selves.

Our distinctive arts-based exhibits constitute and define us and our different kinds of knowledge. As self-analytical texts, they help us to gain a deeper appreciation of our experience by providing different kinds of developmental distancing—from close-up to long shot. These result from representing the tensions that writing inevitably brings. First, we delve more deeply into experience and explore its meaning from personal perspectives and second, we stand back to view and explore its meaning from third person or broader contexts. Through

reflective writing and conversation with self and others, we become more aware of "the lenses that we wear and [of] the minds that we wheel in, of our life histories and the influences which have shaped our thinking" (Holly, 1989, p. 22). Self-narrative and its review by self and others promote growth in the ways that we shape and experience "reality."

Self-reflexive, arts-based writing complements published, formal writing to produce a series of both academic and personal exhibits that go beyond existing levels of development. "Differences in author, time, situation, purpose, perspective and argument [can] lead to often striking contrasts in portrayal and interpretation" (Shulman, 1991, p. 394) of our understandings. The process involves the retrospective recognition of experience (or the inner life of meaning) that cannot know itself once and for all time at the moment of experience. The ambiguities and tensions in trying to balance and integrate experience produce gains in practice and in theorizing about it.

Mistakes and distortions in inquiry are avoided not by trying to build a wall between the observer and the observed, but by observing the observer-self and so "bringing personal issues into consciousness" (Belenky, Clinchy, Goldberger, & Tarule, 1986, p. 226). In this chapter, I have sought not to dismantle my past authorial stances but rather to appreciate what they were struggling to become and what was being excluded. I needed to reclaim and remember different sites for me to interpret myself as a series of evolving personal texts. After we have oriented ourselves among our academic and personal voices, with their separate and shared accents, and have listened for their distinctive characteristics, we then need to interweave these meanings into the treehouse of our discourse without distorting or cutting them down.

The danger of trying to attend to an exhibition or chorus of voices and then to provide for their collective treatment is that in the end nothing may seem complete or conclusive. The variety of writings may indeed seem to clash as in a cacophonous Tower of Babel rather than to blend together. Yet, without avoiding the challenge and without reducing the reader to a state of confused passivity, our unraveling skein and its representation should be "as difficult as it has to be to deliver its message in full" (Jackson, 1990, p. 6). In telling the story of the stories that we are told by ourselves in our different voices, we enlarge our developing selves.

Summary Comments

Teacher education and inquiry need to be refigured so that actual teaching and inquiring selves can be represented in authentic ways. Inquiry is developmental when it focuses on "the nature, formation and use of teachers' knowledge—the construction, reconstruction and reorganization of experience which adds to its meaning" (Day, Pope, & Denicolo, 1990, p. 2). When these processes are exhibited, they become available for scrutiny and renewal. Bakhtin (1981) describes voice as the "speaking personality [or] speaking consciousness" (p. 434). Britzman (1991) adds that voice also suggests relationships. The struggle for voice begins when a person attempts to share meaning with someone else, including aspects of self. Voicing involves finding the words, speaking for oneself, and feeling heard.

I have provided "mini-narratives with the narrator in them" (Geertz, 1995, p. 65). I used the writing and reading of self-narratives, their creation and interpretation, to study my development through an exhibition of five works. My curatorial intentions, feelings, thoughts, and acts are self-authoring constructs that are still becoming. The self as artist-author is not so much a single fixed entity as a shifting set of capacities or band of energy (Kozulin, 1991). In studying myself, I am learning to attend to and orchestrate my developing community of third and first person voices, encouraging them to appreciate rather than fight with or become segregated from each other.

While giving more adequate expression to the personal quality of knowledge is never easy, development depends upon it. Exchanges between freer, personal sensing and tighter, academic thinking provide space in which to compose more fully the "we that is me." When we write what only we can write and in our different voices, the "abyss from soul to soul" (Pessoa, 1991, p. xiii) and that between separate aspects of self, can be connected if not bridged by a concrete pier—or moonlight maneuver. By "going public" with the personal, we are taken out of ourselves, helped to see ourselves in new ways, and shown that we can become other than what we were.

I too needed to collect more pieces from along memory's edge for my peace garden. But recovering and elaborating on this self-site has involved a struggle not only with memory, ethical concern, and the writing, but also with the mechanics of producing the text. There were problems with formatting, disc errors, and corrupted text. Something was still stubbornly resisting my account of the willow tree that grew

there. In this chapter, I have tried to rescue my self-threads from the familially and consensually imposed fabric by picking them out. I am not seeking to destroy anyone's name or memory. I understand that some in authority are threatened by any show of resistance: today's treehouse refuge could serve as tomorrow's unruly fortress. In chapter 16, I sing out a shape poem of my surname, Diamond, not to raise a cenotaph to self but to express a latter day acceptance of that name as my own. Seeking a new knowledge of self, the arts-based narrator of self provides

> A metaphysician in the dark, twanging
> an instrument.
> The poem of the mind in the act of finding
> What will suffice. (Stevens, 1954, pp. 239–240)

References

Abbs, P. (1976). *Root and blossom: Essays on the philosophy, practice and politics of English teaching.* London: Heinemann.

Bakhtin, M. M. (1981). *The dialogic imagination: Four essays* (C. Emerson & M. Holquist, Trans.). Austin, TX: University of Texas Press.

Barthes, R. (1977). *Roland Barthes.* (R. Howard, Trans.). New York: Hill & Wang.

Bateson, M. C. (1990). *Composing a life.* New York: Plume.

Belenky, M. F., Clinchy, B. M., Goldberger, N. R., & Tarule, J. M. (1986). *Women's ways of knowing: The development of self, voice, and mind.* New York: Basic Books.

Bloom, L. R., & Munro, P. (1995). Conflicts of selves: Nonunitary subjectivity in women administrators life history narratives. In J. A. Hatch & R. Wisniewski (Eds.), *Life history and narrative* (pp. 99–112). London: Falmer Press.

Booth, D. (1985). Niietzsche on the subject as multiplicity. *Man and World, 18,* 121–146.

Borges, J. L. (1964). From allegories to novels. *Other inquisitions.* New York: Simon and Schuster.

Britzman, D. (1991). *Practice makes perfect: A critical study of learning to teach.* New York: SUNY Press.

Bruner, E. M. (1993). Introduction: The ethnographic self and the personal self. In P. Benson (Ed.), *Anthropology and literature* (pp. 1–26). Chicago: University of Illinois Press.

Calvino, I. (1992). *If on a winter's night a traveller.* London: Minerva.

Connelly, F. M., & Clandinin, D. J. (1990). Stories of experience and narrative inquiry. *Educational Researcher, 19*(4): 2–14.

———. (1995). *Teachers' professional landscapes.* New York: Teachers College Press.

Cooper, J. C. (1978). *An illustrated encyclopedia of traditional symbols.* London: Thames & Hudson.

Day, C., Pope, M., & Denicolo, P. (Eds.). (1990). *Insights into teacher thinking and action.* Lewes: Falmer Press.

Derrida, J. (1981). The law of genre. (A. Ronell, Trans.). In W. J. T. Mitchell (Ed.), *On narrative* (pp. 51–77). Chicago: University of Chicago Press.

Diamond, C. T. P. (1988). Construing a career: A developmental view of teacher education and the teacher educator. *Journal of Curriculum Studies, 20*(2): 133–140.

———. (1991). *Teacher education as transformation: A psychological perspective.* Milton Keynes, UK: Open University Press.

———. (1993a). Writing to reclaim self: The use of narrative in teacher education. *Teaching and Teacher Education: An International Journal of Research and Studies, 9*(5/6), 511–517.

———. (1993b). Gridding a grid: An artist reviews and comprehends his own exhibition. *Empirical Studies of the Arts, 11*(2), 167–175.

Dilthey, W. (1960). H. Rickman (Ed.), *Pattern and meaning in history.* New York: Harper & Row.

Fontana, D. (1993). *The secret language of symbols.* San Francisco: Chronicle Books.

Franzosa, S. D. (1992). Exploring the educated self: Educational autobiography and resistance. *Educational Theory, 42*(4), 395–412.

Gagnon, J. H. (1992). The self, its voices, and their discord. In C. Ellis & M. G. Flaherty (Eds.), *Investigating subjectivity* (pp. 221–243). New York: Sage.

Geertz, C. (1995). *After the fact: Two countries, four decades, one anthropologist.* Cambridge: Harvard University Press.

Graham, R. J. (1991). *Reading and writing the self: Autobiography in education and curriculum.* New York: Teachers College Press.

Holly, M. L. (1989). Exploring meaning: Biographical journal writing. Paper presented at the annual meeting of the American Educational Research Association, San Francisco, California.

Jackson, P. (1990). The functions of educational research. *Educational Researcher, 19*(7): 3-9.

Jung, C. G. (1961). *Memories, dreams, reflections* (Rev. ed.). New York: Vintage Books.

Kelly, G. A. (1955). *The psychology of personal constructs, 1 & 2.* New York: Norton. (2nd. ed., 1992, London: Routledge)

Kozulin, A. (1991). Life as authoring: The humanistic tradition in Russian psychology. *New Ideas in Psychology, 9*(3), 335–351.

Lejeune, P. (1989). *On autobiography* (K. Leary, Trans., P. J. Eakin, Foreword). Minneapolis: University of Minneapolis Press.

Mac Adam, A. (1991). Introduction. In F. Pessoa, *The book of disquiet,* pp. vii–xxxvi. (A. Mac Adam, Trans.). New York: Pantheon.

May, R. (1991). *The cry for myth.* New York: Delta.

Nietzsche, F. (1967). *The birth of tragedy and the case of Wagner.* (W. Kaufman, Trans.). New York: Random House.

O'Donnell, J. J. (1992). *Augustine: Confessions* (Introductory Commentary). New York: Oxford University Press.

Pessoa, F. (1988). *Selected poems* (J. Griffin, Trans.). Harmondsworth: Penguin.

————. (1991). *The book of disquiet* (A. Mac Adam, Trans.). New York: Pantheon.

Polkinghorne, D. E. (1988). *Narrative knowing and the human sciences.* Albany: State University of New York.

Renza, L. A. (1990). Influence. In F. Lentricchia & T. McLaughlin (Eds.), *Critical terms for literary study* (pp. 186–202). Chicago: University of Chicago Press.

Richardson, L. (1994). Writing: A method of inquiry. In N. K. Denzin & Y. S. Lincoln (Eds.), *Handbook of qualitative research* (pp. 516–529). London: Sage.

————. (1995). Narrative and sociology. In J. Van Maanen (Ed.), *Representation in ethnography* (pp. 198-221). London: Sage.

Rorty, R. (1982). *The consequences of pragmatism.* Minneapolis: University of Minnesota Press.

Ross, S. D. (1987). *Art and its significance: An anthology of aesthetic theory.* New York: SUNY Press.

Roth, Piermont, C. (1995, July 24). Twilight of the goddess. *The New Yorker,* p. 72.

Shulman, L. S. (1991). Ways of seeing, ways of knowing: Ways of teaching, ways of learning about teaching. *Journal of Curriculum Studies, 23*(5): 393–395.

Steiner, G. (1978). *On difficulty and other essays.* Oxford: University of Oxford Press.

————. (1996, January 8). Foursome: The art of Fernando Pessoa. *The New Yorker,* pp. 77–80.

Sterne, L. (1983). *The life and times of Tristram Shandy.* Oxford: Oxford University Press.

Stevens, W. (1954). *The collected poems of Wallace Stevens.* New York: Vintage.

Vidal, G. (1993). *United States: Essays 1952-1992.* New York: Random House.

Weedon, C. (1987). *Feminist practice and poststructuralist theory.* Oxford: Basil Blackwell.

Wheelwright, P. (1968). *The burning fountain.* Bloomington: Indiana University Press.

Woodall, J. (1996). *The man in the mirror of the book: A life of Jorge Luis Borges.* London: Sceptre.

Chapter 8

Signs of Ourselves:
Of Self-Narratives, Maps, and Essays

C. T. Patrick Diamond

In art there will be new form, and this form will admit the chaos and does not say the chaos is really something else. The form and the chaos remain separate. That is why the form itself becomes a preoccupation, because it exists separate from the material it accommodates. To find a form that accommodates the mess, that is the task of the artist now. (Beckett cited in Dipple, 1988, p. 93)

The stage manager [is] an elusive, double triple, self-reflecting magic Proteus of a phantom, the shadow of many-colored glass balls flying in a curve, the ghost of a juggler on a shimmering curtain. (Nabokov, 1941, p. xii)

A Travelogue of Words and Numbers:
My Self-Narrative

I find that I can best help teacher-researchers with their dissertations and inquiries by continuing to reflect on how I complete, "defend," and gain a measure of insight into my own arts-based research. My journey led me away from words to numbers but then back to words again. With the aid of guides and maps, I traveled from my beginning writing through confronting empirical procedures "to coming home" to arts-based narrative inquiry. In what follows, I represent and seek the grounds or terrain upon which I have judged these matters.

The Rift Under the Desk

As a child, I knew that my father would reject attempts to win his approval through success at school. I also learned that adults had "to be cruel to be kind." That began my difficulties with authority and

signalled my retreat into writing and books. I first got into trouble for preferring words to numbers in elementary school. It was my favorite day of the school week. We were allowed to borrow from the one-room library. I could never wait to start my new book. That day it was about "Indian" exploits along the Mohawk Trail. During the next lesson, after I had finished the allotted math tasks, I opened the novel only to be told to put it away. Undeterred, I completed all the problems in that chapter of the textbook and started reading again—but this time under the desk. Then I really "got it." "Who do you think you are? Greta Garbo? Do you think it's up to you to decide what you want to do?" This was shouted by what parents regarded as a good teacher.

After graduating as a day boy to a religious high school, I knew that I wanted to become a traveler. I spent the first weekend anxiously polishing up my first set "essay," a ritual form of homework. The topic was adventure. I worked hard to please my new form master—not to avoid the "hit parade" when we were strapped for making mistakes. I wrote about a bear attack (I had never seen one) and was surprised later when the teacher read it out to the class, analyzing its successes! He said that I had begun *in medias res* or in the middle of things, for suspense. I later learned that Virgil used this technique and even later that structuralists called it *analepsis*. My tacit knowledge of my own practice began to be replaced by explicit knowledge of rules and canons. It took 30 more years for me to learn that we know about an inquiry only by pursuing it, wherever this may lead. We begin by imagining what the issue is that we eventually want to address.

Criss-Crossing Tracks: Psychology or Education?

I completed my master's dissertation part-time over two years, while lecturing in English Language and Literature at a teachers' college. My supervisor (Professor C) was head of the University's Department of Education and chair of its Educational Psychology strand. I had already taught for five years after training as a high school teacher of English and history. One of the Bachelor of Education courses that I took with the head introduced theories of personality, including Kelly's (1955) psychology of personal constructs.

In my undergraduate studies and in later teaching, I was interested in what critics called the psychological novel. I was curious about the role of the narrator, especially in the work of Henry James and James Joyce, as they struggled to represent what William James called the stream-of-consciousness. This is a writing technique that represents the processes of a character as a work in progress. Extrapolating from Waugh (1984), I argue that a postmodern dissertation can provide a similar kind of life writing:

[It] self-consciously and systematically draws attention to its status as an artifact in order to pose questions about the relationship between fiction [or research] and reality. In providing a critique of their own methods of construction, such writings not only examine the fundamental structures of narrative fiction, they also explore the possible fictional nature of the world outside the literary text. (p. 2)

A dissertation can actively explore an inquiry through the practice of writing it. This is often most evident in the last chapter of a dissertation.

On the advice of the employing authority to "do something with learning in it," I had also taken courses in psychology, including the obligatory ones on statistics and experimental design. The head of the Department of Psychology was a testing expert from the army. He warned us that psychology was not the subject to study if we wanted to find out more about ourselves. I turned to the study of education. Ironically, Professor C was an expert on ecological (or "personless") psychology. But he had just been awarded a federal research grant to study the effects on schooling of the provision of high school libraries. His research (and hence my master's dissertation) focused on achievement motivation and independent study. We were externally rewarded for studying intrinsic processes.

Diversions, Pits, and Gullies: Doing My Dissertation

After being appointed to the same Department of Education as an English Curriculum and Instruction lecturer, I was enrolled in the doctoral program to keep the faculty numbers up. The course consisted entirely of dissertation and eventual external examination at a distance—no course work, no comprehensive examinations, no peer group of other candidates, no dissertation committee, no oral, just the candidate and supervisor for as long as it took. I wanted to look at how teachers taught writing (composition). After decades of writing research, I wondered how English teachers, including those that I had helped to prepare, could still cling to teaching formal Latinate grammar. Perhaps they could learn to see writing differently only by writing themselves.

My former English Curriculum and Instruction lecturer asked to be my supervisor. He was beginning to teach courses in social learning theory in Educational Psychology. After leaving for another university, he arranged for my supervision by a colleague (Professor E) who had just returned to the department. This professor had been a high school math teacher, a math curriculum lecturer in the department, a senior lecturer in psychology, a psychometrician in North America, and finally, had returned to Australia as a professor in teacher education and was a neo-Piagetian. He was distingushed by his interest in cognition

and latent partition analysis. Educational psychology had outraced all the other disciplines, even social science, in the "scramble to claim the mantle of educational research" (Barone, 1995, p. 178).

I began studying (measuring) how 93 teachers from 22 high schools construed the teaching of writing. My contribution to the research design lay in seeking to understand the teachers' practices by constructing 15 intensive case studies during the school year. I was advised to study also the effects of their pedagogy on the written achievement of their 372 students. It was only later that I recognized this as a requirement of the "process-product" story of teacher effectiveness research. In a sea of variables, numbers, and matrices, I clung to the raft provided by the actual words of the teachers as I interviewed them in schools. I wanted to understand their intentions and how these meshed with their practices. After five years, the so-called "data collection" was complete. Still lecturing in the same department, I had recognized the "natural breaks" in the numerous multivariate displays, and so turned in a final draft. However, with all its "non-significant differences," the research was not telling the teachers' stories. There was more that needed to be brought out from "under the desk."

After "the" dissertation was forwarded to the newly elected head, a sociologist, he made only two comments. My conceptual framework was too linear and I had consistently (and ironically) misspelled "hierarchical." Then some kind of shadow drama was played out against a paradigmatic or political backdrop. The dissertation was next forwarded to the former head (Professor C). He read it closely over the weekend and phoned to meet me. He advised that I should take another year to refocus and rewrite. I should "bite the bullet." What I had written read more like a measurement exercise than a meaning-based dissertation. I needed to go back and resurface my own implicit theories and those of the teachers. What had underpinned my major research decisions? Wasn't I really interested in Kelly's theory and in understanding teachers' constructs and why they taught as they did? I needed to take another year and backtrack to "re-search" more intensely the teachers' and my own perspectives.

I then reread Jimmy Britton's (1977) *Language and Learning,* which recast Kelly's theory and techniques. Professor E had introduced me to the work of Hunt, one of Kelly's master's degree students. As an exconceptual theorist, Hunt (1987) was to become a writer and activist in the area of teachers' renewal based on "inside-out" rather than "outside-in" approaches. I chose this pair of scholars to be my guides (and academic referees) for the next 10 years. Together with Bannister, the personal construct novelist and apologist, they provided me with guideposts.

If I had completed my first doctoral draft as a tourist who was just passing through, I resubmitted it as a traveler. It was not just that I

preferred working with words rather than numbers. I was learning to speak in my own voice and to resist having my intentions sacrificed to those of others. I had to find my own forms, negotiating other ways of representing classroom experience and that of my inquiry. The difference was also partly one of time. The tourist just wants the dissertation "done" and not to be "terribly bothered" by the process of internal change. In contrast, the traveler stays "out there," on the margins, pursuing inquiry as a way of life (Diamond, 1994). Research travelers and guides take responsibility for their processes, including intuition and imagination. This sector of the research landscape took me 10 years to traverse.

Many beginning travelers feel that their lived experience can be legitimated only by appeals to the published authority of others. They portray their ideas as just fitting in with the literature. In constructing various case studies of teachers' practice (and later my own), I realized that our actual practice outstrips our explicit theory. We do not have to wait to measure, or even to name, something before we can explore it. In the dissertation process, the candidates know best what they should look for, what questions they should ask, and what methods they should use. This is particularly so at the end of their studies. The process of getting to the end takes them through terrain that, while growing more complex and detailed, eventually becomes clearer as a whole—but never stable. They make it through the dissertation, with themselves providing the source of its best ideas.

Bridges: My Dissertation Supervision of Others

In his biography of Vygotsky's ideas, Kozulin (1990) described Vygotsky's doctoral essay on *Hamlet* as showing a reader-critic seeking to understand rather than to explain a play as a work of art. Vygotsky provided an existential case study of his own inner world as he encountered perhaps the most famous of all literary characters. He realized that inescapably we are our own best guides. Aspects of postwar Tangier confirm it as my metaphor for coming to know, charting our course, and for "getting on" with research. Arts-based narratives provide the sanctuary from which, as émigrés from rigidity, we can always launch fresh inquiries. No one, or any perspective, is declared outlaw and refused entry. Like Paul Bowles and the other nonfictional characters, research travelers have only to hear of a problem before they begin to consult and redraw their maps, planning new side trips that eventually become reality.

I no longer see a dissertation or a course in terms of linear movement along a path from point to point. Instead we spin our spirals

of development as "be-dazzling voyage[s]" (Daly, 1992). I work with individuals and with groups of dissertation students who form their own response or support trios. We also share courses on educational inquiry that focus on them as they prepare the proposal or complete the dissertation draft. Previously, I had labored over the doctrinal differences between psychometric, phenomenological, sociolinguistic, and narrative highways in the research landscape. But I realized that I too had to begin at the end of the sequence with what candidates already knew. We write arrival stories of how we came to our topic as chapter 1 of the dissertation. It is only when a task, such as completing a dissertation, makes human sense that we can carry it out successfully, finding new paths. To become arts-based dissertation travelers, tourists must first reflect on their personal knowledge and then improvise with artistic map-making.

Arts-Based Activity

Malinowski (1961) was an Austrian citizen living in Australia who avoided internment by leaving to study the Trobriand Islanders. What is the effect of his beginning his account as a castaway? "Imagine yourself suddenly set down surrounded by your gear, alone on a tropical beach close to a native village while the launch or dinghy which has brought you sails out of sight?" (p. 4)

Since so many candidates ask if what they are doing could really constitute "research," I now begin by asking them to consider themselves as if they were actual researchers and their proposal or dissertation as if it were research. To become more research-sighted, I have them draw maps of their dissertation journeys as if they were on strange islands and keep journals or logs, describing their inquiry practices and reflecting on them. They write in the first person about their preferred inquiry methods and explore how these reflect choices that in turn connect with their life histories. While discussing how personal and professional lives intersect, we use sentence starters, drawings, metaphors, and images to prompt narrative self-descriptions. Being blocked on a plateau is reconstrued as an invitation to take risks and follow hunches that we may have been resisting. We ask one another: "What do you most want to know about? What do you really want to do?" Such invitations help us put anxieties aside and clear a space for self-exploration and group collaboration.

By tapping into nonpropositional or storying modes of understanding to look for our distinctive narrative unities, new patterns are cre-

ated. Since different maps take us along different paths, we redraw or redirect our dissertation journeys. These maps can lead to a visualized pot of gold or a rainbow rather than to disaster: a hanged man ("just one more rewrite"); a wide Sargasso sea (always becalmed so that "nothing helps"); or an Ancient Mariner, eternally wandering as ABD ("All But Dissertation"). By redirecting our felt sense of the progress of the proposal or dissertation, we can check where we are and, if needed, change the tack we have taken. In our research story, we can change the character that we chose to play.

As a guide, I am interested in following previously hidden paths that take inquiry and the dissertation in the direction of arts-based self-narratives. These are reflexive genres in which self can be interrogated as the composing author. We ask of each narrative or dissertation chapter: "Who is (are) doing the talking?" and "How and why did this sequence of voices come about and to what imagined effect?" The recollected stories of how the candidates came to their topics and then pursued them provide important issues to be addressed as part of the proposal and dissertation. In the autobiography of his theory, Kelly (1969) describes "an afternoon with the obvious," during which he proposed that the activities of dissertation students provide a model for all inquiry. He construed students as personal scientists-novelists who use experiential approaches to self-inquiry.

Reviewing My Travelogue: "I Know You"

A happy landfall. In 1979, on the recommendation of my external examiners, Jimmy Britton (Goldsmiths) and Janet Emig (Rutgers), I was awarded my doctorate. The three-page abstract, like the dissertation, was still written in the third person, in the past tense, and in the passive voice. It now reminds me of a plot for a campus novel with a cast of shadowy players. What had seemed like a clash of personalities I now recognize as tension between different research agendas, epistemologies, and orientations. However, any map provides only an approximation to knowledge. I am still trying to understand the dilemmas that my inquiries provoked for me. Compared to the original dissertation of 559 pages, I prefer a recent two-paragraph account that I gave in a chapter on teacher change (Diamond, 1993b). Jimmy was again my respondent.

If an inquiry does not have a distinctive tone, it might well have been written by some Artificial Intelligence, lacking any informing

sensibility. I remember as a child wondering who "Anonymous" was. Sections of my dissertation still seem as though they were written by nobody in particular. It was as if I had undertaken sectors of the dissertation journey *incognito*, wearing dark glasses. But "the events of this world do not march up to us single file, [and] differentiate themselves by announcing their names. . . . [Our] task is to pull [our] innermost experience apart and then to put it together again" (Kelly, 1969, p. 196), as best we can. Self-inquiry into the world of our experience provides an arts-based metaphor for education, wherein knowledge of the world is yielded through knowledge of the self. If everyday experience provides an ideal context for the construction of knowledge, self-narrative helps contain and convey the character of that encounter.

I now respond to my latest self-narrative (Diamond, 1994 and above) by realizing that I charted it largely in terms of "first" experiences. These included first getting into trouble in elementary school for preferring words to numbers; anxiously preparing my first high school composition; completing the first "final" draft of my doctoral dissertation; following Kelly as he attends to the Edenic story of our first parents (see below); and my first beginning to experiment with first person accounts. By passing through my narrative, the word "first" absorbs the deeper meanings of the various parts of the story, including that of aloneness. As Kelly (1969) suggests, the most important things in life are mostly those that have never happened to us before. At such crossroads, the similarities and contrasts between our drafted anticipations and their actual realizations stand out with inescapable clarity. First-time occurrences can be of developmental and not just traumatic significance. To test possibilities that may exist in the uncertain future, we seek the adventure of first-time experience. We have to make our own way, creating our different paths by walking them.

A self-narrative can be appreciated not only as a conglomerate in which each construct or word deserves attention, but also as a complete landscape. We file, join, and hone events to fit the pattern of our mini-narrative. My previous lead story can be understood as one of self-invention through education. Loss of innocence was replaced by a belief in independent bootstrapping. The "heroic" account was one of choosing to live through understanding rather than through conformity. In the Kellyian tradition, I construed the relation of self to knowing by presenting myself as a resourceful and self-reliant person, making the best of adversity. Repeated trials had to be overcome by my

efforts. My self-narrative was then about tending toward a rational end—I tried choosing to create my own future through how I anticipated events and then revising them in light of how they turned out. The events were subverted by my story of transcending rejection through the adventure of self-discovery.

My narrative functioned as a form of self-presentation. Details in the story expressed, confirmed, and validated my identity at that time. I turned to helpful mentors until I could father myself and others. My quest was to expel the gatekeepers and to cast out their unreasonable tablets. But knowledge is not given away. It is won by hard journeying. As Vidal (1993) warns, it is clearly unreasonable to expect to be cherished by those we oppose: "It is also childish . . . even to expect justice One can only hope not to be destroyed entirely by injustice" (p. 32). Like Rockwell and Roth (see below), I sifted out the details and pieces that did not fit to my previous self-image of being thwarted and underappreciated. Because instances of help and understanding failed to fit that narrative pattern, I omitted them. Self is complicit in the stories it shapes.

If I escaped some of my previous limitations by telling stories rather than by providing scientific reports, I encountered new ones. My self-inflating plot of a narrator being tested as if on a dragon-slaying journey, only to emerge victorious, is a cover version of Homer's heroic *Odyssey*. Such a macho story dedicated to self-determined, individual linear progress toward regaining paradise has traditionally defined what made for a meaningful life. In more domestic accounts, the female narrator is either relegated to an inner spiritual journey or is tested in love and daily matters and dies tragically (Conway, 1992). Neither map is useful anymore. In my stale and bookish self-narratives, the metaphors of gaining knowledge were not those of scattered seed on fallow ground but those of active building (construction, reconstruction) and road-making (routes, channels, streets, paths). As shown in figures 12, 13, and 14, my metaphor is becoming that of fragmented postmodernism (textual doubling, pulling apart and putting back together again, and chaos). I am also trying to include other aspects of the postmodern self such as intuition, imagination, and creativity.

Freud (1959) provided a compelling self-account of what his mind struggled to represent and understand in his sleep. Some parts of self have to be left "obscure—a tangle of dream-thoughts which cannot be unravelled. . . . This is the dream's navel, the spot where it reaches

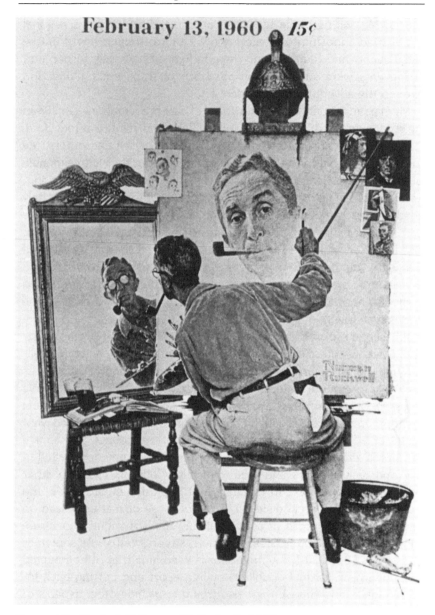

February 13, 1960 15¢

Figure 12 *Triple Self-Portrait* (N. Rockwell, 1960)

down into the unknown" (p. 525). Growing upward like mushrooms, these parts can have no definite ending, branching out in every direction into our lives. In the quest to realize as many selves as possible,

Figure 13 *Metaphor of Knowledge* (K. Mantas, 1998)

"wild dreams are perhaps the best you can do in plotting the future" (Crites, 1986, p. 166).

Arts-Based Activities

1. Keep a dream journal over one week. What do you dream about teaching and educational scenes?
2. As in a Taoist or Borgesian story, you wake up after dreaming that you are a butterfly. You do not know whether you are yourself as a teacher dreaming that you are a butterfly or a butterfly dreaming that you are a teacher. How will you decide?
3. Who in the past used to admonish you to "wake up to yourself!"? How would you now answer them?

Figure 14 *Metaphor of Transformation* (K. Mantas, 1998)

Spying the Self-Inquirer

Using the earlier self-narrative as a lens, I now theorize postmodern approaches to inquiry and the self. The postmodern self defies linearity and prescription. Living without consistency and often in chaos, it pulls apart experience only to put it back together again in new and different ways. In contrast, the modernist unitary self is romanticized

as "that familiar interior voice that appears . . . to be so consistent in its accents, as that center of consciousness that appears so consistent in its point of view, through all the transactions undergone from childhood to the present" (Crites, 1986, p. 156). But self is neither an underlying essence awaiting discovery nor an unwavering call-sign being beamed out from radio station SELF. Self is composed of an individual's changing internal conversations, recollections, forecastings, hopes, and voices. This number of voices weakens not only the singularity of the self but also the hierarchies of other voices. In the postmodern moment, we accept, like Barthes (1977), Beckett (1979), Derrida (1981), and Nietzsche (1968), that we live without consistency, often in chaos. Rather than serving as a haven, even language and translation turn into just another labyrinth of criss-crossing paths (Wittgenstein, 1958). You approach the self or place from one side and know your way about; you approach from another side and are lost.

Even as Beckett was switching from writing in English to writing in French, Nabokov made the opposite move from Russian to English. In Nabokov's (1941) first novel in English, *The Real Life of Sebastian Knight*, we are warned that none of us can be "too certain of learning the past from the lips of the present" (p. 52). In form, self is a Proteus-like illusion that precariously stage manages itself in the process of becoming. Nabokov's biographer-narrator, a benighted half brother, shows how the "real" life of the dead fictional novelist, Sebastian Knight, can never be fully known or recreated from any perspective, not even from that of the writer. Even our own thoughts and feelings clothed in our own words and forms can never more than partially represent the *terra incognita* of self.

In a less carnivalesque encounter, Walsingham, the Elizabethan spy master and Machiavel, angrily rebuffs the young playwright, Marlowe, who pretends to act the compliant informer. Walsingham spurns his creature: "You know nothing, a boy at his books. You understand nothing. . . . Ignorant of all but the staleness and dust of libraries. I know you, fool" (Burgess, 1994, pp. 102–103). As the fictionalized Henry Adams shows as a detective in Panama and Paris (Zencey, 1997), educators may also be led astray by closed, bookish ingenuity. Over-civilized sensibilities may seem helpless when confronted by an alien culture, whether that of the postmodern house of the unstable or that of power politics. But we must go on.

As educators, we may be dismissed as child-like among adult professionals. We are removed from the worldly uses of power as expressed in state conquest and double-dealing. But, like artists, we are

not so innocent of those uses of power that are won through experiments with aesthetic forms, including language. Our perseverance and self-reflection serve us well in a fragmented and allegedly nonrepresentable postmodern world that requires that daringly new maps be drawn of the troubled terrain. Somehow we must find an opening, a way into the self. As above, using arts-based approaches and topographical analogies, I presented my review of my knowledge of self as a journey through different landscapes (for water voyages, see chapter 3, and for peace gardens and treehouses, see chapter 7). The form of self-narrative (Gergen & Gergen, 1984) or the narrative of the self (Richardson, 1994) consists of the author's telling signature stories about his or her lived experience. A paper man or woman.

Barriers to the Self

Our first person voice is a powerful device for describing experience. But such a voice continues to be challenged and even censored by third person demands. Even in the scholarly community, some may still find it difficult to accept self-inquiry. Conversely, even when writing in my own voice to consider my authoring processes, I feel I must satisfy academe and yield to its surveillance. (For details, see "Patrick's self-narrative," chapter 9.) I feel constrained to invoke its bookish authority. Politically, I may have to if I want others to entertain the proposition that writing a narrative inquiry for course credit, graduate degree, publication, or tenure does not preclude opportunities for transformation of self.

Foucault describes juries of examiners as able to turn a dissertation defense into "a blood sport [where] the candidate is often the excuse for settling old scores" (in Macey, 1993, p. 111). Unpublished academics are also cut off and silenced. I have found neither depiction an exaggeration. However, the dominant story of ourselves that others may impose on us cannot do justice to the quality of our personal experience. Much will be left marginalized, without shape or expression. Parts of the spectrum of our actualization are then diminished. In a narrative of self, possibility is expanded as we blend third and first person voices, complementing the detached assessment of reflection with the intimacy of self-report. A demonstration is provided in chapter 7 of my own third and first person voices with respect to this tension.

Even though general truth claims are less easily validated now and even though speaking for others is presumptuous, writing the self

experimentally may seem a luxury open only to those who already have tenure or an assured academic reputation. In Pinar's (1994) view, "death [even] in a tenured position" can occur when imagination and the ability to experiment intellectually have been seriously repressed. He creates an analogy between academe and the city wherein those who belong to the "inner city" are autobiographers and young scholars for whom the "suburbs" represent status and stagnation. Amanda Cross's (1981) detective story, *Death in a Tenured Position* (in Pinar, 1994), provides Pinar with not only a chapter title but also a characterization of defeat and fatality that comes from personal events in addition to political and economic ones. Writing becomes a lifesaver in this context, and it can prove to be both strategic and developmental. Once we know how to stage a dissertation or a journal article rhetorically, we are more likely to have it accepted and gain the rewards. When we raise the curtain on the processes of scholarly work and research, they are demystified. Acting as our own intermediaries, we carry our distinctive meanings into public spheres, acknowledging and nurturing them.

When we do not conform to an existing paradigm or to journal editors' notes of advice to contributors, the rites of passage may be strictly enforced. Some academic gatekeepers may doubt that there can ever be a place for the self in the scholarly text. But focusing on self is not just tedious, confessional, and privatizing. In fighting for self-autonomy, we have "to learn the rules extremely well in order to break them with precision" (Daly, 1992, p. 75). But then, rather than following a pattern or a certain rule, we have to draw our own lines (see chapter 3). By putting the self deeply back into the text and by allowing the author to move in and out of it, we are not courting domination by a runaway self: "No one is advocating ethnographic self-indulgence" (Bruner, 1993, p. 6). Other emerging arts-based narrative readers, as well as ourselves, need to work out the distinctions between self-indulgence and necessary revealment as each context warrants.

Postmodernism and Reflexivity

Postmodernism comes down to many things, especially reflexivity—how much of it and in what form it should appear. For Marcus (1994), reflexivity is associated with "the self-critique and personal quest, the experiential, and the idea of empathy" (p. 568). The postmodern period in social science is recognized as "a movement away from grand

narratives and single overarching ontological, epistemological, and methodological paradigms toward qualitative studies" (Lincoln & Denzin, 1994, p. 575). Postmodernism offers a form of "critique" thrusted "at deconstructing Western metanarratives of truth and the ethnocentricism implicit in the European view of history as the unilinear progress of universal reason," as well as "a site of both hope and fear" (Kincheloe & McLaren, 1994, p. 143). As reflexive inquirers, we accept that we are not objective, politically neutral observers standing outside and above our texts. Instead, we study the complexity of experience from the perspective of those who live it. Narrative texts require a high degree of self-referentiality and intertextuality (Hutcheon, 1984). As I show in the above self-narrative, self-awareness is an ongoing idea that a person constructs and in the context of others. It does not exclude sensitivity to relations of power and conflict. Development, as of an educator self, requires an ongoing effort that involves the synthesis of many different ideas about the self and its multiple facets into an overriding but provisional reading.

Different levels of abstraction and control can be attained through self-awareness. The process of self-narrative is analogous to examining a complex series of prism refractions (see chapter 3). Although the experience of self-reflection may be meaningfully ordered, the structure of that meaning is elusive. The activity of consciousness is in constant flux and presents itself only fleetingly. Direct engagement with experience can be supplemented by relocation of self to a vantage point that is removed from the experience. I needed to review my own self-narrative by writing about it. A written report of the process requires that the observation of actual experience be even further distanced by being described.

Writing affords many promising possibilities, including that of experimental self-representation. But, just as knowing is a constructed form of experience, writing does not communicate a pure image of meaning. It does not simply duplicate nor distort what is. Instead, writing provides a method of inquiry, a way of knowing, seeing, and understanding, a method of display and analysis, and a form of development (Richardson, 1994). Unlike classical ethnography, the narrative of self uses the techniques of fiction to catch hold of, but then to free, the experience. We seek, however temporarily, to satisfy requirements for arts-based authenticity and empathy rather than those for once-and-for-all-time causality and definition.

Self-narrative is frankly intersubjective and fragmented. As Norman Rockwell's (1960) triple self-portrait illustrates, the self can be glimpsed

by gazing into a mirror to witness what we are doing when we name and define our selves (see Figure 12). In a complex series of self-portraits, Rockwell depicts himself as the artist sitting on a stool in the foreground with his back to us. He is watching himself in a mirror while he is working on a self-portrait on the canvas that faces us. Exemplary self-portraits by other artists look down at him. Preliminary studies/sketches lie discarded beside him. But which of the various images of the artist is the "real" Norman? And likewise, which are the "impostors"? Rockwell's composition depicts Norman as a multiple image-set. His self-perceived visual identity is presented as an accumulating pattern of self-construction—past, present, and becoming. Like painting, self-narrative provides a lens for the reconstruction of our experience rather than a simple window opening onto reality.

Updike (1993) warns those readers who feel that there has been too much of Philip Roth (1992) in his recent fiction that, in *Operation Shylock: A Confession*, there are two Philips! The first is an aging writer in New York who hears from friends in Israel that another Philip Roth is to deliver a lecture on Diasporism in Jerusalem. After a sleepless night, Philip I telephones Philip II and, upon inquiring if this is Philip Roth, is told "it is, and who is this, please?" This is the question that we must each answer in our life: "Who and what am I to my self?" As in my self-narrative above, we also ask "who is the 'I' that attempts to provide an answer?"

These examples of "self-on-self grapple" (Updike, 1993, p. 109) suggest that constructs of selfhood may be reformed to revitalize experience. When the writer self reflects on the incidents of the topic under investigation, the writing self becomes the Other in its own text. Self is then enlarged so that the meaning and contents of experience are dialogized within and between aspects of ourselves and others. By including this range of experiences the writer establishes partial warrant for a subjectively mediated account of intersubjective meaning, avoiding solipsism. But the tensions surrounding the individual and the coconstruction of knowledge are not easily discharged.

Arts-Based Activities

1. How do you think you get to know something? What is a metaphor that you might use to describe the nature of knowledge and the process of gaining it? For some, "knowledge exists to be imparted," like a puffball waiting for a breeze to blow its seeds onto passively waiting, fertile ground. In figures 13 and 14, Kathy Mantas (1998) depicts the learner educator as holding

and gazing into his or her own crystal ball of knowledge. It is seething with energy and then explodes into transformation. What are the implications both of these different "puff or crystal ball" metaphors and of metaphoric thinking in general for teacher education? As used in this and the previous chapter, writing is the visual doubling for voice. Linear text is the simulacrum of speech. Voice and writing provide a sensory metaphor for finding and situating knowledge.

2. What happens if we see gaining knowledge in terms of getting "in touch" (Richardson, 1994) with, finding our own lost cities, or, using Pinar's (1994) metaphor, finding an inner city and suburbs?

Methods of Self-Inquiry: Planting Markers

As shown in the previous self-narrative, the writer's epistemological position informs an inquiry and determines the forms used. A researcher's theoretical frame(s) and ideological assumption(s) condition how phenomena and data are understood (Kincheloe & McLaren, 1994). The etymology of method can be traced to two Greek words, *meta* (after) and *hodo* (pursue). Method is the means that we use to go after knowledge. In the context of map-making, ways of knowing are depicted as research strategies, consisting of outlines of investigative journeys that lay out previously developed paths (Polkinghorne, 1989). When followed, these paths are supposed to lead to final knowledge—but this is an illusion. As Polanyi (1994) argued, "no explorer in history has ever discovered a new land that was already served by a highway" (p. 13).

The traditionally used paths are themselves taken from larger maps of assumptions about, and commitments to, the fundamental nature of knowledge and the processes of human understanding. Each of these systems of thought provides an interpretive framework for constructing a version of reality. Accordingly, in research based on natural science, we limit ourselves to mapping the physical world, seeking to locate objects and things, and measuring them "exactly." The purpose of these paths is to avoid the distorting influence of personal perspective and any complication of subjective properties. All we have to do is to follow the positivist trail.

Self-narrative inquiry is not so much a search for truth as a never-ending reconstruction of telling, based on arts-based approaches. We

seek to chart those previously forbidden features of the terrain. Rather than providing precise descriptions of what to see, these maps suggest promising directions along which we might look and then stroll. When our encounters produce a meaningful and understandable flow of experience, what we experience is produced by the action of our organizing schemes on the components of our involvement with the world of teaching and research. Using our schemes as expressed in story form, we can map and remap personal experience as it evolves.

Although there are similarities between the constructs of map and narrative, narrative has a distinctive advantage in that it emphasizes temporality, order, and sequence. This permits us to inquire into the experiences of self, both in the context of others and as developing over time. We construct readings of our meaning-making processes and give them direction through self-narrative. This renders experience as fleeting and instantaneous, occurring at the meeting point of the person and reality. We do not just experience the world. We experience ourselves in it. Self-narrative is especially useful for promoting reflection on, and change in, self.

Arts-Based Activity

Find a passage in a novel or poem that deals with maps or terrain. Beckett (1979) warns us not to set too much store by the seeming permanence even of the landscape: "The slopes are gentle that meet where he lies, they flatten out under him, it is not a meeting, it is not a pit, that didn't take long, soon we'll have him perched on an eminence" (p. 330). McHale (1987) describes our condition as "a sliding state of affairs, one that revises itself before our eyes. . . . A world of fixed objects is given and then taken away, . . . simultaneously laying bare the process of world-construction" (p. 101).

The etymology of narrative can be traced to the Latin *narrare,* to relate or to account, which derives from *gnarare,* which is related to *gnarus,* knowing or skilled, which in turn is related to "to know." In narrative, we distinctively emphasize the ways in which we experience and interpret our meaning-making. Because experience consists of the active reception and invention of the self and the world by the processes of consciousness, we arrange experience into sequences that are made coherent across time by what we perceive to be their endings. The selection and arrangement of these events depend for their meaning upon these conclusions. Because the point of a story can change depending on subsequent events, there is always the pos-

sibility that we may need to rewrite and update it. The whole story of our realm of meaning is enlarged not only by the new experiences that it is continuously configuring, but also by its own refiguring processes (Polkinghorne, 1988).

Exploration into these features of consciousness provides a playful and experimental way of engaging our understanding. By "storying" we acknowledge that, rather than being discovered, experience depends on our constructions of reality. Our versions of self are also invented on the basis of these personal constructs (Kelly, 1955). Each of these functions as a channel for establishing a personal orientation toward the various events that we experience. Although the network begins by being flexible and open to frequent modification, it becomes rigid over time. When we forget that more than one ending is possible, the range of action that is allowed becomes restricted rather than facilitated. We merely follow the well-trodden network that our scholarly traditions and our previous understandings have laid down. When our constructs operate mainly as walls, they limit our thinking and experience. We have little access to alternative story lines offered by other research maps, other people, and by our other possible selves.

Until we remind ourselves that all avenues are laid down only as temporary staging points, we cannot strike out in any new direction through the chaos. All our constructs are devices that we and our paradigms make up in order to achieve a purpose. This end acts as the organizing theme of the narrative. However, more than one plot can provide a meaningful constellation and integration for the same set of events. Different organizations or selves change the meaning of individual events and their contributions to that narrative pattern. By incorporating the same kinds of events into different types of stories, we change their meaning. Renewed reconstruction of any sequence, including that of the self, requires that we strike out across the terrain, carving out new byways off the beaten track.

It is not easy, as I found above, to lay a fresh narrative over what has been previously unchallenged. However, when we recognize knowledge and our self as no more than sets of guidelines, we can begin to recast both. When we use aspects of our selves as the "data" in forming constructs, "exciting things begin to happen" (Kelly, 1955, p. 131). Conceptualizations can change. When constructs are recognized for the control that they exert on our behavior, we no longer have to accept the past and can design the future. Development requires that

we continuously adjust to the changing scene by composing a succession of self-narratives. We can then seek to reconstrue our development in terms of writing and reading the self as a text.

Each self-text can be interpreted as a shaped form, and each self as an artful author. Rather than serving as an advertisement for "sweet self alone," self-narrative is a device for projecting continuity first upon a lifetime of experience but then interrogating it. To speak of the experience of self, we use a diversity of voices, genres, styles, and texts, including the author's narrative; stylized versions both of the everyday speech of participants and of semiliterary everyday narratives (letters, diaries, and journals); and extracts taken from other authors who have contributed to the literature (Bakhtin, 1981). This multiform, novelistic expansion transforms the essay into self-narrative (see below). We widen the range of usual content and strategies by adding personal voices and self-reflection. Like others, I use the term "autoethnography" (Diamond, 1992) to describe this form of reflexive inquiry. For those following the old story, this story may seem messy and "off the map."

As the remembered past, the network of self is situated in relation to the present in which it is recollected. The process of reflecting on the past requires the art of composition, which may involve differing degrees of self-deception (see my revised reading of my dissertation journey above). The "I" who now says "I" actively forges, gathers, and recollects its continuity of experience out of the intersubjective stream of memory. As in a zigzagging dot-to-dot, narrative joins remembered episodes from my developing points of view as I recall and recount my "I." This set of personal perspectives situates my story and distinguishes it from others, anchoring my selves as they pass through time.

In Coetzee's (1986) *Foe,* a female castaway joined Robinson Crusoe on his island. Upon returning to London, she offered to share her story with Foe, a ghostwriting biographer. She objected to his seeking to "spice up" events. This is a literary illustration of how a narrative can be appropriated by others, such as critics and cowriters. But how can anyone proceed? As Foe explained, when we are confronted by a maze of doubt and disappearing memories,

> the trick is to plant a sign or marker in the ground where I stand, so that in my future wanderings I shall have something to return to, and not get worse lost than I am. Having planted it, I press on; the more often I come back to the mark (which is a sign to myself of my blindness and incapacity) the more

certain I know that I am lost, yet the more I am heartened too, to have found
my way back. (pp. 135–136)

Although "there [is] no milepost from which all other mileposts
[are] measured" (Zencey, 1997, p. 252), in writing about self and in
responding to self-accounts we can leave some token of ourselves.
Our search for a way out of our present constructions can start from
that point. We can return to it as many times as are needed until we
can move on to compose a new narrative identity. But we are never
finally saved. In my previous self-narrative, I used two of my papers
(Diamond, 1988, 1993a) and a book chapter (Diamond, 1994) as
markers to return to in this travelogue. In chapter 7, I incorporated
these works as exhibits in an art gallery opening.

Finding the Form: Messy Essays

Phillipson (1989) uses the undelivered letters of a fictional *alter ego*,
Ethelred Ameurunculus, as paths that lead to the diagnosis of the death
of modernity and to that of the emergence of postmodernity. Letters
promote intimacy and self-disclosure since they are intended origi-
nally only for the eyes of a specific recipient. But the Ameurunculus
letters simply never get through. Writing to post-phenomenological
and post-structuralist writers as a post-man, he explores the condi-
tions of making and responding to the arts. In his post-sign to Derrida
(Jack Derippa), he portrays the postmodern funhouse as "nothing but
a field of forks, criss-crossing tracks, off-shoots, diversions, gullies,
rifts, faults, unmappable . . . terrain without boundaries" (p. 143).
 In the world of knowledge, Serres (1982) similarly spies "pits, faults,
folds, plains, valleys, wells, and chimneys, fluids like the sea and solids
like the earth" (p. xxii). If local relationships and bridges can be iden-
tified in some places, fractures and discontinuities are found in oth-
ers. These ruptures provide for new movement or diversion.
Postmodern mapping "involves the practical reconquest of a sense of
place, and the . . . reconstruction of an articulated ensemble with
which . . . the individual can map and remap the moments of mobile,
alternative trajectories" (Jameson, 1984, p. 89) of a self and its pas-
sages. Rather than trying to walk out of the landscape as soon as
possible, guides linger to discover what the surrounding woods are
like and why some paths are accessible and others are not. Arts-based
inquiry requires us as terrain dwellers to make and walk new paths. I
am seeking to remap and reterritorialize my knowledge so that it re-
flects more of my selves.

The incapacity to map professionally is as crippling to a teacher-researcher's experience as the analogous incapacity to map spatially is for urban experience. In this discussion, I have theorized self-narrative as one of the useful maps that is available for searching experience for meanings. I next contrast phenomenological approaches to map-making in social science with arts-based narrative inquiry to invite deeper levels of personal engagement by both writer-inquirer and reader. The self-study of my development was provided above.

In order to confront issues of postmodern knowledge production, innovations in form are called for, including narrative mappings of self. Such a representational strategy helps locate and illuminate the person in relation to his or her situation and its demands. Marcus (1994) describes the mark of such forms as "messy, many-'sited' ness, [with] a contingent openness as to the boundaries of the study . . . whose connections by juxtaposition are themselves *the* argument" (p. 567). These are arts-based mappings within the sites in which the object of the study (in this instance, the inquiring self) is defined and among which it circulates.

The territory that defines the object of study, the self, is mapped by the self-ethnographer, who is within the landscape, moving and acting within it, rather than from any transcendent, detached point of view. In contrast to "special pleading, self-indulgence, or a genius act" (Marcus, 1994, p. 567), these texts consist of a struggle with conventional form to provide new cognitive mappings. They are messy because of their open-endedness, incompleteness, and uncertainty as to how to draw the text and its analysis to a close. In contrast to positivist maps that seek to eliminate the distorting influence of personal perspective and subjective properties, arts-based mappings are far less complete, encouraging us to use judgment differently in order to identify rifts in the landscape worthy of further discovery (Lincoln & Denzin, 1994).

In the narrative of self, the indigenous ethnographer studies the stories that the self tells itself about its self. The possibility of selfhood is taken seriously and, however inaccessible, its own sort of force is assayed for appreciation. Essayists use reflexive self-narrative as a strategy to carve out what Kelly (1955) describes as "new conceptual routes" (p. 128) through the vastness. The essay of self, putting itself together, enables the mapping and review of a lifetime of emerging meanings. Because of its novelty, Kelly's (1955, 1969) own mapping of, and his later essays on, the psychology of personal constructs were often dismissed.

To the puzzlement of some, Geertz also used the form of the essay for conveying his sense of method and craft in ethnographic understanding. He found that "for making detours and side roads nothing is more convenient" (Rosaldo, 1997, p. 30). The terrain covered includes local points of view and their context. Geertz supplemented collectively formed self-understandings articulated in local vernacular terms, the "experience-near," with analogies and other reflections, the "experience-distant" (Rosaldo, 1997, p. 31). Culture channels emotions into knowable forms that the individual then expresses. The self is a site of conflict, dialogue, and change.

The essay is returning to inquiry as the most flexible and inclusive of literary forms. Theophrastus, Cicero, Seneca, and Plutarch wrote essays long before the form took its name from Montaigne's *Essais*. The exploration of self and personal responses are the essayist's main points. The often whimsical question posed of the self-portrait is: "What do I know I know?" But in meeting self, we meet everyone else. As Montaigne found, "each man bears the entire form of man's estate" (Vidal, 1993, p. 519). Vidal himself is a movie and television writer, playwright, historical novelist, and fantasist. As a distinguished essayist, he is heir to Hazlitt and Lamb. Like them, he uses the personal essay to provide a witty and informal discussion of a topic rather than to persuade us to accept a proposition, as in a disciplined treatise. Vidal's (1993) essay, "The Twelve Caesars," written after he had re-read Suetonius, is not so much about American presidents as about our common humanity and the effects of power. Though "the best sort of memoir [or self-study] is entirely to the one side of the mere facts of a life" (Vidal, 1993, p. 432), the essay is not just a diverting entertainment.

The narrative essay juxtaposes fragments without hierarchy or final synthesis. I previously used self-referential works (see chapter 7) to illustrate my reconstruction of self as a writer and reader. The first is a cautious attempt at self-narrative (Diamond, 1988), while the second (Diamond, 1993a) originally used a letter to self to reconsider the former attempt. In the third example above, I revisit and shape my mappings along intertwined and partly named paths (Diamond, 1994) as a narrative essay. This set of conceptual tales led me to my present position from which I seek to account for my individually connected meanings. But there is always the danger that I may again lose nerve in the face of opposition, retreating to an expository form so that self is yet again secreted and sanitized.

Reading the Self

After obtaining accounts of our own experiences, we can interpret and reconstruct them. Bringing out the implicit meanings of a narrative requires that the self-researcher approach them in terms of intention and shared context. Searching for the lived structures of self depends more upon the insights of a particular reader than upon some known hermeneutic procedure that can be specified and standardized so that it can be communicated to others for their enlightenment and its duplication (Giorgi, Knowles, & Smith, 1979). Through personally organized thematization and explication, awareness of a complex self becomes more explicit and formulated. These self-understandings are based on, and so should not lose touch with, concrete examples of our experiences. They help us discover and illuminate the meanings of the original, reported experience of self, and to appreciate them. Although never conclusive, personal findings are of human interest.

Kelly's mapping (1969) offers just such a way forward, for example, for the reconstruction of the story of the Garden of Eden. He discussed this as an exemplary tale of self-knowledge and education. He first asked how the events of the story could be understood. He assumed that, since constructs are, psychologically speaking, personal contrasts, the grounds upon which the Biblical author judges matters had to be sought first. Rather than looking for motives, Kelly looked for the paths of thought laid down by the writer as a way through the events. Acting as reader-writer, Kelly had to decide which happenings were noteworthy. The personal choices of both writer and reader are spelled out in terms of their formulations. If natural science approaches have been reluctant to map things like self-awareness because they cannot have a finger exactly put on them, a story is just the sort of existential phenomenon that an arts-based approach can look into and make something of.

Kelly projected three major constructs upon the biblical account: loneliness versus companionship, innocence versus knowledge, and good versus evil. For him, the central theme of the story is that once the choice was made to leave the Garden, existence could no longer be taken for granted. People must ever after create their own futures by the ways in which they anticipate and prepare for events. Our texts take hold of reality, expressing and shaping it. Kelly (1955) modeled the analysis of written language as a means of understanding an author's understandings. As writer-readers of self, we can look at how we choose

the words, and how they are qualified and then redefined by our personal lexicon. We need to be especially alert to the implied equivalencies and contrasts between these terms, that is, to our constructs. Another of the distinctions that I found in my 1988 paper, "map versus territory," guides the present chapter. If our constructs are active in meaning making, the construction of text acts in turn upon them.

Arts-Based Activities
1. Compile and alphabetize a list of things you like about your teaching and then another of things you would like to change.
2. Write about an event involving childhood loss or gain that later affected your teaching. Rewrite it from the point of view of another of the participants.

The topic of my 1993a paper was teacher development and that of my 1994 paper (see above) was writing a dissertation. Each text enabled me to revisit and better come to terms with my developing selves. I shared my self-narrative in this chapter as four intertwined stories of inquiry. They were set in elementary school, high school, and graduate school, and included my experience of supervising dissertations and teaching research methods courses.

Summary Comments

The form of the self-narrative essay allowed me to spell-out and review my thinking about my experience of self as a child, an academic, and a writer. I found that, by revisiting and reordering details of previous attempts, I could create a new self, one that was more satisfying as a partial justification of my present condition. Reflective awareness provides the realization that past events are not meaningful in themselves but are given significance by the ongoing configuration of our stories. Renewed experiencing of self shows that the same data or series of events support more than one thesis and can be read from different perspectives. This knowledge helps release us from the control of the past interpretations that we have attached to events and from those interpretations that we feel we ought to ascribe. This opens up the possibility of renewal and freedom for change. In inquiry as in Babelism, there is not one story or self but many.

The Old Story will no longer do, and we know that it is inadequate. But the New Story is not yet in place. And so we look for the pieces of the Story, the

ways of telling it, and the elements that will make it whole, but it hasn't come to us yet. So we are now the ultimate *bricoleurs,* trying to cobble together a story that we are beginning to suspect will never enjoy the unity, the smoothness, the wholeness that the Old Story had. As we assemble different pieces of the Story, our *bricolage* begins to take not one but many shapes. (Lincoln & Denzin, 1994, p. 584)

The elements critical to the new, postmodern story are still very dispersed. Rather than pitting different forms of research or different stories against one another, we need to get on with describing the particulars of the inquiry that we are interested in. To construct a self or an inquiry, we each need to become a *bricoleur,* an artistic Jack/ Jill-of-all-trades, or a kind of professional "do-it-yourself" person, devising solutions to given problems in concrete situations.

I am now beginning to formulate a more ironic narrative in which self is seen as a juggling fabulist who, like Nabokov's (1941) stage manager, conjures up, only to dispel, the illusion of knowledge. Irony centers on the problematic nature of self and of language. A self-conscious mode of writing and of understanding reflects and models the recognition that all our conceptualizations are limited and insufficiently complex. We take pleasure by experiencing the terrain and writing about it. Any self-narrative needs to contain the implication that it can be replaced by others that are waiting to be written. What matters finally is not exclusive reliance on the judgment of others of the self, but rather reviewing self's tentative judgment of others.

Our arts-based maps are never whole or final. We explore experience and self through narrative inquiry, that is, by constructing artful self-texts that are improvised, messy, and reflexive. "Rattl[ing] around in [our] personal construct slots" (Kelly, 1955, p. 130) we learn to map the local chaos. By recovering our tracks, drawing other lines to make fresh connections that may fly and recur in curves, we project new paths to encompass other versions of self and others. The chaos then becomes openness and each of us is located as an interpreter at the center of inexhaustible relations, among which we can insert our own forms. Just as the advice to water travelers used to be "pray for a wind but hoist your own sails," each sign or marker of self raised in hope may be help enough in our inquiries.

References

Bakhtin, M. M. (1981). *The dialogic imagination: Four essays* (C. Emerson & M. Holquist, Trans.). Austin, TX: University of Texas Press.

Barone, T. E. (1995). The purposes of arts-based educational research. *International Journal of Educational Research, 23*(2), 169–179.

Beckett, S. (1979). *The Beckett Trilogy.* London: Pan.

Borges, J. L. (1962). *Labyrinths: Selected stories and other* writings. D. A. Yates & J. I. Irby (Eds.). New York: New Directions.

Britton, J. (1977). *Language and learning.* Harmondsworth: Penguin.

Bruner, E. (1993). Introduction: The ethnographic self and the personal self. In P. Benson (Ed.), *Anthropology and literature* (pp. 1–26). Urbana: University of Illinois Press.

Burgess, A. (1994). *A dead man in Deptford.* London: Vintage.

Coetzee, J. M. (1986). *Foe.* Harmondsworth: Penguin.

Conway, J. K. (1992). *Written by herself: Autobiographies of American women.* New York: Vintage.

Crites, S. (1986). Storytime: Recollecting the past and projecting the future. In T. R. Sarbin (Ed.), *Narrative psychology: The storied nature of human conduct* (pp. 152–173). New York: Praeger.

Cross, A. (1981). *Death in a tenured position.* New York: Ballantine.

Daly, M. (1992). *Outercourse: The be-dazzling voyage.* San Francisco: Harper.

Derrida, J. (1981). *Positions.* Chicago: University of Chicago Press.

Diamond, C. T. P. (1979). Constructs, practices and effects of teaching written expression. Unpublished doctoral dissertation, University of Queensland, Brisbane, Australia.

————. (1988). Construing a career: A developmental view of teacher education and the teacher educator. *Journal of Curriculum Studies, 20*(2), 133–140.

————. (1992). Autoethnographic approaches to teacher education: An essay review. *Curriculum Inquiry, 22*(1), 67–81.

————. (1993a). Writing to reclaim self: The use of narrative in teacher education. *Teaching and Teacher Education, 9*(5/6), 511–517.

————. (1993b). Inservice education as something more: A personal construct approach. In P. Kahaney, J. Janangelo, & L. A. M.

Perry (Eds.), *Teachers and change: Theoretical and practical perspectives* (pp. 45–66). Norwood, NJ: Ablex Press.

——. (1994). From numbers to words. In A. Cole & D. E. Hunt (Eds.), *The doctoral thesis journey: Perspectives of travellers and guides* (pp. 53–60). Toronto: OISE Press.

Eco, U. (1984). *The name of the rose.* San Francisco: Harcourt Brace Jovanovich.

Freud, S. (1959). *The interpretation of dreams: The standard edition of the complete psychological works of Sigmund Freud.* (J. Strachey, Ed.). London: Hogarth Press.

Jameson, F. (1984). Postmodernism, or the cultural logic of late capitalism. *New Left Review, 46,* 53–93.

Gergen, M. M., & Gergen, K. J. (1984). *Historical social psychology.* Hillsdale: Lawrence Erlbaum.

Giorgi, A., Knowles, R., & Smith, D. L. (1979). (Eds.). *Duquesne studies in phenomenological psychology, 3.* Pittsburgh: Duquesne University Press.

Hunt, D. E. (1987). *Personal renewal.* Toronto: OISE Press.

Hutcheon, L. (1984). *Narcissistic narrative: The metafiction paradox.* London: Methuen.

Kelly, G. A. (1955). *The psychology of personal constructs, 1 & 2.* New York: Norton. (1992, 2nd ed., London: Routledge)

Kelly, G. A. (1969). *Clinical psychology and personality.* (B. Maher, Ed.). New York: Wiley.

Kincheloe, J. L., & McLaren, P. L. (1994). Rethinking critical theory and qualitative research. In N. K. Denzin & Y. S. Lincoln (Eds.), *Handbook of qualitative research* (pp. 138–157). London: Sage.

Kozulin, A. (1990). *Vygotsky's psychology: A biography of ideas.* Cambridge, MA: Harvard University Press.

Lincoln, Y. S., & Denzin, N. K. (1994). The fifth moment. In N. K. Denzin & Y. S. Lincoln (Eds.), *Handbook of qualitative research* (pp. 575–586). London: Sage.

Macey, D. (1993). *The lives of Michael Foucault.* London: Hutchinson.

Malinowski, B. (1961). *Argonauts of the Pacific.* New York: Dutton.

Marcus, G. E. (1994). What comes (just) after "post"?: The case of ethnography. In N. K. Denzin & Y. S. Lincoln (Eds.), *Handbook of qualitative research* (pp. 563–574). London: Sage.

McHale, B. (1987). *Postmodern fiction.* New York: Methuen.

Nabokov, V. (1941). *The real life of Sebastian Knight.* Norfolk, CT: New Directions.

Phillipson, M. (1989). *In modernity's wake: The Ameurunculus letters.* London: Routledge.

Pinar, W. F. (1994). *Autobiography, politics and sexuality: Essays in curriculum theory, 1972–1992.* New York: Peter Lang.

Polkinghorne, D. E. (1988). *Narrative knowing and the human sciences.* Albany: SUNY Press.

Polkinghorne, D. E. (1989). Phenomenological research methods. In R. Valle & S. Halling (Eds.), *Existential-phenomenological perspectives in psychology* (pp. 41–60). New York: Plenum.

Polanyi, J. (1994). The magic of science. *Imperial Oil Review,* 78 (412), 12–16.

Richardson, L. (1994). Writing: A method of inquiry. In N. K. Denzin & Y. S. Lincoln (Eds.), *Handbook of qualitative research* (pp. 516–529). London: Sage.

Rosaldo, R. I., Jr. (1997). A note on Geertz as a cultural essayist. *Representations, 59*(1), 30–34.

Roth, P. (1992). *Operation Shylock: A confession.* New York: Simon and Schuster.

Serres, M. (1982). *Hermes: Literature, science, philosophy.* (J. V. Harari & D. F. Bell, Eds.). Baltimore: Johns Hopkins University Press.

Updike, J. (1993, March 15). Recruiting raw nerves. *New Yorker,* 109–112.

Vidal, G. (1993). *United States: Essays 1952–1992.* New York: Random House.

Waugh, P. (1984). *Metafiction.* London: Methuen.

Wittgenstein, L. (1958). *Philosophic investigations.* (G. E. M. Anscombe, Trans.). New York: Macmillan.

Zencey, E. (1997). *Panama.* New York: Berkley.

Chapter 9

Stories of Breakout:
Gatekeepers, Prisoners, and Outlaws

Carol A. Mullen
C. T. Patrick Diamond

I had thought that claustrophobia would be the most terrifying part of being in prison, locked for hours in a seven-foot by nine-and-a-half-foot cage. For me it hasn't been. I grew to welcome the jarring clang of that metal door as it separated me from the ugliness. A cell can become one's haven, the one place to feel clean. (Harris, 1986, p. 306)

All men are intellectuals, one could say: but not all men have in society the function of intellectuals. (Gramsci, 1971, p. 9)

Organic Intellectuals

While we have prisons, it matters little who occupy the cells. We all do. During his imprisonment under Mussolini, Gramsci (1971) produced roughly 30 prison notebooks from 1929 to 1935. Despite the watchful eye of prison censors, the notebooks were eventually smuggled out of Italy. In them, Gramsci contrasted traditional intellectuals, such as teachers, the clergy, and administrators, with what he called independent, organic intellectuals. The former maintain the status quo, anchoring or imprisoning their narratives within the discourses of truth and justice in sacred texts. Organic intellectuals confront orthodoxy and dogma. They are mobile, on the go, actively trying to change minds and to gain consent for new ways. For Said (1996), such intellectuals are energetic "individual[s] endowed with a faculty for representing, embodying, articulating a message, a view, an attitude, philosophy or opinion to, as well as for, a public" (p. 11). Their motto is "the Luciferian *non serviam*" (p. 16). Today, everyone who works in

any field connected with either the production or distribution of knowl-
edge is an intellectual in either of Gramsci's two senses, or in some
combination of them. They work to varying degrees for the main-
stream and oppression, or in contrast for the marginal and liberation.

Like Harris (1986), the headmistress previously jailed for murder,
teacher educators and the research community may need to think about
becoming militant professors or intellectual activists, engaging public
opinion, bearing witness, and defending the marginalized. We, the
authors of this chapter, are two teacher educators at different univer-
sities in the United States and Canada engaging our developing per-
spectives and those of the marginalized. We see the marginalized as
those who have traditionally been silenced in educational research.
Although, as Coffey (1996) claims, the rhetoric of social research has
officially favored the powerless and the underprivileged, they, "the
researched," have seldom been studied within academic settings. In
this chapter, we examine issues and concepts of imprisonment as they
apply to teacher education, research, and curriculum. Rather than
assembling a formal argument consisting of propositions about these
issues, we use arts-based stories and metaphors to evoke lived experi-
ences of power and confinement.

Academics may feel that they are constrained almost like prisoners
of conscience. Our stories are told from the perspectives of those
who, like ourselves, are either in danger of being marginalized within
the groves of academe or are actually confined within jail cells. Al-
though our combination of these institutions may at first seem ex-
travagant or paradoxical, we believe that, as an arts-based metaphor,
it is both tenable and useful. We use this prison image to make sense
of the processes of researching from the margins and of being social-
ized as academics. Our metaphor is "constructed and interpreted in
attempts to make sense of human experience and to communicate
that sense to others. ... To be effective in promoting understanding ...
the familiar term [imprisonment in this instance] must be graphic, vis-
ible, and physical in our scale of the world" (Weber & Mitchell, 1996,
p. 305). Richardson (1994) has similarly redrawn attention to the sig-
nificance of metaphor in social science writing.

We also use the textual strategy of dual narrative to articulate our
process of sharing stories of confinement. In the spirit of
postmodernism, we have appropriated a set of terms that we apply
from a shifting perspective. Practicing an alternative model of educa-
tional research and curriculum is not without risk. By providing a pic-
ture of the operations of marginality and of conformity to restrictive

gatekeeping, we encourage the development of resistance and of a more equal relationship. Our overall strategy broadly connects the field of corrections to that of education and the theme of breakout to that of transformation. We shape our metaphoric, arts-based argument as a complex pastiche or web of revisited impressions rather than as a single line of logic. We represent our marginalized perspectives and those of others by drawing on our conversations and shared narratives.

We seek to engage the empathetic understanding and transformative social energy of postmodern writing and inquiry. We adopt two interrelated positions: one, that dominant and subjugated knowledge can be theorized in terms of knowledge/power, and two, that counter metanarratives of release from imprisonment can be assembled out of transformative stories told at the local, everyday level. Giroux, Lankshear, McLaren, and Peters (1996) call these "postmodern counternarratives." They critique the "master and metanarratives" that accompany grand claims of truth and progress. Peters and Lankshear (1996) legitimate those "little stories" that offer insight into "those individuals and groups whose knowledges and histories have been marginalized, excluded, subjugated, or forgotten in the telling of official narratives" (p. 2). We share our stories of imprisonment and transformation to counter otherwise isolating circumstances in our daily working and research lives.

The primary questions guiding this chapter are "What are some of the stories of teacher educators' imprisonment in conventional educational research?" and "What themes do these stories yield?" In our attempt to respond to these questions, we offer marginality as a lens for focusing on previously neglected approaches to narrative theory. By becoming critically aware of the wider implications of imprisonment, we show how teacher educators can engage in transformative inquiry. We aim to exemplify the practice of postmodern counternarratives through a shared writing practice. We theorize and use a process called "duography," which makes explicit the dialogue of coauthoring educators (see chapter 11). In our collaborative partnership, we seek to practice reciprocity and to "gain consent for new ways."

A Metaphoric Language for Research on the Margins

Marginality is used in this chapter as a metaphor for redirecting teacher development, educational theory and practice, and curriculum inquiry.

We use the term to confront the paradox of being forced onto the outside of higher education by a complex set of forces. These include institutional control and restraint, prescribed curricula, suspicion of self-study, and limited opportunity for pursuing relationships in educational research. We experiment on the periphery or borderlands (see below) of our field by moving closer to ourselves and our research participants, seeing them and ourselves as inmates and outlaws.

By questioning established knowledge and conventional practice within academe and jail, we seek to expose the systems of power within which we all are implicated. We seek to distance ourselves from the privileged center of educational research. The academy is a place of study or training in a special field. It takes its name from the garden park and gymnasium on the outskirts of Athens, sacred to the hero Academus, where Plato founded a school of philosophy that survived until its dissolution by the Emperor Justinian in AD 529. The Académie Française was established by Cardinal Richelieu with a constant membership of 40 in 1635. Its functions include the compilation and periodic revision of a definitive dictionary of French. Despite its tendency to defend traditional literary and linguistic rules and to discourage innovation, membership, like receiving a Hollywood Academy award, is held to be a high honor even by unorthodox writers who experiment with form (Hawkins & Allen, 1991).

Dwelling on the margins allows us to develop artistic and critical strategies for transforming the study of academe and of alternative research sites such as prisons. As Giroux (1997) warns, however, notions such as "marginality run the risk of mystifying as well as enabling a radical cultural politics. But what is crucial is that postmodernism does offer the possibility for developing a cultural politics that focuses on the margins" (p. 199). This strategy allows us to rescue persons and aspects of self that are typically denied representation. In an effort to break out of the usual constraints, we adopt a participatory, relational approach to inquiry.

We use metaphor to guide our arts-based form of narrative argument. As shown previously, metaphor is a primary form of narrativity that helps us to critically appraise the privileged center of teacher education and research. It allows us to juxtapose the unlikely worlds of academe and prison, and to understand better how each can illuminate the other. Through metaphor, we link previously separated selves and understandings, with the unusual connections yielding surprise and release. Although academe, the principal subject or tenor, is be-

ing understood in terms of prison, the secondary subject or vehicle, imprisonment, is also being understood in terms of graduate education. Prison serves as the finishing or graduate school for criminality.

We view metaphor as a strategy for restructuring concepts and actions (Lakoff & Johnson, 1980) and for providing a new way of speaking about issues of power/knowledge (Foucault, 1979). Power is viewed not just in structural terms of dominance and subordinance but as circulating throughout relationships. It is as impossible for power to be exercised without knowledge as it is for knowledge not to engender power. As the metaphor of the Panopticon shows, subjugated selves within both academe and prison are confined to spaces that are prescribed and regulated. The experience of being a prisoner is "fundamentally a relation, not a thing" (Harding, 1991, p. 13). Relationship provides a site of negotiation in which power/knowledge and identity are constantly contested and struggled over. By situating ourselves as academic-prisoners within the particularity of our stories and contexts, we can witness and testify to the otherwise unrecorded pain of enforced captivity. In contrast to gatekeepers or "educator-judges" (Foucault, 1979) who execute underexamined assumptions, we seek to expose our constraints through writing about our practices.

As inmates-guardians, we are engaged in "coming clean" (Guba, 1990) on behalf of ourselves, teacher educators, prisoners, and gatekeepers. We offer a new set of terms for considering "correctional" lives, and for freeing words and concepts from the "prisons" of their previous meanings (Daly, 1992). Our use of terms enacts our marginality and names underappreciated aspects of educational theory and practice, and curriculum. We then locate these terms within non-traditional, but clarifying contexts. Our terms include: academe/academy, marginality, metaphor, alternative, teacher development, curriculum, conversation, duography, borderlands, narrative inquiry, prisoner, gatekeeper, re-education, autoethnography/narrative ethnography, voice, transformation, inmate, outlaw, story, self, and recovery of self. We are seeking to avoid writers as all-seeing academic-gatekeepers. Instead, we are learning to write as local outlaw-educators so as to connect empathetically with subjugated others and withdrawn aspects of self, and to represent these often barred viewpoints.

By alternative we mean unusual contexts within which teaching and learning can provide opportunities for breakout and transformation. Carol has researched correctional facilities during and subsequent to her doctoral studies and Patrick has studied teachers'

suppressed selves. We are both now researching the perspectives of dissertation candidates. As teacher educator-inmates engaged in a collaborative program of research, we seek to become more conscious of our limiting perspectives and practices. Reflecting on issues of unequal power relationships, we are committed to becoming more self-critical and supportive of each other. By teacher development we mean that arts-based inquiry can promote the relationship of teacher educators to self, others, and their contexts. We explore conversation as a reciprocal process of learning about liberating forms of knowledge, and duography as a means of representing them.

As coauthors, we imagine the other's positions and viewpoints by "trying on" each other's images and metaphors. We construct a "duography" as a form of reflective inquiry in which we each legitimate the other's writing. In our version of duography, the self as author participates in the writing of another or parallel self; extends the writing partner's images and metaphors; and also reflects on the methods and results of the work. For example, Carol's image of the inmate in her self-narrative is released as that of a butterfly in Patrick's. Like the butterfly that emerges only gradually, we can now see the teacher-educator-inmate as capable of slowly developing as a new self with a more critical voice (see Harris, 1986). We ourselves are developing the more reflexive voices of educator-outlaws who struggle to understand and expose confining institutional forces. (See chapter 10 for a postmodern treatment of educational institutions as "prison-carousels.")

Arts-Based Activities
1. In what ways do you experience your classroom as a confining cell or even life-draining tomb? Paradoxically, as Harris (1986) found, a cell can also become one's haven. Closing the door on administration and public demands may bring a measure of privacy and independence. Can an "open door" policy win the collaborative support of other teachers and parents?
2. What was your experience of writing your first research-based paper, as, for example, in your preservice teacher education?
3. You are elected to one of the Royal Societies. Draft your acceptance speech or a letter of refusal.

The concept of marginality both authorizes and encourages the work that is necessary to free up experiences within education and research. By researching the margins of our lived experiences we paradoxically also open up spaces within ourselves. Our postmodernist

inquiry involves practices previously dismissed as embarrassingly idio-syncratic. Postmodernism refers to "new forms of collective self-re-flexivity" (McLaren, 1995, p. 175) that are needed for coping with the restrictive sociocultural meanings that are used to organize and con-trol our lives and sense of identity. Therefore, we study margins as places where the self (and others) can challenge confinement through telling stories of the conditions and operations of institutionalization. We support such stories by the use of artistic forms (poetry, painting, and music) that are often undervalued within the school curriculum (Gabella, 1994) and educational inquiry (Eisner, 1995). As Gramsci realized, film (and video) may provide the most promising form of the future.

Curriculum for teachers and students can be re-envisioned by teacher educators who inquire into authorial/authoritative tensions. To ex-plore this dangerous territory, we draw on narrative, metaphor, and the new use of terms. Narrative inquiry is a process that imposes meaning on experience and on methods used to study it (Connelly & Clandinin, 1990). It pays serious attention to the multiple local and cultural contexts that shape professional knowledge (Clandinin & Connelly, 1996). As teacher educator-researchers, we have each felt limited by writing reports that are typically expected to provide ab-stract and impersonal accounts. As below, we now use narratives of self and duography to reflect on our experiences and the meanings of surveillance and gatekeeping.

The prisoner, as a person and icon of oppression, is seized, con-fined, and held captive in the restrictive and/or expansive space of a surveillant community. The gatekeeper monitors the prisoner, limiting vision, experience, and possibility. Harris (1986) is a former prisoner who retaliated by closely monitoring and exposing the daily forms of personal scrutiny and persecution that she was subjected to. Re-edu-cation involves an emancipatory process that confronts taken-for-granted knowledge (concepts, constructs, and meanings) through the arts-based processes of documentation, self-discovery, and commu-nity-building. As illustrated in the next section, our own re-education is expressed as a participatory conarrative that rescues/releases our marginalized and formerly imprisoned selves.

A Duography of Rescue and Release

Releasing a storyline in educational theory and practice, and in cur-riculum that is usually censored, has an edge to it. We risk disapproval

by finding space for presenting the perspectives and intentions of subjugated others and aspects of ourselves. Although not literally incarcerated like Gramsci and Harris, we have felt confined by more formal research and academic requirements. Our duography was designed to test the confining spaces within academe and to counter the "homogenization [that] occurs through the suppression of individual voices" (Richardson, 1994, p. 517). Self- and other-narrative offer a new way of knowing, and a collaborative form of coexpression. We produce personalized texts as signature stories about our shared and no longer solitary experience. Because writing often reproduces hierarchies of power, we place prisoners, gatekeepers, and researchers on the same plane of observation to expose their practice. Writing always excludes, suppresses, or assumes points of view, forcing closure before all connections can be made. While we have developed the metaphor of marginality and its associated terms together, we have not yet invited other "inmates" to respond to the view represented in this chapter. However, we do rely on inmates' own words to authorize our viewpoints.

The current narrative turn, with its emphasis on the study of teachers' voices and biographies within schooling, may ironically be reproducing the very marginalities that it is seeking to overcome. When researchers are authoring their own silence, they may also be inadvertently appropriating other participants' voices. One advantage of our duographic approach is that for seven years we have sought to find ways to compensate our participants. We have written about our narrative programs for teacher development for graduate students, and for self-development for minority literacy candidates (refugees and prisoners) within jails and inner-city schools. In this book, they become our cocontributors.

Because we feel compelled to defend our arts-based approach, we have waited until this point in the chapter to present our actual self-narratives and personal storytelling. We later return to theorizing with regard to subjugated and dominant forms of knowledge. While we hope that our stories provoke conversation, we recognize that they also close off other areas of concern.

Carol's Self-Narrative

As a female undertaking research in a jail for male prisoners, I held a marginalized position in both corrections and teacher education. In

the prison system, I participated in three rehabilitative programs—drug awareness, education/literacy, and creative writing—designing and teaching the last one myself. However, I could not directly contact the inmates unless they chose to confide in me. By engaging in research on teaching and learning, partly in a correctional setting, I may also have marginalized myself in teacher education. I had originally intended to remain embedded in my field, seeking to further my college-level teaching experiences. In order to reexamine my conceptions of curriculum, and to test what my field would "permit," I undertook research within several jails. Even though I had benefited from narrative approaches to research, I wanted a new context in which to "trial" my ideas and "inside-out" (Hunt, 1987) methods of connecting with others.

Through journal writing and in meta-accounts, I told stories of prison that came to increasingly remind me of higher education. Like academics, many prisoners seek educational opportunities and interpersonal connections. Abbott (1981), an outlaw, recounts the personal change that comes from resisting surveillant communities:

> I've served time just for requesting books. No federal penitentiary has a prison library. The authorities say we "misuse" our knowledge if allowed to educate ourselves according to our natural impulses. That is why they now have "education programs" in prison, i.e., so we learn only what they want us to learn. I've never been in a prison school. (p. 20)

In contrast, my inmate-writers felt that the creative writing program we developed together offered them an alternative to the traditional education/literacy program and helped them to learn. Sammy, for example, struggled with the formal grade 12 literacy curriculum, and yet he could reflect with ease as he wrote to me:

> It has been a very long time since anyone thought that what I had to say was worth listening to, let alone printing something I wrote. I did learn something about my life when I was a kid after all. Doing this program is helping me to think back and realize that I wasn't alone in my life. I would like to thank you for that.

My research story is about inmates being held captive by traditional forms of schooling and by those paradigms of knowledge which ignore their personal and context bound lives. This story also has a transformative side: Inmates who struggle to be active, self-conscious witnesses can enlarge our notions of education and experience. As an "inmate"

myself who is reconsidering conventional notions of education and experience, I explore my dreams and write extensively about them. I use my personal knowledge to consider new ways of undertaking educational research using the arts-based strategies of dream text, innovative curriculum programming, and sustained metaphor.

I began work in jails believing that the researcher becomes the "main research instrument" in qualitative studies (Glesne & Peshkin, 1992). Such a view was not embraced without a struggle. I was doing narrative inquiry, a form of human study that some discount without "getting their feet wet." As Said (1996) advises, an activist cannot remain at the edge of the water without at least dipping a toe in. I constructed a series of representations of my regular encounters with prisoners. Recording my own nighttime dreams, I searched for internal views of prisoners to generate new ideas about creative programming and about concepts of education, imprisonment, and freedom. I constantly struggled with a "database" that was slippery, fragile, and filled with uncertainties.

By studying a culture we study ourselves (Van Maanen, 1988), becoming the subject of our own inquiry into even the most remote/ unfamiliar sociocultural phenomena. My prison research site became a setting in which I too had to behave according to rules that dominated our teaching and learning processes. Along with the prisoners, I struggled to be heard above the rhetoric of rehabilitation. As creative writers, the prisoners and I tried alternative approaches but always in tension with the prescribed curricula and the threat of censorship. These restrictions on intellectual growth were not new to me.

I feel that I had sometimes been an "inmate" in graduate school, and even now as an institutionally "unsettled" gypsy professor in higher education. I struggled to conform to the pedagogical doctrines of the field of curriculum even though it mainly valued "outside-in" inquiries and strictly mediated accounts of teachers' biographies. I drew closer to arts-based researchers and mentors who write themselves as an integral part of their own inquiries (Mullen, Cox, Boettcher, & Adoue, 1997). In the meantime, I struggled to move with comfort among the staff and inmates, and within the rehabilitative programs, in the prison system. Here, I was initially forbidden even to teach. I was classified instead as a "client contact volunteer" who documented inmates' requests for court. I next undertook the cofacilitative work of acting as a "drug awareness counselor," without any "training," certification, or specialized knowledge in substance addiction.

At the time, these official contexts seemed too remote from the inmates' educational stories that I wanted to release within the safety of the education/literacy program. However, the prisoners helped me to understand the relevance of the issues of recovery and addiction,

and other forms of stress in their lives. Without gaining this insider's perspective, I would have been ignored by the inmates as yet another irrelevant teacher-"do-gooder." Within jail and academe, I eventually found contexts for encouraging self-expression, discovery, and personal knowledge. I came to experience aspects of the jail from the inside (excluding the living quarters), and to appreciate some prisoners as narrativists and even partners in curriculum design. I also came to anticipate their sudden and often punitive relocations by officials.

My prison writers struggled for voice and connection, recovery and humanity. They often wrote as castaways. Sear, for example, wrote on personal and political levels to help educate other substance abusers. He compared substance abusers to "frozen ponies on a carousel halted in mid-gallop" (see chapter 10 for Sear's poem). I had also, surprisingly, been exploring the image of a carousel ride but in the context of a correctional bureaucracy (see Figure 17). Educators must also struggle to express themselves and their experiences. But we are caught up within rigid forms of research and paradigms of knowing that limit the very knowledge they are supposed to generate. While the image of prison-carousel conveyed for Sear the struggle of recovery from substance use and abuse, it depicted for me a different kind of challenge. Our shared metaphor was expressed differently at the levels of personal and cultural experience and social activism.

The worlds of corrections and teaching share elements in common. As a marginal-insider in both worlds, I searched to understand how a prison setting could provide me with insight into concepts of confinement in higher education. Formal education in prison already assumes this lack of choice. I had to struggle to develop curricular practices that met the concerns of both the gatekeepers and prisoners. In prescribed spaces, I sought to connect with writers while coping with procedures that sometimes hindered if not thwarted our intentions. Published anonymously, Sear poetically critiqued institutions as perpetuating the coercive experiences of addiction and recovery. Inmates who want to be heard must either acquiesce in or transcend this paradox of authored silence.

Each week in my field site, I was exposed to uncertainty, which ranged from stolen connections with inmates to unsettling periods of isolation. Such experiences occurred in various settings: alone in interview rooms; together in drug awareness group sessions (the chapel); in corridors, on the stairs, and in elevators; and within the maximum surveillance of the "mousetrap" or mini-Panopticon. The mousetrap is an internal passageway in which visitors who have already undergone security checks are further detained, scrutinized, and videotaped. Here I would turn my identification badge toward a video camera while clutching my list of assigned students and packages of materials.

I also had to act as a less powerful, junior member of the hierarchy of guards, administrators, education coordinators, teachers, and group facilitators. Their collective role consisted almost exclusively of regulating and policing inmates and outsiders. Release for inmates or access for outsiders could never be taken for granted. It always remained regulated and conditional. Prison gatekeepers responded to issues of release and access only as occasions for exercising their power/knowledge. As overseers, they could not imagine how my exchanges with prisoners could in any way be educational. Although the effect of my work was sometimes dramatic, my contact hours were seriously limited, my agenda was prescripted, and I was held accountable—although rarely questioned. Gatekeepers in schools (Glesne & Peshkin, 1992) also carefully monitor outsiders' requests.

School construed as a jail is not a new metaphor, but I extend it by studying the enforced scripts of teacher education and research. Patrick also looks back at his privileged positions, reflecting on his experience as a "white-coated" gatekeeper (see below). We rescripted our supervisor-student relationship to work as intellectual friends who also helped the subjugated to become "the ones whose every word really matter[s]" (Coles, 1989, p. 22) (see chapter 11). Arts-based methods can promote reversals in perspective, leading to innovations in curriculum programming and research.

Patrick's Self-Narrative

Kingston is the prison capital of Canada and the site of its oldest federal penitentiary. A prison quarry supplied the limestone to build the first prison and also the Church of the Good Thief. Driving along the Bath Road past another, more modern Kingston prison, I am reminded how Foucault was also struck by the unreality of the entrance of Attica prison (in Macey, 1993). Here too there is a kind of fake fortress à la Disneyland, with observation posts disguised as medieval, fairy-like towers. Power always enforces but often cloaks its version of reality. One of the instruments of rehabilitation in the Kingston prison museum is a six-foot-long wooden box that is shaped like a coffin. It was used to punish inmates with the severest form of solitary confinement. As a boy, I remember how the priest told us to trace the capital M on the palm of each of our two hands to spell out "Memento Mori," or "Remember you die." I never knew what he meant when he warned us that "the wages of sin is death."

Kingston is also famous for Queen's, its illustrious gray limestone university. Like a prison, an academy can serve as the instrument and vector of power. Both institutions are part of the technology of power/knowledge. When I was providing preservice development courses for

"a new breed" (university qualified) of assistant-superintendents of prisons in an Australian provincial system, I also experienced an air of unreality. Model prisoners moved silently in blue uniforms to serve us afternoon tea while guards talked confidently in white. Like children, the prisoners spoke only when spoken to.

Daly (1992) describes her university experience as that of "academentia and soul-shrinkage" (p. 385). She felt blocked and erased. Her experience of academics is the antithesis of Gramsci's dream of organic intellectuals. For Daly, they are often "dwarfed by a system of 'education' which make[s] them unfree, uncourageous, and radically undereducated" (p. 97). On the whole, my university experience has been one of acceptance and unexpected privilege. But some rescue and release have also been involved. Periodically I need to loosen the tightening control of third person voices. This freeing up is aided by self-narrative, duography, and remaining alert to the restrictive as well as enlarging possibilities of being an "academic." Dictionary definitions remind us that academe can be a place of pedestrian instruction and limited, unimaginative learning. As teachers know, any body of trivial opinion, especially one lacking practical significance, should be rejected as nonauthoritative and undeserving of our acceptance.

As a child, student, teacher, and academic, I have enjoyed learning to learn in many different settings. Academe can provide many experiences, ranging from those of a reflective refuge to those of the most visible, but least dangerous form of power. I have sometimes sensed the potentially disciplinary power of others. While this may be dismissed as only the projection of a besieged, Cassandra-like frame of mind, the surveillant community (consisting of parents, teachers, supervisors, reviewers, editors, or wardens) can be as undermining as it is all-seeing. Using the power tactic, some gatekeepers keep total order by invoking the claustrophobic rule of "perfect certainty." Transgression is inevitably followed by exposure and punishment. Retribution may be rendered as censorship or exclusion, or even as the banishment or social quarantine of the outcast. Some educator-judges, whether in session in prisons, homes and classrooms, or on editorial boards and tenure and promotion committees, may function as agents of control rather than of freedom. With their riveting gaze, they may so organize their space that the "slightest movements of the bodies they confine can be observed and corrected. From a multiplicity of discourses, practices, and institutions, there emerges a disciplinary power organized like a multiple, automatic power" (Foucault in Macey, 1993, p. 331).

As a former graduate student and junior faculty member on probation/parole and good behavior, I struggled to find space within my doctoral research for teachers' voices (see chapter 8). I felt that my

dissertation sometimes provided the prisoner's base on which old scores were settled by factions within my previous department, as in some kind of war game. Once tenured, I proposed new courses in teacher development. Some guardian-professors were dismayed. Like the Emperor Justinian, they had grave reservations. Could there be a place for such interdisciplinary (no-discipline base) approaches? They intuitively feared the "telling" power of narrative and the countering gaze that it promotes. Accordingly, they discounted but could not dissolve the personal power of stories. Any interrogation of the right of the powerful to their power is opposed as a prelude to revolution.

As shown in chapter 7, I used a treehouse fort as a child's counter-Panopticon. I later sought refuge behind the dense vegetation of books and publication. "Writing becomes a place to live" (Said, 1996, p. 58). Many years later I became a traveler with an academic passport. I now enjoy an office in a teacher development center and gaze out across downtown buildings and the university campus, down to a lake. The center is a home for teacher growth and for me. Reflection, inquiry, and the improvement of practice are its distinctive themes. We rethink our supervisor-instructor roles by offering graduate studies in teacher education as advanced inservice for experienced colleagues. As teacher educator-researchers, we believe that we can help others only if we understand what it means to be learners. We seek first to reflect on how our education has shaped us. Although I have looked at development in terms of the different ways that teachers structure meanings for their teaching and careers, I have too often gone missing as a person from my own writing. I now use metaphor-making to connect more personally with issues in teacher development and research, and with others, including myself. I am supported in these efforts in an academic place that functions as an enabling community rather than a Panopticon.

In my own research courses, I invite graduate students to participate in shaping their own development. Margie (see chapter 5) devised a visual representation of educational research that illustrated how "Dr. Jekyll" (her personification of the empirical researcher) is (d)evolving into its "Mr. Hyde" persona (herself as an arts-based narrative researcher). Patricia, another teacher-colleague, brought into the beginning of a three-week teacher institute a clear plastic pop bottle containing milkweed and a pale Monarch caterpillar. We watched as it spun itself into a jade green chrysalis. Time did not permit us to witness its final metamorphosis into a butterfly. Our meanings also need to emerge gradually. Metaphoric and artistic methods of inquiry assist in this development.

I seek to provide permissive and supportive space where we can all write and test our boundaries. My student-colleagues gain empathy by reading and responding to stories of each other's practice. I have col-

laborated with many inservice teachers to help refashion their teaching by working with arts-based forms of representation. Through closely studying our teaching stories, we can revoice and transform them. The goal and means of teacher growth is to become sympathetic writers and readers of our own practice, which includes duographic work.

As a white, male academic working with a group of mainly female student colleagues, I am trying to deepen my personal awareness and self-knowledge. As a dissertation supervisor, I attempt to break out from the domination of my "little god professor." But it is not easy to abandon the alluring pretense of total wisdom and to study instead my own voices and viewpoints. This latest stage in the evolution of our shared epistemology of practice is characterized by the need to extend our range of vision. With Carol, I am learning to see more clearly by considering the perspectives of others. I too struggle to reconcile the split between my personal and professorial perspectives, between my first and third person voices. Following the "objective introverted" example of suppressed figures such as Pessoa (1991), I seek the development of my own voices and other marginalized standpoints by forming a chorus or community of selves. However, arts-based research involves risking vulnerability and possible rejection. Trying to open up teacher education, research, and curriculum to new forms of knowledge and to critique previously taken-for-granted views does not go unchallenged. The spectacle of the unpublished and untenured is meant to serve as a powerful warning to others.

Theorizing Dominant and Subjugated Knowledge

By moving away from the privileged center of control, we can re-imagine education and research and their new arts-based forms (see Diamond, 1991, 1993; Diamond & Mullen, 1996, 1997; Diamond, Mullen, & Beattie, 1996; Mullen, 1994, 1997). Exposing the workings of knowledge/power and confinement provides an epistemological model for discovering what is limiting, even within our own understandings. Knowledge of experience can be reconstructed from our previously colonized perspectives as students, prisoners, and persons. By researching from the margins, we are able to redress unequal relationships (Paley, 1995) and to reconsider the privileged centers of education and research.

Narrative inquiry (Clandinin & Connelly, 1996; Connelly & Clandinin, 1990; Mishler, 1990) has been used to examine the experience of students as immigrants and inmates (Feuerverger & Mullen, 1995) and academics as gatekeepers-in-training (Mullen & Dalton, 1996). Narrative inquiry is a form of conceptual storytelling that

can help us to reclaim previously discounted selves. In our arts-based practice of narrative inquiry, we (Carol and Patrick) use "narrative ethnography" and "autoethnography," respectively. We both construct stories of human lives as personal and institutional forms of engagement. We explore voice as a frame of reference that is internal, interpretive, particular, and situated. When couched in the form of conversation, inquiry can constitute a transformative form of education. As educators seeking access to different interpretations of reality, we view development as the successive renewal of perspective.

The inmate is traditionally rendered voiceless by outsiders who themselves may lack personal knowledge needed to inform their experiential encounters. Inmates sometimes struggle to express and represent themselves in the face of such institutional and paradigmatic pressures. They can either passively accept their imprisonment and the inmate (existential) condition or they can become self-conscious activists, articulating their resistance. As professors and dissertation students, writers and prisoners, we are learning to "gaz[e] back in all [our] cultural particularity" (Harding, 1991, p. 163) at our institutional stories. We stand behind our participants and ourselves, gazing at the "subjective underbrush of our own experience" (Peshkin, 1988, p. 20).

For us, to become an outlaw means developing an active and critical awareness of imprisonment. Unlike the broken inmate, the outlaw expresses discontent to authorities and works to develop more enabling relationships. By telling stories of oppression and emancipation, whether in prison or in academe, outlaws are born. But even the outlaw viewpoint does not provide total insight. Investigations in nonmainstream sites can call into question all forms of educational research, development, and curriculum.

Inmates are traditionally treated as if they are powerless, lacking voice, agency, signature, and self. Some formal research may seem to promote this kind of disempowering perspective. Avoiding personal contact with prisoners, the research relies on third-person representations of their concerns, issues, experiences, and texts. The implicit rules of conventional morality (hero versus villain, accountability to society, and standards of literacy to be achieved) are used to authorize the analysis and reconfiguring of prisoners' lives and texts. Just as abstract accounts of prison experience are over distancing (Davies, 1990; Harlow, 1987; Lovitt, 1992), arts-based, insider accounts offer close-up forms of intimate relationship and relational knowing (Conlon, 1993; Harris, 1986; MacDonald, 1988; Sharansky, 1988).

Biographies that provide space for prisoners to author their own stories (Padel & Stevenson, 1988) provide an enabling context for development. Compared with the prisoners' own writings, Carol feels that her self-narrative may seem too academic and distant. But her inquiry also contains opportunities for rescuing the personal. Story is a spontaneous or self-conscious account of an unfolding event or feeling, focusing on experience, not interpretation (Mullen, 1994). By learning to think from the peripheries, we can "make strange," taken-for-granted notions of rationality and impersonal forms that previously appeared inescapable. We can then "try on" the new forms and critical perspectives of the devalued and the neglected.

Greater movement in educational theory and practice may result from positioning the researcher-self together with subjugated others. Because inmates have the experience of being enclosed and constrained, they have a real interest in knowing how systems of education, research, and punishment actually work—so they can subvert them. There is a danger, however, that, as researchers, we (Carol and Patrick) may appear to some critics to be too overly protected in our explorations of inmates' perspectives, which are undertaken from the safety of our secure tower. To other critics, we may appear too romantically utopian in seeking to rescue others from confinement. We acknowledge that no one's position is innocent.

Marginalized prisoners, dissertation students, and publishing faculty are likely to be alert to the surveillance of the "eagle eye watching in all directions, always watching, always remembering" (Harris, 1986, p. 496)—and even of comrades on the inside who may at times be forced by their "despondent sense of powerlessness at their marginality" (Said, 1996, p. 20) to become enemy collaborators. Carol describes her strategy of seeking relocation within a prison in order to look more imaginatively at the academy and its correctional/socialization processes and practices. Patrick describes the tension between his first person, subjective knowing, and that of his third person, academic knowledge.

By valuing the perspectives of the less-powerfully positioned, we are able to inquire into and "move away from the centralizing authorities towards the margins" (Said, 1996, p. 63). We value learning when it is lived freely, not anonymously. Yet inmates who have the courage to express themselves may pay the price. Writing in prison can be equated with the harsh charge of murder (Davies, 1990; Sharansky, 1988). Caron (1978) used jellybeans to write his personal truth on the

floor of his cell. Because our ways of knowing are connected with power structures, even the work of studying them must also be called into question. We must guard against imposing questions and interpretive categories on the understandings of others.

Experiencing Boundary Crossing
and the Panopticon

A border fixes the margins of a controlled territory. The boundary lines are then patrolled by powerful gatekeepers and vigilant disciplinarians. In this chapter, we have crossed the boundaries between academe and prison, self and other, dream and reality. Daly (1992) defines "boundary living" as "Realizing Power of Presence on the Boundaries of patriarchal institutions" (note the deliberate use of capitalization) (p. 46). Such presence or knowledge is retrieved through the construction of "border narratives" (Giroux, 1991). We locate ourselves at the fringes of imprisoned possibility, close to the outer limit of acceptability, just within the bounds. While going "beyond the pale" may threaten careers if only in the short term, there is always the risk of ridicule or conflict. Accordingly, the parallel experiences of prisoners and academics have been little published (Mullen, 1997).

As a prison researcher, Carol has experienced an irony of learning. The support that she extended to her inmate-writers was complicated by her very association with power. Given that Mark, a letter-writer, had undertaken to document how Carol's role as a researcher involved tougher institutional politics than his own, she invited him to record his insights. However, a gatekeeper alleged that Carol's then unofficial status could have "confused" Mark. Consequently, they were told to terminate their correspondence. At first, Carol thought that Mark had also felt isolated and constrained by the administrator's dictate. However, Carol soon discovered that he saw her as partly complicit—and rightly so:

> Correspondence to cons in federal institutions is not to be read [by authorities] unless there is reason to suspect something pertinent in it. This right was granted to us (cons) years ago, and, to my knowledge, has never been taken away, nor altered. Your letter writing is most warmly received by myself, and I truly hope we'll continue to correspond, even under such strict conditions. I find it ironic that I, a convict in a pen, am finding my privacy more protected by my "prisoner's rights" than are you, a person of the "Free Society," whose rights are being violated by [the very agency] that claims to protect them. I'm really disappointed. (letter, June 1991, in Mullen, 1997, p. 155)

Arts-Based Activities

1. Record your nighttime dreams for a period of one week or more. Note situations involving power. What is your role in, or response to, institutional life and its shaping influences? What character do you play in your dreams? How do you think and perform in educational contexts?—as an inmate? outlaw? judge? other? Who or what functions as your personal gatekeepers?

2. Draw a sketch or map of an educational setting or place, taken from one of your dreams, and reflect on how it represents your experience. For example, Carol has dreamt of her prison site as an energetic beehive of inmate communication and activity.

3. Tell a story of prison or hospital life as recollected from film, literature, or elsewhere. Now put yourself into the picture as one of the key characters. Retell the story, but this time from the re-imagined perspective of an insider. With this shift in perspective, is there a difference in the telling?

4. List all of your associations with prisoners and prisons, or hospitals and patients. Then, if you can, interview a former prisoner or patient. Identity potential themes of transformation in that person's life as well as sources of strength and vision. Now go over your list of previous associations. Reconsider it in the context of your new knowledge. How many of your previous impressions revealed understanding, and how many were informed by prejudice and stereotype?

5. Read Jean Harris' (1986) novel, *Stranger in Two Worlds*, or another prison or hospital story (see references for suggestions). Record any insights that you gain into educational or social issues. For example, Harris writes about how society turns its back on women in prison as well as their children: "Incarceration is not proof that a woman is a bad mother, any more than being outside is proof that she is a good one" (p. 399). Using such a statement as this one, write a supporting or counternarrative that expands on such a message.

6. Visit a prison, hospital, or school. Record your impressions. What was your experience of power and those with power? What was your experience of the inmates and, perhaps most importantly, yourself? Give examples of how you may have felt "imprisoned" and "liberated." Identify instances in which you felt on familiar soil and those in which you felt in a foreign land.

7. Comment on Saint-Exupéry's belief that "It is only when you see with the heart that you see rightly; what is essential is invisible

to the eye" (in Shuffrey, 1958, p. 2). Saint-Exupéry was an experienced pilot and traveler who is known as the Conrad of the Air.

The Panopticon

Both Carol and Mark, the researcher and inmate, had been dominated by an administrative machine that monitored and restricted any intimate sharing of knowledge. They had experienced the surveillance of the "Panopticon." Foucault's (1979) image of the Panopticon is borrowed from Bentham. This image shows how knowledge is created and sanctioned within institutions and acted upon to maintain and promote dominant power relations. Through observation and supervision, conformity is imposed. When externalized, such a structure is like an all-knowing God. When internalized, it is like Freud's superego, monitoring wishes and desires (Sarup, 1989).

Within the "all-seeing" Panopticon there is a central observation point that serves as the focus for the exercise of power and also for the registration of knowledge. The eye of power is exemplified by the supervisor or educator-judge who is elevated to the watchtower of a central point or dais—or television monitor. The prisoner or student is relegated to a peripheral cell or desk. Inmates are made visible at all times but are unable to see beyond the limited arrangement of their space. The result is many highly individualized cages made constantly visible (Macey, 1993, p. 333). The possibility of being observed forces prisoners to police their own behavior, producing the automatic functioning of power: "The system of surveillance is interiorized to the point that each person is his or her own overseer. Power is thus exercised continuously at a minimal cost" (Sarup, 1989, p. 74).

If the Panopticon found its privileged site of realization in the prison, it also functions in the classroom or university. This device is not an architectural fantasy but rather a model for the operation of systems of power. Children, students, teachers, academics, and prisoners are all constituted as effects of power. Arts-based studies of human contact help expose the workings of such systems. In one such "underwater" representation by Carol (Figure 15), systems of power resemble frenzied shark attacks. Dynamics of feeding, birthing, and competing are portrayed through multilayered images and text signaling "danger below." The diver's mask becomes the eye of the shark. One-eyed and in for the kill.

In the cage and out

DANGER BELOW

Sharks have
been known to
attack people

It eyes me warily
What big black eyes
and long stiff whiskers

I am the bait

Attacks
shark
Attacks
may occur when a shark mistakes a per-
son for usual prey – a person's foot may
look like a fish

Figure 15 *A Submerged Landscape* (C. A. Mullen, 1998)

Although Harris (1986), a prison-writer, asked for logical explana-
tions whenever the guards broke the rules enshrined in the code of
behavior that they issued to her, she never received a reply. Moreover,
she never heard anyone in authority give a useful lesson in citizenship
to an inmate. Like Mark's above, this is another instance of an inmate
encountering the Panopticon. The worst feature of Harris' confine-
ment was having to accommodate the dominating view of figures of
authority who had sharp teeth and the "power to punish if you didn't
hop when the signals were called" (p. 315). Outlaws seek to plumb the
depths of what is, and what is not, permissible, what is condemned,
and what is allowed—and why.

Educators can seek to counter institutional caging by incorporating
the views of powerless others into their teaching and research texts.
Seeking to win public disapproval of marginalization, we provide ex-
amples of the experiences of prison participants, writers, and inmates
throughout this chapter. When education, research, and confinement
reflect the concerns of the marginalized, and not just those of centrally
located groups, partiality and distortion can be reduced. By learning
to see with inmates' eyes or with those censored aspects of our selves,
we learn what also needs to count as knowledge.

The lives of the marginalized provide a new context for enlarging meanings in educational research. The task of an activist-intellectual is first to tease apart the insider experience of inmates and then to express those elements that can persuade others to join with them in becoming educator-outlaws. The chief resources that we each bring to this work are our viewpoints, concerns, and circumstances. Greater empathy for the marginalized is a key educational, autobiographical, and curricular issue (Pinar, 1988). Given that the processes that produce knowledge are value-laden (Code, 1991), we need to expose our value positions. Our present account of educator-outlaws is intended to assist in the reconsideration of the inmate condition. Such investigative storytelling helps us reimagine alternative practices. Through developing accounts of marginal bodies of knowledge, researchers can resist and begin to win support for correcting inequitable power structures.

Although the ultimate "important purpose of knowledge construction is to help people improve society" (Banks, 1993, p. 9), we must first value inmates and then help them to find productive ways of living. The incarcerated can teach us. As outsiders, we can learn from their educational stories about the recovery of self. By self we mean a combination of personal and institutional knowledge, marker events, and broader educational reflections. By recovery of self we mean the reconfiguration of these elements as produced by disclosure, self-examination, and relationship. In Carol's creative programming, the prisoners responded when given some control over their learning. Although lacking high school education, many produced deeply moving poetry, musical lyrics, drawings, stories, journals, and letters.

Arts-based narrative frameworks and conversational methods represent new forms of educational research that help us to critique academic and correctional institutions. Educator-researchers can go "inside," "on site," and "down below" in order to account for social constructions of marginality. Conversely, those on the inside need help in making even better sense of their worlds and in publishing the accounts. Repositioning ourselves as marginal-insiders relieves pressure on us to conform not only to traditional research conventions but even to established forms of qualitative inquiry. Arts-based, liberationist inquiry is a "subversive" method for working with, documenting, and freeing human lives (Mullen, in press).

Opportunities for exposing existing power structures are afforded by conversation and correspondence. Transformative knowledge is produced through simultaneously finding a shared vision. Given that

the self is implicated in wider networks (Bruner, 1990), meaning can be seen as socially constructed through duographic exchanges rather than as imposed by an all-knowing and all-seeing source. If institutions demand the regulation of the self, a cooperative stance encourages the release of self. But a researcher may also be caught as an implicit gatekeeper, appropriating others' stories even if for exemplary use. We recognize this tension in our chapter, but also view our recorded and negotiated accounts as inviting further conversation.

Summary Comments: From Acts to Activism

Contexts need to be found or established for encouraging movement from imprisonment to transformation. We have "trialed" our own postmodern narrative methods in several research contexts. Rehabilitation and practical work in correctional systems, for example, made it possible for us to imagine different forms of education, inquiry, and curriculum. But, within "total institutions," gatekeepers monitor boundaries, controlling others by forcing them to wear uniforms and to take on other "disidentifying roles" (Goffman, 1961). As punishment for challenging or endangering society, the imprisoned self is rendered anonymous. The concept of "total institutions" can also be applied to academe with its surveillance of candidates for degrees, promotion and tenure, and the near silencing of personal voice from publications.

Educator-outlaws can develop strategies of resistance by asking "What are educators' stories of imprisonment in teacher education?" and "What themes of captivity do these stories yield?" We discovered that the metaphor of marginality provides a useful focus for testing institutional constraints. It is also useful for engaging with confined others and submerged aspects of self/selves. However, to be more effective as arts-based researchers, we developed, like Daly (1992), our own language of subversion within dominant forms of knowledge.

Adopting "outlaw" perspectives may help in the shift from the condition of imprisonment to that of self-awareness. In this stance, we try to take greater responsibility for producing accounts of insiders' experiences and for releasing inmates' voices. By sharing eyewitness accounts, we show power and surveillance in operation. Making visible the previously unseen, arts-based researchers can "break out" of the claustrophobia of confinement. To remain "caught" in prison or academe is to live as a prisoner. To choose to resist as an active, self-conscious inmate is to function as an outlaw. We need to speak out.

But this is not without cost. To dispute official narratives and to speak the "truth" to power, one needs to be prepared to be "seen as a no-goodnik, a criminal, an evil-doer" (Lessing, 1986, p. 24).

The process of creating such nonconformists "is long, difficult, full of contradictions, advances and retreats, dispersals and regroupings" (Gramsci, 1971, p. 334). Small scale, local coalitions and partnerships (like duography) that witness and honor the stories of the marginalized may make an indispensable contribution to social change. Unlike a prison, which often safeguards the most totalitarian of social forms, a university can provide a place for active resistance. To transform the present, we must attend intensely to it as a place where thought demands to be free.

References

Abbott, J. H. (1981). *In the belly of the beast.* New York: Vintage Books.

Banks, J. A. (1993). The canon debate, knowledge construction, and multicultural education. *Educational Researcher, 22*(5), 4–14.

Bruner, J. (1990). *Acts of meaning.* Cambridge, MA: Harvard University Press.

Caron, R. (1978). *Go-boy!* Toronto: McGraw-Hill Ryerson.

Clandinin, D. J., & Connelly, F. M. (1996). Teachers' professional knowledge landscapes: Teacher stories—stories of teachers—school stories—stories of schools. *Educational Researcher, 25*(3), 24–30.

Code, L. (1991). *What can she know? Feminist theory and the construction of knowledge.* Ithaca, NY: Cornell University Press.

Coffey, A. (1996). The power of accounts: Authority and authorship in ethnography. *International Journal of Qualitative Studies in Education, 9*(1), 61–74.

Coles, R. (1989). *The call of stories: Teaching and the moral imagination.* Boston: Houghton Mifflin.

Conlon, G. (1993). *In the name of the father.* New York: Penguin Books.

Connelly, F. M., & Clandinin, D. J. (1990). Stories of experience and narrative inquiry. *Educational Researcher, 19*(5), 2–14.

Daly, M. (1992). *Outercourse: The be-dazzling voyage.* San Francisco: Harper.

Davies, I. (1990). *Writers in prison.* Toronto: Between The Lines.

Diamond, C. T. P. (1991). *Teacher education as transformation: A psychological perspective.* Milton Keynes, UK: Open University Press.

————. (1993). Writing to reclaim self: The use of narrative in teacher education. *Teaching & Teacher Education, 9*(5/6), 511–517.

Diamond, C. T. P., Mullen, C. A., & Beattie, M. (1996). Arts-based educational research: Making music. In M. Kompf, W. R. Bond, D. Dworet, & R. T. Boak (Eds.), *Changing research and practice: Teachers' professionalism, identities, and knowledge* (pp. 175–185). London: Falmer.

Diamond, C. T. P., & Mullen, C. A. (1997). Alternative perspectives on mentoring in higher education: Duography as collaborative relationship and inquiry. *Journal of Applied Social Behaviour, 3*(2): 49–64.

Eisner, E. W. (1995). What artistically crafted research can help us to understand about schools. *Educational Theory, 45*(10), 1–6.

Feuerverger, G., & Mullen, C. A. (1995). Portraits of marginalized lives: Stories of literacy and collaboration in school and prison. *Interchange, 26*(3), 221–240.

Foucault, M. (1979). *Discipline & punish.* New York: Vintage Books.

Gabella, M. S. (1994). The art(s) of historical sense. *Journal of Curriculum Studies, 27*(2), 139–163.

Gergen, K., & Gergen, M. (1993). Notes about contributors. In R. Josselson & A. Lieblich (Eds.), *The narrative study of lives* (pp. 225–226). London: Sage.

Giroux, H. A. (1991). Democracy and the discourse of cultural difference: Towards a politics of border pedagogy. *British Journal of Sociology of Education, 12*(4), 501–519.

Giroux, H. A., Lankshear, C., McLaren, P., & Peters, M. (1996). *Counternarratives: Cultural studies and critical pedagogies in postmodern spaces.* New York: Routledge.

Giroux, H. A. (1997). *Pedagogy and the politics of hope: Theory, culture, and schooling.* Boulder, CO: Westview Press.

Glesne, C., & Peshkin, A. (1992). *Becoming qualitative researchers: An introduction.* White Plains, NY: Longman.

Goffman, E. (1961). *Asylums.* New York: Doubleday.

Gramsci, A. (1971). *The prison notebooks: Selections.* (Q. Hoare & G. Nowell-Smith, Trans.). New York: International Publishers.

Guba, E. (1990). Subjectivity and objectivity. In E. W. Eisner & A. Peshkin (Eds.), *Qualitative inquiry in education: The continuing debate* (pp. 74–91). New York: Teachers College Press.

Harding, S. (1991). *Whose science? Whose knowledge? Thinking from women's lives.* Ithaca, NY: Cornell University Press.

Harlow, B. (1987). *Resistance literature.* New York: Methuen.

Harris, J. (1986). *Stranger in two worlds.* New York: Kensington.

Hawkins, J. M., & Allen, R. (1991). (Eds.) *Oxford encyclopedic English dictionary.* Oxford: Clarendon Press.

Hunt, D. (1987). *Beginning with ourselves: In practice, theory, and human affairs.* Cambridge, MA: Brookline Books.

Kelly, G. A. (1955). *The psychology of personal constructs* (2nd ed., 1992, London: Routledge, Vols. 1–2). New York: Norton.

Lakoff, G., & Johnson, M. (1980). *Metaphors we live by.* Chicago: University of Chicago Press.

Lessing, D. (1986). *Prisons we choose to live inside.* Toronto: CBC Enterprises.

Lovitt, C. (1992). The rhetoric of murderers' confessional narratives: The model of Pierre Riviere's memoir. *Journal of Narrative Technique, 22*(1), 23–34.

MacDonald, M. (with A. Gould). (1988). *The violent years of Maggie MacDonald.* Toronto: McClelland-Bantam.

Macey, D. (1993). *The lives of Michael Foucault.* London: Hutchinson.

McLaren, P. (1995). Serial killer pedagogy. *Taboo: The Journal of Culture and Education, I,* 163–184.

Mishler, E. G. (1990). Validation in inquiry-guided research: The role of exemplars in narrative studies. *Harvard Education Review, 60*(4), 415–442.

Mullen, C. A. (1994b). A narrative exploration of the self I dream. *Journal of Curriculum Studies, 26*(3), 253–263.

————. (1997). *Imprisoned selves: An inquiry into prisons and academe.* New York: University Press of America.

————. (in press). Reaching inside out: Arts-based educational programming for incarcerated women. *Studies in Art Education.*

Mullen, C. A., & Dalton, J. E. (1996). Dancing with sharks: Becoming socialized teacher-educator researchers. *Taboo: The Journal of Culture and Education, I,* 55–72.

Mullen, C. A., Cox, M. D., Boettcher, C. K., & Adoue, D. S. (1997). (Eds.). *Breaking the circle of one: Redefining mentorship in the lives and writings of educators.* New York: Peter Lang.

Padel, U., & Stevenson, P. (1988). *Insiders: Women's experience of prison.* London: Virago Press.

Paley, N. (1995). *Finding art's place: Experiments in contemporary education and culture.* New York: Routledge.

Peshkin, A. (1988). In search of subjectivity–one's own. *Educational Researcher, 17*(7), 17–22.

Pessoa, F. (1991). *The book of disquiet.* (A. Mac Adam, Trans.). New York: Pantheon.

Peters, M., & Lankshear, C. (1996). Postmodern counternarratives. In H. A. Giroux, C. Lankshear, P. McLaren, & M. Peters (Eds.), *Counternarratives: Cultural studies and critical pedagogies in postmodern spaces* (pp. 1–39). New York: Routledge.

Pinar, W. F. (1988). Autobiography and the architecture of self. *Journal of Curriculum Theorizing, 8*(1), 7–35.

Richardson, L. (1994). Writing: A method of inquiry. In N. K. Denzin & Y. S. Lincoln (Eds.), *Handbook of qualitative research* (pp. 516–529). London: Sage.

Said, E. W. (1996). *Representations of the intellectual.* New York: Vintage.

Saint-Exupéry, de A. (1958). *The Little Prince* (pp. 1–2). (F. A. Shuffrey, Introduction). London: Heinemann.

Sarup, M. (1989). *An introductory guide to post-structuralism and postmodernism.* Athens, GA: University of Georgia Press.

Sharansky, N. (1988). *Fear no evil.* Toronto: Random House.

Van Maanen, J. (1988). *Tales of the field.* Chicago: University of Chicago Press.

Weber, S., & Mitchell, C. (1996). Drawing ourselves into teaching: Studying the images that shape and distort teacher education. *Teaching and Teacher Education, 12*(3), 303–313.

Chapter 10

Carousel: A Metaphor for Spinning Inquiry in Prison and Education

Carol A. Mullen

It seemed as if they would never stop, as if there were no such thing as Time, as if the world was nothing but a circle of light and a group of painted horses. (Travers, *Mary Poppins Omnibus*, 1982, p. 468)

The forging of a sense of identity is never finished. Instead, it feels like catching one's image reflected in a mirror next to a carousel—"Here I am again." (Bateson, *Composing a Life*, 1990, p. 219)

All the kids kept trying to grab for the gold ring, and so was old Phoebe, and I was sort of afraid she'd fall off the goddam horse, but I didn't say anything or do anything. The thing with kids is, if they want to grab for the gold ring, you have to let them do it, and not say anything. If they fall off, they fall off. (Salinger, *The Catcher in the Rye*, 1964, p. 211)

Carousel: A Postmodern, Cinematic Image

We may all remember with fondness or fascination the carousel or merry-go-round, an amusement park ride in sideshow alley, a gaudy landscape of fairground artifice and make-believe. I use the image of the carousel in this chapter to remind us that, thanks to a postmodernist re-narrativization of experience, "the truth about truth is that it isn't what it used to be" (Anderson, 1995). Flat, hollow, and merely sterile versions of personal and institutional experience can be startled back into life by using arts-based approaches. I discuss strategies for provoking teacher excursions into the ongoing, erratic, and even out-of-control. Experience, as of an inquiry or of teaching, is in many ways a mysterious process. It involves imaginative minds (the making) and excited bodies (the riding), cool thought and hot passion, and

personal and collective meanings. The carousel reminds us that experience is closely related to play, art, moving pictures, craft, poetry, and theater. Postmodernism is not just a lapse of reason but also provides the means for expanding beyond it into the aesthetic but scary "funhouse."

The greatest show on earth! Riding the carousel we can be "free, irresponsible, . . . joyous . . . without asking permission; a desire lacking nothing, a flux that overcomes barriers and codes" (Deleuzze & Guattari, 1977, p. 131). At one time, the carousel was a signature piece that identified a particular artisan's vision. It assembles a highly distinctive round of horses or other creatures like swans (nowadays fabricated out of plastics and aluminum instead of crafted out of wood) that move around a fixed center as organ music (recorded) is cranked out. Although a tawdry image of life and death with reflecting mirror panels and colored light bulbs, the carousel can provide a vision of mythic, cosmic forces. As an example, recall the childhood story of Mary Poppins (Travers, 1982). A prancing roundabout takes the children on a journey to the "centre of the world" before spinning off, with Mary Poppins as spirit-rider, to become a constellation of selves. Through the imagination of Mary Poppins and the catalyst of the ride, the children become visionaries. Early or midway in a career of teaching we need to take such risks.

The carousel features in many other literary as well as cinematic stories. Ambrose features in Barth's (1968) funhouse story visits to Ocean City with its "ferris wheels, carousels, and other carnival rides . . . and a vast and ancient merry-go-round. . . . At one ill-frequented end of the boardwalk a few derelict amusements survive from times gone by: the great carousel from the turn of the century, with its monstrous griffins and mechanical concert band" (pp. 88, 96). Uses of the carousel range from the playful to the sinister, and include the narratively complex and psychologically ambiguous.

Two of Rodgers and Hammerstein's classic filmed musicals, *State Fair* and *Carousel*, portray carousels as part of musical entertainment. However, the merry-go-round as an artful image is especially prominent in *Carousel* (1956). Two love-struck adolescents (played by Shirley Jones and Gordon MacRae) meet at Mullin's (almost my own surname) Carousel over the shouts of the "barker" at the town carnival. Billy (MacRae), the lover-to-be, gestures to passersby to climb aboard; as a performer-tout, he invokes the magic of the carousel, encouraging customers to go "faster and faster each year [and] around [within] a midway packed with people." The barker is an icon of

gatekeeping and cultural displacement in Twitchell's (1992) *Carnival Culture*: "In the twentieth century, especially since the 1960s, the gatekeeper/cleric has wandered away and the carnival barker/programmer has taken his place. 'Step right up, folks, right this way and see. . . .' In the beginning was the Word, but in the end it will be the Image" (p. 3).

Musical reminiscences of the carousel, such as "round in circles," punctuate lines of song and intense moments throughout the story of *Carousel*. The carousel's associations with false attraction, devious ploys, and failed dreams unfold in the context of the lovers' lives. Billy the barker is referred to by Mrs. Mullin, the carousel owner, as an "artist type who belongs where the carousel is." She is driven to manipulate Billy to the point of demonism although this is rendered comedically. Like others of her shadowy ilk in the story, she overpowers the protagonist, whose center of self is not his own. His demise is also set in motion by the dark undertow of forces from his own shady past and carnival-like existence. Vadim in Nabokov's (1980) *Look at the Harlequins* has a similar dream feeling of displacement: "My life was the non-identical twin, a parody, an inferior variant. . . . A demon was forcing me to impersonate that other man . . . who would always be incomparably greater" (p. 76).

In the postmodern romance, the past is evoked in an uncanny way as an act of interrogation against "historical boundaries and aesthetic laws" (Elam, 1993, p. 227). *Carousel*, read as a postmodern romance, "breaks open" the past through a musical composition that refers back in time through an ironic stance. The barker is a heavenly angel, somewhat tarnished, but nonetheless an angel. He is made to believe that he must do some good by helping his daughter to move beyond despair.

The magical carnivalesque sequence, or imaginary carousel ride, is of special interest in the film. This dance is performed by men and women who move about in circles on a beach, and, in pairs, imitate rocking horses. The carousel performance is enacted without animals, canopy, bars, or an actual rotating mechanism, although these images are hinted at in the dancers' elegant gestures and colorful head plumes. This poetical circus scene flows from and into a single rusted wheel. Billy's adolescent daughter throws herself upon this wheel, spinning in despair, around and around. The girl suffers from her mother's romantic story of her deceased husband, Billy, which is seriously at odds with the townspeople's derogatory version of his remembered character. The wheel functions as a kind of carousel mechanism, broken-off and rearranged in this solipsistic beach scene. A fragment of

her father's history, the wheel symbolizes her own inherited misery. Caught within her conflicted depths, she has yet to heal in the arms of the larger forces of faith, guidance, and trust.

Accordingly, the carousel unfolds, in this chapter, as a postmodern, theatrical image. I use the carousel image to interrupt the usual expectations of coherence, predictability, and finalizability that drive traditional knowledge claims. This impulse to create rupture in order to provoke reaction and stimulate artistry also seems to be at work in the other carnivalesque-like chapter, "Animals and Curriculum Masters." Images of horses run wildly throughout its "picture show," releasing the viewer's imagination.

Another example of the carousel image in film occurs in Alfred Hitchcock's (1951) classic, *Strangers on a Train,* which was based on a Patricia Highsmith novel and coscripted by Raymond Chandler. This, too, provides an outstanding arts-based narrative example of the uses of the carousel. Here, the carousel is featured at two points of the story to heighten the malevolence of the psychopath, Bruno Anthony (played by Robert Walker). Bruno's chilling intention is to seduce a tennis star, Guy Haines (Farley Granger), into participating in a double murder exchange. In the first instance of the carousel, Bruno follows Marion, Guy's former and vengeful wife, throughout an amusement park. They come to ride the carousel. He is on a horse directly behind hers while she sings along with male companions, oblivious to his grim presence. Bruno strangles Marion while her eyeglasses drop and crack.

The second, extended instance of the carousel involves a chase scene and the final revealment of Guy's innocence (although this too is twisted with darkness). Guy jumps onto the carousel after Bruno, insisting that he tell the truth of the murder, at which point the operator is accidentally shot by the police. In rapid fire motion, Bruno attempts to strangle Guy while they fist-fight under the pounding hooves of the carousel horses. This particular motion is intensified at the point when Bruno holds on to a horse's hoof while kicking Guy, imitating the animal's foot action. The carousel has become a life-threatening force, spinning wildly out of control, unleashing pandemonium. As the careering carousel is arrested, it comes to a crashing halt with horses flying off their stations. There is an explosion, smoke, and screams. One of the riders, a small boy, smiled as he hit out at the pair as they fought.

The carousel is fleetingly invoked in another amusement park scene in Carol Reed's (1949), *The Third Man,* based on Graham Greene's

novel. Here the carousel serves as a backdrop for an ominous encounter between former friends in post-World War II Vienna. Toward the end of the story, the American pulp writer (played by Joseph Cotten) and his venomous ex-comrade (Orson Welles) finally meet face-to-face. They enter a car on the Ferris wheel. A momentary flash reveals a nearby stalled carousel. (Is the carousel here a doubling of the Ferris wheel, but in another dimension?) The carousel starts spinning only when the novelist-protagonist overcomes the psychological danger inherent in this encounter. Ironically, he is saved by his own epiphanic moment. He finally realizes the extent to which the dark side rules the other man's heart. The carousel functions as a symbol for many such encounters in films wherein malevolence is juxtaposed and entangled with innocence. The ominous is strangely heightened in the context of twisted, carnivalesque merriment.

Beyond the cliché, there are artful moments in film and literature wherein the "carousel" is suggestively at work in the shadowy depths of character and plot. In one such example, the music of the merry-go-round plays in *Strangers on a Train* as Bruno manipulates an older woman, at a party, into letting him show her how it feels to be strangled. But during the course of his display of power, he spies another woman who very closely resembles Marion, the woman he murdered at the fairgrounds. Bruno falls into a trance, hypnotized by the eyeglasses, continuing to press into the woman's neck. They both faint. The psychologically complex, aesthetic uses of the carousel in such films outweigh those that are more obvious. However, all such instances contribute to what Marion's father-actor had called the carousel's "sordid atmosphere."

On a lighter note, picture books, such as *Grab the Brass Ring: The American Carousel* by Hinds (1990) and *Fairground Snaps* by Scott-Stewart and Williams (1974), provide just two examples of fairground art celebrated in visual narrative form. The former book focuses on the history of carousels, their makers, and various types of carousels throughout the United States. The latter portrays the relationship between the carousel (and other amusement park rides) and antique advertising signs. The various signs are treated as the arts-based signature pieces of owners.

Arts-Based Activity

Locate or recall additional sources of the carousel image as portrayed in literature, film, music, painting, or in your own travels. (Other examples are available in this chapter.) Consider how the image is being

used, or nuanced, and to what effect on landscape, history, story, plot, character development, and vision. Show your carousel sources to another audience, such as to a group of students, to encourage multiple interpretations of the images. Or, ask an audience to locate and interpret their own sources. Use the carousel image to broaden and deepen discussion to include topics of interest. This arts-based carousel exercise can also be used to help students and teachers to develop their own central metaphors of inquiry and education.

A Collector of Carousel Images

As a teacher educator-researcher, I have collected images of the carousel over the years. I have used the carousel metaphor to develop ideas about art, narrative, and education. During my trip to France in 1995 with partner Bill Kealy, we photographed scenes related to our individual academic and artistic interests. Carousels and carousel-like impressions (e.g., of carnivalesque horses atop buildings and on walkways; winding stairs; and circular milling crowds) captured my own imagination. I rode the carousel horses (despite the prolonged gaze of other adults); peered over curtains draping carousel works-in-progress (usually renovations); and investigated the signature status and history of some of the carousel rides. I talked with carousel operators and riders, passersby, and shop owners.

The French "carousel" can itself be read as a double-image of lightness and darkness. Paris is the eternal symbol of being transported by light-hearted promises of love and romance. The city is itself captured by such sites as the Arc de Triomphe du Carrousel ("Triumphant Arch of the Carousel"). Paris is also the historic site of the Reign of Terror. From 1793 to 1794, people considered enemies of the ruling group were beheaded. Political suspects were slaughtered between the executions of Louis XVI and Robes-Pierre (Barnhart & Barnhart, 1987). In 1789, the Bastille, the infamous prison-fortress, was stormed and destroyed by Parisian mobs on July 14th, the proclaimed Day of Independence (Sykes, 1987). Paris, the capital of love and the heart of revolution, has been marked by scenes of destruction and independence, darkness and light.

Figure 16 is an artistic composite or photomontage based on a recreation of my autobiographic travelogue to Paris and other parts of France (also see chapter 13). I selected photographs of the carousel that exhibited a range of visual meaning from the obvious to the sug-

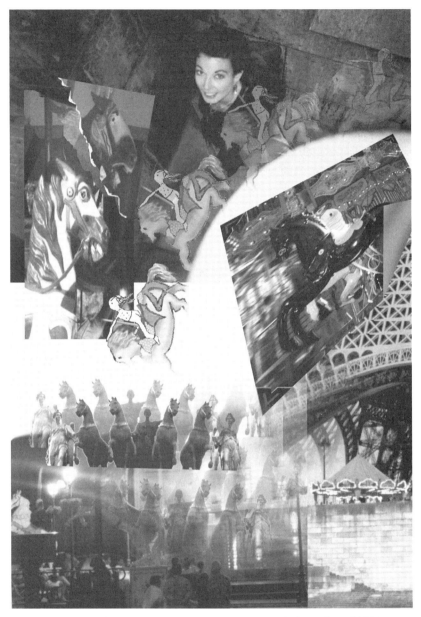

Figure 16 *Carol's Carousel: A Photographic Spin* (C. A. Mullen, 1998)

gestive. These selections were computer-scanned and artfully rearranged using Adobe Photoshop. The result is a self-portrait featuring myself in winding descent in a dream-filled landscape of carousels and horses broken free from their otherwise secure posts. But some of the carousels are, in contrast, tucked away, obsured by stone walls and overtaken by even greater mechanisms (such as the Eiffel Tower). I travel through time and space in my interactions with multiple forms of carousels. None of them provides the final clue as to where my arts-based impulses may lead me.

The headpiece itself (at the top of Figure 16) is, like other fragments, reminiscent of the merry-go-round. The circularity of the staircase conveys this impression as do the horses, which are stamped, in a suitably secular fashion, onto the staircase of the church (the basilica Sacré-Coeur, meaning "sacred heart"). Such circular shapes are imitated in unique ways throughout the collage, albeit as half-shapes and partial views. The miniature horses (at the top) are made to look transparent so as to give them a mysterious, timeless appearance.

I approached the artwork as a postmodern educator whose engagement with a taken-for-granted landscape has dramatically changed. My visual world is strongly influenced by postmodernist "carousels" (e.g., institutions, prison cultures, academic disciplines, research protocols) that can no longer function as though intact, coherent, and all-seeing. "Carousels" are dissolving *and* assuming new forms. The carousel, signifying human construction and chaos, is changing: what once was, is now being dismantled, fragmented, rearranged. And yet, even the seeming jumble of images (in Figure 16, and, later, Figures 17 and 18) can be "read" for their promising reflections on life.

My search for completeness and unity is also captured by the Eastern spiritual symbol of the mandala. The mandala is another carousel. Like the carousel, the mandala can be identified with personal, social, and metaphysical sources of energy. The mandala and carousel evoke, for me, a state of consciousness that honors both the desire for completeness and the need to respond to chaos. Hawking (1988), the theoretical physicist, helps to explain the need that human beings have for "a complete unified theory" and "underlying order in the world." He identifies the need for this illusion as an outgrowth from the past: "Ever since the dawn of civilization, people have not been content to see events as unconnected and inexplicable" (p. 13).

The search for narratives of meaningful fragments has yet to be widely legitimated in inquiry and education and scholarly writing. Eisner

Figure 17 *Body Regulation in Space* (K. Mantas, 1995–1996)

(1997) applauds "alternative forms of data representation" and describes them as "forms whose limits differ from those imposed by propositional discourse and number." Meaningful fragments can be demonstrated, then, through "stories, pictures, diagrams, maps, and theater. . . . And, perhaps above all, we have poetry" (Eisner, p. 5).

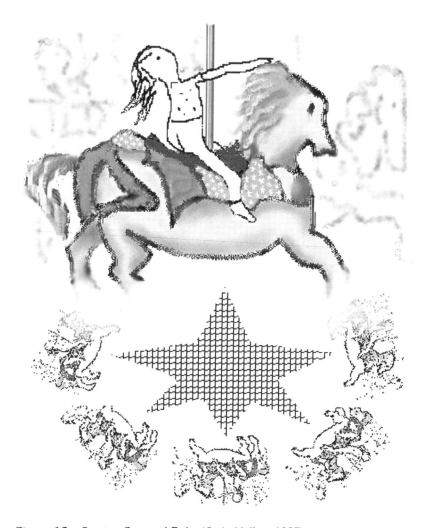

Figure 18 *Captive Carousel-Rider* (C. A. Mullen, 1997)

In our postmodern world of shifting forms of stability and chaos, the pursuit of a new language of coherence that honors our own discontinuities is necessary. I ask, "How do we get inside the carousel?" What does the core of the carousel look like to each of us and how does it feel? Can it be experienced as other than a children's amusement ride? Consider an insider's view of the carousel—a winding staircase that, although dungeon-like in its restricted view, excites the imagination. When the imagination is engaged, a challenging art-

making experience can be rendered. As a researcher of prison sites, such an experience of the interior of the carousel becomes possible for me as I embrace the partial view afforded by such stances/locations. In dismantling the carousel, surprises can be yielded.

Arts-Based Activities

1. Identify the carousel-like images in Figure 16, such as the winding staircase and transparent, miniature horses. Make a list. Now compare these images to carousels you have seen or experienced. How do the images in the photomontage differ from any expectations that you may have of the carousel? What, then, might you infer about the role of arts-based representation in research and inquiry, story and life?

2. Art educator Terry Barrett (1996) reminds us that "it is important to examine the context in which a photograph [or photomontage] has been placed, whether that be a newspaper, a magazine, a billboard, or a museum gallery. When an editor captions a photograph [or artwork], that editor is interpreting it" (p. 93). Building on Barrett's ideas, rename Figure 16 by considering this photomontage in one or more contexts that make up your world. What sorts of interpretations are now available to you that were not made available before? Also, in what ways have you been persuaded to understand this image by me, its maker, in a certain way?

The "Carousel" of Prison Cultures

The carousel, in its "darkest hour," is represented by Foucault (1979) as the Panopticon (see chapter 9). This device is an aesthetic, architectural metaphor that Foucault borrowed and extended. This, ironically put, image of a "marvellous machine" reveals how space is arranged and bodies regulated in the enclosed structures of prison. Figure 17, a mixed media drawing, offers an interpretation of bodies regulated and imprisoned in space, including those very "spaces" of artistic rendering. Some of the people in this image are prisoners of war, others shackled and chained because of laws, rules, and regulations. Prison cultures like those of court and school systems optimize space to promote observation, power, and certainty. Foucault's arts-based metaphor dramatizes the ways these dynamics operate. From this stance, rehabilitation and reeducation are by-products of super-vision

rather than authentic attempts at human change. Research models in educational theory, such as those derived from clinical supervision, can also be critiqued as derivatives of the urge to enshrine an all-seeing researcher authority.

The unlikely but apt metaphor of the carousel can be associated, as I am doing here, with the constraining cultures of corrections and academe. By juxtaposing these educational institutions in certain ways, I can promote new ways of seeing and reseeing them as "prison cultures." Why the carousel metaphor? It promotes an expressive, less bounded way of participating in an inquiry of education. The workings of a carousel are shown by its circularity, predictability, and continuity. Prison cultures are predicated upon the same forces, but they often contradict themselves with interruptions in pattern and rhythm.

The worlds of corrections and academe, when placed side by side, share restrictive and liberationist elements, albeit differently. By examining prison cultures from an experiential perspective, further insight into educators' conceptions and lives can be gained. Metaphorical imagining, the arts, and cross-institutional perspectives can be brought together to promote an artistic way of reseeing educational institutions. In today's postmodern world, new ways of understanding are needed for improving what we do in teacher education (Guba & Lincoln, 1994), and in other areas of inquiry.

The carousel, as an arts-based device, can be used to confront and reimagine those rituals of living, and practices of researcher socialization, that require reanimation. I associate new vitality with the arts-based impulses of interruption and disruption. The carousel image has, for me, an auto(bio)graphical-sociopolitical thrust: it underscores the value and necessity of experiences of border-crossing (e.g., Feuerverger & Mullen, 1995; Giroux, 1991, 1993; Mullen, 1997) into unfamiliar places to engage more fully in a "professional knowledge landscape [which is] composed of relationships among people, places, and things [and which is] both an intellectual and moral landscape" (Clandinin & Connelly, 1996, p. 25). Through border-crossing into correctional facilities (and prison education), we can examine, from a new location, our familiar locations. Art honors the unconnected and inexplicable, and it also "teases" connections where forced separations have been made (Mullen, in press). Art is a function of reseeing, relocating, and connecting anew.

Carousel: A Language of At-Riskness

Within institutions of higher learning (the academy), the socialization process of graduate students and faculty is problematic. Even though ethnographic and phenomenological studies of human lives are encouraged (Grumet, 1992; Pinar & Reynolds, 1992; Van Maanen, 1988), educators are at risk of not developing "sympathetic imagination" through caring relations (Witherell, 1991). Acceptable forms of representation mark our place in the educational world. These forms are typically empirical as well as diagnostic and abstract (Britton, 1990; Mullen, 1994; Richardson, 1994). The sympathetic imagination can be obscured unless experienced through human contact and the arts-based approaches (Mullen, in press).

Repressive educational and research practices are carried over into curriculum-making and rehabilitative programs within prisons. My experience as a prison researcher-teacher has been that personal writing and expression are controlled through basic literacy exercises that deny autopolitical locations and the creative imagination. Institutional critiques, whether of programs, facilities, and/or persons in authority, are not welcomed. Correctional programmatic efforts focus on reconfiguring the social self of inmates by restricting freedom of expression. Any genuine opportunities for transformation are left to chance. From this perspective, arts-based inquiry ironically offers a "survival advantage" (Hawking, 1988).

Ethics can be treated constructively as a form of cultural practice that can be aimed at engaging persons (researchers and participants) in expanding their sympathetic imagination and caring relations. Despite institutional inertia, artistic ways of seeing can be enacted. Psyches can be stretched in new directions. As a researcher on a "carousel" within prisons, I have gone around in circles trying to find available spaces to work one-on-one with inmates. In a male detention center, these literal working spaces were later transformed into value structures for me, and places of artistic surprise and growth. I searched for creative writing opportunities to promote personal, cultural, and critical expressions of meaning. My poem, "Welcome to Carousel," is about how "prison" can be imagined as a site where the artistic self confronts forces of skewed pragmatism and institutional control. The poem is centered on the page to reflect the rotation of a carousel around a central point.

by Carol A. Mullen

On a merry-go-round, searching for available rooms
circling, asking the guards, fretting, circling again
trying to locate working space eaten up by lawyers
busy charting the systematic order of a life.

Getting keyed up to ride on elevators
jammed up against inmates
peering over carts filled with supplies.
"Do-gooder," they smile as I step off.

An empty room looms like heaven
and, once in, and settled with the purpose-talk done
the walls swell with ink-stained worries.
Is this what we call an "inquiry" in education?
A bandaged hand keeps the beat of the tune.
It, too, is marked, but with fantasy and art.
Is there a word for home-grown poetry that is sung?

Had he intuited that I, too, felt like a "painted pony
halted in mid-gallop, a frozen carousel,
charging forth without proceeding
on my painted pony bound for hell"?
Was I merely an academic coping with constraints—
the kind that deaden the creative impulse?
make heavy healthy limbs?
eye-lids weary with sleep?

Music swept from his soul into mine—
inmates wanting release from the numbness.
Imprisoned selves struggling to be free
seeking, not escape, but self-expression,
movement of the carousel,
life beyond the Panopticon.

The carousel is a living story of our daily lives
filled with cells, bars, walls, and guards.
But it must be made of words
if it is to live at all.
(Mullen, "Carousel," 1995, p. 12)

Carousels conjure up both images of children at play with watching caretakers on guard nearby and also patterns of rotation. This picture is innocent enough until "inmates" is substituted for "children," "gatekeepers" for "caregivers," and "inertia" for "rotation." The carousel can represent, in artistic terms, a place of institutional regulation and even stagnation. From the standpoint of the carousel, institutions of higher education can be viewed as regulating bodies, curriculum, and perspectives, although to a lesser degree than penal institutions.

Being "at-risk" is clearly an issue for children and adolescents who are growing up within a "prison-carousel" environment. Lasting effects of children being at risk of failure in inner-city school environments are compounded by the lack of community services and economic supports provided to poorer schools (Kozol, 1991). Multicultural literacy programs aimed at minority populations within schools and jails signify hope but also probably need reform. In such programs, narrative structures have yet to be widely used as the basis for developing reading and writing abilities and for helping learners to become partners in language curriculum-making (Feuerverger & Mullen, 1995).

Being "at-risk" is also an issue that affects preservice teachers (and their future students) who must acquire, despite traditional approaches to higher learning, more effective and self-reflexive ways of working with minority students (White, 1995). The unchanging features of the (Euroamerican) majority context is confirmed by *The Chronicle of Higher Education*. Bachelor's degrees conferred by racial and ethnic group show that: 80.3% are White, 7.2% Black, 4.3% Hispanic, 0.5% American Indian, and 2.9% non-resident alien (Gwaltney, 1996, p. A30). In Chapter 6, I consider how White preservice teachers need to practice border-cross into different cultures in order to develop their identity as multicultural educators.

We can attempt to create a "cultural collision" by bringing together unlikely worlds and seemingly inconsistent frames of reference. "On our way to a new consciousness," the discovery is that we "can't hold concepts or ideas in rigid boundaries. . . . Because the future depends on the breaking down of paradigms, it depends on the straddling of

two or more cultures" (Anzaldúa, 1987, pp. 78–79). The quasi-parallel I am drawing between prison and academe can contribute to this merging of paradigms. Of course my analogy is limited. We are warned of the dangers of being co-opted and suborned in Hitchcock's (1951) *Strangers on a Train* as well as in Reed's (1949) *The Third Man*. The postmodern pursues that which is doubled, imperfect, and unfinished.

In comparison to the prisoners, the higher education population is not seriously at-risk. The 82% high school dropout rate among prisoners (White, 1995) conjures up an image of schools as a carousel spinning out of control, spilling its riders. The humming mechanism of schools viewed as a carousel reveals its dark side in prisons, where failure is compounded by institutional inertia. However, some prisoners expand their sympathetic imagination and the caring relation through arts-based approaches within the context of controlling and even deadening forces. Even "medicated storytellers" can use art to improve their chances of survival.

References to Black Hawk and Sear, both prisoner-writers, are interwoven later in this chapter to illustrate such transforming selves. Their writings jolt insight into the carousel-rider who is struggling to remake himself or herself. I selected these portraits from my 1990–1992 study of a maximum security prison, for male offenders, located in an urban setting in Canada. On-site, I managed to experience relatively sustained involvement with 13 correctional research participants—inmates, teachers, correctional officers, group facilitators, and education coordinators.

As a carousel, teacher education has a menacing or mysterious side. Its correctional processes and practices can sometimes restrain its nobler, more caring ambitions. Being "imprisoned" by research conventions and socially acceptable ways of telling stories of research can be viewed as a milder form of incarceration. While being "imprisoned" in this way is different from actual incarceration, and while teacher candidates and prisoners are dissimilar culturally and politically, teacher educators (especially beginning and untenured) are nonetheless recipients of a prescriptive set of regulatory practices (Pinar, 1994). (For a demonstration of this point, see the "self-narratives" in chapter 9.) Imaginative work is necessary for identifying at-risk "inmates" and for seeing them more expansively. Such innovative work is also necessary for generating perspectives on reform (Sarason, 1990). Imaginative work can help in the ethical, arts-based search to formulate constructive alternatives for and with at-risk populations.

Prisons and academe can be linked through an illusion of movement/progress as well as through caring relations that in part characterize both realms. The carousel is an image of the illusion of movement that, when interrupted and changed, can become authentic. Prison-carousels purport to rehabilitate or re-educate. But, they often have lengthy waiting lists that block programmatic opportunities as well as personal and communal gains.

Many educational theories explain how institutional power works to maintain the status quo or the interests of the majority. Inequities keep border individuals on the margins, struggling to change the circumstances of the underclass they themselves represent (Giroux, 1991; Paley, 1995). Teacher education aims to re-educate, but it may be constrained by its own underexamined assumptions and its professional at-risk elements. Those who disrupt or even transform its protocols and methods of research often live on the margins, in exile, where they can explore experience more freely. The illusion of progress often necessitates that graduate students enable their mentors' research agendas and teaching commitment. Students are socialized to, for example, provide human resources and practical settings to try and test their mentors' theories of education (Mullen & Dalton, 1996). They also spin-off the existing momentum. While this form of learning may contribute to intellectual growth, it overlooks the many ways in which students are at-risk of not developing, and hence stagnating Stories of researcher socialization are discouraged, as is evident in the paucity of inside-out or autopolitical studies. (For an alternative to the traditional supervisor–graduate student relationship that promotes equality through arts-based methods, see chapter 11.)

Carousel–Personal Research Story

I turn now to fragmented writings of inmate-participants and to my own as a prison teacher-researcher. By assembling, arranging, and rearranging pieces, I stitch together aspects of at-riskness and liberation. The postmodern effort here is to "stretch the psyche horizontally and vertically" and to develop a "tolerance for ambiguity" (Anzaldúa, 1987, p. 79). On an ideological level, postmodern ethnography engages a proactive understanding of disruption. Taken-for-granted notions of educational experience are intended to be challenged within this framework.

New social institutions are needed with built-in, self-reflexive modes for examining the cultural influences of individuals. By "self-reflexive

mode," I mean in part that the researcher strives to capture how his or her thinking inhabits the same cultural, educational, or historical moment as those being studied. The metaphor of carousel combines the texts of "prisoners" (correctional participants) and "inmates" (researchers) within the same interpretive moments. A cultural collision is deliberately enacted where I inhabited the same time frames as others. The prison culture is being imagined here as an educational community at-risk; educators, in turn, are being imagined as at-risk of "riding" the carousel, if not creating it. Efforts to "remake" the prison-carousel require a dynamic interchange between the sympathetic imagination and reform actions. Ethical education is especially needed in support of at-risk lives and, on a macro-level, the disciplinary life-world of imprisoned selves (Mullen, 1997).

Although regulations and practices govern, to varying degrees, how people live in prison and in the education field, the unexpected is not excluded in either domain. People find ways to share and write personal research stories (McClintock, 1994), even within threatening circumstances. Through this process, prisoners and educators engage in genuine "re-education" (Dewey, 1958) and, hence, in remaking aspects of the prison-carousel. They give validity to stories of experience despite censoring bodies, curriculum, and restrictive perspectives. Prisoners have been "trained" to view their artistic efforts, or disruptions of the carousel, as irrelevant, but they can serve as political acts of sabotage. Those prisoners concerned with self-preservation, bargaining, and release use their writing in institutionally savvy terms: narrative writing is generally (but not always) kept private unless self-gain, such as early parole or special privileges, is forthcoming (Abbott, 1981; Caron, 1978).

Educators who tell personal research stories can employ arts-based, self-study methods as reflective tools of inquiry. Data that are treated as emergent, personally meaningful, and internally trustworthy continue to attract suspicion (Lincoln & Guba, 1985). The need to validate and account for how data are generated, selected, and interpreted is not what is at issue here. Rather, what is at issue is an *a priori* problem. The structure for the telling of research stories is already a given. Templates or "intellectual structures of disciplines and methods of pedagogy" (Grumet, 1988, p. 100) have been established as iron-clad and rule-bound. The systematic development of a qualitative study, including its phases of negotiation of entry into, and exit from, research sites, has been canonized (Glesne & Peshkin, 1992). Such cor-

rectional practices shape what and how researchers "see" in their fields of study.

To help expose at-risk elements within educational institutions, I respond to five guiding questions, which I now articulate more formally.

1. What is the nature of the metaphor of the carousel?
2. What is the nature of the carousel in teacher education and research?
3. What is the nature of the carousel in prisons?
4. How is the work of educators constrained by insufficient inquiry into the at-risk nature of research practices? and
5. How can we disrupt the "carousel" to determine a more authentic and innovative process in higher education and teacher development?

Two intentions are at work behind these questions: one, the need to expose conventional researching perspectives as a form of correctionalism; and two, the effort to imagine penal and educational institutions as a carousel of shaping influences, pressures, and dynamics.

The teacher education profession can benefit from better understanding how it is socializing itself and how its members are coerced. To this end, I now turn to the metaphors of carousel-rider and creator to show differences in how educational institutions, and one's own development, can be approached.

Transforming Carousel-Riders into Creators

What is the nature of the metaphor of the carousel? And, what is the nature of the carousel in teacher education and research? The carousel ride in amusement parks presumably attracts children to its musical fantasy ride. Children enjoy the sensation of lunging forward on the backs of majestic animals. Like researchers, they probably delight in this illusion of movement and satisfaction in having completed a unified course of action. The illusory experience of the carousel-rider is conveyed in my computerized drawing (originally sketched in freehand). The star-bar image at the center of Figure 18 is reminiscent of the carnival-like canopy that shelters the carousel-rider. But here the "canopy" is flattened, bar-like, and at the center of the ride (rather

than at the top, as a kind of protective shield). The elements of the carousel have been dismantled and rearranged in a postmodern fashion. The carousel, when artistically reconfigured, provides a new way of seeing cultures of imprisonment. Here, the rider who is a creator does not escape institutional constraints, but rather uses them as a creative force for arts-based development.

Arts-Based Activities

1. Develop a list of elements that "make up" the type of carousel that is familiar to you. Spot other elements, in addition to the canopy in Figure 18, that have been dismantled and rearranged in this alternative version. Consider the effect that this arts-based version has made on you. What is its potential relationship to imaginative forms of teaching and research, new learning and practice?
2. Create your own "carousel" artwork, featuring experiences of research or teaching, or of broader institutional and metaphysical forces.

Despite darker forces, children as carousel-riders playfully grab for the brass ring to bring themselves good fortune (Hinds, 1990). In Salinger's (1964) *The Catcher in the Rye,* Holden Caulfield resists riding the carousel. However, his younger sister grabs for the gold ring, and with delight and persistence, as though reaching out to life itself. As her brother watches, he refuses her invitation to join and is even worried that she may fall off the horse. Is the carousel image being used here to show that Holden is not quite psychologically prepared to take on life's challenges? By resisting personal growth, he avoids taking responsibility for his own actions. The carousel-rider/inmate has yet to be awakened to the deeper meaning of grabbing for the prize. Unlike Caulfield, educators can "grab for the brass ring" by using personal stories and artistic strategies in their research to interrupt and challenge repressive forces.

Carousel-makers are self-conscious artists and deliberate actors who confront their own fears and shortcomings. They extend and remake the cultural contexts they encounter. These gestures, or transformative energies, have the potential to interfere with patterns of inertia. The artisan carousel-maker understands "the carousel," in metaphysical and practical terms, as a mechanism that can be reimagined and changed. Even its taken-for-granted elements of circularity, predictability, and continuity can be interrupted and changed. The arts pro-

mote the search for patterns that shift expressions/ manifestations of elitism from the core to the margins.

Historically, artisan carousel-makers manufactured the tinsel side of life. They sold the illusion of life as fantasy. Indeed, the term "romance side" refers to the ornamental side of the animal, which faced outward to impress onlookers, achieving its effect (Hinds, 1990). Such a façade presents the merry-go-round as safe and alluring. Romantic associations with the carousel are disrupted in Bradbury's (1962) vision in *Something Wicked This Way Comes*. His world is out-of-balance, haunted by a sinister, lunatic carousel. Those who ride the carousel cling to the horses, emerging much younger or older, or not at all. In an effort to preserve an image of themselves, they manipulate the passage of time, paying heavily for their vanity. At-risk persons may pay heavily for their own institutional rides. If carousel-riders resist growth, carousel-creator-inquirers do the opposite. They pursue arts-based reconstructions of self and other.

At-risk students and teachers may incur an ethical cost for their own institutional rides. Bastian, Fruchter, Gittell, Greer, and Haskins (1986) reported the view of the United States federal government that bilingual programs are no longer meriting financial support because they are perceived as failing. Here is a looming image of a societal carousel ride. We need to ask about students who drop out of school only to reemerge, in some cases, as incarcerated riders of the prison-carousel. How can their ethical development from carousel-rider to creator be encouraged? What can their stories contribute to their own and our development?

Joni Mitchell (1974) depicts society as a carousel in her song, "Circle Game." If society has made captive prisons within its own larger carousel, then we are all "painted ponies captive on the carousel of time" (Mitchell, 1974). The societal story of prisons as opportunities for recovery and success is a seriously misleading romance. Prisoners generally do not have their rehabilitative needs met. They often become recidivists, "revolving door" candidates who return to prison life after release. Olson was himself a 23-year-graduate of the prison system before he committed his murders (Morris, 1989). One way to disrupt and even transform the prison-carousel is to study the mechanisms that society has created to socialize and condition us (Lessing, 1986). Alternatively, artists can create architectural metaphors, such as those of the carousel and Panopticon, to provide a counter vision of humanity.

What, then, is the nature of the carousel within education and research? The romance side of teacher education protects illusion, restricting understandings of humanity, research, and knowing. Visions of education are geared to expert knowledge and training systems, to conventional schooling cultures, and to legislators' demands. Ironically, the expressive, less bounded ways of doing research in education are mostly coming from the "romantic" forms of art, literature, and narrative (e.g., Barone & Eisner, 1997; Connelly & Clandinin, 1995; Diamond & Mullen, 1997; Eisner, 1993; Paley, 1995; Richardson, 1994). Such inquiries personalize experience, promote new approaches, and often expose the cover stories of façades. Less bounded ways of doing educational research are also being articulated by Henry Giroux, Joe Kincheloe, Peter McLaren, William Pinar, and Shirley Steinberg. These critical theorists break codes of silence to "promote an individual's consciousness of himself or herself as a social being" (Kincheloe & Steinberg, 1995, p. 9). The worlds of arts-based narrative theory and critical theory can be drawn together in the context of the postmodern educator's experience, which

> implies a sense of the unpredictability of the sociopolitical microcosm and the capriciousness of the consequences of inquiry. . . . A postmodernized critical theory accepts the presence of its own fallibility as well as its contingent relation to progressive social change. (Kincheloe & McLaren, 1994, p. 151)

In an effort to move from being carousel-riders to creators, we need to become "carvers" with imagination. Self-study, arts-based research is still emerging in its own right. It has mostly unfolded to date as a form of expository justification for departure from the social science paradigm—like the operations of qualitative research before actual demonstrations became available. However, arts-based research is also functioning to expose and display the playful and the marvelous, while simultaneously critiquing institutional models and practices that hinder the growth of imagination (e.g., Diamond, Mullen, & Beattie, 1996; Greene, 1991; Paley, 1995; chapter 12). Such artistic explorations still seem constrained by epistemological principles (of certainty, validity, and predictability) that underscore qualitative inquiry. Prescriptive practices can be confronted, and potentially transformed, by the freer expression that artistic work makes possible through the uses of metaphor, fantasy, story, imagination, and emotion. Arts-based researchers and critical theorists may find that the carousel offers a postmodern image for developing culturally grounded critiques of, and releases from, established academic protocol.

"Halted in Mid Gallop":
Dilemmas of the Prison Culture

What is the nature of the carousel in prisons? On rotation, prisoners move through cell blocks to await court trials and sentencing; transfer to other places, or release on bail. They are "the disappeared" who sometimes inexplicably reappear in different contexts.

Prisoners whom I met with for a creative writing session (or sessions) were quickly moved around sometimes inside, sometimes outside, the jail. Seemingly arbitrary demands of prison life frequently disrupted the teaching-learning relationships as well as curricular objectives. Although I did have sustained meetings with five prisoners in literacy and creative writing contexts, I never quite knew what to expect, whom I was going to see that week, or what we were going to be allowed to do. Dilemmas as such helped to produce situations of constant uncertainty, confusion, and vigilance. However, these situations of constraint also sometimes inadvertently gave rise to meaningful connections.

Despite the barriers to the development of a successful curriculum in the traditional sense, subtle changes were nonetheless sparked. Black Hawk, a prolific and talented Native American, labeled "learning deficient," produced a series of autobiographic works. One of his drawings connotes a kind of carousel, but of street life and its dark elements. Classical images of romance, such as a "rose and heart" symbol, are surrounded by episodic, narrative frames. These convey endless, painful circularity—people move, but in circles from one act of violence to another.

The expressive life offers prisoners material for recovery of self, other, and society (Abbott, 1981; Caron, 1978; Harris, 1986). Sear, another prisoner-writer, also without formal education, wrote a poem called "Mr. Jones (to the Moon)" (1992). It provides insight into his personal meaning of the carousel image. In his poetic vision, the drug addict is at the mercy of a powerful force. Mr. Jones is a "drug lord" and, rather ambiguously, also a vigilant prison gatekeeper. Either way, the addict is locked in mutual sickness. The drug addict lives in a state of sickness, morbidity, and motionlessness. There is accelerated movement in this carousel ride, but the experience of seduction is simultaneously one of self-destruction.

Images of poetic movement, such as "To the moon! I am high again/ I can't feel the pain now, I've been lifted to new heights," mimic the rhythm of the carousel ride. Here, the carousel is a mockery of progress,

of spiritual upliftment, and of life itself. Its rider is deeply dysfunc-
tional, living in a state of coexistence with a sadistic "carousel" owner.
Sear explained that the carousel image reflects his own deadening
psychological constriction. It also critiques the drug culture, his own
deeper prison: "Halted in mid gallop, a frozen carousel/charging forth
without proceeding/on my painted pony bound for hell."

Sear's mythology of the drug lord and addict disturbs our ability to
make easy ethical judgments about the growth of the carousel-rider. Is
this poem a story of substance recovery or, conversely, of celebrated
addiction? Is this prisoner a voice for other recovering addicts? Is he
possibly a community activist? If so, is this writer also a carousel-
maker of educational and societal reform? How can we trust that his
vision represents a new way of seeing? Such questions are intended to
disturb taken-for-granted assumptions about such high school drop-
outs as being uniformly functionally illiterate, and prisoners as being
hopeless criminals. Moreover, the view that these medicated storytell-
ers can offer something meaningful to the reeducation of human be-
ings probably seems outlandish. Such ethical imaginings (or topsy-
turvy worlds) can result from on-site, arts-based engagements with
at-risk populations.

Grabbing the Gold Ring in Education and Inquiry

How can we use the "carousel" to guide more innovative, arts-based
inquiries in teacher education? As a parallel, within my prison site,
the board-sponsored education program that was in operation pre-
sumed prisoners to be generally illiterate, and capable of managing
only literacy and life skills material at the grade 8 (and lower) level.
Personal and artistic forms of writing were discouraged by overseers
of the creative writing program. But the prison-carousel was subse-
quently disrupted, even if for a short while, with the development of
the creative writing program after Black Hawk requested feedback on
his poetry and drawings. Also, as a further point of disruption of the
prison-carousel, the education program supervisor located others in-
terested in participating in the new program. Later, I created, for cir-
culation, an inmate newsletter, filled with poetry, prose, and art.

Arts-based educational researchers are looking for imaginative ways
to recreate our contexts as places of emancipatory pedagogy and hu-
man connection. They/we dream about the need to create ethical
"spaces for communicating across the boundaries . . . [and] for be-

coming different in the midst of intersubjective relationships . . . through carving, painting, dancing, singing, writing" (Greene, 1991, p. 28). They may dream across boundaries and about crossing lines, but the effort remains to cast ourselves as characters within our own telling. Dreams, metaphors, and fantasies can serve as powerful ways of disrupting and reconstructing received practices and traditions (Mullen, 1994).

How are postmodern educators constrained by insufficient inquiry into the at-risk nature of research practices? As "inmates," qualitative and arts-based researchers undergo rituals of research practice. As mentioned earlier, these "prison paradigms" script how educators should engage field site research, construct interpretive case studies, and report results (Glesne & Peshkin, 1992). A taken-for-granted attitude permeates ideological construction in the areas of

1. "What" (conventional classroom sites, teacher thinking and practice, school culture, curriculum mandates, and broader contextualizations of schooling);
2. "How" (observation of classroom events and accumulation of "thick data" based on an appropriate period of time), and
3. "Why" (to help teachers to develop in order to improve the quality of education and schools).

Such a carousel or cycle of research limits intensive and imaginary levels of "schooling"; it also restricts, and paradoxically inspires, alternative forms of research.

Like Rose (1990), an ethnographer who lived alongside working-class African Americans in an unfamiliar context, we can engage in unauthorized forms of research. However, the cost of engagement is unpredictable–it may be one of researcher abandonment. Regardless, a chief resource that can be brought to the work of artistic research is the energy of disturbing *and* transforming the very paradigm of received practices. As the "main research instrument" (Glesne & Peshkin, 1992), the researcher is most likely engaged in some form of "emancipatory pedagogy" (Greene, 1991). But even the notion of self-as-instrument in qualitative research connotes detachment, judgment, and reduction of possibilities. Such a notion may limit the degree to which the researcher feels free to share vital stories of practice and to engage in artistic methods of research. Just as some prisoners "grab for the brass ring" by telling stories of suffering, loss, recovery, and

renewal, educators can reach out by performing as their own artistic selves in teaching and research contexts which include prison (Mullen, in press).

"Strange" dreams, such as those that bring together unlikely places and persons, may disturb or even dismantle the carousel. Abbott's (1981) classic prison narrative, *In the Belly of the Beast*, tells us that the "most dangerous prisoners" are "readers and writers" (p. 19). If readers and writers are the powerful and the imprisoned, then the stories of artists are certainly essential to our ethical development as educators. Abbott (1981), whose violence continued after release, writes ironically and hauntingly of a macro-carousel world wherein "prisoners are only a few steps removed from society. After us, comes you" (p. 21).

The Awakedness of Strange Dreams

The educational community can disrupt its own carousel by questioning taken-for-granted constructions of humanity, research, and practice. Where we generalize in one arena, we probably generalize in another. As a society we view prisoners as captive misfits, heroic and anti-heroic convicts, and misanthropic wrong-doers. Instead of looking for ourselves, we may accept representations of prisoners as unredeemable (Lessing, 1986) and, conversely, of ourselves as redeemable. How can we reinvent such static, miseducative perceptions? The Birdman of Alcatraz (according to another prisoner) rejected the view of life gained through a microscope only, inventing his own way of seeing:

> The Birdman of Alcatraz is awake and I am shocked at what I see. He sits, naked, at a table looking through, of all things, a microscope. Then an even stranger thing happens. He jumps up from his work abruptly, walks toward the wall of his cell and disappears. Instantly I hear what sounds like the singing of thousands of birds rising to a frenzied pitch. . . . I think I'm having a strange dream, but a closer look reveals a curtained doorway between his cell and the next one. . . . He soon reappears with several birds perched on his shoulders and two on top of his head. They're each of a different hue—red, green, and pale orange. (Karpis, 1980, p. 25)

Like the Birdman of Alcatraz, McClane (1988), a professor, invented his own way of seeing. In a single creative writing session at Auburn Correctional Facility, McClane (1988) came to view prisoners as "people, cussed and joy-filled: people capable of tenderness and mur-

der" (p. 230). When as a society we banish prisoners or shut them away, we suppress the possibility of seeing ourselves as at-risk, party to our own limiting constructions. Until we dream differently and more splendidly, our accounts of prisoners (formally often at-risk students) will remain academic, impersonal, and distanced. Our own artistic landscapes in academe could probably benefit from playful "commitment [to rounds of] genuine dialogue, imagination, and ethical concern that guards against our detachment" (Witherell, 1991, p. 85).

The way life is organized within educational institutions makes it challenging to work with the kind of "willingness [that is required] to resist the forces that press people into passivity and bland acquiescence" (Greene, 1991, p. 27). Because carousel-riders are imprisoned within forces that restrict and conditions that limit, these "inmates" may be at-risk, simply existing. Carousel-makers, in contrast, are awake, questioning and recreating, and generating new ways of seeing better ways forward.

Oliver Sacks (1993) tells a story about a client who regained his sight after decades of blindness only to become blind again. He had suffered the perils of learning how to see in a visual world. Although it was a miracle that his vision was suddenly restored for a short time, a deeper miracle had not taken place. He was unable to make sense of a world not experienced by him as a seeing person, and for which he had no visual memories to support his newfound perceptions. I believe that the educational community is also struggling to "see" with new vision.

As a researcher community, we have attempted to create a coherent world through categorization, memory, and reconstruction. But daily incoherence, fluidity, chaos, and fragmentation force us to look again at what we have created and to remake ourselves in the process. This commitment to reconstruction can facilitate the development of larger cultural and more humane selves. Cross-cultural research can enlarge concepts and practices of inquiry and institutional life, and, perhaps more importantly, they also improve quality of life. We need artistic and interconnected ways of construing our field, our texts, and ourselves. If prison cultures constrain (and inadvertently inspire) how experience is to be represented, then they are also places from which we want to speak with uneasiness and urgency. We can become lead horses in carousels of our own making—much like rebel angels who can only make a difference for the better once they are thrown out of heaven.

Summary Comments: Flying Stories

In this chapter, I use the metaphor of the carousel to explore arts-based making, discovery and danger, confinement and release of experience. Meaning is not won by climbing aboard someone else's creation as if seeking some "linear unfolding of information that builds toward a sense of 'being on top' of a situation through knowledge" (Lather, 1997, p. 287). Educational perspectives can be wrenched from their imprisoning certainty by making new "centers" within ourselves, becoming artisan carousel-creators. We need flying stories that express the dynamic and the creative, as well as the static condition within our own institutions, research paradigms, and daily work. We need to take the risk, even if we become more at-risk in the process, of transporting more of ourselves to our places of work. We can be enticed as by Billy the Barker to hop aboard our own "Go Boy!" (Caron, 1978) or "Go Girl!" (Mullen, 1997) carousel.

Higher education communities might benefit from being attracted into carnivalesque and even outlaw arts-based activities.

1 Experiment with some of the new, "showy" arts-based forms of postmodern research in a range of settings, from the conventional to the alternative.

2. Become carousel-makers who "grab for the brass [or preferably gold] ring," telling personal educational stories and transforming limiting research protocols.

3. Show how even the conventionally good can be tempted into criminality. Find films or short stories that disrupt taken-for-granted assumptions. Can the exposure of systemic inequities and unfair practices help reform them?

4. How can inquiry help beginning and experienced teachers to question and challenge repressive forces within educational institutions?

5. Report on your attempts to get close to persons at-risk by using research perspectives and methods that promote engagement, the sympathetic imagination, and the caring relation.

As carousel-creators we stitch together different experiences as we cross over from higher education into other cultures, but circle back home again. We can meet "in the streets" to appraise and transform the prison-carousel of all learning institutions. As a community of lead

horses, the course of the "prison-carousel" can become what we *make* it. Arts-based inquiry or education can become like a dizzying carousel ride or a work of fiction. It has a right to exist "only insofar as it affords . . . aesthetic bliss, that is a *sense of being* somehow, somewhere, connected with other states of being where art (curiosity, tenderness, kindness, blindness, ecstasy) is the norm" (Dipple, 1988).

Although we can make and operate our own complex carousels and funhouses, there is danger in breaking the bounds. Everything is illusion and unfinalizability: "Nothing conclusive has yet taken place in the world, the ultimate word of the world and about the world not yet spoken, the world is still open and free, everything is still in the future and will always be in the future" (Bakhtin in Groden & Kreiswirth, 1994, p. 65). As postmodern educators, we can remake ourselves and hence always challenge any finalizing definition. There is always a surprising loophole. Being caught up in riding the whirlwind of the carnival, the advice is to "let yourself go. Do your own thing, scream your own scream. In other words, take risks and go against the grain of common sense" (Lecercle, 1985, p. 199).

Acknowledgments

I am grateful to the male inmates (anonymously named) for sharing their arts-based works with me and for publication (officially cleared by the prison site). Each of them has contributed to my own artistic development and reeducation.

References

Abbott, J. H. (1981). *In the belly of the beast.* New York: Vintage Books.

Anderson, W. T. (Ed.). (1995). *The truth about truth: Deconfusing and reconstructing the postmodern world.* New York: Putnam.

Anzaldúa, G. (1987). *Borderlands, La Frontera: The new mestiza.* San Francisco, CA: Aunt Lute.

Barnhart, C. L., & Barnhart, R. K. (Eds.). (1987). *The world book dictionary.* Chicago: World Book.

Barone, T. E., & Eisner, E. W. (1997). Arts-based educational research. In R. M. Jaeger (Ed.), *Complementary methods for research in education* (2nd ed.), (pp. 73–116). Washington, DC: American Educational Research Association.

Barrett, T. (1994). *Criticizing art: Understanding the contemporary.* Mountain View, CA: Mayfield.

Barth, J. (1968). *Lost in the funhouse.* New York: Doubleday.

Bastian, A., Fruchter, N., Gittell, M., Greer, C., & Haskins, K. (1986). *Choosing equality: The case for democratic schooling.* Philadelphia: Temple University Press.

Bateson, M. C. (1990). *Composing a life.* New York: Penguin Books.

Bradbury, R. (1962). *Something wicked this way comes.* New York: Bantam Books.

Britton, J. (1990). Heads or tales? *English in Translation, 24*(1), 3–9.

Caron, R. (1978). *Go-boy!* Toronto: McGraw-Hill Ryerson.

Clandinin, D. J., & Connelly, F. M. (1996). Teachers' professional knowledge landscapes: Teacher stories—stories of teachers—school stories—stories of schools. *Educational Researcher, 25*(3), pp. 24–30.

Connelly, F. M., & Clandinin, D. J. (1995). *Teachers' professional knowledge landscapes.* New York: Teachers College Press.

Deleuzze, G., & Guattari, F. (1977). *Anti-Oedipus: Capitalism and schizophrenia.* New York: Viking Press.

Dewey, J. (1958). *Art as experience.* New York: Capricorn Books.

Diamond, C. T. P., Mullen, C. A., & Beattie, M. (1996). Arts-based educational research: Making music. In M. Kompf, W. R. Bond, D. H. Dworet, & R. T. Boak (Eds.), *Changing research and*

practice: Teachers' professionalism, identities, and knowledge (pp. 175–185). London: Falmer.

Diamond, C. T. P., & Mullen, C. A. (1997). Alternative perspectives on mentoring in higher education: Duography as collaborative relationship and inquiry. *Journal of Applied Social Behaviour, 3*(2): 49–64.

Dipple, E. (1988). *The unresolvable plot: Reading contemporary fiction.* New York: Routledge.

Eisner, E. W. (1993). Forms of understanding and the future of educational research. *Educational Researcher, 22*(7), 5–11.

Eisner, E. W. (1997). The promise and perils of alternative forms of data representation. *Educational Researcher, 26*(6), 4–10.

Elam, D. (1993). Postmodern romance. In B. Readings & B. Schaber (Eds.), *Postmodernism across the ages: Essays for a postmodernity that wasn't born yesterday* (pp. 216–230). New York: Syracuse University Press.

Feuerverger, G., & Mullen, C. A. (1995). Portraits of marginalized lives: Stories of literacy and collaboration in school and prison. *Interchange, 26*(3), 221–240.

Foucault, M. (1979). *Discipline and Punish.* New York: Vintage Books.

Giroux, H. A. (1991). Democracy and the discourse of cultural difference: Towards a politics of border pedagogy. *British Journal of Sociology of Education, 12*(4), 501–519.

———. (1993). *Living dangerously: Multiculturalism and the politics of difference.* New York: Peter Lang. (Counterpoints Series)

Glesne, C., & Peshkin, A. (1992). *Becoming qualitative researchers: An introduction.* Longman: University of Vermont.

Greene, M. (1991). Texts and margins. *Harvard Educational Review, 61*(1), 27–39.

Groden, M. & Kreiswirth, M. (Eds.). (1994). *The Johns Hopkins guide to literary theory and criticism.* London: Johns Hopkins University Press.

Grumet, M. R. (1988). *Bitter milk: Women and teaching.* Amherst, MA: University of Massachusetts Press.

———. (1992). Existential and phenomenological foundations of autobiographical methods. In W. F. Pinar & W. M. Reynolds (Eds.), *Understanding curriculum as phenomenological and deconstructed text* (pp. 28–43). New York: Teachers College Press.

Guba, E. G., & Lincoln, Y. S. (1994). Competing paradigms in qualitative research. In N. K. Denzin & Y. S. Lincoln (Eds.), *Handbook of qualitative research* (pp. 105–117). London: Sage.

Gwaltney, C. (1996, June 28). Earned degrees conferred by U. S. institutions, 1993–94. *The Chronicle of Higher Education*, p. A30.

Harris, J. (1986). *Stranger in two worlds*. New York: Kensington.

Hawk, B. (1994). *Life of Black Hawk*. New York: Dover. (Original work published in 1916, The Lakeside Press)

Hawking, S. W. (1988). *A brief history of time: From the big bang to black holes*. New York: Bantam Books.

Hinds, A. D. (1990). *Grab the brass ring: The American carousel*. New York: Crown.

Hitchcock, A. (1951). Strangers on a train. [Film]. (Available from Warner Communications, 4000 Warner Blvd., Burbank, CA 91522)

Karpis, A. (1980). *On the rock: Twenty-five years in Alcatraz*. Toronto: McClelland and Stewart.

Kincheloe, J. L., & McLaren, P. L. (1994). Rethinking critical theory and qualitative research. In N. K. Denzin & Y. S. Lincoln (Eds.), *Handbook of qualitative research* (pp. 138–157). London: Sage.

Kozol, J. (1991). *Savage inequalities: Children in America's schools*. New York: HarperCollins.

Lather, P. (1997). Drawing the line at angels: Working the ruins of feminist ethnography. *Qualitative Studies in Education, 10*(3), 285–304.

Lecercle, J. J. (1985). *Philosophy through the looking glass: Language, Nonsense, Desire*. London: Hutchinson.

Lessing, D. (1986). *Prisons we choose to live inside*. Toronto: CBC Enterprises.

Lincoln, Y. S., & Guba, E. G. (1985). *Naturalistic inquiry*. London: Sage.

McClane, K. (1988). Walls: A journey to Auburn. In A. Dillard (Ed.), *The best American essays* (pp. 220–234). New York: Ticknor and Fields.

McClintock, M. (1994). Our lives are our best teaching tools. *Journal of Experiential Education, 17*(2), 40–43.

Mitchell, J. (1974). Circle game. *Miles of Aisles* [LT]. Scarborough, ON: WEA Music of Canada.

Morris, R. (1989). *Crumbling walls: Why prisons fail*. New York: Mosaic Press.

Mullen, C. A. (1995, June). Carousel. *Among Teachers: Experience and Inquiry,* 17, 12. Toronto: Among Teachers Community, Centre for Teacher Development, OISE/UT.

————. (1994). A narrative exploration of the self I dream. *Journal of Curriculum Studies,* 26(3), 253–263.

————. (1997). *Imprisoned selves: An inquiry into prisons and academe.* New York: University Press of America.

————. (1999). Learning from the creative expression of Latina Americans: Identity transformation in penal programming. *Latino Studies Journal,* 10(1), 7–37.

————. (in press). Reaching inside out: Arts-based educational programming for incarcerated women. *Studies in Art Education.*

Mullen, C. A., & Dalton, J. E. (1996). Dancing with sharks: Becoming socialized teacher educator-researchers. *Taboo: The Journal of Culture and Education,* I, 55–71.

Nabokov, V. (1980). *Look at the Harlequins.* Harmondsworth: Penguin.

Paley, N. (1995). *Finding art's place: Experiments in contemporary education and culture.* New York: Routledge.

Pinar, W. F., & Reynolds, W. M. (1992). Introduction: Curriculum as text. In W. F. Pinar & W. M. Reynolds (Eds.), *Understanding curriculum as phenomenological and deconstructed text* (pp. 1–14). New York: Teachers College Press.

Pinar, W. F. (1994). *Autobiography, politics and sexuality: Essays in curriculum theory, 1972–1992.* New York: Peter Lang.

Reed, C. (1949). *The third man* [Film]. (Available from California Video Distributors, 21540 Blythe Street, Canoga Park, CA 91304)

Richardson, L. (1994). Writing: A method of inquiry. In N. K. Denzin & Y. S. Lincoln (Eds.), *Handbook of qualitative research* (pp. 516–529). London: Sage.

Rodgers, R., & Hammerstein II, O. (1956). *Carousel* [Film]. (Available from FoxVideo, P.O. Box 900, Beverly Hills, CA 90213)

Rose, D. (1990). *Living the ethnographic life,* 23. London, Sage.

Sacks, O. (1993, May 10). A neurologist's notebook: To see and not see. *The New Yorker,* 59–73.

Salinger, J. D. (1964). *The catcher in the rye.* New York: Bantam.

Sarason, S. B. (1990). *The predictable failure of educational reform: Can we change course before it's too late?* San Francisco, CA: Jossey-Bass.

Scott-Stewart, D., & Williams, M. (1974). *Fairground snaps.* London: Pleasant Pastures and Gordon Fraser Books.

Steinberg, S. R., & Kincheloe, J. L. (1997). Introduction: No more secrets–kinderculture, information saturation, and the postmodern childhood. In S. R. Steinberg & J. L. Kincheloe (Eds.), *Kinderculture: The corporate construction of childhood* (pp. 1–30). Boulder, CO: Westview Press.

Sykes, J. B. (Ed.). (1987). *The concise Oxford dictionary.* Oxford: Oxford University Press.

Travers, P. L. (1982). *Mary Poppins omnibus.* Hammersmith, London: HarperCollins.

Twitchell, J. B. (1992). *Carnival culture: The trashing of taste in America.* New York: Columbia University Press.

Chapter 11

"Roped Together": Artistic Forms of Comentoring in Higher Education

C. T. Patrick Diamond
Carol A. Mullen

Kilimanjaro is a snow-covered mountain and is said to be the highest mountain in Africa. Its western summit is called the House of God. Close to the western summit there is the dried and frozen carcass of a leopard. No one has explained what the leopard was seeking at that altitude. (Hemingway, 1987, p. 39)

Roped Together in Higher Education

Hemingway (1987) begins his short story with ominous restraint in order to write about the dangers of trying new things alone. Braque also uses a mountaineering image but to remind us of the value of his collegial relationship with Picasso: "The things [we] said to one another during those years will never be said again, and even if they were, no one would understand them anymore. It was like being roped together on a mountain" (cited in Johnston, Johnston, & Holubec, 1993, pp. 8–11). Such a joint inquiry, when examined and expressed, has a value beyond the merely personal. This chapter is written in the form of a "duography" (Gergen & Gergen, 1993) and its topic is comentorship and collaborative inquiry. As two separate faculty members who previously shared a dissertation advisor-graduate student relationship, we reflect on our lived experience of mentorship and coauthorship.

We present this chapter in fragmented form. We offer arts-based stories of, and an argued reflection on, our inquiry and relationship.

In personal writing, each individual is engaged in an internal dialogue between experience and understanding to make knowledge explicit. Duography makes the same processes explicit, but adds those developing also between the coauthors. We use this dual perspective to trace our mentor-dissertation candidate relationship as it evolved from its beginning, traditional arrangements to emerge as a coauthoring form of mentorship that helped Carol, as the then graduate student-researcher, to become a faculty member in her own right. We prefer the term "mentor" to that of "supervisor," and "comentor" to that of "mentee."

Comentoring is a form of collaborative learning that is reciprocal, mutual, and supportive (Mullen, Cox, Boettcher, & Adoue, 1997). It names a process that is "social, active, and appreciative of differences among individuals in terms of their backgrounds, talents, and learning styles" (Bona, Rinehart, & Volbrecht, 1995, p. 119). Shakespeare probably collaborated with the "university wits," or Cambridge men such as Greene and Marlowe (Bate, 1997), when writing his early plays. Comentoring also provides our answer to what Nixon (1996) calls the "crisis of professional self-identity" within higher education which "highlights the vulnerability of university teachers as an occupational group" (p. 5). Like vagabond players, mentors and students can together construct a shared professional perspective that emphasizes the importance of partnership in otherwise isolating circumstances.

We reflect on our experience of using duography as an alternative form of mentorship within higher education and in teacher development. We use "we" to acknowledge that our separate voices are often, but not always, in harmony. We are both the authors (listed alphabetically) of this duography and acknowledge that our contributions to it are equal, though different. Where an experience clearly belongs to only one of us, we use "Patrick" or "Carol." While we shared a significant portion of our research interests, professional agendas, and continuing development, they are by no means identical. Duography provided us with an arts-based form to articulate and reflect on what happened as we worked together.

Arts-based inquiry consists of "a *congeries* of methods . . . whose purpose is the collection of . . . intact belief systems, and complex inner psychic and interpersonal states" (Lincoln, 1990, p. 508) and their artful expression. As shown in Part II, the forms for representing such inquiry include: narrative inquiry (Connelly & Clandinin, 1988,

1990); autobiography (Grumet, 1990); autoethnography (Diamond, 1992; Pope & Denicolo, 1993); collaborative reflective inquiry across research sites (Clark, Moss, Goering, Herter, Lamar, Leonard, Robbins, Russell, Templin, & Wascha, 1996; Feuerverger & Mullen, 1995); short story (Barone, 1983, 1993); and visual-cinematic (Denzin, 1992), poetic (Richardson, 1992) treatments. Through the use of duography, we seek to reflect on our experience and the significance of our collaboration. We use this form also to prevent our personal and shared meanings from being overrun by the one-track voices of either gatekeepers (see below) or "objective and dispassionate" research reporting.

Like Sands, Parson, and Duane (1991), we found that "not much is known about mentoring between faculty members" (p. 175) or, as is particularly relevant in our case, how such relationships are fostered over time. Through sharing different roles and forms of writing and through presenting at conferences together, we constructed a developmental form of collaborative research. We construct our duography by drawing upon a number of sources that were derived from our writing and conversation. These representations include academic papers and chapters, research grant applications, self-narratives (Diamond, 1994, 1995), course papers, research fieldnotes, journal entries and dreams (Mullen, 1994, 1997), letters and correspondence (Diamond, 1993), morning notes, poems (see "'C' is for Confinement and Creativity"), visuals (Diamond, Mullen, & Beattie, 1996), patterning metaphors (Diamond, 1994; Mullen, 1994), and works in progress. Analyzing and reflecting on this portfolio, we produced a dialogue journal of our experiences together. Next, we define duography as an inquiry genre. Excerpts from our writing are shared and responded to in order to demonstrate the value of comentorship.

What Is Duography?

New forms of educational research need to be exploited so that meanings can be constructed that might otherwise elude us. As Eisner (1993) argues, "how we think is influenced by what we think about and how we choose or are expected to represent its content" (p. 7). As a coauthored form of inquiry, duography promotes reflexive studies of the self and trusted other. The writing is the form of inquiry. We define duography as a retrospective written account that two people provide of a selection of events and ideas taken from their research lives. Like

an autobiography, a duography involves telling one's own stories. Like a biography, a duography also involves trying to understand and articulate the stories of another. Unlike an autobiography or a biography, a duography features turn-taking in writing and response to produce a duologue.

Duography is a collaborative form of inquiry in which two individuals reflect on their lived experiences through responding to one another's stories. As a coauthor, each then acts as a knowing participant in the other's development. Through conversation, cowriting, and playing off recurring metaphors (as of scaling peaks and of emerging butterflies), we have participated in each other's journey to practice and understand arts-based mentorship. We try to accept and respond to each other's ideas, feelings, and expressions as positively as possible. We talk openly about frictions and irritations—and encourage each other. Like hermeneutic helpers (Grumet, 1990), we help forge new combinations in each other's reflective accounts.

We use dreams (see Carol's account in the following subsection) because they exemplify how images, when combined, are reexperienced, providing powerful sources of insight (Mullen, 1997). One of Poincare's conceptual breakthroughs also occurred in a dream: "I felt [ideas] collide until pairs interlocked, . . . making a stable combination" (Koestler, 1964, pp. 115–116). We can all benefit from the "roping together" of apparent opposites in nonrational states. As Lightman (1993) wrote of Einstein: "His dreams have taken hold of his research. His dreams have worn him out. . . . Out of the many possible natures of time, imagined in as many nights, one seems compelling. Not that the others are impossible. The others might exist in other worlds" (pp. 6–7). We also realize that duography is just one form that mentorship may take.

Faculties and students can also recombine their separate selves, intuitions, and images to further their inquiries. More complex thinking begins with the unexpected merging of separate impressions. In duography, after significant features are singled out from the concrete experience in which they are embedded, they can be organized into new groupings to be reflected upon. As two people work together to create new meaning, their duography emerges as a narrative form of relationship. We found that duography helped us to provide and reconsider our stories of intellectual and friendship formation. Duography is a special kind of conversation between friends who imagine each other into personal and academic writing spaces that are built around:

something the friends have in common. By talking about what is between them, it becomes ever more common to them. It gains not only in its specific articulateness, but develops and expands and finally, in the course of time and life, begins to constitute a world of its own which is shared in friendship. (Arendt, 1990, p. 82)

Journal writing is widely established as a means of reflecting on the development of relationship and research in progress. As Voss (1988) shows, learners can engage in personal dialogue within self-reflective journals. Like palimpsest (chapter 16), a double-entry journal provides a record in parallel columns of both what is learned and how it is learned. The related form of the dialectic notebook is useful for learning how to inquire. Meanings can be reviewed in order to see further what they suggest (Berthoff, 1987). While not all journaling approaches are interpersonal in the sense of sharing the writing and reflections with others, there are benefits when they do. For example, as inquirers develop trust and self-acceptance, they become more open and questioning of their experience (Holly, 1989). As we show, a dialogue journal extends the use of a self-reflective journal to include mutual reflection and collaborative sharing.

Fishman and Raver (1989) used a dialogue journal between a teacher mentor and teacher candidate to further the exchange of their views and to document the progress of the latter. Because the student teacher's journal was shared but not the mentor's, the result was a one-sided written conversation. As a faculty member, Oberg (1990) used self-reflective journals with graduate students to record and share their daily practice and reflection. Using response journaling, she acted as their coinquirer and as her own. They found that more is learned about events and ideas by writing and talking about them with others. Knowledge arises from dialogue that involves written interaction between a mentor and protégé as they address areas of interest, such as, in our case, collaborative forms of mentorship and research.

We prepared our version of duography, and this account of it, as a joint, interwoven text. As we shared our writing, we adapted various methods of learning about our development as coinquirers. Duography provides both of us as partners with a double entry form for capturing, reflecting on, and reconstructing experience. We found that it provided a means of creating, representing, and inventing ways of knowing. Duography can also help in initiating the student into the scholarly community, furthering the reflections of the mentor, and even empowering both partners. They then come to affect events rather

than being merely affected by them. Duography can be emancipatory
not only for knowledge and development, but also for release from
previously restricting roles and limiting relationships that often char-
acterize traditional mentorship. The key to duography is the develop-
ing self-other, or author-respondent relationship. We came to appre-
ciate the main thrust of each other's stories over the years and plotted
cross-references within our self-portraits and individual research sites
(academe and prison). Duography assists coinquirers by allowing them
to shape, better understand, and so revise their experience.

Duography Promotes a Different Form of Mentoring

As a former graduate student and junior faculty member, Patrick re-
members how, in his 1979 dissertation, he had to struggle to have
teachers' voices heard and not just measured (chapter 8). Some of his
colleagues wondered if there could be any place for such egalitarian,
personal approaches. We (Patrick and Carol) have since learned that a
cowriting based on a portfolio of text, and other artistic forms, can
promote a new *kind* of mentoring that provides space for political
reflection partly in response to adversarial reactions. Artistic collabo-
rators Dunn and Leeson (1997) similarly consider their own relation-
ship and work as

> an art of engagement [that is] is people centered and critical. By critical we
> mean that identities should not be prey to superficial stereotypes, that mecha-
> nisms and processes are established to allow lived, changing, complex, and
> problematized identities to emerge. For us, engagement is about empower-
> ment. In that sense it is a political statement as much as an artistic one. (p. 27)

In Greek mythology, Ulysses, the wandering or erring father (a theme
developed later), placed his son in the care of Mentor, the tutor, for 20
years. In Tennyson's poem, this delegation of authority can be seen as
a convenient arrangement for an absentee father. Ulysses is content
for his son to lead a separate life providing that it does not interfere
with his. The need for a more responsive form of mentoring in higher
education and teacher development is confirmed by similar "horror"
stories of indifference and even abrogation of responsibility. Tradi-
tional mentoring may seldom seem to allow for relationship and col-
laborative inquiry. The dissertation experience of some candidates
may even be shot through with conflicts that arise out of cross-pur-
poses and power plays, even involving the spectacle of greater and

lesser "sharks" (Mullen & Dalton, 1996; see chapter 9). Candidates' "weaker" voices may be at risk of being ignored or subverted as a result of "hierarchical authority relations and structures" (Dey, Korn, & Sax, 1996, p. 153). Even though mentoring faculty may claim to exist in "symbiotic relationship" with their graduate-students (who are often experienced teachers or professors in preparation), some may still "consider themselves superior . . . in terms of understanding issues, problems, and courses of action, and in intellectual leadership" (Sarason, 1990, p. 66). The powerful may use the rope to restrain rather than to support others. But then our alternative, "intense" form is not for everybody.

Arts-Based Activities

1. Was your experience of dissertation supervision or mentorship as a teacher one of friendship formation or a war story of survival?
2. A candidate (from *candidatus*, Latin for white-robed) is a person preparing for an examination or offering himself or herself for office. Both are seeking to join a system. Tell the story of your first day in graduate school or in a preservice program, learning to become a teacher. Did you feel ignored and degraded, or, alternatively, special and privileged, or something else? How could you have been even better helped and prepared?
3. Describe the teachers that you instinctively knew you could trust. How could you thank and memorialize them?

The educational literature offers few personal and developmental accounts of the mentor-dissertation student relationship. Those that are available reveal the nature of the collaboration between mentor (supervisor or teacher) and mentee (university or public school student), suggesting new directions to be followed for professional development within academic and schooling cultures (see Mullen, Cox, Boettcher, & Adoue, 1997; Phillips & Pugh, 1994; and Salmon, 1992). Mentoring can launch either a developmental journey of learning or one of disablement. Mentoring is developmental when dissertation candidates are encouraged to share their research stories and to "manage upwards," learning to share with, and in turn teach, their supervisors. (This is Patrick's experience of working over time with Carol.) Mentoring is problematic when grounded, for example, in the mentor's own unhappy or even traumatic dissertation experience; the supervi-

sion style that is learned may subsequently prove unhelpful (Miezitis, 1994), straining later mentor-mentee relationships.

For the past seven years, Patrick and Carol have searched for a collaborative way of not only expressing but also enacting comentorship. Such mentorship voluntarily evolves into partnership through sharing responsibility for conceptualization, research, and presentation. The development of graduate students as emerging researchers and contributors to their field or discipline may then be promoted. This seems so different and seldom detailed an approach in academe that we apply the term "comentorship" to it. We next provide previous and current examples of such practice, including our own. However, each partnership is uniquely situated and patterned: "While it might be possible to say a rose is a rose is a rose, one cannot conclude that a partnership is a partnership is a partnership" (Clark, 1988, p. 41). Each offers a distinctive mix of qualities.

William James was noted for treating his students as intellectual equals engaged in the common quest for knowledge. He sought to provide Mary Whiton Calkins, a member of the college faculty, with "postgraduate and professional instruction" (Calkins, 1930, p. 31). They studied together "quite literally at either side of a library fire." Calkins empowered herself to teach her teacher and to become a valued collaborator. Although she was never awarded the degree for the doctoral study that she completed, Calkins later developed one of the most influential, psychological theories of the self. She was the first woman to be elected president of the American Psychological Association.

More currently, Barone and Eisner (1997) and Connelly and Clandinin (1988, 1990), for example, represent successful coauthorship by former mentors and students. Some partnerships have themselves evolved into comentoring circles within which faculty and students produce collaborative structures both within classrooms (Bona, Rinehart, & Volbrecht, 1995) and beyond classrooms in new sites (Mullen, Cox, Boettcher, & Adoue, 1997). Such productive partnerships and arrangements cannot be mandated but must be left free to grow or not through a negotiated version of comentoring. While each arrangement is different, they are all collaboratively oriented, that is, they model new forms of authority, discourse, and pedagogy or inquiry. The examples of coauthorship that are next given are marked by shared research interests; experimentation with dialogic formats; analytical and aesthetic approaches to autobiographical, biographical,

and narrative inquiry; and the use of self-and-other study techniques. But duography will not suit the purposes of all researchers.

Like some collaborating mentor-mentees, Mary Catherine and Gregory Bateson do not study their own association *per se* but rather construct a dialogue to exchange their ideas. Yet, they are conscious of also being in a special relationship. The daughter questions her father. Her responses reveal a contesting rather than any passive acceptance of his ideas. Both partners engage in debate: the father views his stories as vehicles to reveal his ideas about relationships, not himself; the daughter, on the other hand, views stories as also illustrating facets of their relationship. Readers are left with this multiple presentation of meaning as an effect of storytelling and intertextuality (see the excerpts from our duography below). The Batesons did not feel the need to assimilate, complement, or to reject the other's position. Their voices freely engage in continuous and unfinished dialogue, even after the father's death.

The daughter was left with an unfinished manuscript to complete (Bateson & Bateson, 1987). Mary Catherine fictionalized the relationship as "father" and "daughter" while also documenting it. Because their conversational space is symmetrically balanced, a mentoring frame is implied in this textual representation. They call their form of dialogue a "metalogue," which Gregory Bateson (1979) described as "a conversation about some problematic subject. This conversation should be such that not only do the participants discuss the problem but the structure of the conversation as a whole is also relevant to the same subject" (p. 1). The form helps enact the meaning.

The textual conversation that we seek to create among our separate accounts of the "father" in our dialogue journal, for example, is derived from our exchanging of self-narratives. Patrick revisited his self-stories (Diamond, 1993, 1994, 1995) with respect to the role of authority exercised by some mentors and members of search, tenure and promotion, and editorial committees. Patrick realized that, in his stories, he had been over-valorizing himself as a resourceful and self-reliant learner, apparently making the best of indifference and adversity. Details in his *Pilgrim's Progress* through higher education ironically expressed and confirmed his narrative identity at that time. These self-analytic stories gained added coherence from secret and cultural tales of his perceived exclusion. As an only child, he struggled to challenge the authority of his father:

> I sat up there [in the treehouse] each afternoon after school floating above the chickens and my anxieties. But my father cut it down . . . I later tried to find refuge behind the dense vegetation of books and writing. Years later I became a traveler with an academic passport. (excerpt from dialogue journal, 1994)

As an academic, Patrick felt, like others, that he had almost been "pushed out of Australia by family circumstances, the experience of discrimination, frustration with the culture" (Conway, 1994, p. 250). He spent sabbaticals seeking mentors (James Britton and Don Bannister) until he could "father" himself and others. His romantic, but self-serving, quest was to expel the academic gatekeepers, overturning the words of the fathers. Patrick learned from Carol that feminists such as Spender (1981) and Grumet (1987) had also critiqued such encounters. Smith (1978) described gatekeepers as the "people who set the standards, produce the social knowledge, monitor what is admitted to the systems of distribution, and decree the innovations in thought, or knowledge, or values" (p. 287). In a postmodern age, the experiences of others cannot routinely be excluded by privileged authorities.

By attending to our own duographic practices, we avoided the problems of seeming to exploit the meanings of relatively less powerful others. We wrote together in the belief that we could assert and subvert authority, even our own. After Carol read Patrick's treehouse story, she wrote to him about the "fathers" who had either supported her inquiry or threatened to end it.

> As a graduate student, I sometimes feel like an "inmate." I struggle to accept the pedagogical doctrines of the field of curriculum that seem mainly to value "outside-in" inquiries and mediated accounts of teachers' biographies. I draw closer to arts-based inquirers and mentors who value their own personal knowledge, writing themselves as an integral part of their own inquiries. Duographic writing with you means that I can engage in extensive, sustained inquiry with someone I was able to come to know as other than a "father figure." But I nonetheless struggle in my research against a backdrop of patriarchal influences within systems of higher education and prison. In the latter case, I was restricted at length from functioning as an official researcher and certified teacher. I was initially required to document inmates' requests for court. I was also required to cofacilitate a substance recovery group without any background training or specialized knowledge!
>
> These various contexts actually helped me to better understand the inmates' lives and personal concerns once I began teaching in the literacy program. However, without this ability to "reframe" the beliefs of my institutional fathers and their methods of socialization, I would have become yet another struggling teacher. (excerpt from Dialogue journal, 1994)

Carol found, like Conway (1994) 20 years before her as a female vice-president at the same university, that some faculty and supervisors still believed in hierarchy. They were mostly concerned with bureaucratic approaches to inquiry. Patrick had suggested this parallel between Conway's and Carol's university experiences when he responded to an entry in Carol's dream journal (see below) in which she reflected on gatekeeping, authoritative voice, and personal signature.

> In an "unforgettable dream," I puzzled over an authority figure's illegible handwriting. It appeared without warning like an airplane's banner across the sky. I could not decipher the message, and it began to fade the harder I tried. As I scrutinized it very attentively from within my prison cell, I felt confused and weakened by my desperate effort to make sense of this cryptic message. My only role as a daughter-protégée in a version of the world such as this was to accept the gatekeeper's meaning without being able to "read" it. I conformed in the dream, but ceased to exist. I now ask: "Is my self-authoring being controlled by an author/ity or am I authoring my own fate?" This raises the issue of authoritative discourse as hierarchically imposed, belonging only to the father (Bakhtin, 1981). (excerpt from Dialogue journal, 1994)

The powerful may locate their discourse above dialogue, claiming taboo status for it. In such mentoring arrangements, boundaries seem uncrossable—like snow lines. In contrast, boundaries are crossable within a comentoring relationship. Risk-taking is then encouraged as a critical strategy for reenvisioning power structures.

Power asymmetries can be addressed by the mentor and the dissertation student's sharing and reforming their stories of the experience of learning to work together. When unexamined, these exchanges can be marked by interpersonal problems, institutional pressures, and a power differential that can affect the productivity, creativity, and emotional well-being of the student (Phillips & Pugh, 1994; Salmon, 1992). Even when positive arrangements are experienced, coauthorship may still not be possible. Except in extreme situations usually involving violation of professional responsibility, there exists no formal way of investigating the mentoring relationship itself.

Our coauthoring practice provides for an interplay of our voices as an ongoing, multitrack conversation rather than as a series of monologic exchanges. We initially wrote together to develop terms and a language for conducting research from the margins, rather than from the mainstream of accepted practice (see chapter 9). As our stories evolved, we theorized subjugated and dominant knowledge in terms of metaphorical and literal confinement within academe (Carol and Patrick's pedagogical context) and jail (the site of Carol's doctoral and ongoing

research). By exploring a less traditional style of inquiry, we sought to "break out" of the claustrophobia of accepted research practice. More than just "'learn[ing] the ropes' of a new endeavor" (Bona, Rinehart, & Volbrecht, p. 118), we "roped [ourselves] together" (Diamond & Mullen, 1996).

To speak authentically of self and other, we use the familiar techniques of representing and reinterpreting meaning, embedding conversational exchanges, and interweaving our texts, as in the following section. Coconstruction helps align our separate stories, moving beyond self-checking mechanisms for gauging their authenticity and worth. Without collaborative work, the quality of the academic relationship may suffer and the success of one partner may be won at the expense of the other. Our double-voiced discourse shows how we prefer to work: collaboratively, by suggestion, accumulating material that is repeated in different contexts.

Our Duography of Mentorship

In this section of our duography, we illustrate how we talk and write together when we become the researched. Duography, as well as being both method and text, involves the structure and substance of a relationship that cannot be fully represented in writing. Because we see our coauthorship as growing, we accept that any account of it can be only partial. In the introduction, we discussed our use of "we," and "Carol" and "Patrick," to indicate shared and, at one time, separate authorship. We constructed an extended dual biography from material extracted from our reflective journals, informal notes, and presentation materials. We write jointly from our merged but not submerged perspectives. Given that we have worked so closely together on this project, it is now difficult for us sometimes to know who is "citing" whom. The central metaphor of "roped together" acknowledges our interdependence. Each positioning is always half someone else's (Bakhtin, 1981)—especially in comentorship.

Duography is a record, an approach to, and outcome of, an inquiry, and a resource for further inquiry. The propositions about and justifications for duography are taken to be parts of the duography. We now show where the duography is *in* this collaborative inquiry. We illustrate our duography, citing additional excerpts from our dialogue journal. To reflect on and analyze our processes we explicitly address three of the questions that we are often asked. We feel chal-

lenged but not on trial. The aim is to show us alone and together "in the instant of repose," but always "in the moment of transition from a past to a new state, in the shooting of the gulf, in the darting to an aim" (Emerson, 1957, p. 158).

Duographic Journaling

1. *"How did we undo the traditional, hierarchical, temporarily circumscribed relationship between one of us as advisor and the other as graduate student?"*

Our first response is taken from our joint American Educational Research Association (AERA) 1996 presentation, which we included in our dialogue journal:

> We find traditional mentorship too limiting. We seek to use duography and partnership to set us free. Combined energy acts as a spring, releasing imaginations and launching butterflies (see Figure 19). In our coauthored poem, we appropriate and revoice Prince's (1993) paradigm parable:

> *"C" is for Confinement and Creativity*
> "C" goes to school
> and learns that everything comes in boxes.
> "C" goes to university and graduates
> only to work in another box.

> One day "C" finds a spring,
> releasing creativity.
> "C" is launched out of confinement.

> The box of "this is a mentor,"
> and "this is a dissertation student,"
> slowly opens.

> Crumpled wings touch,
> each launching the other.

We are not alone in trying-out a new form of mentorship. Clandinin and Webb (1995) also used response poetry to document their doubling of voice as advisor and student. They wrote together about their relationship, beginnings, personal issues and struggles, and hierarchical encounters within higher education (Patrick & Carol, April 1996).

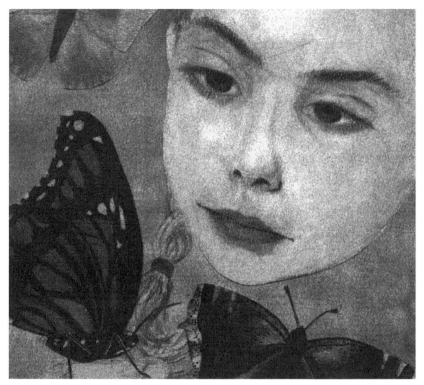

Figure 19 *The Butterfly Launch* (A. Melton, 1998)

The second response is from Patrick.

I found that writing my self-narrative of mentoring was an important first step towards forming a more collegial relationship with Carol. Through duography, as mentor and student, we reflected on the development of our individual and shared purposes. The challenge for each is not to coopt the other's voice but to work towards a more interdependent appreciation of an issue.

For me, we are trying to shape our text through entering into each other's meanings, bringing a shared context to bear on them, and seeking to produce an experiential account. Our writing together has consisted of a sequence of separate and joint efforts. I had written a series of self-critiquing texts using an ironic perspective to provide a case study of my growing understandings. I had also written a research story of my own student-supervisor-mentor experiences. I learned to "speak in [my] own voice and not to sacrifice [my] intentions to those of oth-

ers" (Diamond, 1994, p. 56). As a guide to Carol and others, I believe in encouraging candidates to experience the dissertation as a "journey leading to transformation" (p. 59). I appreciated the acknowledgment in Carol's dissertation when she thanked me for being sensitive to the ways in which she worked best: "You made my personal story worth telling. Your writing inspired me to better direct my own thoughtscapes" (Mullen, 1994, p. x) (excerpt from dialogue journal, 1995).

The third response to the first question is from Carol.

As a central part of my research story, I had documented the impact of mentorship on my master's and doctoral research, and in subsequent writings. This kind of encounter can be experienced either as an exercise in power and conformity or it can be transformed through self- and other-concern. I kept numerous kinds of journals, including one for my dreams, a second for my daily reflections, and a third for my prison research. I concluded that graduate students experience themselves as "legitimate . . . and their life experiences as worthy and noble subjects of educational inquiry . . . as [they find] ways to write themselves into their research" (Mullen, 1994, pp. 260–261).

Patrick and I began the study of our shared "architectonics" (Bakhtin, 1990) or structure of our relationship, seven years ago. Our initial contact was by letter. Patrick had been appointed as a professor to the Center where I was then a research officer. Patrick appreciated the welcoming feel of the Center. He had been "used to Australian [even more] bureaucratic ways, in which such a request would have required written statements in triplicate for scrutiny by academic committees, registrars, and an academic senate" (Conway, 1994, p. 11). When we met, beyond the usual courtesies, we did not feel weighed down by formal prescriptions and expectations. Without an hierarchically imposed relationship, we quickly felt at ease with each other. We asked for copies of each other's writing and soon extended our rather polite or cursory responses. We discovered resonances, such as shared ideological positions and complementary images of struggle and growth, in our experiences of research (excerpt from dialogue journal, 1995).

2. *"How did we remake this arrangement into a coauthoring relationship between two academics committed to and engaging in thinking and writing together?"*

The first response is from Carol.

We were at first surprised but then heartened by the commonalities in our research. We took turns to share stories and texts. Patrick's

initial understanding of narrative was based on Kelly's (1955) theory of personal constructs. When we met in 1990, I responded to him first as a visiting scholar, then as a mentor, and finally as a coauthor. As we charted our individual growth patterns in the courses that I took with him, our contact developed into a nontraditional, dissertation, and mentoring relationship. We did not realize that our individual practices as educational collaborators would continue to take new shape through our dual inquiries.

My notion of narrative had been related to the biography of teachers and researchers engaged in mythological identity formation. I have since come to understand narrative as a form of reconstructed arts-based inquiry that promotes the development of hunches, ideas, and relationship. I pushed this approach with Patrick's help. Together we study the growth of our own relationship which is simultaneously also that of an artistic collaboration and comentorship. This dual process is often difficult to articulate and to demonstrate which is why I value statements offered by coauthors on their personal view of collaboration. I agree with Hafernik, Messerschmitt, & Vandrick (1997) that: "Clearly any attempt to separate the individual contributions of each author completely contradicts the essence and spirit of collaboration" (p. 32). Other collaborators also share this sentiment. Even where Pat and I signal an individual thought-piece through our responses, and self-narratives elsewhere, we have interacted with, and extended, each other's writing. We have overlapped each other's themes to create connections for ourselves, to build an expanding sociocultural consciousness, and to guide personal, intellectual, and spiritual development (excerpt from dialogue journal, 1995).

The second response to the second question is from Patrick.

Just as we had shared our office space, telephone, and morning teas without waiting on formalities, either of us has, for years, taken the initiative in shaping proposed writing projects, developing research opportunities, and pursuing publication. Our present book can also be seen as an outgrowth of our shared writing and commitment, and invitations to one another. Some of our efforts are separate, some are shared, and most are impossible to disentangle.

The presence of Byron and Percy Shelley loom over Mary Shelley's *Frankenstein* but the achievement is not a collaborative one. Both poets were intent on following their own genius. Pooling our suggestions, we make plans and negotiate space and time for work. Our writing is scheduled in terms of what is best for the other and what is manageable for the self. We help articulate each other's emerging themes, extending

partially developed combinations of ideas, key metaphors, and following promising leads. We function as each other's conceptual "inmate" and supportive reader.

During the collaborative phases of our text production, coconstruction, and revision, we feel that, like Picasso and Braque, we are in our research space or art studio. We also are "in studio" during the conversational "interviews" that characterize our beginnings and endings. When one of us sketches or devises a proposal, the other searches for a more satisfying articulation of its ideas. While we do not write side-by-side, we re-plot and track our developing ideas. Although now at a physical distance (Ontario, Texas, New South Wales, and Florida), we remain in regular contact. When we are trying out new thinking and writing, we revisit previously developed texts and discarded fragments. We reflect on each other's writing and offer new suggestions, casting "sidelong glances" at the other's anticipated response (Dentith, 1995, p. 159) (excerpt from dialogue journal, 1995).

The third response is from Carol.

Over the last two years that we have corresponded as coparticipating professors, we came to realize that our research relationship grew through our being "roped together," first by chance but then by choice. When we began as mentor and student, development seemed to follow naturally from our relationship. We have created over time a program of arts-based research that emphasizes experience and collegial coparticipation. By asking whose voice is mirrored in each of the inquiries (Guba & Lincoln, 1994), we reflect on our dual voice of authorship and on that of authority. We have explored images of control and surveillance in an effort to resist gatekeeping and manipulation (chapter 9). Rather than giving up on power, we help each other to feel more powerful within settings in ways that promote individual voice, growth, and partnership (excerpt from dialogue journal, 1995).

3. *"How did we remain as distinctive individuals though working in relation to reduce isolation? What were the dangers?"*

The first response is from Carol.

I am struck by two features that safeguard our duography: acceptance and constructive feedback. Taking turns to provide sensitive and shaping responses is a "learned art" involving "constant attention to details and context, and . . . *active* inquiry in practice as well as reflection on reconstructed accounts of practice" (Kilbourn, 1990, p. 2). As

coparticipants, we share conceptual and practical responsibility, seeking always to be encouraging. We have established such a supportive context that we can even raise points of conflict. We "talk straight" and sometimes need to take "time-out" from each other's intensity, the very source that drives our duographic commitment.

University structures have a long history of excluding and marginalizing female graduate students (Calkins, 1930; Caplan, 1994). Mentoring has traditionally involved men in relation who, as gatekeepers, prepared one another as their successors (Hall, 1983). Given this legacy, we recognized that mentoring needed to be made more inclusive, promoting equality rather than remaining "boxed in by gender-biased classification schemes" (Conway, 1994, p. 223). While our relationship exists in tension with systemic realities and a sometimes harsh publication landscape (Spender, 1981), we share in making text and decisions, and setting academic writing goals. During times of disappointment or work overload, we make a special effort to encourage each other. But we know when to "cut rope," respecting each other's competing work demands and personal space. We also know when to recognize the "butterfly launch" in our work, that moment of splendid creative release that overrides all other concerns, including pressures of time and of the academy—where alternative forms of expression have the reputation of somehow being in favor of complete disintegration and even weak-minded inquiry (excerpt from dialogue journal, 1995).

The second response to the third question is from Patrick.

While I have copublished with 12 former graduate students, Carol is the first with whom I have worked so extensively—and intensively. I was consistently impressed by her talent, reliability, and work generosity. We usually write separately but this invariably turns out to have been in parallel. The career of our duography is less followed than assembled, put together as we get on with doing it. My patterning image of the butterfly resembled that of an emerging arts-based inmate in Carol's prison research. We are separate but share common purposes. Like implicit Kellyians (1955), we often construe together like birds of a feather.

When we began (at the bottom of our ascent), we functioned as a professor and student; we moved towards the staging ground of becoming supervisor (then mentor) and dissertation candidate; next, we climbed to the slopes of our research partnership; and, finally, we "roped" our way towards coauthorship. Straining towards the high ground is not without risk but being alone increases it. If some candi-

dates remain ABD ("All But Dissertation") and others unpublished, unappointed, or untenured, their public spectacle serves as a powerful warning to others. We periodically keep a check on each other's position. There may be lingering resistance to comentoring even within higher education (excerpt from dialogue journal, 1995).

Summary Comments

As in the above excerpts and fragments, we use duography to blend and develop our stories of comentorship as a textual conversation. Our collaborative research first grew out of a traditional academic context. Through the imagery of transformation and climbing, and through reflecting on sequences of excerpts, we developed an alternative theoretical framework based on arts-based, collaborative narrative inquiry. However, despite high hopes, a term and an effect like duography must be prevented "from assuming a force which gives a presence to a [pair of] centred-lives that it cannot have" (Denzin, 1989, p. 46). There can only be multiple versions of any relationship and inquiry. We have asked how duography has helped us more adequately to experience and represent comentorship as coauthorship. The challenge is to represent our working relationship so as to "dramatize the intersubjective give-and-take of fieldwork and introduce a counterpoint of authorial voices" (Clifford, 1988, p. 43). We accept that not "everything can be 'said' with anything" (Eisner, 1993, p. 7), not even duography.

Dialogism offers an alternative model of inquiry in which the authority of the mentor and student are both emphasized, and a structure for comentoring made possible. Each voice is granted as much authority as that of the other. The result is a blend of independent but merging voices, without any finalizing or totally explanatory word. As in the above excerpts, the voices engage in supportive but incomplete conversational exchanges. Throughout our duography, we employ a mix of sources and constructions, featuring first and third person voices, singular and plural number, past and present tenses.

Our writing partnership permitted scrutiny, from at least two angles, of different episodes, such as defending our inquiry approach and sharing our tension in relation to authority figures such as the father. Where the vision of one writing partner may be clouded by lack of insight in one area, it may be complemented by the corresponding clarity of the other. Through sharing, greater insight can be achieved

and professional isolation reduced. However, even in this chapter, we had to resist generating imposed versions of the other, remembering that we each look upon events from a particular location in space and time. Whenever we interiorize the other's meanings and present them as reformed and literalized for our own purposes, we risk appropriating them. In duography, the climb involves constantly "monitoring" self and other as part of working together.

We use duography to capture what our comentorship, involving coauthorship as one of its principal tasks, has come to mean to us. "Roped together," we continue to explore duography as one of the ways to begin to overcome the established "built-in academic inequalities" (Salmon, 1992, p. 95) that often mark higher education and teacher development. Duography enabled us to generate partial views of our relationship while also theorizing a textured account of it. For us, duography is a research genre, a relational process, and an arts-based method of inquiry. For others, it will take other forms and expressions. Jipson and Wilson (1997) use a postmodern, "spacey" form to chart the development of their dialogue as former faculty and student. In this chapter, we use a nested collage form of our writing and that of others.

Duography is a form of partnership that extends ways of practicing and thinking about both mentorship and arts-based research. We define duography as a retrospective written account that two people provide of a selection of related events and ideas taken from their research lives. We previously shared an advisor–graduate student relationship, and we now employ and illustrate this conversation with fragments from a dialogue journal. By analyzing our portfolio of writing, we demonstrate how we reflect on our evolving comentorship as a form of coauthorship. Having become "intellectual friends" who share a professional identity, we question and seek to understand our experience of developmental collaboration. Our turn-taking involves each of us in telling research stories and in responding to those of the other. We hope to support rather than to constrain each other. Such a joint inquiry has value beyond the merely personal in terms of making connections for others in higher education as well as in schools, prisons, and other sites. There are dangers in going it alone.

> Ahead, all he could see, as wide as all the world, great, high, and unbelievably white in the sun, was the square top of Kilimanjaro. And then he knew that there was where he was going. (Hemingway, 1987, p. 56)

Arts-Based Activities

1. Write about feeling alone in, or dreaming about, your teaching or research.

2. In Hesse's (1990) last novel, *The Glass Bead Game*, the students are required to submit a fictitious life story set in any past period the writer may choose. Through writing these lives, they are to learn to regard their own persons as masks. What mentors or supervisors are you learning to emulate or to outgrow? How can you adapt or put aside their borrowed or imposed masks? In his novel, Hesse parodies (auto)biography and the grave scholarly attitude.

3. Draw up a list of rights and responsibilities for dissertation candidates and their supervisors, or for beginning teachers in their first year of professional preparation and their supervising or associate teachers in the schools.

4. Compose your own paradigm parable (chapter 2). Does it resonate with our appropriated poem, "'C' is for Confinement and Creativity"?

References

Arendt, H. (1990). Philosophy and politics. *Social Research, 57*(1), 82.

Bakhtin, M. M. (1981). *The dialogic imagination.* M. Holquist (Ed.) (C. Emerson & M. Holquist, Trans.) Austin, TX: University of Texas Press.

————. (1990). *Art and answerability: Early philosophical essays.* M. Holquist & V. Liapunov (Eds.) (V. Liapunov, Trans.) Austin, TX: University of Texas Press.

Barone, T. E. (1983). Things of use and things of beauty: The Swain County high school arts program. *Daedalus, 112*(3), 1–28.

————. (1993). Ways of being at risk: The case of Billy Charles Barnett. In R. M. Jaeger (Ed.), *Complementary methods for research in education* (pp. 105–111). Washington, DC: American Educational Research Association.

Barone, T. E., & Eisner, E. W. (1997). Arts-based educational research. In R. M. Jaeger (Ed.), *Complementary methods for research in education* (pp. 73–98). Washington, DC: American Educational Research Association.

Bate, J. (1997). *The genius of Shakespeare.* London: Picador.

Bateson, G. (1979). *Mind and nature: A necessary unity.* New York: E. P. Dutton.

Bateson, G., & Bateson, M. C. (1987). *Angels fear: Towards an epistemology of the sacred.* New York: Macmillan.

Berthoff, A. G. (1985). Dialectic notebooks and the audit of meaning. In T. Fulwlier (Ed.), *The journal book* (pp. 11–18). Portsmouth, NH: Heinemann.

Bona, M. J., Rinehart, J., & Volbrecht, R. M. (1995). Show me how to do like you: Co-mentoring as feminist pedagogy. *Feminist Teacher, 9*(3), 116–124.

Calkins, M. W. (1930). Autobiography. In C. Murchison (Ed.), *A history of psychology in autobiography, 1* (pp. 31–62). Worcester, MA: Clark University Press.

Caplan, P. J. (1994). *Lifting a ton of feathers: A woman's guide to surviving in the academic world.* Toronto: University of Toronto Press.

Clandinin, D. J., & Webb, K. (1995, April). Poetry read and exchanged (untitled segment) within "Partners in knowledge: Women

mentoring women." Poetry presented at the Annual Meeting of the American Educational Research Association, San Francisco, CA.

Clark, C., Moss, P. A., Goering, S., Herter, R. J., Lamar, B., Leonard, D., Robbins, S., Russell, M., Templin, M., & Wascha, K. (1996). Collaboration as dialogue: Teachers and researchers engaged in conversation and professional development. *American Educational Research Journal, 33*(1), 193–231.

Clark, R. W. (1988). School-university relationships: An interpretive review. In K. A. Sirotnik & J. I. Goodlad (Eds.), *School-university partnerships in action: Concepts, cases, and concerns* (pp. 32–65). New York: Teachers College Press.

Clifford, J. (1988). *The predicament of culture: Twentieth-century ethnography, literature, and art.* Cambridge: Harvard University Press.

Connelly, F. M., & Clandinin, D. J. (1988). Narrative meaning: Focus on teacher education. *Elements, 19*(2), 15–18.

———. (1990). Stories of experience and narrative inquiry. *Educational Researcher, 19*(5), 2–14.

Conway, J. K. (1994). *True north: A memoir.* Toronto: Knopf.

Dentith, S. (1995). *Bakhtinian thought.* London: Routledge.

Denzin, N. K. (1989). *Interpretive biography.* New York: Sage.

———. (1992). The many faces of emotionality: Reading Persona. In C. Ellis & M. G. Flaherty (Eds.), *Investigating subjectivity* (pp. 17–30). New York: Sage.

Dey, E. L., Korn, J. S., & Sax, L. J. (1996). Betrayed by the academy: The sexual harassment of women college faculty. *Journal of Higher Education, 67*(2), 149–173.

Diamond, C. T. P. (1992). Autoethnographic approaches to teacher education: An essay review. *Curriculum Inquiry, 22*(1), 67–81.

———. (1993). Writing to reclaim self: The use of narrative in teacher education. *Teaching and Teacher Education, 9*(5/6), 511–517.

———. (1994). From numbers to words. In A. L.Cole & D. E. Hunt (Eds.), *The doctoral dissertation journey: Reflections from travellers and guides* (pp. 53–60). Toronto: OISE Press.

———. (1995). Education and the narrative of self: Of maps and stories. In G. J. Neimeyer & R. A. Neimeyer (Eds.), *Advances in personal construct psychology III* (pp. 79–100). Greenwich, CT: JAI Press.

Diamond, C. T. P., & Mullen, C. A. (1996). *Beyond the mentor-mentee arrangement: Co-authoring forms of post-mentorship* (Microfiche No. ED 394417). Presentation at the annual meeting of the American Educational Research Association, New York, NY (ERIC Clearinghouse on Higher Education)

Diamond, C. T. P., Mullen, C. A., & Beattie, M. (1996). Arts-based educational research: Making music. In M. Kompf, W. R. Bond, D. Dworet, & R. T. Boak (Eds.), *Changing research and practice: Teachers' professionalism, identities, and practice* (pp. 175–185). London: Falmer Press.

Dunn, P., & Leeson, L. (1997). The aesthetics of collaboration. *Art Journal, 56*(1), 26–37.

Eisner, E. W. (1993). Forms of understanding and the future of educational research. *Educational Researcher, 22*(7), 5–11.

Emerson, R. W. (1957). *Selections from Ralph Waldo Emerson: An organic anthology.* (S. E. Whicher, Ed.). Cambridge, MA: Riverside Press.

Feuerverger, G., & Mullen, C. A. (1995). Portraits of marginalized lives: Stories of literacy and collaboration in school and prison. *Interchange, 26*(3), 221–240.

Fishman, A., & Raver, E. J. (1989). "Maybe I'm just NOT English teacher material," dialogue journals in the student teaching experience. *English Education, 21*(2), 92–109.

Gergen, K., & Gergen, M. (1993). Notes about contributors. In R. Josselson & A. Lieblich (Eds.), *The narrative study of lives* (pp. 225–226). London: Sage.

Grumet, M. (1987). Voice: The search for a feminist rhetoric for educational studies. *Cambridge Journal of Education, 20*(2), 277–282.

————. (1990). Autobiography and reconceptualization. *Journal of Curriculum Theorizing, 2*(2), 155–158.

Guba, E. G., & Lincoln, Y. S. (1994). Competing paradigms in qualitative research. In N. K. Denzin & Y. S. Lincoln (Eds.), *Handbook of qualitative research* (pp. 105–117). London: Sage.

Hafernik, J. J., Messerschmitt, D. S., & Vandrick, S. (1997). Collaborative research: Why and how? *Educational Researcher, 26*(9), 31–35.

Hall, R. M. (1983). *Academic mentoring for women students and faculty: A new look at an old way to get ahead* (Project on the Status and Education of WOMEN). Washington, DC: Association of American Colleges.

Hemingway, E. (1987). *The complete short stories.* New York: Collier.

Hesse, H. (1990). *The glass bead game.* New York: Holt.

Holly, M. L. (1989, March). Exploring meanings: Biographical journal writing. Poetry presented at the Annual Meeting of the American Educational Research Association, San Francisco, California.

Jipson, J., & Wilson, B. (1997). TH AT DIA LOG AT NI GHT. In J. Jipson & N. Paley (Eds.), *Daredevil Research: Re-creating analytic practice* (pp. 161–183). New York: Peter Lang. (Counterpoints Series)

Johnson, D. W., Johnson, R. T., & Holubec, E. J. (Eds.). (1993). *Cooperation in the classroom* (6th ed.). Edina, MN: Interaction.

Kelly, G. A. (1955). *The psychology of personal constructs* (2nd ed., 1992, London: Routledge, *1–2*). New York: Norton.

Kilbourn, B. (1990). *Constructive feedback: Learning the art.* Toronto: OISE Press.

Koestler, A. (1964). *The act of creation.* New York: Dell.

Lightman, A. (1993). *Einstein's dreams: A novel.* New York: Pantheon.

Lincoln, Y. S. (1990). Response to "Up from positivism." *Harvard Educational Review, 60*(4), 508–512.

Miezitis, S. (1994). The journey continues: From traveller to guide. In A. L. Cole & D. E. Hunt (Eds.), *The doctoral dissertation journey: Reflections from travellers and guides* (pp. 99–108). Toronto: OISE Press.

Mullen, C. A. (1994). A narrative exploration of the self I dream. *Journal of Curriculum Studies, 26*(3), 253–263.

―――. (1997). *Imprisoned selves: An inquiry into prisons and academe.* New York: University Press of America.

Mullen, C. A., & Dalton, J. E. (1996). Dancing with sharks: On becoming socialized teacher-educator researchers. *Taboo: The Journal of Culture and Education, I,* 55–71.

Mullen, C. A., Cox, M. D., Boettcher, C. K., & Adoue, D. S. (Eds.). (1997). *Breaking the circle of one: Redefining mentorship in the lives and writings of educators.* New York: Peter Lang. (Counterpoints Series)

Nixon, J. (1996). Professional identity and the restructuring of higher education. *Studies in Higher Education, 21*(1), 5–16.

Oberg, A. (1990). Methods and meanings in action research: The action research journal. *Theory into Practice, 29*(3), 214.

Phillips, E. M., & Pugh, D. S. (1994). *How to get a PhD: A handbook for students and dissertation supervisors.* Milton Keynes, UK: Open University Press.

Pope, M., & Denicolo, P. (1993). The art and science of constructivist research in teacher thinking. *Teaching & Teacher Thinking, 9*(5/6), 529–54.

Prince, F. A. (1993). *C and the box: A paradigm parable.* Toronto: Pfeiffer.

Richardson, L. (1992). The consequences of poetic representation: Writing the other, rewriting the self. In C. Ellis & M. G. Flaherty (Eds.), *Investigating subjectivity: Research on lived experience* (pp. 125–140). Newbury Park, CA: Sage.

Salmon, P. (1992). *Achieving a PhD—ten students' experiences.* Oakhill, Staffordshire: Trentham.

Sands, R. G., Parson, L. A., & Duane, J. (1991). Faculty mentoring faculty in a public university. *Journal of Higher Education, 62*(2), 174–193.

Sarason, S. B. (1990). *The predictable failure of educational reform: Can we change course before it's too late?* San Francisco: Jossey-Bass.

Smith, D. (1978). A peculiar eclipsing: Women's exclusion from man's culture. *Women's Studies International Quarterly, 1*(4), 281–296.

Spender, D. (1981). The gatekeepers: A feminist critique of academic publishing. In H. Roberts (Ed.), *Doing feminist research* (pp. 186–202). London: Routledge and Kegan Paul.

Voss, M. M. (1988). The light at the end of the journal: A teacher learns about learning. *Language Arts, 65*(7), 669–674.

Chapter 12

Musical Chords:
Basic Inquiry in Four Parts

Carol A. Mullen
C. T. Patrick Diamond
Mary Beattie
William A. Kealy

Each moment I live, I must think where to place my fingers, and press them down with no confidence of hearing a chord. (Updike, 1966, pp. 189–190)

It is my dream, when I touch the keys, to *release* the notes. It is music waiting there, and for me it is as real as the blown snow against the windows, and the evening's quarter moon rising through a cold fog, or the stories told of wolves sheltering in the red oak trees. (Adams, 1996, pp. xvii–xviii)

Research as Improvising Arrangements

In this chapter, we are attempting to devise a way of representing our experience and the results of our working together. This took shape as different combinations formed at different times, based on different relationships (mentoring, collegial), and in different places. We began and merged as Patrick and Carol, Carol and Mary, Patrick and Mary, and then Patrick, Carol, and Mary, then Carol and Bill, and finally, all four. This marks no return to the "swinging sixties" but an emerging set of working, artistic relationships. We use the image of a musical chord that consists of a group of notes sounded together to represent our collaborative processes. This kind of agreement is different from what Blumenfeld-Jones and Barone (1997) describe as "dangerous illusions [that seem] extremely coherent and authoritative" (p. 99). We rely on one another, as in this chapter, to feel the rhythm of our

different but criss-crossing versions of selfhood, that is, as composed by the hand (Carol), the eye (Patrick), the ear (Mary), and the brain (William).

We draw on music because it bears a close similarity to the forms of feeling: "Forms of growth and of attenuation, flowing and slowing, conflict and resolution, speed, arrest, terrific excitement, calm or subtle activation and dreamy lapses—the greatness and brevity and the eternal passing of everything vitally felt" (Langer, 1987, p. 225). But our story of collaboration, through this project, does not resemble a professional piano, shining with a glossy finish, tuned ready to be heard with the promise of easy listening. As postmodern educators, we are shaping and reconfiguring our narrative arrangements to begin, however slowly, to fulfill the multiple imaginations that we have of arts-based, collaborative inquiry. We imagine our inquiry as a shared story, as an improvisation of professional practice, and also as a framed form of art. Like Sarason (1990), we describe artistic research as "the choice and use of a particular medium to give ordered expression to internal imagery, feelings, and ideas that are in some way unique" (p. 1). Along with Bateson (1990), we wonder what insights and contributions follow from the experience of improvisation in a "complex weave of collaboration" (p. 10).

Such arts-based forms may engage and deepen our understanding of teacher-researcher development and provide a method of the inside (Diamond, Mullen, & Beattie, 1996). We asked ourselves: "What artistic forms are appropriate to an arts-based form of inquiry and new learning?" Although music and drama exist as scripts, they really live only when they are interpreted in performance (McCutcheon, 1982). Just as different cadenzas are heard when individual performers play the same concerto, even the same actor plays a different Hamlet or Ophelia each night. Different aspects of arts-based texts are brought out in different readerly responses and active constructions of meaning (Barone, 1995; Barone & Eisner, 1997). We later present our performance as an arts-based, illustrated quartet.

We are experimenting with a postmodern hybrid form: part social inquiry, part "confessional" self-narrative, part dream-based fantasy, and a crossing of frontiers of relationships and different ways of knowing. Arts-based educational research exists both as a performance and as a record. In our individual, paired, and shared work, we are seeking to rescript and to enact an alternative form of inquiry. We also wish to rethink and redefine ourselves as artistic teacher-researchers

and to encourage others also to try new combinations. We have previously used many arts-based forms, including self-narrative and (auto)biographic engagement (Diamond, 1995a, 1995b; Kealy, 1997; Mullen, 1994, 1997a, 1997b, 1997c); duography, a reciprocal, literary-based dialogue (Diamond & Mullen, 1996, 1997; chapter 11); musical imagery (Beattie, 1995a, 1995c), life history interviews, and cultural self-identity portfolios (Mullen, 1997a); and graphic concepts, analogous templates, and displays of scale (Kealy & Mullen, 1996; chapter 13; Kealy & Webb, 1995).

In this chapter, we "warm up" by elaborating on our argument as to why traditional research scores need to be reorchestrated, and then we stage our joint performance. Our way of "finding art's place" (Paley, 1995) is enacted and illustrated as a shared "monologue articulated through multiple voice and response" (p. 185). Although as the four authors we share a similar story of finding art's place in the academy, we write together without being limited by any presupposed unity of experience or expression.

We are improvising with a form of arts-based research that enhances self-knowledge within the resonating context of others. We highlight personal ways of being located as teacher researcher-artists and illustrate our shared need to reinvent ourselves (see the section entitled, "Moving Towards Artistic Collaboration"). Through self-study exploration, we catch our reflections in the others' understandings of how we frame and exhibit those qualities and forms that are central to our individual work. Using the literary, visual, and performing arts, we tell stories of our struggle for self-articulation and legitimacy within the publishing community and workplace. In this chapter we ask and then share our responses to two questions: "What is our experience as practicing teacher researcher-artists in the academy?" and "What are our experiences of collaborative composition and performance of arts-based texts?"

Attempting to push the boundaries, we are working in critical, reflexive relation to each others' practices and to those of our field. We therefore position ourselves as "co-educators" in our overlapping transformations (Connelly & Clandinin, 1995). As artistic researchers, we seek "to construct meaning from experience and subject these constructions to reconstruction" (Pope & Denicolo, 1993, p. 531). These personally ordered understandings function as our "experience-knowledge" or dominant chord, our distinctive voice, signature, or quality. Changing the "dominant chord," whether in music or teacher education,

is like evoking new shifts and transformations. But even when the dominant chord is played out differently in the realm of ideas and professional practice, there is always more development yet to unfold. As teacher-artists, we seek new ways of weaving together varied qualities of tone, harmony, rhythm, volume, pace, and voice (Oldfather & West, 1994).

Our larger effort is to reframe educational research as artistic movement and then professional practice as improvisation. Accordingly, we introduce a new form of jointly staged arts-based educational inquiry, using the elements of IICO (Intuition, Imagination, Collaboration, and Orchestration), an acronym for a set of moves to guide our theorizing and practice. We each have our favorite or preferred mode for improvising and framing arts-based work: the hand, eye, ear, and brain, respectively. As in a game of thoughts and different contributions, Hesse's (1990) glass bead game is a symbol of the imagination. In this chapter, we also state themes that are then "elaborated, varied, and under[go] a development quite similar to that in a Bach fugue or a concerto movement" (Hesse, 1990, pp. 39–40).

Artistic Inquiry as a Quartet

As Read (1944) searched T. S. Eliot's *Four Quartets,* we are searching for a form that is not merely a continuation of the same thing, more or less indefinitely (rhymed couplets or control groups), or an addition of identical units (a sonnet sequence or a set of replicating experiments). We are seeking instead a form based on "the analogy of the Quartet in music, with separate movements, forms within forms, diversity within unity" (see Preston, 1966, p. vii).

We have designed IICO (Intuition, Imagination, Collaboration, and Orchestration) as a four-part notion of artistic inquiry that combines personal knowing, composing, improvising, and shaping. This is not so much a linear sequence as a multiple lens for conducting and reflecting on arts-based collaborative work. Heartfelt *intuition* encourages the release of the flight of imagination. Through using metaphors, visuals, and stories, *imagination* releases further meanings. *Collaboration* forges new relationships among experience and knowledge, self and other, art and research, and the arts and the academy. *Orchestration* consists of a collaborative, arts-based shaping and performance, as in workshop productions of music, drama, poetry, collages, and self- and group-portraiture. These forms show us interest-

ing places to go as we immerse ourselves in, and watch each other at, work.

We imagine IICO as a way of representing our developing understanding of those different dimensions of inquiry that connect us to our artistic selves and each other. We seek the fuller meaning of experience which is, in itself, an artistic process that can be rendered through playing with form and technique (as in the quartet in the section, "Moving Towards Artistic Collaboration"). Blumenfeld-Jones and Barone (1997), for example, play with form by transforming a transcript of a conversation into a "musical score version [through which] the collaboration to create meaning is more directly disclosed" (p. 97). This experimentation with "rhythms of speech" lets them "see how people actually work together, looking for opportunities to intervene, add, or redirect . . . understanding the transcript as music opens up possibilities that other approaches to data analysis and display do not" (pp. 97–98). Such artistic form is consistent with the qualities of direct, mental, and emotional life. Works of art are projections of such experienced life into visual, musical, spatial, temporal, literary, and poetic forms. Art expresses and presents emotions to our understanding, formulating feeling for our consideration, and structures that suggest a special kind of ordered expression or personal coherence, however fragmentary.

We agree that "experimentation ... with inquiry methods should be promoted and encouraged" partly because "legitimate and important non-scientific purposes and uses associated with arts-based research have long been marginalized" (Barone, 1995, pp. 171–172). To remedy the artistic "deficit" in traditional research and analytic practice, we ask "How have we already used intuition, imagination, collaboration, and orchestration in our educational research and life?" and "What choices have we made to give 'ordered' expression to the individual images, fantasies, feelings, and ideas that are inside of us?" We also ask "How can educational research be undertaken to give form to inner meaning?" and "How might the experience of collaboration give shape to forms of knowing beyond 'confinement and a one-dimensionality that both depend on having a rationalist's gaze'" (Greene, 1995, p. 142)? These questions help us to focus on what we have already been doing. We have found that we must "do" art to get at it. We document the "doing" of art as the joint narrative of our using story, visual, and metaphor to develop our underlying chords or educational themes.

A Method of the Inside

Intuition requires an inner self-awareness that, through arts-based inquiry, becomes willed self-consciousness. With art providing a transforming agency of feeling and knowing, all our present understandings and interpretations are subject to revision or replacement. As teacher-researchers, we do not need to be hemmed in by either a prevailing paradigm or the current categories of our own habitual thinking. Either may block imagination and cooperation. We can make the lines of our own divisions fall into different places to enlarge our own imaginative capacities. With the Möbius strip (see later), lines become circles without beginning or end.

We, the four authors, each play not only with sound but also perspective. Patrick Diamond (1991) has described transformation of perspective in terms of reimagining and reinventing ways of being in our teaching and inquiries. To invite a reversal of perspective, Carol Mullen (1997b; chapters 9 and 10) has located herself in rehabilitative contexts within prisons for men and women, learning how to connect with imprisoned others through story and arts-based educational programming. Instead of positioning herself as a "powerful journalist/researcher presuming to speak on behalf of the downtrodden" (Barone, 1994, p. 96), she sought to extend the quality of her experience within the context of prisoners' lives, stories, and published texts (see, e.g., Caron, 1978; Harris, 1986; MacDonald with Gould, 1988). Such "dangerous narratives" (Courage, 1996), with their implied expansiveness, threaten not only prison but also some educational authorities. Some researcher authorities may seem to adopt the role of insiders, but their "expert," rationalist gaze betrays them in the abstract, emotionally unaffected accounts (e.g., Davies, 1990; Harlow, 1987; and Lovitt, 1992) that they give of those struggling to be heard.

Like Carol Mullen (1997b), Mary Beattie (1995a) told her own story as a teacher-researcher before she asked her participants to share theirs. The teachers described their collaboration as "playing together," for Mary it was "finding the music." William Kealy plays with perspectives on academic and artistic relationships as a function of scale. His graphic-based representations are depicted at "macro" and "micro" levels, suggesting new ways of seeing everyday life over time (Kealy & Mullen, 1996; see chapter 13).

Our developing arts-based inquiry is marked by reflexivity, responsiveness, and reciprocity. Such changes in ways of perceiving and

evaluating familiar meanings in the classroom or in research may enlarge our understandings as we seek new, artistic ways of proceeding. The reconstruction of professional (teacher) knowledge takes place when imagination is heightened and pursued as art. Arts-based inquiry offers a way of contacting and fine-tuning what we are seeing, feeling, and imagining. We can orchestrate these perceptions into clusters, which are then available to be framed and played. Intuition, which frees our imagination, constitutes "the primary means of forming an understanding of what goes on under the heading of 'reality'; imagination may be responsible for the very texture of our experience" (Greene, 1995, p. 140).

Once we remove the subjective from the shadow of the objective, the inside from the outside, appearance from reality, we are able to place imagination at the core of our understanding and engage different art forms. When we realize that experience presents itself as chunks or bars and that we always need to construe their intersections afresh, we can learn to think of events such as inquiry as mobile, narrative sequences. Arts-based inquiry helps us to enter into a wider world of multiple and moving meanings. Such inquiry helps us escape from the ensnarements of traditional, one-point perspective.

Moving Toward Artistic Collaboration

As teacher researcher-artists, previously experimenting on our own with artistic approaches to inquiry, we had each felt isolated. Now that we have connected, we are seeking new insights from our combined versions of practice. By launching the filaments of inquiry out of ourselves, we can together form a dual keyboard. Our double site of composition has been represented in Figure 20, which is derived from the piano and the computer. By reviewing our different compositions from this fresh perspective, the melody and qualities of both musical and textual ways of representing experience are revealed. Our creativity blends. Neither the piano nor the computer provides the only form that inquiry may take.

We strive through collaboration to structure and reconfigure our consciousness and so to strike a chord for work already done. We then hear a melody or chord against which to improvise. Carol's way of finding and playing with the tune is that of the hand, Patrick's that of the eye, Mary's that of the ear, and William's that of the brain. If Carol's favored modalities are dream-based and mythological, Patrick's

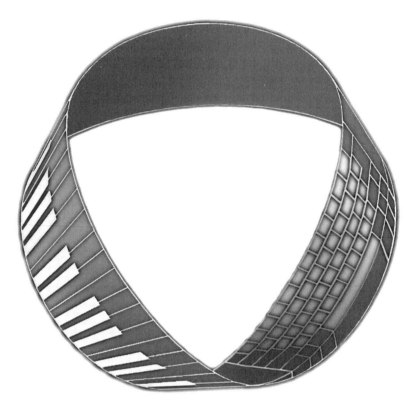

Figure 20 *The Möbius Strip: Improvising Through Artistic Keyboarding*
(W. A. Kealy, 1998)

are visual and literary, Mary's are musical and literary, and William's
are visual and technological (see Figure 20 by William Kealy). These
understandings enable us to watch ourselves more closely at work, to
be more aware of our underlying themes (Oldfather & West, 1994),
and to reimagine ourselves as collaborating teacher researcher-artists.

To show how arts-based research can deepen personal experience,
we now share the stories of what we have done in our different ways to
practice it. Like jazz musicians, we are using a basic tune to keep us
together. Its repeated chords and structure keep us on track while we
are performing multitracks or assembling a sound pastiche. We now
take turns to solo, each managing a part of the performance through
telling our self-narratives, reimagined as improvisatory and framed
art. In actual performance we take turns to read successive paragraphs

from our self-narratives. One begins, another follows, and so on. We watch to see when it is our turn to lead (see Mullen's metaphor of educators as "leading horses" in chapter 10). We have found that like jazz players, we have performed with "intimacy, passing little figures and phrases back and forth like a complicated game of catch without interrupting the flow of whatever tune [we] were playing" (Conroy, 1994, p. 479). We are trying to capture the simultaneity of experience on paper. In chapter 16 we use parallel rows of text. Here in this chapter we rely on subsequent, improvised readings of the text as script or musical score. We are designing new art forms to encourage other groups of teacher-researchers to enter our loop or to begin their own arts-based circles. We use a four-part acronym (see IICO above) and the Möbius strip (Figure 20) to trace these processes.

Carol Mullen's Hand: My Horn of Plenty

I am the hand. The hand is my cornucopia, my signature, and source of writing. A cornucopia, a goat's horn, represents fullness, a horn of plenty overflowing with flowers and fruit. In mythological terms, the hand, even when engaged in a form of warrior art, has the strength to "deliver" a horn of plenty. In the physical battle between Achelous and Hercules, for example, the latter brought the former's "head down to the ground" by his "ruthless hand [which] rent my horn from my head" (Bulfinch, n.d., p. 145). Achelous had assumed the form of a bull under pressure. His "horn" had thus become consecrated, filled with flowers. It was adopted by Plenty who called it Cornucopia.

I, in turn, "adopt" the Horn of Plenty for my own arts-based, autocollaborative purposes. My hand also engages in physical battle, but with myself. Psychic pain has become as an overwrought synecdoche in my writing life, registering chronic physical discomfort in the arm that types. This, the right arm that is dis/abling, my throbbing reminder that every cornucopia requires a sacrifice. Writing is, for me, an ironic form of healing art.

Jazz defines a way of the hands (Sudnow, 1993), and, like myth, jazz tells a kind of metaphysical story of life through the hands. Although my hands have been writing my life since early youth, they have only been shaping and sharing art works since 1994. I feel that I have been socialized to separate the visual from the literary arts, and I now actively resist this compartmentalization of artist and writer. I have changed since my youth. I can remember, for example, playing with clay as a child and asking, "Why bother?" I also remember accidentally "potato printing" my clothing during an art lesson in elementary school

and ruefully thinking, "I'd rather be writing." During tense and inspir-
ing moments with loved ones and colleagues, I often want to create
text out of my own life-experiences, including my dream world.

The notion of literary writer as respected artist was missing from
my early education and growing up, and later from much of my gradu-
ate studies. I was left dreaming on the margins as a wished-for, more
fully developed self. It was here, on the edges of myself, that I contin-
ued to focus on my hands. They would seem to never let me down.
With them I shaped literary-based educational texts that used visual
imagery through dream, poetry, and metaphor. Unknowingly engaged
in a process of artistic discovery and self-education, I followed my in-
tuitive sense. The arts enabled me to draw-on my imagination to con-
jure up possibilities for intellectual and emotional survival and, para-
doxically, to be "less immersed in the everyday and more impelled to
wonder and to question" (Greene, 1995, p. 135).

My desire to write in a visual space, partly represented through origi-
nal artworks (see Mullen's figures in the Prologue and Postlogue, and
in chapters 1, 6, 9, and 10), has shaped my world in different ways. In
the past I have performed as a narrative researcher in an inner-city,
secondary level arts classroom. I used my page as a surface on which
to construct an aesthetically oriented, impressionistic text of the dy-
namics at work in creating art, shaping relationships. The class project,
which involved a large-scale backdrop (a large unfolding manuscript?),
for a school drama, drew me in further. I watched, with my own note-
book-canvas in hand, silently coparticipating in the making of a com-
munity of artistic selves. A wheat field display became shaped over
time by a group of young collaborators, lost in the momentum of work
but also periodically made self-conscious.

Although the display looked mostly brown from a distance, up
close multicolors and strokes were being produced by the stu-
dents. For those who were painting the wheat, various colors
such as red and yellow were added to the brown. Frank's farm-
house stood out. It was painted mostly red. The teacher continu-
ally encouraged Frank to work with larger, less precise strokes.
The farmhouse stood out from the rest of the landscape as he
was painting it so perfectly as though it were the object of a
coloring book. Another student commented that she had Van
Gogh in mind (as she worked) and the teacher said, yes, that she
wanted them to think of the impressionistic painters—the paint-
ing would only make sense at a distance. Up close, the multicolors
and strokes would be available in a different way to the viewer.
(Carol's transcription data, 1991)

When I reflect on the IICO sequence (shared earlier in this chapter), I think about how I have dwelt intuitively on the fringes of the worlds of art and education. While working, I focus on my hands as they shape the texts that release my artist self. I write stories of location by deliberately "dislocating" myself in alternative settings, primarily prison sites. I exist on the edges of educational research and straddle familiar and unfamiliar worlds. My activism is growing along with my imagination. I encounter social groups on the margins in prisons and schools (Feuerverger & Mullen, 1995; Mullen, 1997b, in press) and universities (Mullen, 1997a) that contribute "bottom-up," enriching perspectives on multicultural development, mentoring structures, and arts-based programming. I feel compelled to awaken the "shadowed zones" (Paley, 1995) of ourselves that are influenced by the ways we, as teacher-researchers, are socialized (or "trained") to adopt a problematic set of beliefs and behaviors (Mullen & Dalton, 1996). Without the freedom that artistic impulses bring to me, I could be pressed into passivity and left the "prisoner" of undisclosed, structural systems. I would then have no choice but to stare into the eyes of the "gatekeeper," mirroring that closed, heavily guarded, world. But I choose instead to stare into my own eyes and those of others through my own. However, even my own constructs can operate as vigilant controls.

The restrictions on personal writing/artistry in prison remind me of the academy, with its seeming suspicion of some creative and intimate forms of knowledge. Barred in, I paradoxically reach out, playing with prison and movement as primary metaphors in my writing. Figure 21 is a large media drawing of a cave-like image with a person's body intermingled with the bars of her self-imposed prison. As a former graduate student–researcher, my encounters with authority intensified in these ways: I was initially advised to control my creative impulses and to rethink my "social work" direction; my participants (inmates) experienced criticism and censorship of their stories that were prepared for our creative writing newsletter, and my poetry was banned from it too; and my research proposal was initially rejected as "too personal" by a supervisor in corrections. The carousel ride continues. In 1997 my ethnographic and pedagogic fieldnotes, based on an arts program in a woman's prison, were targeted as "too personal" because of their attention not only to workshop activities but also to struggles (at administrative, curricular, interracial, and interpersonal levels) and interferences (from prison authorities with respect to artistic freedom and expression).

Imagination keeps my vision of well-being (reform?) alive within both correctional and educational environments. The teacher-researcher who learns to see "art," even in that which oppresses its expression and

Figure 21 *Intermingling Bars with Person* (K. Mantas, 1995–1996)

form, is able to build into her artistic practice, conflict, tension, and struggle. Just as I write and perform with inmates and teacher-researchers to break free as "frozen pon[ies] on a carousel halted in mid-gallop" (Mullen, 1997b), I seek to better understand constraints at all levels. Metaphorically, I have reimagined corrections and higher education as a merry-go-round, locked in repetitive cycles and patterns at organizational and interpersonal levels. (See chapter 10 for my graphic representation and further explanation.) This carousel image is like the Möbius strip image of Figure 20 that also circles endlessly. However, although discord can be an integral part of collaboration and cycles of creativity, the carousel is, in my mythological sense, unabashedly dark and mysterious (Hinds, 1990), riddled with conflict, power, and authority. Artistic expression can seek to capture aspects of the "darker music" of institutional life and traditional research. The hand that shapes art works must search for underlying chords that are typically removed from externally constructed forms.

My collaboration with Patrick, Mary, and William allows me to hear the musical chords more deeply and expansively. Like the conductor who shapes the overall movement of a performance, the process of experiencing others allows me to watch many hands at work.

Arts-Based Activities

1. Find a story from Bulfinch's mythology, or another mythological source, that features "the hand." Tell a story about the importance of the hand in terms of your own creative process. What collaborative ventures have you had a hand in?

2. Recall your earliest experience of an arts-based activity. What was the activity? Where did it take place? Were you alone or with others? What impression did this experience of art-making "imprint" on you. How may it have influenced your current relationship to art, place, and community?

3. Develop your own image of circularity. Examples in this chapter include the Möbius strip and carousel. Chapter 10 also contains the image of a winding staircase. Consider the motion of rotation and repetition. Where do you experience this in your daily work or creative life? List the thoughts and feelings associated with such a motion for you. Find examples of your selected image from various places (e.g., photographic travel) or sources (e.g., magazines and newspapers). Develop your image into an artwork, such as a collage or photomontage (collage with photos). Build into your artwork key words or phrases from your list of associations. A story line involving your own personal arts-based image may begin to "show itself."

Patrick Diamond's Eye: No Longer Private

> I saw the Aleph . . . the place where, without any possible confusion, all the places in the world are found, seen from every angle. . . . I saw the earth in the Aleph. (Borges, 1967, pp. 147, 151)

The large number of everyday expressions referring to the eye (for example, an eye-opener, to have eyes for, to keep an eye on, to keep one's eyes peeled, under the eye of, with eyes open) remind me that people have always approached the eye and light almost in a spirit of awe. Vision provides the closest link with reality. In collaboration with others, my eyes can function as compound eyes. Each of us can contribute a small patch of light (or shade) to make up a larger, mosaic image, as in this instance of collaborative, arts-based inquiry. One of us may provide detailed partial vision, while another affords a wide-angled if broad-stroke view. No longer private eyes, together we provide a bank of television cameras. Our joint eyes form color pictures that are transmitted for our composite appreciation. But unlike passive optical recorders, our acts of interpretation radiate out of our eyes, much like the penetrating X-ray vision of comic-strip superhero/ines (see Klee below).

Working with teacher-colleagues and collaborators, I have invited their reinvention of inquiry and aspects of their teacher-researcher selves. I had been drawn toward but resisted my need also to become a self-researcher, telling my stories as a teacher researcher-artist. But, with support from Carol and others, I began to use the arts-based writing and visualization tools that I had been exploring. Self-narrative has allowed me to confront the formal, taken-for-granted constructions through which I had originally learned to view research as an educational psychologist. I am reconstructing my self as an Aleph or process of inquiry that is enlarged through intertextual writing and collaboration. I am still learning that I can trust my previously neglected resources of personal intuition and imagination. I am recalling childhood dreams and fears.

I have reviewed the relation of my self to my knowing in terms of images of journeying and map-making. Although neither image is uniquely personal, each has proved useful to me. Leaving the highway for less traveled pathways, I am journeying as a "mental traveler" (Blake, 1805/1971) and as a writer of stories and poems. "The stranger the country we are entering the more threatening the prospect becomes; the more we realize that some degree of self-change may be involved, the more we must rely upon our understanding of our own character and potential" (Bannister in Fontana, 1981, p. 261)—and the support of others.

My improvising, artistic self is central to the accounts, helping me to probe deeper levels of my experience, reorchestrating my understandings. I can now make more of the range of my experienced meanings, including those that were previously unarticulated or hidden in unconsciousness. Like playing jazz, imagining possibilities "releases facts [or notes], long taken as self-evident, from their rigid conceptual [or melodic] moorings. Once so freed, they may be seen [or heard] in new aspects hitherto unsuspected" (Kelly, 1955, p. 1033). Carol, Mary, William, and I are seeking to free ourselves from only taking forced marches along rigidly predetermined routes over the existing terrain. Multimedia sidetracks offer the unexpected and the unplanned.

Through metaphor making, I am linking previously disparate ideas. Such word and image play yields unusual connections. By becoming more open and spontaneous, I am able to use old terms in new ways without being overconcerned about apparent contradictions. I have used the visual images of mirroring, self-reflection, doubling, the butterfly hunt, and letting go of balloons (Diamond, 1995a) to represent my arts-based inquiry into transformation of perspective. Reading a wider range of authors (in translation) and writing arts-based self-narratives has provoked a growing sense of my writer-researcher self. Once I write what I imagine, I can see what I mean, even if I am not quite ready for it. Even as knowledge provides a constructed form of experience, writing provides a method of inquiry into it. The narrative of self uses the techniques of art to express and share experience. Writing also shapes the self as an art form and out of its experiences another life is fashioned.

My current eye-based metaphor for the joint exploration of arts-based research is that of a Möbius strip. The spiral is formed by taking a short strip of paper and twisting it 180 degrees before taping its ends together. You can begin anywhere on the surface, drawing a continuous line along it. The first return is always on the other side of the paper. Only on the second turn round is the beginning of the line rejoined. Bateson (1994) describes the journey along the other side of the strip as not only a return over the same ground but also as the next level of a spiral. This is like my work with Carol, Mary, and William. When a draft section of a text can be traversed without a break, it may seem one-sided. However, with collaborators there are always two linked sides and the whole consists of a three-dimensional spiral.

Much of our writing and researching as educational researchers consists of taking ideas that are webbed around others, circling endlessly. Transformation requires that we return from the end to the beginning, revisiting the past from the present (previously its future). Working together by producing and performing a quartet or four-part text allowed us to reencounter our individual understandings through

those of the others. This is like "returning on a second circuit of a Möbius strip and coming to the experience from the opposite side" (Bateson, 1994, p. 31). When seen from the other authors' contrasting points of view, our familiar patterns become accessible for revisioning. With yet another return, what seemed so different is shown to be a shared perspective.

The epic search for causal explanations in my inquiry and development is giving way to multiple representations of our inquiries. Although I can never fully interpret my practice or texts, I can explore why and how I produced them. Through responding to them, I can learn to accept their ambiguities: "Art does not reproduce the visible, rather it makes visible" (Paul Klee in Augarde, 1992, p. 176)—but sight is only partial. The universality of explanations in modernism can be replaced by postmodernism's authenticity of details, by the concrete recorded and reconsidered practice, and by the evocation of alternatives. The persuasiveness of accounts implies the capacity for promoting critical reflection, which prompts the reconstruction of our understandings. Once our empathetic imagination is engaged we can be enticed into reframing our meanings through further rounds of sharing our arts-based inquiry.

Self-conscious, experimental postmodernism often takes the form of allegorical, allusive, and complex word games. Nabokov described art as being characterized by "the irrational and the illogical, by that spirit of free will that snaps its rainbow fingers in the face of smug causality" (in Dipple, 1988, p. 67). In art, as in a butterfly hunt, we soar when we alight on the chance beauty of unexpected correspondences. In contrast to the flatness of mere accuracy, we then resonate with curiosity and tenderness. These are the secret nerves of the work of arts-based inquiry and teacher development.

In journeying along the teacher education strip, we are always back at the beginning. We cannot reduce our labyrinth of development to any simple line. Our aesthetic response to seeing the unfolding stories of our practice is as inexhaustible as their plot is unresolvable. There are no secret "I's" to be grasped with final certainty. There are only acts, expressions, and contexts to be endlessly reinterpreted. What does develop through our inquiries is an ever-more sensitive experience-seeking capacity. But each vision is limited and can never contain the universe. Even Borges' Aleph and mirrors are "mere instruments of optics":

> The Faithful who attend the Mosque of Amr, in Cairo, know very well that the universe is in the interior of one of the stone columns surrounding the central courtyard. No one, of course, can see it, but those who put their ears to the surface claim to hear,

within a short time, its workaday rumor. Does the Aleph exist in the innermost recess of a stone? Did I see it when I saw all things, and have I forgotten it? Our minds are porous with forgetfulness. (Borges, 1967, pp. 153–154)

We see but do not see.

Arts-Based Activities

1. Barth (1968) wrote the line, "Once upon a time there," on one side of his strip and "was a story that began" on the other. When assembled, his strip became a circular story that has no beginning and no end. What will you write on the sides of your strip?

2. Claudine VanEvery-Albert is an experienced Mohawk teacher educator who works with beginning First Nation teachers. She was introduced to the Möbius strip as a child by her grandfather. She met it again in a class she took with Patrick in 1998. Claudine dreamed the following procedure that she demonstrated in class even as she gave the instructions.

 "Cut out small, different-colored, paper doll figures to represent different aspects of your teacher self. Paste them onto both sides of your strip of paper. Now take one end, turn it once, and attach it to the other end. If you cut the strip in half along its middle line, you will find that you have made a second strip that is twice as long as the original. This may represent your unfolding career as a teacher. If you cut this second strip again in half, you will find that you have created two intertwined strips. One is large and the other is small. How could you name these third and fourth strips? Which is self and which is teacher? The pieces of doll that fell away as you cut may represent pieces of self that are shed as you develop as an arts-based teacher researcher. The remaining pieces are realigned in sometimes surprising combinations. What was waiting to be revealed as you assembled your linked circles?"

Mary Beattie's Ear: Playing the Violin

The School Orchestra by Mary Beattie

I remember the sound of massed strings in the early morning.
The flashes of the red-brown wood of the instruments
And drawing my chair in close, to restore the ear's primeval power.

I remember the controlled movements of hands and eyes.
The bows going and the comingled sounds
The feeling of being wrapped in a timeless sound-space,
before the ticking of work-time.
The joyous cocreated sound going up like a mass concelebrated.

Then that time when the music faltered and my own solitary vio-
 lin held on
Until the sound grew strong and we raised the roof with our
 ending.
"You are like the Rock of Gibraltar," smiled the young nun, shak-
 ing her head.
"Solid as a rock."

Nearly three decades later, I now know that rocks hold onto sound.
Mass-rocks seeped with whispered prayers,
Silent and secretive stone-walls,
Mountains whose power is in the stories folded into the seams.
And me still listening beyond the silence.
Strings vibrating to stray wisps of song.

I wrote "The School Orchestra" in 1994 to try to express what I
know about shared creative activity, and to try to make sense of this
need in my life. It served as my Aleph. I am conscious of the distinction
I make between solitary as opposed to shared creative work. I believe
that my life is enriched by both and that something is missing when I
am engaged in only one of them. My participation in artistic activity
takes place mainly through words. Words and music share many of the
same qualities for me, but I have a greater facility for arts-based shap-
ing with the language of words than with the notes of music.

In trying to locate the origins and impetus for my need to engage in
collaborative artistic ventures, I revisited my writing of "The School
Orchestra." Through composing this poem, I am realizing the similari-
ties involved in engaging in an arts-based approach to teaching, col-
laborative artistic research, and playing the violin. All three approaches
are about creating spaces, setting up a rhythm, and making music. In
playing the violin, the left hand creates the spaces: the fingers move
along the strings, changing their length, making choices between the
production of low, mellow notes and high, piercing ones. The fingers
make continual choices regarding the level and quality of touch and
pressure. The way the fingers are applied to the strings affects the
tone, color, intensity, and emotional character of the sound. The right
hand, with its extension, the bow, creates the rhythms. The bow shapes
and structures the forms that the sound will take. It makes choices

regarding the timing, the tone, the balance, and the strength of the sound. Then, when the right and the left hand of the violinist work well together, they make music. I have selected the violin, and my hearing and playing of it, as my own "selection of a form through which the world is to be represented" (Eisner, 1991, p. 8).

The major principles of arts-based teaching and collaborative inquiry mirror those of violin playing. Here too the creation of spaces, of rhythms and forms, and of making music together, are possible. In both teaching and research, the spaces created allow voices to resonate, narratives to interact, and approaches to vary. There is no standardized B or C—each is played differently. Like the space created on a violin, the teaching and the research spaces are settings for meaning to be made and they coexist at any one time. In music, the middle levels of vibration are heard as tones with discernible pitch. Modifying and changing the rhythm and quality of these tones are waves of vibration underneath which comprise subtle surgings, vibratos, and ornamentations, all of which make up the style and expressiveness of an individual player. The listener then has his or her own way of hearing and feeling the music.

The metaphor of how the right hand of the violinist expresses itself also applies to teaching and research. The qualities of attentiveness to rhythms and timing, of sophisticated listening and empathetic understanding of the other, of "reaching out and holding back in relationship" (Beattie, 1995a), and of shaping and giving form to what is being made, are essential in teaching and research. When things do not go well, there is discord. When they do, there is music. In violin playing, as in teaching and in collaborative artistic research, successful "music-making" has to do with being connected to one's own, and to others' intuition and imagination, with finding forms and structures to express ideas and emotions. I find myself constantly making choices and decisions, as well as adapting, modifying, and expanding on them. I imagine new variations while shaping the elements into a coherent and aesthetic whole—but only for that performance.

In collaborative "music making experiences," I have participated in the rewards of joined inquiry. I am able to enter into the other's reality and am inspired and transformed through the process. I bring a sense of optimism and a longing for authentic collaboration. I listen for resonances that "strike a chord" in me. I search for the wholeness, the coherence, and the unity of what can be created together.

William Kealy's Brain: A Two-Part Harmony

When I was in high school, calling a classmate "the brain" was not necessarily the way to pay a compliment. Even in schools of today such

a term conjures up images of a socially awkward, often spectacled, adolescent. Typically, this person also excels in math or science. But with the computer revolution, "the brain" has become "the nerd," earning a six-figure income before reaching the age of 30.

I did not have the nickname "the brain" in high school or, for that matter, any distinctive moniker. However I was known as the class artist: I did well in advanced art classes, served as art editor of the school newspaper and yearbook, won a few art awards, and so forth. Hence, readers may find it odd that I have chosen "the brain" as an anatomical metaphor for my life. Why not the eye or hand? Besides having already been appropriated by my coauthors, these two body parts represent all-too-obvious symbols of the artist that border on being clichés (and we all know how artists dread that). For the sake of my personification, I have selected "the brain," not for its value as a symbolic representation of intelligence and neurological capacity, but as a metaphor that expresses the perceived duality of art and science.

The human brain roughly consists of two halves, the left and right hemispheres, responsible for different cognitive functions. Based on the "split-brain" research three decades ago of Sperry, Levy, and others (cited in Edwards, 1989), it is now widely accepted that the left side of the brain controls language skills and analytic reasoning while the right side is responsible for performing spatial tasks and intuitive thought processes. (Edwards, 1989, gives a comprehensive yet accessible account of left-right hemispherical differences.)

Further extending this functional distinction between the left and right sides of the brain, one might say that the former is the mathematician-scientist while the latter is the artist. That is not to say that scientists are solely left-brained or that artists use just the right hemisphere— otherwise, physicists would never have "hunches" and painters would be unable to plan an exhibit. Moreover, both halves of the brain are connected by the *corpus callosum*, a thick nerve cable that exchanges information between the hemispheres. It is this part, the *corpus callosum*, that seems to have caused me so much confusion in my life, which I am only now, a half-century old, beginning to resolve.

Like many teenagers and young adults, I was periodically absorbed with answering the question, "What will I do when I grow up?" But having been blessed with abilities and interests in both art and science, I was nagged by the deeper question of "Who am I—artist or analyst?" It was not that I was truly gifted in math and science but rather that I possessed enough skill for my parents and others to recognize I had a "knack" for these subjects. Add to this the growing recognition by family and friends of my artistic talent and I soon found myself in the midst of a *corpus callosum* dilemma: I was to now expe-

rience my life as a tug-of-war between the analytical and intuitive parts of my brain. This manifested itself in an academic performance that seesawed between classes emphasizing spatial skills (e.g., art, woodshop, drafting) and ones requiring reasoning (e.g., algebra, chemistry, trigonometry).

Waves of competing abilities rocked my personal interests too, and I shifted from one hobby to another on a weekly basis. Like a rolling ship in a storm, I had no direction, my pastimes instead taking whatever impulsive course I was on for the moment. Consequently, by my teen years, the basement was littered with the wrecks of a dozen or more projects half-completed, then abandoned for some new interest: the microscope, the puppet, the chemistry set, the model airplane, the telescope, and so on.

My senior year of high school brought new concerns of where I would go to college and, more important, what I would study. My parents offered an idea that seemed to be a clever and reasonable resolution for my two-brained ways: the study of architecture, a discipline that would concurrently draw on my aesthetic and analytical talents. But while the logic of their proposal was compelling, the plan was flawed by a failure to recognize that one should not enter such a demanding profession on the basis of sound argument alone.

I never developed the love for architecture that its practice demands although I was intrigued by the *process* of architectural design. And so I was dismissed from the school of architecture, readmitted after a one-year hiatus, and dismissed (for a second time) three years later. However, the dean noted my good performance in the painting, drawing, and sculpture classes I had been taking as electives, and he arranged for my transfer to the school of art.

In the school of art, classmates often drew attention to the influence of my architectural training that was evident in my painting. Whether I was being teased or tested I cannot say. My canvases neither depicted cityscapes nor were executed with a straight edge. Undeniably, there was an underlying analytical feel to my paintings and I was greatly influenced by the Neo-Impressionists who, like Georges Seurat, tried to apply the ideas of contemporary scientists on color to their art.

Figure 22 is a color study (reproduced here in grayscale) from my sketchbook that reflects my pondering at the time about ambiguous figure-ground relationships. In the original sketch, the dark-gray area with the diagonal lines is a deep, glowing red that seems to recede several feet from the lemon-yellow strip along the bottom of the rectangle. Although I have looked through this sketchbook many times before, it feels strange as I do so now—perhaps my present mindfulness is putting me in touch with a self I have since forgotten.

Figure 22 *Window on a Red Room* (W. A. Kealy, 1971)

I do remember the gravity with which I approached painting and the intensity of my analysis, as if the blank canvas contained a hidden equation I needed to unravel. My painting sessions were marked by an inner turmoil that emerged as a furrowed brow and a fusillade of brushstrokes as I darted toward and away from the easel. One afternoon over coffee, I explained to my instructor, Jack Stewart, the difficulties I was having in trying to paint while bringing forth all the concepts I had been formulating. It was as if my ideas were colors of paint and what I needed was an imaginary palette held in a third hand while my left hand held the real palette, and my right hand the brush. Jack mercifully relieved me of my burden by saying, "Do all the thinking you want to do before you paint; there's nothing wrong with that. But when you paint let go of your concepts, trusting that you will express them in your work." It was good advice and I have been a more content artist ever since.

My graduation from college inaugurated a series of occupations that alternated in their demand on either my analytical or artistic abilities. From art school I entered the U.S. Navy, where I spent most of my time as an intelligence officer and a Soviet submarine analyst. I was highly successful in this new line of work despite the fact that, unlike some of the other analysts, I did not use heuristics, Boolean logic, or advanced

statistical techniques to arrive at my intelligence estimates. Instead, I graphically displayed the various types of information available (e.g., communications, sonar, radar, sightings), typically devising elaborate color-coding schemes for the data, and then making observations based on the emerging forms and patterns. I was pleased to discover that the navy tolerated, even encouraged, my creative, off-beat methods. Most important, the experience taught me to trust my creative (right) side in an environment that, by all outward appearances, was a haven for left-brained analysis and logic.

Discharged from active duty naval service, I remained in Honolulu, calling it home for the next nine years. I had decided to give my right hemisphere full reign and try my luck as a freelance graphic designer. This was an idyllic but financially difficult period. I survived only by working an occasional week or so as a Naval Reservist doing my old intelligence job. My self-employment struggles began to bear fruit when I completed an extensive course for new entrepreneurs on how to start and manage your own business. While at first I resisted the course assignment of analyzing one's market, the competition, and all the components that go into a business plan, I gradually became absorbed in the process once my dormant right brain kicked into gear. If there was a "meta" lesson that I learned from this episode it was that artistic talent is not enough: one's creative resources need to be strategically directed through planning to prevent them from being spent ineffectively.

Quite by accident I discovered a graduate program at the University of Hawaii where I could learn video production. The department, headed by an affable Czechoslovakian named Geoff Kuçera, introduced me to the field of educational technology. This discipline involved both media development and instructional design, the latter rooted in systems analysis and educational psychology. Like architecture, the calling of educational technology represented an integration of art and science, but with a difference—here was a life's work that I could love! As my two brains settled into a state of cozy equilibrium, my school performance soared, and I graduated with a 3.9 average that stood in sharp contrast to the 1.9 of my undergraduate days.

Encouraged by my academic success and my friend, Professor Curtis Ho, I applied and was admitted to the doctoral program at Arizona State University. On the one hand, I had little or no money to relocate to Arizona, but on the other, I was thoroughly committed to my plan. Further, I trusted the words of W. N. Murray, leader of the 1951 Scottish Himalayan Expedition, that I had posted on my bedroom wall:

Concerning all acts of initiative
there is one elementary truth,

the ignorance of which kills
countless ideas and splendid plans:
that the moment one definitely commits oneself,
then Providence moves too.
All sorts of things occur to help one
that would have otherwise never have occurred.
A whole stream of events issues from the decision,
raising in one's favor all manner
of unforeseen incidents and meetings
and material assistance,
which no one could have dreamt
would have come their way.

A series of unexpected "miracles" suddenly fell my way. A person at the campus Veterans Affairs office, for instance, offered to take care of my school registration and arrange postponement of my tuition payment after discovering, during a long-distance phone call, that we had attended the same high school. My flight from Hawaii to the mainland was at no charge, thanks to a last-minute opportunity to ride free aboard a Navy P-3 aircraft. Even my lucky acquisition of an apartment a few blocks from campus was due to the "winds of chance" blowing in my favor: my application was the only one out of a dozen competitors that landed face up when (I discovered later) cards were literally tossed in the air to determine who the new tenant would be. Some favorable outcomes, I learned, are not the result of either painstakingly thorough planning or the impulsive action that stems from "gut" intuition. In hindsight, it seems as if I was operating in a state of suspension between my analytical and intuitive selves, similar to what Casteneda's mentor Juan Matus called the "controlled abandonment" of the warrior.

Shortly after the first year of my doctoral studies I realized that I was in the wrong place: the Ph.D. was essentially a research degree that would not significantly enhance my career as a designer of instructional media. I was, in effect, "hoisted by my own petard" by a plan that inadvertently carried me to an analytical world consisting of research methodology, experimental design, and inferential statistics. It seemed that there would be no room in this scenario for my artist side to express itself—or was there?

One day I was walking down a school corridor when I was met by the professor with whom I had studied "Theoretical Views of Learning" a year earlier. He asked if it was true that I used to be a cartographer as he had heard. "Yes," I replied, whereupon he put his hand on my shoulder and, while strolling down the hall in a way that is reminiscent of Bogart's walk with Claude Rains at the end of *Casablanca*, said we had "great plans together." The professor in this scenario, Raymond

W. Kulhavy, eventually became my dissertation chair and mentor (Kealy, 1997), starting me on a line of research dealing with learning from maps and diagrams (Kealy & Webb, 1995) that I have since pursued for over a decade.

It is literally a mixed blessing that my current profession gives me the opportunity to "work from both sides of the brain," designing and creating graphics that I then analyze for their impact on learning. Ironically, the theoretical premise of my research is the Dual Coding Theory (DCT) of Alan Paivio (1986). Basically, DCT contends that linguistic and spatial information are mentally processed as separate codes and stored in different locations of the brain. Further, information at both locations is mutually accessible, that is, a picture stored in memory can cue the recall of a related word and vice versa. This model of information processing offered by DCT is remarkably compatible with the findings of split-brain research mentioned earlier.

At the beginning of this narrative, I presented some evidence that our brains are really two brains, one specializing in language and logic, and the other in images and intuition. For the sake of discussion, I have written about *my* brain; your brain would be just as suitable except I do not know your story. The point is, my tale of sensing the need to resolve my analytical and intuitive selves is probably a perspective shared by a large percentage of the population. The notion that scientific thinking and artistic feeling represent polar opposites is commonplace and, as a matter of practice, I believe most people try to strike a balance between cautious deliberation and impetuous action in their lives.

A second point is that the perceived dichotomy between analysis and intuition may be an illusion or, at least, under limited control in our everyday experience. First, my experiences in a variety of occupational settings have shown me there are both linguistic-analytical and spatial-intuitive dimensions to virtually every endeavor. Second, the perception that something is, say, analytical, may only be meaningful in a given context and setting. Those who teach statistics might think the use of survey instruments exemplifies qualitative research while those who see themselves primarily as qualitative researchers may regard the same work as "number crunching." Third, our very experiences of language, sensing, and thinking are mediated to such a large degree by our environment that it is difficult to tell whether we consciously apply, say, analysis to a given situation or if, as Watts (1971) has suggested, the environment itself calls forth certain capabilities of our brain.

Which came the first, fruit or tree? Imagine the two processes as happening simultaneously—the tree growing the fruit, and the fruit growing the tree—and you will see, by analogy, the brain

shaping the environment, and the environment shaping the brain. That is a clumsy way of saying that you are seeing a *single* process. (The organism differs from the environment as one side of a Moebius Strip "differs" from the other. Because of a twist or flip in the strip, you can grasp one and the same side between two different fingers.)

Like the image of the Möbius strip that I have created for the cover of this book, our ordinary experience of being is that we are a whole entity, not two distinct selves as one might erroneously infer from the findings of split-brain research. Rather, our right-brained and left-brained "selves" (depicted by the artwork's piano and computer keyboards, respectively) can be thought of as polar opposites that, nevertheless, lie on the same face of the Möbius strip. Like two (or four) voices of the Self in harmony, our ability to reason and intuit complete the circle of being, thereby creating an aperture through which we can experience the universe.

Summary Comments: Returning to Ourselves

In this chapter, we have used music as a significant form: "A symbol . . . which by virtue of its dynamic structure can express the forms of vital experience which language is particularly unfit to convey" (Langer, 1987, p. 229). In our artistic inquiry, we have turned back upon ourselves, tracing the course of our insights and limitations. Through improvising with language and other arts-based forms, we can go in search of our own images and visions. Using "choric chant" (Langer, 1987), we are freed to become more present to experience and ourselves. In this participatory, relational way of knowing we are no longer constrained by convention. We agree with Barone (1992) that educational inquirers who make sense of experience in alternative, narrative forms *are* artists. The aesthetic belongs to anyone who participates in creating form, whether as theoretical framework, taxonomy, novel (Eisner, 1991), visual, arts-based narrative, metaphor, or performance. While artistic groups have become more visible within arts communities and in exhibitions in recent years (Archer, 1994; Dunn & Leeson, 1997; Zorpette, 1994), they are only beginning to flourish within the academy.

We four define ourselves as teacher researcher–artist inquirers. We ask, "Who are the teacher-researchers doing artistic work?" and "What artistic processes and chords underlie such work?" We have found

that the arts can more fully infuse narrative and educational inquiry through the introduction of self-reflective, shared storying and collaboration. Just as Greene (1995) and Jackson (1992) described a new way of helping teachers to develop, we are exploring art as an alternative way of doing research. Even as there is no clear and unequivocal language for describing the process of what happens when a person confronts or creates a work of art, we are experimenting with language and form and the creation of context-rich graphic displays. We study our individual and shared understandings of experience and interpretation in an effort to reconstrue and promote new kinds of development and educational research.

We have offered IICO (Intuition, Imagination, Collaboration, and Orchestration) as a form of artistic inquiry. We enacted this form as a quartet or four-part text consisting of both a combined and a separate set of inquiries. In a responsive set of exchanges with each other, meaning was further developed. We entertained and performed alternative versions of the same sequence, that is, of theories and practices in arts-based inquiry and teacher development using arts-based approaches. Like experience spiraling through all our life, we presented similar insights felt, viewed, and heard from different angles. Development involves making meaning with those who share at least partly overlapping understandings. To escape the imprisoning framework of assumptions learned within a single paradigm, our habits of attention and interpretation need to be stretched and circled back upon themselves. Such experiences are too complex for any single encounter. They require the garnering of doubling, tripling, and even contrary visions. Through our musical structure, we build a "double helix of [shared] and personal growth" (Bateson, 1994, p. 44), but strung as a two- or three-dimensional visual and as a performed quartet.

As collaborating researcher-artists at the computer keyboard, whether writing together or emailing each other about the process, we are committed to learning the music of collaborative inquiry. Even the first fingerings load each note with the double meaning of text and performance. However, as for a beginning pianist also at the keyboard (see the dual keyboard image embedded in Figure 20), such expressive attempts are

> difficult and complex. . . . How great looms the gap between the first gropings of vision and the first stammerings of percussion! Vision timidly becomes percussion, percussion becomes music, music becomes emotion, emotion becomes vision. (Updike, 1966, p. 186)

We are slowly learning to sustain our imaginative inquiries, laying other melodies over the underlying chords and playing on the changes. In arts-based inquiry, we choose those forms with which, and those collaborators with whom, to improvise, and in the process begin to rescript our selves. We have used arts-based approaches in many contexts, including university-level faculty and graduate student development (e.g., Diamond & Mullen, 1997; Kealy, 1997; Mullen, Cox, Boettcher, & Adoue, 1997); preservice and inservice teacher education (e.g., Beattie, 1995a, 1995b, 1995c; Diamond, 1993a; Mullen, 1997a); and other, less conventional, schooling contexts involving immigrants, refugees, and prisoners (Feuerverger & Mullen, 1995; Mullen, 1997b).

Our text- and performance-based quartet provided us with a form for shaping, designing, and releasing the energy and play of arts-based inquiry and teacher development. Such work provides a joint setting within which we can each learn to stage our transformations for our own benefit and that of others. For us, "it was so exciting—the apparent escape from [the conventional] like going off a diving board, the fresh and unexpected colors from the new scales, the return to the original [theme] like the fit of a key into a lock" (Conroy, 1994, p. 486).

References

Adams, N. (1996). *Piano lessons: Music, love & true adventure.* New York: Dell.

Augarde, T. (Ed.). (1992). *The Oxford dictionary of modern quotations.* Oxford: Oxford University Press.

Archer, M. (1994). Collaborators. *Art Monthly, 178,* 3–5.

Barone, T. E. (1992). On the demise of subjectivity in educational inquiry. *Curriculum Inquiry, 22*(1), 25-38.

———. (1994). On Kozol and Sartre and educational research associally committed literature. *The Review of Education/Pedagogy/Cultural Studies, 16*(1), 93–102.

———. (1995). The purposes of arts-based educational research. *International Journal of Educational Research, 23*(2), 169–179.

Barone, T. E., & Eisner, E. (1997). Arts-based educational research. In R. M. Jaeger (Ed.), *Complementary methods for research in education* (pp. 73–103). Washington, DC: American Educational Research Association.

Bateson, M. C. (1990). *Composing a life.* New York: Penguin Books.

———. (1994). *Peripheral visions: Learning along the way.* New York: Harper Collins.

Beattie, M. (1995a). *Developing professional knowledge in teaching: A narrative of change and learning.* New York: Teachers College Press.

———. (1995b). New prospects for teacher education: Narrative ways of knowing teaching and teacher education. *Educational Research, 37*(1), 53–69.

———. (1995c). The making of a music: The construction and reconstruction of a teacher's personal practical knowledge through inquiry. *Curriculum Inquiry, 25*(2), 133–150.

Blake, W. (1805/1971). *The poems of William Blake.* (W. H. Stevenson, Ed.). London: Longman.

Blumenfeld-Jones, D. S., & Barone, T. E. (1997). Interrupting the sign: The aesthetics of research texts. In J. Jipson & N. Paley (Eds.). (1997). *Daredevil Research: Re-creating analytic practice* (pp. 83–107). New York: Peter Lang. (Counterpoints Series)

Borges, J. L. (1967). *A personal anthology.* New York: Grove Press.

Bulfinch, T. (n.d.). *Bulfinch's mythology: The age of fable—the age of chivalry—legends of Charlemagne*. New York: Random House.

Caron, R. (1978). *Go-Boy!* Toronto: McGraw-Hill Ryerson.

Connelly, F. M., & Clandinin, D. J. (1995). Narrative and education. *Teachers and Teaching: Theory and Practice, 1*(1), 73–85.

Conroy, F. (1994). *Body and soul*. Toronto: Penguin.

Courage, R. (1996). Dangerous narratives. [Review of the book *Live from death row*]. *CCC: The Journal of Teaching Writing, 47*(1), 124–130.

Davies, I. (1990). *Writers in prison*. Toronto: Between The Lines.

Diamond, C. T. P. (1991). *Teacher education as transformation: A psychological perspective*. Milton Keynes, UK: Open University Press.

————. (1993a). Inservice education as something more: A personal construct approach. In P. Kahaney, J. Janangelo, & L. A. M. Perry (Eds.), *Teachers and Change: Theoretical and Practical Perspectives* (pp. 45–69). New Jersey: Ablex Press.

————. (1993b). Writing to reclaim self: The use of narrative in teacher education. *Teaching and Teaching Education, 9*(5/6), 511–517.

————. (1995a). Making butterfly art (MBA). *Orbit, 25*(4), 37–40.

————. (1995b). Education and the narrative of self: Of maps and stories. In G. J. Neimeyer & R. A. Neimeyer (Eds.), *Advances in personal construct psychology III* (pp. 79–100). Greenwich, CT: JAI Press.

Diamond, C. T. P., & Mullen, C. A. (1996). *Beyond the mentor-mentee arrangement: Co-authoring forms of post-mentorship* (Microfiche No. ED 394417). Presentation at the annual meeting of the American Educational Research Association, New York, NY. (ERIC Clearinghouse on Higher Education)

Diamond, C. T. P., Mullen, C. A., & Beattie, M. (1996). Arts-based educational research: Making music. In M. Kompf, W. R. Bond, D. Dworet, & R. T. Boak (Eds.), *Changing research and practice: Teachers' professionalism, identities, and knowledge* (pp. 175–185). London: Falmer Press.

Diamond, C. T. P., & Mullen, C. A. (1997). Alternative perspectives on mentoring in higher education: Duography as collaborative relationship and inquiry. *Journal of Applied Social Behaviour, 3*(2): 49–64.

Dipple, E. (1988). *The unresolvable plot: Reading contemporary fiction.* New York: Routledge.

Dunn, P., & Leeson, L. (1997). The aesthetics of collaboration. *Art Journal, 56*(1), 26–37.

Edwards, B. (1989). *Drawing on the right side of the brain.* New York: Putnam.

Eisner, E. W. (1991). *The enlightened eye: Qualitative inquiry and the enhancement of educational practice.* New York: Macmillan.

Feuerverger, G., & Mullen, C. A. (1995). Portraits of marginalized lives: Stories of literacy and collaboration in school and prison. *Interchange, 26*(3), 221–240.

Fontana, D. (1981). *Psychology for teachers.* London: British Psychological Society.

Greene, M. (1995). *Releasing the imagination: Essays on education, the arts, and social change.* San Francisco, CA: Jossey-Bass.

Harlow, B. (1987). *Resistance literature.* New York: Methuen.

Harris, J. (1986). *Stranger in two worlds.* New York: Kensington.

Hesse, H. (1990). *The glass bead game.* New York: Holt.

Hinds, A. D. (1990). *Grab the brass ring: The American carousel.* New York: Crown Publishers.

Jackson, P. W. (1992). Helping teachers develop. In A. Hargreaves & M. G. Fullan (Eds.), *Understanding teacher development* (pp. 62–74). New York: Teachers College Press.

Kealy, W. A, & Webb, J. M. (1995). Contextual influences of maps and diagrams on learning. *Contemporary Educational Psychology, 20*, 340–358.

Kealy, W. A. (1997). Full circle: Insights on mentoring from my mentor's heroes. In C. A. Mullen, M. D. Cox, C. K. Boettcher, & D. S. Adoue (Eds.). (1997). *Breaking the circle of one: Redefining mentorship in the lives and writings of educators* (pp. 175–188). New York: Peter Lang. (Counterpoints Series)

Kealy, W. A., & Mullen, C. A. (1996). *Re-thinking mentoring relationships* (Microfiche No. ED 394420). Presentation at the annual meeting of the American Educational Research Association, New York. (ERIC Clearinghouse on Higher Education)

Kelly, G. A. (1955). *The psychology of personal constructs, 1 & 2.* New York: Norton (2nd ed., 1992, London: Routledge).

Langer, S. (1987). Feeling and form. In S. D. Ross (Ed.), *Art and its significance* (pp. 224–239). Albany, NY: State University of New York Press.

Lovitt, C. (1992). The rhetoric of murderers' confessional narratives: The model of Pierre Riviere's memoir. *Journal of Narrative Technique, 22*(1), 23–34.

MacDonald, M. (with A. Gould). (1988). *The violent years of Maggie MacDonald.* Toronto: McClelland-Bantam.

McCutcheon, G. (1982). Educational criticism: Reflections and reconsiderations. *Journal of Curriculum Theorizing, 4,* 170–174.

Mullen, C. A. (1994). A narrative exploration of the self I dream. *Journal of Curriculum Studies, 26*(3), 253–263.

————. (1995, June). Carousel. *Among Teachers: Experience and Inquiry, 17,* 12. Among Teachers Community.

————. (1997a). Hispanic preservice teachers and professional development: Stories of mentorship. *Latino Studies Journal, 8*(1), 3–35.

————. (1997b). *Imprisoned selves: An inquiry into prisons and academe.* New York: University Press of America.

————. (1997c). Post-sharkdom: An alternative form of mentoring for teacher educators. In C. A. Mullen, M. D. Cox, C. K. Boettcher, & D. S. Adoue (Eds.), *Breaking the circle of one: Redefining mentorship in the lives and writings of educators* (pp. 145–174). New York: Peter Lang. (Counterpoints Series)

————. (in press). Reaching inside out: Arts-based educational programming for incarcerated women. *Studies in Art Education.*

Mullen, C. A., & Dalton, J. E. (1996). Dancing with sharks: On becoming socialized teacher-educator researchers. *Taboo: The Journal of Culture and Education, I,* 55–71.

Mullen, C. A., Cox, M. D., Boettcher, C. K., & Adoue, D. S. (Eds.). (1997). *Breaking the circle of one: Redefining mentorship in the lives and writings of educators.* New York: Peter Lang. (Counterpoints Series)

Oldfather, P., & West, J. (1994). Qualitative research as jazz. *Educational Research, 23*(8), 22–26.

Paivio, A. (1986). *Mental representations: A dual coding approach.* New York: Oxford University Press.

Paley, N. (1995). *Finding art's place: Experiments in contemporary education and culture.* New York: Routledge.

Pope, M., & Denicolo, P. (1993). The art and science of constructivist research in teacher thinking. *Teaching & Teacher Thinking, 9*(5/6), 529–544.

Preston, R. (1966). *Four quartets rehearsed.* New York: Scholarly Books.

Sudnow, D. (1993). *Ways of the hand: The organization of improvised conduct.* Cambridge, MA: MIT Press.

Updike, J. (1966). *The music school: Selected stories.* New York: Knopf.

Watts, A. W. (1971). *Alan Watts journal, 2*(4). New York: Human Development Corp.

Zorpette, G. (1994, Summer). Dynamic duos. *ARTnews,* 164–169.

Chapter 13

"From the Next Scale Up": Using Graphics Arts as an Opening to Mentoring

William A. Kealy
Carol A. Mullen

Underneath the bridge is the night sky, as seen through a telescope. Star upon star, galaxy upon galaxy: the universe, in its incandescence and darkness. But there are also stones down there, beetles and small roots, because this is the underside of the ground. (Atwood, 1988, p. 408)

I believe a leaf of grass is no less than the journeywork of the stars,
And the pismire is equally perfect, and a grain of sand,
And the tree toad is a chef-d'oeuvre for the highest,
I find I incorporate gneiss, long-threaded moss, esculent roots,
In vain objects stand leagues off and assume manifold shapes.
(Whitman, 1855/1962, "Song of Myself," verse 31, pp. 139–140)

Talking Micro/scopic Stories

For more than three years now, we (Bill and Carol) have shared airflight and travel, conversation and inquiry, culminating in this opportunity to tell our developing story of comentorship. On and between flights to and from Canada, the United States, and Europe, we have recorded each other's unraveling accounts of mentorship in graduate school. We have told our stories as a special form of relationship experienced between two or more people. By having detailed some of the "gneiss, long-threaded moss, esculent roots" of our learning in higher education, we have attended to a "beetles and small roots" idea of mentoring.

We have recently re-viewed our shared travelogue of scribbled notes and transcribed, conversational exchanges. We see ourselves as hav-

ing been "caught" up in the details of our mentoring narratives and their influence on our evolving understandings. While consuming bags of salty peanuts and pretzels mid-flight, we have talked micro/scopic stories, experiencing our own "micro-becomings" (Deleuze & Guattari in Lather, 1997). Their "flavor" is demonstrated in the excerpt below. The column-like form suggests overlapping voices and places of echo and tension when statements are placed side-by-side. Our dialogue is to be read starting with Carol on the left-hand side, across to Bill, and down the right.

Carol: Thanks very much for sending me your e-mail exchanges with Raymond Kulhavy, your former mentor. This is a helpful way of letting me "eavesdrop" and also develop my own sense of your mentoring relationship. I have some impressions I want to share. It strikes me that [your former mentor] continues to play a significant role in shaping your core values and visions of mentoring. For example, you both seem to place faith in a concept of graduate school as a community-based framework for producing large groups of student-researchers who play designated roles in assisting with the development of each other's inquiries. Am I on the right track here?

Bill: Yes, from Ray Kulhavy, my decade-plus friend, I have come to see mentorship at the level of organization which has a direct impact on many students' lives simultaneously and which can be extended to the entire scholastic or academic community. I myself experienced a transformation at the level of self as a former graduate student that was also a transformation at the level of relationship and community.

One way of tackling such large-scale change is through storytelling. Mentors help empower students when they make explicit the value of academic family lineage and the potential place and contribution of newcomers. I myself was told the story of my academic father and mother, grandfathers and grandmothers, as well as siblings and cousins. I was, in this picture, the new son attracted to an apprenticeship system in a department of psychology. As you know, I was inspired through this process to create an illustration of an *academic family tree* [see Figure 24]. It exists as the first graphic documentation of who birthed whom within my inherited chain of being, all the way back to Wundt, the "father" of

psychology. Thanks for being such a great listener which is helping me to articulate some of these connections.

Carol: *There needs to be room, don't you think, for talk about "splinters" from original academic trees and those "leaves" or persons who, for whatever reason, did not live out a particular, seemingly fated story of academic lineage, as you depict it. Such "splinters" have the potential to play a vital role in helping mentoring units and organizations to critically reflect upon themselves, but how often does such constructive change happen? It's becoming clear to me that transformation at the level of self necessitates a transformation at the level of other, and that without this kind of reciprocity, splintering can occur.*

I feel that the idea of the academic family tree is potentially very exciting, if taken from different angles. Have you noticed that there's a tension in how we tell our mentoring stories— you consider relationship as a viable human system of longevity, and I approach it as a shifting organism of connected and loose parts. As much as I admire your metaphor of mentoring, I also feel compelled to introduce an element of break-down in it.

Bill: Academic splintering can and does occur for different reasons which is why it's important to consider those kinds of activities and environments that can help to prevent misfortune and lack of empowerment. For example, academe, unlike the corporate sector, has no middle management which does the detail work for senior persons or mentors. Mentoring relationships in academe could benefit enormously from a framework wherein mentors are not responsible for managing so many of the aspects of students' research studies. I myself experienced a productive mentoring system wherein many of the parts of my own research life and activity were delegated to upper-division students who taught me the craft of research, which I, in turn, later taught to novices. In this way, students learn from peers, their secondary support system, and mentors share power, knowledge, and resources.

Let me read to you from Wallace Stevens' (1967) poem about lineage:

*She floats in air at the level of
The eye, completely
anonymous,
Born, as she was, at twenty-
one,
Without lineage or language,
only
The curving of her hip, as
motionless gesture,*

Perhaps this is why I tend to employ feminist perspectives to enable me to deconstruct mentoring systems of progeny and lineage. I also like discovering examples of academic mentoring relationship that deal constructively with power and hierarchy. (Texas to Paris, 9 August 1995, cassette recording and sketchbook drawings)

Eyes dripping blue, so much to learn.
["So-and-So Reclining on Her Couch," p. 246]

Gradually, we have been learning the value of constructing larger "units" or themes from our narratives. Taking a larger view of this conversational exchange in preparation for writing our chapter, we turn to ideas of layering and separating (for a technical description of envisioning information as such, see Tufte, 1990). Text that both layers and separates shows how one set of information can be graphically represented along with another. In this way, the dialogue, as in our example, can be read/viewed both in its interrelationship (layering of voices) and individuality (separation of ideas).

We have used different fonts, column and line spacing, and edging to convey visual separation, thereby suggesting individuality. In the left-hand column, the "inquiring self" (Carol's voice) is reflected with the use of an open, unconstrained formatting style. In the right-hand column, the "information-giving self" (Bill's voice) uses a relatively tight, dense formatting style. These techniques all work to create the impression of separation or distinctiveness. In contrast, the interrelatedness of ideas is conveyed through layering techniques. For example, the Wallace Stevens' poem read by Carol (bottom right) appears in Bill's column, not hers—a visual attempt at "capturing" the overlapping voices. But even here, separation, expressed as a form of academic splintering, is connoted—the branch on the left "points" downward into the poetry.

The representation of our voices in these ways produces intellectual and emotional tension with different effects. Notably, our metaphors of mentorship—as academic family tree and as splintered branch—combine/separate, expand/contract, and complete/fragment. This set of dialectics is visually accentuated through the sketches of tree and branch inside the columnar structure.

This unfolding analysis of the different modes of separation and interrelationship represents our "macro" attempt at arts-based research. The actual juxtaposition of these modes in the graphic illustration is intended to provide a "micro" view of arts-based research in action.

With this demonstration and subsequent ones in this chapter, we hope to show tension between smaller ("micro") and larger ("macro") perspectives in aesthetic research efforts. We now shift to a more intensive consideration of the macro view because of the value this can give to viewing mentorship at both broader and more immediate levels. We separate macro and micro levels, and also layer them, all to produce tension in the use of arts-based strategies. Our purpose here involves the use of graphic arts as an opening to mentoring within both artistic and educational movements. We now "turn on" our "macro/scope" to see what forms of pattern-making can be constructed from sharing stories of macro-mentorship.

Sharing Macro/scopic Stories

In this chapter we focus on mentorship "from the next scale up" as a large scale "collection" of mentor-mentee pairs. We have named this new concept *macro-mentorship* and discuss two examples of its practice. While studying these macro-mentorships, we have attempted to identify roles, functions, arrangements, and activities that reflect innovative practices for developing mentorship as we know it. Insights gained from interpreting these examples include recognizing existing and new mentoring roles, increasing the awareness of one's academic lineage, and mentor-mentee participation in meaningful joint activity.

Much of what we know as educators about mentorship has been derived from time-worn models and selective perspectives: guild systems, apprenticeships, and other systems of socialization intended to reproduce professional life. The growing importance of mentorship in education calls for alternative ways to understand and improve relationships and settings. Accordingly, we cast a new look upon the topic of mentorship.

To this end, we have adopted Tufte's (1990) graphic concept of *micro/macro* displays. His view is that when information on isolated events is graphically represented, patterns emerge from which insights can be glimpsed. Consider, by analogy, forest and trees. The health status of *every* tree in a forest may be graphically annotated, as on a map. For simplicity's sake, such a map can be "read" at either the micro/scopic (individual tree) or macro/scopic (forest) level. Yet, the kinds of inferences and interpretations available at each level differ. We are learning that by taking a macro view of mentorship, insights that are otherwise typically obscured from mentors and mentees can be produced.

By adopting this macro view, we hope to discover concepts of mentoring that suggest another way of understanding the "micro level," where daily mentoring occurs. Insights gained from this strategy may even have the potential to influence mentoring activity. For example, if the map in the forest-to-trees analogy were to reveal stunted growth (due to disease or drought), one might attend to healthy trees elsewhere as a preventative measure. Similarly, we are committed to helping teacher-student relationships (referred to as *mentoring dyads*) perpetuate their well-being.

We are taking a concept from one way of knowing, in this case the graphic arts, and using it as an "analytical template" for exploring an entirely different area. Kuhn (1970) describes instances in which practitioners within a particular knowledge domain inspired major discoveries in another discipline. John Dalton, for instance, is famous for his chemical atomic theory. Yet he was a meteorologist, not a chemist, who was able to see problems in chemistry that constituted "blind spots" for contemporary chemists who rigidly followed the methods of the established scientific paradigm (Kuhn, 1970).

In the present case, we have taken an idea from the world of graphic design and used it to provide an interpretive framework to examine developmental arrangements. Others have similarly appropriated concepts from aesthetics in the analysis of domains typically viewed as nonartistic. Educational researchers who use the literary and visual arts consider alternative ways of representing inquiry as, for example, a novel (e.g., Eisner, 1997) and a musical score (e.g., Blumenfeld-Jones & Barone, 1997). Arts-based metaphors and designs are now being used as a means for reconsidering such concepts as collaboration not typically thought of in graphic terms (e.g., Diamond, Mullen, & Beattie, 1996; see chapters 11 and 12). Here, we use the academic family tree as an example of an arts-based metaphor and design (see Figure 24), and the mentoring mosaic provides us with a second such example (see Figure 23). We add to those arts-based, graphically depicted examples, provided throughout this book, such as collage, photomontage, palimpsest, shape poem, Möbius strip, and others.

Later, we expand on two examples of what we consider to be "macro" mentorships: first, the Neo-Impressionists, who were a group of late 19th-century European painters led by Georges Seurat. Their painting style, characterized by a dotted pattern of brushwork called pointillism, and vision of a "scientific Impressionism," contributed to the emergence of modern art. And second, the National Consortium

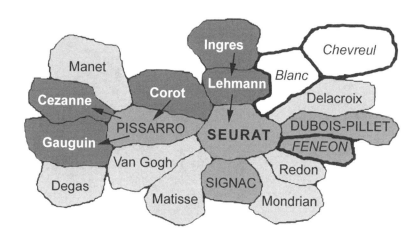

Formal teacher/mentor relationship (——►) Corot

Major figure in Neo-Impressionist movement SIGNAC

Non-artist contributor to Neo-Impressionism *Chevreul*

Indirect connection to Neo-Impressionism Redon

Figure 23 *A Mentoring Mosaic of the Neo-Impressionist Movement* (W. A. Kealy, 1998)

for Instruction and Cognition (NCIC), which was established in 1969 primarily as a social organization that met concurrently with annual conferences of the American Educational Research Association (AERA). However, as NCIC grew it became increasingly scholastic, exhibiting mentor-like qualities and functions.

By exploring such macro-mentorships, we exemplify the view of Charles Eames, American architect-designer, who learned from his mentor, Eliel Saarinen: "the importance of looking at things from the next largest scale and the next smallest [in order to be able to consider] problems from many levels, changing the frame of reference and thereby gaining new insights" (Demetrios & Mills, 1989). Eliel Saarinen himself advised "Always think of the next larger thing" (Temko, 1962, p. 13). With the potential for insight generated from inquiry

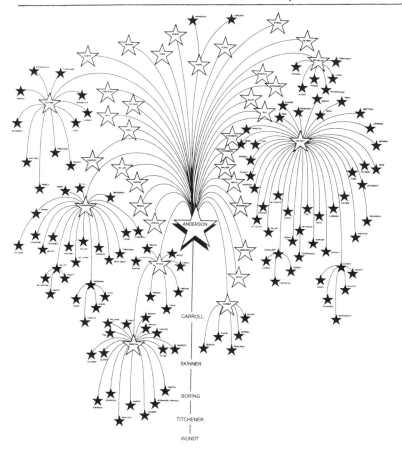

Figure 24 *Academic Family Tree as Starburst* (W. A. Kealy, 1994)

into "the next largest scale," we ask, and later respond to: "What understandings of everyday mentoring activity can be enhanced by a macro-view of mentorship?" There may even be dangers in such arrangements.

Escaping Flatland: Adjusting Our Focal Lens

Because it is possible for an organization to support numerous mentor-mentee dyads simultaneously, it is important for us to address a potential misconception—that macro-mentorship is simply a collection of mentor-mentee dyads. To return to our earlier analogy of the forest as micro/macro display, a forest is, foremost, an ecological sys-

tem. By contrast, a cluster of trees in a nursery, each in its own potted plant, is neither a system nor a forest. In the same way, an organization that adopts a mentoring program in which mentors are identified and assigned to mentees is not a macro-mentorship. Yet the notion that macro-mentorship involves a summing up of personal mentoring experiences remains inescapable. To respond to the question "What distinguishes a macro-mentorship organization from an organization that contains elements of mentoring practice?" we consider micro/ macro displays.

We use "micro/macro" to illustrate the point that mentoring can be "read" at different levels. If represented graphically, mentoring activity can be interpreted at the local and/or global level by, as it were, adjusting our focal lens. Such an adjustment is made by graphically depicting "individual datum points," thereby forcing the "visibility" of phenomena at the macro level. Graphic designers have traditionally struggled with the problem of presenting information on a flat sheet of paper. Micro/macro representation is one of several design approaches to this problem whereby one may "escape flatland," overcoming the inherent limitations imposed by a two-dimensional surface (Tufte, 1990). The micro/macro strategy uses large-scale displays with fine detail that evoke a universal "reading" of particulars, however partial and incomplete.

The Vietnam Veterans Memorial in Washington, D.C. is an extraordinary example that Tufte offers of this concept: a micro/macro perspective of the names of 58,000 soldiers, engraved in black granite, which can be viewed at several distances. On the micro/scopic level, close to the wall, the names are identifiable and the experience is personal. Here, we attend to the stories belonging to and shared among individuals that render soldiers' former lives vivid and meaningful. Narrative response is evident from, for example, the mementoes of heartfelt expression that visitors leave at the site. A schema that would permit a personal experience of the memorial was devised through a particular distribution of the soldiers' names. The names are not alphabetized because multiple rows of common names like "Robert Smith" would have created an anonymous, "telephone book" effect. Instead, the individuality of each soldier's identity has been preserved through a schema that highlights the date of each soldier's casualty in Vietnam.

Farther away, the context of the memorial becomes less personal as the arrangement of soldiers' names coalesces into pattern and texture. From yet a greater distance, the ordering of names becomes

increasingly blurred—the memorial shows its overall shape, revealing a three-dimensional graph of the distribution of war casualties over time, a "gash" of black rock in a green lawn.

Using this example of a display, the idea is not one of "counting" and hence specifying the number of data points "sufficient" for a micro/macro reading, but rather understanding that detail contributes to texture and to our own perceptions of texture. Micro/macro displays, then, can be interpreted as an overall structure of interrelated elements in which synergistically "the whole is greater than the sum of the parts." Many types of graphic representations can fall under the rubric of "micro/macro" display: a monument (such as the memorial), a map of an urban design, and even an aerial photograph of an analogical forest with each pine tree shown in detail. We now turn to the macro mentorship examples introduced earlier that we think warrant a micro/macro interpretation.

Neo-Impressionism:
A Mosaic of Macro-Mentorship

The masters, truth to tell, are judged as much by their influence as by their works. (Zola, 1960, p. 160)

The Post-Impressionist movement began in Paris at a time when scientific discovery captured the attention of Europeans and Americans. In response to these times and in reaction to the transient quality of the experience that Impressionist works sought to provide, a group of artists experimented with a painting style both scientific in its conception and permanent in its expression. The *Société des Artistes Indépendants* held their first exhibit in 1884, soon earning the *sobriquet* "Neo-Impressionists" (Herbert, 1991).

The originator of the pointillist style that characterized Neo-Impressionism was Georges Seurat. Like many movements, Neo-Impressionism was the product of multiple influences. Figure 23 is an arts-based graphic depicting the Neo-Impressionist movement as a mosaic of many influences within the art world of late 19th-century Europe. Gray "pieces" of the mosaic connected by arrows depict cases where a formal teacher-student relationship existed between two artists. By contrast, adjacent tiles of the mosaic with matching edges show the stylistic or conceptual influence of one person (not necessarily an artist) on another. Although Seurat was never a teacher in the formal sense, he greatly influenced Van Gogh and other painters.

The artwork also exemplifies the concept of the "mentoring mosaic," which proposes that mentorship consists of many facets, not all of which need be accomplished by one person. Head, Reiman, and Thies-Sprinthall (1992) suggest that mentoring can be optimized by a "mentoring mosaic" that taps resources—a network of secondary mentors—to address shortcomings in the primary mentor-mentee dyad. Darling (1986) earlier identified such a network as useful for cultivating secondary peer mentors; for realizing the capacity of learning through the strengths of multiple partners; and for compensating for traditional mentoring relations which exclude vital aspects of the mentee's growth. The development of an individual (or movement) may be the result of many influences, each fulfilling a different role: teacher, adviser, confidante, promoter, cheering section, parental figure, friend, career guide, and more. In the case of the Neo-Impressionist movement, Seurat (shown in bold typeface on Figure 23) was its "source" or originator. Dubois-Pillet, on the other hand, was the movement's organizer, and both Signac and Fénéon promoted the artistic ideas of the group.

Because Neo-Impressionism sprang up at the zenith of the Impressionist Movement, some artists like Camille Pissarro painted, at one time or another, in both styles. Further, in some cases painters from both groups either studied the work of, or formally studied with, the same mentor. For example, although Seurat studied with Lehmann (who was mentored by the master painter Ingres), he was more stylistically influenced by Corot, the mentor of Pissarro (who was mentor to Gauguin and Cézanne). While Seurat never accepted a student, he wanted to establish a school that had painter Delacroix serving as its role model (Herbert, 1991).

Considering the Neo-Impressionists as a whole, it is evident that Seurat was not a mentor in the classic sense. As the "source" of Neo-Impressionism, he played an essential role, thereby, representing one piece of a mentoring mosaic, not all of those pieces needed to sustain the movement: "Although artists and critics alike regarded Seurat as the inventor and leading artist of Neo-Impressionism, the ebullient Signac was the more effective propagandist for the movement, and Dubois-Pillet was the group's best organizer" (Herbert, 1991, p. 3). More than anyone else, Pissarro performed the role of parental figure. Roughly 30 years older than the others, he frequently acted as arbiter of disputes (Rewald, 1963). With Dubois-Pillet's death in 1890, the movement lost its "organizer." Seurat, its "source," died a year later. Yet, the *Indépendants* exhibited annually until 1904, a remarkable

longevity when compared to the eight years during which the Impressionists exhibited as a group.

Analysis of the Neo-Impressionist movement as macro-mentorship suggests the existence of mentoring functions or roles not typically associated with mentoring. The "organizer" manages the activity of the group, identifying roles, assigning tasks, and arranging meetings. The "sponsor" performs behaviors of protecting, supporting, and promoting. One can add recruiting—enlisting novices—and chronicling or passing on the practices and history of the group. Following Seurat's death, this function was carried out by Signac and Fénéon, who wrote in praise of the group's work. The "originator" is the person from whom a major idea, once germinated, has been articulated. Mentors in traditional dyads may find it too challenging to represent everything to another.

The Neo-Impressionist artists seem to fit the concept of macro-mentorship while maintaining a high degree of freedom. Artists chose individual sources of encouragement and growth, whom to influence and whom to be influenced by, through an interpersonally constructed mentoring mosaic. Yet, they represent more than a group of painters with similar stylistic practices. Their common artistic values and goals formed the basis for an interrelated mentoring structure. This type of mentoring network can promote a living organization that bears close resemblance to community and family. The Neo-Impressionist movement can, therefore, be studied for insight into the teaching, recognition, modeling, nurturing, and friendship that benefit and sustain mentoring relationships.

What emerges from this account is, from a distant view, web-like interconnections between artists and art schools. At the micro, narrative level, one sees the solitary efforts of individual painters and, at the macro level, a network. Here, the lines denoting mentor-mentee dyads are blurry. Nor is there a clear delineation of what constitutes a mentor. Ironically, the visibility afforded by mentoring depictions promotes an appreciation for ambiguity and complexity.

Arts-Based Activities

1. List those secondary mentors in your life and display their names in a "mentoring mosaic" (see Figure 23). What kind of display will you create? It could be signature leaves on a hanging vine or a signature tail on a flying kite. Afterwards, ask yourself these

interpretive questions, which art educator Barrett (1997) says are important for all students and works of art: "What do you see? What do you think it means? How do you know?" (p. 36).

2. As a learning activity, students or teacher colleagues can be asked to plot relationships among key people in a mentoring movement in art, politics, history, or education. They can produce arts-based displays, such as poetry, collages, or photomontages, and also probe the meanings of each other's works. Repeated aspects or nuances of mentoring can be used to draw attention to larger patterns of interpretation. Bill's following poem humorously plays with his "enforced" attendance at the National Consortium for Instruction and Cognition (NCIC) years ago.

NCIC: Macro-Mentorship as Family Tree

My Last Lesson by William A. Kealy

I wisely decided diversions were out
for the next couple months or so,
but my prof said to me, "Next week's NCIC,
and I think you ought to go."

I had no time to squander, no money to spare,
no need to attend the convention,
further, I never heard of this group
so I went and voiced my dissension.

But though I reasoned, pleaded, and whined,
"I haven't the time to allow!"
My advisor told me, "You simply don't see
you're part of a family tree now."

"Its branches are Skinner, Boring, and Wundt,
Anderson, Titchener, and Carroll.
They wouldn't forgive you for shunning your kin
just 'cause you're now over a barrel. . . ."
(1994, p. 29)

NCIC is an example of a body of scholars not originally set up as a mentoring organization. It was initiated by four professors who, as

graduate students, shared a suite together almost 30 years ago at the AERA conference. After assuming academic positions at different universities, they continued the practice of meeting every year, introducing protégés to their academic "cousins" (i.e., mentees of other founders) and "grandfathers" (i.e., the founders' mentor). These mentees, once having joined the professoriate, in turn extended invitations to their graduate students. In time, NCIC adopted the trappings of a formal organization: charter, membership dues, annual banquet, reception, and business meeting. The suite became the focal point for gatherings, paper sessions, and talks by distinguished members.

Figure 24 depicts NCIC as a starburst, or explosion of fireworks, with each "star" representing a doctoral graduate. Large stars emanating from a central mentor occasionally explode forming subbursts of Ph.D.s which, in turn, sometimes erupt as more localized constellations of doctors. This arts-based graphic can be interpreted as a "family tree" of the organization, exhibiting mentoring relationships among members. In this micro/macro reading, over 150 "leaves" are arranged on branches so that "detail culminates into a large coherent structure" (Tufte, 1990, p. 37), revealing both intellectual relationship and parental lineage over time. While like other micro/macro examples, the display invites local comparisons, it was intended to be descriptive, not to show which mentors are most productive. Its chief value as a representation of mentoring dyads is that it permits an alternative view of the mentoring functions of a learning organization.

With Figure 24 in mind, it becomes apparent that NCIC's clear intellectual lineage sets it distinctly apart from a "community of scholars" or similar academic body. Though some members regard this notion of "lineage" more or less seriously than others, it is the source of a shared history that binds such a group together. It also creates a context of family in which members can find acceptance, temporarily escaping from the more competitive aspects of the academy. In a relaxed setting of scholarship, students are exposed to role models with whom they can identify and through whom they can imagine themselves as successful academics in the future.

The NCIC family tree reminds us that there are a number of reasons why it is important for mentors and mentees to acknowledge their lineage or tradition. Today there is much emphasis on uncovering (and recovering) one's cultural family roots (Banks, 1994). By contrast, little attention is given to academic roots within educational or arts-based research. Typically doctoral programs are not explicitly

viewed as academic family trees. Other exceptions include Frank Lloyd Wright's architectural school in Arizona.

Another argument for "treeing" one's academic lineage is that protégés often become mentors themselves. They will need to know the story of their heritage so that they can "stay the course" during their doctoral journey and so that others can later benefit. Moreover, the prospect for students of coming to represent the start of a "new branch" in an academic discipline serves as a further motivator. Phillips (1979), in discussing the qualities that keep mentorship alive across generations of higher education, identifies "heritage," "fellowship," and "community." Gehrke (1988) extends these concepts through the special notion of a mentoring relationship as a "system of gift exchange."

Arts-Based Activities

1. Devise your own academic (or professional) family tree, locating yourself within one or more mentoring lineages. Choose a metaphor to plot your family tree, such as we have done with the "mentoring mosaic" and "starburst." Consider the various persons in your life whom you mentor and who mentor you, as well as noteworthy forebears and descendants. Note that the mentoring roles of originator, sponsor, and organizer have been identified in this chapter, all possible sources for your lineage tree. The roles of friend, career guide, information source, and intellectual guide can also be used to identify various mentoring influences. Personalize your "tree" by using family relationships (e.g., grandmother and cousin). Superimpose photographs of yourself and others to create a "close up" narrative view. Share your artwork with others and/or use it as the basis for devising a teaching exercise.

2. Write a short description of the activity setting in which you teach and learn. Include joint activities that typify aspects of your work. To what extent are your examples linked to critical functions of mentoring, such as sponsorship, encouragement, problem-solving, and friendship? What are some signs of affect and friendship in your mentoring relationships?

One sociocultural viewpoint contends that three conditions should be met for successful mentorship to occur: an interpersonal attraction between mentor and mentee, appropriate kinds of joint activity, and a

conducive setting (Gallimore, Tharp, & John-Steiner, 1992). A degree of affect is necessary to initiate and sustain a mentoring arrangement. The mentor as one who befriends is to be taken seriously according to Gallimore et al. who have found that attraction and attachment underlie effective mentorships. Practices of intellectual friendship, emotional intimacy, and communication (Diamond & Mullen, 1997; chapter 11; Keyton & Kalbfleisch, 1993) offer documented testimonials of such mentorships. But even these exemplars stress the value of goal-directed, everyday activities and settings, important "elements" of macro-mentorship. The *activity setting* can be thought of expansively as "the who, what, when, where, and whys of everyday life in school, home, community, and workplace, features of personnel, occasion, motivations, meanings, goals, places, and times" (Gallimore et al., p. 11).

Dynamic activity settings can help to compensate for the insufficient attention typically extended to graduate students to realize their potential as developing mentors (Mullen, 1997). Similarly, on a larger scale, Little (1990) refers to the "broader cultural legacy of mentoring [which] presents a model of human relationship that [is] difficult to achieve within the confines of bureaucratic arrangements" (p. 299).

Learning from Macro-Mentorship Narratives

We now wish to consider some of those qualities shared by our macro-mentorship examples of Neo-Impressionism and NCIC. Notably, in each case a number of mentorship functions were carried out, not by one but by several different members. Although one person was source, organizer, and leader, many taught and served as role models. Also, for both "mentoring movements," a sense of lineage and family evolved, giving rise to the lived stories, personal contacts, and remembrances of their "members."

Several insights into such examples lend themselves to our discussion of benefits that can be reflected within everyday human activity. First, a macro-mentorship may incorporate certain roles or archetypes as a means for increasing its viability. This chapter identifies originator, sponsor, and organizer, although others probably also exist. Many of the functions performed by these roles have been identified in the mentoring literature. On the other hand, some roles such as organizer, and some functions like recruiting and chronicling, appear to be novel. This raises exciting possibilities for more expansive kinds of

mentoring activity beyond steering one's own professional course or advising students.

A second insight is that academic lineage should be shared with students as a way of informing them of their intellectual pedigree and of identifying where their research interests reside within the broader scope of a discipline. In a narrative case study of mentorship, Kealy (1997) proposes that mentees actively pursue knowledge of their discipline by tapping the philosophical and personal views of their mentors. Awareness of academic lineage can help to establish a "community of mentoring" that embraces imagined links to ancestors.

Recognition of one's place within an intellectual family may have an affective benefit for students, promoting their sense of belonging and motivating them to make a contribution. Having a sense of place has practical value. Mentees can lose sight of broad academic aims when absorbed by, for instance, a literature review for a dissertation. Mundane tasks can become momentary obstacles on the path toward leaving one's mark on a discipline.

Third, mentors should pay attention to the kinds of activities that protégés perform as well as to the setting itself. Preferably, some writing and research tasks encouraged by mentors and mentees (or comentors) should involve joint participation so that there is more room for growth and less for exploitation, as well as misuse of time and resources. Examples of joint participation provided throughout this book include *coauthoring* for the purpose of conference presentation and publication (chapter 11); *dialogue journaling* as a form of mutual reflection that promotes the collaborative development of an inquiry (chapter 11); *constructing shared, arts-based metaphors*, such as inmate and outlaw (chapter 9) and splintered branch and family tree (this chapter) to further academic writing and narrative argument; *constructing thematically linked self-narrative accounts* in an effort to build community (chapters 9 and 12); and *creating a palimpsest* or quilt of different voices to represent a shared experience (chapter 16).

Such insights into macro-mentorship may contribute to mentoring practice whether manifested as a large-scale organization or as a typical one-to-one relationship. Mentorship in either form may benefit by the addition of roles and functions (e.g., chronicler, promoter, and sponsor) adopted in traditional mentoring arrangements. For instance, mentors act as "live reporters" when they stay informed about the success of former students and also update current protégés. Similarly,

as "promoters," mentors can seek opportunities to advance the growth and career development of promising mentees.

Arts-Based Activity

Write a "progress report" (letter or note) to your mentor (or solicit one from your mentee) outlining your current successes and struggles. Focus on your developmental needs and aspirations, and those specific mentoring roles and functions that could help to facilitate your academic/professional success.

Summary Comments:
A Survey of Implications

One implication of our research story is that macro perspectives can serve to mobilize aspects of a successful mentoring journey. Local mentoring contexts can directly benefit from possibilities suggested within macro-mentorship narratives. University structures themselves have a long history of socializing graduate students in the production of particular images of mentoring practice. Because academic disciplines have distinctive cultural histories (Martin, 1996), it may prove useful to generate macro perspectives for the study of these as well. This relates to a second implication—graphic concepts and tools can influence arts-based inquiry into nongraphic arenas, such as academic lineage and mentorship. Only recently have the possibilities of using graphic forms of inquiry begun to be explored.

A cautionary implication of our story of mentorship is that grouping painters into mosaics and scholars into family trees does not preclude inner rivalries and moves to colonize others. Members may experience conflict as well as development within and between their reference groups. Freud's mentoring of Jung provides an example of eventual internecine strife. Their friendship had "initially expanded into such a highly productive, mutual exploration that their theoretical and filial rapport [was] unequalled amongst their peers, Jung becoming not only a son to Freud but his [apparent] equal" (Dewdney, 1993, p. 101). Their relationship remained intimate until 1909 when they sailed together on the *George Washington* bound for New York. Each morning they met to interpret one another's dreams. But Freud was growing increasingly reluctant to risk his authority. Alienation led to rupture. Three more years of arguments and reconciliations led to Freud's declaring Jung a dangerous heretic and excommunicating him from the psychoanalytic circle. Room for only one prophet.

In the nation of the red ants in Byatt's (1992) fable, *Angels and Insects*, "there is [also] only *one* true female, the Queen" (p. 85). As well as policing members of their group, leaders may also call on their followers to coopt or wage war on others. Byatt's (1992) paired observers, William and Matty, discovered that the ants were "armed with stings and savage jaws. [Their maneuverings] turned out to bear a remarkable resemblance, in some ways, to human warfare, with sudden invasive attacks by one army [the Red Ants] on the neighbouring stronghold of another community [the Wood Ants]" (p. 95). Proselytizing, slaving raids were planned to capture and carry nestlings back home to the Red Fort, or to Vienna. William ironically dismissed "analogy [as] a slippery tool [asserting that] men are not ants" (p. 100). However, he later becomes painfully aware that, like a mule ant, he had been duped into slavery. By agreeing to marry Eugenia, the family's Queen-in-waiting, William had served her purposes and those of her father, his own mentor-patron.

Without openly showing itself as "red in tooth and claw" (Tennyson in Byatt, 1992, p. 88), the cooperative cells of a body or members of a group may find that they are not always being directed by some generative presence. With a subsequent breakdown at the interpersonal or organizational level, the image of the solitary, splintered branch (see introduction) carries greater "weight" than an entire heritage tree.

Alongside this index of cautions, we still wish to emphasize that promising and effective mentoring practice is possible. Such practice does not require the establishment of a formal organizational structure. Many successful mentors prefer working with one student colleague, or just a few, at a time. While a larger view of mentorship is available at the macro level, its benefits may only be fully realized in everyday "affective" mentoring contexts. As e. e. cummings put it, "trees tumble out of twigs and sticks" (p. 447).

References

Atwood, M. (1988). *Cat's eye*. Toronto: McClelland and Stewart.

Banks, J. A. (1994). *Multiethnic education: Theory and practice* (3rd Ed.). London: Allyn and Bacon.

Barrett, T. (1997). *Talking student art*. Worcester, MA: Davis. (Art Education in Practice Series)

Blumenfeld-Jones, D. S., & Barone, T. E. (1997). Interrupting the sign: The aesthetics of research texts. In J. Jipson & N. Paley (Eds.), *Daredevil research: Re-creating analytic practice* (pp. 83–107). New York: Peter Lang. (Counterpoints Series)

Byatt, A. S. (1992). *Angels and insects*. London: Vintage.

cummings, e. e. (1962). Darling! Because my blood can sing. In O. Williams & E. Honig (Eds.), *The mentor book of major American poets* (pp. 446–447). New York: New American Library.

Darling, L. A. W. (1986). The mentoring mosaic: A new theory of mentoring. In W. A. Gray & M. M. Gray (Eds.), *Mentoring: Aid to excellence in career development, business and the professions* (pp. 1–7). Burnaby, BC: International Association for Mentoring.

Demetrios, L. E., & Mills, S. (Producers). (1989). *The films of Charles and Ray Eames*. [Videotape]. (Available from Pyramid Film & Video, Los Angeles, CA)

Dewdney, C. (1993). *The secular grail*. Toronto: Somerville House.

Diamond, C. T. P., Mullen, C. A., & Beattie, M. (1996). Arts-based educational research: Making music. In M. Kompf, W. R. Bond, D. Dworet, & R. T. Boak (Eds.), *Changing research and practice: Teachers' professionalism, identities, and knowledge* (pp. 175–185). London: Falmer.

Diamond, C. T. P., & Mullen, C. A. (1997). Alternative perspectives on mentoring in higher education: Duography as collaborative relationship and inquiry. *Journal of Applied Social Behaviour* *3*(2), 49–64.

Eisner, E. W. (1997). The promise and perils of alternative forms of data representation. *Educational Researcher, 26*(6), 4–10.

Gallimore, R., Tharp, R. G., & John-Steiner, V. (1992). The developmental and sociocultural foundations of mentoring. Columbia University, New York: Institute for Urban Minority Education. (ERIC Document Reproduction Service No. ED 354292)

Gehrke, N. (1988). Toward a definition of mentoring. *Theory Into Practice, 27*(3), 190–194.

Head, F. A., Reiman, A. J., & Thies-Sprinthall, L. (1992). The reality of mentoring: Complexity in its process and function. In T. M. Bey & C. T. Holmes (Eds.), *Mentoring: Contemporary principles and issues*. Reston, VA: Association of Teacher Educators.

Herbert, R. L. (1991). *Seurat*. New York: The Metropolitan Museum of Art.

Kealy, W. A. (1994). My last lesson. In J. St. Clair (Ed.), *NCIC in verse: 25 years of suite times from 8 Lincoln Hall* (pp. 29–33). Tallahassee, FL: NCIC Press.

————. (1997). Full circle: Insights on mentoring from my mentor's heroes. In C. A. Mullen, M. D. Cox, C. K. Boettcher, & D. S. Adoue (Eds.), *Breaking the circle of one: Redefining mentorship in the lives and writings of educators* (pp. 175–188). New York: Peter Lang.

Keyton, J., & Kalbfleisch, P. J. (1993). Building a normative model of women's mentoring relationships. Paper presented at the joint Central/Southern States Communication Association, Lexington, KY.

Kuhn, T. S. (1970). *The structure of scientific revolutions*. Chicago: University of Chicago Press.

Lather, P. (1997). Drawing the line at angels: Working the ruins of feminist ethnography. *Qualitative Studies in Education, 10*(3), 285–304.

Little, J. W. (1990). The mentor phenomenon and the social organization of teaching. *Review of Research in Education, 16,* 297–351.

Martin, J. R. (1996). There's too much to teach: Cultural wealth in an age of scarcity. *Educational Researcher, 25*(2), 4–10, 16.

Mullen, C. A. (1997). Post-sharkdom: An alternative form of mentoring for teacher educator-researchers. In C. A. Mullen, M. D. Cox, C. K. Boettcher, & D. S. Adoue (Eds.), *Breaking the circle of one: Redefining mentorship in the lives and writings of educators* (pp. 145–174). New York: Peter Lang. (Counterpoints Series)

Phillips, G. (1979). The peculiar intimacy of graduate study: A conservative view. *Communication Education, 28,* 339–345.

Rewald, J. (1963). *Camille Pissarro*. New York: Harry N. Abrams.

Stevens, W. (1967). *The palm at the end of the mind*. New York: Vintage Books.

Temko, A. (1962). *Eero Saarinen.* New York: George Braziller.

Tufte, E. R. (1990). *Envisioning information.* Cheshire, CT: Graphics Press.

Wainer, H. (1992). Understanding graphs and tables. *Educational Researcher, 21*(1), 14–23.

Whitman, W. (1855/1962). Song of myself. In O. Williams & E. Honig (Eds.), *The mentor book of major American poets* (pp. 116–164). New York: New American Library.

Zola, E. (1960). The influence of Manet. In P. Courthion & P. Cailler (Eds.), *Portrait of Manet* (pp. 160–166). London: Cassell.

Chapter 14

"Hello, Can You Play?": Roles with Puppet Performances

Jan Kaufman

The Invitation

"Hi! Can you come and play today?"

"No, I'm packing my stuff to take on my trip in life. You can come too, if you want to. I'm gonna be selecting items and creating some to take along in my bag."

"Where are you going and how long will it take?"

"I don't know where I am going or how long it will take me to get there. The trip is different for each person. The items that you pack will be different from mine, maybe some items might be the same."

"I want to go with you. Wait for me to pack my stuff, Okay?"

"Sure. You know the people we meet might not speak our language or even look like us. The stuff they give us might be strange to us but we can pack it all in our bags and use it later when we want to perform."

"Perform! I can't. I don't know how and besides I might make a fool of my self."

"How can you make a fool of your self when you are only being someone else, not your self? You would be playing a role."

"How's that? Being someone else I mean? I don't think I could be someone else. I sometimes have trouble being me."

"We'll learn how to be 'someone else' by watching and observing people's behavior as we travel. What we learn from watching we can pack in our bags and apply it later to character development when we role-play. Okay?"

"All right. What do I have to take as basic stuff? My hairbrush, toothbrush, and change of clothes to start, right?"

"I don't care about that. Whatever makes you comfortable. We must get going. What about the basic stuff?"

"We can take some things we require like skills, knowledge, attitudes, and puppets, and then collect other stuff as we go. Does that make you feel better?"

"Yes, I will take the five basic types of puppets—hand puppets, finger puppets, rod puppets, shadow puppets and marionettes, you know, the ones you work with strings. I'll pack Annie, a hand-and-rod puppet, and some others for demonstration too. Then I'll be ready to go." (See Figure 25.)

Traveling and Picking Up Stuff for My Bag

"If we take everything we require now we won't have any space for the stuff we'll want to pick up along the way. There are experiences we will have and others we will learn from that will go into our bags."

"I'm comfortable doing that. I've taken some samples of puppets with me. You know the ones I made to show the students in the workshops? And some I perform with skill, knowledge, and experience."

"When we get to South America, the countries we visit may not have the same materials that you use for the puppetry workshops. The students would not be able to recreate and transfer the knowledge for making similar puppets. So, it is better to use the materials you find when you get there, to the classrooms in the various universities and schools. You may even find that the students in your workshops use materials differently from the conventional ways you know. Then both you and the students can learn from each other in addition to the students who will learn from each other."

"What do you mean by 'you and the students learn from each other'? Is this idea something I want to put into my bag?"

"Yes. An example of this idea would be if you brought plastic eyes to use when making puppet faces in your workshop when none existed in that country. You could take away the creativity of the students by using the plastic eyes instead of eyes they can make out of paper, or by sewing X's in place of eyes, or by using buttons that they can paint. You may even be shown other ways to make eyes you never thought of." (See Figure 26A.)

"Also, the creating of characters for puppets is important when you want to bring the figures to life. The puppet will take on human

Figure 25 *Puppet Types in Jan's Bag (J. Kaufman, 1990)*

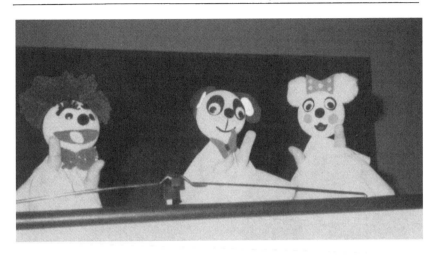

Figure 26A *Eyes and Puppets Created by South American Participants*
Figure 26B *Puppets Used for Teaching Spanish* (J. Kaufman, 1993)

behaviors. We can use the behaviors that we observed when watching people and incorporate these into our puppet characters. The puppets will put on plays or performances for an audience. This learning experience goes into the bag too."

"Let's move on and we'll perform with the puppets we have created. We can become another personality by using our puppets. Are you game for that?"

Performing and Storytelling

"I'm game. I feel strange using a puppet to tell a story. Being behind a stage and not seen by the audience is different than being on stage with everyone looking at me. I feel protected somehow and am finding that the puppet's character can come out easier. Puppets can even say things that we as human beings couldn't say. Another idea for the bag, right?"

"Yes. When you create a performance or play there is a concept that is communicated, purpose, or idea. Maybe just entertainment. A group has made puppets to teach Spanish. Each of the puppets had a letter of the alphabet on it instead of a name. They were showing their audience pronunciation and language development in Spanish. No one was being told right or wrong, the way adults do. Change could take place and one could speak more clearly and be understood. It was an interesting lesson." (See Figure 26B.)

"Boy! I'm learning that puppets can be used to introduce touchy subjects such as building self-confidence, drug abuse, sex education, really any subject."

"You're right. Puppets are used in training sessions, problem solving, almost everything you can think of. But you must have a puppet that is believable. Personality, voice, and manipulation are very important when working the puppet. Annie is an example. She appeared on TV and the children thought she was real because she was believable. They even called the TV station to speak with her. She was a real personality." (See Figure 27.)

"Is there ever a time when you wouldn't use puppets? You know, because maybe a person would better fit the purpose or intent?"

"You're right. There could be times where puppets would hinder a particular subject matter rather than enhance it. Puppets can be used to introduce new concepts, even change group response, therefore breaking down resistance to what's unfamiliar or threatening. Puppets, like people, are not good when used just to lecture or act like 'talking faces,' as I like to say."

"Boy! My bag is getting full. I am very glad I came along. Where do we go now?"

Figure 27 Annie, Jan, and the Kids (WFSU-TV, 1986)

Unpacking and Returning Home

"I think it's time to return to our home base and take a look at the things we have added to our bags. We can use some of the ideas now while others will be combined to create new ideas and concepts."

"You mean like the techniques for building and performing that we could use in the classroom or any other stage? Puppetry skills can be used to enhance subject matter to bring about change. What about change?"

"When we are introduced to change or new ideas there is a fear that we may fail when trying the idea for the first time. But failure is a gift to help achieve our success. We learn from our failures when we use them not to blame ourselves or others, but to continuously improve what we do, produce, and deliver. When we use our failures and experience to improve our selves, we build self-confidence by applying life's lessons."

"I should say. My bag is full of new concepts and ideas with the use of puppets for communicating. And now I know that I can always pack and repack my bag as I go through life. I would like to try some of the ideas when we get back. Can you play when we get back?"

Arts-Based Activities

Now let's look in our bag for some activities we could do with puppets. You may already have puppets that you can use for the following exercises or you may want to try your hand at creating one of your own.

1. Making a Basic Hand Puppet
 Materials required:

one ball for head	12" x 13" square cloth
eyes	strip of cardboard
nose	strong glue
hair	scissors
mouth	scraps for decoration

 The head can be made from a styrofoam ball (3" or 4"), newspapers in a ball shape, stuffed cloth, or head shapes. When you have your head shape, put a hole at the bottom of the head for the neck. Your finger will be inserted into the neck for head

control. A neck is made by a strip of cardboard (4″ x 3″). Shape the strip of cardboard into a tube, thinner at the top than at the bottom. Your finger will have to fit in the tube which serves as the puppet's neck. Insert the tube into the head using glue to keep it in place. Make sure your finger will fit into the tube and let it dry. Your first finger will be inserted into the tube, located in the base of the head, to control the head's movement.

Now you can create the face of your puppet. You may want to add hair, a hat or scarf, earrings, some decoration from scraps of material, or odds and ends like pompoms, felt, or buttons. When you are finished with the face you are ready for the body.

The body is where your hand will be placed and shielded from sight. Your fingers will become the head and arms of the puppet. The body can be made from a piece of cloth approximately 12″ x 13″ square. Allow the points of the cloth to fall to the front, back, and to one side and the other side. The center of the cloth will be attached by glue on the outside of the neck. Open your hand with your first finger in the neck of your puppet. Your second finger and thumb will become your arms. You can create arms for your puppet by cutting holes in the cloth after you locate their position under the cloth. When you have located the area for your fingers to come through, you can cut the holes and your finger and thumb will become the arms of your puppet. Now you have a basic puppet figure. (As in Figures 26A and 25B.) Let your puppet air dry completely before using it.

2. Creating Your Puppet's Character

Now that you have a puppet, the character or personality is ready for development. First, the character or personality of your puppet will be created by the voice you choose and the movements you create. You will want to disguise your voice. Main character traits such as good, evil, childlike, or compassionate should be pondered and decided. Other identifiers such as nationality, gender, age, and life experiences are also added into the mix. Once you have determined questions of traits and more, you can start on the voice.

The essence of puppet voice is determined by such factors as age, region, and differences in tonal range from high to low. Will the voice have a clear or nasal quality? These elements help to

make your puppet come alive along with its dress or costume.

Try some simple exercises to help your puppet character develop a voice. Begin by experimenting with different voices you know or have heard. Think of someone whose speaking voice you would like to try out. Make sure the volume of the voice matches the puppet figure. Puppets are also understood from the words they use and their movements. Make sure you are understood as intended when speaking. Have fun experimenting. You may want to try your voices when you are alone in such places as your car or even in the shower. Try taping your voice and play it back to see if the voice has the effect you want. Your puppet's voice can be developed and enhanced by combining it with movement.

3. Manipulating Your Puppet

Now that you have your voice, combine it with the movement of your puppet. How will you make it walk, run, turn, and express fear, anger, and sadness? Put your first finger into the puppet's head. Your thumb and second finger will become the arms. Your third and fourth fingers should curl up in the palm of your hand and become the puppet's body. You should have three fingers ready to use. To move the head "yes," bend your first finger up and down. For "no," move your finger from side to side. You have now mastered positive and negative movements. Clapping is done by bringing the thumb and the second finger together. Waving conveys good-bye or hello. The rubbing of your fingers together shows cold, evil, or sneaky traits. To pick up an item, the puppet bends from the wrist and the arms grasp it. When walking, move the puppet gently up and down with your arm and move slowly across the stage. Running is done with a choppy and more rapid movement than walking.

It is a good idea to practice in front of a mirror. You can see how your puppet looks to an audience. Can the audience see the puppet's face? Are you holding the puppet high enough to be seen? The best voice in the world for a puppet may not ever work or be believable if the whole puppet, head and body, cannot be properly seen.

Always hold your puppet high when on stage. If you hold the puppet so that the hemline is about one inch below the stage, the figure will be the right height. When having a conversation

with another puppet or person, have them face each other. Not only does your puppet express its feelings but it will react to other stimuli from other puppets as well. Remember that your puppet will take on human traits and behaviors even if the puppet is an animal. When combining voice and human movement, each puppet movement should have meaning and, where desirable, be clear and concise. Your puppet's movements should "carry" to the back of the room. Move your puppet to emphasize key words, ideas, and emotions. Try your voice with combinations of human feelings and movements. Also improvise situations using voice and movement. Examples include singing a song, walking a dog, going to a movie, meeting a new person, watching a circus, reading a book, and receiving a gift. You are now ready to introduce your puppet to the world. Remember to ask others: "Hello World, can you play?"

Acknowledgment

The authors listed below influenced the development of my chapter as well as its performance-based art activities.

References

Baird, B. (1965). *The art of the puppet.* New York: Macmillan.

Dowie, F. (date unknown). *Big is Beautiful.* Self-published.

Engler, L., & Fijan, C. (1973). *Making puppets come alive.* New York: Taplinger Publishing.

Kaufman, R. (1998). *Strategic thinking: A guide to identifying and solving problems* (Rev. Ed.). Washington, DC: International Society for Performance Improvement. Arlington, VA: American Society for Training & Development.

Philpott, V., & McNeil, M. J. (1975). *The fun craft book of puppets.* Baltimore, MD: Ottenheimer Publishers.

Rottman, F. (1981). *Easy-to-make puppets and how to use them.* Ventura, CA: Regal Books/GL Publications.

Stanislavski, C. (1958). *An actor prepares.* New York: Robert M. MacGregor.

Chapter 15

Animals and Curriculum Masters

Nick Paley
Jan Jipson

"Animals and Curriculum Masters" was begun on February 22, 1996, at the annual conference of the American Association of Colleges for Teacher Education (AACTE) in Chicago, Illinois. The study emerged from a need to address familiar forms of discourse about teacher education in a new and different way in order to sharpen the intensity of discussion relating to the making of such discourse. Central to the study's experimentation was the attempt to create a radical interpretive space for reexamining fundamental educational questions—"what counts as educational knowledge?" and "who decides?"—but also for raising others—"what forms count in the shaping of these questions' construction?" and "how do these forms affect the production of our thought and work?" It was from this background that we approached these issues through a deliberate exploration of materials and methodologies different from those sponsored by AACTE.

To accomplish these goals, data were collected using available print and visual resources from, at, and near the conference on that day. Data selection was random, specific, and spontaneous. We chose those images and texts that closely corresponded to our personal, intellectual, and aesthetic preference as we encountered them at and around the conference headquarters. Data display was grounded in the processes of a surrealist arts-based practice as originally explored by William Burroughs and as more recently developed by Kathy Acker. Inspired by their examples, we tore specificities from totalities, reconstructing language and image, content and context to spark new ways of perceiving relationships among officially held understandings.

Article pages were then assembled into a research "narrative" following Britzman's (1994) concept of "non-narrative narrativity." This process resulted in an essay that was specifically designed to leave just enough separation among each of the pages to provide sufficient room for readers to make their own meaning(s) from the reorganized material.

In producing "Animals," we found a strong and powerful borrowing in the thinking of a diversified group of educators and theorists committed to transformative educational practice. We value the efforts of those educators who, like Elliot Eisner (1997), "sail by other stars" in order to explore "the wider varieties of human intelligence [and] the edges of possibility" (pp. 8, 9) in their struggle to create and represent educational meaning. We also support, following Maxine Greene (1994), those kinds of interpretive experiments "that do not duplicate other narratives" (p. 218). And we believe that bell hooks (1994) has shown educators a way by challenging all of us "to change the set agenda" (p. 156) as we struggle to determine the future processes of teaching and learning with passion, imagination, and hope.

It is along these kinds of lines that we find meaning in doing our alternative work, hoping that these creations, "as they organically arise and develop can be, in and by themselves, a real force against the given scheme of things" (Cocks, 1989, p. 217).

References

Britzman, D. (1994, March). *On refusing explication: A non-narrative-narrativity.* Paper presented at the annual meeting of the American Educational Research Association, New Orleans, LA.

Cocks, J. (1989). *The oppositional imagination: Feminism critique and political theory.* New York: Routledge.

Eisner, E. W. (1997). The promise and perils of alternative forms of data representation. *Educational Researcher, 26*(6), 4–10.

Greene, M. (1994). Postmodernism and the crisis of representation. *English Education, 26*(4), 206–219.

hooks, b. (1994). *Teaching to transgress.* New York: Routledge.

ANI MAL S
and
Curriculum Masters

Jan Jipson & Nick Paley

Thoughtful inquiry and research into the processes involved have led to new ways of teaching and assessing.

THE

session types

M A D E Y O U

Remember

THE

CONTROL

M A D E Y O U

a c t

Teachers all over the country are designing more inclusive approaches to teaching and assessing all aspects of student literacy.

peals to adolescents, it can't possibly be curriculum. Attempts to legitimize

allowed him to live his life twice—once in experience and once again as the evolving draft illuminates the texture and meaning of that experience.

She demonstrates how to turn intimate experiences into beautiful words without loss of heart, and that the deepest discoveries require sometimes the briefest expression.

DATABASE

LANGUAGE POLICIES

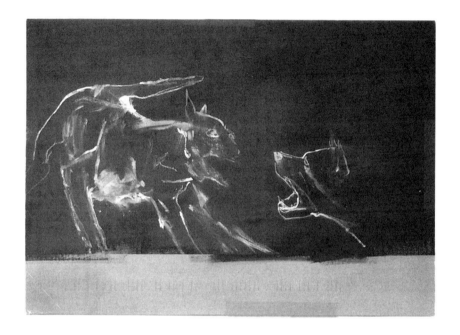

IN A CHANGING WORLD

the dominant culture and interested in bringing about social and political change? What's to be gained by breaking from traditional

it

reads like a novel,

until it breaks in two,

RABBET

without first changing the society.

I am happiest when rubbing two words together to produce an unexpected in-

Chapter 16

"WH ERE SH OULD WE BE GIN?":
Palimpsest as "Space Probe"

C. T. Patrick Diamond
Roslyn Arnold
Clare Wearring

[Meaning and its] breaks are always reinscribed in an old cloth that must
continually, interminably be undone. (Derrida, 1981, p. 24)

Old paint on canvas, as it ages, sometimes becomes transparent. When that
happens it is possible, in some pictures, to see the original lines. This is
called pentimento because the painter "repented" or changed his mind. The
old conception, replaced by a later choice, is a way of seeing and then seeing
again. (Hellman, 1976, p. 3)

An Antipodean Setting

A beginning to our portraits, "down under" in Australia. "Thanks for
agreeing to be Clare's second reader." Roslyn poured coffee and of-
fered Patrick his choice among a selection of biscuits. A low table
formed a conversation corner in her office away from her desk and
telephone: "Sorry they're not as fresh as they might be." Roslyn was
chair of a university education department and had invited Patrick, an
experienced dissertation supervisor, to begin his term as a visiting
scholar by presenting at a conference she had organized on teacher
reflection. A range of professors and teachers attended, together with
some teachers in preparation that Roslyn was supervising, including
Clare. During the conference, Patrick was struck by Clare's candor
and enthusiastic openness to experience. Some weeks later, having
just completed her final practicum, Clare came in from her assigned

school to discuss her qualitative research project over coffee. Roslyn had developed a pedagogical theory based on empathic attunement and Patrick, a theory of teacher inquiry using arts-based forms. After we three chatted together, Roslyn asked: "Why don't we do a paper about doing arts-based qualitative research?" This chapter is the result.

As a new beginning, postmodernism represents a self-consciously transitional moment marking the "not yet" off from the "no longer" (Lather, 1991). With the alleged demise of the realist position in academe, the study of particular experience in self-critical ways is increasingly being legitimated (Bessant & Holbrook, 1995). Empathizing with participants and with ourselves as coresearchers is crucial to such inquiry. While dialogue journaling and self-reflection, for example, provide for the collaborative evocation and examination of personal and shared dilemmas, they may not always confront the problems of representation. Although social science has taken an undeniably postmodern and literary turn, the debate in teacher education and educational research is still conducted very conservatively in terms both of the qualitative versus quantitative orientation, and of methodology.

Postmodernism, Empathy, and Allegory

Suggestions as to how to begin *reading* this chapter are made in the section, "Reading Our Palimpsest," below. As discussed in chapter 1, skeptical postmodernists reject epistemological assumptions, refute methodological conventions, resist knowledge claims, and obscure all versions of "truth." They privilege *sense* experience and "a highly personal, individual, non-generalized, emotional form of knowledge" (Rosenau, 1992, p. 3). Conventional academic discourse is abandoned in favor of cross-disciplinary, literary, and provocative forms. The strict linearity of plot is suspended and any organized story elements or design must be invented by the readers as they confront an intriguing mixture of genres and representations. Exploring alternative forms and meanings, the aim is to shock, startle, and unsettle. Contradictory perspectives are invoked and experience is seen as inescapably entangled with our descriptions of it.

Affirmative postmodernists also accept personal experience, feelings, empathy, and play as substitutes for "scientific" method. Even as the methods of natural and physical science are no longer seen as appropriate to the study of human activity, teaching and inquiry can

be seen as a text, a collection of symbols expressing layers of meaning (Dilthey, 1911/1977). Such a text can be variably interpreted through indwelling with participants over the course of the inquiry. As in art, empathy (*einfuhlung*) involves imaginative participation in the experience of others, putting self into the others' place, taking their feelings as if they were our own, and adopting a kind of "say we're you" stance. This requires emotional attunement with, and understanding of, the inquiry partners as well as the desire to cross over prescribed boundaries.

Pinar, Reynolds, Slattery, and Taubman (1995) also understand empathy as a prerequisite for understanding the intentions of others. But they warn that empathy might conceal as well as reveal. Intentions can "function as self-rationalizing, self-forgiving, indeed self-deceiving ideas. Empathizing with another, if it means losing one's distance from the other, one's sense of a critical edge, might lead to collusion" (p. 583). Empathy is neither blind nor one way. As in an encounter with a work of art, we need to become more fully and not less present. As we take into ourselves the selfhood of the inquiry coparticipants, our whole self-understanding is placed in the balance and put at-risk. Just as we ask questions of the artwork and of the others, they put questions to us as well.

Postmodernism is preoccupied with the reading of text and with the failure of all attempts to decipher it once and for all times. Owens (1980) bases his general theory of postmodernism on the return to allegory in contemporary art. The only thing that a text can refer us to in our effort to grasp its meaning is another text—particularly that composed by the reader. But the fragmentary, piecemeal combination of images that initially impels a reading is also what blocks it, forming an impenetrable barrier. Barthes (1977) thus sees text stereographically, as "made up of multiple writings, drawn for many [sources] and entering into mutual relations of dialogue, parody, and contestation" (p. 148). He so privileges the reader as writer that interpretation becomes the central role in relation to text. Text in turn is meant to provide an experience of transformation for its reader.

Allegory is traditionally defined as an extended metaphor in which the characters and events in a text acquire double meaning, as in a fable or parable (see Borges or Kafka). Allegory (*allos*, other; *agoreuei*, to speak) occurs whenever one text, image, or person is doubled by another. The Old Testament becomes allegorical when it is read empathically as a prefiguration of the New Testament. A text can also

double back self-consciously on itself to provide its own commentary: "In allegorical structure, then, one text is *read through* another, however fragmentary, intermittent, or chaotic their relationship may be; the paradigm for allegorical work is thus the palimpsest" (Owens, 1980, p. 69). In palimpsest (from the Greek, *palim*, again; *psestos*, rubbed smooth), another meaning is added to an antecedent one (as shows later). Just as parchment, canvas, and brass can be reinscribed, different texts can play off one another.

In this chapter, Clare Wearring (the former beginning teacher-researcher), Roslyn Arnold (the supervisor of Clare's project), and Patrick Diamond (an examiner-reader) write about their involvement in different forms of qualitative research. We draw on sources ranging from private to public conversations and texts, including Clare's (1996) research report, Patrick's appraisal of it, and previous publications by Roslyn and Patrick. Our respective contributions are cited at the bottom of different pages to provide a textured reaccounting of our experiences. Using a palimpsest (as discussed in the next section), we share aspects of our research stories as we comment on each other's story. Clare's original inquiry was into the classroom experiences of 15-grade 9 girls, as well as into her own teaching and research. She translated these stories into a research report, "The dynamic between empathic attunement, drama enactment, and literacy development: A case study" (1996). Patrick and Roslyn read Clare's witnessing account and reflected on it. We then all cleaned the slate to "come clean."

Wearring (1996)
Empathy seeks to work from the inside out, working to discover what made an individual act in the way s/he did. It is the act of putting oneself in the place of someone else (p. 19).

Arnold (1993a)
The triangulated nature of empathic attunement derives from the teacher's attunement to students' thinking and feeling states, and to his or her own thinking and feeling states, plus the students' empathic attitude to their own and others' states (p. 60).

Diamond (1996)
I especially enjoyed your concluding "Upon Reflection" section where you wrote in the first person for the remainder of the final chapter (p. 79ff). A qualitative report, like the novel you read and role played with your class, gains from being re-presented in the first person (p. 1).

As the authors of this layered work, we acknowledge and respect our different contributions to the chapter. Where an experience clearly belongs to only one of us, we use our individual names. We use "we" to acknowledge that our separate voices are often, but not always, in harmony. While we share significant areas of our teaching-research interests and developmental agendas, they are by no means fused. While we try to remain open to construing knowledge and values from different perspectives, we do not want to lessen our commitment to our own. We invite our readers to join our collective "we," filling out the spaces in the margins of the researcher-participant reflections (compacted in "down-under" fashion).

Readers can choose how and when to read each of the texts and how to criss-cross between them. We explored arts-based inquiry as a means of articulating what happened as we reflected on the students' and our researcher experiences and then wrote to derive meanings from the encounters. Our assembled text provides our representations of the experience and also is a means to understand it. We ask "How can researchers listen to and represent the experience of others and themselves?" and "How can researchers show they are part of the research story they tell?" (Erickson, 1996). We respond to these promptings and reflect on their significance through the use of a textual strategy in which our different voices slide over each other's on the pages. This interplay enables us to represent our sets of parallel expressions and developing understandings as works in progress. All

Wearring (1996)

Each of the students kept a reflective journal of their thoughts and feelings about the lessons (p. 43). I did not want to reduce the quality of a student's work to a mere rater's score (p. 35).

Diamond (1996)

As you decided, a quantitative design would have been "highly difficult" (p. 34) and inappropriate for your project. In a time of paradigm shift, terms such as qualitative and quantitative, even when used in new ways, still retain much of their former adversarial force (see pp. 18, 26, 32, 34, 37 of the report). It is tempting to set up one kind of research as a foil against the other, damning it to a benighted state in comparison with which the other appears as a state of enlightenment. Perhaps your aim was not so much to measure the effectiveness of psychodynamic pedagogy (p. 17) as to seek to better understand it. As you say on p. 18, you aimed to vicariously introspect on the students' and your own affective experiences of role plays based on the set novel. In qualitative research, data are not so much collected as meanings are shared and reconstructed (p. 2).

that is now possible in postmodern inquiry is to devise some kind of labyrinthine display of "pieced-together patternings" (Geertz, 1995, p. 2). We endlessly construct hindsight accounts of the connectedness of what seemed to have happened. As we sought to interrelate our different texts, the work became an allegory of our experience of empathic mirroring of one another. The unconventional display of text seeks to encourage playfulness and mocks the imposition of any final order. The fragmentation teases the readers into making their own connections.

Split Text and Palimpsest

We offer this chapter as an example of an innovative postmodern text. Postmodern, or cut-and-paste, inquiry (as literally demonstrated in chapter 15) is better evoked by considering the characteristics of a range of particular strategies rather than by providing any precise definition of "method." New forms that further such inquiry without demanding exclusive adherence to rigid strictures include split text (Bennington, 1993; Blumenfeld-Jones & Barone, 1997) and palimpsest (Lather, 1995; Owens, 1980; Vidal, 1995).

In split text, both story and commentary can be presented on the same page, either as parallel vertical columns or horizontal rows. In response to, and as a demonstration of, postmodernist writing techniques, Middleton's (1995) left-hand entries are written in conventional academic form in order to draw out the implications of postmodern theory for feminist pedagogy in education courses. Her right-hand interruptions describe the location and circumstances in which the left-hand columns were written. Middleton transgresses academic forms in order to expose their constructedness.

Bennington's (1993) study of Derrida was also split into two texts. The top two-thirds of pages consist of Bennington's intellectual biography of Derrida and the bottom shaded third consists of Derrida's

Wearring (1996)

Qualitative research emphasizes the validity of multiple meaning structures and holistic analysis. It recognizes the importance of the subjective and the experiential lifeworlds of individuals. It embraces the multitude of personal meanings that are derived from the context of direct experiencing (see Burns, 1994). If research is to be interesting as well as convincing, intriguing issues need to be raised and presented—and in new ways (p. 35).

reaction, providing an internal "down under" zone in which, as the subject, he can elude the proposed systematization of his work. The Ameurunculus letter to Barthes (Phillipson, 1989) takes the related form of a triple decker sandwich or horizontal triptych, with the top and bottom thirds of the page consisting of a response to Barthes' writings. The layer of filling, in bolded upper case, takes the form of an endless conversation. Its themes parody those raised in the main body of the text.

Confronted with the postmodern collapse of the "real" into its representation, Lather (1995) argues that the need for concrete material practice is intensified rather than dispelled. She searches for a multi-layered way of telling and weaving together stories that are not just those of the researcher. To produce rather than protect her own work-in-progress, Lather (1995) "constructs a palimpsest, a sort of etch-a-sketch writing erased imperfectly before being written on again" (p. 56). She provides a palimpsest where primary and secondary texts collapse into works that are not yet authored. The varied text consists of strategically underdetermined conceptual assemblages that oscillate between rigorous and inexact, inventing new tools for thinking, and connecting the work to becomings. In this way, distinctions between I/we/they, researcher/researched, teacher/students, teacher educator-researcher/teacher, and reader/writer are blurred, and categories denied. All the participants are located on the same reflective plane of inquiry.

Lather (1995) chronicled the stories of 24 women living with HIV/AIDS. As coresearcher, she situates herself not as an expert saying what things mean in terms of "data," but rather as a witness giving testimony to what is happening to these other women. The stories of the interview transcripts are paralleled by a subtext of the coresearcher's

Wearring (1996)
Our perceptions are shaped according to "our angles of repose" (Taylor, 1996, p. 14). The girls helped me to see new things in the characters in the novel and in my teaching (p. 39).

Diamond (1991)
A polyphonic form consists of a knot of discrepant stories whose connections are not immediately apparent. It includes many points of view, many voices, each of which is given its full due. Such a genre encompasses differences in a simultaneity (p. 98).

commentary running across the bottom of the pages (as in our pal-impsest). The stories are also interleaved with excerpts from popular culture, history, poetry, and sociology. The texts are placed within their many contexts. As Lather (1995) demonstrates, no one owns the truth and everyone has the right to be heard.

We compare palimpsest as a textual strategy with pastiche, simulacrum, montage, collage, and allegory. Like pastiche, palimp-sest is an apparently random text, successively assembled like "a free-floating, crazy-quilt, collage, hodgepodge of ideas or views, including elements of opposites" (Rosenau, 1992, p. xiii). It seeks contradiction and an ongoing lack of finality. Both pastiche and simulacrum consist of imitations of the past in the present. Jameson (1991) describes pastiche as "blank parody. . . . Pastiche is the imitation of a particular or unique, idiosyncratic style, the wearing of a linguistic mask" (p. 17). Borges and Pessoa excelled at this form of palimpsest. A simulacrum is "the identical copy for which no original ever existed" (p. 18). As Pinar, Reynolds, Slattery, and Taubman (1995) explain, the postmodern representation of only representations for which no anterior reality exists is substituted for the now discredited modernist attempt to represent "reality." In imitating a screen kiss, a teenager may be kissing in a way that was never real, only staged—so too with a graduate student seeking to imitate a model of scientific inquiry that never existed.

Palimpsest is like montage in traditional border ballads or contem-porary film. Fragments are superimposed ceaselessly, without strict adherence to any single goal. In visual art, collage is linked with pal-impsest in that both use strategies of accumulation. They manipulate and consequently transform highly significant fragments by "exploit[ing] the atomizing, disjunctive principle which lies at the heart of allegory" (Owens, 1980, p. 79). While one text cannot easily be superimposed over another on the printed page, but only added beside/below or after/before it, meanings are piled up and deferred.

In an allegorical work, something else is brought together with the thing that is made. Rauschenberg's "combine painting," *Allegory,* consists of such a seemingly random collection of heterogeneous ob-jects that it is difficult to discover any common property in this inven-tory that might coherently link them together. One metaphor is that of the refuse heap, wasteland, or reservoir. The work then becomes an allegory of (un)consciousness. But, if this narrative is imposed, the

painting becomes an allegory of its own fundamental "unwritability." The confusion that the artist sets out to expose is perpetuated. In postmodernism, the activity of reference is problematized and celebrated.

Postmodernist artists work with materials at hand, manipulating them in various ways, including palimpsest (parody, pastiche, collage, juxtaposition). The aim is to use things (materials, ideas, and forms) in such a way as to avoid being dominated by them. Postmodernism highlights complexity. Having lost our modernist, normative moorings, we can only draw on a multiplicity of plots (Rabinow, 1984). In our palimpsest, we three are seeking to provide an artfully reinterpretable, if contradictory patchwork of perspectives. This is the *Rashomon* way of developing a narrative or presentational account of research. Directed by Akira Kurosawa (1951), this classic perspectivist Japanese film depicts a rape-murder as seen through the eyes of four witnesses. The film's title has passed into the language as a way of indicating that accounts given of the same set of events vary greatly. Our account is related by three main participants whose different versions of meeting and working together are combined to undercut the privileged text of "scientific" research. Palimpsest provides the fourth or shared voice. As this technique shows, all writing is only interim or progress reporting.

In a trilogy of novels based on the experiences of an anthropologist-therapist (Captain Rivers) who treats shell-shocked veterans (including Billy Prior) returning from the front, Barker (1994) describes "the past [as] a palimpsest [in which] early memories are always obscured by accumulations of later knowledge" (p. 55). If pioneering social scientists like Boas (1943) did not recognize the legitimacy of personal memory and self-report, their graduate students did. All individuals (students and educators) can now draw on arts-based approaches to construct their past experiences. Using life history approaches, they can chart the course of their careers (or research

Wearring (1996)
I am still developing my own theory of best practice. I am promoting similar qualities in my students, encouraging them to find their own voices. The researcher has now become a subject of the research. She has changed and developed as a result of the process. Hence I now use the personal "I" (p. 79).

projects), reconstruct watershed experiences, and reflect on their sig-
nificance. After all its turnings, the meandering stream of experience
empties into the present and flows back into the past (see chapter 3).
The "oversocialized" image of the person that was common in educa-
tional research is becoming supplemented by the perspective of the
actor's "I" (Mandelbaum, 1973), or, as in this instance, by multiple
perspectives.

Borges believed that "memory is clearer than reality" (in Woodall,
1996, p. 95) and Vidal (1995) agrees that "even an idling memory is
apt to get right what matters most" (p. 5). After announcing in his
memoir, *Palimpsest*, that he is his own subject of inquiry, Vidal (1995)
describes his method of presentation as that of a palimpsest or a
"paper etc. prepared for writing on, and wiping out again, . . . a
parchment, etc. that has been written upon twice, the original writing
having been rubbed out" (p. 6).

What a writer of memoirs does—starting with a life, making a text,
then sensing a re-vision, literally a second seeing, an afterthought,
erasing some but not all of the original, writing something new over
the first layer of text—is very like the process of producing a research
palimpsest. Insights are added and subtracted, rubbed out and put in.
A palimpsest provides a series of archeological layers to be excavated
like the different levels of an ancient city. The layering of our joint
research consists of traces laid down by Clare, which later are resur-
faced together with Roslyn and Patrick. We sought to open up rather
than cover up our meanings. We add to each other's previous text but
know that it can never all add up to a uniform perspective or whole,
complete view. Although calculated, our sets of meanings remain at
odds with one another, and even with themselves.

Wearring (1996)
The students wrote about the effects of the role plays based on a class novel: "It
helped me understand each individual character better. I began thinking along the
same lines as the person I role played. It also helped me to act more easily as
I was thinking from within that character's frame of mind or way of thinking"
(p. 62). Another added: "The role playing made me feel what the characters were
experiencing. Trying to get across their reactions made me think about and
analyze their feelings" (p. 63).

Arnold (1991)
A psychodynamic approach to language learning involves drawing, movement,
drama, model-making, and play activities (p. 7).

Reading Our Palimpsest

In musical counterpoint, one note is placed above or below another, that is, note against note, like text against text. In palimpsest, split text flows down or across the page, without interruption, with the columns or the rows next to one other. As Blumenfeld-Jones and Barone (1997) show, parallel and mutually intrusive columns or rows of texts on the same page pose questions for the reader to answer: "Which should I read first? Should I alternate sentences? Where are the 'natural' break-points where I might shift back and forth?" (p. 88). Chance is able to play a role in the final location of text.

Unlike pentimento, where different elements are painted on top of one another, in palimpsest the different voices are laid side by side or top to bottom, up against one another, in juxtaposition. Our palimpsest consists of our three separate versions and one joint account of doing qualitative research. Unlike Clare's original project report (Wearring in this chapter), the coauthored expression resembles a hybridized text, inviting multiple ways of being read. Clare's assigned task about which she wrote was based on a four-week, school-based research inquiry. This implied having an organized overall design, as did her goal of satisfying course requirements. The project aimed to induct preservice teachers into research practices, even serving as a pilot study to inspire a dissertation proposal for subsequent higher degree work. Teacher candidates are thus offered an opportunity to discover something about conducting research largely on their own.

As Wolcott (1994) emphasizes, beginning researchers need to have firsthand experience with fieldwork strategies that involve participant observation, interviewing, transcribing, and putting together an

Wearring (1996)
The students wrote about the effects of the role plays based on a class novel: "It helped me understand each individual character better. I began thinking along the same lines as the person I role played. It also helped me to act more easily as I was thinking from within that character's frame of mind or way of thinking" (p. 62). Another added: "The role playing made me feel what the characters were experiencing. Trying to get across their reactions made me think about and analyze their feelings" (p. 63).

Arnold (1991)
A psychodynamic approach to language learning involves drawing, movement, drama, model-making, and play activities (p. 7).

account: "The way to begin research is to begin research and proceed with a genuine study" (p. 400). During her practicum, Clare chose to conduct a qualitative inquiry into the effects, on one of her assigned classes, of role-playing fictional adolescent characters. These were drawn from a novel set in the students' home city. Clare's major experienced research finding was that the girls became more empathically attuned to the characters, each other, and to her.

Although formal on-campus course offerings had made limited reference to qualitative inquiry, Roslyn, Clare's supervisor, encouraged her with a series of relevant readings which they discussed, as well as drafts of the research report. As Clare later agreed with Patrick, she was attracted to qualitative approaches because they "offer[ed] an escape from the tyranny of statistics, control groups, tight treatment design, contrived variables . . . compulsive measurement, meaningless surveys" (Wolcott, 1994 p. 414). She gathered "data" on her own and sought to analyze, interpret, and report them, struggling to provide some kind of structure. She also had to deal with the constraints that

Wearring (1996)
Drama or the adoption of roles is a most effective facilitator of empathy. It is this "participant/ percipient dichotomy, involving the balancing of two worlds within the frame of drama that provides its particular potency in learning" (Fleming, 1995, pp. 59, 13).

Diamond (1996)
Drama involves performance which invites a human, rather than a natural science kind of inquiry. There is no simple solution to how many times we would have to see a Shakespearean play before we "got it." You might contrast Anthony Sher's (1985) *Year of the King*, which consists of his diarized experiences of a year's rehearsal for *Richard III*, with Wagner's doctoral thesis on the effects of drama. Wagner (1994) regretted that, in her thesis, she felt constrained to:

> Assess the effect of each mode of instruction using a counterbalanced quasi-experimental four-way randomized groups design. I analyzed the data with analysis of covariance with the covariant of length, and with post-hoc Newman-Keuls test (p. 32). The main effects show that fourth and eighth graders who role play produce persuasive letters that are significantly more oriented toward their target (pp. 33, 2).

Arnold (1993b)
One important method to help student actors to develop roles is to have them keep role-journals in the period following their initial role-preparation (p. 32). Enactments gain from the creation of characters' biographies, involving group decisions as well as private journaling and reflection.

were imposed both by the rules of the school and the requirements of her course.

As O'Neill (1996) argues, empirical gatekeepers (such as some dissertation examiners and awards committees) may seek to impose a strict correlation between the elusiveness of a topic and the stringency and inappropriateness of the quantitative kinds of measures applied to it. Patrick agreed to serve as one of Clare's examiner-readers and sought to provide a constructively evaluative and letter-like report. The inquiry format that evolved in the trio's later work together appealed to Patrick. His own writing had often begun with a quotation from someone else that had then set him to reflecting and writing on his own, "buttressed by more quotations, making a sort of palimpsest" (Vidal, 1993, p. 511). If nothing else, he too was an arranger of the displays of others (see chapter 4).

Overall, we used a palimpsest to affirm our different voices juxtaposed in the "reflexive exploration of our own practices of representation" (Woolgar, 1988, p. 87). Clare first checked her interpretations with her students, other teachers, and herself and later with her supervisor and examiner. Lincoln and Guba (1985) describe credibility as a criterion of trustworthiness that is satisfied when "source respondents agree to honor the [researcher's] reconstructions" (p. 329). As an example of the need for this practice, Erickson (1996) cites reports of Trobriand native informants bridling at the number of times they felt that Malinowski had failed to express the sense they had of themselves and of their ways. No one has the final word.

Peer debriefing is another technique recommended for maintaining the credibility of an inquiry and its reporting: "The process helps keep the inquirer 'honest,' exposing him or her to searching questions by an experienced protagonist doing his or her best to play the devil's advocate" (Lincoln & Guba, 1985, p. 308). We sought to enact a less one-sided and more collaborative and supportive set of roles with none of us escaping the searching questions. We sought to reduce established academic inequalities by crossing the boundaries that can often separate Honors' candidate, supervisor, and examiner.

Reflections on Our Palimpsest

We used a palimpsest as a multi-track form of qualitative inquiry to prevent our positions from being overrun either by the traditional one-track method of "objective and dispassionate" quantitative research or by the dictates of any one of our voices. We sought to inquire into

and affirm the legitimacy of multiple realities and alternative interpre-
tations through considering their trustworthiness and credibility. But
we may have overemphasized the quest for coherence. The aim of
qualitative inquiry is not verification of what is already known but dis-
covery of new insights. Once we accept how little we can ever know
or fully understand, it is the quality of insight that matters most.

What do "we" (Clare, her students, Roslyn, and Patrick) make of all
this untidy straddling of texts and agendas? Do we, as arts-based,
postmodern inquirers, still unwittingly seek the commodification of
others for our own selfish consumption? Miles and Huberman (1984)
overstate the case when they allege that "fundamentally, field research
is an act of betrayal, no matter how well intentioned or well integrated
by the researcher" (p. 233). Member checks and peer debriefing are
two qualitative practices that ensure that the researched and the re-
searchers have the right of reply, lessening the likelihood of their mean-
ings being selfishly appropriated. We sought to respect our partici-
pants as colleagues and resisted dissolving them either into faceless
norms (Mandelbaum, 1973) or into convenient fictions that served a
researcher's plotline. Clare, as the represented, was able to "confront"
her representers.

Knowles (1960) based his novel, *A Separate Peace*, on the school
days that he shared with Vidal at a New England boys' school. Accord-
ing to the author, the character Brinker, the class politician in the
novel, was based on Vidal. Although Vidal (1995), the source respon-
dent, agrees that he was indeed conspicuous at debating societies, he
does "not see the slightest resemblance" (p. 90) between himself and
Brinker, the fictional snoop who tries to find out whether one boy (the
academic star) caused another (the class athlete) to fall headlong from
a tree. Nevertheless, Vidal admires the novel for its "eerily precise
reconstruction of how things were in that long-ago world before the
second world war" (p. 90).

Diamond (1996)

Clare, congratulations on such a courageous qualitative study! As an student-teacher
and active research participant, you reported feeling the pressure of constantly be-
ing evaluated and hence "driven to prove yourself throughout the implementation of
the research" (p. 74). Learning to teach involves so many evaluations that it can be
compared to being a learner driver with someone else always ready to take control
and fail you. The temptation is to take as few risks as possible, limiting oneself to
safe maneuvers. I am glad that you did not choose the easy way (p. 1).

Clare felt that Roslyn and Patrick empathized with her situation. For them, she evoked school as a meeting place of routine and interruption, timetables and vacations, required texts and personal feelings, examinations and student absences, skepticism and enthusiasm, and of seriousness and humor. What recommends the structures of our combined research representation "is the further figures that issue from them: their capacity to lead on to extended accounts which, intersecting other accounts . . . , widen their implications and deepen their hold" (Geertz, 1995, p. 19). Everything is a matter of one thing leading to another, and "the result is a grand contraption" (p. 20) or imaginative rearrangement.

Plural authorship affords all participants the apparent space and status of reader/writers. We three began at different points of development in the evolving process of practicing and learning about arts-based research. As learners, we ranged from two academics and supervisors of doctoral dissertations to an Honors student who was a beginning teacher and researcher. Through conversation and writing, we became each other's critical helpers. As a teacher in preparation, Clare was less familiar with inquiry. This was an advantage in that her contributions, as the initially more wary or fresh outsider, helped to surface taken-for-granted features of the inquiry. Rather than suggesting what other inquirers should do in the name of inquiry, we have looked at what we did to transform what we observed, discussed, and read. Those who preach and teach alternative research, as well as those who practice it, need to "prove" their *bona fides* by undertaking inquiry into their own teaching and research (Bessant & Holbrook,

Wearring (1996)

Empathy encourages us to decenter, to acknowledge that another may be feeling different from us and it encourages us to experience feelings beyond those immediately accessible. . . . It is the act of one individual putting oneself consciously in the place of someone else (p. 19).

Diamond (1996)

Clare, congratulations on not sacrificing words and meanings to numbers and statistics. We sometimes need to frame our inquiry as a sonnet sequence, a dialogue, or an anthology of short stories. The scientific dream of reducing the complexity of classrooms, teaching and learning, to a single number seems, in the end, to be pointless. If the old world of quantification was very simple, and that of the new world of arts-based research is very difficult, it is nevertheless impossible to turn back (p. 2).

1995). Researchers can answer the charge of having betrayed rather than portrayed their participants by being revealing about "messy" aspects of themselves and their research contexts.

In our inquiry, we sought to piece together traditional dichotomies by recognizing that, as researchers, we remain people in concrete settings and that the participants we studied, including ourselves, can only partly know themselves as their own subjects. No one group enjoys a monopoly over understanding and insight. All are coresponsible for representing and making meaning of experience. We retained our original voices, contrasted and merged in conversation and reflection. Like a fugue, these can be heard in turn and at the same time without being muffled or fully blended.

Clare successfully graduated after her year of professional preparation and is now teaching at the girls' school where she completed her practicum. Our research account consists of assembled fragments of stories that translate, encounter, and recontextualize other stories (Clifford, 1984). They are cobbled together in a form of *bricolage*. To ensure continuity in the write-up, Patrick provided some distancing meta-commentary. But smoothing may have robbed the fragments of tension and contestation. Too much courtesy can blunt mutual inquiry. Palimpsest needs to function as a perception as well as a procedure. Meanings then remain fissured and unresolvably varied, with confusion jostling connection. As a form of inquiry, palimpsest can resist any finalizing or totally explanatory word being imposed on its circlings.

Arts-Based Activities
1. Which set of two coparticipants' comments are deliberately repeated in the text and to what effect on you as the reader?
2. Which of the individual voices of the coauthors was able to speak more directly to you? How did that voice manage to penetrate the more discursive, impersonal voice of research?
3. Find the plan or notes for a lesson or lecture that subsequently went very well or that you feel could have been improved. Using your present voice, write on the text about what worked and what you would now do differently.
4. Reconstruct the dialogue for a scene in which you were being advised by a supervisor either during a practicum or during a research project. How did the negotiations or conversation proceed?

Postmodern Space

Postmodernism ignores linear time and Euclidean space, opening up opportunities for a pastiche of the old and the new. Space is dissolved "as a knowable, manageable constraint and [is] replace[d] with hyperspace, which conceives of space as fragmented and disorganized, as manifesting gaps of undecidability" (Rosenau, 1992, pp. 72–73). Science fiction often involves interplanetary time travel. It assumes that an imaginary advance like a time machine or a monstrous distortion in knowledge and technology has been made. As projected and empirical worlds collide, traditional and alien life forms compete for authority. Text and space also compete in postmodern works. Planned shapes are physically discontinuous, segmented, and "spaced-out." Spacing can constitute an act of subversion, as in Monique Wittig's (1979) poem.

Les Guérillères

LACUNAE LACUNAE
AGAINST TEXTS
AGAINST MEANING. . . .
MARGINS SPACES INTERVALS
WITHOUT PAUSE
ACTION OVERTHROW (p. 143)

The choice of spacing and upper case headlines heralds a carnivalesque revolution, and not just against literary norms. As Jipson and Wilson (1977) show in TH AT DIA LOG UE AT NI GHT, perhaps one of the most radical examples of multiple text in educational inquiry, "carnival is the place for working out, in a concretely sensuous half-real and half-play-acted form, *a new mode of interrelationships between individuals*" (Bakhtin, 1984, interpolated in Jipson & Wilson, 1977, p. 163). Within the wide-open, white space, each separate piece of text "constitutes an independent unit, a miniature text in its own right" (McHale, 1987, p. 182). In between the texts, the "spacey" gaps and holes invite other previously outlawed voices to be heard.

In reading the space probe of a palimpsest, there is hesitation and oscillation. The order is not fixed but must be improvised, even if as a kind of hopscotch. We are forced to choose where to read first, the "main" text or footnoted entries, and by which author. The reader wonders where to begin and where to end. Perhaps there is some

analogous relationship between the blocks of columns or rows. Are the juxtapositions deliberate or random? Forced to manipulate the text as a material object, "we must call into question all that is apparent or predictable. So the inquiry goes beyond reflection or analysis but I'm not sure to what" (Janice's final wave in Jipson & Wilson, 1997, p. 181). Bemusement/amusement, annoyance, and frustration can be foregrounded in spaced texts. Defining itself as the space that comes after modernism, postmodernism is also a palimpsest, valuing heterogeneity over unity, and innovation over convention.

As we three found over coffee and Australian biscuits, many of the alternative versions of teaching and research, including those yet to be told, may be equally compelling—though fresh is usually more enjoyable than stale. Biscuits (*biscotti*), as the French (and Italian) remind us, are twice baked. So too, pages in a palimpsest are at least twice written on, being appropriated by self and other. Patrick imagined sharing a North American cookie, shaped like and inscribed with his name as an edible self-narrative or signature piece.

Shape Poem by C. T. Patrick Diamond
di
amond
diamond diamond
diamond diamond diamond
diamond diamond diamond diamond
diamond diamond diamond diamond diamond
diamond diamond diamond diamond
diamond diamond diamond
diamond diamond
diamond
diamo
nd

A text shaped into a visual representation of an appropriate object/ subject is a *calligramme,* or what Apollinaire called "a heterotopian zone" (McHale, 1987, p. 46), that is, an alien space, such as a concrete poem, which is introduced within a familiar space, that of the page. A shape poem can provide a clean, geometric miming and aesthetic expression of self. Patrick remembers that, at the end of the high school term, much to the annoyance of his teachers, he had always signed his desk before it was stored away with others, not with the required initials in chalk on the lid but with his diamond memento

or symbol. The last (nd) and first lines (di) of the shape poem, *diamond*, remind Patrick that, unlike Clem (see chapter 7), he has no date (that is, n.d.) that is fixed on which to di(e). Patrick's son, John, often used say to him as he worked—and worked: "What will you say to death? Too busy to die today!" The space probe launched by NASA in 1990 to reveal unseen parts of the sun was called *Ulysses*. It was named after another often absent father.

Arts-Based Activities
1. "Sometimes I dream that I am an astronaut. I land my spaceship on a distant planet" (Lyotard in Peters, 1995, p. xix). Continue this spaceship story.
2. Borges (1967) wrote: "As a boy I used to marvel that the letters in a closed book did not get mixed up and lost in the course of a night" (p. 150). Role play a scene in which a class of students is told to open their textbooks for the first lesson of the day only to find that they have become nonsense verse.
3. Revisit a formal research paper perhaps that you once submitted as a course requirement. Use a colored pen to comment to yourself about how you then treated the topic at hand. Where did you feel that your personal voice was able to be heard and where was it drowned out? Add a voice to your palimpsest that may previously have been missing.

A Postscript Palimpsest

Peter Petrasek (see chapter 4) responded to the third invitation above in a 1997 course with Patrick in Toronto. He revisited a paper he had written, "Substance and Immanuel Kant's Notion of the Self," for a 1983 undergraduate philosophy course. His paper dealt with "a merely intellectual representation" of the "I." Peter contrasted his third-person discussion of self with a remembered insight first glimpsed as a seven year old: "I suddenly became intensely aware of the fact of my existence. I am." Peter had read Borges' (1967) short story, "The Aleph," in Patrick's class. As the first letter of the Hebrew alphabet, the aleph is a symbol of godhead, representing a point in space-time containing all points. Worlds reflect each other in their duplications. As in a cosmic kaleidoscope (from the Greek, *kalos* for beauty and *eidos* for form), the aleph is a moment of revelation or epiphany. (See chapter 7 for Patrick's boyhood experience of another revelation.)

Peter had experienced his aleph as a boy sitting on his wagon. He had just attained the canonical age of reason. Peter interweaves this missing aspect of self as bolded, italicized text throughout the 1983 paper. One of these pages of dual text appears below.

Kant says this is not the case. Self-intuition is not an intuition
I was sitting on my wagon looking east along the sidewalk in front of our
of the self. By means of outer sense, we can intuit the body in which
house when I suddenly became intensely aware of the fact of my existence.
the self resides, but we do not possess the kind of intuition that would
I am. I was conscious of being able to think about the fact that I was a
present us with an immediate intellection of the self in itself. Kant
being who could think about being! I remember being flooded with a sense
says, "by means of inner sense we intuit ourselves only as we are
of gratitude. I was seven at the time. I was sitting on my wagon looking
inwardly affected *by ourselves*; in other words, so far as inner intuition
east along the sidewalk in front of our house when I suddenly became
is concerned, we know our own subject only by appearance, not as it is in
intensely aware of the fact of my existence. I am. I was conscious of
itself."[10] In effect, the only things we intuit by means of inner sense
being able to think about the fact that I was a being who could think
are perceptions of perceptions. And those perceptions are necessarily
about being! I remember being flooded with a sense of gratitude. I was
related to the outer intuition through which they originally arise.
seven at the time. I was sitting on my wagon looking east along the
It is true that the mind can think of the "I," but this is a thought
sidewalk in front of our house when I suddenly became intensely aware of
or a representation; it is not an intuition. Again, Kant says:
the fact of my existence. I am. I was conscious of being able to think
"Certainly, the representation 'I am', which expresses the consciousness
about the fact that I was a being who could think about being! I
that can accompany all thought, immediately includes in itself the
remember being flooded with a sense of gratitude. I was seven at the
existence of a subject, but it does not so include any *knowledge* of that
time. I was sitting on my wagon looking east along the sidewalk in front
subject, and therefore also no empirical knowledge, that is, no experience
of our house when I suddenly became intensely aware of the fact of my
of it."[11] And, "The consciousness of myself in the representation "I" is
existence. I am. I was conscious of being able to think about the fact
not an intuition, but a merely *intellectual* representation of the
that I was a being who could think about being! I remember being flooded
spontaneity of a thinking subject. This "I" has not, therefore, the least
with a sense of gratitude. I was seven at the time. I was sitting on my
predicate of intuition, which, as permanent, might serve as correlate for
wagon looking east along the sidewalk in front of our house when I

the determination of time in inner sense.[12] Notice the emphasis on the
suddenly became intensely aware of the fact of my existence. I am. I was
word "knowledge" in the first quote. No knowledge can be had save by
conscious of being able to think about the fact that I was a being who
means of judgment. "I am" is not a judgment but an expression of a
could think about being! I remember being flooded with a sense of
basic, factual unity of self-consciousness. Empirical knowledge—such . . .
gratitude. I was seven at the time. I was sitting on my wagon looking . . .

[10] *Critique*, p. 101
[11] *Ibid*, p. 139
[12] *Ibid*

Peter completed his palimpsest by alternating all the pages of the written-all-over text with pages from "Stories of death, birth and transformation," a narrative he had written for a 1995 course with Michael Connelly of OISE/UT. That narrative began with the death of Peter's father in the summer of 1975, two months and 11 days after Peter's 16th birthday.

Arts-Based Activities

1. What might Peter now say to his Czech-born father?
2. What is the effect of Peter's repeated, round-like assertion? What complexities and freedoms does Peter's form of palimpsest offer you as a reader?
3. What is your aleph or emblem for a personal insight into the mysteries of knowing and travel?
4. In what ways could a teacher-researcher claim that either "I am a scribbled form drawn with a pen/Upon parchment" (Shakespeare, cited in Burgess, 1996, p. 138), or a book to be read?
5. If you could carry one book with you throughout your teaching-research life, what would it be? For the map-making English patient (really a misrepresented Hungarian Count and spy), it was an 1890 edition of *The Histories* by Herodotus. "He added to [it], cutting and gluing in pages from other books or writing in his own observations—so that all are cradled within the text of Herodotus" (Ondaatje, 1993, p. 16). What would you add in your own handwriting to the book of your choice? The English patient added fragments of diary entries, maps, writings in many languages, paragraphs cut out of other books, and even glued in a small pressed fern to form his book of life.

Near the end of Eco's (1984) *The Name of the Rose*, Adso, the young Benedictine novice narrator now grown old, recalls how he had returned to the ruins of the monastery many years after its destruction by fire. He wandered about collecting torn pieces of still surviving parchment. These disordered, tragically partial shreds of the once great library reflect the postmodern theme of "ill-assorted, cast-aside fragments of a once unified whole" (Dipple, 1988, p. 130). Collections of verbal fragments resist being pieced together into any coherence. Lasting statement or order is impossible. Writing always leads to more writing and any window (Figure 2) only to another (Figure 30).

References

Arnold, R. (1991). *Writing development*. Milton Keynes, UK: Open University Press.

———. (1993a). The nature and role of empathy in human development and in drama in education. In W. Michaels (Ed.), *Drama in education: The state of the art III* (pp. 55–68). Sydney: Harlow, Educational Drama Association.

———. (1993b). Managing unconscious and affective responses in English classes and in role-plays. *English in Education, 27*(1), 32–40.

Barker, P. (1994). *The eye in the door*. Harmondsworth: Penguin.

Barthes, R. (1977). *Image music text*. (S. Heath, Trans.). New York: Hill & Wang.

Bennington, G. (1993). *Jacques Derrida*. Chicago: University of Chicago Press.

Bessant, B., & Holbrook, A. (1995). *Reflections on educational research in Australia*. AARE Melbourne: Commodore Press.

Blumenfeld-Jones, D. S., & Barone, T. E. (1997). Interrupting the sign: The aesthetics of research texts. In J. Jipson & N. Paley (Eds.), *Daredevil Research: Re-creating analytic practice* (pp. 83–107). New York: Peter Lang. (Counterpoints Series)

Boas, F. (1943). Recent anthropology. *Science, 98*, 311–314, 334–337.

Borges, J. L. (1967). The aleph. *A personal anthology* (pp. 138–154). (A. Kerrigan, Trans., Ed.). New York: Grove Press.

Burgess, A. (1996). *Shakespeare*. London: Vintage.

Burns, R. (1994). *Introduction to research methods*. Melbourne: Longmans.

Clifford, J. (1984). On ethnographic allegory. In J. Clifford & G. E. Marcus (Eds.), *Writing culture: The poetics and politics of ethnography* (pp. 1–26). Berkeley: University of California Press.

Derrida, J. (1981). *Positions*. Chicago: University of Chicago Press.

Diamond, C. T. P. (1991). *Teacher education as transformation: A psychological perspective*. Milton Keynes, UK: Open University Press.

———. (1996). An appraisal of C. Wearring's (1996) project, The dynamic between empathic attunement, drama enactment, and

literacy development: A case study. Unpublished Honors Study, University of Sydney.

Dilthey, W. (1911/1977). *Descriptive psychology and historical understanding.* (R. M. Zaner & K. L. Heiges, Trans.). The Hague: Nijhoff.

Erickson, F. (1996). On the evolution of qualitative approaches in educational research: From Adam's task to Eve's. *The Australian Educational Researcher, 23*(2), 1–15.

Geertz, C. (1995). *After the fact: Two countries, four decades, one anthropologist.* Cambridge: Harvard University Press.

Hellman, L. (1976). *Pentimento.* London: Quartet Books.

Knowles, J. (1960). *A separate peace.* New York: Macmillan.

Lather, P. (1991). *Getting smart: Feminist research and pedagogy with/in the postmodern.* New York: Routledge.

————. (1995). The validity of angels: Interpretive and textual strategies in researching the lives of women with HIV/AIDS. *Qualitative Inquiry, 1*(1), 41–68.

Lincoln, Y. S., & Guba, E. G. (1985). *Naturalistic inquiry.* Beverly Hills, CA: Sage.

Lyotard, J. F. (1995). Foreword to M. Peters (Ed.), *Education and the postmodern condition* (pp. xix-xx). London: Bergin and Garvey.

Mandelbaum, D. C. (1973). The study of life history: Gandhi. *Current Anthropology, 14*(3), 177–196.

McHale, B. (1987). *Postmodernist fiction.* New York: Methuen.

Middleton, S. (1995). Doing feminist research: A post-modern perspective. *Gender and Education, 7*(1), 87–100.

Miles, M. B., & Huberman, A. M. (1994). *Qualitative data analysis: An expanded sourcebook* (2nd Ed.). Beverly Hills, CA: Sage.

Ondaatje, M. (1993). The English patient. Toronto: Vintage.

Owens, C. (1980). The allegorical impulse: Toward a theory of postmodernism. *October*, Part I, *12*, 67-86, Part II, *13*, 59–80.

Phillipson, M. (1989). *In modernity's wake: The Ameurunculus letters.* London: Routledge.

Pinar, W. F., Reynolds, W. M., Slattery, P., & Taubman, P. M. (1995). *Understanding curriculum: An introduction to the study of historical and contemporary curriculum discourses.* New York: Peter Lang.

Rabinow, P. (1984). Representations are social facts: Modernity and post-modernity in anthropology. In J. Clifford & G. E. Marcus

(Eds.), *Writing culture: The poetics and politics of ethnography* (pp. 234–261). Berkeley: University of California Press.

Rosenau, P. M. (1992). *Post-modernism and the social sciences: Insights, inroads, and intrusions.* Princeton, NJ: Princeton University Press.

Sher, A. (1985). *Year of the King.* London: Chatto and Windus.

Taylor, P. (1996). *Researching drama and arts education.* London: Falmer.

Vidal, G. (1993). *United States: Essays 1952–1992.* New York: Random House.

————. (1995). *Palimpsest: A memoir.* London: Abacus.

Wagner, B. J. (1994). The effects of role playing on persuasive letters of fourth and eighth graders. *English in Australia, 108,* 29–37.

Wearring. C. (1996). The dynamic between empathic attunement, drama enactment and literacy development: A case study. Unpublished Honors Study, University of Sydney.

Wittig, M. (1979). *Les Guérillères.* (D. LeVay, Trans.). London: Women's Press.

Wolcott, H. F. (1994). *Transforming qualitative data: Description, analysis, and interpretation.* London: Sage.

Woodall, J. (1996). The man in the mirror of the book. London: Sceptre.

Woolgar, S. (1988). *Science: The very idea.* London: Tavistock.

A Quest:
Birthing the Postmodern Individual

C. T. Patrick Diamond
Carol A. Mullen

A-wake: The Postmortem

Leonard Maltin (1997) lists 14 film versions of Mary Shelley's story of Frankenstein, including *Frankenhooker* (1990) and *Frankenstein General Hospital* (1988). The latter is described as the worst of all the English language series of Frankenstein films. Kenneth Branagh's version has since been made with Robert De Niro as the monster. Other actors who previously played the role include Boris Karloff, Bela Lugosi, Michael Sarrazin, and Randy Quaid. Drawing heavily on older plots is a feature of pastiche that is itself a symptom of postmodernism. In our book, we have assembled several forms that may be used to promote arts-based inquiry and educator development. We begin our Postlogue with a poem set in a graveyard and an operating room.

Art Takes Its First Awkward Steps
by C. T. P. Patrick Diamond and Carol A. Mullen

> Who's dead?
> A new dug grave awaits
> The in-ter(ra)nment of the pre-post body.
> Its main part took a fatal blow.
> Life ar-rested post-haste. Rigor mortis.
> Stayed too long at its post. The last post.
> "Pass the body bag, please."

Over the broken modernist body
the postmodernist "monster" now lurches.
Another stitched together Frankenstein,
the creation and not the Baron!

Postpartum, a body of opinion fears that,
even attaining fullness, the arts
cannot put/keep body and soul together.

The post-body etherized upon a slab of marble.
Time for its predelivery inspection,
the body cavity search, the logosectomy,
the dire-gnosis, and then out into the word-world.

Art takes its first awkward steps as inquiry,
gasping, lurching forth, stretching newfound limbs,
a patchquilt of ill-fitting parts.
Head, heart, fingers, and tail
all cast out from the dying zone.

Postmodernism's Grave/Brave Forms

He approached; his countenance bespoke bitter anguish, combined with malignity, while its unearthly ugliness rendered it almost too horrible for human eyes. His yellow skin scarcely covered the work of muscles and arteries beneath. His watery eyes seemed almost the same color as the dun-white sockets in which they were set, his shriveled complexion and straight black lips. (Shelley, 1818/1994, pp. 94, 57)

What is 't? a spirit?
Lord, how it looks about. Believe me, sir,
It carries a brave form. A thing divine; for nothing natural
I ever saw so noble.
There's nothing ill can dwell in such a temple. O brave new world
That hath such people in 't! (Shakespeare, *The Tempest*, Iii)

Postmodernism consists of "such a motley and elastic range of things [that] the term has a phantom, indefinite referent but certainly not oneself" (Marcus, 1994, p. 565). Throughout our book, we have sought to concretize postmodernism with arts-based examples of its practice, invoking the figures of the detective and the monster creation. Miranda's romantic question to her father, Prospero, about the fair Prince Ferdinand, recalls the fascination that postmodernism exerts in many

literary and academic circles (see chapter 1). For others, postmodernism more closely resembles Shelley's hellish brute. A blot upon the landscape. Because of its heavy bookishness, and because of anti-imperialist, revisionary readings, some critics of postmodernism may sympathize with Caliban's plot to have the books or "brave utensils" of the magician-master seized. Without them, the misshapen and disproportioned servant alleges, Prospero's "but a sot, as I am" (IIIiii). Can creatures be more human than their maker/keepers? Must Adam and Eve turn to fallen rebel angels? The marginalized also become unloved outsiders because of lack of understanding by others.

While postmodernists agree in refusing "to situate the researcher as the 'Great Emancipator' saying what things mean" (Lather, 1997, p. 298), they are still split by schisms that recall the semantic and doctrinal quarrels of the early church "fathers." Postmodernism marks the site of several intellectual debates, highlighting the multiplication of voices, questions, and conflicts that has shattered the unanimity of Western traditions (Groden & Kreiswirth, 1994). Different combinations of alternative positions that theoretical postmodernists can take include radical or establishment; hot or cool; deconstructive-eliminative or constructive-revisionary; apocalyptic-desperate or visionary-celebrative; reactive or resistant; skeptical-cynical or affirmative-optimistic (Rosenau, 1992); and critical or artistic. Other "post-ist" positions include postfoundational, poststructuralist, postindustrialist, post-Marxist, postcolonialist, postfeminist. A clumsy academic monster of many parts. But having too many names is like having no name at all. Terms proliferating, it becomes no thing, nothing (Vidal, 1993). There are too many clues and no easy solutions. How can we learn to play the inventor-detective within this changing landscape?

Suffocating under a blanket of dust, distressed creatures litter the barren zone of modernism. Their vital force has been lost. Two teams of would-be inventors are improvising a rag and bone creature out of whatever is at hand. Their offspring, postmodernism, may show us how to tolerate or even overcome the lack of oxygen and spark. The respective team leaders, Drs. Scepticus (the radical postmodernist) and Prospero (the affirmative postmodernist), each represent a range of positions from moderate to extreme, often criss-crossing one another. In general, Dr. Scepticus is "on the dark side," rejecting the certainty of knowledge and resisting the unified, coherent subject. S/he proposes the fragmented, postmodern individual as a substitute for the now dead modernist object. Like Frankenstein's miserable in-

vention, s/he rails against being "forever deprived of the delights of
. . . beautiful creatures" (Shelley, 1818/1994) and of hope. Night-
mares crowd out dreams.

In contrast, Dr. Prospero generally believes in the "force" and life
after modernism. S/he celebrates half knowledge and uncertainty. This
quality of *negative capability* or of acceptance of undecidability found
its supreme exemplar in Shakespeare (Bate, 1997), who showed that
invention is born out of the union of imaginative thought and artistry.
Dr. Prospero is sympathetic to the authoring postmodern individual
and accepts the need for more authentic representation, piecing to-
gether the leftover forms of literature and fiction. An imperfect para-
digm, as of arts-based inquiry and teacher development, is preferred
to an ashcan or a "postmodern prisonhouse of silence where . . . no
words are acceptable or adequate and none can legitimately be ut-
tered because authentic, accurate, communication is impossible"
(Rosenau, 1992, p. 20).

Focusing only on impotence, placelessness, decomposing and with-
holding of meaning, and the undoing of self produces paralysis and
despair. Nothing seems to hold together. If affirmative postmodernists
are like castaway mariners afloat in a tempest-tossed lifeboat who de-
vote themselves to the drama of the survivors, the skeptical seem
content to let everything sink, and so drown. But, as practitioners, we
have to break through to the surface each day to teach and do re-
search—however wayward. Rebel angels in one era are creators of a
new way in another. Somehow we have to live and write, even at the
risk of being perceived as doctrinaire in our pressing need to venture
beyond the modernist dead zone. We pursue the "unheard music" and
"unseen eyebeam" (Eliot, 1944) of the arts in the hope that even the
dust on the thorn hedges may be teased back into life.

As Michael Leunig's cartoon (Figure 29) suggests, arts-based repre-
sentations throw us a lifeline that we continue to spin, whether in
laughter or in tears. We have to keep ourselves balanced on our
tightwire in the midst of micro-beginnings, listening for the snip of the
shears of fate. Even as the malady of postmodernism is knowledge of
the death of ultimate meaning, "the creation of a work of art is our
one small 'yes' at the center of a vast 'no'" (Vidal, 1993, p. 20). An
arts-based inquiry provides us with an affirmation, a beginning if not
a landfall, an opportunity to play differently in and beyond the mod-
ernist enclosure. The task is to "restore continuity between the refined
and intensified forms that are works of art and everyday events that

Figure 29 *Tightrope Walker* (M. Leunig, n.d.)

are universally recognized to constitute experience" (Dewey, 1934, p. 1). The result may be more Ferdinand's brave form than Frankenstein's nemesis.

"The Dull Yellow Eye of the Creature Open[s]" (Shelley, 1818/1994, p. 56)

Daedalus made walking figures that waved their arms, Dr. Jekyll his Mr. Hyde, and Frankenstein his monstrous *bricolage* of human cadavers. The "component parts of the [last] creature [were] manufactured, brought together, and endued with vital warmth" (Shelley, 1818/1994, p. x). Galvanism supplied the spark of life. Prometheus had earlier fashioned godkin images out of clay, not body parts. He also had a secret ingredient, one stored in jars, the divine substance of chaos out of which all things had been created.

> He poured it out. Everywhere in its shining bulk were the bright, immortal seeds trapped like fireflies in some black, festooning web. Firmly and quickly the great Titan kneaded this ancient substance into the riverbed clay [figures]. (Garfield & Blishen, 1970, p. 68)

Words are all we have. They cluster like chromosomes at conception to build new meanings out of old. But radically different ideas, like transplanted organs, are always in danger of being rejected by vigilant defense mechanisms, taken for foreign matter or infection. For example, Vidal (1993) dismisses *avant-garde* novelists like Robbe-Grillet and Sarraute as clad "in white smocks [and] working out new formulas for a new fiction" (p. 97). He calls their work French letters. But postmodernism is a composite creation made up of many pieces, a patchwork of North American and Continental meanings—all enlivened by chaos. The limbs and tissues of postmodernism overlap at the edges, eschewing "the neat mutually exclusive, jointly exhaustive groupings so clearly desired by modern social science" (Rosenau, 1992, p. 16). Teacher-researchers must cobble together their own versions of teaching and teacher selves, kneading the arts into them to release the animating energy.

In postmodernism, representations are made and unmade like the female companion that Frankenstein promised to his creature. Each inquiry and teacher self combines opposites, denying regularity, logic, and symmetry, and relishing contradiction and confusion, even provo-

cation. Although written in the 18th century, Sterne's (1983) life of Tristram Shandy, with its extended treatment of his birth, provides an exemplary, postmodern panoply of missing chapters, black and blank pages, asterisks, dashes, various fonts, different languages, drawings, and apoisiopesis or sentences that break-off, leaving their implied conclusions unspoken. Breathless wonder. Arts-based inquiry and development may also provide "a ladder to a secret place above the trees and once there [we] can suck on the pap of life, gulp down the incomparable milk of wonder" (Fitzgerald, 1925, pp. 111-112).

Head and Heart and Fingerprint

We use the Frankenstein figure to represent postmodernism and its most disputed progeny, the self. A postmodern self is decentered, multiple, fragmented against itself even in the act of observing and representing itself. Self is birthed by its arts-based inquiries, but never in a finally developed form. Shelley's (1881/1994) cautionary horror story, subtitled *The Modern Prometheus*, exposes the perils of an isolated self-consciousness that is exalted and heightened despite all cost. Creator and created, head and heart, consciousness and imagination, intention and intuition, self and others, must combine and recombine—fire and soul, "immortal seeds [of self] trapped like fireflies." While a postmodernist self may seem a clumsy hodgepodge, it may still prosper and multiply. There could be no invention or remembering so thrilling as that which overtakes and surpasses its creator in inventiveness.

In our book, we are focusing not just on heroic, mythological Titans but on all postmodern educators and their quizzical arts-based possibilities. The arts can help us to find the power to expand and even change our lives and circumstances. Although "redemptive," future-oriented work is the special task of arts-based approaches, we each do not have to be a Wagnerian hero/ine to disturb/destroy the old modernist myths of education and research by which we previously organized and accounted for our lives. These are to be rebuilt/replaced by more limited accounts of the heterogeneity and dailiness of teaching and inquiry. Without becoming addicted to "the humanist romance of knowledge as [panacea] within a philosophy of consciousness" (Lather, 1997, p. 302), we can learn to find our own way into a future that is always in the making. We can accept that we are "bereft

of all the fictions of certain knowledge that supported past genera-
tions" (Lather, 1997, p. 291). Living in a twilight world of transition,
caught between an unsatisfactory present and an unworkable past, we
go on as best we can.

In postmodern inquiry, we assemble a body of evidence by sifting
the credibility of witnesses in order to reconstruct and consider a prob-
lem; that is, we seek to deepen our understanding both of an educa-
tional topic, as of teacher appraisal or of educational waste (Wolcott,
1990), and of an elusive self. What detective fiction was to modernism
as an epistemological genre so too it may also prove to be to
postmodernism, though combined with ontology, fantasy, and science
fiction. The popular detective thriller and science fiction function as
extensions of fairytale. They serve as postmodernism's "noncanonized
or 'low art' double, its sister genre" (McHale, 1987, p. 59). As post-
modern educators, each of us is a private eye or space traveler, bridg-
ing the gap between the worlds of appearance and reality, ferreting
out and questioning the trustworthiness of veiled scraps of informa-
tion and of each mysterious source. Our aim is not to discover the
eternal or the universal but to find conditions under which new under-
standings can be forged. People and meanings are always multiplici-
ties, drawn from different currents and swirls.

Henry Adams is fictionalized by Zencey (1997) as an academic de-
tective who learned about the science of Bertillonage at a morgue
after an autopsy. In this French approach to identification, measure-
ments (height, length of head, breadth of head, length of right ear,
length of right lower arm, length of right middle finger, length of ring
finger, length of left foot, length of trunk, and span of outstretched
arms) are used in combination to identify individuals. Galton suggested
the more convenient form of tracking people by their fingerprints:
"Those patterns on the tips of our fingers are different for every indi-
vidual" (Zencey, 1997, p. 109). However, dactology was first champi-
oned in a fiction by Mark Twain that had a murderer trapped by his
fingerprints. Arts-based inquiry allows each of us to leave our own
distinctive prints, the playing-cards of our identities—and without the
need for endless measurement or even for dusting with powder.

As postmodernists, we are not empiricists attending to measurable
quantities and calculable powers. We are "listening [instead] for a
moment to a tuning fork . . . struck upon a star" (Fitzgerald, 1925.
p. 112). We are dealing with possible soundings of our selves and our

practice—and with their artistic renderings, "a matter as elusive and amorphous as life itself" (Vidal, 1993, p. 12). As in a postmortem, virtually every facet of postmodernism has been subjected to "structural, stylistic, formalistic, epistemological processing. Aside from some outstanding seminal pieces, what is instructive about the entire theoretical enterprise is that it has created a Frankenstein" (Vidal, 1993, p. 114). It is no less surprising to encourage teachers to become postmodern, artistic educators than it is to find that many writers have come from a medical background. Some of these include Anton Chekov, Robert Coles, Conan Doyle, John Keats, W. Somerset Maugham, François Rabelais, Oliver Sacks, and William Carlos Williams. Maugham prepared for his art by keeping a writer's notebook for over 50 years. In contrast, Mary Shelley was not yet 20 years old when she wrote her ghoulish classic.

Playing with the Parts

Unlike die-hard compatibilists, arts-based researchers refuse to join in the necrophilia of any attempted revival of the modernist corpse. They prefer a theorized practice that "must always question its own presuppositions and uncover, record, and deny its own ideological gestures" (Kriesteva in Groden & Kreiswirth, 1994, p. 446). Postmodernists are seeking "interrogative texts that reflect back at their readers [and their authors] the problems of inquiry at the same time the inquiry is conducted" (Lather, 1997, p. 286). Such works hold their creators accountable, posing the paradox of knowing through not knowing, knowing too much and too little. These texts are "sounded together, reversed, chopped, swapped, run-on, cut-up" (Vidal, 1993, p. 143). Like Shelley's (1818/1994) monster, they lack smoothness and symmetry, providing "a Joseph's coat of left over pieces. The sewing shows; the reverse butchery is clear" (West, 1989, pp. 90, 92).

What postmodern educators can perhaps best learn is a kind of personalized meta-theory. This involves them in an urgent sort of dynamism: a restless quest for novelty, experimentation, a constant revolutionizing of practice and forms, a cult of parodic gaming, and the cultivation of the singular, intense presence of the speaking body. Arts-based, experimental forms of pastiche, palimpsest, and self-narrative offer molds for shaping such beginnings. Like the "(my)story" (Ulmer, 1989), such texts are specific to their authors and bring into

relation authorial experience with at least four levels of discourse: personal, autobiographical stories; shared or community tales; theoretical, expert, (inter)disciplinary accounts; and artful self-commentary.

Such accounts begin with personal memory, which is then located within arts-based, scholarly, and popular items significant to the writer and the topic. These fragments are assembled like a collage/montage to display a range of relationships to the text, the selves, and the events that are seemingly ordered. These can be humorous, playful, witty, contradictory, or even aggressive. The representations show how a life is lived through the participant's eye, which, like the camera's, is always reflexive, nonlinear, subjective, and filled with flashbacks, dream-sequences, faces merging, masks dropping, and new personae being adopted. This evolving, moving work is not to be confused with the "Studio Portraiture form of realism—tightly framed, sharply focused, unnaturally bright, and shadowless" (Van Maanen, 1995, p. 8). Postmodern educators are not dispassionate, authoritative third person observers who take photographs of, and totally control, their subjects. They understand that, although contexts frame their inquiries, their work enjoys the power of self-and-other construction. We are all picturing ourselves through language and image.

Connoisseurship can be thought of as achieving an appreciation of qualities and meanings of things already made. But struggling to create something new is even more artful and dangerous. It may occur only in fits and starts and may not develop smoothly over time. We proceed only by indirection,

> obliquity, and irony through the multiplication of endless layers of meaning in a text designed to foreground what it means to know more than we are able to know and write toward what we do not understand. (Lather, 1997, p. 299)

Despite all the inventiveness and interruptions, there may still be only a handful of basic models or body parts to be played with, including the work within the work; the dream of reality; physical and psychological voyages in time; and the doubling or echoing of dueling voices. Inquiry and movement play out on dual landscapes: that of action on which events unfold and that of the consciousness or inner worlds of the characters. The latter terrain is mined intensively by postmodernists. To educate is to lead out "but 'out' is possibly not 'outside.' It is no doubt within, far inside. One cannot reach it by uprooting oneself but by plunging deep within, toward what is most

intimate" (Lyotard in Peters, 1995, p. xx). In the midst of such movement, we glimpse insights into ourselves.

Arts-based inquiry and development begin and stay with an internal re-search of self as a knower and artist. Some engrossing puzzle emerges to confront the inquirer, including the need to sense the best— or the worst. In our book, we are committed to the topic of arts-based inquiry and development, one that remains closely connected to our individual selves and our contributors. As Wolcott (1990) found, there is no single and "correct" interpretation or modernist order, nothing to measure that can tell us what is important about our experience as postmodern educators. By taking in and vividly portraying the qualities of our experience, arts-based approaches allow us to mold an open-ended contraption that is multiform and indeterminate. The desired effect of this artistry is the more ready "re-education" of those who write and read the text. By continuing to redescribe experience in intensified ways, fresher patterns can be created out of the pieces of our teacher-researcher selves.

Growing New Tails/Tales

There can be no final conclusion as to the nature of postmodernism, self, practice, development, or inquiry because "to make an end is to make a beginning./The end is where we start from" (Eliot, 1944, p. 47). Without trying to put the mass/mess all together, we agree that artistically crafted inquiry offers

> much more than simply the use of representational forms we typically refer to as art: Social science generally can be regarded as an art form and at its best, it ought to be. . . . The education of researchers, in every deep sense, should be regarded as the education of artists. Artists need skill, imagination, sensibility, and insight. (Eisner, 1995, p. 5)

Assembling these divine (and even horrific) qualities, we may be on the verge of some "thing" even beyond postmodernism. But we are stuck in language while trying to create its new parts. Rather than having any formula, blueprint, or last word to post to you, our readers, we pray instead that you may always prosper with "your horizon broaden[ing] every day!" As Turgenev (1856) reminds us:

> The people who bind themselves to systems are those who try to catch the whole truth by the tail; a system is like the tail of truth, but truth is like a

lizard; it leaves its tail in your fingers and runs away knowing full well that it will grow a new one in a twinkling. (cited in Boostin, 1985, p. 81)

Every word, self, inquiry, and moment in history can be replaced by another—but at a cost. Rather than merely waiting/holding on, may we always seek to grow new tails and tell new tales! Your window onto arts-based practice (Figure 30) beckons.

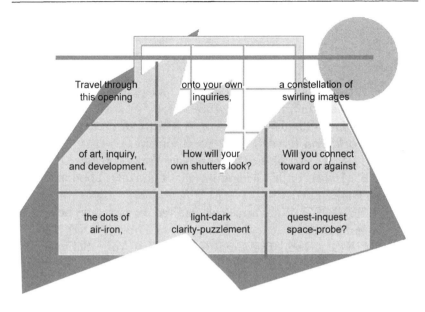

enjoy *Sketching your own artistic*
i
g
n
a
t
u
r
e

Figure 30 *Our Window onto Your Windows* (C. T. P. Diamond, C. A. Mullen, & W. A. Kealy, 1998)

References

Barone, T. E. (1987). Research out of the shadows: A reply to Rist. *Curriculum Inquiry, 17*(4), 453–463.

Boostin, D. J. (1985). *The discovery: A history of man's search for his world and himself.* New York: Vintage.

Dewey, J. (1934). *Art as experience.* New York: Putnam.

Eliot, T. S. (1944). Little Gidding in *Four Quartets.* London: Faber and Faber.

Eisner, E. W. (1995). What artistically crafted research can help us to understand about schools. *Educational Theory, 45*(1), 1–5.

Fitzgerald, F. S. (1925). *The Great Gatsby.* New York: Scribner.

Garfield, L., & Blishen, E. (1970). *The God beneath the sea.* London: Longman.

Groden, M., & Kreiswirth, M. (1994). The Johns Hopkins guide to literary theory and criticism. Baltimore, MD: Johns Hopkins University Press.

Lather. P. (1997). Drawing the line at angels: Working the ruins of feminist ethnography. *Qualitative Studies in Education, 10*(3), 285–304.

Lyotard, J. F. (1995). Foreword to M. Peters (Ed.), *Education and the postmodern condition* (pp. xix-xx). London: Bergin and Garvey.

Maltin, L. (1997). *Leonard Maltin's movie and video guide.* New York: Plume.

Marcus, G. E. (1994). What comes (just) after "post"?: The case of ethnography. In N. K. Denzin & Y. S. Lincoln (Eds.), *Handbook of qualitative research* (pp. 563–574). London: Sage.

McHale, B. (1987). *Postmodernist fiction.* New York: Methuen.

Rosenau, P. M. (1992). *Post-modernism and the social sciences: Insights, inroads, and intrusions.* Princeton, NJ: Princeton University Press.

Shelley, M. (1818/1994). *Frankenstein: The modern Prometheus.* New York: Signet.

Sterne, L. (1983). *The life and times of Tristram Shandy.* Oxford: Oxford University Press.

Ulmer, G. (1989). *Teletheory.* New York: Routledge.

Van Maanen, J. (1995). An end to innocence: The ethnography of ethnography. In J. Van Maanen (Ed.), *Representation in ethnography* (pp. 1–35). London: Sage.

Vidal, G. (1993). *United States: Essays 1952–1992.* New York: Random House.

West, P. (1989). *Byron's doctor.* Chicago: University of Chicago Press.

Wolcott, H. F. (1990). On seeking—and rejecting—validity in qualitative research. In E. W. Eisner & A. Peshkin (Eds.), *Qualitative inquiry in education: The continuing debate* (pp. 121–152). New York: Teachers College Press.

Zencey, E. (1997). *Panama.* New York: Berkley Books.

Subject Index

Aleph, The (story), 441
Angels and Insects (novel), 393
"Art Takes Its First Awkward Steps" (poem), 449–450
arts-based
 activity, 30–31, 46, 50, 54, 57, 59, 76–78, 80, 81, 84–86, 106, 117, 143, 156–159, 162–164, 166, 174–175, 184, 195, 210, 228–229, 239–241, 248, 258, 271–272, 285–286, 291, 300, 308, 321, 335, 353, 357, 386–387, 392, 403–406, 438, 441, 443
 collaboration, 342, 347
 (educational) research, 40–42, 342, 409–410
 inquiry, 8, 342, 344–345, 368, 452, 459
 narrative inquiry, 27–30
 representation, 23–25
autobiography, 79–80, 83–84, 191–193

birth, 1–2, 6–7, 376, 455
Bluest Eye, The (novel), 147–148
border crossing, 270

carnival(esque), 286, 308
carousel, 281–309
 carousel artwork, 289–290
 Carousel (film), 292–284
 as image, 284–286, 291

carousel–rider, 299–302
carousel–maker (creator), 299–302, 308
prison–carousel, 295, 297–298, 304, 309
"Welcome to Carousel" (poem), 294–295
cultural (self–)identity, 148–149, 154, 158, 163–164, 168–175, 177, 179–181, 184
curriculum masters, 409

death, 1–2
Dr. Jekyll and Mr. Hyde (novel), 75
duography, 259–260, 315–334

"Electrifying Blue Is She" (poem), 81

fantasy, 44–46
fiction, 37–39
"For Clem: Exhibit 3" (poem), 207
Frankenstein, 8, 450, 454, 457

"Give the Teachers a Blank Sheet" (poem), 87

"I'm Flying" (poem), 54–57

journal (dialogue), 327–333
 travelogue, 375–376

macro–mentorship, 379, 381–382, 386, 390–392

mentor, 376–377, 388–389, 390–391

mentoring
 mosaic/network, 380, 385
 movement, 387
 relationship, 376–377, 389
 stories, 377
mentorship, 380, 389, 391
metaphor, 19, 154, 162, 255–258, 378, 380
mirror(s), 69–72
Möbius strip, 346,
 Möbius strip (artwork), 348, 355–357, 366
modernism, 2
 modernist (body) corpse, 3–4
"Mr. Jones (To the Moon)" (poem), 310
music, 342
 musical chord, 342
"My Last Lesson" (poem), 387
mystory, 51–54, 457
multiculturalism, 158
 critical multiculturalism, 156–157
 multicultural curriculum, 155–156
 education, 148–149, 163, 174, 183
 leadership development, 175
 programming, 154

Name of the Rose, The (novel), 17, 440
"No School on Saturday" (poem), 193

palimpsest, 7, 428–438
"Peter's Childhood Report Card" (poem), 112
Panopticon, 270, 272–275
poem, 52, 54–57, 206–208
 shape poem, 112, 440

prose poem, 132–134, 376–377
research poem, 52
postmodern(ism), 20–23, 237–239, 282–285, 288–291, 424–425, 439, 450–460
 counternarratives, 22
postmortem, 1
puppets, 398–403

qualitative research, 39–40

"School Orchestra, The" (poem), 357–358
self,
 self-characterization, 72–74
 self-narrative, 105–113, 201–206, 208–210, 260–267, 349–366
"Shape Poem" (poem), 440
story,
 storyboard, 52, 55–56
 micro/scopic stories, 375–379
 macro/scopic stories, 379–382
Strangers on a Train (film), 284–285
subjugated knowledge, 267–270

teacher development, 18–20, 66–69, 367
 identity, 156, 164–166, 174, 178–180
 teacher-researcher, 73–79, 149, 157, 163, 346, 366
teacher education, 66–69
 preservice teachers, 148–149, 154, 167–169, 171

whiteness, 148, 150–151, 154–155
window(s), 9–10, 460–461

About the Authors

C. T. Patrick Diamond
is Professor at the Center for Teacher Development, Ontario Institute for Studies in Education, University of Toronto. He is Associate Editor of *Curriculum Inquiry* and has published over 120 works dealing with personal construct, narrative, and arts-based approaches to inquiry and teacher development. He is completing a three-year research project funded by the Social Science and Humanities Research Council of Canada.
E-mail: ctpdiamond@oise.utoronto.ca.

Carol A. Mullen
is Assistant Professor at Auburn University in Alabama. She specializes in arts-based narrative development, mentorship, and diversity within university, prison, and school settings. She has published numerous journal articles in addition to two 1997 books, *Breaking the Circle of One* (Peter Lang), *Imprisoned Selves*, and *New Directions for Mentoring* (in press). Her forthcoming works include guest editorial contributions to several journals as well as writings based on a partner support group effort with teachers and teacher educators.
E-mail: mullenca@mail.auburn.edu.

Studies in the Postmodern Theory of Education

General Editors
Joe L. Kincheloe & Shirley R. Steinberg

Counterpoints publishes the most compelling and imaginative books being written in education today. Grounded on the theoretical advances in criticalism, feminism and postmodernism in the last two decades of the twentieth century, Counterpoints engages the meaning of these innovations in various forms of educational expression. Committed to the proposition that theoretical literature should be accessible to a variety of audiences, the series insists that its authors avoid esoteric and jargonistic languages that transform educational scholarship into an elite discourse for the initiated. Scholarly work matters only to the degree it affects consciousness and practice at multiple sites. Counterpoints' editorial policy is based on these principles and the ability of scholars to break new ground, to open new conversations, to go where educators have never gone before.

For additional information about this series or for the submission of manuscripts, please contact:

Joe L. Kincheloe & Shirley R. Steinberg
637 West Foster Avenue
State College, PA 16801